# TAMARA DE LEMPICKA

# TAMARA DE LE

## A Life of Deco and Decadence

# MPICKA

*Laura Claridge*

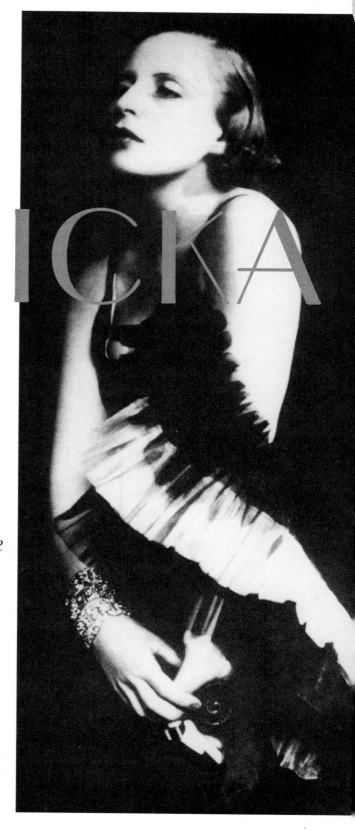

CLARKSON POTTER/PUBLISHERS
NEW YORK

Grateful acknowledgment is made to the following for permission to reprint previously published material: The Estate of Janet Flanner: Excerpts from *Paris Was Yesterday* by Janet Flanner. Originally published in *The New Yorker*. Reprinted by permission of William Murray on behalf of the estate of Janet Flanner. *Financial Times:* Excerpt from "Dada and the New Reality," by William Packer, September 20, 1977. Manchester University Press: Excerpts from *Women Artists and the Parisian Avant-Garde* by Gillian Perry, 1995, Manchester University Press, Manchester, UK. Simon & Schuster, Inc.: Excerpt from *Michael and Natasha: The Life and Love of Michael II, the Last of the Romanov Tsars* by Rosemary and Donald Crawford. Copyright (c) 1997 by Rosemary Crawford and Donald Crawford. Reprinted with the permission of Scribner, a division of Simon & Schuster, Inc.

Photographs of *La Fûite* and *Fruits sur fond noir* were reproduced through the courtesy of the Musée des Beaux-Arts de Nantes; other photographs appear through the kind offices of Alain Blondel, Victor Contreras, Victoria Doporto, Leah Erickson, Christie Tamara Foxhall, and Kizette Lempicka Foxhall.

Published by Clarkson Potter/Publishers, 201 East 50th Street, New York, New York 10022. Member of the Crown Publishing Group.

Random House, Inc. New York, Toronto, London, Sydney, Auckland
www.randomhouse.com

CLARKSON N. POTTER, POTTER, and colophon are registered trademarks of Random House, Inc.

Printed in the United States of America

DESIGN BY JANE TREUHAFT

Library of Congress Cataloging-in-Publication Data
Claridge, Laura P.
Tamara de Lempicka: a life of deco and decadence / Laura Claridge. —
1st ed.
1. Lempicka, Tamara de, 1898–1980.  2. Painters—United States—
Biography.
I. Lempicka, Tamara de, 1898–1980.  II. Title.
ND237.L545C59    1999
759.13—dc21
[b]          99-19700          CIP

ISBN 0-517-70557-5

10   9   8   7   6   5   4   3   2   1

First Edition

For Dennis Oppenheimer

∽

*"You were made perfectly to be loved—and I have loved you,
in the idea of you, my whole life long."*
—ELIZABETH BARRETT TO ROBERT BROWNING

# CONTENTS

~

# LIST OF ILLUSTRATIONS

*All photos except where noted are from the collection of Kizette Lempicka Foxhall, or her daughters, Victoria Foxhall Doporto and Christine Tamara Foxhall.*

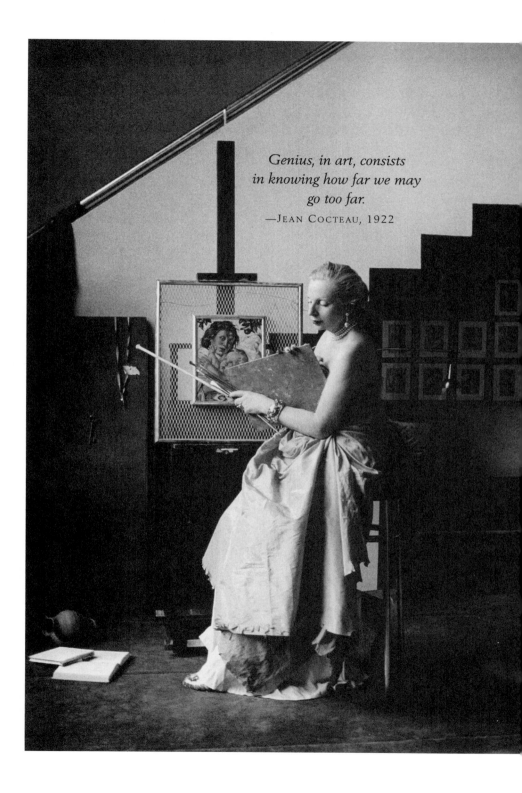

*Genius, in art, consists
in knowing how far we may
go too far.*
—JEAN COCTEAU, 1922

# INTRODUCTION

One warm summer day in the mid-1970s, Tamara de Lempicka was walking through the streets of Paris with a young woman friend, Countess Anne-Marie Warren. The painter, in her late seventies, was enthusiastically describing the "stupendous" naked bodies she had witnessed in a recent production of *Hair*. Stopping short as she walked, she nearly caused Anne-Marie to lose her balance. Confused, the countess stared at the artist, who stood still on the Place de la Concorde, silently weeping. "It is too much to believe, even now," the elderly woman said softly. "How could they have cut off the head of their own queen, a very good mother at that?" Several minutes passed before Tamara's friend realized the painter was referring to Marie Antoinette, guillotined almost two hundred years before on the spot where the two women stood.

"I was stunned," the countess recalls. "This woman had delighted in taking her granddaughter to the Beatles' concerts in Paris and New York, because she enjoyed the contemporary scene so much. And she was practically drooling as she remembered the nude cast of a musical she'd seen more than once. How in the world could such a *modern* woman be crying for the memory of a dead queen as if she'd been executed only weeks ago?"[1]

Such paradoxical behavior characterized one of the most powerful painters of the twentieth century—and one of the most thoroughly neglected. Omitted from the major encyclopedias of modern art, ignored even by feminist scholars, Tamara de Lempicka was an anachronism almost from her birth. She was born into wealth, but her life as an aristocrat was cut short when she escaped the Bolshevik Revolution by fleeing to Paris, where she believed she could become a self-made woman. Though influenced by the French Cubists as well as the—to her, more important—Renaissance masters, she invented her own kind of painting. Eventually and uneasily categorized as Art Deco, her work was diminished by a term that most often referred to design and architecture, not to fine painting. Some time later, on the wrong side of safety yet again, she and her Jewish husband

1

fled Hitler's Europe for Hollywood, then New York, Houston, and Cuernavaca, Mexico. "Life is like a journey," she told her granddaughter Victoria throughout the girl's youth. "Pack just what you need, since you must leave room for what you pick up on the way."[2]

Named by her mother for the heroine of one of Mikhail Lermontov's poems, either *Tamara* or *The Demon*, she fit the expectations that both comparisons to passionate women suggested. Sexually voracious, theatrical, stylish, smart, and talented, she was among the century's most dramatic and imposing personalities.[3] Whether it be her careless sexual affairs with any man or woman she considered beautiful, her glamorous parties, complete with drugs and naked servers, or her refusal to provide information about her past, the aura of decadence that came naturally to her ensured that she played always at center stage. Lempicka's theatricality eventually attracted celebrities to her work: while much of the art world elite remained unaware of her existence, Jack Nicholson, Madonna, Luther Vandross, Barbra Streisand, Wolfgang Joop, and Jerry Moss became major collectors, popularity that compromises her acceptance among certain connoisseurs. And though her paintings of the 1920s had helped create the image of the modern woman, Marie Antoinette's sense of entitlement, order, and self-indulgence were every bit as much a part of Tamara's character as twentieth-century values were. Her complexity extended to her painting; perhaps that is why she was neglected by those who defined the Modernist canon. She painted in iconoclastic, dramatically modern styles, while she also pledged allegiance to Giovanni Bellini, Pontormo, Antonello da Messina, and Caravaggio, in color and in brushstroke. She boldly painted the nude female with a lover's eye, yet she refuted classification by gender. She refused to court the avant-garde but defiantly participated in café society, even when it was clear that such frivolous associations caused other artists to underrate her talent.

In life and in her work, she did not play with the idea of depth versus surface. And it is here that she fits, after all, within Modernism's boundaries. Clement Greenberg, who probably did more than anyone in deciding how the story of Modernism would be told, defined Modernist painting by its self-containment—its typical refusal to refer to a subject outside itself, and by its flatness—its glorification of surface and of the medium itself. Greenberg rejected high finish, and a central tenet of Modernism became the proud vaunting of the brushstroke rather than the Renaissance invisibility that Tamara took as her inspiration. But art historians have failed to note when rejecting Tamara from their definitions of Modernism that her high artifice rehearses a major Modernist tenet. This artifice consists of a narcis-

sism so extreme that it becomes its own subject, constituting in the process a self-contained, self-referential painterly sphere.

Tamara's egoism, her lack of sensitivity to others, her refusal to make the compromises that might have extended her career—these undeniable qualities can threaten even today to diminish our regard for her achievement. When one gets close to the artist, however, it becomes clear why her dearest friends—generally low-key, impressive, and intelligent contributers to the century's progress—remain unapologetically loyal. Tamara, they claim, was never false; she was incapable of being anything but genuine. Such authenticity also made her oddly vulnerable, as if she simply didn't understand that intention alone was not enough to control her destiny. But the most constant point of agreement between those who loved Tamara de Lempicka and those who hated her occurs here: no one disputes that she was inimitable.

Alexandre Dumas fils described the kind of Slavic woman Tamara most nearly exemplified: "These ladies [are] endowed with a fineness of sensibility and an intuition far above the average, which they owe to their double inheritance as Asiatics and Europeans, to their cosmopolitan curiosity, and their indolent habits . . . these strange creatures who speak every language, hunt the bear, live off sweets, and laugh in the face of every man who cannot master them . . . these females with voices at once musical and hoarse, superstitious and skeptical, fawning and fierce, who bear the indelible mark of the country of their origin, who defy all analysis, and every attempt to imitate them."[4]

These characteristics contributed to the charisma that made Tamara the star of so many local dramas. But such narcissism also created an obstacle to normal social relations, especially in her old age when her histrionics appeared faintly absurd instead of charming. Conveying the vulnerability and strength, the humor, and the sly self-awareness that undercut her melodramatics—these qualities that finally laid claim to my affection—has proved to be the major challenge of this biography. There was no danger of hagiography here; rather, Tamara's faults too often threatened to obscure the fondness that this flamboyant, demanding artist inspired even in those who endured her demands firsthand.

Reconstructing, or even attempting to interpret, the life of Tamara de Lempicka has thwarted would-be biographers because of the almost total lack of letters, journals, diaries, and other documents that typically support personal histories. Determined above all to narrate her own story, Tamara told anecdotes, complete with punch lines, instead of revealing the substance of her life. Since critics could find nothing else to rely on, they

repeated her provocative stories as fact, unaware that she had fabricated almost everything, even the country of her birth. Luckily, Tamara's obsessive accumulation of press clippings regarding her shows and her social life proved a useful substitute for more conventional materials. Even more important to the writing of this book was the cooperation I received from several old friends of Tamara who had hitherto been silent about their secretive comrade. I also gained invaluable assistance from the U.S. Immigration Office and the Polish, French, and Swiss governments, as well as two important research agencies, Blitz (Russian-Baltic Information Center) and the Russian Archives at the University of Leeds (Richard Davies), superb sources of information about Russian life at the turn of the nineteenth century. They helped me find everything from Tamara's childhood street addresses to century-old telephone numbers. Tamara's personal phone book, random notes taken during the last years of her life, and several interviews she granted just before she died also served my project well. Others, too, who have spent years working on her secrets, were generous in providing information, Alain Blondel in particular, as well as the authors of various catalogs and summaries of Tamara's oeuvre.

Longtime supporters and admirers of the artist have, understandably, lamented the paucity of information previously available about her, reminding us that anonymity is not useful in achieving critical recognition. Tamara justified her reluctance to answer questions about her past by claiming that her art was all that mattered: people should not confuse the personal life with the creative product. Although I am convinced that an artist's person and her productions are, in fact, intertwined, the unanswerable question is exactly how and where the two relate to each other.[5] Locating such an intersection is, of course, impossible; biography is not the place to search for the absolute application of a life to its art. Biography, if it is honest, can only suggest correlations between the two, but it earns those suggestions, if it is successful, by the considered presentation of both.

Authors of initial biographies enjoy the priority of reference, but they risk the pain of seeing themselves—if they have made their subject rich enough to merit a future—superseded as more information becomes available. Even the seemingly simple question of the artist's name assumed significance with this first history: I use "Tamara" at times, denoting the intimacy she achieved with those closest to her; and "Lempicka" at others, as public testimony that she was first and foremost, according to her own self-definition, a professional artist. And I allow her to speak often in her own idiosyncratic English syntax, so that readers get as close as possible to the real thing.

Tamara's ghost, often late at night, has occasionally granted me moments of intimacy—a sudden guttural chuckle in my ear, a haughty smile flitting across my face but clearly sketched there by someone else; studying a painting or a relationship, I sometimes sensed her presence. And it felt benign, for all its power. Tamara's dear friend Victor Contreras, who believes in the mystical realms that Tamara considered absurd, has steadfastly maintained that he felt Tamara's blessing on my project: "I know she sent you here to us in Cuernavaca," he solemnly intoned as we stood on a balcony overlooking the lushly beautiful city that the artist loved. "I feel her spirit present, telling us you will comprehend who she was." That I can only hope is true; but what I unquestionably came to understand was the extraordinary presence she exerted, even in death. In spite of my constant frustration in following the trail she had hidden so carefully all her life, I was rewarded by meeting others who have experienced the visceral pull, the potency, of an artist who was determined not to be forgotten. Although a few modern philosophers are bold enough to frame discussions in terms of "presence," most twentieth-century theorists disdain such a metaphysical concept. Nonetheless, after spending five years in the presence of Tamara's paintings and among the traces of her life, I capitulate to the notion of an aura that attaches itself to greatness, however anachronistic its manifestation. Tamara has convinced me of that.

*Chapter 1*

# MYTHICAL BEGINNINGS

**B**y early afternoon on 19 March 1994, Christie's main auction room at 502 Park Avenue in New York City was filled to capacity. Emanating scents from the thirties—Chanel No. 5, Joy, and the newly revived Arpège—several expensive-looking women, craning their necks to study the forlorn latecomers standing in the back, seemed more interested in the company they were keeping than in the objets d'art. In the middle of the crowd, three drag queens, vamping the roaring twenties in their gold lamé gowns and feather boas, examined the lavish catalog. Their exasperated comments suggested that the presale estimates were higher than they had anticipated. For days the wealthy potential buyers (carefully targeted by Christie's thorough preregistration) had been attending publicity events—dinners and video shows—that emphasized the glamorous, high-profile nature of this sale. Christopher Burge, Christie's crisp British president, took his place at the front of the suddenly silent room, and the dais began to rotate as one exquisite object after another sold quickly, most of them for predictable prices. Gustav Stickley furniture, Tiffany lamps, Jacques Lipchitz paintings: the spotlight lent each item the Hollywood glow of the collection's owner, Barbra Streisand. As the digital board at the front of the room lit up with Japanese, French, and German cur-

rencies competing against the dollar, the wood-paneled room seemed to hum with excitement.

Suddenly a collective gasp escaped the audience. Tamara de Lempicka's *Adam and Eve*, painted at the end of 1931, shimmered at the front of the room, its impossibly luminous nudes confounding even those who believed themselves inured to the old-fashioned finish that pre-Modernist artists had valued so highly. Dealer Michel Witmer nodded a bit smugly; he had already provoked many arguments by contending that this painting would prove the crowning jewel of the show. In the face of his colleagues' disbelief, Witmer, adamantly maintaining that *Adam and Eve* was not painted on canvas, insisted that the preternatural glow of the flesh tones could only result from oil on wood. After all, he had said, "during the 1920s, Lempicka spent hours at the Louvre on a weekly basis studying what she considered the masterpieces of light and color. Clearly she was influenced by the sixteenth-century Dutch paintings that achieved a translucence in their figures partly due to painting on panels."[1]

"What am I offered for this extraordinary panel painting by Art Deco's most famous portraitist, Tamara de Lempicka?" Mr. Burge quietly but imperiously began. As the numbers climbed rapidly from the already extravagant presale estimate of $600,000, the room filled with chatter. Promoting the painting, the auctioneer alluded to the peripatetic life that had inspired the artist's dramatic works: Warsaw, St. Petersburg, Paris, Milan, and Cuernavaca. As if on cue, a spate of international phone bids raised the price even further. When the offer reached $1 million, the room grew tense. Numbers were flying on the digital printout, and everyone watched Michel Witmer to see how far his client would go. A woman dealing by phone for her Saudi Arabian collector offered $1.25 million; turning toward Witmer, Christopher Burge intoned, "One point five?" The dealer nodded. Back to the phone: the anonymous caller raised her bid to $1.8 million. After an almost imperceptible sign from his client, Witmer shook his head, refusing the offer to exceed $1.8 million. "Going once," the audience heard, "going twice . . . sold for one point eight million dollars." With commissions added, the final sale was $1.98 million.[2]

On that mild March afternoon when the gavel sounded in Christie's main salon, one of the twentieth century's most important and iconoclastic artists was returned to the limelight after a long hiatus. Years of comparative obscurity would yield to public scrutiny as the painter's reputation began its most significant reevaluation in over fifty years. Tamara would have loved and hated the whole affair. Money defined artistic worth in her world: she had refused to sell paintings when the offers insulted her pride. Both the sale

price and the international flavor of the bidding would have pleased the painter who lived her life as a citizen of the world. But had she been accosted by the reporters on her exit from the room (as the underbidder for the painting was), she would have raged at their implication that she was being rediscovered, and at their suggestion that her talent increased in proportion to her Hollywood connection. Celebrity was something she appreciated. She had, in the late 1930s, enjoyed socializing with the members of the movie industry, but she had never thought them great judges of art. During the two years she lived in Los Angeles she was known as the Baroness with a Paintbrush, an epithet that motivated her to move to New York in the hope of reestablishing her reputation as a serious artist.

A mere four months after the auction at Christie's, the Montreal Museum of Fine Arts held a Lempicka retrospective. Art historian Robert Rosenblum enthusiastically observed that Tamara was "a liberated woman and she was frankly erotic . . . a thinking woman's Léger." But in a review entitled "The Price Will Go Up, Tamara," *Newsweek*'s art critic, Peter Plagens, referred to the painter as "practically forgotten," producing "almost soft porn," with only "eighty-four paintings known to exist." (Minimal research would have revealed the current count of almost five hundred.) Tamara, he pronounced, was "the end product, not the producer of art that influences other artists."

Among the other astonishing inaccuracies in Plagens's article, it would be difficult to find a less apt description of Tamara de Lempicka than "not very inventive." But Lempicka herself created the context for such flagrant misrepresentations. Until she died in 1980, up to the last moment taking drags off her Viceroy, then gulping down oxygen to feed her emphysema-ravaged lungs, she insisted to everyone, including her family, that she was her own maker—with perhaps a grudging nod in God's direction.[3] To maintain her myth of self-creation, she developed a calculated, refined repertoire of anecdotes, which she repeated throughout her adult life. Her relentless manipulation of the facts backfired, however: by leveling the real drama of her life into a calcified catalog of stories, Tamara reduced herself to a caricature. Instead of being mistress of her own history, she ended up illustrating better than most the fact that each of us is the child of the historical and social conditions in which we live.

Wherever she relocated throughout her life, the itinerant Pole never wavered in her Keatsian conviction that the universal truth of art was beauty, the basis of all great painting. Yet in terms of the zeitgeist, her timing was off: nothing could have been less Keatsian than Modernism. Sensing that she was rowing against the tide, Tamara eventually tried to present herself as a kind of romantic outsider. But the rewards of such deliberate marginality

were meager recompense for the professional ignominy she endured during her lifetime. Early in her life she suffered because, as a Pole without a country, she was on the losing side of European political struggles. Later, when her talent as a painter took shape, she found herself displaced by artists more politically and professionally savvy than she. As a result of her singularity, art histories ignored her or, at best, patronized her as an anachronism.

Tamara's own version of her life was undeniably spectacular: she was working, after all, with excellent raw material. The turn of the century, and the belle epoque, the Bolshevik Revolution, the *années folles*, and two world wars carried her from birth to middle age. Her creative rewriting of history, however, distorted facts as fundamental as her date of birth, most often cited, even on official documents, as 11 May 1898. This date appears to be several years too late when juxtaposed with other major events in her life. Like many upper-class women of her time, Tamara stretched the truth about her age as far as she dared. The *New York Times*, for instance, accepted the account the painter provided just before she died, a courtesy that allowed Tamara's obituary to read "born in 1902."

Many women of Tamara's generation lied about their age, but it was not routine to hide one's place of birth. As a result of her subterfuge, every biographical entry on Tamara starts with a falsehood: her own assertion that she was born in Warsaw. Family marriage licenses and death certificates, stepchildren's recollections, and family photographs establish that Tamara

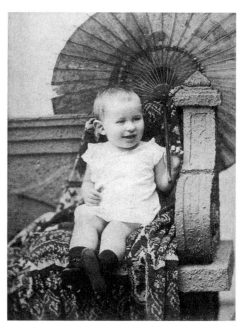

was actually born and raised in Moscow, where many wealthy Poles lived at the time.[4] Determined to hide the fact that her Polish mother had married a Russian Jew, Tamara lied about her birthplace on official documents throughout her life.

Several of Tamara's friends now whisper that she confided the truth to them, along with a paranoid warning of vague but disastrous repercussions to her if they passed on the information.

*Tamara Rosalia Gurwik-Gorska, c. mid-1890s.*

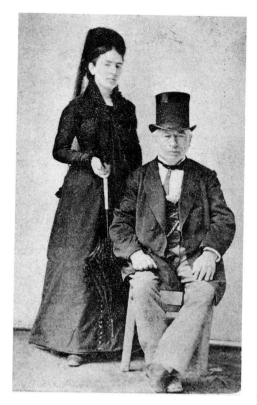

*Clementine and Bernard Dekler, Tamara's maternal grandparents, early 1880s.*

Her daughter Kizette Foxhall surely knows the truth about her mother's birth, but she professes a weary indifference to the subject. And when Tamara's stepniece Françoise Dupuis de Montaut was asked about the Cyrillic inscriptions on Tamara's early childhood photographs, she replied with surprise, "Of course the family was born in Moscow, and they grew up there. I always knew that; it was no secret with Adrienne [Tamara's sister]. But the fact was brought home to me in the 1960s, because when my husband was being investigated for top-secret clearance by the Canadian air force in the 1960s, background research left the Canadian government nervous about the Russian connection of my father's wife [Adrienne]. They had to ensure that everything was okay on that end."[5] Always more straightforward than her sister, Adrienne cited her birthplace as Moscow on her marriage license, and it is listed again on her death certificate.[6]

Family evidence and archival records in Moscow and St. Petersburg suggest a plausible if incomplete genealogy. Tamara Gurwik-Gorska was born in Moscow to a wealthy Polish mother, Malvina Dekler (variants: DeKler, Decler, and Declaire), and a well-to-do Russian merchant father, Boris Gurwik-Gorski. Malvina's grandfather Dekler had migrated from France to Holland to Poland during the Napoleonic Wars. When Malvina was a young woman, her parents, Bernard and Clementine Dekler, moved from Warsaw to Moscow so that Bernard could head a local branch of the bank he then worked for, probably Crédit Lyonnais. With branches in major cities throughout Europe, the bank often sent its Polish executives to Russia, since one-third of Poland was under Russian rule at the time.

The prosperous Bernard Dekler is known primarily through several faded

*Tamara's maternal grandmother, Clementine Dekler, c. 1910.*

sepia photographs in Tamara's collection, two labeled in Polish, one in Russian. The grand surroundings of one portrait—the baroque velvet chair he leans on, the marble inlaid fireplace behind him, the hint of ceiling frescoes—substantiate Tamara's references to the Dekler wealth, whose source was alluded to vaguely as "a family history of the professional class, bankers and lawyers for the most part."[7]

Bernard took his place in the Dekler mythologies as a worthy and genial breadwinner for his talented brood, but beyond this function, apparently little was thought or said of him. Tamara claimed that she recollected him most strongly for his "unfortunate appearance": the bright blue eyes and "short, straight" nose pleased her, but she was repulsed by "his round face and beard, the latter in the style of Napoleon III."[8]

Family life centered instead upon Bernard's wife, Clementine, a large-boned and imposing woman, handsome rather than pretty. Remembered most often by her progeny for her skill in music, embroidery, and languages, Clementine inspired an easy happiness among her children and their families. Most important, she conferred authority upon all things female.

Tamara's maternal lineage was the source of her family pride. Her complete omission of the Gorski past contrasts dramatically with her pleasure in recounting Malvina's background: "The great-grandparents of my mother's generation came to Poland as refugees from the French Revolution: their life-size portraits hung on the walls of my grandmother Clementine's house."[9] Malvina had three sisters and two brothers, though the few extant pictures of Clementine and Bernard Dekler's clan show only the four daughters. Several weeks before his death in 1996, Clement Dekler, Tamara's cousin (born in Warsaw on 14 December 1911 and named after his grandmother), carefully reconstructed the family tree.[10] According to his account, Clementine and Bernard Dekler encouraged an ethos of achievement in the boys and one of cheerful class consciousness in their sisters. Zigmund

*Stefa, Malvina, Franka, and Eugenie Dekler, c. late 1880s.*

became an engineer, later distinguishing himself as a pilot for Poland in World War I, during which he was killed. Edmund worked as an accountant with the Polish internal revenue. After marrying a German woman, he and his wife moved to Russia before the Bolshevik Revolution. During the upheaval the couple separated, whereupon he returned to a fragmented Warsaw, while she went to France with their three daughters, one of whom is still alive, though uninterested in discussing her family.

For no clear reason, Tamara at age eighty provided an entirely different account of her two uncles, one that is not consistent with the few remaining relatives' memories. Claiming that the men were named Maurice and Jules, she wrote that Maurice attended the University of Belgium, where "he got a girl pregnant." The unfortunate Jules, according to Tamara's brief notes, took his own life when she was five years old. Maurice was in fact the name of Stéphanie Dekler's husband, a happy man to the end of his life; and Jules was a nickname for Tamara's father-in-law, who died a natural death.

Whether unconscious or deliberate, Tamara's careless treatment of the Dekler men emphasizes the matriarchal structure of her family, in which men were the leaders in name only: Clementine, Malvina, and her

sister Stéphanie (Stefa) were the authorities. A vivacious, fun-loving woman, Malvina (who in photographs appears to be the eldest daughter) enjoyed giving lavish parties for family friends. Typical of her class, she attended finishing school in Switzerland, frequented resorts in Italy and Monaco, and became a fixture at the seasonal parties in St. Petersburg, a history recounted and later reenacted by her daughter Tamara. The few surviving pictures show her slender yet voluptuous, her narrow face featuring a rather broad nose and mouth.

*Malvina Dekler Gorska, pregnant with Adrienne, late 1890s.*

Even when pregnant, the youthful Malvina projects an easy, friendly confidence as she focuses, a bit flirtatiously, upon the camera.

The other Dekler girls were also considered good-natured. Françoise (Franka) married Bronislaw Schultz, who became conductor of the Philadelphia Philharmonic in the 1920s. The couple later moved to Israel, where they had two sons: the charming, debonair Andrew, who played the piano brilliantly; and his more somber younger brother, Richard. Both of Franka's sons committed suicide—Andrew upon learning that his German wife had been in the SS, in charge of a concentration camp, and Richard, unaccountably, a few years later. Clementine's third daughter, Stefa, married a wealthy banker and lived in St. Petersburg, then called Petrograd, before the revolution. They had two sons: Constantin, who became an architect in Paris and married his uncle Edmund's daughter, his first cousin; and George, a bon vivant who taught English. The fourth sister, Eugenia, remains unaccounted for; both Clement Dekler and Kizette recall their other aunts, but Eugenia is little more than a name.

During the early 1890s, Malvina Dekler married Boris Gurwik-Gorski, whom Tamara vaguely described as a "wealthy businessman or banker, someone my mother met at one of the European spas they both visited."[11] A large number of upper-class Gurwiks (in Russia, Gurwik is almost always a Jewish name, and Tamara rarely included it as part of her own name) were Muscovite bankers and merchants. Friends have long assumed that Tamara's father was Jewish, a conclusion based on vague intuitions: "She just gave out hints, and acted funny about her supposed Catholicism."[12] Tamara's reticence on this particular subject, at least, is understandable. Russia was deeply anti-Semitic; a special permit had to be granted for a Jew even to live in St. Petersburg. Boris Gorski, in the only photograph Tamara saved of her father, appears to be a handsome, tense, mustachioed wealthy man, with wavy hair down to his ears. Somewhat swarthy, he stares insolently out of deeply hooded eyes (which Tamara inherited) of an unsettling, brilliant blue. Malvina and Boris had three children, born probably between 1894 and 1899: Stanislaw (Stanzi), Tamara, and Adrienne (Ada).

Boris Gurwik-Gorski remains the most thoroughly expunged person in Tamara's life, her most successful secret. Until Tamara died, she insisted she could not remember her father and did not know what had happened to him. One of Tamara's treasured photographs from the late 1890s seems to be of a couple, but all that remains is a torn remnant showing the playful-looking Malvina, its jagged edges suggesting Boris Gorski's early disappearance from his daughter's life. At various times, Tamara declared she was "one

*Boris Gurwik-Gorska and Stanislaw, Tamara's father and her brother, c. 1900.*

year old," "two or three," and "five" when suddenly her father vanished. "No one knew what happened to him," she told her daughter. "I never heard about him again."[13]

But in a cache of personal notes that Tamara made in the late 1970s, when she was contemplating writing her memoirs, she recorded vivid early memories of her parents' arguments, recollections that contrast with her vague dismissals of her father from the family album. Instead, she now admitted that "Ma mère Malvina et mon père vivaient mal ensemble. Querelles malentendus—mon Père est parti—un jour il n'est plus revenu—

j'apprends le divorce" (My mother, Malvina, and my father were unhappy together. Arguments and misunderstandings—my father left—one day he didn't come back—I learn of the divorce).[14] She dictated these notes to Kizette in her odd amalgam of French and English, resulting in six pages of family background.[15] Disappointing in their brevity, the memories nonetheless evince a greater awareness of her early life than Tamara previously had admitted. At age eighty-two or -three, the artist devoted her waning energy to setting the story of her life straight, as if she was determined to shed the mystery she had cultivated until then. The reminiscences abruptly stop, however, after she describes her twelfth year, as if she found it too stressful to separate fact from fancy after so many decades of secrecy.

More important than any specific revelations, the notes imply the logic by which Tamara constructed her half-truths, half-fictions. Her family history, for instance, includes the claim that her uncle committed suicide. Jules, ill and reclusive, lived with Grand-mère and Grand-père, and barely spoke to anyone: "Le frère cadet, Jules, Julek, c'était un grand secret, car on ne disait rien aux enfants" (The younger brother, Jules, Julek . . . that was a big secret, because nothing was said to the children). When Tamara was about five years old, the problem of Jules's mental instability became public knowledge. One morning the maid knocked on Jules's door. When he didn't open it for his breakfast, she pushed until she forced her way in. There she found "blood dripping everywhere": Jules had shot himself in the head with a pearl-handled revolver.

In her fractured French, Tamara recorded the scene: "Grand-mère pleurait—soeurs pleuraient—a 5 ans mon premier grand chagrin—première fois j'ai compris qui'il se passe des choses auxquelles on ne peut aider. La MORT." (Grandmother cried . . . sisters cried . . . at five my first great pain . . . first time I understood that there are things one can't help with. DEATH.) Tamara claimed that Clementine and her aunts sobbed for days.[16]

The major problem with this believably somber account remains the insistence of the methodical Clement Dekler that there was no uncle named Jules. The only suicides, he maintained, were Aunt Franka's unstable sons, Andrew and Richard, in the following generation. Perhaps Jules was a third son born to Clementine and Bernard, one not mentioned to family members born after his death in the early 1900s. Clement Dekler, whose early life was caught up in the war, may never have known about Jules. But Olga Campbell, Clement's daughter, demurs: "My father was very careful with his family's genealogy. I can't believe he would not have discovered a third son, if one existed."[17] Or Jules may have been the younger brother of Clementine, not Malvina, a distinction that Tamara blurred during the lapse of almost eighty years.

On the other hand, the anecdote conforms to a certain pattern by which Tamara invented her personal mythology. Almost compulsively, she incorporated something nearby—whether spacial, temporal, or psychological—into the narratives she created. Rarely were her stories entirely fiction. By the time she wrote this account of her phantom uncle's suicide, she had married a man whose father was, in fact, named Julian. Her own father had disappeared, at least by the time she was five, and except for her sister Adrienne's citation of a "deceased father" on her own marriage license in 1939, there is no mention of him anywhere.

Given the mystery surrounding Boris Gorski's absence and the confusing story of the "troubled brother Jules," it seems most plausible that it was Tamara's father, not a third uncle, who committed suicide when the girl was five. Boris Gorski fought so often with his wife that perhaps the young girl combined the traumas of divorce and suicide into her explanations of loss. At the turn of the century, suicide carried a more severe stigma than did divorce.[18] Until further death and divorce records can be located in Moscow, it is impossible to know just how Boris Gorski disappeared. Even in 1979, when asked by interviewers to state her father's name, Tamara refused "because they are still there, the Russians. . . . Because they are nasty people, you know, they can kill me today."[19] Her adult fear of communism may have attached itself retrospectively to her Russian father, Boris Gurwik-Gorski; both deprived her of her patrimony, and both were off-limits as topics of conversation.

Whatever the reality of Boris's departure, Tamara's mother seems to have relied upon Clementine and Bernard for her livelihood, an inference that is supported by Tamara's consistent references to her grandmother's homes and the lack of any mention of a separate familial household. Bernard Dekler clearly fulfilled the role of father until her uncle, Maurice Stifter, replaced him when Tamara was an adolescent. At one point in her notes, she confusingly claims that her father was "très sévère" with the children: when the three siblings were eighteen, twenty, and twenty-two years old, she recounted, they were forced to hide from him the costumes they were sewing for a masked ball.[20] Since by these ages the "children" were dealing with World War I and the Russian Revolution, and she herself was living with her aunt and uncle, Tamara's chronology must have been confused by her own advanced age as she dictated her memories. But her conflation of different men—father, uncle, grandfather—conveys her conviction that the precise identity of the man wasn't important.

While recalling such paternal sternness, Tamara suddenly retrieves a fond memory of herself as a very young child who happily sat on her father's

*Bernard Dekler and Tamara, early 1900s.*

lap. Every morning they enacted the same routine: "spoiling" her, her relative "forced her to taste" each item he was served, in contrast to the strict child-rearing conventions of the day.[21] "Jusqu'a ce jour je ne peux oublier le gout de ces petits pains croustillants, du bon beurre, du poisson fist, du fromage, du jambon délicieux, et parfois même de son café (à l'age de 3 ans)." (To this day I can't forget the taste of those crusty rolls, of the good butter, of the fish, of cheese, of the delicious ham, and even occasionally of his coffee [at age 3].) This childhood memory—the earliest that Tamara recorded or even mentioned to anyone—braids love and food in a theme that would be repeated throughout her life, from the odd anecdote of the unnamed and almost mythical father feeding her from his lap, to a later admonishment by her art teachers to stop eating the pastries that had been set up as still life models, to her final, resigned acceptance of a wealthy older suitor with whom she shared little passion except for gourmet meals. The "hunger" that, according to the artist Françoise Gilot, was Tamara's most salient feature—the palpable appetite that Gilot believed reverberated from her person and her paintings—registered in Tamara's lifelong quest for physical satisfaction.

Regardless of Bernard Dekler's kindness, his granddaughter's convergence of memories—loss of her Russian father with her later loss of the country as she knew it when the Bolsheviks took over—caused the adult Tamara to reject all references to Moscow. From the time she was a young adult, whenever she had the opportunity, she strove to establish that she was a Pole from Warsaw. Much later in life she insisted that an interviewer "put down that my husband [Tadeusz Lempicki] was Polish, just like me."[22]

Although life in Moscow contributed to her artistic development, Tamara never acknowledged her debt to her Russian past. Despite her Muscovite youth, she maintained two unshakable (and today controversial) convictions throughout her life: that her personal identity as a Pole was spe-

cific and localized, but that the basis of her painting was timeless beauty, the universal mandate of art.

Suspended at her birth between the end of one epoch and the beginning of another, Tamara de Lempicka exemplified many of the conflicts regarding class, gender, and the nature of beauty that define the ongoing debate over Modernism.[23] Born approximately ten years before Henry Ford introduced the Model T and almost fifteen years after the first Chicago skyscraper had transformed not only its own midwestern landscape but much of the Western world, Tamara depended on both icons to shape her art. Cars and American skyscrapers: speed and geometric severity, vertigo produced by steely lines and insolent angles. Even in the Slavic cities of Tamara's early years, these industrial harbingers of a new age gained renown, since the wealthy, educated upper class traveled abroad and returned eager to share their observations.

As a young adult, Tamara witnessed the radical reconfiguration of Russia, but by then she was well acquainted with the instability of governments and territorial boundaries. Born toward the end of Poland's infamous period of partitions, 1795–1918, she nonetheless inherited a strong historical identity as a Pole from her mother, Malvina. Until the aftermath of World War I, Poland suffered constant political interference from outside. All twenty to thirty million Poles in the compartmentalized nation of Tamara's youth—a land divided between the Russian czar, the German kaiser, and the kaiser-könig of the Austro-Hungarian Empire—considered themselves unalterably to be Poles.[24] That this *idea* of Poland possessed such strength was crucial to the country's continuity; on the eve of World War I, Poland did not even appear on the map as a separate entity. Many of the identifying institutions of the old republic had been dismantled in 1795, an erasure that its citizens were determined to avenge. The country had at least maintained a set of cultural traditions that ensured the survival of the Polish language, which was integral to the Polish identity, though outlawed at various times and places throughout the nineteenth century.[25]

In Tamara's youth, the "Polish question" of independence was a constant on the agendas of earnest young men debating in the cafés of Warsaw, Danzig, and Krakow, in, respectively, the Russian, German, and Austrian provinces. According to her cousins' accounts, much of the pleasure of the children's trips to Poland stemmed from the café society awaiting them there, at least from the time they were ten or eleven, when they were allowed to accompany the adults. Here they felt they were no longer outsiders. Though essentially the equivalent of sidewalk conversation in Paris and Moscow, Warsaw café debate gained its singular passion from the par-

ticipants: the very fate of their nation seemed at stake. Such commonly held convictions yielded a camaraderie that was apparent even to the young girl trailing along with her uncle or his friends.

In spite of her early interest in politics, Tamara became bored quickly if, in the throes of academic debates, café society forgot one of its honored conventions, appealing already to the prepubescent youth: the art of flirtation, the break from everyday tedium. "Never was Tamara patient with talking about theories," her daughter Kizette recalls. "Even when she talked about witnessing shouting matches between other artists in the 1920s, she acted as if the philosophical element was interesting only for its drama. She used to say that 'it was the same everywhere—Warsaw or Paris, men talking about how to change the world. I wanted them to relax and smile at each other.'"[26]

Tamara's mother and grandmother impressed upon the girl the artistic and cultural legacy of their homeland, and they encouraged her to spend as much time in Warsaw as she could, at least until 1912. When her upper-class family took breaks from Moscow and mingled in Warsaw society with friends such as the statesman and musician Ignace Paderewski and the pianist Arthur Rubenstein, they taught Tamara that the impressive legacy of Chopin continued to seed Polish achievements. And though the artists she admired were not members of the nobility, the complicated political history of Poland encouraged the loyal young Pole to associate great art with the perquisites of an aristocratic society, in spite of her own *grande bourgeoisie* status. In Tamara's youth, Warsaw's artists took as their aesthetic ideal the values of King Stanislaw August II Poniatowski, the last king to rule over an undivided Poland, from 1764 to 1795. Inspired by the cultural revolutions sweeping Europe, including the French Enlightenment, King Poniatowski had created a heady international environment that was friendly to artists and political theorists. His court had blended the philosophical tradition of the French ideologues with its own intellectually polyglot views developed from the three national influences. As she formed her own aesthetic values a century later, Tamara absorbed two sources of artistic inspiration—a love of the classical and a cosmopolitan appreciation of difference.[27] Reared to value royalty as the fountainhead of stable social institutions, Tamara also associated the nobility with cultural refinement. Her family, though involved in banking and commerce, taught her that the relationship of court to culture was a natural, divinely appointed tenet of Polish life.

Despite Tamara's nostalgia for the civilized times when King Poniatowski ruled, Poland's impressive aesthetic achievements were arguably the result precisely of the country's centuries-old unstable political history. The delicate negotiations carried out by the Poles, which allowed them to main-

tain their national character while learning to adapt to foreign aggression, in many cases served them well. Without a doubt, Poland's strength under oppression shaped Tamara's own resilience when she met repeatedly with geographic and cultural displacements. The complicated history of Polish identity increased her loyalty to a Slavic sensibility. But it also encouraged her to adopt the world, rather than a single country, as her adult home.

Tamara was reared in Russia, but as an adult she spoke of the times she spent in the Dekler family homes in Poland as if they formed the core of her self-image. She interspersed her day-to-day life in Moscow with extended vacations to the Dekler estate in Warsaw or, at times, to the family's country house just outside the city. The Polish artist Feliks Topolski recalls the capital of Tamara's youth as "a very vigorous city, culturally and socially. Its mood, its consciousness, was not that of some snow-covered Eastern village. Warsaw received many visitors from abroad, from England and France. People of a certain class spoke foreign languages; they had great style and elegance. The Polish aristocracy was as good as that of any other country in Europe. . . . The snobbery was fantastic."[28]

Tamara's anecdotes support a highly developed Polish sense of class consciousness. Author Ron Nowicki, who grew up in Warsaw and later emigrated to the United States, recalls the rigid compartmentalization of his native culture. Nowicki agrees with this assessment by a prominent figure of the wealthy inner circles: "Socially there existed innumerable divisions and subdivisions. People met in charitable and social work, men belonged to the same clubs, but often they remained only acquaintants, not taking any intimate part in the lives of groups outside their own set, their families, and a few friends. At the head of the social scale stood the aristocracy, which centered in the Hunters Club. This very exclusive institution was definitely closed to anybody who earned his living. It was, of course, the ambition of a few snobs to be admitted to the aristocratic society."[29] Tamara was shaped by such class awareness; in her infrequent accounts of her childhood she inevitably refers to the social rank of visitors to her childhood home or to the titled nobility with whom her family fraternized.[30]

The reassuring charm of tradition, however, offset the potentially dangerous social divisions of Poland's old kingdom. One Dekler residence, described by Tamara as "very grand," was located in the most beautiful and interesting area of Warsaw, near Old Market Square where her family enjoyed strolling through the artisans' stalls.[31] The market square had been the center of town life since the Middle Ages, offering an area where produce and crafts were for sale next to boxes of used books. Luxurious town houses and antiques galleries lined the streets, and when people took their

evening stroll, streetlights caused the red tiles of the buildings to glow, projecting a unique warmth to the evening urban life.[32]

Another Warsovian, Grace Humphrey, wrote fondly in 1934 of the street life that during Tamara's youth had filled the colorful square. "You would see . . . university students, the color of the velvet on their caps announcing in what Faculty they belong; a group of strolling musicians who play and sing in your courtyard; young women in mourning, with their veils put on at one side of their hats and brought around like scarves; and peasant women in gay headkerchiefs; a bride and groom in a carriage upholstered in white satin; and a droshky driver in long blue coat and high boots, with his number hanging at the back of his collar so that you may see it from your seat; if you have an old coachman with crowns on his silver buttons, you'll know he was once employed in a nobleman's family."[33]

Though appreciation of high art was mandated by Clementine's child-rearing principles, the Dekler family consistently indulged its clan's sense of fun as well. The sisters and their children often vacationed in the northern coastal town of Sopot, one of Tamara's favorite resorts. Its elevated regions demanded an athleticism the girl never possessed, but Sopot proper was a beach town where visitors could take "the cure" in soothing waters. A faster-paced stroll along the boardwalk was the antidote to the children's restlessness and provided a socially sanctioned spot for young romances to take wing.[34] Clement Dekler recalled that one day he "risked riding my bike

down a busy street of shops, even though my mother had forbidden this. I couldn't believe my bad luck when I almost ran into Aunt Malvina, but for a minute I thought I was safe because she had very bad vision. She was busy gathering her shopping bags anyway, so I started to turn the corner fast. I thought I heard her call out, but I chose to believe I was wrong. The next day, when my mother and I met my aunt at the beach, she went into a

*Clement Dekler, Tamara's cousin, in Sopot, c. 1920.*

detailed description of my sin. I couldn't believe my ears: how could she have seen that I didn't stop at the corner before I turned? She wasn't supposed to be able to see that far. At first I was scared, because I might be badly punished while on holiday, but my aunt made so many jokes that everyone ended up laughing, and after that whenever we all went to Sopot together, she retold the story and the family laughed some more."[35]

For natural beauty, Tamara's family took longer trips to southern Poland, where the Carpathians (Europe's second major mountain range, after the Alps) awed city visitors with the grandeur of their rugged high peaks, among which could be seen the occasional centuries-old castle fortress.[36] When there was not enough time to journey to the mountains, the family drove an hour outside of Warsaw to Kampinos National Park, near the homestead where Chopin had been born in 1810. During the German occupation, the Nazis executed thousands of Poles in the beloved park. Whenever Tamara spoke of her "birthplace," she emphasized that she referred to Poland as it was before the bloodying of the Kampinos greens; after Hitler, she acted as if the real Poland were only an idea once again.

Most of Tamara's allusions to her childhood recall her life in Moscow, though she avoided mentioning the city by name, even substituting "Warsaw" in its stead. Although the two cities were almost 700 miles apart, the lack of national borders caused many Russians to regard them as sisters. Undeniably, Moscow and Warsaw were in many respects alike. The leisure classes shopped in Europe's most prestigious markets. They imported clothes and interior furnishings from Paris, ballet from St. Petersburg, and sexual attitudes from Berlin. The upper classes of Moscow and Warsaw patronized the theater and the ballet, but they were not immune to the smoky allure of the German cabarets that invigorated their cities' nightlife. Nor, for that matter, did the presence of certain outré Slavic artists in Paris go unnoticed. At the turn of the century, Paris proved a fertile source of experimentation for large numbers of visiting Russian and Polish artists, in some cases providing a haven for debauchery. When Tamara was four or five, strange stories of the sculptor Cyprien Godebski's pact with the devil were excitedly passed among the social elite back in Warsaw and Moscow. Princesse Mathilde, Napoleon's niece, had apparently invited the Godebski family to become part of the infamous Dr. Samuel-Jean Pozzi's secret Parisian society, the League of the Rose, whose members played a "kind of orgiastic truth game" and acted out their sexual fantasies in front of each other.[37]

At the time of Tamara's birth, cosmopolitan Moscow was growing as quickly as New York City. Industrial and fast-paced, with eleven railways connecting it to the rest of the country, Moscow was Russia's commercial

capital.[38] The businesslike aura of the city lent it a brusqueness that was captured by Tolstoy in *Anna Karenina:* "In all Moscow people, there's something uncompromising. They are all on the defensive, lose their tempers, as though they all want to make one feel something." Muscovites with means hired French governesses to help educate their children; those with the greatest resources flaunted their family's wealth by hiring English nannies. Another luxury that promoted one's social standing was the country home— Tamara's family maintained one fifteen miles outside of Moscow—though the city still retained many bucolic neighborhoods of "quiet, tree-lined sleepy lanes" dotted with wooden houses.[39]

Tamara's routines in Moscow reflected the customs of upper-class Poles of the period. Four or five trips each year to Paris, Berlin, Vienna, and St. Petersburg helped ensure excellent food when the travelers returned home, Parisian feasts as well as the hearty Polish meals that Tamara would later serve at her dinner parties. The waistlines of Tamara's family were regularly assaulted by borsch, pierogi filled with onions, beef, and cheese, as well as glorious bread and sausage. When Malvina and Clementine threw lavish parties, their cooks and maids would spend days prior to the event preparing gourmet treats: beluga caviar, jellied meats, meringues, petite fours, German tortes. Tamara's many cousins and young friends who lived in Moscow at the turn of the century frequently accompanied their parents to these affairs, though once they arrived, they were ushered off to be tended by a servant.

By age seven the energetic and theatrical young girl had developed a routine: she improvised a long, pitchforklike device from kitchen utensils, craftily sneaked it across the sacred boundary of the kitchen door, and thrust it into the cages of desserts, aiming between the bars of the iceboxes that contained the tiny jam-filled layer cakes the cooks had baked that morning. "After I took as much as I dared before the hysterical housekeeper convinced me to leave, I shared my riches with my little companions waiting, anxious, in the next room. They were always dressed in white socks and white boat collars, and to me they were sailors awaiting my orders."[40] The stolen culinary masterpieces, at times still sprinkled with the sawdust used to keep the ice from melting, became trophies Tamara bestowed upon those playmates who believed in her.[41]

From vague references to the surrounding areas, it appears that the Deklers lived on Ilinka, the fashionable street beside the Kremlin, the seat of the grand dukes and later the czars, before Peter the Great moved the government to St. Petersburg. The Deklers' Russian house was impressive and perfect for parties: unusually large for its time, it had two living rooms for entertaining and an office where her grandfather (whom Tamara referred

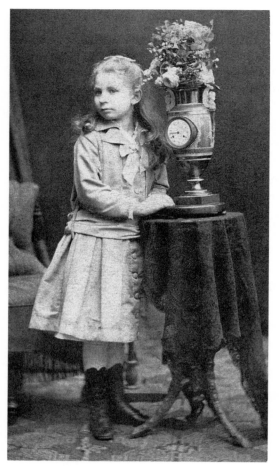

*Tamara in Moscow, c. 1905.*

to as her stepfather in her notes) received his associates. References to a special wing for the children, extending like a corridor off the center of the house, and a two-oven kitchen, located farther from the children's rooms, dominated Tamara's later descriptions.[42]

Appreciated by her mother from the beginning, Tamara received even more attention from her grandmother Clementine, who thought the child, when a baby, resembled Malvina at the same age.[43] Unlike Clementine, who clearly doted on Tamara as her favorite grandchild, Malvina distributed her love and lavished attention equally if inconsistently among her three children.

Aware of the instability of a fatherless brood, Tamara determined early to create a strong position for herself among the Dekler clan. She followed the typical middle-child protocol by distancing herself from the oldest, barely acknowledging Stanzi's sense of being the "little man" of the family, responsible always for doing the right thing. Instead, Tamara schemed with her more focused younger sister in plots meant to ensure that her socialite mother and adored grandmother could not overlook her.[44] Various family members recall that Adrienne played the role characteristic of the oldest child—she was thoughtful and ambitious from the beginning—while Tamara appropriated the part of the pampered youngest. The sisters seem to have ignored Stanzi totally.

On the basis of her gift for reading and drawing, Adrienne had been

declared the family talent; Tamara, noted for her spontaneity and energy, assumed the role of the risk-taker. Instead of the competition typical between siblings so close in age, the girls developed a strong bond in part through the clear delineation of their family roles.[45] In her later years Tamara dismissively answered a journalist who asked for information about the relationship by remarking: "There was nothing to say; we were sisters."[46]

Determined to live up to her reputation as the adventurer, Tamara balked at any restrictions that her proper if frivolous family imposed. One spring morning a few months short of her ninth birthday, she rebelled at kind but condescending family words meant to remind her of her youth: "You can't make your own food, young miss. That's for adults who know what they're doing." When recounting the event for her daughter, Tamara said, "I don't remember if it was the servant or my mother who laughed then, when I tried to prepare my own supper, but I know I was very angry when it happened, and I had to show them I could take care of myself."[47] Motivated to prove her independence, the child created small, perfect pink and green paper flowers, which she then sold on a side street near her house to pay for her room and board, until her shocked German governess insisted she come inside.[48] Solemn Adrienne stood loyally by Tamara in such endeavors, as long as her sister didn't expect her to participate in the deed. Throughout her life, Tamara respected Adrienne, one of the few people she considered more talented than herself and whose advice she regarded as unfailingly sensible.

While her serious sister read voraciously and memorized poetry, Tamara practiced diligently upon the piano she had persuaded her mother to install in the bedroom the two sisters shared. She told the story that once, maniacally, she had practiced in a frenzy for seven or eight days. Clementine had sanctioned Chopin as an aesthetic retreat from the tedium of everyday living. But Tamara was inspired to such feats of concentration by her genuine love of great music and by fantasies of public adulation.

Whenever her grandmother wanted a respite from her large and sometimes overwhelming family, she would retire to her parlor, where for three or four hours she played nothing but the romantic music of the Polish composer. Tamara could occasionally sneak into Clementine's beautiful living room and hide behind the sofa undetected. During these precious experiences as the solitary audience to Clementine's performance, the girl developed a fantasy of herself displaying comparable talent on a stage in front of a huge crowd. She would be wearing a low-cut floor-length black dress and three short pearl necklaces, her hair adorned with ruby-studded combs. Most important, her music would leave the listeners breathless with its

beauty.[49] Even after Tamara entered the local boarding school, every weekend she eagerly anticipated the chance to hide behind the couch when Grand-mère Clementine played the piano.[50]

But although Tamara took lessons for several years, she was, by her own admission, no more than a competent pianist. Her lackluster musical development was partly attributable to her reluctance to repeat others' achievements. "To play Chopin was not so important, in comparison to being Chopin," she decided. Enacting an artist's intentions was secondhand creativity; the composer alone could lay claim to originality.[51]

The piano ritual was not the only treasured routine that Clementine's household offered for the fatherless girl. One of Tamara's favorite rites of childhood was the game she and her siblings played on an oversize pale green rug covering the unusual marble living room floor. The bunches of pink roses that Clementine had stitched on the green wool provided the children with jumping spots, allowing them to invent a variant of hopscotch, using a small stone. Tamara loved games, and this one in particular gave her great satisfaction, possibly because she made up the rules for it and partly because of its dependence on her grandmother's talent as an interior designer. Clementine embroidered so expertly, even drawing the patterns herself, that Tamara sat for hours, watching her at work in her bedroom among the dark Napoleon III furniture grandly arranged to receive boudoir guests.[52]

Clementine drew her artistic inspiration from her monthlong annual trips to Italy and the south of France, an itinerary, she irreverently claimed, that let her "absolve my sins in the Italian landscape before I profane myself at the casino's altar."[53] Tamara, who yearned to travel with her grandmother, hatched a plan around 1907 to leave her girls' school (probably one of the elite Moscow boarding schools that children of her social class most often attended) and accompany Clementine. Prior to spring term, she overheard a doctor advise a classmate's worried parents to take their sick daughter to a warmer climate. From this eavesdropping, Tamara concocted a plot by which she too would be removed from school for medical purposes and transported to the south, clearly more hospitable to her sudden and vicious cold. Throughout her life, Tamara claimed that her "coming to art" began when she "tricked" her grandmother into believing that her cough required a trip to a warmer climate. In her unpublished notes, however, Tamara speaks simply of a real cough that upset Clementine, because it reminded her that Jules had experienced a similar illness before his suicide. A twelve-year-old's cold and familial disaster: if the association was real, the girl may have exploited Clementine's and Malvina's fears to get what she wanted. But per-

haps the connection was imagined after the fact, and Tamara was once again using the logic of assimilation to make sense of her life.

Tamara's tendency toward self-dramatization inevitably found a sympathetic mark in her grandmother Dekler, who encouraged the girl to think of herself as exceptional. Malvina's own high spirits and love of pleasure had reproduced themselves so obviously in her child that Clementine swore she forgot who was who: the matriarch's daughter and granddaughter were like twins.[54] Malvina in turn reveled in the closeness between her mother and her child, and in anticipation of their trip south she helped Tamara pack several trunks of clothes for what was to be a yearlong vacation.[55] A cache of schoolgirls' farewells, dated 1907, implies that Tamara's departure from school was both precipitous and permanent. Embossed delicately with tiny flowers of gold, a little blue leather journal contains several dozen professions of undying love in Italian, French, English, Polish, and German from classmates who seem to fear they might never see Tamara again.

One girl, Claire Picasso, wrote: "La sua vita, cara signorina Tamara, trascorrse lieta e felice" (May your life, my dear signorina Tamara, go on light and happy). Claire's sister Ethel implored, "Cara Signorina, si ricorditime, qualche volta! . . . Sua affirna amica" (Dear Signorina, remember me, think of me, sometime. Your absolute friend). A less effusive Karolina wrote only, "Alla mia cara Tamara" (To my dear Tamara).[56] The finality of these sentimental farewells in 1907 suggests that the occasion is Tamara's extended trip to Monte Carlo and Italy with her grandmother, after which the young woman would normally attend gymnasium, a secondary level of education. If Tamara was actually born in 1898 she would have been only nine years old when she left school for her yearlong journey, not twelve as she always claimed. Since the one known photograph of the trip captures a young woman entering adolescence, it appears likely that Tamara was born in 1895, three years earlier than she most frequently claimed. Careful to avoid saving any mementos that would date her, she nonetheless maintained scrupulously the little leather book in which her classmates launched her on her trip south with their sweetly adolescent farewells—and which renders unlikely her preferred birth date.

Given the ultimate importance of the journey to her development, however, it is no accident that the usually hardheaded artist safeguarded this literary symbol of her childhood passage into the adult realms of both art and decadence. From her illicit hiding place behind the couch, Tamara had come to Chopin's études with nothing more than her own inchoate imagination. Now she was licensed to test her aesthetic reactions to a much larger

world. The train took Tamara and her grandmother first to Florence, where the girl's intuitive response to beauty, to the realm of the senses, found its natural home. Clementine herself had never tired of the Renaissance masters. Nonetheless, she was astonished as well as pleased by the intense appreciation shown by the tireless schoolgirl as she listened to her grandmother's enthusiastic lectures on each "important" painting or sculpture they passed. Fifty years later, with unflagging energy, Tamara would repeat the itinerary with her own granddaughters, extolling the line of a body, the mastery of flesh tones, of shadow and light, and the clarity of a color. Until she was too weak to hold a paintbrush steady, Tamara returned yearly to study the great Italian museum holdings of Renaissance and early-fifteenth-century paintings, in order to be reminded of what greatness on a canvas looked like, of what beauty could be.

The mature artist that Tamara became in her twenties—an artist who valued clear color, careful drawing, drapery and shadows that celebrated rather than obscured the artfulness of the picture—took shape in the museums of Florence, Rome, and Venice—and in their burial grounds as well.[57] Contemplating for the first time the homage paid to the dead through the presence of magnificent if broken artifacts representing them, Tamara was overwhelmed by the peculiar power of cemetery statuary. Like the narrator in Shelley's "Ozymandias," she decided that the decay of a "colossal wreck" might possess more life than people, who inevitably turned into ash beneath the beautiful relics themselves.[58]

Clementine and Tamara traveled to Venice and Rome, staying in Italy for about six months before making their way to a hotel convenient to Monte Carlo. They must have made an interesting pair, one that attracted many second glances. A picture from this period captures Clementine in her early sixties, a rotund and imposingly handsome figure, with an adolescent granddaughter pleasingly plump by late-twentieth-century American standards. The only photograph of Tamara that survives from the trip shows the newly voluptuous girl dressed in high boots and a velvet-trimmed coat, staring at the camera like a sulky Lolita. The child was at a pivotal moment in her development: still possessing the openness and curiosity of a youngster but mentally poised to think less categorically, less routinely, about the world her grandmother was determined to open for her.

The two set up housekeeping at a first-class hotel in Menton, a town one mile inside the French border. Clementine established a daily routine of eating breakfast with Tamara and then taking the train to the casino at Monte Carlo's Hôtel de Paris, leaving the girl behind to find her own diversions. "But this was the question, how do I amuse myself?" the artist recalled when she

was in her seventies, as if the vexatious boredom had occurred the day before. She tried athletic activities, such as archery and swimming, but enjoyed them no more on vacation than she did at home.

Finally her grandmother rescued the girl from her ennui. Clementine hired a handsome young Frenchman—tall, with long dark hair and chiseled features—to teach Tamara to paint with watercolors on wood and stone. "What was more beautiful, I wondered, the clear colors of the seaside transposed onto the flat rocks or the lovely face of the young man kneeling beside me as I painted?" she reflected.[59] Young Henri presented her with both a stationary and a collapsible easel. Against all probability, she decided they were meant as gifts of love, not as part of the package that was her due as a result of her grandmother's generosity.[60]

At times Clementine would relent and take Tamara to Monte Carlo with her for the day, though the child was not allowed inside the casino. Instead, flirting with the admiring adults who surrounded her outside the back door, she drew crowds by playing diablo, in which the player throws a spool into the air and tries to catch it on a string pulled taut between two sticks. Tamara daringly threw the spool higher and higher as more people gathered around her, only to catch it every time on the thin cord between the sticks, which by now had begun to rub calluses on her hands. After a few weeks of this, she decided to make the spool fly higher than the roof of the casino. Almost seventy years later, she proudly recalled her success: *"Je gagnai"* (I won!)

With her almost waist-length, slightly curly hair spread around her shoulders like a veil, and her heavily hooded eyes already lending her an air of mystery, the provocative, confident child also attracted the attention of an older man, who made his admiration a little too clear, at least from Clementine's vantage point. In the evening, when a bored Tamara

*Tamara playing diablo, c. 1910.*

joined her grandmother's table to listen distractedly to Clementine's new friends discuss art and politics, Monsieur Tevenin stared directly into Tamara's eyes. The girl, whose vanity was mollified only a few afternoons a week by her young instructor, Henri, was flattered by the attention. At the same time, as Tamara later told the story, she felt nervous, as if something awkward or inappropriate had occurred, though she couldn't tell what. Ultimately, Monsieur Tevenin went too far: he asked Clementine if he could marry her granddaughter. Tamara's notes at this point imply uncertainty over whether the entire flirtation was a joke or even a result of her own coquettish attempt to gain attention. Whatever the complete context of the little romantic intrigue, the man was made to understand that he was no longer welcome at the Dekler table.

By the time Madame Dekler and her precocious granddaughter returned to Moscow, Tamara had filled out so much that Adrienne barely recognized her. Appreciative as she always was of her sister's value, Ada noted with some awe that "your cheeks look like round peaches." Tamara was dressed for her return in ludicrously sophisticated adult finery—a dramatic red and black cape, a long skirt, and a hat almost larger than she was. The child-woman had bought all her clothes from Poiret, her mother's favorite designer, during a couture stop in Paris. Paul Poiret, the "prince of Paris fashions," took his inspiration from Léon Bakst's Russian stage costumes, and the resulting apparel, long on luxurious fabrics and colors and short on subtlety, provided the ideal props for a young girl experimenting with various dramatic identities.[61] The next stage in Tamara's artful self-construction had begun.

Soon after Clementine and Tamara returned to Moscow, Malvina took the children to the Dekler summer retreat just outside of Warsaw. The country house was meant, in Tamara's social class, to function as a family's own kingdom, where the youth were reminded of their life of worldly privilege and of their predestination to rule over others: "There were servants pounding away, washing sheets, servants making and unmaking the beds, servants pressing everything in sight, even the shoelaces—servants starching clothes, sewing, mending, carrying coal, wood, and water, emptying chamber pots, waxing floors, sweeping, grooming horses, tending gardens, announcing guests . . . polishing glass and silver, baking brioches and bread, cakes and pâtés for the incredibly copious meals. . . . [The cellars were stored with] huge tubs of butter, casks of wine, hundreds of jars of preserves, hams from the Ardennes, and great rounds of cheese."[62] Extravagant picnics could include "caviar, smoked salmon, cold game, cold sturgeon, with a vegetable salad and horseradish sauce [and if it wasn't too warm], sizzling hot sausages and potatoes baked in the embers."[63]

Trying to build on Tamara's new appreciation of art, Malvina commissioned a portrait of the girl to commemorate her thirteenth birthday; the painting was to be executed by a well-known local artist. Emboldened by the Italian journey, Tamara announced that she found the finished product of the highly paid professional deficient. The artist had used pastels, rather than oils or watercolors, not only to capture the dreamy pastoral quality of the Gorski country home but also in keeping with the tradition of child portraiture of the time. Tamara liked neither the medium nor the result. She declared that for all the torturous hours of posing she had suffered, she was rewarded with a picture of blurry, sentimental borders produced by the inept use of the chalk. Boundaries and outlines were extremely important to the young girl even at this age, and she set about proving, with her sister as her reluctant model, that she, a novice, could paint a cleaner, closer likeness than did the professional artist using pastels—though she never explained what medium she herself employed. Tamara later compared the professional product to her own: "The lines, they were not *fournies*. . . . It was not *like* me. . . . I painted and painted until at last I had a result. It was *imparfait* but more like my sister than the famous artist's was like me."[64]

Although Tamara would deny receiving any formal training until the 1920s, Adrienne's assertion that Tamara, from her very early childhood, always had a talent for painting, suggests otherwise.[65] It seems likely that the privileged girl, accustomed to receiving instruction in whatever subject appealed to her, had taken art lessons prior to her trip to Italy, even before she was twelve.

The summer after she painted Adrienne, Tamara apparently enrolled in a boarding school in Lausanne, where the emphasis was on perfecting one's French and one's manners. Swiss officials can find no records indicating that Tamara registered as a temporary resident in the city, but between 1908 and 1914 she may have taken up brief residence at Villa Claire, according to Kizette's sparse recollections of her mother's references to the school. Tamara was resigned to, rather than excited by, her secondary education. "I didn't care about learning what others said I should. I was so bored; I stared out the window and fantasized myself in different places, where I was doing something great."[66] Like many other girls, she would no doubt have found school less boring had she received instruction equal to her very quick mind. Her equally dauntless Polish friend Misia Sert expressed a similar reaction: "Too impatient to be a scholar, yet too intelligent to enjoy the shoddy education and too spoiled to submit to authority," Misia believed herself to be attending a mere "finishing school she could hardly wait to finish."[67]

The academic content of such schools was meager, focused on gaining

facility in the major European languages as well as English. When Tamara was growing up, children from her class learned French as their primary tongue. Even for the well-educated upper classes, Tamara's oral facility with languages was impressive, though her writing never developed adequately in even one language. By the middle of the second year of boarding school, the curriculum included Greek and Roman plays; during the last two years, literature and eighteenth-century history were added. But the only real nutrient Tamara felt she received was exposure to modern art: "While I was in Lausanne, I saw some of the early Cubist work that was being done in Europe at the time." Aside from producing worldly if superficially educated sophisticates who assumed they would gain an enhanced identity through marriage, such expensive schools made little impression upon their wealthy female boarders.

Tamara's male cousins were sent, by contrast, to such rigorous institutions as the elite boarding school Rydzyna, perched precariously on the German border of Poland, the building itself a fantastic seventeenth-century castle built by one of Poland's last kings. The school was known for its high standards and for requiring students to do extracurricular work in an academic subject of their choice in addition to the required courses in mathematics, history, science, and literature. If their education was highly regimented, the students graduated at least assured of their identity. For men, marriage was simply an arrangement that would ensure fulfillment of their physical and economic needs. According to Professor Alexander Lempicki, Tamara's cousin by marriage, who attended Rydzyna, "Any boy who finished a good boarding school left knowing who and what he was for sure."[68]

Instead, Tamara's self-knowledge evolved not from her sparse formal education but from the strong influence of the loving Clementine, with whom she associated the joy of losing herself in great art and extravagant living.[69] Like many spiritual or romantic quests, Tamara's recognition of her grandmother's legacy occurred years later, on a second journey to Italy's museums, underwritten again by a woman companion. Catalog prefaces invariably repeat Tamara's dramatic assertion that her devotion to quattrocento notions of beauty commenced overnight as a child, but her unpublished notes establish that her love of Italian art, planted by Clementine, came to fruition only retrospectively.[70]

The aesthetic bequests of both the energetic Clementine and the high-spirited Malvina included more than the lessons of high culture. If beauty was important, pleasure was the best context for its realization. Malvina customarily spent long winter vacations in St. Petersburg, where she reveled in the lively social season that began in January. The severe cold encouraged

many aristocratic Russians, including Malvina, to take the luxurious St. Petersburg–Cannes express train, initiated in 1898, to indulge in the more felicitous climate of southern France. And in 1908 or 1909 she began to include Tamara on her trips to St. Petersburg. Malvina's sister Stefa had conveniently moved to the capital with her husband, Maurice Stifter, so that the visits became family reunions as well as pleasurable respites from Moscow's rigors. By 1910, Tamara was regularly accompanying her mother to her aunt's luxurious house, from which they both witnessed the resurgence of glamour in the beautiful palace-rich city of the czars. At times Malvina and Tamara stayed instead at the opulent Hôtel de l'Europe, the Hôtel du Parc, or the newly opened Astoria Hotel, whose modern glass-roofed restaurant, the Winter Garden, provided an excellent view of St. Isaac's Cathedral. It was hard to believe that only five years earlier, in 1905, her family had been forced to acknowledge the dangerous hostility of St. Petersburg's peasants. Political tension between the czarists and the masses had erupted into the messy debacle of Bloody Sunday, when Nicholas II ordered his troops to fire on peaceful protesters, killing or wounding 4,500 citizens, by some accounts. For a year or so after that incident Malvina omitted the capital from her holiday visits. But though some of the anti-Royalists believed the episode presaged greater unrest—Lenin later would claim that "without the 'dress rehearsal' of 1905, the victory of the October Revolution in 1917 would have been impossible"—supporters of the nobility, the Dekler family among them, preferred to believe that St. Petersburg's quick return to order augured a stable future.[71]

By 1910, St. Petersburg had become a thirty-five-square-mile city of enviable high style and culture, blending a new commercial vigor with the older court traditions of wealth and indulgence. Though modeled upon European rather than Russian cities, it was made the capital of Russia in 1712. Founded in 1703 by Peter the Great as an industrial port reclaimed from the Gulf of Finland's swampy shores, this fortress capital of rivers, canals, and bridges was Russia's "window on the Western world and a record in stone of the powerful reshaping of Russian society in the eighteenth century." St. Petersburg transformed Russia into a seafaring country, with the port exporting "flax, timber, charcoal, pork fat, wax, honey, ropes, caviar, tar, race horses and wheat."[72] The city's rapid industrialization created the wealth for massive construction projects, which in turn produced some of the finest buildings in eighteenth-century Europe. Among them were the Winter Palace of the czars, built to accommodate 1,500 servants and, in the late twentieth century, housing a large part of the Hermitage Art Museum; the Cathedral of the Resurrection, a domed Baroque building designed by

Bartolomeo Rastrelli, the same architect who created the Winter Palace; the Alexander Nevsky Monastery; and the Kronverk arsenal, now the Museum of Military History.

Peter the Great had imported Italian workmen, architects, and designers to create what became a "triumph of Baroque and neoclassical architecture—reminiscent of Venice, but on a grander scale."[73] Most of the structures reflect the eighteenth-century fascination with a new aesthetic that combined classicism with Baroque decoration, in the process foreshadowing the strategies of early-twentieth-century Russian artists. The merging of commercial and artistic pursuits created a receptive environment for art as a commodity. Nevsky Prospect, the street of twenty-eight prominent banks, also contained stores selling Fabergé's precious jeweled eggs, diamonds displayed on black velvet, well-executed oil copies of masterpiece paintings—all offered in shops that were equally likely to sell Singer sewing machines. After the scare of 1905, the city's many "self-indulgent bourgeois" sought to establish with an imposing display of imported riches a warning to the lower-class agitators, as well as reassurance to themselves: the violence of the underclass, they implied, would remain an aberration. An illusion of unlimited prosperity was created by the stores overflowing with "oysters from Paris, lobsters from Ostend, flowers from Nice" and, on Nevsky Prospect, a shop where, according to Vladimir Nabokov, one could revel in English "fruitcakes, smelling salts, Pears soap, playing cards, picture puzzles, striped blazers, talcum-white tennis balls, and football jerseys in the colors of Cambridge and Oxford."[74]

Tamara grew to love the city so much that she traveled frequently to stay with her relatives, the Stifters, even when Malvina could not accompany her. St. Petersburg soon replaced Warsaw on the adolescent's itinerary. During one of her many vacations there, around 1911 or 1912, the maturing but still awkward young woman, now fifteen or sixteen years old, was invited to a very adult costume party with her aunt and uncle. Much of St. Petersburg society would be present, and the pragmatic girl, brought up among Muscovites, knew that she was not yet equal to the glamour of the capital's denizens. Carefully considering her options for a costume, Tamara chose to camouflage her less than lithe body under a peasant outfit, which then justified her leading two squawking geese onto the ballroom floor. As the fowls' webbed feet struck the slick dance floor, the birds started sliding, honking frantically as with every attempt to move they slipped even more. The spectacle amused the guests tremendously, who gathered to applaud the bravura performance—of the geese, not of their owner, as Tamara still pouted years later.

Laughing hard along with the other guests was the magnificent Tadeusz

Lempicki, a "beautiful" twenty-two-year-old lawyer, who, Tamara quickly noticed, was surrounded by many of the best-looking women at the party.[75] Over six feet tall, his muscular yet lanky frame exemplifying a rare languid masculinity, Lempicki wore his black hair slicked back in a style that placed the focus on his clean-shaven face, with its high cheekbones and slightly ironic, speculative blue eyes. Impeccably turned out in his cutaway coat and tails—apparently not all the men were required to wear costumes—he was easily the handsomest man in the large ballroom. As Tamara recalled later, "I looked at him and I said, 'How lucky he is to have all these beautiful girls around him.' And I asked, 'Who is he?' They said, 'His name is Thade Lempicki.' And I said, 'But he is Polish'—and I was Polish. And right away, I fell in love with him because he was so good-looking. And because he was all alone with ten women around him."[76]

Always vulnerable to extreme good looks, the adolescent girl was particularly susceptible to Tadeusz's type of attractiveness, which carried with it a carelessness, the insouciance of privilege bestowed through beauty. Vying for his attention, bejeweled women, "covered with diamonds" in their court costumes, clustered around the sardonic but amused young lawyer in the corner of the room. Garbed in a babushka, with geese in tow, the lust-stricken girl seven or eight years his junior was unable, for once, to contrive a scheme by which to approach the object of her desire. But she knew she'd think of something. Confident from early childhood that she could get whatever she deserved, Tamara was practical enough to realize she'd have to work hard in order to deserve it. Tadeusz Lempicki, she surely calculated, would be worth the effort.

# Chapter 2

# COMING
# of AGE
# in ST. PETERSBURG

*Tadeusz Julian Junosza-Lempicki was* born in Warsaw on 16 November 1888. A middle child with two brothers and two sisters, he possessed an impressive genealogy. The Lempicki family traced its roots to Lempice, a fourteenth-century village northwest of Warsaw. Before World War I the large clan had splintered into three branches, of which Tadeusz belonged to the most prominent.[1] Julian Arthurovich Lempicki, Tadeusz's father, was a hereditary nobleman, a status displayed in Tadeusz's Junosza family crest.[2] After graduating from the Law Department of Warsaw University, Julian began clerking at the local district court. He quickly advanced, becoming assistant to both the Council for Railway Affairs and the Council for Tariffs Affairs. Eventually, as representative of the Warsaw-Vienna Railway, he moved to St. Petersburg, a governmental reward for his loyalty and hardwork.

Tadeusz's mother, Maria-Sophia Norwid, was the granddaughter of one of Poland's most famous poets, Cyprian Kamil Norwid, one of the four "natural bards" who created Poland's Romantic literature toward the end of the nineteenth century.[3] The poet Norwid, unrecognized in his

38

own time, had become by Tadeusz's adolescence a symbol among educated society of the tragic genius doomed to an early death.

Julian, Sophia, and their five children occupied an apartment at 29 Millionnaia Street, one of the best addresses in St. Petersburg. Running through the center of the city, the street parallels the Dvortsovaia Embankment of the Neva River and ends at Dvortsovaia Square, near one of the facades of the Winter Palace. Between two of the buildings of the Hermitage, which fills the square, the Zimniaa Channel flows perpendicular to the Dvortsovaia Embankment. Through the wooden latticework of the Zimnii bridge, the Neva is visible, with thin, steep stone staircases leading to the water. Traditionally a romantic spot for lovers, the bridge would have been a perfect place for Tadeusz to rendezvous with his numerous inamoratas, especially in the brilliant white nights that overtook St. Petersburg during the late spring and summer.

A few blocks away from the Lempicki home at 27 Millionnaia was one of the palaces of Her Imperial Majesty, Great Princess Maria Pavlovna. His Imperial Majesty, Grand Prince Nicolai Nikhailovich, lived at 19 Millionnaia. Both maintained reserve homes on the other side of the street as well. Between these buildings were the private apartments attached to other palaces, maintained for representatives of the Russian aristocracy and various well-placed citizens. Inevitably, the interiors of the apartments were appointed to echo the grandeur of the palaces themselves. Tadeusz's neighbors included the princes Saltykov, the princes Obolenskii, the princes Bariatinskii, the barons Maidel, the barons Ginzburg, the counts Stakel'berg, and the counts Chertkov.[4]

Clearly, Tadeusz Lempicki, living in the reserve palace of Grand Prince Vladimir Aleksandrovich, was better placed socially than even Tamara's illustrious family. In spite of Tamara's lifelong tendency to denigrate everything about Lempicki except his looks, the reality remains that at the time she met him, he was an impressive prospect. Tadeusz had studied for eight years at Number 3 Classical Gymnasium in St. Petersburg, where he pursued the typical courses of the day, with an emphasis on Latin and Greek.[5] After graduating in May 1906, he attended university in St. Petersburg (which one is unclear), and in 1910 he received his master of arts in law, with a specialization in commerce and industry. Drafted into the czar's army, he was released almost immediately because of a "slight defect in his left foot" —cited nowhere except on his military records. Because he had not yet performed his residency (the equivalent of today's bar exam), his employment consisted of part-time jobs. From 1910 to 1918 he worked as a legal assistant for various companies and banks in St. Petersburg. Although Julian's

own father, Arthur Lempitski, had been a major engineer for the Warsaw-Petersburg railroad, the paternal lineage of hard work apparently stopped short with Tadeusz, at least at this stage of his life.

Tadeusz had spent many more years in St. Petersburg than in Warsaw, but in spite of his easy command of Russian, French, English, and German, he identified deeply with Poland, the land of his birth and ancestry. His father had always intended to move back to Warsaw before Tadeusz went to college, and apparently Thade, as his closest friends called him, assumed the same. Instead, Julian ended up accepting increased responsibilities in St. Petersburg; by the time he returned to Poland, the country was engulfed in the First World War.

When Tamara encountered Tadeusz at the costume ball in 1911, he had recently graduated from law school and was now free to frolic. If her sketchy account of her romance with Tadeusz can be believed, Tamara was always the pursuer, in spite of the commanding veneer that Lempicki wore. The exact chronology of the courtship is unclear, but it apparently took place over three or four years, from the time she first saw him until they married in late 1915 or early 1916, when she was between eighteen and twenty.

Her strategy to woo Lempicki depended upon two of her most salient characteristics: overabundant sexual energy and a near obsessive devotion to hard work and discipline. Highly pragmatic rather than romantic, Tamara was convinced that merit was rewarded only when accompanied by extreme effort, whether in one's professional or personal life. The only exception to this rule—the almost mystical function of inherited aristocracy—was partly what enamored her of the nobility.

Six or seven months after her role as a peasant girl at the costume ball, the increasingly frequent visitor to the Stifters wangled an invitation to tea at the home of a distant acquaintance, where—according to the girl's cousin Constantin, or Costa—Tadeusz Lempicki was sure to appear. Stationing herself near a large group of his friends, she overheard them arranging to meet at a performance at the Mariinsky Theater. Tamara promptly developed a desire to see the same production: could Aunt Stefa arrange for her niece to be accompanied by the English governess?

Stefa, as usual, granted Tamara her wish. She knew Malvina's daughter too well, however, to believe that a love of drama alone motivated the urgency of the girl's request to attend the performance at the Mariinsky. When her cosmopolitan niece attended the opera or the ballet, an erotic spectacle usually turned out to be the center attraction. This had certainly been the case in 1910, when Stefa took Tamara to a performance of the Ballets Russes, where Diaghilev's company had outdone itself with Fokine's *Schéhérazade*.

Tamara remembered that performance in great detail years later, though she recalled it less poetically than did Harold Acton: "[The] erotic fantasies were brought to life in the floating, gliding, whirling, twisting, crouching, leaping, soaring bodies of the young Russians. The new Russian theatrical art was an explosion of emotion, presented with a virtuosity and an expressivity never before seen. . . . [There was] the thunder and lightning of Negroes in rose and amber; . . . the fierce orgy of clamorous caresses; death in long-drawn spasms to piercing violins. Rimsky-Korsakov painted the tragedy; Bakst hung it with emerald curtains and silver lamps and carpeted it with rugs from Bokhara and silken cushions. Nijinsky and Karsavina made it live."[6]

Always forthright in her appreciation of the physical, Tamara for some time had appeared to her aunt to possess a preternaturally erotic sensibility. Probably Stefa knew about the girl's infatuation with Tadeusz Lempicki, but she was also aware of Tamara's interest in the male dancers' newly revealing costumes, which scandalized St. Petersburg society. Ignoring Stefa's smiling condescension at her niece's cultivated airs, Tamara spent several hours before the performance choosing from among her aunt's diamonds, which the unfailingly gracious woman encouraged her to borrow. Intent upon contriving a more dazzling appearance than even the divas who were singing, Tamara knew she could show herself to her best advantage in this glamorous theatrical venue.[7] The Mariinsky was constructed so that the audience, which numbered over a thousand, felt nearly as important as the celebrated artists they had paid to watch.

That evening, Tamara made as regal an entrance as she could manage. In her attempt to match the sophistication of the women who made up Tadeusz's typical entourage, she stepped into the glare of the still novel electric lights. A white-stockinged usher in faux military regalia escorted her to her seat.

The performance seemed longer than usual to Tamara, who was watching Tadeusz, waiting for her chance to fall accidentally into step with her fantasy lover after the final curtain. Her plans, however, were nearly sabotaged when the governess announced that their car was waiting at the door. Following the assertive Englishwoman to the automobile, Tamara begged her to wait while she spoke to someone "very important."

As the two argued, Tadeusz emerged from the theater and looked around for his own car. With no time for delicate maneuvers, Tamara strolled over to him and imitated the best manners of a woman ten years her senior: "Tadeusz, you might remember me from the costume ball, where I had two geese as my friends."

He replied that he did indeed, whereupon she asked him to tea at Aunt Stefa's. Puzzled at first by this unexpected invitation, the young man appar-

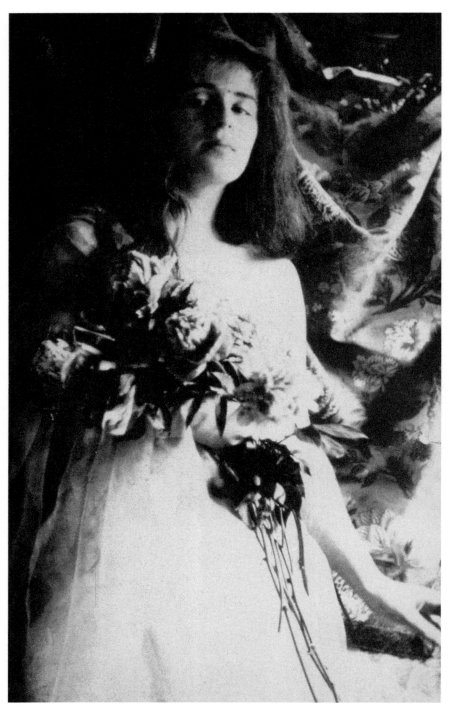

*Tamara's earliest glamour shot, c. 1913.*

ently quickly assessed the social benefits of establishing relations with a wealthy local family and accepted, assuring the delighted girl that he knew her address. When telling the story, Tamara never seemed to remember the outcome of the arranged family tea, only that Tadeusz accepted, impressed by her social status.[8] She had calculated from the beginning that her aunt and uncle's reputation for being rich, for having a home with three glorious floors, decorated by the best Parisian firms and overflowing with servants, would compensate for her own youth.

Although Tamara did not recount Tadeusz's reaction to her home, it seems likely that he would have been easily swept up into the Stifters' social life. For people of their means in St. Petersburg, "the season was lived at an intense pace. Evenings might be spent at a bal masque in one of the many grand palaces to be found in the city [many on Tadeusz's own street] or as a guest in the crimson-and-gilt private theater in the Yusupovs' princely palace on the Moika River, or at a recital followed by supper in some magnificently furnished mansion. St. Petersburg, 'the city that ordered its champagne by the magnum, never by the quart,' was an endless round of parties."[9]

While the young woman was busy wooing Tadeusz, she also confronted the saddest event of her life thus far: at about the time she first met with Tadeusz Lempicki in 1911, Clementine died. Tamara's sparse accounts omit direct comment on what was surely a major trauma for the adoring granddaughter; instead, she mythologized her certain grief into less upsetting, fictionalized stories, maintaining dramatically, for instance, that her mother remarried at this time, though she did not. At the very least, the death of her grandmother allowed the girl to make changes in her life, in part because Clementine's demise reshuffled all the pieces of the Dekler family in Moscow. Finished with her formal education, such as it was, Tamara decided to move to St. Petersburg and live there year-round with Aunt Stefa and the genial, wealthy Maurice.

Russian archival records from the period suggest that several Dekler male family members now worked in the capital and lived at expensive, fashionable addresses. Soon after Clementine's death, Bernard Dekler himself, the patriarch fondly recalled by various great-grandchildren as oft-married, appears to have moved to St. Petersburg, where he worked as an attorney for Mavritskii Nelken, one of the twenty-eight banks on Nevsky Prospect. During 1912 he lived at 17 Grecheskii Avenue, but the next year he moved to 12B Bol'shaia Ruzheiinaia Street, where, in 1916, he was joined by a new wife, Anna Petrovna. Their house was owned by the Russian Society of Capitals and Incomes: Bernard was a hardworking businessman, a commission member of the Northern Glass Manufactory Society and the Petersburg

Company for Preservation and Mortgage of Different Movable Property, and a member of the joint-stock company, "the First St. Petersburg Pawnshop." Probably Bernard's brother already lived in St. Petersburg, where he worked as an attorney for the Crédit Lyonnais, as did Maurice Stifter. Petr Stepanovich DeKler, as he spelled his last name, rented an apartment in Natalia Pavlovna's house at 11 Millionnaia Street before becoming the manager of the Crédit Lyonnais in 1894. He then moved to 29 Bol'shaia Koniushennaiia Street, where he died the following year. The French archives of the Crédit Lyonnais suggest that Petr Stepanovich may have been from Amsterdam (which would make Bernard, of course, Dutch as well) and that his relatives migrated to Moscow in the mid-nineteenth century. But if Moscow had been a safe place to raise a family, St. Petersburg was the place to have fun when the children were a bit older, and presumably the Deklers were happy to relocate there upon being offered a transfer.

As a result of Tamara's early winter holiday visits to this magical capital, she had long determined that she would move to St. Petersburg as soon as she was old enough.[10] The capital lent itself to the romantic images beloved by adolescents: "Endless star-shaped flakes of snow, sometimes soft and silent, sometimes lifted like confetti by sudden gusts of wind" fell on its inhabitants as they walked through the "streets lined with pastel palaces, thoroughfares where troikas scudded by, where smart one-horse sleds were driven by gentlemen in furs, where coachmen slapped their arms briskly across their chests, their steamy breath visible in the falling snow."[11]

Predictably, Tamara's own vague account of why she moved to St. Petersburg—one that sought to occlude her family's residence in Russia—introduced yet another distortion of reality: "At home in Poland, my mother was getting married again, and I was jealous of her new husband. I wanted to go live with Aunt Stefa, where I knew I would be given lots of attention because I would be the only girl in the family. I always loved beautiful things, and Aunt Stefa had the most beautiful house and clothes and jewels I had ever seen."[12] There was, however, no new husband for Malvina, who continued to live in Moscow with Adrienne (Stanzi enlisted in the army). She would die almost thirty years later as Bronislaw (Russian for Boris) Gorski's widow, never having remarried.[13]

Trying to assuage Tamara's sorrow over Clementine's death, Stefa arranged an especially exciting trip to Paris as a prelude to her niece's move to Petersburg.[14] It was probably on this trip that Tamara was exposed to Little Poland, a community of glamorous Polish aristocrats and rich artists, many of whom had benefited greatly from France's generosity in extending opportunities to foreigners. The city was filled with Polish pianists and sculp-

tors who maintained their national traditions in the midst of their new identity as Parisians. With her aunt, Tamara visited several members of the old royal family, the Poniatowskii, who lived near the Arc de Triomphe and on the Île St.-Louis in the elaborate Hotel Lambert. Increasingly, the young woman felt at home in disparate cultures, since wherever she traveled, her family's social status opened doors to other well-placed cosmopolitans, many of them displaced Polish aristocrats.[15]

Stefa and her young companion accompanied several of the Poniatowskii to the Ballets Russes, where they applauded the costume designs that the Russian Natalia Goncharova had created for the Paris production of Diaghilev's *Le Coq d'Or*. The lavish outfits reminded Tamara of the almost magical facility her grandmother Clementine had possessed with an embroidery needle, and she remarked that perhaps a kind of Eastern skill of design was bred into Slavic women. "Would you like to work in the theater?" her aunt asked. The teenage girl answered that "I'd rather design windows for a cathedral or the glass for the blue and yellow buildings of the Hermitage," the czar's palace on the Neva.[16]

Perhaps her ready response came from the fact that women artists were everywhere in Paris, seemingly free to do as they pleased. The young Tamara had observed their presence even on her earlier visits to the city in 1910 and 1911. Gill Perry points out that as early as 1903, a reviewer in *The Studio* had noted the phenomenon: "Women artists were flocking to Paris around the turn of the century, for despite the constraints, the city offered them a stimulating artistic environment and better opportunities for exhibiting and training than those available in . . . European art centers."[17]

During the afternoons in Paris, while her aunt endured tedious hours of pinning and draping by the couturiers, Tamara found herself free to visit the art galleries.[18] Her objective, even before admitting to any sort of professional interest, was to ferret out the best there was.[19] She realized quickly that Montmartre operated largely as a tourist site, and began frequenting instead the considerably more chic art world of Montparnasse, probably guided by acquaintances at the Académie Russe, the school for Russian émigrés, or by Louis Marcoussis, a well-respected Polish painter who was then part of Picasso's circle—and a member of the Dekler social circle back in Warsaw.[20]

Insisting that her aunt leave her to her own devices, Tamara sat at the cafés in the late afternoon, smoking fiendishly. She listened eagerly to the fast-talking students who seemed to own the streets. The young Pole must have looked quite exotic, her colorful Oriental-inspired clothes from designer Paul Poiret contrasting dramatically with the drab student attire.[21]

Yet for all the drama of her appearance, it was Tamara who was astonished at the theatricality of her surroundings. To the wonder of a girl from a nation racked by centuries of conflict, she heard orators enthusiastically extolling the glories war would provide, the cleansing of a putrid past that battle might achieve. Her own dissenting views might have encouraged a certain aloofness on her part, but she developed a way of showing interest with a slightly cocked eyebrow that assured café society that she was one of them.[22] Even if she wasn't, she learned that hailing from St. Petersburg conferred an automatic cachet upon her. The young men and women who haunted the Louvre wanted to talk to her of Malevich's theories, and she felt herself even luckier than before to be moving to the Russian capital.

The exact date when Tamara left Moscow for St. Petersburg is unclear, but by 1 August 1914, the day the capital was patriotically renamed Petrograd (a Russian inflection substituting for the German-sounding name), Tamara had been living in luxury there for some time. Given the complete insulation of her family's class from daily hardships, she was probably unaware that the assassination on 29 June of the heir to the Austrian throne, Archduke Francis Ferdinand, had caused Russia and Germany to declare war against each other.

She lived either with her grandfather Bernard or, as she claimed, with Stefa and Maurice Stifter, who had two homes, one at Mokhovaia 15 and a dacha (a country cottage, used primarily in the summer) on Kamennyi Ostrov, Petrovskaia, 10, a small, exclusive island suburb of the city.[23] Bank records reveal that Stefa's husband directed a Russian branch of the Crédit Lyonnais before moving to its Paris office in the 1920s.

Stefa and Maurice treated Tamara like the daughter they had always wanted. Their seventeen- or eighteen-year-old niece was asked to do nothing except amuse herself and look for a suitable husband in the process. Aunt Stefa, raised among a bevy of sisters and now mother to two sons, welcomed the company of Malvina's middle child. As a rich banker's wife, she was expected to entertain lavishly, so she spent much of her time picking out elegant clothes and accessories and planning the most creative, delicious food, two activities that Tamara delighted in for the rest of her life.

Stefa loved to show off her attractive, personable young niece. Among the first acquaintances she urged upon Tamara were members of the Yusupov family. During Tamara's youth, Prince Felix Yusupov and his wife, Princess Irena, Czar Nicholas's cousin, lived in one of the most luxurious private palaces in all Petrograd, an impressive status symbol in a city known for its extravagant homes of the nobility. An imposing yellow neo-Baroque building, it contained one of the most beautiful private theaters in all of

Europe, located within a few miles of the Mariinsky itself, and with a clear view of the gilded dome of St. Isaac's Cathedral.

Occasionally Stefa and Maurice were invited, along with a hundred other members of society, to the Yusupov Palace for a late dinner, following the opening of a ballet or opera. Tamara eagerly accompanied them on at least one such occasion, which stayed in her memory as the setting for the "grandest chandelier and staircase she ever saw in her entire life."[24] Another time, soon after she moved to Petrograd, she and her cousins accompanied Aunt Stefa to a musical soiree sponsored by Prince Yusupov at the Ecktensberg Palace, the summer home of the czars. Its renowned Amber Room was paneled with floor-to-ceiling Baltic amber. The walls had been carved and gilded by eighteenth-century artists, though contemporary artists such as Cyprien Godebski, father of Tamara's acquaintance Misia Sert, were invited to add sculptural decorations.[25]

Socializing in such interiors developed Tamara's sensitivity to the formal and historical elements of art. It also encouraged her to emulate the expensive habits of her adored aunt. Uncle Maurice's bank partnerships in Paris, Warsaw, and Petrograd allowed him to indulge the expensive tastes of both his wife and his niece. Conveniently for the women, Maurice's office on Nevsky Prospect offered daily opportunities for them to visit the banker during the afternoon, followed by shopping among the jewelry stores in the passageway from Nevsky Prospect to Mikhailovsky Square.

Later, when Tamara spoke of haute couture, she inevitably remembered gleefully helping to unwrap Stefa's boxes from Paris. Many of these were, with elegant simplicity, marked "Jansen," indicating the famous Maison Jansen, the firm that provided her aunt's sheer blouses and intricately detailed embroidered dresses, and that had outfitted the interior of the Stifters' new home in Petrograd. Still, "what made me the happiest of all was when Aunt Stefa let me open her separate drawers of emeralds, diamonds, and rubies and choose from them what I thought she should wear."[26]

Stefa's extravagance was at home in the land of the Romanovs, whose jewelry collection was famous for its priceless earrings shaped like cascades of glittering water drops and its diadems decorated with flowers and feasting bees. Imperfectly executed, such excess would have been intolerably vulgar. But superb craftsmanship somehow legitimized these displays of great wealth. Even the French were amazed at the drama presented by the well-coiffed Petrograd woman, who took as her example the style of the Russian rulers as well as the couture of the Parisian designers. Indeed, wealthy women in Russia bragged that Petrograd society dressed far more lavishly than did the French, from whom they ordered their clothes.

Nor did the debaucheries of Paris society match the aristocratic games played in Petrograd and exported by its denizens. Grand Duke Dimitri was ordered by a worried czar to stop hobnobbing with Prince Yusupov, whose behavior included dressing up in women's clothes for social occasions. When Yusupov appeared at a Parisian theater in feminine attire, Britain's King Edward VII was so impressed with "her" appearance that he requested an introduction to the "lovely young woman," an episode which, Yusupov claimed, "greatly flattered my vanity."[27]

Ironically, given her lifelong fear of all things Russian, it was St. Petersburg that gave social and aesthetic form to the sensibilities inchoate in the Polish girl.[28] Accompanying her aunt to soirees, delighting in the small talk exchanged over after-theater drinks, and participating in the cultural richness of the city's fine arts "finished" Tamara in a way that her boarding schools had barely begun. Her attendance at the theater and the ballet and her inclusion in the gossip of her well-placed family were to offer later inspiration. In the middle of the decade, for example, Petrograd was abuzz with talk about a commoner, Natasha Brasova, who had married Duke Michael Romanov. In spite of being snubbed by the rest of the royal family, the headstrong young wife proved that high drama could be harnessed to win over public opinion. Not allowed to sit with her husband in the aristocracy's theater boxes at the Mariinsky, she made her entrances dressed in jewels more dazzling than the chandeliers. Seated next to the royal box, and aware that all eyes below were watching her every move, she was quickly joined by Michael and his loyal friends, who brought her champagne to sip. It was clear that the woman, supposed to be at a severe disadvantage, "enjoyed attracting the attention of the whole theater as she appeared [in] scenes [that] seemed to make her more rather than less important." The upshot of Countess Brasova's proud public attitude was that "the ban on Natasha rebounded in her favor."[29]

Natasha held informal court over lunches at the city's lavish Hôtel de l'Europe, where she entertained friends she shared with Stefa Stifter. Tamara, however, gained appreciation for strong Slavic women from more than the examples of royalty and her own family. She could not have avoided the public fascination with the much feted artistic beauties Olga Glebova-Sudeikina and Mathilda Kchessinska, whose activities saturated the daily press. Almost twenty-five years later Tamara would emulate their particular blend of aggressive femininity and commercial success in her bid for critical respect in America.

The Russian model would not serve her well in the United States. But in the second decade of the century, as the young woman sought to estab-

lish her identity, she no doubt admired the achievements of Olga and Mathilda. Olga was an amateur dancer whose fame depended more on being married to the celebrated artist Sergei Sudeikin than on her arabesques. Sudeikin, who had decorated the interior of the Stray Dog, the avant-garde nightclub-café that flourished for five years in St. Petersburg, conferred a certain cachet of artistic respectability upon his wife. Otherwise her renown was linked to her impeccable mode of flirting. Her famously perfect "Diana's bust" saucily exposed by plunging gowns, Olga perfected a deliberately eccentric practice of taking visitors to dusty antique shops in order to show-case her knowledge of style and beauty. As cultured an admirer as the poet Akhmatova collected Olga's recipes and sought her advice on "female" matters: "Dust rags must be gauze . . . cups must be thin and the tea strong. . . . Dark hair should be smooth and blond hair must be fluffed and curled. . . . Never take your eyes off [the men] . . . they love it."[30]

An even greater influence on Tamara's self-concept as a woman artist was Mathilda Kchessinska, the imperious ballerina who was mistress first to Nicholas II, then to two grand dukes. Solomon Volkov summarizes her power: "[She] was the symbol and proof of the success to which an artist, a woman from the demimonde, could aspire."[31] Dazzled by her brilliance as a dancer, St. Petersburg's finest turned out for her performances, which produced the most heavily perfumed, beautifully gowned and coiffed audiences the Mariinsky Theater had ever seen. Critics argued over her virtues: Akim Volynsky, for example, an influential dance critic, described her "incredible pas, her blind glorious diagonal dance across the stage . . . a miracle of a real high art." But Vladimir Telyakovsky, the director of the imperial theater, pronounced her performances a triumph of "vulgarity, triteness, and banality."[32]

These performers, especially Kchessinska, must have appealed to the girl who had entertained fantasies of artistic glory as she listened to her grandmother play Chopin. The dancers were adored by the masses for their art, for their charm, for their ability to attract men, and for their ability, in the case of Kchessinska and other women artists of this period, to gain financial support through the offices of the royal family. Even Anna Akhmatova was rumored to have had an affair with Nicholas while he was the heir apparent. Throughout Petrograd, beautiful, artistically successful women were sexually active and thriving. As Tolstoy's *Anna Karenina* had illustrated, the divisions between the social ranks were fast blurring: "The third circle with which Anna had ties was preeminently the fashionable world—the world of balls, of dinners, of sumptuous dresses, the world that hung on to the court with one hand so as to avoid sinking to the level of the demimonde. For the demimonde the members of that fashionable world believed that they

despised, though their tastes were not merely similar, but in fact identical."
Tamara's Russian years, as she approached adulthood, prepared the way for
her to become one of the "modern women" in Paris the following decade.[33]

During this period Tamara took art lessons, probably at the prestigious
St. Petersburg Academy of Arts.[34] Though a conservative student, she was in
touch daily with the currents of the avant-garde. At the end of the century,
impresario and producer Sergei Diaghilev had started a highly influential art
magazine, *Mir Iskusstva* (World of Art), which promoted modern art inde-
pendent of the pallid academic styles, meshing Art Nouveau, the Vienna
Secession, and Symbolist tendencies.[35] Crafts and the fine arts coalesced in
a credo that claimed "in essence so-called industrial art and so-called pure
art are sisters, twins of the same mother—beauty—and resemble each other
so much that sometimes it is very hard to tell them apart."[36] Though the
magazine folded in 1904, the resultant association of artists included
Alexander Benois and Léon Bakst, as well as Diaghilev.

It seems clear that Tamara was deeply affected by the Mir Iskusstva aes-
thetic, if only indirectly. The avant-garde movement attracted a buying pub-
lic among whom were many family friends—"stockbrokers, doctors, lawyers,
and big bureaucrats who wanted to be au courant and fashionable."[37] By the
time she was knowledgeable enough to take deliberate measure of the
trends, the work of Kasimir Malevich was inspiring local painters. Malevich,
in spite of his spiritualist musings, reinforced Tamara's intuitive love of order
and deliberate composition. This Cubo-futurist style had already influenced
the art of the age, as had the aftereffects of F. T. Marinetti's 1909 *Manifesto
of Futurism*. But Malevich's unyielding attention to sharp angles and mini-
mal volume had little impact on Tamara's development as an artist. Later,
when Malevich vied with Vladimir Tatlin for control over the Russian avant-
garde, Tamara would reject their work completely. Their belief that a Com-
munist revolution would clear the way for radical ideas repelled her. In the
best Modernist fashion, both Malevich and Tatlin aspired to become leaders
of the masses, albeit artistic ones. To that end, they preached a "religion" of
mysticism, the study of a "fourth dimension," and a quest for a "new reality."
Such ideas had been disseminated through the popular Russian theosophist
P. D. Ouspensky, and all of them offended Tamara's more practical nature.[38]

In 1915 painting and literature successfully merged in a portrait of
Akhmatova shown by a twenty-six-year-old Jewish artist, Natan Altman, at
a Mir Iskusstva exhibit. Already an unusual event because of the difficulties
faced by Jewish artists in Petrograd—Jews were banned from the city unless
they obtained special permits based on class status—the portrait was impor-
tant as an example of a new combination of forms in an old genre. Its angu-

lar lines and vivid yellow and blue palette delivered the force of a manifesto. Altman's painting appeared to many viewers to introduce Cubist forms into traditionally recognizable portraiture. At the same time, through its representation of luxuriant folds of blue silk, it emphasized the erotic nature of the previous decade's decorative aesthetic.[39]

When Tamara spoke of the painting by Altman (in her old age she confused him with the American film director Robert Altman), she lauded the composition's classical reference, evident in spite of the portrait's innovative torsion.[40] Although the picture's debt to graphic illustrative modes of art gratified the Mir Iskusstva artists, the portrait proved to Russian connoisseurs that Cubism could move in a direction more representational than Malevich's compositions allowed. Its kinship to the Cubism of French theorist and artist André Lhote helps explain Tamara's attraction to it: Lhote would be the only teacher she credited with influencing her.

As she transformed herself into a woman of the world, Tamara gained confidence in her appearance and her self-sufficiency. By early 1915 she had developed a careful strategy to win Tadeusz Lempicki. After finding out with whom he most frequently socialized, she began showing up where his friends did, attending the same parties. She invited the group to a lavish party of her own where her hostess duties included flirting with as many men at once as she could, especially whenever Thade was watching. By the end of the year, Tamara and Tadeusz were participating in the social life of wealthy Petrograd together. On Wednesdays and Sundays, they often attended the ballet at the Mariinsky, where Tadeusz enjoyed the dance, and Tamara loved the music and costumes. They stopped in at avant-garde concerts, probably as much to be seen as to satisfy Tamara's love of piano music; her more classical taste often prompted the couple's premature departure. For a few months before the club closed down, they occasionally met friends at the Stray Dog, though the slightly leftist feel of the café made Tadeusz squirm while his companion yawned. They would be confronted by patrons of the "Dog" who argued against standing for the Romanov anthem, or they could be drawn into debates over the ballet: was it a czarist institution?

Although the Stray Dog paralleled the role played in Paris by cafés like Les Deux Magots and La Coupole, its circle of regulars assumed a more serious tone than that of the Left Bank cafés.[41] A Marinetti week had been held at the Dog, and it received prodigious press coverage, ensuring that Tamara was acquainted with the Futurists and their manifestos at the height of their popularity.[42]

The company of Tadeusz and his friends at the Stray Dog reassured Tamara, because they scoffed at revolutionary enthusiasms as merely the lat-

est trend among the intelligentsia. The aristocratic edge of the *haute bour-geoisie* to which they belonged remained, in fact, dangerously indifferent to the war. Its repercussions—the shortages of food, the huge loss of human life —hardly affected their daily routine in Petrograd. As to revolution within Russia itself, the prosperous social elite reminded themselves fondly that their countrymen inevitably thought first one way, then another—radicals over a vodka glass, not over a rifle.

Tamara and Tadeusz often met for afternoon coffee at the stylish cafés that lined Nevsky Prospect, where French pastries and good cigars seemed more inviting than the company of provocative wits bent on raising tempers and tensions at the Stray Dog. Tamara was too much the intellectual novice to fit in with such a group anyway, and she had little tolerance for academic posturing. Bored with talk of nothing but politics, she did not yet know enough about art to share aesthetic insights, and she found herself ruminat-ing on the freer social mores in Paris. But for now Tadeusz Lempicki, a well-heeled lawyer obviously appreciated by many sophisticated women, satisfied her longing for a broader future. Tamara's uncle thought otherwise; he noted that Tadeusz didn't even have a job.

"He's a lawyer," the determined girl insisted to her uncle.

Her uncle replied, "He is an unemployed lawyer: what kind of job is that? And he has a reputation as a man with many mistresses as well."[43]

The Deklers routinely hired friends and family members; Maurice Stifter would therefore have been impatient with Tadeusz's pride, which prevented him from getting a job through his father. Tamara complained more than once over the next decade about Tadeusz's refusal to obtain work through relatives; after all, the tradition of nepotism was a strong and respected one in Russia.

The gossip wending its way from Warsaw to Petrograd did nothing to help Tamara make a persuasive case for her lover. Busier than ever, Tadeusz's father had become the Polish government's consultant for important engi-neering projects and had moved back to Warsaw by the end of 1915. Dur-ing March, the Society of the Kiev-Voronezh Railway had dispatched him to a conference convened in Budapest to build a direct Russian-Romanian railway. But though Julian continued to receive similarly important assign-ments for the next several years, he became reckless.[44]

After returning to Poland, Tadeusz's father began philandering in earnest, allowing his drinking and expenditures on women to land him in debt. As a result, he was in serious danger of losing his patrimony, which con-sisted of very large, valuable acreage. Soon notorious around Warsaw for flagrant, drunken womanizing, Julian nonetheless possessed such charm that

*Julian Lempicki, Tadeusz's father, c. 1913.*

his wife, Maria-Sophia, unfailingly had his dinner ready and his slippers waiting whenever he returned from his carousing. Eventually, however, he lost his motivation to work. His land went uncultivated and had to be sold off to pay expenses. At some point Julian's profligacy cost him the family home and he became known as someone who could not take care of his own family, a dishonor that humiliated his children.[45]

Maurice Stifter insisted that his niece's wisest course was to forget Tadeusz, who, he feared, was destined to be a ne'er-do-well like his father. The young man had intended to return to an office job in Warsaw, but in August 1915 the German army invaded Poland. Preoccupation with World War I finally overcame her uncle's anxiety about her choice of a husband, and after months of insisting that she would be satisfied with no one else, Tamara persuaded her uncle to allow Tadeusz Lempicki to marry her, whereby the groom received a particularly large dowry.[46]

Why did Tadeusz Lempicki marry Tamara? In her later accounts, she offers none of the conventional signs of an increased interest on his part. Maybe Julian's overspending was already painfully apparent to his son. Or possibly Tamara omitted from her reminiscences Tadeusz's active role in their courtship because she wanted to control the entire course of their romance. It is most likely, however, that the missing link is the old story of a pregnancy out of wedlock.

Tamara maintained that she and Tadeusz were married in 1916—she never mentioned the exact date. Their only child, nicknamed Kizette, she cited as born in Paris in 1918 or 1919. But on her 1939 application for a visa to live in the United States, Tamara lists the birth date of her daughter, Marie Christine, as 16 September 1916.[47] Today Kizette upholds silence on the subject.

Certainly if Tamara became pregnant at the end of 1915, she was sophisticated enough to realize she did not have to have the baby. Indeed, it

is unlikely that the pregnancy was unplanned on her part at all; rather, it was part of her master strategy to marry the man of her choice. And Tadeusz himself, who seems often to have followed the path of least resistance, was probably content with the shape his life was taking. He and Tamara had much in common, especially their upper-class Polish background.

Whatever the circumstances, within months of Uncle Maurice's capitulation, Tadeusz and Tamara were married sometime before September 1916, when their child was born. Possibly Tamara traveled back to Moscow, where many of her friends lived, and was married in a ceremony there, with Malvina and Adrienne in attendance; but consistent in her otherwise conflicting stories about the wedding is her reference to her mother's absence. Tamara most often said that the marriage took place in the Knights of Malta chapel in Petrograd, though at this time, the Order of St. John of Jerusalum, the official name for the venerable order of the Knights of Malta, did not have formal representation in the city. Tamara's method of crafting half-truths from the geographical and temporal pieces close by suggests she may have been married in the local Malta chapel, near the Stifters' home. In the reign of Paul I, the Convent of the Maltese Order had occupied the building subsequently used by the prestigious Page Military school, attached to which were two churches, one Catholic and one Russian Orthodox. Tadeusz would have been allowed the special privilege of marrying at the churches affiliated with the Page school, where boys who later served with the czar were educated, since his uncle had in fact been a member of the elite Knights of Malta. But even the religion of the Lempicki wedding ceremony is unclear: the Catholic chapel, by architect J. Quarengi, was small, hardly large enough for the fête Tamara later described.[48] No Catholic records of the marriage have surfaced, suggesting that although both participants were Catholic, the ceremony may have been performed in the Russian Orthodox religion. Especially since in his later life Tadeusz attended a Dutch Reform church in Poland—and given the hint of a Dutch background to the Dekler clan (sometimes rendered DeKler)—it is also possible that their wedding took place in the convenient Dutch church just down the street from Aunt Stefa's house. Finally, though unlikely given Tamara's repeated story about the extravagance of the event, they may have been married in a civil ceremony, to avoid the issue of the bride's Jewish heritage.

For whatever reasons—perhaps only to hide the truth about Kizette's early birth—Tamara carefully controlled information about the wedding. She did, however, reminisce at every opportunity about her perfect wedding dress, which had a train that stretched the entire length of the chapel. "That's the way everyone's wedding gown should look," she later declared. "You only

get this one chance in your life to have everyone turn to stare at you, no matter whether you're beautiful or not."[49]

She later told Kizette that the church was packed with czarist functionaries and foreign dignitaries, including the consuls from Sweden and Siam. Such an illustrious crowd is plausible, considering the pedigrees of those in her uncle's and Julian's social circles. Outside the chapel, Aunt Stefa and Uncle Maurice urged the bride to give alms to the beggars who now lined the street in growing numbers: "It's good luck," they insisted. Descriptions of the unlimited champagne and caviar at the couple's wedding banquet suggest that to Tamara's family, food shortages belonged to a different place and time. But Petrograd was now a city of two and a half million inhabitants, many of whom were tired of being hungry, although Tamara's friends more typically complained about being overweight.[50] Ignoring the obvious signs of deprivation and want that surrounded them, Tamara and others in her social class would soon learn the cost of their isolation.

For the first year of their marriage the newlyweds enjoyed the comfortable style of young couples sustained by family wealth. They lived in a small but fashionable apartment in the center of Petrograd, at 31 Zhukovskii Street. Decorated with wedding gifts and heirlooms, their home was filled with tapestries, silver candelabra, and oil paintings. On 16 September 1916, Marie Christine (Kizette) Lempicka was born. Based on the patterns of her own childhood, as well as her practice as her daughter became older, Tamara probably assigned the task of mothering to Malvina, who may well have taken the baby back to Moscow to stay with her and Adrienne.

Tamara would not yet have been worried about Kizette's safety, but she was intent upon perserving her own freedom as a young married woman. Indeed, almost until the moment the Bolsheviks secured control of the government in October 1917, Petrograd seemed to be much the same as it had ever been, with its Alexandrian culture of salons filled with patrons of the arts, cultural gathering places of both decadent and avant-garde talents. Shortages of food, the devaluing of the ruble, the shootings that occurred more and more often in Nevsky Prospect: the wealthy classes felt these were aberrations, merely the overflow of tensions from the war against Germany. To be sure, because of the wartime manpower shortage and the conservation of government resources, the fountains in the Summer Garden weren't functioning. So too there would be other inconveniences to deal with, until the Russians taught a lesson to those who dared to challenge them.

But there were plenty of diversions. Russian cabaret—a stage show combined with a café—provided pleasurable places for friends to gather casually. As newlyweds with a large circle of friends, the Lempiccy frequented

Comedians' Hall, a cabaret where various representatives of Russian and European Modernism gathered to talk, eat, and watch the evening performance. The main hall, with its gold and black walls, evoked the sensuousness of Venice; another part of the interior recalled a Montmartre bistro; and frescoes à la Piero della Francesca adorned a third area.[51]

Aunt Stefa's czarist family continued its tradition of religious orthodoxy, although more for social than spiritual reasons. They had made it a ritual to attend the special church service held every December 6 to honor the saint's day of Nicholas II, and to dress in their finest jewels for the performance in the czar's honor that night at the Mariinsky Theater. On 6 December 1916, the newlyweds turned themselves out smartly in their emperor's name to attend the theater—courtesy, of course, of Tamara's wealthy aunt and uncle.

George Balanchine, by age six a dancer whose studies were subsidized by the government, was at twelve among the children performing in the last act of Nicholas's favorite number, the final march of the pedestrian ballet *The Humpbacked Horse*. Years later, Balanchine gave a good sense of the air of splendor still prevailing in the year before the Revolution:

> Everyone thinks that the royal box at the Mariinsky is the one in the middle. Actually, the tsar's box was on the side, on the right. It had a separate entrance, a special large stairway, and a separate foyer. When you came in, it was like entering a colossal apartment: marvelous chandeliers and the walls covered with light blue cloth. The emperor was there with his entire family—the Empress Alexandra Fyodorovna, the heir, his daughters; we were lined up by size and presented—here they are, Efimov, Balanchivadze, Mikhailov. We stood at attention.
>
> The czar wasn't tall. The czarina was very tall, a beautiful woman. She was dressed luxuriously. The grand duchesses, Nicholas's daughters, were also beauties. The czar had bulging light eyes and he rolled his r's. He asked, "Well, how are you?" We had to click our heels and reply, "Extremely pleased, Your Imperial Majesty!"
>
> Then we received a royal gift: chocolate in silver boxes, marvelous ones! And mugs of exquisite beauty, porcelain, with light blue lyres and the imperial monogram.[52]

Regardless of the czar's obvious weaknesses as a ruler, Tamara's family believed that respect was due a monarch because of the inherent dignity of his office. And the czar, at least, understood that their class was meant to exhibit beauty and a worldly knowledge of the finest that life could offer.

Yet the extraordinary excesses of the czarist style, and the Dekler family's imitation of such extravagance, had more nefarious effects than merely directing Tamara toward an aesthetic of decadence. The ostentatious materialism of the Romanov rulers, to whom Tamara's family pledged their loyalty, effectively obscured from the young girl the dramatic poverty that most of Russia experienced even as her rulers thrived on their subjects' ill-paid labors.

Meanwhile, it was becoming less likely that the masses of hungry peasants could be appeased with the right words from the czar to whom Tadeusz and his associates were still so loyal. There was a moment of hope for a reinvigorated Nicholas in December after Grand Duke Dimitri and Prince Felix Yusupov killed Rasputin, who they believed controlled the czar through his hold on Empress Alexandra. As word circulated of the monk's almost comical refusal to die easily—the assassination weapons included poison, bullets, and submersion in the icy Neva—the *haute bourgeoisie* rallied in appreciation of the noblemen's bravery. But as the ruble continued its devaluation, people like Tadeusz, who were more nervous about losing money than about working-class anger, started growing tense.

Throughout the winter, while privileged citizens applauded *The Hump-backed Horse*, the masses—with no coal to heat their homes and not enough bread to feed their children—were held prisoner by extreme cold. The price of food—what little there was to be found—rose by fifty percent over a period of months. Yet the upper classes appeared to entertain more often, more lavishly, more decadently, than ever before, their increased wealth a result of their investment in the continuing war against Germany. Even a French visitor to the Russian capital was shocked at the discrepancy between the living conditions of the rich and those of the poor: "Never before have I seen so many cars in the street, so many diamonds glittering on the shoulders of women. All the theaters were crammed. The fashionable restaurants were the scene of incessant orgies; a bottle of champagne fetched a hundred rubles and people amused themselves by pouring it out by the bucket."[53]

During January and February 1917 workers' strikes were organized until, during a Socialist-backed gathering incongruously named Women's Day, the leaders lost control of the crowd. In a sudden frenzy, the masses started shouting "Down with the autocracy! Down with the war." On vacation with his family, Nicholas II refused to take the situation seriously. His absence encouraged the mobs who now gathered daily to protest, and there was talk of forming a "workers' soviet." By the end of February the general strike had developed to the point that the trams stopped running and newspapers were no longer printed. Members of the Duma, the largely symbolic parliamentary arm of the government, urged Nicholas to deal with the

imminent danger, but the czar called the reports nonsense. On February 26 troops of the Pavlovskii Guard Regiment fired on a crowd that gathered in popular Znamenskii Square (near Tamara's apartment) and killed civilians. More annoyed than concerned at the continued upheaval, Nicholas ordered insurgents to be fired upon, a directive that created confused loyalties, with the Royalist soldiers arguing among themselves over whether to shoot their fellow citizens. The Petrograd police alone were absolute in their allegiance to the czar. Days of fighting ensued, and casualties mounted until one afternoon, observing the police firing into an unarmed crowd near Catherine Canal, some members of the old czarist army turned their rifles in disgust upon the police.[54]

As anger over the February riots grew, and competing interests vied for power, a provisional government was installed in Petrograd. On March 3, Nicholas II abdicated. Despite the aristocracy's unwavering confidence that the empire would somehow survive, the monarchy was abolished. Until the Terror began at the end of 1917, no one could be sure what political group would end up in control. And the almost slapstick succession of ousters and reinstatements made young men such as Tadeusz confident that the civil conflict would come to a quick halt once the economy had recovered from the ravages of World War I. Monthly, sometimes daily, the government switched hands. In July, for instance, Lenin and the Bolsheviks mounted a somewhat halfhearted attempt to take over the provisional government, but their efforts backfired. The successful counterrevolution waged against the Bolsheviks resulted in lynchings and beatings of the Reds by the hundreds.

Even the aggressive young Stalin urged the Bolsheviks to take a "wait and see" position toward the provisional government, though Lenin, when he returned from hiding in Finland after his attempted coup, wanted to strengthen the Socialist party and push for their platform. Over the next few months, Mensheviks, Social Revolutionaries, liberals, reactionaries, and Bolsheviks all argued about the type of government the country should assume. The provisional government, under the control of Aleksandr Kerensky, ordered the Bolshevik party banned. As part of a successful attempt to undermine the militancy of the working classes, the rumor was floated that Lenin was a spy for the hated Germans. During August 1917 it looked as if Kerensky, backed by reactionaries, might maintain control. Tadeusz Lempicki was sure that "his" people would soon be back in power.

But on 12 September the *Times* of London announced that Russia had no government. Nicholas Sukhanov declared that his country was being run by a "comic opera" team.[55] It is easy to understand how people of Tamara's

class could simply avert their eyes from the unrest and decide that the mass confusion was a spillover from the war and a vestige of Russia's endless history of conflict. The Lempiccy supported the counterrevolutionary tactics of the right-wing General Lavr Kornilov, later deserted by his own army.

Until the autumn of 1917, Tamara remained insulated from food and coal shortages, and since she depended upon a private car for transportation to go to the theater, she hardly noticed the darkness of the streetcars, one dramatic effect of the strikes sweeping the city. Petrograd's descent into chaos largely escaped her attention.

But in October the Bolsheviks took control of Russia; by December, Lenin would be in a position to begin a serious and severe campaign against subterfuge and counterrevolution. Many members of the upper class hoped that if they lay low they would be overlooked: They would have to leave too much wealth behind if they fled precipitously. A few, however, including Tamara's aunt and uncle, did acknowledge the danger. As early as the February riots, the Stifters had begged Tamara and Tadeusz to go with them to Denmark. They were no longer able to look the other way: only blocks from their home, a vengeful crowd had descended upon the mansion of the ballerina Mathilda Kschessinska on Kammenny-Ostrov Prospect and destroyed it from top to bottom in protest against the imperial favors she enjoyed. Warned beforehand, the famous dancer had disguised herself with a shawl and fled with a small suitcase containing her most valuable jewels.[56] Tadeusz, however, insisted to Tamara's relatives that everything he had going for him—including, it can be inferred from hints Tamara gave to her daughter, his newfound career as a counterrevolutionary—was here in Petrograd. He and probably Tamara remained in the city, hoping that the Whites, as the military opponents of the Socialists were called, would beat back the Bolsheviks.[57]

Instead, the Terror bore down relentlessly upon the privileged. The Cheka—the Petrograd Extraordinary Commission, or Bolshevik secret police—apprehended Tadeusz that winter. It seems clear that he was a highly visible and active member of the opposition, since the police during this period were pursuing only the new regime's most important dissenters. Given Tamara's fear until her dying years that the Russians might come and get her, it seems possible, even likely, that she and Tadeusz were deeply involved in attempts to restore the czar to the throne. Tadeusz, like many upper-class young men of the time, may have been a member of the czarist secret police; if so, such activity probably began before his marriage and would explain the young lawyer's apparent lack of employment.

As Tamara later told the story, the Cheka came for Tadeusz in the middle of the night, their customary calling time. He and Tamara were making love, and they failed to hear the men pounding on the door. The police didn't wait for an answer but just kicked it in. Tamara, nude, wrapped the sheets around herself as the soldiers ogled her. The contrast between their black leather coats and her nakedness stood out in her memory forever. Tadeusz dressed while the Cheka ransacked the apartment, taking any objects of obvious value that they could carry and sweeping papers off the desk after examining each one.[58] When they were unable to open a stuck desk drawer, they simply left it and pushed the snarling Tadeusz out the door, knocking to the ground his deliberately incongruous choice of an expensive fur hat with which to depart for prison.[59]

Terrified, Tamara threw on her husband's robe and ran out to the street where she glimpsed the men pushing her husband into a small black car. She reached them before they drove off, but as she approached the car's still open door, the men pushed her back. She would never forget that she fell into a snowbank and almost landed on top of a dead, frozen horse, whose flanks had been randomly butchered by hungry passersby. Carcasses on the street were not uncommon in those days; Tamara had merely failed to register them until now.[60] As she struggled out of the snowbank, she stared at Tadeusz's head, framed in the window of the departing automobile. It was perhaps the first time she had conceived of her husband as a vulnerable human being.

Upstairs in their warm apartment, she overcame her trembling long enough to pry at the desk drawer, which apparently held seditious documents listing the names and addresses of Lempicki's associates in his counterrevolutionary activities. Tamara didn't know how to get it open, so she clawed the nails out of the wood and laboriously, page by page, pulled the contents of the drawer through the little opening she had made. By the time she had retrieved all of the papers she needed to destroy, her hands were bleeding, her skin peeled back like a glove being removed in reverse.[61]

According to Tamara's account of this period, when her family learned of Tadeusz's arrest, they urged her to join Aunt Stefa's brood in Copenhagen, where Malvina and Adrienne had fled as well. Denmark was a neutral country, and the Danish embassy's presence just a few houses down from Tadeusz's own home on Millionnaia Street might have ensured an earlier acquaintance with officials. But even though the executions in Petrograd were beginning to seem frighteningly ordinary, Tamara elected to stay in her suddenly dangerous beloved city. According to her own version of events,

she combed the dozens of makeshift jails that the Bolsheviks had erected all over the city out of whatever empty rooms they could find. No one could or would tell her where her husband was. Finally understanding that she had to sacrifice her sense of fashion in order to survive, she disguised herself in plain woolens as she determinedly, sometimes despairingly, went about her search. She was lucky not to have landed in the women's prison at 2 Gorokhovaya Street, on the fourth floor of Cheka headquarters: women who so openly sought to save their husbands were often accused of being accomplices. Only three months earlier, Countess Natasha Brasova had been detained there while hunting for her husband, Michael Romanov. Natasha's behavior in the dangerous conditions she faced testifies to the sense of entitlement that women like Tamara were fed from birth: determined to make "a thorough nuisance of herself . . . continually complaining about everything and demanding all sorts of impossible things," the vulnerable countess refused to be treated like a common prisoner, instead ordering (and receiving) from the Cheka guards, whom she regarded "as a collection of half-witted menials," a collection of "luggage . . . beds, bedding, linen, crockery, books, candles, cushions, towels, and all spare available food."[62]

Tamara retained her dignity as best she could, but she was initiated into a new standard of living. Like thousands of other citizens, she routinely witnessed horses in the death throes of starvation and freezing; and she watched hungry mobs hack the flesh off the fresh carcasses, leaving remains such as those she had fallen upon outside her apartment. For the first time in her life, she experienced hunger when obtaining food became difficult even for the rich. She turned to the foreign consuls who still remained in Petrograd, convinced that they could demand Tadeusz's release. After all, most embassies were located on or near Millionnaia Street: she and Tadeusz had attended countless parties where their gayest companions had been the very people from whom she now sought help. Until she made all the rounds, however, she had failed to realize what a precarious relationship the formerly powerful had with the young revolutionary government. One after another they apologized for being unable to help.

Finally she found one who was willing to assist her, the Swedish consul. But the price of her freedom, as well as her husband's, would be herself.[63] Her sex may have kept her from being thrown into prison along with her husband, and she now realized it could help get him out. As the consul listened to her plight, he continued eating a large Russian meal at his desk, the aromas reminding her of the pleasures of a full table, which until recently had been hers.

"Surely you would like some food?" he asked the ravenous young woman.

"I am not so hungry," she answered proudly.

He persisted. "I must ask you to stay so that I can learn more details about your family, as well as express my concern for how you are faring yourself under these harsh conditions."[64]

Tamara yielded to the man, both to his offer of food and to the sexual quid pro quo he established in exchange for her husband's freedom. The timing of the sexual consummation is unclear. She did remember "throwing up in the gutter" as soon as she left the room, "from eating so much rich food all of a sudden."[65] The following day the consul called on her with a plan to locate her husband and eventually to persuade the Russians to release him.

According to her dramatic rendering, the consul honored his bargain. Although it took him several days to arrange the escape, he procured safe passage out of the country for both Tamara and Tadeusz. But the diplomat stressed to her that the Bolshevik leaders had privately warned him that her situation was more dangerous than either of them had realized. Tamara must leave immediately and trust him to get Tadeusz out as soon as possible.

At first she resisted leaving without Tadeusz, but the consul had won her trust. He told her, "If you force me to push the negotiations too fast, so that your husband can go with you, the whole plan will backfire." When she agreed to do as he believed best, he made plans to take her by train to Finland the very next day.

As they reached the station, the consul reminded her, "Speak nothing but French on the train, and try to look natural when you give the guards this Swedish passport." Too nervous to speak at all, she focused on steadying her hand as she held out her forged identification to the soldiers who were demanding to see everyone's papers.

With an acute sense of loneliness, she leaned out the window of the train, and as it curved in a giant arc, she glimpsed the hammer and sickle on the engine. The barren gray landscape was hardly visible when she arrived at the border in the dead of the freezing winter night. When Tamara accompanied the consul across the wooden footbridge into Finland, she stumbled, still afraid she would be found out.

Once on the other side, Tamara and the consul spent the night together, and then he arranged her boat passage to Copenhagen, where her relieved family thought it wiser not to ask how she had escaped: what mattered was their reunion. Tamara nonetheless explained the terms of the exchange as a business deal, one in which the man had kept his promise.[66]

For several months she lived with her aunt and uncle in a luxury hotel

in the Danish capital. Nicholas II and the empress were under house arrest in Ekaterinburg, but the refugees in Copenhagen still hoped for yet another typically Russian change of power. Furious at the peace Russia had signed with Germany, the Allies were invading Russia, and it seemed quite reasonable to hope for a return to their old way of life. "After all," as Aunt Stefa reminded them, "things could be worse." The family was shocked out of their optimism by news of a fresh wave of executions, which would eventually include the basement murders of the royal family.

Tamara never discussed when or how Tadeusz joined them. Since Polish state records show that in 1918 her husband applied directly from Petrograd for repatriation to a newly independent Poland, he may have been released from revolutionary Russia several months after his arrest and allowed in early 1918 to travel immediately to Warsaw, where documents cite him as staying briefly before moving to Paris later that year.[67] Given the unstable conditions—World War I was not yet over—he might well have reached Warsaw by way of Copenhagen, where Tamara would have joined him on the trip back to Poland. Or perhaps Tadeusz arrived in Warsaw independently of his wife. According to Polish government records and the accounts of Stefa and Maurice Stifters' descendants, the group from Copenhagen remained in Warsaw for some months, perhaps even a year, before they emigrated at various times to France. Interestingly, Poland's state files contain a job application wherein Tadeusz Lempicki claims "never to have been in prison" and "never to have been convicted of a crime." Because the early Bolshevik arrests were not, strictly speaking, processed in legal courts, and since Tadeusz had acquired no criminal record before being released, it was perfectly legitimate for him to make such a statement. But it remains impossible at this stage to know the exact sequence of the Lempicki couple's brush with Bolshevik terrorism and their release from it.

Sometime during her separation from Tadeusz, however, either during her brief residence in Copenhagen—one marked by ennui, since Denmark was a "nice but boring little country," she recalled years later[68]—or during her short stay in Warsaw, Tamara entered into her first extramarital affair, which she recounted proudly throughout her life. (Either the Swedish consul didn't count as a true conquest, or she had forgotten the story she had created with him at the center.) A Siamese ambassador who had flirted with her at her wedding more than two years earlier would assume pride of place as the first of her many sexual liaisons.[69] Encountering the dashing, self-confident diplomat in Denmark, Tamara was reassured by his elegance that the world she treasured still existed. Poised, content, a man of the world in no way impaired by an inconvenient revolution, he joined (if only politely)

in her family's hopeful laughter at the silly peasants who really thought they could run a government. Tamara thrilled once again to the pleasure of a lover's beauty: the fineness of his gold cuff links, the perfect fit of his suit, even the meticulous way he groomed his fingernails.

She promptly manufactured a flimsy excuse for her family that she probably intended them to see through, in order to accept the wealthy diplomat's invitation to travel with him to England. To add to the excitement, she persuaded him to visit Paris as well: "He said, 'What would you like?' And I said, 'I would like only the things which are very difficult.' 'Then tell me what you like.' I said, 'I would like to go to France.' And he said, 'But France is in the war.' 'That's why I want to go.' And we went to France. To London and to France." By now, the pianist and statesman Ignace Paderewski had established a fund in London for the relief of Polish émigrés, and given Tamara's later involvement with the cause, perhaps she agreed to do patriotic volunteer work in England.[70] And the large Polish community in Paris, which included many Dekler family friends, would have provided a thin veneer of respectability for her visit to a city still under siege by the German army.

Since the timing of her reunion with Tadeusz is uncertain, it is also unclear whether her affair occurred before or after her husband's release. Their marriage appears to have changed radically after he left Petrograd, although their separation had been brief, surely no longer than three or four months. Tamara assumed she would get back the same husband who had been snatched from her. Instead, he was now sullen rather than attractively dark, sardonic versus laconic, and bitter instead of gay. She felt impatient with him. After all, she herself had suffered so much, and his depression smacked to her of ingratitude.[71]

Given her deep disappointment at the careless scorn Tadeusz aimed at her after his release from the Bolsheviks, Tamara felt she had no reason to hide the debt she thought he owed her, or her belief that she was the one who deserved special consideration now. And so she exacted her own payment from her still-devastated husband. In light of comments she made about Tadeusz's jealousy, dating from the Bolshevik scare, Tamara apparently made little effort to hide from him her affair with the Siamese consul, who had, after all, "wanted to sleep with me at my wedding."[72] Years later, in her carefully crafted account of the trip to London, she insisted that she was open with everyone about the arrangement: one of courtship by an elegant man who could afford to take care of her and protect her from the misery of her recent history.

If her husband, the former playboy, had any energy left with which to

begin a new life, this unexpected role as cuckold quickly sapped it. Tamara had finally conquered him, if not with Cupid's arrow, then with ammunition of a more vicious sort. Nonetheless, Tadeusz would remain the only man she ever loved completely, the only man who ever inspired in her both physical lust and emotional devotion.

In truth, Tamara Lempicka—soon she would add the "de" to elevate her stature—was deeply traumatized too, whatever the reality of her escape and Tadeusz's rescue. Her London affair may have been a desperate, ill-guided attempt to regain her sense of self-determination. Or marriage to Tadeusz might have revealed to her that she had stronger sexual urges than did her debonair, depressive spouse.

Although Tamara never talked about the dynamics of a marriage that appears to have fallen suddenly off course, it seems as if the young woman herself had changed overnight. As she rebounded from her loss of a life of privilege and security, she discovered that the husband she had once considered a real prize for a "pudgy girl" might actually be weaker than she. Until the moment when courage was demanded, Tamara had viewed herself as an interesting debutante, one who had family money, a great sense of style, and a dilettante's talent for novel activities, with little else except an inner conviction that she was meant for bigger things. Whatever the truth of her rescue, and Tadeusz's as well, the Bolshevik scare taught her that she contained within herself the resources to get ahead in the world.

Within only a few years of her flight from Russia, she began narrating the events of that time with suspicious polish and structure. Apparently she realized that she could control her own history by eroticizing episodes that would otherwise confound and worry her. Her stepniece, Françoise Dupuis de Montaut, remains puzzled over Tamara's suppression of her entire childhood in Moscow and her subsequent dramatization of the flight out of Petrograd. "She had nothing to be ashamed of," Françoise claims. "Many upper-class Poles lived in Moscow; it was quite the fashionable thing to do at the time. Adrienne Gorska never obscured her past."[73] But Ada was always her sister's psychological opposite. And the stolid young woman, though she fought her own battles in World War II, did not confront the life-and-death drama that the Bolshevik Revolution thrust upon her sister.

Throughout the rest of her life Tamara would sink into a panicked silence at the very mention of communism. Yet paradoxically, the painter would not have existed without the Russian Revolution. The complexities that had defined the willful young girl took on a coherent shape when her expulsion from a predestined life of privilege transformed her into a modern woman.

Lifelong nostalgia alongside a commitment to the new; financial self-sufficiency undergirded by the security of marriage; worship of talent and achievement over all else except royalty and wealth; steely self-control that indulged in gluttony and lust; an erotic abandon that still takes viewers of her paintings by surprise, from an artist whose narcissistic coldness seemed one with the machine—it took the Bolshevik Revolution to cast such contradictions into the permanent mold of the adult. A real-life Slavic Scarlett O'Hara, shaped by a different civil war, Tamara made up her mind that she would never go hungry again, nor would she be reduced to depending on others for her security. The spirited little girl in Moscow who had insisted she could take care of herself had been right all along: she was her own best solution.

# Chapter 3

# The PRACTICAL ÉMIGRÉ

*Poland's political instability toward the end* of World War I prevented Tamara and Tadeusz from resettling in their native land. After a brief stay in Warsaw, the Lempiccy followed the Deklers to France. In June or July 1918 the young couple and their little daughter arrived in Paris in the same state as the many other displaced aristocratic Eastern Europeans—disheveled, exhausted, and confused. Tamara was reenacting in reverse the flight her forebears had made from revolutionary France a hundred years earlier. Within two years she would translate her family's concern with national boundaries into her personal painterly preoccupation with clean edges. But at the Gare du Nord in the summer of 1918, the twenty-three-year-old wife and mother was not pondering an artist's career. Instead, she observed the weary French soldiers wandering the noisy corridors, officially still on duty since the war had not yet been won.[1]

The young émigrés were swept up into a routine of nighttime air-raid drills designed to keep citizens alert.[2] When the alarm sounded, everyone had to "jump out of bed and dash into the street and then into a shelter—the depths of dismalness."[3] But if the vestiges of a four-year war remained, Tamara and Tadeusz at the same time encountered a city eager to come back to life—and when the war

ended, Paris's rejuvenation ensued with a vengeance. For Tamara, life in Paris during this period, which historians refer to as the *années folles* or *inter guerres*, fulfilled desires that she had recognized even as a freedom-seeking eight-year-old child who had tried to sell flowers on the Moscow streets. The Great War had buried the belle epoque; the next decade would see a dramatic loosening of social norms as a burgeoning consumerism furthered women's economic and professional liberation. Tamara was ready for such change: since leaving St. Petersburg (the name she always used), she had led an unexceptional, tedious existence among traditional wealthy Russian refugees.

During the first six months of 1918 almost all the members of the Dekler family relocated to Paris. Because they spoke French as their first language and had regarded Paris for years as a second home, the émigrés assumed that their new domicile would offer them easy assimilation.[4] The presence of others like themselves encouraged such optimism: when the Lempiccy reached Paris, close to a quarter million Russian and Polish citizens had already arrived there.

Many of these Eastern Europeans were White Russians—exiled aristocrats whose "mother tongue was French," suddenly living in genteel poverty far from their "old world of . . . courtly privileges."[5] Having been unable to escape their homeland with their fortunes intact, they now depended for their livelihood upon the kindness of more fortunate fellow citizens or, just as often, upon the sale of whatever family jewels they had hidden in their bags. Selling diamonds and emeralds to buy the necessities of life was a common practice: even Natasha Brasova Romanoff, self-exiled in London, was observed stepping out of her Rolls-Royce at a Bond Street jeweler, where she sold an enormous pearl to pay her expenses.[6] Often the dispossessed nobility found themselves taking respectable but low-paying jobs—modeling for haute couture houses, for example, or operating tearooms. Some, like Natalie Paley, the beautiful daughter of Grand Duke Paul, married well, if unconventionally—in her case, to couturier Lucien Lelong. Those who in Russia had been among the few to own private automobiles became taxi drivers, a circumstance which moved Tamara to recall in later years that "it was the only time in my life when my chauffeur was a count."[7]

Tamara supported her own family for several months by selling a valuable emerald ring with which she had escaped. In their new status as refugees, Tamara and Tadeusz at first could afford only one room in a hotel, with a sink that doubled for kitchen duties and for bathing Kizette. "The poor baby, our food, everything [was] washed in that one bowl," Tamara later remembered. "We were three together in one room, no bath."[8] The hotel was run by a woman whose supercilious airs Tamara found insulting, but such

disdain quickly lost its strangeness. As one Russian émigré from the period recalled, "The concierges, particularly, persecuted their Slavonic tenants, and urged them to enlist as volunteers [in the army]: 'Otherwise, out!'"[9] The woman nonetheless accepted the itinerants when Tamara showed her their collateral: her three-carat round diamond wedding ring with four perfect ruby ovals recessed into the filigreed twenty-karat gold setting.[10]

From Tamara's frequent references to her family's cramped quarters, it seems likely that their comparative poverty exacerbated the tensions already festering between the married couple, and soon after the Armistice on 11 November 1918, Tamara decided she needed a break from her husband in order to figure out their financial future. Demonstrating her usual independent and often self-centered thinking, she announced to Tadeusz that she was selling her last remaining jewelry of value so that they could pay their rent for eight weeks and still afford for her and Kizette to vacation in Nice, an attractive destination given the bitter cold of Paris's winter that year. "We are lost," she dramatically informed him. "We have nothing. . . . I will be there until I recover, until I . . . find what to do."[11] Her husband's response to her plan to recuperate without him goes unrecorded; as usual, she did as she wished.

In the south of France, mother and daughter lodged at "the cheapest hotel, on the top floor," close to a small Russian restaurant where a number

of restless and newly poor Russian aristocrats were pondering their futures as well. One day, after watching the perfect table manners of two-year-old Kizette, a Russian countess from a nearby table came over to compliment Tamara on the girl's behavior. "Your little child . . . is so well educated and so beautiful that I want to congratulate you," the elderly woman commented to the proud mother.[12] Such praise encour-

*Tamara and three-year-old Kizette on vacation, c. 1919, the south of France.*

aged Tamara, reminding her that she retained a legacy of education and breeding to pass on to her daughter; and it fueled her conviction that she remained worthy of the privileged life to which she aspired.

Upon her return to Paris, Tamara was heartened further by the speed with which the Stifters had reestablished their social standing. Thanks to their shrewd intelligence, her aunt and uncle were faring better than most other upper-class refugees.[13] Maurice Stifter had transferred his money slowly and steadily into the Crédit Lyonnais on the Boulevard des Italiens before leaving Russia, in the process safeguarding most of his family's fortune. The grand house in Petersburg, filled with the Louis Quatorze furniture and thick woolen rugs Tamara loved, was the only important asset he lost in the Revolution. Maurice had started working at the Paris branch of the Crédit Lyonnais soon after Tamara and Tadeusz arrived in France. His position allowed his wife to begin almost immediately to hold weekly luncheons at their spacious apartment near the Champs-Élysées for the exiles now congregating in Paris. Prince Yusupov, their scandalous acquaintance from Petrograd, occasionally joined the group, most often without Princess Irena, who was usually busy working for whatever couturier needed a cutting model.[14]

Despite Tamara's attendance at her aunt's teas and soirees, she preferred the café life of the new Paris, with its Pernod, coffee, and endless arguments about politics and art. Among the various groups of expatriates, the Americans seemed to the war-weary Europeans to be the ones with money, energy, and a future. Years later novelist Djuna Barnes, writing from the security of New York during the Second World War, recalled nostalgically the vibrant yet relaxed life at the Café des Deux Magots, one of the major meeting places for the artistic crowd: "I would give all I have . . . to be back in Paris again as it was, sitting at a bistro table with its iron legs in the sawdust from the escargot baskets, the cheap, badly pressed cotton napkin coming off all over my best cloak—that napkin with its hems always half turned and heavy with the blood red of yesterday's burgundy—a carafe of vin ordinaire before me, an oval dish of salade de tomate, a bowl of cress soup, a blanquette de veau, green almonds—anything—only to hear again the sad, angry popping of the taxi horns, the gracious flowing language chattered by clerks off for two hours."[15]

The city's upper-class Russians, however, would prove less nostalgic about these years. The Parisian avant-garde had little sympathy for the czar, and in their eyes the White Russians had been on the wrong side of the revolution. As a result, these émigrés bore the double burden of financial woes and the contempt directed their way by the artistic and intellectual elite of

*Adrienne Gurwick-Gorska, c. 1920.*

Paris. But the Dekler women had come from strong stock, and Malvina and her sisters bequeathed their resilience to the next generation as well. Within a year of Tamara's arrival in Paris, her talented sister Adrienne had been accepted at the École Spéciale d'Architecture, where she would earn her degree in three years. Already accustomed to her role as the family's intellectual, Adrienne gained further confidence from being admitted to a well-regarded school opened to women only two decades before. (Tamara would nonetheless inflate the honor by claiming that Adrienne had graduated from the even more prestigious École des Beaux-Arts.)[16] Now around twenty years old, Adrienne was being supported by her aunt and uncle, whose son Costa was also studying to become an architect.[17]

Bolstered by her academic success, Adrienne resumed her symbolic function as wiser sibling to the floundering Tamara. Her older sister needed good counsel, that much was clear to the perceptive young woman. By this time the entire family was concerned about Tamara's unhappy marriage. Unpleasant public exchanges suggested that she and Tadeusz were fighting constantly, and the occasional bruise, which Tamara vaguely explained away, made her sister particularly nervous.[18] Finally, Adrienne intervened at a party given by Stefa, during which Tamara seemed distracted and confused, drifting around as if she didn't know where to sit, and unable to make conversation. Such uncharacteristic behavior prompted her sister to guide Tamara into an unused parlor and ask her what was wrong.

"We have no money," the young wife sobbed, "and he beats me."

Adrienne knew about the former and had suspected the latter. "Then you must work," she responded.

At first, Tamara could not imagine what sort of work she might find. As she recalled later, the most common occupation for women of her class was as a model for the dress designers of the day. "I said, 'Work? Work what? All

the grand duchesses, they were Chanel mannequins . . . but they had the thin figures.'"[19] Adrienne reminded her unfashionably voluptuous sister of her talent for painting, and suggested that Tamara study at the Académie de la Grande Chaumière, where no tuition was charged. She could then support her family by selling her art.[20]

For the rest of her life Tamara maintained that her vocation as a painter was born at this moment from the need to achieve financial independence through a family-sanctioned talent. Adrienne's confidence in her sister was crucial, since throughout her life Tamara respected Ada more than any other woman.

Less than a year elapsed between this interchange in late 1919 and Tamara's completion of two highly successful, sophisticated portraits executed in 1920, *The Card Player* and *The Girl in Blue*, an achievement suggesting a talent that was already well developed. But Tamara preferred throughout her life to appear unschooled in painting and so she consistently minimized whatever training she did receive. Her version of her life story followed a simple trajectory: she had natural ability whose emergence was fostered by her trips to Italy, then further promoted by economic necessity. On the one hand, Tamara expressed a sense of her vocation as fortuitous: if a man had supported her properly, or if the Bolshevik Revolution had been averted, she would never have become a painter. At the same time, her artist's narrative implied a sense of preordination; it was in the stars for Tamara de Lempicka to become a great painter. Only three years after her crucial conversation with Adrienne, Tamara's work would be included in the juried Salon d'Automne show.[21]

But before Tamara had a chance to act on her sister's advice, Malvina, now living in a pension on Rue Paul Saunière where she maintained a room for Adrienne as well, asked her daughters to accompany her on a short trip to the German border. There she sought out German officials who might know what had happened to Stanzi. Although Malvina still waited hopefully for the return of her only son from the war, she had heard nothing from or about him for over three years. The women's efforts met with complete failure; the Germans were quite willing to cooperate, but they simply had no account of him. Driving back to Paris, Malvina was distraught over the loss of her oldest child. She told Adrienne and Tamara, themselves not particularly upset over their brother's disappearance, that this pain was worse than her sorrow over the suicide that had occurred when Tamara was five.[22]

For the next three weeks Malvina mourned deeply while her daughters took care of her. Tamara asked Kizette to be especially affectionate to Grandmère, and within the month, Malvina seemed quite herself again, even eager

to baby-sit once more.[23] To distract her, Adrienne raised the question of Tamara's pursuing painting as a career, and Malvina gave the plan her blessing. This timing—a mother's grief for one child juxtaposed with her imprimatur upon another's plans for the future—inspired Tamara to redeem through her talent something, however vaguely defined, for her family.

After her mother had recovered, Tamara made arrangements to pursue formal art training in Paris. But she was worried about Tadeusz, who now bore little resemblance to the man she had married. The ennui of the jaded lover in Petrograd became, in Paris, a real exhaustion with life. Toward the end of the war he had fleetingly considered joining the Polish soldiers in France, an "Allied belligerent army," consisting partly of Polish troops raised in Russia.[24] Finally, however, he eschewed all involvement in the war, a decision possibly motivated by the defective foot that had plagued his earlier attempts to pursue a military career in Russia. More likely, his own loyalties were hopelessly confused: on the one hand, he had no love for Germany, a country that had been brutal to his native Poland; on the other, he could not envision himself supporting a war effort that would benefit revolutionary Russia.[25]

According to Kizette's memories of her father in Paris, Tadeusz appeared alienated from everyone.[26] Except to recall his good looks, Tamara rarely referred to him in later years, and his daughter remembers him best from this period as the tired, handsome man who either lay silent on the sofa or, when he summoned the energy, yelled at her mother. Tamara urged Tadeusz to help support the family by clerking at her uncle's bank, but he bristled at what he thought was a dismissal of his talent and training as a lawyer.[27] He would get a job when he was ready.

In contrast to her husband, Tamara felt more energetic daily. By the end of 1919 she was enrolled in the Académie Ransom, directed by the widow of Paul Ransom, a Fauvist painter who had founded the school a decade earlier. Maurice Denis was among its prominent teachers.[28] A friend of Paul Gauguin's, Denis was a leader of the avant-garde; his 1890 manifesto, *The Definition of Neo-Traditionalism*, would become one of the most important documents in Modernist aesthetics, though late-twentieth-century critics dismissed him as a painter. But even in the 1930s, Tamara downplayed Denis's importance to the development of her art, at times denying she had ever studied with him. Admitting at most that she had been Denis's pupil for "only a few weeks," she added, "and then I never liked it. . . . I wanted to have my own ideas."[29]

Despite her attempts to declare herself sui generis, Tamara's lifelong

choice of brilliant pigments echoed Denis's palette. His tendency to flatten masses, to lift the horizon, and to dispense with traditional perspective also influenced her technique. Finally, regardless of her impatience with theories, her idiosyncratic synthesis of classicism and realism recalls not only Ingres, commonly cited as a major influence upon her work, but also Denis's famous statement that "it is well to remember how a picture, before being a battle horse, a nude woman, or some anecdote, is essentially a flat surface covered with colors assembled in a certain order."[30]

Denis tended to be somewhat metaphysical, a propensity often reflected in the themes of his paintings, and one that was sure to alienate Tamara, who deeply disliked what she referred to as "mystical mumbo jumbo." In pre-Bolshevik Russia, many of the painters who indulged in such popular rhapsodies had, from her point of view, ended up backing the wrong side.[31] Denis, on the other hand, was committed to the reactionary nationalistic movement L'Action Française, whose goal was to restore the French monarchy. Such a political orientation, unusual among the prominent artists of the time, should have endeared the teacher to his Royalist student. But any initial enthusiasm faded quickly when she read an article in the influential journal *Source*, in which Denis extolled the mysterious and irrational forces present in art—a position exactly opposite to Tamara's pragmatism.

However dismissive of her formal training she later became, Tamara took her studies very seriously at the time, and she applied herself to them with the same manic intensity typical of her social life. She haunted the Louvre, where she scrutinized the Dutch painters for their use of light and the Italians for their color. When studying modern art, rather than limiting herself to her own instructors or to the titans of early Modernism, Picasso and Braque, she also looked carefully at other French Cubists, who sought to humanize the rigidity that characterized the style in its formative years. Of this group, Albert Gleizes, coauthor of the seminal work *On Cubism*, particularly interested her. After Gleizes visited New York and painted several versions of the city's architecture, Tamara adopted his Manhattan skyline for her own portraits. Inspired by the way the backgrounds of Renaissance portraiture anchored subjects to their time and place, she frequently positioned her urban patrons in front of a geometrical New York cityscape.[32]

As a pupil, Tamara correctly believed herself already beyond what Denis could teach her. She arrived at the academy able to sketch beautifully; his insistence on practice must have quickly seemed superfluous. She enjoyed drawing rudimentary still-life studies, but she yearned to work from live models, which came much later in Denis's program. Furthermore, the young artist spent hours each day in the Louvre copying heads and hands from

Renaissance paintings. At home she would paint from books. Chafing at the uniformity she believed Denis imposed on his students, Tamara was convinced that the impressive detail and emotion she evoked in these studies (Plate 1) proved she was wasting her time with a teacher who was unwilling to tutor her according to her own abilities. When she was later asked to discuss her position vis-à-vis her contemporaries, she would assert: "Everything that I did was never done like the others were doing. . . . Somehow I did always differently. . . . I wanted to do what I want."[33]

Tamara valued deeply her own originality yet had no need to disavow the wisdom of more experienced painters if she appreciated their work. Had she agreed with Denis's aesthetics, she would have deliberately incorporated his strengths into her painting. Increasingly, however, she believed that his artistic allegiances conflicted with her own instinct for beauty.[34] She was uncomfortable with her instructor's adherence to the school of Cézanne, which emphasized the subjective nature of perception and thus strained the boundaries of realism. Nor did she appreciate the imprint of the Fauves, the "wild beasts," upon Denis's theories: their exploitation of bright, often dissonant colors was too extreme for her taste.

Cézanne in particular became a negative touchstone for Tamara, because he produced, she believed, an art of muddy hues. Abhorring such dishonesty to nature, she sought instead the clear colors of the Italian quattrocento, and of the Dutch and Flemish schools, where fine drawing was accompanied by a luxuriant mixture of pigments. If a blue was needed, she felt the color should be worthy of the Venetians, to whom the brilliant blues of Giovanni Bellini's *Saint Francis in Ecstasy* or *Madonna and Saints* were the standard of perfection. Today connoisseurs speak of the influence of Bellini's blue, sometimes recast as "Tamara blue," upon her most characteristic works.

Tamara's patience with Denis expired totally when, as she exasperatedly told her sister, he forced her to listen for the fourth time to how he had painted his *Homage to Cézanne*, which he had presented to the master himself in 1901. Denis was invoking the grand tradition in nineteenth-century portraiture of art students exchanging portraits (as did Jacques-Louis David and his students and, in Denis's day, Gaugin and van Gogh), though he was careful not to imply equal stature with the man he had painted. Tamara recognized the implicit message: Denis anticipated being similarly honored by his own grateful epigones, and she wanted no part of that plan.[35] She left his class, determined to find a new teacher.

Coincident with this decision, she decided to hunt for a home more appropriate for an artist. While searching the avenues that radiated from the

Étoile, she found a three-room apartment in Montparnasse. As she had learned years before in her prewar visits to Paris, Montparnasse encompassed the true modern-art scene, unlike the flashy Montmartre, now mostly a tourist site where visitors gawked at the sidewalk artists. She loved the seediness as well as the chic of Montparnasse, where "narrow . . . inordinately long" streets were peppered with "shabby perfumeries, secondhand book stalls, cheap hat shops, bars frequented by gaily painted ladies and loud-voiced men. . . . You could walk for hours."[36] Large apartments were scarce in Montparnasse, but Tamara's lucky find was secured by a drunken manager so responsive to her flirtation that he evicted his own father and sublet the apartment to her instead.[37] She later would recall nostalgically the apartment at 5 Rue Guy de Maupassant, with its bathtub hidden by a screen and its large dining room windows opening upon a beautiful row of trees outside. Tamara never admitted that her husband contributed to their financial welfare, but Tadeusz in fact enabled this move by taking a job at the Banque de Commerce, where he would continue to work until its bankruptcy in 1931.[38]

Observing the latest trend in interior design, the young artist painted most of the walls inside their new home a fashionable gray. The apartment contained three large separate living spaces—a bedroom, a living room, and a dining room—as well as a small room for Kizette, painted in pink and decorated with Italian drawings. Most important, the window in the living room admitted excellent northern light, which Tamara deemed essential to achieve the clarity of line and color she demanded in her paintings.[39] By the end of 1920, Tadeusz, Tamara, and Kizette had left shabby hotel rooms behind forever, and Tamara entered a new phase as a working artist in her small but smart apartment.

Feeling herself part of Montparnasse's invigorating neighborhood life made the flamboyant twenty-five-year-old even more certain that she had chosen the right career. What had been a quiet part of town was becoming a new Bohemia of artists and personalities bent on topping each other's outrageous behavior. An influx of foreigners in the early twenties had only added to the neighborhood's glamour; here Tamara felt safe being an outsider. Artists and hangers-on crowded the Rue de Montparnasse. They gathered at the Café du Dôme, and the ultramodern La Coupole grew increasingly popular. Café Rotonde, at the far end of the street from the Dôme and more refined, if more expensive, stayed much the same as it had been for years. Still, the newly noisy, crowded *quartier* no longer offered the tranquillity of earlier times.

Sylvia Beach's hospitable American bookstore, Shakespeare and Company, offered a place for quiet reflection. Soon to become famous for pub-

lishing James Joyce's *Ulysses* when no one else would, the expatriate Beach was known for supporting Modernist literature. Tamara, however, preferred to frequent the friendly French competition across the street, Adrienne Monnier's La Maison des Amis des Livres.[40] At least twice a week she "took her exercise," in the phrase she used throughout her life, by quickly walking from the Rue de l'Odéon to the Boulevard St.-Germain, toward the church of St.-Germain-des-Prés. Upon reaching the sidewalk tables of the Deux Magots, she sat down and waited for Adrienne to finish her classes, so that she could join the architecture student and her friends as they drank, smoked, and reviewed their morning activities.

This stylish, knowing city, which she had loved visiting with Aunt Stefa as a girl, when she had yearned to be old enough to join the handsome, fashionably dressed men and women—this, Tamara now felt, was hers. Even if other artists thought it unlikely that a busy young mother could also be a successful full-time painter, she would compete with them as if she were on a level playing field. It was true that, as one writer put it, "women with creative energy and varying degrees of talent, women with a passion for art and literature, women without the obligations that come with husbands and children, were especially drawn to the Left Bank."[41] Such women had a professional advantage, but Tamara was nevertheless determined to find her own place beside them.

Several years earlier, illustrator Gordon Conway had satirized for *Vanity Fair* the contradictions that ambitious modern women faced when they were burdened by family commitments. Conway sketched a newly single woman who is "fed up and disillusioned. . . . She has hung out the red flag . . . bobbed her hair, and invested in a litter of bombs. . . . Her cry now is 'Down with Husbands . . . Down with marriage—up with the flag of freedom.'"[42] Tamara had no intention of doing without her husband and child; she just decided that it was expedient, in many cases, to pretend that they didn't exist. And at other times, she would find that they offered a convenient validation of her propriety.

From the beginning she was alert to the need for strategies; never did she naively assume that talent alone would ensure an artist's success. But she possessed a near fatal need to control her destiny, to refuse to allow others to help clear her path to artistic prominence. Even in daily financial matters, her pride threatened to undercut her visibility among other aspiring artists. Had she been willing to depend longer upon family support, Tamara would have remained freer to experiment in her work; but she was embarrassed by her need for the Stifters' help.[43] The fledgling painter did, however, recognize the importance of participating in the afternoon café gatherings and of

purchasing the books her companions were discussing, and so she permitted Adrienne to pay her café and book bills—for which she was reimbursed by their aunt—at least until early 1921, when her need to make up for the time lost in her all-night debaucheries cut short her visits to the Deux Magots.

Tamara was wise to recognize the importance of café life as she began her career. Her reputation would have benefited had she paid even closer attention to the conversations humming around the afternoon tables, instead of impatiently seeking enlightenment elsewhere. Informal café society offered one of the major conduits for new developments in art during the 1920s. It replaced the antiquated salons of the nineteenth century, where wealthy visitors had ritualistically gathered to discuss politics, art, and literature. Such soirees had degenerated into an excuse to enjoy a hostess's rich food and expensive wine, a staleness captured in D'Annunzio's irritated response when Madame Aubernon imperiously asked him to declaim on love: "Read my books, madame, and let me eat my dinner."[44] By the beginning of World War I, intellectual discourse had become a more democratic commodity. The educated exchanges that had previously occurred in the salons became the daily currency of life in the cafés, where even students could afford to linger for hours as they nursed a cup of coffee or a glass of wine. Before the war, Tamara had enjoyed herself as a foreign visitor to café life; now she became, for too short a time, a regular.

When she was not with Adrienne at Deux Magots, the painter preferred sitting at the round tables of Café Rotonde, where she could view the canvases of Modigliani, Kisling, and Soutine, all of whom had paid the proprietor with paintings when they lacked cash. In later years she reminisced with her daughter about the poses she adopted during such afternoons. Rarely speaking, chain-smoking instead, she would practice the art of looking interested in others' conversations, while most often allowing a hopeful man beside her to pay for her café crème and hot croissant. Sometimes arching her back to show off her breasts as she pursed her lips, she appeared deep in thought, which in truth she was, since she was usually thinking of the painting on which she was working at the time.[45]

Tamara's self-absorption was a form of protection. Recognizing that academic thrusts and parries ruled this intellectual realm, she wisely discarded the finely calibrated form of verbal seduction that elsewhere had served her well. Although she knew at least five languages, she tended to mix them together, and she was self-conscious about her eccentric patois. But if her silence caused her to be ignored, she was not offended: the afternoon café crowd was made up mostly of students who flaunted their poverty and flouted the social graces, postures that Tamara considered repellent. Unless

they were devastatingly handsome, even the men were not worth a second thought. She was to develop a distinct taste for sailors over the next five years, and they, of course, had earned the right to be crude and dirty; such authentic roughness was erotic. Artists and intellectuals, on the other hand, were supposed to be sophisticated.

Café life soon troubled her on other fronts as well. The leftist leanings of the Dadaists and Louis Aragon's increasingly influential Surrealist group, with their vague theosophy, reinforced Tamara's suspicion that mysticism was somehow linked to communism. Dedicated to desecrating the old and celebrating the nonsense of life, these artists and theorists spiritualized the language in which they promoted rebellion. The Surrealists were also inhospitable to ambitious women artists: women's role was to "inspire or enthrall but not to participate in the Surrealist revolution."[46] In reality, however, Russians on both sides of the revolution had embraced spiritualism. One of the habitués of the Café Rotonde, Princess Maria de Naglowska, founded a mystic cult of which she was herself the sole member. Throughout Montparnasse she circulated her publication, *La Flèche*, in which she wrote about "body dynamics," "ecstasy," and the dark mysteries to be conducted on the Christian Sabbath.[47] The princess sat at the Rotonde for hours, reading her treatise to anyone who would listen, but even Tamara, with all her Royalist leanings, refused to talk with the tedious woman.

Across the street at the Dôme, the Bolshevik journalist Ilya Ehrenburg also sat watching in disgust the lunacy of the princess and the circus atmosphere let loose by Aragon and his liberal friends. Reactionary and revolutionary alike believed that the seriousness of art was undercut by such flamboyant cultural politics. Tamara was furious that leftists could dare to preach freedom under the banner of art and that nobility could stoop so low; Ehrenburg was outraged that the adolescent high jinks besmirched the sacredness of the revolution and that Naglowska, a member of the aristocracy, still presumed to speak in the name of Russia.[48]

Tamara failed to gain the important aesthetic direction and the support of like-minded friends that café life offered to many other artists. When asked in later years if she had inhabited the circles of artistic power in the early twenties, she replied impatiently, "I was not there . . . because I was so busy working. . . . It takes time to go out and sit and discuss art. I wanted to work, to work, to work."[49] The most important influences on her painting would develop from experiences outside the usual artistic settings.

One such influence was a friendship—shrouded by Tamara in a cloak of mystery—that probably encompassed her first lesbian affair.[50] A "very wealthy girl who lived across the street . . . , a redhead who sat for many

paintings," entered Tamara's life sometime after she and Tadeusz had settled in their Montparnasse apartment. During the early 1920s intense female friendships were idealized as a means of establishing a woman's independence from the dominant male culture. In her essay collection *Wir Frauen*, Leonore Kühn captured the ethos of the "best friends" who accompanied successful women of the time: "[Contemporary women] must conquer, confirm, and achieve everything anew and to that purpose only a woman friend can help. She is by nature like-minded, perhaps also more experienced in hacking a path through the jungle. . . . In this fashion, the girlfriend is often the recipient of emotions that before were directed at a man: all the need for love, tenderness, understanding, and spiritual quest that a woman harbors is now based on the woman friend."[51]

The redheaded neighbor on Rue Maupassant appears to have fulfilled such a role for Tamara. Refusing ever to supply her name, Tamara referred to this friend simply as "the one with the English mother and father," or the one whose "sister was an epileptic."[52] The young woman modeled for Tamara and, early in their acquaintance, treated the painter to a first-class trip to Italy, paying all the expenses. On this trip, which retraced the itinerary she had followed years before with her grandmother, Tamara discovered the works of Sandro Botticelli and of Antonello da Messina. In emotional if broken prose, she later recalled breathlessly: "Bouleversée de cette decouverte. Reste base de ma peinture." (Stunned by this discovery. Remains basis of my painting.)[53] In an interview she gave the year before she died, Tamara summarized her Italian trip: "There I visited the museum. . . . And I said, 'It's all fantastic. Why can't I do that, just as simple as that?' And then . . . I did."[54]

The trip with the unnamed beautiful friend motivated Tamara to paint even more prodigiously upon her return to Paris. Now she began working from midnight to dawn and spending eight hours a day sketching from live models. With her compulsive need for order, she must have been able to compartmentalize her activities and emotions. In the process, her husband and child found themselves functioning as addenda to the artist's overcrowded schedule. Tamara believed, however, that the sacrifices her family had to make would result in their eventual happiness when she finally started making money from her art.[55]

At times her public command of herself, her strict ability to mete out her energies, gave way to a private want of self-control, especially where delayed gratification was required. On one occasion she was unable to finish a still life because she ate the *religieuses*—the little whipped cream and chocolate cakes—that she was supposed to paint. And on a brief holiday to Monte Carlo an admiring passerby gave Kizette a pear, which, while she

slept, was replaced by a more mundane apple—another casualty of Tamara's lack of restraint.[56]

Without a doubt, the frenzied rhythms of her life suited her art. She developed quickly, producing within two years of arriving in Paris several oil paintings that retain their power and presence today. *The Card Player*, from 1920, shows the unmistakable influence of the preceding generation's strongest woman painter, Suzanne Valadon, whose clear effect upon Tamara's early work has gone, remarkably, unnoticed.[57] *The Card Player* tames the grotesque into something recognizable and real, whose domestication nonetheless threatens to exceed the boundaries of decorum. Maurice Denis's Fauvist leanings reverberate in this painting's bright colors, more garish than the jewel-like shades of the mature Lempicka. The composition itself anticipates Valadon's ferocious *Self-Portrait* of 1923 so impressively that it seems Valadon must have seen the earlier painting. In Tamara's work, the woman's breasts sag within her red bandeau, suggesting the weight of age, but the amount of pictorial space given to her contrasting bright yellow skirt suggests that this is a woman still to be reckoned with. The face, with its ominous frown and narrowed eyes, threatens the person she glares at sideways. With broad, obvious brushstrokes Tamara strengthens the aggressive tone of the painting.

If Tamara was inspired by Valadon's almost violent aesthetic, her painting also contains something of van Gogh's bold stroke and of Gauguin's strong color, suggesting that Denis's high praise of both men found expression in his reluctant student's art. Ten years before she began studying with Denis, he had published an important essay that discussed the work of these artists, the two primitivists he found worth emulating. Most significant for Tamara, he claimed that Gauguin especially translated a love "of the decorative" into an absolute insistence upon clear colors as "a sign of intelligence."[58]

The same principles Denis ascribed to van Gogh and Gauguin are evident in the haunting beauty of Tamara's portrait, from 1920, *The Girl in Blue*, where the subject's ripe voluptuousness contains its own inevitable degeneration. Though still a deliberate formal function of the painting, the obvious brushstrokes are muted to enhance the loveliness of the young woman's soft skin. The girl occupies most of the pictorial space, a triangular pillow behind her echoing the larger, softer triangle formed by her upper torso. The precipitous peak of the background triangle, placed at the same level as the girl's large, slightly accusing brown eyes, heightens the painting's emotional impact. Tamara reworked the color of the girl's gown for the next decade, until she had perfected it into her signature blue.

The model for *The Girl in Blue* was probably Ira Perrot, whose hair

Tamara painted during the next ten years as black or red-black.[59] The red-dish halo around the dark hair in this portrait is similar to that in a color pencil sketch of Ira that Tamara executed during the early twenties (Plate 2). The red hair, her role as model, and the decade-long friendship between the two women, which Kizette recalls as "very deep," reinforce the suspicion that Ira Perrot was the neighborhood friend who took Tamara to Italy and enabled her to discover Botticelli and Messina.[60]

Invoking her devotion to the Italian masters, Tamara displayed several characteristics in these early paintings of 1920 that were to recur in her later work: a striking tendency to fill the canvas entirely with the subject, a lack of delicacy in the human form, and a relationship of figure to background that deliberately flattens the perspective. As Tamara herself noted: "There is very little background in my paintings. I want you to see the figure, that is what is important." She admitted that she deliberately made the tops of some portraits appear incomplete: "People thought I had made a mistake, I had chopped off a piece of their heads. But I wanted it to look like the people ran in and out, leading their busy lives." The Romantic emphasis upon the artist's inner vision appalled the classicist from St. Petersburg: Tamara maintained instead that "you have to paint from what is external and real."[61]

In the early months of 1921, Adrienne insisted that it was time for Tamara to seek an outsider's opinion of her work. She persuaded her nervous sister to line up her paintings to be examined by one of Adrienne's best

*From left, Ira Perrot's husband (name unknown), Ira, Tadeusz, Tamara, and Kizette in front, probably in La Coupole, c. 1925.*

teachers. When the professor pronounced "Beau métier"—that she had a fine technique—Tamara almost collapsed in relief. After he further suggested that she had enough paintings for an exhibition, the two sisters and Kizette rushed off to tell Malvina, and then to buy the best new brushes Tamara could find.[62]

Tamara's exhilaration during these early years must have been almost tangible; here she was, after years of playing at life and hoping to get a plum role, suddenly participating in painting's important post-Cubist flowering. Just as she had noticed years earlier, women seemed to be integral to the evolution of art in Paris, and Tamara had reason to believe her gender would abet, not delay, her success. "When I started to paint," she recalled late in her life, "it was a time when many women started to paint. There were more women than men, at that time."[63] The novelist Jean Rhys noticed the same phenomenon in the 1920s, less enthusiastically: "It's pretty awful to think of the hundreds of women round here painting away, and all that."[64]

Opportunities for women painters had increased in the late nineteenth century, but many of those artists were later relegated to second place in the official chronicles. Class often compensated for gender, however: an aspiring woman painter with the social pedigree of, say, Mary Cassatt, was far more likely to retain her place in history. This earlier group of successful women helped pave the way for those of Tamara's generation who now believed art to be a respectable career instead of a finishing school activity. Always practical, Tamara had made sure that the profession she chose provided opportunities for women.

But despite the new possibilities for women artists, hurdles still existed. Art students of the period continued to be taught from such books as Walter Sparrow's *Women Painters of the World*, first published in 1905. The well-meaning Sparrow emphasized as his central theme the eighteenth- and nineteenth-century notion that "feminine art" was "emotional and womanly," most often forming a "decorative genre," in contrast to the "intellectual masculine genre" of its male counterparts. Until the late 1890s, the only state-funded art school open to women in Paris was the École Nationale pour les Jeunes Filles, which encouraged its students to explore the decorative and applied arts rather than the "masculine" territory of art proper: easel painting aimed at the timeless.[65]

Famous Modernist artists in the 1920s did pursue textile and stage set design, but with varying results. When painters such as Braque, Picasso, and Matisse contributed to the decorative arts, their reputations as painters were enhanced; when women engaged in such endeavors, including the elaborate theatrical productions designed by Sonia Delaunay, their identities as deco-

rators, versus serious artists, were promoted. In spite of the success many male artists enjoyed as set and costume designers, women needed to consider the possible costs to their artistic reputations before they sought similar employment. Marie Laurençin was able to design the sets and costumes of Diaghilev's ballet *Les Biches* without losing standing among her peers because her critical reputation was secured by her wide circle of male artist friends, including her lover, Guillaume Apollinaire. Tamara, who loved designing clothes and who executed studies for stained-glass windows, steered clear of this work and took pains throughout her life to hide her excellent tailoring skills.[66] The young painter understood that however brilliant the decorative arts, the vestiges of domestication that clung to them would render them always inferior.

Unimpressed by the avant-garde prejudice that representational painting was secondary to geometric, or abstract, art, Tamara maintained an artistic allegiance to the painted figure. But gender norms inflected the bias of Modernism against the figure: the "emotional" quality that Walter Sparrow had considered peculiarly feminine was thought to be most clearly expressed in the less intellectual, more literal, figurative art. As Alfred Stieglitz, a purveyor of Modernism, had written in his 1919 essay "Woman in Art," "Woman feels the world differently than Man feels it. And one of the chief generating forces crystallizing into art is undoubtedly elemental feeling. . . . The Woman receives the World through her Womb. That is the seat of her deepest feeling. Mind comes second."[67] By the middle of the 1920s, figurative painting had become the obvious artistic arena for female painters. Of the women frequently mentioned in Parisian art reviews of the 1920s, Emilie Charmy, Marie Laurençin, Suzanne Valadon, and Mariette Lydis, all painters of major achievement, usually saw their exhibitions analyzed in the vocabulary of gender—the feminine or masculine qualities of their art.[68]

At least these women were becoming publicly visible. In several art histories written during the 1920s, however, women Cubists were omitted from official accounts of the movement, even though they had worked vigorously within the rubric of a still-developing Cubism. Although these women—including Alice Halicka, Marie Vassiliev, Suzanne Duchamp, Maria Blanchard, and later in the 1920s, Tamara herself—remained on the fringes of the movement in terms of their influence, their presence in the salons and reviews of the times would seem to have ensured for them a place in its history.

The story of Alice Halicka, a fellow Pole, must have served the young Lempicka as a cautionary tale: she repeated it more than once, always fretfully, to several of her friends.[69] Born to a wealthy family in Krakow in 1889, Halicka had enrolled at the Académie Ransom and had also studied under

Maurice Denis about ten years before Tamara did. She married the Polish painter Louis Marcoussis in 1913 and developed her Cubist transformations of space and bodies while Marcoussis was fighting in the trenches of World War I. Her work was soon considered accomplished enough for the prominent dealer Zbororowski to offer her a contract. When Marcoussis returned from the war, however, he insisted that she reject the contract offer and renounce what he deemed her increasingly unappealing Cubist direction. She complied, and after deliberately destroying half of her works, she turned to fabric design, thereby making a decent living for the two of them. After a short period of experimentation with collages on wood, she revived her flagging reputation in the twenties and thirties through her designs for the ballet. In spite of Halicka's later moderate success, however, Tamara always believed that her fellow Polish artist had sold her painterly soul for the approval of a man who validated his wife's talent only when she pursued beauty outside her own sensibility.[70]

Unlike the literary world, where women like Sylvia Beach could develop a network of female authors who supported and promoted one another, the art world rewarded women if their professional work was accompanied by a personal, most often physical, connection with a better-known male artist. Female access to the avant-garde circles of painters often depended upon a romantic association.[71] Diego Rivera, who was just beginning to make his way among the Parisian Cubists, explained this system to his lover, the artist Marevna. After telling her that Apollinaire had been responsible for Marie Laurençin's success, he added, "You see? That's what you lack, you need a friend like that. I myself haven't got enough influence or authority here to help you as you ought to be helped."[72] Once a woman artist was admitted to that world, she was expected to behave as outrageously as the men. Private lesbian encounters were considered de rigueur, but women artists were to enact their most profligate, antibourgeois desires in front of their male cohorts or sponsors. Laurençin, for instance, whose work has remained a canonical model of a successful "feminine" style of painting, shocked even Picasso with her habit of urinating in front of her various lovers, then laughing at their squeamishness. She tortured her lover Apollinaire with her penchant for threesomes, but she continued to paint elongated, pastel-soft reassurances of woman's true nature.[73]

Still, strong women had nurtured, encouraged, and indulged Tamara from birth. Between that family legacy and her own newfound strength as a better survivor of war and dislocation than her husband, the painter possessed considerable resources with which to compete in the still unbalanced worlds of gender and art.

But she needed a mentor. Crucial to Tamara's artistic success was finding a teacher willing to encourage her independence while shoring up her prodigious natural gifts with strict training. It is to André Lhote's credit that he augmented Tamara's private vision with his own theory of formal beauty. It is clear that Tamara had begun to study with him by the summer of 1922.[74] A renowned painter and teacher, Lhote taught at the Académie Notre-Dame des Champs between 1917 and 1922, after which he founded the Académie Montparnasse.[75] According to art historian Daniel Robbins, Lhote "was one of the few twentieth-century artists and theoreticians who not only accepted the term 'decorative' in connection with art but also exalted it, finding in mural painting the highest public realization of his ambitions. Like Albert Gleizes and Fernand Léger, he welcomed the limitations of wall painting because its conditions insisted on flatness as integral to a large plane surface."[76]

André Lhote had become the first steady art critic for *La Nouvelle Revue Française* in August 1919. Within the next year and a half he proved, through his "talented, lucid" articles, to be the "most coherently conservative critic to be drawn from the Parisian avant-garde," according to art historian Jane Lee. Lhote defended Cubism as a "new classicism," and he lauded Picasso and Braque for their *"rappel à l'ordre"* (return to order), which all "decent" painters must heed. His conservatism sought to place classicism within the great traditions of the "primitives, the Renaissance and the school of David," and to that end he gently faulted the Impressionists for not knowing how to bring their romantic ideals within the larger history of painting.[77]

In contrast to her experience with Maurice Denis, Tamara liked studying with Lhote. She had felt hemmed in at the Académie Ransom, with no room to "have my own ideas," but it was different with Lhote. In later years she readily acknowledged his influence on her work, especially at the beginning. Nonetheless, though invariably respectful when Lhote's name was mentioned, Tamara hated the idea of admitting she had followed any conventional path of learning, or that the training had mattered to her: "Everybody starts from a school, gets a diploma, gets a prize, I don't care."[78] In any case, her training with Lhote was probably entertaining: the painter Hananiah Harari, who studied with him a decade after Lempicka, recalled that "it was a theatrical experience. Most of us students painted up on the balcony, with Mr. Lhote standing far below, gesturing and lecturing."[79]

Although he was praised by Maurice Raynal, the authoritative art historian of the 1920s, André Lhote nonetheless held the same equivocal reputation in Tamara's time as he does at the end of the twentieth century. In 1912 he had been a major organizer of the special exhibition called La Sec-

tion d'Or, which introduced Cubism to the masses; Tamara implied that she had seen the show when visiting Paris from St. Petersburg. To those artists who were part of the previous decade's avant-garde, it was clear that these exhibitors were trying to humanize Cubism by granting more attention to the figure. This "Synthetic" Cubism, a mediation of the older "Analytic" Cubism, earned its proponents, including Lhote, the enmity of dealers from the previous decade, who wanted to protect their investments. Although Picasso would classicize his own geometric works a decade later, in 1912 the avant-garde accused the painters of Section d'Or of sentimentalizing the radical nature of modern painting by reintroducing classical concerns such as subject and emotion. As Michael Kimmelman observes, "Lhote preached a doctrine that sought to link the French classical tradition of Poussin and David to Modernism."[80]

The art historian John Richardson describes the masterly attack that Picasso's dealer D. H. Kahnweiler mounted on the Section d'Or group the year before they exhibited. Kahnweiler had shrewdly erected a "cordon sanitaire" around Picasso and Braque to isolate them from competing Cubists, who also claimed to have originated the movement. From the beginning of their public exposure, the Section d'Or artists were deliberately cut off from the earlier movement's giants.[81] Lhote's advocates were referred to as the "salon Cubists," a smug reference to their ties with society as well as their academic conservatism, in contrast to the (now remunerative) outsider positions of the original Modernists. Even those painters whom Lhote took to be his friends, such as Diego Rivera, were skeptical of his direction. After Lhote's public lectures, all of which he religiously attended, Rivera would snort enviously to his mistress, Marevna: "He understands nothing about real Cubism, any more than he does about Constructivism. He comes and picks up whatever I may tell him and then makes the rounds of Gris, Braque, and Pablo, and makes a fine omelette out of it all. You've only to look at his pictures!"[82] The strong formal resemblance between Lhote's 1921 *By the Beach* and Rivera's figurative paintings of the twenties and thirties suggests the anxiety that lay beneath Rivera's defensive swagger. His fear of appearing derivative is demonstrated by Marevna's accounts of the tortured hours he spent justifying to Lhote each line and angle of his work.[83]

Other artists were freer to admit their indebtedness to their teacher. The photographer Henri Cartier-Bresson, also taught by Lhote, described that training in terms that illuminate the lessons that Lhote passed on to Tamara: "You can't have freedom without discipline. . . . There must be freedom, yes, but always with a sense of form and structure behind it."[84] Cartier-Bresson attributes the success of Pierre Bonnard, "the greatest painter of the

century," to Lhote as well.[85] André Lhote's theories gave Tamara the tools with which to reenvision Cubism according to her own neoclassical tenets. She appreciated his emphasis on spatial balance, his sensitivity to form and angle, and, always important to her, his clear colors. He taught her to depend upon what he called plastic, or parallel, rhyme: the formal reappearance of one element in a painting at an opposite (usually diagonal) position elsewhere on the canvas. Furthermore, Lhote felt that the artist should restrict the palette to two or three colors for each painting, deploying gray as a transition between the colored spaces.[86] The only discordance between teacher and pupil was Lhote's belief that Cézanne was the greatest painter of recent times, a position Tamara took pains to disavow.

In spite of her teacher's positive influence on her technique, Lhote's mentorship in fact damaged her reception among the newer and younger Surrealist artists, who were moving increasingly toward distorting the figure. Perceived as reactionary and conservative, Lhote's French school of Cubism was dismissed as merely fashionable—the ultimate pejorative. But Lhote was in fact little interested in keeping step with the fashions of the day, an independence that was demonstrated by his dated aesthetic loyalties. By 1920, Dada had successfully invaded Paris. In the space of two years, well-known contributors to the avant-garde magazines *Littérature* and *391* already included Tzara, Céline, Picabia, Breton, Aragon, and Éluard. Within a few more years, Max Ernst, Hans Arp, and Man Ray would all move to Paris, strengthening its Dadaist movement. During this same period, while the Surrealists were trying to recruit Picasso, Lhote was eagerly espousing Ingres, a major influence on most Modernist painters at one time or another in their careers, but hardly, by this point, a deliberate reference for the avant-garde. Lhote's enthusiasm for Ingres's highly enameled surfaces and clean, clear lines provided a guidebook made to order for Tamara's own artistic impulses.

In 1922 she painted several nudes inspired by Lhote's lessons, at least two seated models and one reclining version all revealing a new attention to form. Comparisons of Lhote's Ingresque nudes with Lempicka's show the student quickly surpassing the teacher as she incorporated his approach into her own. Where Lhote's nudes at times offer a formulaic if highly competent Cubist redaction of an earlier classical inspiration, the younger artist achieved a torsion that produces a new, architectonic voluptuousness, with each rounded contour of the body severely exaggerated.

Tamara's stylization of the human form and her reliance on the illusion of heavy volume contained within a shallow pictorial space were to function as her lifelong aesthetic. Three years after painting her nudes, for instance,

she would execute another version of the seated woman, invoking the same sculptural vocabulary to invigorate the corpulent model with voluminous, clearly sexualized curves. When asked later by her mother to explain the difference between the two nudes of 1922 and 1925, Tamara answered, "It is obvious. One model [the later] was rather plump, and men would want to take her to bed. The other one was fat, and only her children could love her."[87] In reality, however, the paintings show two separate tendencies at work: in the first *Nu Assis*, the model's extreme obesity, her huge lumpy overspills of flesh, makes her appear almost inhuman. Lempicka's adaptation of Lhote's principle of plastic rhyme is perhaps too eager in this painting to be entirely successful. Its strongest manifestation appears in the triangular pubic region, the small focal point of the painting, which cleverly echoes the elongated triangles of fabric in the folded curtains behind the nude. In the second *Nu Assis* of 1925, a cooler palette of rose, blue, and green provides relief to the body's formal oppressiveness, also suggesting an oneiric environment wherein the viewer becomes a voyeur. The first painting's swollen, inert profanity is now enlisted in service of the libido.

By the end of the summer, Tamara had finished two portraits, one of Ira Perrot and one of Tadeusz. She entered them, along with *Nu Assis*, in the Salon d'Automne of 1922, held from 1 November to 16 December. Her acceptance into the show was due, no doubt, to the presence of her talented sister, Adrienne, and her former teacher, Maurice Denis, on the committee that juried the exhibition.[88] Now Tamara began receiving critical notice: a journalist for *Le Seine et Marnais* singled out from the hundreds of entries in that salon the "three portraits of Madame de Lempitzky [*sic*]" for their "superb color work, reminiscent of Benjamin Constant," and *Le Figaro* noted that while the already established Alice Halicka "paints [in a particular neatness by using] gray, Madame Lempitzki paints with a disquieting precision."[89] The *Petite Gironde*, a Bordeaux publication, applauded Tamara's excellent color sense, praising her and Fernand Léger in the same sentence.

Artists in Paris could pursue several paths to fame during the *années folles*. Gallery shows, private dealers, and public auctions at the Hôtel Drôut were all important commercial venues. Previously, however, most painters had achieved renown by exhibiting at one of the salons. During the nineteenth century, the annual state-supported exhibition (organized and controlled by the École des Beaux-Arts) known as Le Salon had constituted the center of the public display network and the artistic economy. By the 1880s, however, discontent with the salon's conservative jury system, which excluded such progressives as Manet, Courbet, and the Impressionists, had fostered a reform effort. As a result, in 1884 a rival to the state salon was

founded, the Salon des Indépendants. Nine years later, in 1903, a competitor to that salon was in turn created, the Salon d'Automne, whose opening was described by the highly respected Modernist gallery owner Berthe Weill as a "sensational event." Tamara had attended its annual shows whenever she visited Paris, along with everyone else hoping to spot the up-and-coming artists.[90] Throughout her career the salons would prove pivotal to Lempicka; they were especially important in 1922 and 1923 in allowing her to exhibit her work while she was still a novice.

Salon participation was particularly significant for Tamara's emotional security, helping to solidify her new Parisian identity and distancing her from all that was represented by contemporary Russia.[91] Representation at the salons, though diminished in prestige from a decade earlier, still carried considerable clout during this period.[92] Tamara was a Russian émigré with no existing reputation, a married woman living a seemingly conventional life, and she needed to participate in salon life in order to be taken seriously as an artist. Most important, access to a buying public came from the salons. All the paintings hung there were for sale; in addition, members of the public could pursue favorite artists to their studios, where they could make purchases or arrange commissions.

But though the salons were forward-looking in providing a showcase for developing talent, they suffered from their democratic impulse: even the juried Automne salon contained more paintings than the public could bear to view at one time. The Indépendants was still worse, since even mediocre paintings were accepted by this egalitarian institution. In 1914 over 1,300 artists had exhibited, sometimes displaying several paintings each; sixteen years later, in 1930, the number had almost doubled.[93]

By the early twenties when Tamara first participated, the committees of both salons were attempting to bring coherence to the disorder by dividing the paintings according to nationality and by hanging them in alphabetical order. Avant-garde groups that wanted to present their work as a single, evolving entity were thus dissuaded from participating, with the result that by 1923 most of those determined to keep alive the possibility of an avant-garde ceased exhibiting at the Indépendants altogether. The salons nonetheless continued throughout the twenties to be useful launching sites for upcoming artists. And despite the endless posturing throughout the years over the most authentic conduit for modern art, the vast majority of well-known painters continued to show at the salons; Tamara was among them.

Lempicka's now busy work and social life meant that she needed help at home. Despite his job at the Banque du Commerce, Tadeusz continued to be discouraged by a profound sense of rootlessness. The once proud

*Tadeusz holding Kizette, c. 1925.*

playboy came home some evenings to drink and then fall asleep, his long body slouched in an overstuffed chair or couch. At other times he did not return home until midnight. Either the housekeeper or Malvina tended to six-year-old Kizette in the afternoons while Tamara made at least an appearance at the cafés, where she could quickly pick up gossip about who was sleeping with whom, and which artists were thought to possess the most talent. She organized her life so that she was able, most evenings, to be home in time to tuck Kizette into bed, but she expected Tadeusz to then take care of their daughter while she went to the theater or cabaret with the Stifters.

By the fall of 1922, Tamara was trying to live the life of student, painter, wife, mother, breadwinner, and debauchee at the same time. In spite of the obvious challenges, which no doubt contributed to her smoking three packs of cigarettes a day and to her daily use of the sedative valerian, she felt confident that she could conquer Paris.[94] With her flair for drama and self-mythologizing, Tamara was well suited to the theatrical atmosphere that infused Parisian life. Typical of the dramatic displays much in vogue was a man who arrived at a soiree clad only in a loincloth made of chocolate-caramel strings, which he offered to his host and the other guests to nibble until he was nude. His bigger joke, however, was his punishment for their lusty appetites: the chocolates were laced with an unusually severe purgative and sent the guests in desperate search of bathrooms in a matter of minutes, leaving him alone at the party.[95]

Such scandalous parties were merely one of Tamara's diversions. She developed a demanding schedule of going out regularly for evening entertainment, first to a cabaret or opera, depending upon her mood, then to a reputable if risqué club; and then returning home to work. It was hard for Tadeusz to complain about this arrangement; the social norms of the age dictated that the modern women of the 1920s "flock to theater openings, catch the final cabaret number, and dance the tango and the Black Bottom till dawn. . . . [Such a woman defies] the old adage that the early bird gets the worm; she crawls into bed at dawn, sleeps through the day, and comes out

after dark."[96] Asking his energetic, aggressive wife to forgo her own activities in the face of his continued passivity would have been difficult to justify. To the young Tamara in St. Petersburg, Tadeusz had appeared to be the consummate cosmopolitan, but his self-assurance depended upon a feeling that he belonged to the local culture.[97] And instead of receiving Tamara's sympathy, Tadeusz now became the object of her condescension. Their fights escalated and they frequently screamed at and hit each other as the tension became unbearable.

When Tamara did sweep into the apartment, arms laden with groceries, she expected the beauty and abundance she prized in art to be translated quickly into perfect meals, in spite of the fact that she was home only to paint and that Tadeusz was depressed and listless. Occasionally she would cook, most often from old Polish recipes, and such meals did comfort her husband temporarily. More often, however, she concentrated her domestic energy on managing the help, which the couple could now afford to pay for by themselves instead of relying on the Stifters' generosity.

Tamara's standards of housekeeping were as high as those she set for her

painting. Obsessively neat, she was also ever the artist, even at dinner, where she might suddenly throw away a dish or a glass that the servant had bought that day but which failed to pass her scrutiny. Preoccupied with "finish," which to her included completeness, coherence, and deliberateness, she broke any piece that was "vulgar," announcing in the process, "one glass less." As she later explained, "I'm very precise. The table has to be . . . perfect. Otherwise it disturbs me. I have precision in everything, the same in my paintings. My paintings are finished

*Tamara and Tadeusz Lempicka, c. 1924.*

*Kizette with hoop, early 1920s.*

from this little corner to this little corner. Everything is finished."[98] The overwrought home life fostered by these obsessions upset Tadeusz, whose absences from the family dinner table became commonplace.

As 1922 progressed, Tamara painted ever more feverishly, with the lack of moderation that now characterized her entire life. She also developed an increasing need for physical distraction that the discreet and infrequent affairs she had been conducting for several years no longer satisfied. By autumn her behavior suggested the manic side of what psychiatrist Kay Redfield Jamison has persuasively outlined in clinical terms as bipolar illness. Her need for extreme stimulation and her restless physical appetites were accompanied by a frenzy of high-quality artistic production, recalling Jamison's description of "an elevated and expansive mood, inflated self-esteem, abundance of energy, less need for sleep, intensified sexuality . . . and sharpened and unusually creative thinking, [marked by] increased productivity."[99]

Tadeusz's habit of drinking himself to sleep every evening or going out alone would have made it easy for his wife to meet with men of her social milieu, but Tamara developed a taste for dangerously seedy outings. She began to frequent bars that most members of her class would never have entered. Orgies among artists were, it is true, a legend of early Modernism: "When we [departed] at dawn, we left behind a regular battlefield. The floor was covered with strips of paper torn from the walls, bottles and broken glasses and overturned furniture, more or less damaged; here and there lay the bodies of drinkers and drug-takers, unable to get up, like motionless corpses, half-naked, their clothes torn and soiled with vomit," recalled Marevna of the nights in Montmartre.[100] But these were orgies among friends, not the anonymous encounters that characterized Tamara's debaucheries.

When Tamara precipitously left a stylish club or party at midnight, her fellow revelers assumed she was returning home, another victim of bourgeois family expectations. Before her putative curfew, of course, her deliberate show of decadence impressed them: what other housewife sniffed as much cocaine as Tamara did or danced with her pelvis grinding into whatever man or woman partnered her, a technique for which she quickly became popular? Nor could any ordinary woman stare at a man's trousered crotch with Tamara's icy elegance, a gaze that the seductress would follow with a long drag on her ebony cigarette holder.[101] Though showing off was expected among the determinedly wild devotees of the early Jazz Age clubs, Tamara's energy seemed without bounds. But when she made a suddenly demure reference to her patient husband and little daughter asleep at home, her club companions would comfortably conclude that she was just playing at being bad.

Yet Tamara was not going home. Her sexual drive stoked by a near constant supply of cocaine, she would make forays to the hastily constructed dirt-floored lean-tos that dotted the Seine's bank. Here shabby clubs harbored heavy drug use and group sex among a rough assortment of types, including sailors, a few college students, male and female, and one or two upper-class society women. One man who occasionally accompanied such women, Alexander Chodkieweitz, remembers that Tamara refused to kiss or be kissed during these episodes. Her favorite sexual activity was to be caressed over her "very colorful, very excitable" nipples and genitals by a beautiful young woman, while she performed similar activities on the most handsome sailor in the group.[102] After such nocturnal stimulations, she returned home full of confidence and insight—and cocaine—and in a near frenzy painted until six or seven A.M. After several hours of sleep and a quick breakfast with Kizette, she resumed her daily routine of art classes and café socializing, before preparing to begin her night life anew.[103]

Though Paris in the early twenties certainly earned its bohemian reputation, Tamara was playing the game hard by anyone's standards. It seemed to her that she could have it all: respect, money, and sexual gratification on the side. She had arrived at the Gare du Nord only four years earlier, gifted with a painter's talent and a family history of feminine power. Encountering a cultural climate that affirmed art as a remunerative career for women, she also felt freed personally by the Modernist mantra to "make it new" that underwrote every aspect—trivial and profound—of daily life. She was determined to embody that icon of the age, the new woman.

*Chapter 4*

# EARLY SUCCESS *in* PARIS

*The term "new woman" first surfaced dur-*
ing the feminist protests of the nineteenth century. From
the early teens in Greenwich Village to the Weimar deca-
dence of the 1920s, it had continued to refer, however
vaguely, to the expanding freedoms embraced by Western
women. In Germany, an explicitly political edge accompa-
nied the term; in France, where women did not receive the
vote until 1944, its importance was enmeshed in the idea
of the new woman's "costuming," as one chronicler of the
period notes: "what her face and body looked like; what
clothes she wore; what pose she struck; and what roles she
played, or aspired to play, in the culture. Such an outlook
added a visual and aesthetic dimension to women—real or
imagined." Now "the new woman was part of a congenial
'consumption community.'" One magazine set forth the
credo of the new woman as believing that "as you wear—
so you are."[1]

The mythology of the modern woman was widely and
quickly disseminated throughout the 1920s: in the movies,
on billboards, in newspapers and magazines, the postwar
female in Paris encountered calculated representations of
her modernity wherever she looked. Self-image became a

market commodity, since advertisers were quick to capitalize on the opportunities offered by this cultural shift.[2] And as the image of the new woman gained power, the appeal of female autonomy grew.[3]

Determined early on to control her own destiny, to be financially independent, and to achieve sexual fulfillment, Tamara had fashioned herself into a new woman before the identity became commonplace. Avoiding the clichés of the period, she rejected the wildly popular style of the cool, liberated, flat-chested flapper, which her friend Coco Chanel had created, celebrating instead the equally audacious but voluptuous narcissistic woman. When asked in 1979 if her friendship with Chanel had kept her portraits up-to-date, she responded by asserting her singularity: "I do what I want to do and I hate to do what I have to do. . . . My life was never conventional. . . . I'm not the 'classic' type of person."[4]

Insisting that her mother's Slavic temperament was essential to her free-thinking yet paradoxically rigid character, "just as it was to her copatriot Misia Sert," Kizette Foxhall contends that the grandiosity of such women was inseparable from their achievements. "It's not a question of stereotypes," she maintains. "It's who they were, believe me. My mother became an emblem of the new woman, but she was always different from the majority of even those supposedly modern females. If you don't comprehend that, you can never sympathize with Tamara." Tamara's granddaughter, Victoria Doporto, agrees: "It's true. She and Misia—it all came from their backgrounds. Grandmother was a perfect woman for the Jazz Age, yes, but she was a privileged Slav, first and foremost. That's what gave her the nerve to do whatever she wanted."[5]

"Without a doubt, though, she was an advertisement for the age. It was always very important for Mother to be up-to-date," Kizette emphasizes. "She didn't want to be left out or seem old-fashioned. Really, except for her adamant insistence on the old masters in art, she had the most naturally liberated, modern personality I've ever known. She did whatever struck her as interesting, whenever that was, even in little things. She shocked us all one day, when I was about six years old, when she decided she wanted to look like some ad she had seen in a magazine. She went to Carita salon in Paris and came back with short, sleek hair. Before long she had convinced my aunt Ada [Adrienne] and my grandmother to do the same thing."[6]

Tamara was a unique kind of new woman, to be sure. Assuming the privilege of a princess and displaying the agility of the émigré, she exuded a mysterious air that attracted the attention of writers as well as painters. In early 1923 she became acquainted with the American expatriate and poet Natalie

Barney, who had moved to France from Cincinnati in the early 1900s.[7] Natalie could be found many nights in Paris's most sensational nightclubs, alongside such regulars as the aggressive lesbian, the Duchess de la Salle, and Tamara's old acquaintance, Prince Yusupov.[8] The duchess favored a man's tuxedo, which she would later wear while posing for her portrait by Tamara, and the prince, loath to give up his old Russian habits, sometimes dressed as a woman.

One evening the amazonian duchess beckoned Tamara over to join her group of friends, who were busy crushing hash pellets into their sloe gin fizzes, the new American import. The duchess returned Tamara's praise of her dramatic black suit by inviting her to attend Natalie Barney's Friday afternoon salon. Tamara made some comment that revealed her insecurity about being accepted into such a high-toned literary assemblage, but she was quickly assured that her resemblance to Greta Garbo, whom Barney adored, guaranteed her instant success with the group.[9] (Garbo had in fact once appeared at the salon with her lover, Mercedes Dacosta, an event that excited even the normally blasé guests: Barney and her friends considered Garbo "the *non plus ultra* of what they were all about."[10])

An invitation to Barney's salon bestowed immediate cachet. Aside from Gertrude Stein, Barney was probably the most famous lesbian in Paris; her home, the Temple of Love, was ostentatiously dedicated to Sappho. In spite of Barney's own plain looks, her powerful personality enabled her to seduce countless women and to attract the talented and famous: regular visitors to her salon ranged from James Joyce, Jean Cocteau, and Thornton Wilder to Paul Poiret, Isadora Duncan, and Colette.[11] Janet Flanner, an American chronicler of Paris between the wars, remembered Barney's salon for its "introductions, conversation, tea, excellent cucumber sandwiches, divine little cakes . . . and then the result: a new rendezvous among ladies who had taken a fancy to each other or wished to see each other again."[12]

Although discreet when asked about her experiences with the amazon crowd, Tamara mentioned to her American actor friend, Tonio Selwart, that she had participated in several of Barney's Friday gatherings on Rue Jacob. Indeed, Barney's circle of acquaintances would serve Tamara well as a steady source of commissions over the next years.[13] Her interest in becoming a regular visitor, however, faded quickly as she became bored with the pretensions of the literary salon set.[14]

Tamara considered salons other than Barney's a still greater waste of her time; Gertrude Stein's weekly gatherings at 27 Rue de Fleurus lacked even a veneer of the glamour she sought. She casually dismissed Stein and Ernest

Hemingway, whom she met several times at Gertrude's and at Deux Magots, as "boring people who wanted to be what they were not—he wanted to be a woman, and she wanted to be a man."[15]

André Gide, who frequented Barney's salon as well as the clubs, did impress Tamara, however. Gide spent time in bars where homosexuality, cross-dressing, and an anything-goes attitude set the tone, and he and Tamara quickly became friends. In mid-1923 she arranged to meet him at Lhote's studio in Montparnasse; Lhote and Gide, both members of the Salon d'Automne's jury that year, wanted to look over the work Tamara hoped to present.

Due to the men's influence, the painting that they preferred, Tamara's *Perspective*, also known as *Les Deux Amis*, was allotted an excellent hanging site at the salon. Its easy visibility, combined with its distinctive and sexually charged treatment of the human form, garnered an impressive amount of press coverage for a beginning artist whose work hung amid that of a thousand others.

Eventually acquired by the Petit Palais de Genève, *Perspective* conveys its potent homoerotic charge through a combined classical and contemporary approach. Two nudes, one reclining, one sitting up with her hand on the knee and inner thigh of the other, compose a slightly off-center triangle. The seated woman's exaggerated round breasts echo the curved lines of her stomach, which almost touches the melon-shaped lower torso of her companion. The heads of the two nudes repeat, in parallel rhyme, the shape of their breasts and stomachs, while the hand draped at the top of the painting constitutes a diagonal to the draped hand of the reclining model. Luxurious folded cloth creates the background for the left half of the painting, suggesting a curtained space for the viewer's voyeuristic pleasure and demonstrating that Tamara had already mastered the difficult task of evoking volume in draped material. Broken arches and fragmented caves line the right side of the canvas, an allusion, perhaps, to ancient debaucheries in Rome and Greece.

The title *Perspective* encouraged the critics to emphasize the painting's preoccupation with space and volume.[16] French reviews cited the arresting quality of the painting, its combination of Cubist and classical principles—and its emotional coldness. Then, as now, *Perspective* bothered its audience: the two models almost fill the pictorial space with their aggressive nudity, overwhelming the viewer with the artist's own implied proximity to her subject. At the same time, the "presence" of the painting itself, the force it exerts as it compels the audience to stop and consider it, is undeniable.[17]

The notion of presence—an opaque, metaphysical concept that haunts any attempt to talk critically about art—occurs repeatedly in discussions of

Tamara's work, from its first public exposure to its current reception. Presence defies all attempts at definition, but, as Debra Pesci, who works with America's largest Lempicka dealer, has commented, "Put any major Lempicka in a room with twenty other first-rate modern pieces, and the Lempicka commands all the attention."[18] Her paintings' presence stems partly from their implied violation of social norms, an aggressive quality that has confounded reviewers since 1923. During that year, a Polish art critic praised Tamara, bringing her to the attention of the prestigious journal *La Renaissance;* but he assumed such profound presence meant that the painter had to be a man.

It seems clear that the confusion of gender was Tamara's intent, since she invoked the masculine ending in signing her name "Lempitzky."[19] This signature during the first few years of her exhibitions—with slight variations, "T. de Lempitzky"—implies that Lempicka was not totally convinced it was as easy to be a woman as a man in the art world of the twenties. She explained to an Italian friend and collector in the mid-thirties that she used "Lempitzky" to soften her own sense of being a poor refugee, and that she felt she "deserved" the respect that the male inflection engendered.[20] Her ambivalence about her professional identity probably registered with the critics, if only obliquely, since the early press reviews noted her fondness for painting "amazons," a code word for lesbians.

The general embrace of hedonism during this period ensured an enthusiastic reception for sexually suggestive painting: naked bodies, in life or art, were popular. The "call to order" that André Lhote issued after World War I had created a renewed interest in the classical female nude, and the backlash against the previous decade's lack of recognizable figures especially encouraged the disparate group of painters known as the School of Paris to take up this subject.

Like many Modernists, Tamara is alternately included in and omitted from the School of Paris, definitions of which have differed dramatically both in the 1920s and at the end of the twentieth century, depending upon the writer. George Heard Hamilton dates the 1917 production of Sergei Diaghilev's new ballet *Parade* as "symptomatic of the international character of the so-called School of Paris."[21] Diaghilev had hired avant-garde talents from different countries to create the libretto, sets, costumes, choreography, and music. Earlier, the Café Guerbois, the Nouvelles-Athenes, and the Closerie des Lilas had been gathering places for Impressionists and Symbolists intent on creating a modern art. Now their foreign and French heirs, attracted to the freedom these late-nineteenth-century rebels had helped create, took their place at the Café Flore, the Deux Magots, and the Dôme;

for some historians, this is the group that constituted the School of Paris. The work most often referred to as School of Paris was executed between 1920 and 1940 and tends toward figurative and recognizable representation.[22] To many critics the rubric typically includes the foreign artists in Paris from 1910 to 1930, more commercially inclined than either the French Cubists or the Dadaists and Surrealists competing for preeminence during the same decades. But a category that includes Chaïm Soutine, Moïse Kisling, Diego Rivera, Tsuguharu Foujita, Constantin Brancusi, and Jacques Lipchitz alongside Amedeo Modigliani, Jules Pascin, Marc Chagall, and Marie Laurençin quickly loses explanatory value.

The term's lack of rigorous descriptive power is further illustrated by the inclusion at various times of such disparate painters as Picasso and Lempicka. Clement Greenberg, for instance, acknowledged the first but not the second.[23] In general, the term "School of Paris" very loosely denotes a commercially successful group of painters in Paris who allowed women access to galleries, salons, and dealers far more generously than did the Cubists or Surrealists. Equally significant, the School of Paris promoted women's painting of the nude.

The paradoxical potential of nude portraiture had become apparent as early as 1861, in Gustav Courbet's infamous *Birth of the World*. Unlike classically inspired nude studies, which render the subject's pubic area discreetly, the model's luxuriant triangle of pubic hair is the focus of Courbet's painting, while the unselfconscious splaying of her limbs suggests an independent and formidable sexual power.[24] Although the painting was not, in its time, widely known to the public—even today, certain connoisseurs consider it pornographic—it is hard to view the later aggressive nudes of female painters such as Suzanne Valadon without sensing the shadow of the stimulating, provocative Courbet.

By the early 1900s the female nude had already become as important a subject to women artists as it had traditionally been for men, but it took several decades for society to sanction the women's efforts. Tamara's increasing interest in the nude built upon erotic studies by contemporary women painters working in the genre; Emilie Charmy's *Reclining Nude* of 1912, for example, compromised the immediate innocence of the sleeping odalisque through the model's foregrounded erect right nipple.[25]

A decade before Lempicka began her work with nudes, Valadon had sketched a cartoon suggesting the challenges to women artists seeking to claim the nude as their own. Her *Grandmother and Young Girl Stepping into the Bath* shows a nude adolescent lifting her leg high, buttocks exposed to the viewer as well as to her grandmother, who is heavily dressed and seated

next to the tub. The contrast between the two figures—age and youth, covered and nude—creates tension, its allusion to the social mores governing girls' modesty heightening the sexual charge.[26] Lempicka's nudes join the fully fleshed, aggressive paintings of Valadon, from her *Abandoned Doll* to *The Fortune Teller*, in protesting the denial of female sexuality. The younger painter, however, developed a style that, in its precise draftsmanship and unabashedly beautiful colors, spared her Valadon's reputation as a "masculine" painter, in spite of the assumption of critics such as Woroniecki that "Lempitzki" was a man."[27]

In addition to School of Paris painters Suzanne Valadon and Emilie Charmy, fairly well established women such as Jacqueline Marval, Maria Blanchard, Alice Halicka, and Marevna Vorobev were actively pursuing ways to develop the nude in a style all their own.[28] Encouraged the year before by the 1922 Galeries Styles show in Paris of the nude in Western tradition, Tamara along with these older artists became freer to experiment. This road eventually led to some of her most extraordinary paintings, including *La Belle Rafaela*, which would be called "perhaps the most important nude of the twentieth century."[29]

Seductive but not obscene: Sir Kenneth Clark's description of Correggio's and Botticelli's sexual figures neatly captures the early inspiration Tamara received from her beloved masters. "Art," Clark declared, "contains bodily form within limits upon the nude beauty; the obscene, instead, is form beyond limit, representation in terms of excess."[30] By the end of the nineteenth century, however, news of Courbet's *Birth of the World* had spread among the sophisticated; and the possibility of containing excess through form may well have been lost forever. Insistent upon calling attention to themselves, Tamara's nudes installed a new kind of eroticism at the center of high art. They took Courbet as their guide, though clearly they were indebted also to Botticelli, who had helped rescue the nude from religious proscriptions. And although it became more obvious after 1925, Tamara's earliest nudes already bore the freight of a narcissism that made them unforgettable to critic and lay viewer alike.[31]

But if nude paintings of women were both artistically and commercially viable in the French art world of the twenties, the real-life subjects of these paintings had long been associated, in polite bourgeois society, with prostitution. This knowledge, coupled with the mental image of women undressing for other women, encouraged the assumption that female painters were often "amazons"—lesbians interested in easy sex while they plied their trade. From the anecdotal evidence of café and cabaret life, as well as the popularity of androgynous fashions for women, it is often assumed that French soci-

ety in the 1920s was legally and morally comfortable with homosexuality. The reality was different: only when homosexuality was presented as either depraved or absurd, as in Proust, was it acceptable to the middle classes. When someone assumed a deferential attitude toward the subject, as did André Gide in *Corydon*, public hostility proved sufficiently extreme to block his initial nomination to the Académie Française.[32] Although women were allowed more latitude in their sexual orientation, they were expected to play at lesbianism, not to grant it respectability. Tamara's female portraits in many cases dangerously blur this distinction, as they convey their seriousness precisely in their homoerotic overtones.

Lempicka deliberately positioned her nudes, from the 1923 *Perspective* to her Edenic *Eve* in 1932, as part of a new style in art, though at the same time she consciously defied easy categorization. The severely sculptured faces, the bright lipstick and nail polish—all clash with her deliberate references to Ingres's softened classicism. Even as the painter paid homage to classical artists, she reconceived the nude to comment on the modern woman's relationship to her own sexual pleasure.[33] *Perspective* alone ensured her placement in the camp of the "new woman." The use of a female nude did not, of course, constitute by itself a signature of the modern, but three key elements of Tamara's nudes facilitated such a reading by the critical press: a geometric vocabulary, a rhythmic composition, and a representation of the modern woman similar to the media's own, announced her alliance with all that was contemporary. Futhermore, by eliminating the horizon, using shallow foregrounds to flatten out the pictorial space, and leaving no defined middle ground in many paintings, she created a strong line that broke down conventional compositional space.

It was not only the nude that showcased Tamara's ability to sculpt form in paint. By the beginning of 1924, she had been paid to paint a portrait of Gide, who was already one of France's great men.[34] The commission, which raised her stature among the cognoscenti of Paris, resulted in an aggressively confident work, exhibiting none of the tentative moves of the talented but hesitant newcomer evident in the works of 1920. And for the first time, Tamara's Slavic heritage was visible in her art: the portrait bears distinct echoes of the sculptural style of two Russian painters, the portraitists Juri Annenkov and Boris Grigoriev, who had moved from Petrograd to Paris. Grigoriev's *Self-Portrait* (finished in 1921), with its cubelike reduction of the human head and its strong use of contrast to create volumetric form, seems likely to have influenced Tamara's early paintings. Grigoriev was also a regular contributor to the periodical *Zhar-Ptitsa* (Firebird), a publication catering to the Russian émigré community of Paris and containing color

reproductions of various artists' work. It is even possible that Lempicka had studied with Grigoriev when he was flourishing in Petrograd from 1915 to 1918, during the early years of her marriage. The resemblances did not go unnoticed: given her secrecy about her birthplace, Tamara was probably not pleased when, in February 1927, an article in *Vanity Fair* mentioned in passing the neoclassical similarities between her (referred to as "the Pole") and Grigoriev, seeming to suggest a Russian rather than Polish background to Lempicka's art.

But if homage to the past inspired Tamara's portrait of Gide, a bid toward the future motivated her to court the commission. Gide was known to be homosexual, and by the time Tamara painted his portrait, she understood the importance of bisexuality to forward-looking artists who wanted to *épater les bourgeois*. Shocking the middle class increased their appearance of modernity, allowing them to disregard convention even as their rising commercial appeal implicated them in creating the very society that they scorned.

Until the end of her life, Tamara would claim that she had "tried everything" and that artists, at the very least, had a responsibility to do so.[35] In all of her sexual relationships, she took pleasure from beauty, whether in voluptuous female bodies or in angular males. Men and women consistently recall Tamara's need to connect physically: "She had the oddest habit of touching anyone she liked on the face, sometimes cupping their chin in her hands, sometimes stroking the cheeks—especially with anyone who was attractive and not thin," her friend Countess Anne-Marie Warren remembers. In the summer of 1923, Tamara engaged in her only recorded episode of cross-dressing: a few months before her *Perspective (Les Deux Amies)* was exhibited, she accompanied a friend to the notorious lesbian nightclub the Rose, after which she and the woman drove to the seedy riverside shacks Tamara preferred. There, however, the two women, dressed in black tuxedos and starched white shirts, were greeted with catcalls. They returned to the club, where Tamara insisted on undressing her friend in front of the other patrons, in order to see if she would serve as a good model for her paintings. Holding up her plain-glass monocle, Tamara slowly and deliberately looked the naked woman up and down, then stretched her hands over the large breasts that had begun to respond to the sexual gaze directed at them. "Round enough," she determined, and then, placing her hand boldly between the woman's legs, she announced sadly, "but too wet for a painter to concentrate."[36]

In popular memory, the Jazz Age exhibited its decadence most obviously through sexual inversion. Dozens of female American, British, and German expatriates flamboyantly wore masculine dress as a sign of sexual

deviation; other artists who made homoeroticism a frequent theme, such as Romaine Brooks and Nancy Gluck, used cross-dressing partly to signify their distance from a male-dominated sphere. Several years earlier, the publication of sexologists' research into lesbianism as a sexual lifestyle had already lent support to bohemian erotic license. Havelock Ellis and Sigmund Freud had posited that bisexuality was a natural state of being from which all other sexual activity ensued. Still other sexologists argued that there was a "third sex," the homosexual, a theory used by the enlightened to campaign for greater acceptance of what was, after all, congenital.

A bizarre offshoot of this argument, drawing on the work of an earlier German writer, Otto Weininger, maintained that "manlike women wear their hair short, affect manly dress, study, drink, smoke, are fond of mountaineering, or devote themselves passionately to sport. . . . A woman's demand for emancipation and her qualification for it are in direct proportion to the amount of maleness in her."[37] Lesbianism functioned, in Weininger's view, as a sign of superiority precisely because it heightened the masculinity in what was otherwise the weaker sex.

To Tamara, however, borrowed masculinity was an admission of a woman's insecurity. Other than the *Duchess de la Salle*, Lempicka did not paint androgynous figures. Instead, her homoerotic suggestions are conveyed through an exaggeratedly voluptuous female. Tamara's production of a lesbian subtext followed the blurred gender lines implied by Emilie Charmy, Suzanne Valadon, and sometimes even Marie Laurençin, all of whom sought to challenge the normal claims of the spectator upon the canvas. But Tamara's erotic paintings bespeak an extreme narcissism by which she establishes herself as the paintings' most important audience.

Her self-regard was not limited to her art. By the middle of 1924 her increased workload and her nonstop evening forays into cabarets and clubs had taken a severe toll on Tamara's family life. Three or four times a week she ate dinner with Tadeusz and Kizette, then tucked her daughter into bed, after which she and Tadeusz argued loudly about the propriety of her going out alone. "You're one to talk," the increasingly confident wife taunted her outraged husband. "Everyone knows you can't let a pretty girl walk by without wanting to have her on the sidewalk."[38] In truth, the sexual power dynamics between the couple had shifted dramatically. Tadeusz, while still highly attractive to women, wanted a traditional, even monogamous marriage just as Tamara was becoming a modern woman. The tacit arrangement she expected made him feel like a cuckold. His wife did not demand sexual fidelity from him; she only asked that he conduct his affairs without her

knowledge. She assumed he would continue to love her as she did him, the only person she cared for both emotionally and physically. Sex itself was for Tamara the satisfaction of a strong appetite, little different from the pleasure she got from chocolate desserts or from studying a favorite Botticelli.

But the more she invoked her freedom, the more Tadeusz insisted she commit herself to a traditional household. Kizette became the pawn in the couple's struggle to establish dominance. "My mother was always impatient with me," she remembers, "but as she became more successful, she turned more demanding. One night my father was furious about rumors he had heard, and she just ignored him and prepared to go out as usual. First she came in to hear me say my prayers. I don't remember why, but I was angry with Chérie [Kizette's nickname for her mother] and I refused. 'Child, say your prayers,' she repeated. Finally I did, but when it got to the part where I blessed my family, I left her out. 'You forgot to say "God bless Mommy,"' she corrected me. We struggled for so long, and I even blessed the day and night, but I refused to bless her. The nurse begged my mother to let me go to bed, but to no avail. Only when my father came in and told her to leave me alone did I crawl back under the covers, because they started yelling at each other and forgot about me."[39]

Tadeusz arranged occasional trips back to Poland, where he yearned to resettle near his family, who had all left Russia. His distant cousin Alexander Lempicki, now a professor of physics at Boston University, remembers his awe at age six or seven when he saw the couple during one of their visits: "Their glamour was obvious even to a child, and it was impossible to miss how handsome the tall husband was."[40] When Tamara and Tadeusz attended a wedding at a Catholic church, their stylish self-assurance registered more keenly on the young boy's memory than did the bride and groom.

Tamara's attention to her family's needs diminished further as her confidence in her work grew. She knew that Kizette, tended by Malvina, Tadeusz, and the housekeeper, was in good hands, and so she increasingly lived her life outside the confines of her role as wife and mother. No longer hesitant to join the arguments conducted daily at the cafés, she now held her ground when praising the fifteenth-century Italian classicists as well as the neoclassical architecture of her beloved Petrograd, in spite of the increasingly old-fashioned appearance of such a defense.

To invoke the tenets of classicism was decidedly risky by this time, when the word invited scorn from younger artists. "Gilded mediocrity" was typical of the condemnations flung at those reactionaries who dared support classical aesthetics; the new generation was exhorted to manhandle the past, if only

metaphorically.[41] In 1924, for instance, at Anatole France's state funeral, the pomp and ceremony were offset effectively by the Surrealists, who issued a manifesto asking, "Did you ever slap a corpse?"

Although Tamara disagreed violently with such anticlassicism, she sought equally hard to define a modern idiom that would carry her ideals into the avant-garde. Sometime in 1924, Filippo Tommaso Marinetti, the founder of Futurism, who celebrated the "beauties of war" and the "odors of decomposition from the battlefield," shared an afternoon coffee with a group of students from the École des Beaux-Arts. Tamara joined them, either at La Rotonde or, according to a later comment she made, "at La Brasserie, a nicer place."[42] Never one for theorizing—she disdained the idea of manifesto art, whose didactic tendencies now influenced the Dadaists and Surrealists —Tamara must have regarded even Marinetti's famous 1909 Manifesto as drivel. Everything about the man bespoke the mere posture of decadence: indulgent conceits that implied a personal freedom he had never really embraced. Although he had claimed in his 1919 *Democrazia Futurista* that the bourgeois family was an "absurd, prehistoric prison," he championed the rights of women primarily for the sake of racial development. "La donna non appartiene ad un uomo, ma bensì all'avvenire e allo sviluppo della razza" (Woman doesn't belong to a man, but instead to the future and development of the race).[43]

During that afternoon at the café with Tamara and her friends, Marinetti pompously urged his listeners to "make it new," to "burn the Louvre, destroy the past." The young students were quickly caught up in the excitement, and even Tamara was so eager to be part of the moment that she offered her little car, parked outside, to get them to the Louvre where presumably they were to assault the walls.

The crowd rushed out, only to find that Tamara had parked illegally and the car had been towed. Marinetti politely accompanied her to the police station to help retrieve her automobile, after which efforts, the plan to torch the Louvre evaporated.[44] The only trace of Marinetti's machine-based Futurism in Tamara's painting occurs in her famous *Autoportrait* of 1929, where she sits in the driver's seat of a Bugatti. Given its renown, it is unfortunate that the painting represents her least interesting work, lacking her typical subtle formal puzzles and without any modulation of the garish or modish into the aesthetic. The Marinetti moment did not serve her artistic reputation well, for all that she enjoyed retelling the story of her afternoon with him in later years. She would find, however, that this brief encounter did help promote her social and professional interests in Italy the following year.

Marinetti represented the wrong kind of Italian sensibility anyway:

Tamara always respected the homage the Italians paid to their artistic past. They knew to appreciate the extraordinary mannered roundness of Caravaggio, the unearthly sculpted drapery of Michelangelo, the clarity of color and of light in Titian, all values that would resonate in her own work. She was also in many ways far better suited to the social structures that supported the art world in Italy than in France. Never completely comfortable talking art in intellectual circles, and even less at ease when forced to defend her unpopular conservative political views, Tamara was fascinated by the lives that the Italian minor nobility—most of whom patronized contemporary artists—managed to lead. Rumors abounded that either climate or lineage had endowed the men with suprasexual abilities. After a two-week liaison with a handsome titled professor who was vacationing in Paris from Bologna, Tamara told her friend Ewa that "the Italians fuck longer than any other men," a staying power she associated with an earned arrogance toward life in general.[45] Marinetti's melodramatic proclamation that "we speak in the name of the race, which demands ardent males and inseminated females" was one of the few elements of his agenda that Tamara could sympathize with.[46]

In confronting Paris's polyglot culture, Lempicka was trying to define herself as an artist who could consciously borrow the best from a culture's repertoire and still retain an identity conceived in a radically different place and time. Every morning her housekeeper delivered three newspapers to Tamara's bedroom so that the artist could read versions of the world's events in Polish, French, and English. Then, after an hour of solitude, she called Kizette to come join her. While she was served her daily orange juice, croissant, and coffee with milk and sugar, she discussed with the seven- or eight-year-old child the news of the day.[47]

Tamara continued to make important contacts among the French intellectuals. Jean Cocteau—beguiling, foppish, witty, and treacherous—became one of Tamara's most constant friends in Paris; twenty-five years later she would still look forward to meeting him for lunch on her return trips to the city.[48] In the 1920s, Cocteau's home at 10 Rue d'Anjou reflected his old well-to-do Parisian family; consequently, he preferred to stay instead at a nearby hotel, an idiosyncracy Lempicka could easily comprehend. Whenever he traveled, he tried to re-create his Paris hotel room, where the air would inevitably fill with opium smoke when he had been thinking or writing.[49] Tamara continued to fuel her own creativity with cocaine at night and with the herbal supplement valerian each morning to calm her nerves; she could well appreciate Cocteau's habits.

Similarly, Cocteau's narcissism, which included prominently displaying his beautiful hands in every photo opportunity he could get, a hand fetish

she imitated fifteen years later.[50] But she failed to notice the scorn that Cocteau's interest in society elicited from his fellow artists, and she neglected therefore to apply its message to her own life. A week rarely passed now without the Paris newspapers recounting her lavish soirees and her well-connected acquaintances. Lempicka depended financially upon the commissions she received for her portraits of the rich and famous. But to gain the respect of her peers in the art world she would have done better to demonstrate that she was conscious of the irony therein: a Modernist who seemed to have been co-opted by the establishment.[51] The *appearance* of being conflicted over these contradictions was all that was required, as many better-received portraitists of the time realized. Far from shrugging off her press coverage, however, Tamara gloried in the newspaper accounts of her glamorous dinner parties.

Determined to command the spotlight as a master of the unconventional, Lempicka intensified her social and sexual game-playing as if to prove that no one could fetishize sex or orchestrate desire as well as she. Still astonished by the memory, Tamara's friend from the twenties Alexander Chodkieweitz, vividly recalls a party the artist held in the mid-twenties for sixty or seventy worldly acquaintances, where the entertainment was provided by the young female servant who passed the hors d'oeuvres. The rules of the game were that each time the girl's platter was emptied by the eager guests, she was required to remove one article of clothing until she was naked. She was then transformed into Tamara's canvas: the artist used a cheese spread to affix oysters, pâté, grapes, and figs to various parts of the girl's body. For her finale, the hostess invited her favorite guests to eat the appetizers off their living tray. How did the hired help feel about being the center of this party game? The elderly Chodkieweitz mused that "those were the times when chic parties provided hashish like breath mints today; I suspect Tamara made sure the girl was as primed to laugh nonstop throughout the dinner as we were. I remember one man and his wife comparing notes on where the poor thing tasted best."[52]

Countess Anne-Marie Warren of Lausanne believes that Tamara's aggressive flouting of conventional norms cost her in ways that still reverberated fifty years later. Parisian cosmopolitans were not all of one mind about modern mores; many, including the countess's own sophisticated parents, had refused to attend Diaghilev's productions, which exceeded even the flexible boundaries of artistic propriety. To some extent, there was a political edge to the standards of decorum: in the interwar period "the wealthy sought discretion through bourgeois guise and it was no longer advisable to flaunt one's tiara in the midst of 'Bolshie' agitation."[53] Such

"bourgeois guise" condemned sexual frivolity in art or society, but Tamara instead rejected all restrictions on her indulgences. She would, for example, see nothing wrong with organizing, in 1924, a dinner party for various conservative acquaintances at which ornate silver platters of food were carried around by nude girls whose hair alone was dressed, flamboyantly, with huge red and silver feathers. And the painter paid for her artistic license with the respect of the very society she courted.[54]

Tamara maintained a lifelong covenant with pleasure. Unwilling to stake her claim with the antiestablishment art world, however, she apparently thought she could don or remove the degenerate's guise at will. Her faulty assumptions led her to insult the people associated with the identity to which she aspired. The result was distrust on everyone's part. To artists she appeared to be an upper-class dilettante, and to the nervous *haute bourgeoisie* she seemed arrogant and depraved.[55] She wanted to prove to her extended family in Paris that she was responsible; to the upper-middle-class art market that she was commercially viable; and to other painters, free of the first two constraints, that she was a serious artist. If ever Tamara had a chance of winning on all three fronts, she lost her opportunity to secure a reputation as an artist of the first rank when she rejected Paris's Left Bank art world in favor of its well-heeled society set. Her liaison with the world of commerce was not the problem; her defiant flaunting of it was.

*Chapter 5*

# COMING
# of AGE
# in ITALY

*However short of propriety she fell, the* first few months of 1925 found Tamara caught up in a heady blend of professional success and social attention. By the mid-twenties, women painters felt emboldened to pit their artistic independence against the avant-garde— whatever manifestation the avant-garde took that year. Many art connoisseurs appreciated what they considered the feminine middle ground: women's painting, although shadowed by a masculine Cubism on the one end, warded off the Surrealism closing in on the other. As a result, Suzanne Valadon and Émilie Charmy, who, with the much younger Lempicka, were arguably the period's best painters of nudes, continued to enjoy great professional and finan- cial success in Paris as the decade progressed. Charmy received the chevalier award of the Légion d'Honneur, and Valadon signed a contract with the Right Bank Bernheim- Jeune gallery that made her rich.

The energy Tamara now poured into her career allowed even less time for her home life. As their daughter wrote in her memoir years later, Tadeusz registered the deterioration of their marriage: "He noticed that she never spent time

with her family. He noticed that she never ate a meal without inviting an art critic or a fellow artist or a rich patron, that she never made a friend these days who could not help her with her career, that she never talked about anything but herself, that she spent every franc she made on herself, that in private and in public she was someone he had never met before. And he told her so."[1]

Tamara basically ignored his grievances, but she did seek new ways to entertain Kizette. Several times during the winter of 1925, when the painter could take a break from her professional demands, mother and child took the Metro to the popular open-air ice-skating rink at the Palais de Glace. Although herself unathletic, Tamara enjoyed watching Kizette engage in sports, especially when she could observe other fashionably dressed mothers at the same time. And Kizette loved the skating ritual, from the costume —a black wool skating skirt and boots that laced up to her knees—to the gossip that the nine-year-old gathered to share with her dashing mother. She and Tamara both enjoyed watching the "extremely wealthy Rothschild girl" take her skating lessons. Slightly older than Kizette, the child always arrived with a gregarious entourage that treated her like royalty. Kizette, who lived with more solitude than most children, observed her enviously. Though lovingly tended by either her grandmother or a housekeeper when Chérie was away, Kizette accepted that her mother's busy life left little time for child-centered social activities. Chérie was different from other parents, because "she was an artist always, before anything else." No matter how much Tamara loved her daughter, she reserved her greatest passion for her art, and no one pretended otherwise.[2]

By 1925, Tamara's tenacity was reaping impressive rewards. She was making more money than she'd thought possible, and meeting many wealthy and famous Parisians in the process. But her financially sound refusal to impose any distance between art and commerce continued to harm her reputation, causing other serious artists to marginalize her. While Tamara gained social advantage from her access to minor aristocrats who sought immortality in oils, Émilie Charmy furthered her stature by courting commissions from writers, politicians, and other artists, such as Colette, Briand, and Rouault. Lempicka's subjects echoed the kind of Old World order conventionally connoted by portraiture; Charmy's patrons instead reflected the aura of a new age.

Tamara was aware of the suspicion cast upon portraiture in general, but she concurred with André Lhote's judgment that imagination and technical skills commingle dramatically in the genre. "I paint someone as they really are, but inside too, not only their outside. I have to use my intuition and all the talent I have to capture the real person, which is more important than

painting things with no meaning."[3] Throughout her career, for example, she rarely painted eyelashes on her subjects, as if to convince her audience to trust her naked and immediate insight into character. Resentful of history's later dismissal of the stylized portraiture of the twenties as decorative, Tamara believed that such evaluations arrogantly denied art's proper business of depiction.[4]

As the avant-garde hardened its resistance to art as commerce, the huge 1925 Exposition Internationale des Arts Décoratifs Industriels Moderne, an exhibition of arts ranging from sculpture to posters and furniture, opened in Paris and ran from April to October.[5] Although a small number of oils and watercolors were displayed, painting was the show's least important attraction; salons and galleries, after all, existed for these artists.[6] The show had first been proposed in 1913, but World War I intervened. The aesthetic and ideological message of the exhibition was mixed. As Carolyn Burke rightly notes, on the one hand, the plethora of luxury boutiques lining the approach to the exhibition implied that it was "meant to appeal to persons of means." The abundance of expensive materials—"incised crystal and glass, inlaid woods, gleaming metals, rich fabrics and tapestries"—projected a life "lived by a happy few."[7] But the presence of artists such as Le Corbusier, clearly influenced by the Bauhaus celebration of mass-produced design, undermined the privilege otherwise implied. The overall, if paradoxical, impression was that beauty should be within the reach of everyone.

Not until a retrospective of the 1925 exposition was held in Paris in 1968 was the original name of the exhibition shortened to "Art Deco," a term coined to describe a movement or a style (no one could agree which) in art.[8] But though "Art Deco" gained descriptive power for painters and critics only at the end of the 1960s, Art Deco as an aesthetic had emerged as early as 1910 with the *Gazette du Bon Ton*, whose illustrations transformed the painterly traditions of beautifully clad women into a marketing device. The postwar politics of a "return to order" rejected Art Nouveau, the century's earlier rococo-inspired amalgam, and created space for its sleeker heir, although the 1925 exhibition still contained many overwrought, overdesigned objects. With Art Deco proper, a hybrid aesthetic began to influence the appearance of all cultural items: not only traditional art objects but domestic items such as toasters and irons, clothing and book bindings revealed German Bauhaus gracefully inflecting French design.

Art Deco style can most easily be defined as a popular, stylized form of Cubism, occurring in France and spreading throughout Europe and the United States by the late 1920s. If considered an avant-garde movement within Modernism itself, Art Deco assumes the stature of Dadaism, Surre-

alism, or Expressionism; if viewed as a symbol of modernity, it becomes a minor genre subsumed under the larger rubric of Modernism. Certainly mainstream Modernist artists prided themselves on playing games and confusing the viewer with abstraction, in contrast to Art Deco's allegiance to simplifying, though never to the point of obscuring, its subject matter. Art Deco's formal characteristics, as various as those of any far-ranging movement, include foregrounding essential lines and curves, exaggerating recognizable shapes into a voluptuous or skeletal mannerism, emphasizing formal symmetry and parallelism, returning to single perspective, conveying modern life through sharp angles and generous curves, reflecting technology (cars, trains, urban life) and the new cult of the individual (portraiture), and making references to mythology and the classical world that sharply contrasted with the chaos wrought by World War I.

Art histories have typically been written as if "Art Deco painting" is an oxymoron; post-1968 accounts use "Art Deco" only to refer to objects, interiors, and architecture. Those unfortunate painters who have been consigned to its boundaries, including such talents as Meredith Frampton, Glyn Philpot, Bernard Boutet de Monvel, Marcelle Cahn, Mariano Andreux, Raphael Delormé, Jean Dupas, René Buthaud, and Dod Procter, play no significant part in Modernist canons as a result. Art Deco's easy accessibility, its mass appeal, its feminine allegiance to figurative art, and its technical allusions to classical norms all emphasized the movement's obvious relationship to the marketplace. Its advocates flouted Modernism's founding myth, a redaction of Romanticism. Since the late nineteenth century, modern artists had perpetuated the belief that they were not of the middle or upper classes. Their implied difference—the radicalness thought to neutralize their real bourgeois background—was a badge of avant-garde worth. In reality, many of Modernism's early Impressionists and Post-Impressionists had been born into educated social classes. As James Mellow notes, "Degas's father was a well-to-do banker; so was Cézanne's. Van Gogh's was a dignified pastor. Morisot's father was a wealthy magistrate; Cassatt's a rich American stockbroker. Monet's and Pissarro's fathers were, respectively, a grocer and a shopkeeper. Renoir was the son of a modest tailor. Sisley's father was a successful British silk merchant." The "favored stereotypical view of the modern artist as the complete social outcast"[9] became even more important by the 1920s, because of the profligate wealth in Paris that was directly related to unseemly war profits. Many painters enjoyed unprecedented financial freedom, since the postwar economy ensured eager patronage for their art. Such indentured leisure increased their determination not to appear to celebrate the very society they meant to critique.

Once the rubric "Art Deco" emerged in the late 1960s, painters hopeful
of inclusion in Modernism's history and champions of dead Modernist artists
were careful not to become associated with it. In reality, however, dozens of
famous painters termed "Modernists" created Art Deco masterpieces, once
the nomenclature is allowed to compete with more conventional ways of
classifying art. Diego Rivera perhaps illustrates the case most economically.
His early and later art comprise prime examples of the Art Deco style,
whether *Savia Moderna* in 1906 in Mexico City; *Montjoie,* commissioned for
a 1914 book; or the poster for his famous frescoes in Cuernavaca in 1932.
Even Rivera's 1940s portraits of women depend upon Art Deco principles,
including his 1943 *Portrait of Natasha Z. de Gelman* with its jewels, calla
lilies, and sharp delineation of severe lines and round angles; in his *Nude with
Flowers* of the following year, a profusion of calla lily blossoms forms an
eroticized background for the model. Rivera's murals also show the influ-
ences that typify Art Deco painting. As Octavio Paz says about the murals
in the Mexican Secretariat of Public Education in Mexico, they show a "por-
traitist who at certain times is reminscent of Ingres; the skilled discipline of
the quattrocento . . . and the consummate craftsman of volumes and
geometries. [Rivera] was capable of transferring the lesson learned from
Cézanne to the surface of a wall; the painter who prolonged Gaugin's
visions."[10] Had Rivera not become a leftist political hero in the modern art
world, his primitive flatness, reliance on bold color and exaggerated curves,
his references to the past, would cause him to be labeled an exemplar of Art
Deco. Indeed, as Edward Lucie-Smith asserts, Rivera's work "is pioneering
and retrograde at the same time; it adapts Modernist means to traditional
ends. In doing so, it calls into question the historical domination of Mod-
ernism itself. And it offers a sound explanation of why, even to those best
equipped to recognize it, the existence of an Art Deco style in painting has
long remained invisible."[11]

Rivera is but one of a multitude of Modernists whose work justifies the
legitimacy of Art Deco as a category of painting. Lucie-Smith rightly iden-
tifies Georgia O'Keeffe's stylized skyscrapers (similar to the city illustrations
of Boutet de Monvel) and her celebrated flowers as Art Deco.[12] Picasso's *At
the Beach* as well as his sentimental *Woman in White* easily fit the classifica-
tion; so does the work of such diverse American regionalist artists as Edward
Hopper, Thomas Hart Benton, George Bellows, and Grant Wood. Yet except
for Boutet de Monvel, it remains almost impossible to refer to the Art Deco
paintings of these artists, in spite of the powerful explanatory power that the
category possesses. In contrast, it is artists whose commercial success con-

sisted of a repetitious kind of mannered exoticism, such as Erté and Icart, who are often labeled representatives of the style.

Ultimately most significant in condemning Art Deco to an aesthetic limbo were the political aims to which the aesthetic was applied. Refugees from the war, like Tamara, might embrace a "return to order," but it was the leaders whose barbarism depended upon a pledge to purify culture who would profit most from this platform: Mussolini and Hitler. The appropriation of neoclassicism by the monsters of twentieth-century history did much to ensure that the Art Deco aesthetics would imply some kind of decadence. Art Deco painting aimed at creating a new art that harnessed the past in the service of a revivified present. But when theorists began speaking of the aesthetics of fascism and illustrating their politics with Art Deco examples, the slur "derivative" suddenly seemed benign.[13]

Retrospectively, Tamara's portraits and nudes of the twenties and early thirties helped define the Art Deco sensibility, and in the last years of her life she recognized that her only hope of a place in history was to accept this designation. By 1978 she had rewritten her script and was claiming that she had, in fact, created Art Deco herself. It's "the greatest thing I did. I said, 'Why do you have to imitate Cézanne and make all the apples, why? Why not do something which is new?'" And with that realization, she claimed she painted the picture of the woman in the gray dress (*Irene and Her Sister*, 1925), exhibited and sold it, and launched Art Deco painting in the process.[14]

Within months of the opening of the 1925 Art Deco exhibition, Paris showcased another art form that thrilled Lempicka and encouraged her perception of America as a democracy of talent: eighteen-year-old Josephine Baker burst upon the City of Light with a fervid display of sensuality. *La Revue Nègre*, Baker's celebrity vehicle, opened to unanimous acclaim at the Théâtre des Champs-Élysées. With its garishly painted rose-colored hams and pink watermelons, the stage setting for the spectacle remained with the prominent American journalist Janet Flanner throughout her life. Flanner sought to praise the performer even as she patronized her:

> *[Josephine Baker] made her entry entirely nude except for a pink flamingo feather between her limbs; she was being carried upside down and doing the split on the shoulder of a black giant. Midstage he paused, and with his long fingers holding her basket-wise around the waist, swung her in a slow cartwheel to the stage floor, where she stood, like his magnificent discarded burden, in an instant of complete silence. She was an unforgettable female ebony statue. A scream of salutation spread through the theater. What-*

*ever happened next was unimportant. The two specific elements*
*had been established and were unforgettable—her magnificent*
*dark body, a new model that to the French proved for the first time*
*that black was beautiful, and the acute response of the white mas-*
*culine public in the capital of hedonism of all Europe—Paris. . . .*
*As Josephine's career ripened, she appeared with her famous fes-*
*toon of bananas worn like a savage skirt around her hips. She was*
*the established new American star for Europe.*[15]

Tamara recounted to one of her Hollywood friends her own pleasure at
having seen Josephine Baker perform: "The woman made everyone who
watched her weak with desire for her body. She already looked like one of
my paintings, so I could not consider asking her to pose." When her friend
asked if she was surprised to be watching Negro performers, she seemed
taken aback: that color might have anything to do with genius was unfath-
omable to her.[16] In spite of her attention to social class, Tamara had assumed
from childhood that ability and talent cut across all barriers, including race,
sex, and even class. She was as apt to ask her servant, "Michelle, what have
you done worthwhile lately?" as she would a fellow artist.[17]

The influx of talented black performers furthered Tamara's sense of
America as fostering a variety of talents, a country mercifully untouched by
recent wars, one rife with opportunities for all progressive artists. In truth, it
was not America's largesse but Paris's easy racial blend that encouraged the
many black women entertainers who followed Josephine Baker to the
French capital. Adelaide Hall and Florence Mills, stars of an all-black review
at the Moulin Rouge, became city residents. "Bricktop," born Ada Smith in
Chicago, ran a popular nightclub in Montmartre where Man Ray and Robert
McAlmon became regulars and which painter Nina Hamnett, writer Kay
Boyle, and the infamous Montparnasse model and entertainer Kiki occa-
sionally visited.[18]

But in spite of the freedom they might encounter, few female black writ-
ers became part of the Parisian literary salons, nor did the women engage in
long-term friendships with local female painters. Only in music did black
artists mingle with their white counterparts. At the famous Champs-Élysées
café-concert, Les Ambassadeurs, which Tamara frequented enthusiastically,
Florence Mills and the Blackbirds and Cole Porter's first musical show (at
which George Gershwin played the Paris premier performance of *Rhapsody
in Blue*) met with rapturous applause. Although she herself painted with
Wagner blaring in the background, Tamara was also attracted to Gershwin's
music; she remarked that it was "full of passion for people, not ideas."[19] She
attended jazz concerts through her seventies, intrigued by the idea that the

music was improvised, though she talked afterward of the "mystery" of jazz more than of her own enjoyment of it.[20]

Jazz held its own, but throughout the decade it was only one diversion among many: whether it was Molière at the Comédie-Française or the nude revues at the Folies-Bergère, Tamara and the members of her social circle sampled everything. Kizette recalls that her mother "took from the Folies inspiration for the servants' attire [or lack of it] at her parties" and that she "thought Josephine Baker was fantastic as well."[21]

More important to Lempicka the artist than her evening entertainments was her continued study of the Renaissance whenever she had enough time and money. "Whenever Mother sold a picture, she spent the money on a trip to Italy," her daughter recalls. "Until I was a teenager, I usually went with her." During July or August 1925, Tamara took Malvina and Kizette by train to visit Italy's museums and churches. As they passed through different towns, an increasingly irritable Tamara fretted at her mother and scolded her daughter until she finally located the clear north light she insisted she must have in order to paint. At lunch on one particularly bright day in Rome, Tamara "suddenly pushed the platter of sliced oily meats onto the man's lap nearest her, and she almost shouted, 'There is an unforgettable light coming through the window opposite us. Please move, monsieur, so that I can study how it bends the red and white lines of the tablecloth.'"[22] At such moments the drama was real; Tamara's theatrics disappeared amid her conviction that perfection of light was essential to great art. Once she found it, the effect eased her into a state of inspired, almost beatific energy.[23]

As a result of the trip that as a young adolescent she had taken with Clementine, and even more the journey taken as friend or lover to her rich female neighbor in Paris, Tamara had identified Italy as the country that best satisfied her own needs and desires. The vision of the Renaissance and quattrocento artists—Botticelli, Messina, Michelangelo, and Caravaggio—nourished her soul, and the Italian culture fed her love of caprice, spontaneity, class consciousness, drama, and style. She had already realized that Italy's proudest sport consisted of mental fencing: "Outsmarting the other fellow, making him look dumb (*far fesso*), always wins great admiration in Italy— whether a motorist slips like a tiger into the only free parking slot while a clumsier driver who saw it first is still maneuvering in reverse gear, or a financier with borrowed money takes over a big company in a lightning raid and proceeds to strip it of its assets," a longtime observer of the country explains. In Italy, Tamara could express the opposite of her obsessive and perfectionist tendencies: spontaneity and messiness. In Italy she could release her compulsive need to control. Paris's climate of sexual debauchery encour-

aged her trips to the seedy clubs in the early morning hours; in Italy, the openly carefree arrangements made by the Italian nobility to accommodate their pleasures granted her permission to misbehave more publicly, less furtively. Tamara found the Italian view of sexual relationships liberating beyond even that of Paris, where propriety was demanded by much of upper-class society. She relaxed in the knowledge that ever since Boccaccio in his *Decameron* and Machiavelli in *La Mandragola* made fun of cuckolds, "adultery and unfaithfulness [had] always been major themes in Italian life and art," with erotic and extramarital entanglements usually considered entertaining farce.[24] Before the First World War, Italy was considered the most disorganized, hedonistic society in Europe, and there was little dramatic change afterward. If the French disdained Italian sloppiness and excess, Tamara's Slavic sensibilities found more of a natural home in Italy than any other place outside of Poland and Russia. Italy would remain central to Tamara's identity throughout her life.

On her trip to Rome in 1925, Tamara stayed as usual at the Excelsior Hotel on the Via Veneto. One evening she dined with several French acquaintances and discussed the religious grandiosity of the city. She mused sadly over her ravioli that there was nothing in Rome to equal the masculine power of Michelangelo's *David* in Florence, though the sculpted drapery of the *Pietà* in St. Peter's was partial aesthetic recompense. After several weeks in Rome, her little entourage traveled to Florence, where Tamara spent a month copying Michelangelo and Botticelli. Almost immediately after they boarded the train to return to Paris, the artist informed Malvina and Kizette that she needed to stop in Milan for a few days by herself to share some photographs of her work with the wealthy arts patron Count Emanuele Castelbarco.[25] Castelbarco's new gallery, Bottega di Poesia, had in recent years become the fashionable site of literary readings and art exhibits. In recounting her foray into Castelbarco's office, Tamara later told her daughter that she had confidently tucked her portfolio under her arm, smoothed her hair behind her ears and inside her beret, and handed the doorman a letter of introduction she had procured "from a friend." The count agreed to see her "only because the doorman told him she was young, blond, and good-looking."[26] He immediately gave her a date for a November show, then began debating what shade of gray they would paint the gallery walls to suit the thirty pieces he expected her to produce. "I am very happy to have this opportunity," she told him primly, "but I live in Paris and I do not have the necessary funds to insure and ship so many paintings to you." Castelbarco countered that he would underwrite those costs in exchange for a dealer's fee of forty percent rather than the usual twenty. Elated, Tamara agreed.[27]

Tamara had arrived at Castelbarco's too well prepared for the visit to have been as spontaneous as she claimed. Probably her introduction to the count came through one of the wealthy art patrons she had painted in Paris, or perhaps through Marinetti, who lived in Milan and knew Castelbarco. In spite of her dramatic protestations that this proposed show created a crisis for her—how could she ever create enough paintings to meet the count's deadline?—she actually had already completed many of the pieces. Since one of the paintings she would exhibit at Castelbarco's was a portrait of the well-respected Milanese socialite Renata Treves Bonfili Fontana, it is also possible that she stopped over in Milan to execute previously arranged commissions, at which time one of her patrons took her to meet Castelbarco.[28]

Tamara had been painting for five years by now, and not every work had been exhibited. Furthermore, she had already started preparing for the Salon d'Automne show before she took her summer trip to Italy. The timing couldn't have been better: back in Paris, she spent the next four months producing portfolios for both the salon and the gallery show. She declined commissions unless permission was granted to exhibit the paintings in Milan. She cajoled friends and family into posing for her, and she completed several fine still lifes as well. Most important, she was able to exploit her growing interest in painting nudes.

In Parisian art schools, studying the nude was an arduous endeavor. The painter Marevna remembered the physical sensations that the crowded studios fostered: "The building was filled with a whole army of young students of all nationalities, and all the rooms were packed. In the one where we were drawing from the nude the air was stifling, because of an overheated stove. We were positively melting in an inferno permeated by the strong smell of perspiring bodies mixed with scent, fresh paint, damp waterproofs, and dirty feet; all this was intensified by the thick smoke from cigarettes and the strong tobacco of pipe smokers. The model under the electric light was perspiring heavily and looked at times like a swimmer coming up out of the sea. The pose was altered every five minutes, and the enthusiasm and industry with which we all worked had to be seen to be believed."[29]

Tamara, however, had found her own way to obtain models. In explaining to interviewers how she found the right woman to complete a group of nude figures, she described a scene at the Théâtre de Paris.

*One night I went to the theater with two handsome boys. I always needed attention like that. I saw a pair of bare shoulders in front of me, and when the lights came up, she turned and I saw her profile. I looked at her and thought, I was painting in my studio a big*

*painting of five women and I could not find the model for the fifth woman. Nobody was fitting, [but now I knew] "This is the face. This is what I need." I talked to my two boys: "Look, I want to speak with this lady." I explained to them what I wanted and said, "You better get out because I don't know how she will react." And they said, "No, you cannot do this. How can you ask? She's a lady. You won't ask her to sit for a nude—you can't." I said, "Look, this is my business. Leave me alone. Wait for me at the door." They both went. I looked at them. They were at the door, standing there, thinking: "What will she do?" And I touched the woman on her shoulder. I said, "Madame, my name is Tamara de Lempicka. I'm a painter. I'm doing now a big work. Five personalities. One is missing, and that one is you. Would you sit for my painting?"*

*And my heart was beating. What would she say? What could she say? "You take me for a model? What's wrong with you? You are impertinent! How can you ask me to sit?" And I told her, "Nude?" She looked at me and said calmly, "I will sit for your painting." The next day I went into my studio two hours before to prepare the big canvas, finished all but for one woman [Le Rythme]. And my heart was beating. Will she come or not? No, she will not. Why should she come? She doesn't know me. At eleven o'clock to the minute . . . knock, knock, knock. I invited her in. "You can change upstairs. It's the little bedroom on the first floor." A few minutes later she came back. She had on a little nightgown, no bigger than that, from here to here, a little gown, green, pale green in mousseline. Perfection of body, beautiful color of skin, light and gold. For three weeks it goes on like this, and every day she asked at the end, "I'm coming tomorrow?" and I would say, "Yes, please." I never asked her name, and she never told me anything about herself. On the day I finished, I said, "That's it. I'm done. I would like to thank you. I don't know how. Could I send you perfume?" "Oh no, I don't use perfume," she replied. "Flowers?" "No, I think they should be in the garden." When she reached the door, all wrapped up in her fur coat, I said, "Chocolate?" "No." "Money?" "No, thank you." So I asked her why she sat for me for three weeks and gave me all her time. "I knew your paintings and I admired them. Good-bye." Then she disappeared forever, just like that. I never knew who she was.*[30]

Many nude models were prostitutes, and Tamara's profession of ignorance about the identity of the "lady" suggests that she either understood the model to be a high-class call girl and was merely being coy or that she enjoyed thinking that the model might indeed be a member of upper-class

society, someone so smitten with Tamara's talent that she would indulge in otherwise unacceptable behavior. The story's erotic tone accords well with the evidence of her increased lesbian activity at this time. Ira Perrot, her attractive neighbor, continued to model for Lempicka and remained her best friend. Alexander Chodkieweitz, the acquaintance from the early Paris years who witnessed many of the painter's friendships, recalled that Tamara spoke almost worshipfully of Perrot's lithe figure and beautiful full breasts. And he remembered that at least once his own fiancée attended a small party of women at the home of a well-known lesbian model whom Tamara had befriended at the Théâtre de Paris, the same place where she found the anonymous beauty. The women at the party went off in pairs or threesomes into corners of the room. Tamara engaged in her infamous routine of arranging food artistically on the naked body of a woman, this time her hostess, and slowly "eating her midnight meal."[31] Almost exactly one year later, *Myrtle*, a painting of two nude women whom reviewers assumed to be homosexual, was hung at the Salon des Indépendants.[32] Her inspirational techniques inevitably proved successful, however unusual they were. Reviews of the year's Salon d'Automne were enthusiastic: "A nude of excellent fluidity from Lempitsky," said *Artist of Today* (1 October 1925); other small papers concluded that "all the nudes are interesting" (2 October 1925) and that "from Lempicka, very seductive, beautiful nudes"(14 October 1925).[33]

Several of her finest nudes were done during this period: *The Model* and *The Four Nudes* were influenced by her Florentine studies. *The Model* (Plate 3), signed "Lempitzki," reveals her classical style as well as her mastery of André Lhote's plastic rhyme. Superficially a fairly conventional piece, it plays against traditional form to create its sense of harmony. Deftly lifting a chemise, a forearm and hand rise at disjointed angles from the model's trunk, revealing in their coy action a leg too large for the small exposed breast and midriff. A massive arm lifts from the shoulder to shield the model's face. Undulating around the figure, a dark curve frames the woman, setting up the metaphor of movement—the waviness of the curve, S-shaped and parallel to both sides of the figure, combined with the large, exaggeratedly rounded thigh, convey a continuing motion, as if the leg is about to sweep the plane demarcated by the S. The overly generous right arm furthers this movement, with the oddly positioned, mannered left forearm emanating from the model's hip. This discordant appendage assumes special significance as an early example of one of Lempicka's signature elements: the gesture that resists total audience voyeurism. Through such visual resistance, the painter contributed her own form of anti-illusionism to modern art. Even in her

most famous nude, the highly lauded *La Belle Rafaela* of 1927, the suggestion of the monstrous saves her portraiture from being consigned to the purely decorative.

*The Model* illustrates Lempicka's allegiance to Bellini's treatment of light and his attention to folds and drapery. More surprisingly, Vermeer's *Lady at a Spinet*, whose strong angles dictate the pattern of sunlight, seems an antecedent to *The Model*, with its similar strong treatment of black and white, and the spill of light onto the left of the figure. Even Vermeer's careful inclusion of color—the gold of the framed picture on the wall, and the triangle of blue formed by the shawl of the woman, the velvet seat of the chair, and the painted sky on the spinet underside—resonates in Lempicka's version of Lhote's plastic or parallel rhyme.

The plastic rhyme of *The Model*, though extreme, is totally integrated: the curve of the stomach under the slip echoes the left breast and shoulder and palm of the right hand; the thumb on the right hand parallels the mannered treatment of the left arm, extending from the hip. Echoes of triangles play throughout the otherwise round, voluptuous portrait: the shadow under the neck, the plane of the slip in the upper right, the shadow at the

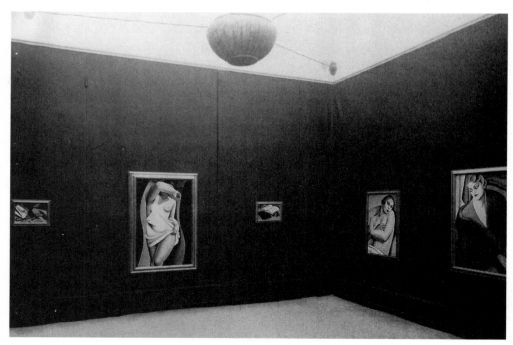

*Tamara's first solo show, at Count Emanuele Castelbarco's gallery, Milan, winter 1925.*

groin, the gathering of fabric into a triangle grasped by the left hand. The expanse of gray that constructs the intraframe of the black *S* acts as a keyhole; the viewer may be peeking, observing an innocent victim in the act of dressing or undressing. Yet the title "The Model," conferred by Tamara, suggests that this is a willing victim. In the painting's implied forward movement, the subject seems to be stepping aggressively out of the picture space —and into the private zone of the voyeur. Such transgression of boundaries disrupts the spectator's sense of ownership and self-possession and reasserts the artist's primacy.

Focused on her goal, Tamara finished enough paintings to return triumphantly to Castelbarco's Bottega di Poesia in Milan with fifty-one works. There she was feted as a rising talent of the artistic community. From 28 November to 13 December 1925, Lempicka could consider herself among the premier painters of the time.

In a fussy, fulsome introduction to the Italian show's limited edition catalog, Jacques Reboud, a distinguished French historian, apostrophized the artist. In part because of Reboud's reputation, an extract from his introduction was quoted in the French press, even before the exhibition opened:

> *You asked me, madame, to address your Italian friends about your works, though I was born under the French skies. Why ask me? Perhaps my study of the Roman and classical arts. . . . I had been somewhat afraid that your attachment to your native Poland might get ruined if overexposed to the abundance of Western European styles. I'm glad you still are attached to your native land and that it still shows in your work. I recall the words "All who search to generate through fire want to build through destruction." . . . I was about to measure the weight of the pictorial revolution our France got into after the war—imitation of novelties, the worst of art. Thank God now discipline is sharper; the newcomers are talented; and you have a link to the simplicity of Severini and Delaunay, the initiators of the reborn arts, the Renaissance, born in 1912 to form that new movement [Cubism] in Paris, the mind-set that was a new way of being. Italian Futurism has [also] escaped from a conventional formula of art. What is your school, Tamara? I don't know much about it, and I won't be eloquent about your painting; we see your paintings, and so there is no need for me to elaborate. Zagotta was the disciple of Cubism; you will be its evangelist. Any one who has contemplated the* Duchess de la Salle *will have discovered the genius of your canvas. You must continue your*

*efforts along this line. In all of Europe it will be very famous. . . .*
*[But] the glory that you want comes slowly step by step.*

In 1928, Reboud inscribed for Tamara his book *The Origins of Greek History* with "To the beautiful and charming Tamara, much affection." How the two became such good friends remains unclear.

More important than the press she received, the centuries-long Italian veneration of portraiture and patronage served Tamara well. If in the fifteenth and sixteenth centuries the French had used for "portray" the verb *contrefaire*, a word which became associated with the forged, feigned, and therefore second rate, the Italian use of *retratto* for portraiture implied throughout the years only the dignity of the artfully rendered reproduction. Now Tamara was able not only to absorb, at first hand, Italian Renaissance art but also to take advantage of the financial, sexual, and cultural possibilities set before her at an opportune moment in her career. Her entrée into this expensive, expansive culture was thanks to Castelbarco. Only in the Italian venues of the minor aristocracy would there exist a culture fertile and capacious enough to appreciate fully Lempicka's natural tendencies. Count Castelbarco would indirectly, through his friendships with other nobles, help translate the primal Italy of Tamara's artistic inspiration into the site of her greatest commercial success.

She quickly ingratiated herself among the count's friends; her Slavic drama and her aristocratic airs found an easy audience with the Latin nobility of Milan. During this month as Castelbarco's darling, she was befriended by a heady society of minor nobles and their various consorts, several of whom she would paint. The earlier dating of Renata Treves's portrait establishes that Tamara was previously acquainted with the baroness, and now she took full advantage of Treves's Milanese salon, "one with cultural airs, receiving intellectuals and artists, both Italians and foreigners visiting Milan," according to scholar Giovanbattista Brambilla, who adds that Treves possessed a "beautiful home with . . . luxuriant garden," the site of many balls honoring royalty. Treves, whom Tamara had painted as a modern, cosmopolitan woman with knowing eyes and a fully fleshed body, was a "fascinating, intelligent" friend of important painters and musicians, including Arturo Toscanini, and a "tireless organizer of 'evenings' and benefit-celebrations, concerts and special events of all kinds."[34]

Tamara was also befriended by an important local prince and his household, who invited her to return the following year to paint several portraits. Although Kizette identifies Guido Pignatelli and his wife as Tamara's new patrons, it is almost certain that the commission and hospitality were offered

instead by Marquis Guido Sommi Picenardi, whose wife was the talented sculptor Manana Pignatelli Aragona Cortés. Brambilla, who has researched the Picenardis exhaustively, believes that, through them, Tamara became extraordinarily well connected to important European cultural figures of the time: "They were friends with everyone, certainly with the royal Polignacs; and they knew Alice Keppel and her daughter, Violet Trefusis. Thus Lempicka must have been part of that large lesbian scene that comprised Italian society too."[35] Violet Keppel Trefusis was the lover of Vita Sackville-West, a love affair that caused Trefusis to seek the Venetian salon of Winnaretta Singer, Princess of Polignac, as a refuge. Mutual friends included Colette; Countess Anna de Noailles, a patron of modern art in Paris; and Maria Ruspoli de Gramont, the beautiful countess whose resemblance to figures in Lempicka's *Portrait de Femme* of 1929 and *Le Telephone* of 1930 suggests she was Tamara's model.[36] The Italian circle with which Tamara became intimate included people of exactly her outlook: they appreciated bisexual behavior; physically pretty, dandified but masculine men; and discreet but prolific sexual adventures. Furthermore, they all believed that serious attention to the arts was an essential part of life. Guido Sommi Picenardi was an excellent Futurist musician, trained at the Venice Conservatory; his wife was a talented artist. They would have welcomed the talented Lempicka as a natural member of their Italian coterie, and they would have furthered their friendship by socializing together in Paris.

Back home from Milan in time for Christmas, Tamara was gratified to see the mother-daughter pictures of herself and Kizette that had appeared in the November issue of the American magazine *Harper's Bazaar*. Although her daughter remembers the encounter with the fashion photographers on the Bois de Boulogne as a result of pure chance, Tamara's careful manipulation of her public image makes that unlikely: "Chérie told me that the Americans were so taken with our stylish looks when they accidentally happened upon us that they decided to snap our pictures for their magazine." The painter and her daughter laughingly face the photographer, with Tamara dressed in the latest fashions, artfully representing the modern woman who filled the pages of *Vogue*, *Vanity Fair*, and *Die Dame* alongside some of the best fiction of the period.[37] In the *Harper's Bazaar* photo, Tamara is dressed in a calf-length striped wool coat, with twelve-inch velvet cuffs extending to her elbows. She wears a wide-brimmed cloth hat and leather pumps with one-inch heels and a huge black bow on the instep. Kizette, her beautiful blond curls spilling onto her shoulders, laughs as she looks at the camera and tries to balance her hoop, which is revealed upon closer inspection to be discreetly anchored by her mother's hand in the back. The child has on a check-

ered wool coat ending several inches above her knees, white gloves, and lace-up boot-shoes with white socks. Most striking is Tamara's expression—one of her broadest, most uncalculated smiles.

Tamara, the Polish girl of twelve who upon her return to Warsaw had been absurdly overdressed in Paul Poiret's latest Parisian red, now was an authentic arbiter of high fashion. And haute couture would remain a significant pleasure for Tamara her entire life. In just five years she had gone from being a refugee wearing her aunt's hand-me-downs to being a fashionable painter sought after by designers who offered her lavish gifts of their clothes. She often accepted the couturiers' presents; since they were the latest styles, they helped her gain even greater exposure in the society pages of magazines and newspapers, where the outfits of important partygoers were often described in detail. Nonetheless, she didn't like the implication that her clothes were as important as her paintings: "I would not like those things [accepting free couture in exchange for press coverage]. Because what interest did the clothes have for me? That is nothing to do with my art," she said years later when eagerly prompted by her interviewers to discuss such publicity ploys.[38]

Inspired by her success at Castelbarco's, Tamara decided that she should be represented by a gallery in Paris. She sometimes told the story of how she haunted the galleries on both the Left Bank and the Right until she located one that was of an acceptable caliber and was sympathetic to her painting. Given the connections she had made by now in the art and social worlds, it is far more likely that a well-placed acquaintance sent her to Colette Weil's. A respectable dealer, Weil was sophisticated enough to sell a Braque and a Matisse but was typically the source of more commercial products sought by the newly wealthy middle classes. Interestingly, Lempicka often merged the story of her beginning as a poverty-stricken artist—walking around Paris where she noticed that "mostly every good painter was a woman"—with the tale of her "discovery" by Weil.[39]

Representation at a gallery had, in fact, become central to artists' commercial and professional success, even since Tamara had started out in Paris. By 1925 the salons were no longer functioning as important venues of radical contemporary art, nor were they a driving force behind aesthetic innovation. In 1925, Lhote himself declared the Salon des Indépendants a preserve of the establishment—even worse, of "Sunday painters"—though his judgment was no doubt influenced in part by the founding role he had played in the competing Salon d'Automne in 1903. Having one's own dealer and mounting solo exhibitions were not novel approaches in 1925—both had been used previously to create the kind of exclusivity that would drive

up prices—but during the second half of the 1920s such practices became the sine qua non of any artist's success.

The account Tamara gave of the Colette Weil gallery perpetuates her preferred image as an untutored, totally independent artist. Omitting mention of her solo show brokered by the well-known Castelbarco, as well as the notices she had garnered from the Automne and Indépendants salons, Tamara claims she approached Weil as a naïf. Dramatically recounting how she hid her insecurity and shyness and forced herself to go inside with several canvases under her arm, she remembered "fervently praying" that Weil would take a look at them.[40]

> *I'm telling you the story [of my career]. . . . We came to Paris, I said I had no money. And I was going around and seeing the exhibitions at that time. . . . And I found out that the gallery which was called Colette Weil, is the most written up in the newspaper: Colette Weil had a vernissage [a private showing]. Colette Weil had an exhibition of good painters, this name and that name, and so on. Well, I wanted to see the gallery. And I went, and I saw a young woman, very pretty, that was there. I approached her, and I said, "Madame, I am a painter, a young painter, not known. But I would like to show you some of my paintings." And I had with me, two small paintings . . . and she said, "Show me." She looks at the painting, and she said, "When did you do that?" I said, "Now, lately." "Well, do you have more paintings like that?" I said, "I have a few photographs." "Show me the photographs." I show her the photographs. And she said to me, "Come back next week. I would like to talk to you." My heart was beating. I was waiting to see what will she tell? I was trying to find the best things which I could find. And I went there, and at the moment I went there the door opened, and came a man and a woman. And they came there. And they bought my paintings, not the ones they first saw of Marie Laurençin.[41]*

In this coy story Tamara forgot to mention that her mentor, André Lhote, exhibited at the same gallery—and that she herself was quite well established at this point.

Tamara spent the first half of 1926 painting for the Salon des Indépendants and for a growing number of the newly rich who had heard that her portraits were more interesting than those of Kees van Dongen, the respected portrait painter whose reputation had until now easily surpassed her own. She also put the finishing touches on her composition of five nudes, *Le Rythme.* Although this work was well received at the time, it is not as suc-

cessful a composition as the *Four Nudes* (Plate 4). The tight arrangement of the latter painting's writhing amazonian women gives way in *Le Rythme* to a looser experiment both structurally and stylistically. The striking parallel movement of the second woman's rounded back and the bent posture of the bass player against the arched fifth nude enacts Lhote's thesis too neatly; and the double bass in the left corner seems an uneasy parody of the early Cubist icons of violins and guitars. Nevertheless, this piece earned Tamara some of her best press reviews yet: "The works by Lempitsky [*sic*] are interesting" (*Un Livre*, 3 March 1926). "The compositions are like pieces of life, in which the nude is the central theme" (*Le Figaro*, March 1926). "Never does Mrs. Lempicka have a firmer command of her painting than in *The Rhythm;* in fact, the rhythm is contained in the beautiful attitude of the women, especially in the curved line used to express movement. *The Rhythm* is also felt in the woman who plays the musical instrument, which is probably a symbol of correspondence between the arts of music and painting, between arts of the soul. . . . The Cubists have always pretended to reclaim Ingres as belonging to them. But can Ingres be thought of as a Cubist painter? In this painting, Lempicka makes us believe it can be true" (*Le Cinema*, March 1926). On 26 March *Renaissance* proclaims that "the nude of Lempicka is of a genius composition." In April of the same year, *Le Figaro* declares that "despite some slightly contorted or exaggerated movement, Mrs. Lempicka shows in *The Rhythm* bodies that are flexible, firm, beautiful; and she arranges the forms well, and the relationships between them." In the only thoroughly negative review, the March issue of *Paris World* complained about her dangerous proclivity toward the decorative: "The nudes from Lempitski [*sic*] rest basically upon a style which is decorative and predictable."

Increasingly confident of her talent, Tamara set off for another summer study trip to Italy. In addition to spending time in Florence, she would go to Milan to follow up on the commission for a second portrait of Marquis Guido Sommi Picenardi, whom she had initially painted after the Castelbarco exhibition. The first portrait's extreme angularity, its muscular Cubism, both accentuates and compensates for the effeminate prettiness of the subject's face, the kind of appearance she favored in a man. As Giovanbattista Brambilla points out, "This was a man who had many portraits painted of him, but Tamara's is among the best. He actually had reddish blond hair, the heritage of his Russian mother, but it started graying early, so he colored it black with a tiny silver streak, which Lempicka's painting [done when Picenardi was thirty-one] shows. He posed in the exact outfit he chose for other artists as well." Her portrait of Picenardi reflected the ease she felt

in his company: he referred often to his relationship with one of the czar's generals through his Russian mother, Nadina Basilewsky, and no doubt Tamara and Guido had common acquaintances in Petersburg.

The Castelbarco show had anointed Tamara the new painter of choice for wealthy Italians. On this particular summer visit in 1926, the Picenardis served as her hosts for several weeks at one of their homes in or near Milan: possibly at their castle, the Terre de Picenardi, forty kilometers south of Milan; or in their apartment in the Via della Spiga, a mere fifty meters from the Castelbarco gallery, and even closer to the Hotel de Milan, where the artist enjoyed dining whenever she visited the city.[42] During this visit with her Italian friends, Tamara was included in Gabriele D'Annunzio's invitation to the entire household to attend lunch at his extravagant home, Il Vittoriale. He had apparently flirted with Lempicka when he attended her show the previous autumn at Castelbarco's. Physically, Tamara was the poet's favorite type: at five feet seven she was an inch taller than his minimum for women in their bare feet; and her long legs must have satisfied the short man as well. As scholar John Wayne notes, D'Annunzio had once written of being pleased by a woman "because she had legs of an elegant length like the *Salome* of Filippo Lippi."[43] D'Annunzio already shared several acquaintances with Tamara: close friend to Emanuele Castelbarco and comrade of Marinetti, he was also the longtime admirer, if not lover, of her hostess Manana's mother, Princess Aragon Cortez. Tamara had not been especially impressed with the "aging poet," but she knew him to be a "lover of genius," and thus his attentions flattered her. She also enjoyed the intrigue he constantly created around himself, according to the titillating gossip that circulated among Tamara's friends. Even before the artist arrived at Vittoriale, she clearly had some idea of what to expect.

Lake Garda, the site of his palace, was approximately an hour's drive from Milan. The largest and one of the most beautiful of the Italian lakes, its winter climate is famously mild, with olives, lemons, oranges, and grapes growing in abundance. Il Vittoriale, a complex of buildings on Lake Garda's shore, had belonged to Richard Wagner's family at one time. D'Annunzio added to the compound, so that in the mid-1920s it contained a Greek amphitheater, a hangar for D'Annunzio's World War I biplane, and a ship called the *Puglia*—all in various stages of construction. Il Comandante (the title used by his followers and servants) had become larger than life after the famous Fiume affair, in which he had protected, for one year, the small contested Italian city from Yugoslavia's postwar claims. Gabriele D'Annunzio, now a particularly dusty footnote in twentieth-century literature and history, was for years a kind of Napoleanic figure for the Italians and French, a

celebrity of heroic proportions in spite of his five-foot-four-inch height. He always "owned at least a hundred suits" and "changed clothes at least five times a day."[44] He shaved his head entirely rather than risk the aging effect of gray hair. By the time Tamara met him, he "used at least a pint of Eau de Coty daily, and an ordinary perfume bottle lasted only five or six days. . . . He devised his very own signature scent and named it in Latin form, after himself, Aqua Nuntia." John Wayne, a lifelong student of Il Comandante, continues that "[in] life, Gabriele D'Annunzio seems to have taken a page from Lord Byron, then one from Beau Brummell, then Poe and Baudelaire, Dante Gabriel Rossetti and Oscar Wilde. His visions were like those of Dante Alighieri, of Leonardo, of Nietzsche, single, solitary men of genius. As an Italian lover . . . D'Annunzio could be carrying on major love affairs, six to a week, with princesses, countesses, singers, dancers, actresses—Sarah Bernhardt . . . Eleanora Duse . . . Isadora Duncan—*and* be writing, that same week, a major drama for a cast of at least two hundred! His writing is so complex that even most Italians have trouble with it. Most of it remains untranslated, maybe even untranslatable. His use of language is personal and powerful, perhaps unique."[45] Known as well for his skill as a soldier, he had courageously flown his little biplane over Vienna during World War I, dropping pamphlets exhorting the enemy to surrender. At the end of the war, D'Annunzio captured and became sole ruler of Fiume, in an ultimately futile attempt to keep the annexed territory Italian. Too popular with the Italians for Il Duce's comfort—"Italian schoolgirls flocked to join D'Annunzio's rebels, their pockets loaded with bombs"[46]—he was removed from the political arena when Mussolini strong-armed him into a retreat at Il Vittoriale.

Tamara was excited about the chance to visit a place she had heard so much about. She recounted to her daughter, years later, that "we piled in the Prince's [Guido Sommi Picenardi's] Isotta Frascini which he was driving himself like a mad man, and after running over several chickens and scattering children at play on the dusty road, we arrived at the Vittoriale where D'Annunzio met us at the gate."[47] Kizette paraphrased her mother's dictated account of Il Comandante's house tour, which sounds much like the standard melodrama he produced for all his guests, according to his biographer, Philippe Jullian:

> D'Annunzio led them on a tour, room by room, showing off his treasure. A reproduction of Michelangelo's David was swathed from the torso down with a piece of black material. D'Annunzio explained that he could not stand anything less than perfect— Michelangelo had used a block of marble too small when he created David so that the legs were too short for the otherwise well

*proportioned body, and so he, D'Annunzio, had to hide the legs by swathing them in that black cloth so his sight of the masterpiece would not be offended!*

*Another room was to be his death chamber. It contained a small narrow coffin, and above it in a niche on the wall, a small glass box. This box, he explained, was to contain his ears after his death, "because my ears have always been the most sensitive part of me in hearing music—I have in my ears my nativity and my destiny."*

*The tour continued, from the macabre to the theatrical. They came to a room dominated by a huge armoire. D'Annunzio threw open its doors and there came tumbling out yards and yards of precious material, costumes from past decades, semiprecious jewelry, theatrical mementos—these he piled at Tamara's feet, bidding her to chose [sic] anything she wanted as his gift. Embarrassed by these attentions, she modestly chose a pair of silk stockings.*

*At the luncheon table D'Annunzio's wit and charm were so great he had every man and woman enthralled, hanging on his words. However, he could also be sarcastic and biting, as when one of his guests spoke of having been to China, D'Annunzio's indifferent comment was "Ça ne se voit pas" (It does not show).*[48]

Tamara returned home to prepare once again for the Salon d'Automne show, then returned to Italy in November 1926 to work in Florence, at which time she hoped to find that D'Annunzio had been serious about an earlier request for a portrait. Her autumn reviews had been largely excellent, though increasingly a note of uneasiness appears, inspired by her eccentricity, and directed most clearly at her homoerotic *Myrtle:* "Mrs. Lempicka showed a very interesting nude painting, a double portrait of a young woman of some value because of the style and because of the careful and meticulous brushstrokes" (4 November 1926, *Le Figaro*). The November *Correspondence Artistic* commented that "among the majority of critics we must remember the amusing painting of Lempicka because of its bizarre strangeness." *Pologne* nervously emphasized the background's classical treatment that saved the "life-size" nudes from an untoward earthiness: "Mrs. Lempicka likes to treat models life-size and in movement, but she does so by stylizing the background and clothing and using heavy but simplified pleats, a very pleasing tendency toward a synthetic conception of her model" (December 1926).

Emboldened by her growing reputation, Lempicka sent D'Annunzio a letter from Florence in December that discussed the motivation for her current trip to Italy: "Why [am I in ] Florence? Because I am studying the cartoons [the church frescoes] of Pontormo." As both Gioia Mori and Maurizio

Calvesi have proposed, the group nudes Lempicka was executing around this time dramatically reinterpret Pontormo's frescoes for the choir in San Lorenzo, the drawings for which were at the Uffizi museum.[49] Her letter to D'Annunzio continues: "[I am here] to purify myself by contact with your great Art, to breathe the air of this delightful city, to dispel the blues, to have a change of scene—that's why I'm here, I'm staying in a 'casa per studentesse,' where I get up at seven-thirty in the morning because at ten one has to be in bed, and in this atmosphere, along with my little companions—I'm fine and I feel very pure!" She then flirts with D'Annunzio, whom she addresses as "Maestro and friend (I hope and pray)": "I'm sorry to be so bad at expressing my ideas, I would have so liked to talk to you and confide to you my thoughts, for I think you're the only one who understands everything and doesn't say I'm crazy, you who have seen everything, experienced everything, tried everything. . . . For the Christmas holidays I go back to Paris. I'll pass through Milan, where I'll probably stop for two days. Would you like me to pass your way too? (In the good sense of the word?) I'd like to—how about you? I send you, my brother, all my thoughts, the good ones and the bad ones, the mischievous ones and those that make me suffer. Tamara de Lempicka."[50] Apparently D'Annunzio answered immediately, since two days later Tamara wrote him again, exclaiming: "Thank you, I'm coming! I'm so glad—and afraid. What are you like? Who are you? And me, will you like me looking like a little student, without my Paris gowns, my makeup, etc., etc.?"[51]

For the next fifty years, Lempicka would narrate her dealings with D'Annunzio as if she had visited him only once, when in fact she stayed at Il Vittoriale twice over several months. In her old age, she was forced to confront the truth of her visits as a result of a lavishly produced book published by the wealthy Italian art maven Franco Maria Ricci, owner and editor of *FMR*, a chic and glossy periodical. In the expensive, beautiful volume centered upon Lempicka's oeuvre of the twenties, Ricci published the diary kept by D'Annunzio's housekeeper, Aélis Mazoyer, which chronicled Tamara's most dramatic visit to the villa. Also reproduced were the letters (some of the few extant examples of Lempicka's writing) that the poet and the painter exchanged after her first abortive attempt to paint D'Annunzio's portrait in December, as she "passed through" Italy. As a result of Ricci's published account, whose explicitness Tamara angrily denounced as "lies," the artist provided her own version of the truth to her daughter, who dutifully took dictation, translating her mother's patois into conventional English. For the most part, these dictated notes simply omit from the housekeeper's account much that was indiscreet, and they combine the two visits into one.

In contrast to the sanitized version decorously narrated by the eighty-

year-old painter in 1978, the salacious details that Aélis Mazoyer provided appear authentic to people who were familiar with Tamara's and D'Annunzio's habits. If Aélis was jealous of Tamara, she was outraged at the pride the young Slavic woman—"that Pole," as Aélis referred to Tamara—displayed to the Commandant, whom she herself felt so honored to serve. Tamara probably insulted Aélis more personally as well, since she did not hesitate to treat employed help imperiously.[52] The housekeeper's diary emphasizes that the entire female household at Il Vittoriale—the resident pianist, the visiting ballerina, and the servants—all considered Tamara a "superficial" trouble-maker because of her insensitive treatment of their master, D'Annunzio.

Lempicka visited D'Annunzio's villa twice between December 1926 and February 1927, the second trip an attempt by both artists to reconcile their differences. During the first visit, Lempicka had taken ill after days of trying to adjust to D'Annunzio's eccentric habits—his resolute disregard for time, his spontaneous meals, his daily dependence upon cocaine and sex to render him hospitable. Feeling trapped by his insistence that she sleep with him, Tamara fled in the middle of the night to Gardone, the village at the bottom of the hill, then drove on to nearby Brescia, an important museum town half an hour from Milan. Explaining her precipitate flight in a letter from Cannes to Il Comandante, Tamara wrote that she had now "known hours of suffering" due to their misunderstanding. D'Annunzio telegraphed her within days that he "had written you a letter too long but so disturbing and beautiful that I keep it in memory of the secret tragedy. Like a good soldier I detest neutral territory. Letter departs with this telegram. Wire me after you read it. Leda is impatient." He signed it "Ariel."[53] Throughout the next week, as she wended her way back to Paris, she and D'Annunzio exchanged messages filled with overwrought sexual innuendos, all of which Tamara accepted as a game that might still allow her to paint the famous man's portrait. She finally promised him that although she had to go home to her family for the Christmas holidays, she would return to Il Vittoriale after the New Year.

Those holidays of 1926 were among the nastiest ones her daughter recalls ever spending: "My father found a telegram that D'Annunzio sent Chérie, and he hit the roof," Kizette remembers.[54] Careless as ever of her husband's feelings and of her own marital loyalties, Tamara had supplied the poet with both her own address and her mother's: "Mon adresse à Paris: 5 Rue Guy de Maupassant: ou bien chez ma mère: Madame M. Gorska 5 Rue Paul Louière, Paris." Perhaps D'Annunzio was deliberately hunting her in her own home, but in any event, he sent his telegram to the Lempicki apartment, beseeching her to return to his villa for a second visit, and Tadeusz intercepted it.[55] Addressed to "Madame Tamara Lempizka, 5, Rue de Mau-

passant, Paris," it read, "I want. I expect you. Please wire me what day, what hour, what station, so I can send car. Please tell me also if this time you will accept the fraternal or paternal hospitality of the beautiful apartment you already know. Gabriele."

Flattered by his pursuit, and determined to paint the famous man sometime in January 1927, Tamara traveled to Milan, where she wrote D'Annunzio, who had obviously been informed of her itinerary: "Dear brother, I'm working here at the Brera [museum] and the short delay is perfectly all right. . . . All my thoughts, Tamara." In a postscript, she added, "The ivory brooch and pin—superb!" Back at the villa, the poet's delay in sending a car for Tamara had been caused by the inopportune appearance of his wife, Donna Maria. He was carefully timing the departure of the marchesa to coincide with Lempicka's arrival. "I do not want any awkward meetings," he told Aélis, whose job it was to coordinate her employer's love affairs. The housekeeper pointed out to him how amusing it was that "the Polish woman" should arrive just an hour after Donna Maria's departure. "I suppose the bed will still be warm," she offered dryly. D'Annunzio replied that he was determined to act discreetly and not rush things, since he wanted to treat Tamara "like a real lady." "Besides," he went on, "it may just be one more delusion [a reference to his recent bouts of impotence] to add to the others. But if it all falls through, she can still paint my portrait, which will be good publicity for her."

He made his "first pass" at Tamara the night she arrived, after which he reported to Aélis that "things had gone very badly, that Tamara was a blockhead, an opinionated woman who does nothing but argue and has no feeling." The next day, Tamara, as directed, took her paints to the Leda room, which contained a bed on whose headboard was carved an image of Leda's rape by the swan. Again she rejected D'Annunzio's advances by telling him, according to the poet's account to his confidante, that she didn't want to get syphilis because "I have a very young husband and wouldn't care to give him such a present. You always have such a great number of women that I wonder if it's possible to rely on you." She later added that she was afraid of getting pregnant.

Aélis told the poet that only a "professional"—presumably one of the prostitutes she regularly procured for him—would think of syphilis, and she and D'Annunzio had sexual intercourse that night in the doorway of the Leda room, hoping Tamara would hear them and register their contempt. Aélis herself writes that revenge provided the sexual excitement she knew D'Annunzio needed: "As for my job, I don't know why but that evening I invented something which made him kiss my hands and tell me that my sen-

sitivity was comparable only to his art." D'Annunzio reported the next night that, after Tamara had tried valiantly to proceed with the portrait, she had allowed him "soulful kisses, to be kissed in the armpits," and had let him feel her body through her clothes. He thought it appalling that she told him he could only ejaculate against her "with your clothes on."

It rained for the next three days, during which D'Annunzio's ramblings about his theology of art, souls, and sexual conquests interested Tamara more than his body did. Every night, however, the two repeated the same scene. The aging seducer berated his houseguest that she had his entire menagerie "hanging by a hair of her cunt." She responded by writing him little notes meant to keep him interested long enough to sit for his portrait while keeping him physically at bay: "I adore your message that begins 'Darling child,' for the rest I close my eyes. You end with 'soon,' when for you is soon?" But instead of encouraging him to follow through with the commission, Tamara's flirtatiousness motivated D'Annunzio to try to impress her by flying her over the lake in his private plane. Whether the trip, the weather, the erratic eating and sleeping patterns, or just an attack of acute anxiety, something caused Tamara to fall feverishly ill. That evening, D'Annunzio undressed her as she sweated profusely, and he "ran his erection slowly over her body. As he was about to enter her, she asked him: 'Why do you do such horrid things to me?'" He left, only to return the following evening after the painter said, in a "very sweet letter," that she was expecting him.[56]

Next he tried to bribe her with cocaine, a ploy Tamara was alert enough to resist at this clearly crucial confrontation, except to rub some around her gums. By now well acquainted with the pleasures of drugs, she had underlined references to opium wherever they appeared in Baudelaire's *Les Fleurs de Mal*, which D'Annunzio also admired.[57] The housekeeper's diary recounts a comment that is omitted by Lempicka's daughter in her memoir: Tamara told D'Annunzio that she was afraid of "falling into a vice she'd had a few years ago."[58] D'Annunzio, assuming that the drugs would lead, finally, to sexual consummation, removed his pajamas to exhibit to her "the beauty of [his] body." Turning away in horror, Tamara complained that she despised "pornography."[59] Furious at his lack of interest in her painting, she told him that "perhaps you've avoided mentioning it [the commission] because you did not know my prices." D'Annunzio sniffed to Aélis that he responded, "What, madame? Is that the way you talk to Gabriele D'Annunzio? Well, good-bye!" Tamara insisted in her account to Kizette that he instead started to sob and shout at her, "I am old, an old man! That's why you don't want me."[60]

D'Annunzio has been labeled by many of his chroniclers the exemplar

of the irresistible Latin lover. His narcissism, his eccentric heroism, his baroque verse, his glut of women—including his long liaison with the most famous Italian actress of the time, Eleanora Duse—had already, by Tamara's visit, contributed to an image of him that would be envied by the most ambitious Don Juan. Women typically professed, however, to be physically repulsed by him: Sarah Bernhardt, who like almost all others nonetheless succumbed, said his "darting eyes" were "like caca." Described almost without exception by his devotees and enemies alike as singularly unattractive, his celebrity as a lover led the lesbian Nancy Gluck to remark that "any woman who had not slept with D'Annunzio was a laughingstock."[61] Il Comandante enjoyed one of the most extraordinary reputations for sexual conquest ever recorded, including being perhaps the only man ever to have inspired real sexual desire in Romaine Brooks, a lesbian with whom he eventually shared dancer Ida Rubenstein. By 1926, when Tamara visited him, his priapic activities were confined to an established group of sexual partners. Tamara, who never could bear to be judged in comparison to others, was not attracted by the invitation to join either the roster of female greats from his more vigorous past or his present banquet of leftovers.

Nonetheless, the remarkable sexual success D'Annunzio had enjoyed ensured that he was a formidable opponent. An anonymous countess never forgot her own encounter twenty years before Tamara's visit to Il Vittoriale:

> I was tempted to move away a little so that he would not touch my body, but I caught myself in time, realizing that such a gesture would be absurdly prudish and out of place. . . . A second later, the Poet removed all doubt by taking my two hands in his and caressing them while he talked to me very slowly. . . . His voice seemed to dominate and destroy my very personality with a magical force. There are words which burn more delightfully than the most passionate of kisses. D'Annunzio seemed to have them all at his command. There are kisses and caresses which are more soothing than the most consoling words. He possessed them, too. From his gestures, from his voice, there came a limitless and invincible wave of desire which engulfed me and enveloped my whole being in an irresistible atmosphere of love which did away with whatever resistance I still retained. The woman to whom he spoke . . . was transported, in spite of herself. . . . Flesh and blood could not resist him.

The countess goes on that, whether due to the jasmine tea or to "the enchantment of D'Annunzio's words and voice," she fell asleep, "drugged by the delicious poison of the Poet's musical word. . . . Before my eyes on the

wall was the marvelous *Prisoner* of Michelangelo. . . . I regained conscious-
ness in the green twilight beneath the frozen stare of the *Oracle of Delphi.* A
quarter of an hour later I found D'Annunzio in his Library. . . . He was in
evening dress. He accompanied me to the gates. He uttered not a word—
and for that delicate discretion I have always been extremely grateful to him.
When we reached the carriage, he lingeringly kissed my hands—'to warm
them,' so he said—and the truth was, they were icy cold. . . . As I drove
away, my hands fell on something very soft and fresh to the touch—roses. I
cannot tell you whether I was happy or sad."[62]

If D'Annunzio had treated Tamara with the same theatrical restraint,
she might have felt differently about him. Aélis's diary, in conjunction with
Tamara's own account, strongly suggests that his nonstop histrionics, includ-
ing his habit of sleeping in his own coffin, offended her. She too was the-
atrical and narcissistic, but she knew enough not to parody her own
extravagance.

After the abortive cocaine seduction, Tamara left the house for good and
traveled to Milan. The Commandant apparently regretted driving his house-
guest away—or perhaps he simply hated not having the last word. Accord-
ing to Lempicka's account to her daughter (the story does not appear in
Aélis's diary), the poet arranged a stunning denouement to their failed affair:

> One morning at dawn I came back from one of those intimate
> parties for about two hundred people and fell on my hotel bed
> exhausted. I had been asleep for what seemed like a few minutes
> when there was a knock on the door. From a heavy sleep I yelled
> "Avanti," but the knocking just went on. Finally I got up and
> opened the door a crack—this revealed a bellboy with an impudent
> smile on his face who said: "Madame, there is a messenger for you
> downstairs."
>
> "A messenger? What messenger? Why a messenger . . . ?" My
> mind, confused and still befuddled from last night's champagne,
> simply refused to focus on this crisis. "Have him come up," I said.
>
> "He cannot do that," said the bellboy. "He wants you to come
> downstairs."
>
> I became quite furious at this insistence, and finally the bellboy,
> who seemed to be enjoying this situation, said, "He comes from
> D'Annunzio."
>
> At the sound of that name I became fully awake and, throwing
> on a heavy robe, I rushed downstairs to the lobby.
>
> The first thing I saw was what seemed a throng of people
> milling around a large white horse. The man mounted on the horse
> had trouble restraining him and keeping his hooves from trampling

*the people. As I approached him, he leaned down toward me and said, "Il Comandante wishes you to have this"—and he handed me a parchment scroll on which D'Annunzio had written a poem in his strong, beautiful handwriting. The poem was dedicated to "La Donna d'Ora" (the golden woman). Of course I could read no more, with the noise and the milling around. The messenger then handed me a small box like a jewel box, which I opened with a beating heart, as what woman wouldn't, and which revealed a huge topaz mounted on a heavy silver mounting. This was an extraordinary design, especially in those days, when women wore small dainty jewelry—usually diamonds or tiny precious stones. The ring fitted me perfectly and when I learned D'Annunzio had it made especially for me by the artisans he had living on his property, it became doubly precious and I would not have exchanged it for any amount of diamonds.*[63]

Tamara kept the topaz ring and wore it often until her death; the message she took for what it was, an invitation to resume the sexual tease with the would-be lover she still addressed formally as *"vous."* Certainly she had recognized the sexual overtones of the portrait commission from the very beginning. D'Annunzio's sexual appetites were well known all over Europe. And even in Cannes, in the aftermath of her first disappointing visit, the correspondence between the poet and painter had been sexually overripe, as Tamara had striven to match the extravagant, outdated, and ornate verbal patterns of the poet: "Perhaps one day, one evening, one night, you'll feel an irresistible need to speak to me—and then you'll write me again. I wait. I hope. I want. Tamara."[64]

At some point in their brief and tortured friendship, she had become convinced, correctly, that the ambitious D'Annunzio respected both her success and her womanliness. The former, however, led him to insist on conquering the latter. She never felt that her singularity as a woman or painter created in him a deep desire for her personally: she was just another trophy among his collection of accomplished, attractive lovers. Her self-esteem was nourished at least as much by the three books he had given her as by the topaz. Inside a copy of D'Annunzio's famous work *The Martyrdom of Saint Sebastian* (the saint whom her beloved artist Antonello da Messina had painted) he had written, "To the great Tamara, for her to consider as she contemplates the role of Martyr: One must kill his love so he can live seven times more intensely." And on the title page of his *Triumph of Death* he wrote, "To Tamara, who is 'the triumph of Life.'"

It is no exaggeration to claim that Tamara de Lempicka is best known to the general public, perhaps to the art world as well, through her brief contact with Gabriele D'Annunzio. Rarely does a minor misalliance cause such distortion of a reputation, even as it ensures at least name recognition for the otherwise undervalued artist. Two related events in the 1970s—the publication of the Ricci book and the highly successful Los Angeles and New York theatrical production *Tamara*, by John Krusick, subsequently based on its revelations—gave D'Annunzio a causal role in Tamara's fame rather than the footnote he deserved. This sensationalized association of the debauched young artist with the pleasure-driven Italian poet has fueled contemporary interest in her portfolio ever since.

At the same time, their brief relationship undeniably reveals much about Tamara. Her personality and character were strikingly, often oppressively strong, according to anyone who spent even fifteen minutes with her. As Houston doyenne Jane Owen recalled, "I've had many very impressive friends in my long life, but Tamara had a strength of self-knowledge and sense of who she was in the world that no one else conveyed." As if afraid she hadn't made her friend's defining characteristic clear, Owen pronounced each syllable slowly and emphatically: *"She knew who she was."*[65] Yet when pressed to elaborate upon such a personality, Tamara's acquaintances are unable to get beyond such generalizations. Her encounter with D'Annunzio at least furnishes pieces of the private logic by which she governed her life.

D'Annunzio and his friend F. T. Marinetti, Tamara's acquaintance as well, were exactly the type that Tamara enjoyed knowing—and bragging of her acquaintance with—while not the sort she took seriously, either sexually or intellectually. They failed her test of style: neither bore the burden of fame lightly, the formula for which was to convey absolute awareness of one's own worth while shrugging it off in pursuit of other pleasures. Marinetti had barely amused Tamara even when she was new to the art world in Paris and happy to listen to his diatribes against institutional authority. In his earnest passage extolling the need to keep boys away from girls, Marinetti had inadvertently pointed to the tremendous fear both he and D'Annunzio had of women, an emotion that emasculated them for the intuitive Tamara: "We will finally do away with the mixture of males and females that during the earliest years always produces a harmful effeminizing of the male."[66] The men Tamara chose for sex or close companionship inevitably loved women in a forthright way, though at first glance the panoply of pretty gay men she preferred might seem to contradict this. But Tamara liked homosexual men who were at ease with their sexual preferences and who simply enjoyed and

admired much that was feminine. Men who were characterized by covert struggles with and ambivalence toward women left her unresponsive.

Tamara liked to play; she enjoyed the theatrics of seduction, which were to be understood as mere gesture. Her fellow actors had to be equally sophisticated; only buffoons, their emotions uncontrolled, took these dramas seriously. The overblown, protofascist virility of both Marinetti and D'Annunzio led to a sexual and social politics that Tamara, who preferred a "democratic oligarchy," could never accept. Four or five years after she had associated briefly with Marinetti, she found herself equally incapable of finding D'Annunzio sexually attractive. In spite of her unflagging eagerness to further her career, she flatly and unequivocally refused the chance to be the famous D'Annunzio's lover. Her sexual games with him have been interpreted, incorrectly, as a bid for time while she made up her mind. But she was never in doubt, and not only because Il Comandante failed to meet her standards of physical beauty. She was offended by his unintentional vulgarity and by the realization that he'd included her among the beauties he thought would be easy to bed. And if there was ever any chance that she would sleep with him, her routine of painting first and having sex later was inviolate: "When I work, I'm extremely concentrated on my work and I have only one idea, it's how to do the best I can. And there is no flirting, nothing in my mind. The man who sits for the portrait is, for me, like a statue. And I am the person who has to do the statue. . . . The flirt can be in the evening with somebody else. But never with the person that is sitting," she explained when asked her method of socializing with those she painted.[67] D'Annunzio's arrogance prevented him from seizing the one chance he might have had to conquer her—to let her do his portrait, as she kept imploring him. Her sexual code apparently required "having" her subject by painting him or her first, in the process assuring herself that she was in control—a compulsion throughout her life.

A perfect understanding of this sort apparently existed between Tamara and her patron, Guido Sommi Picenardi, the bisexual nobleman with whom she had an affair. Her carefully edited account to Kizette of the immediate aftermath of her departure from Il Vittoriale in January includes an interesting ellipsis in the dictation her daughter wrote down: "[After traveling back to Milan], I met and fell . . . but that's another story." Tamara then explains that she went to a party, danced all night, and returned to the Hotel Excelsior in the early hours of the morning when everyone else was just getting up. She apparently started to say "fell in love" as she narrated for her daughter, and it is likely that she "met" yet again the—to her—gloriously

handsome Marquis Guido Sommi Picenardi: "When I had to leave [after finishing a portrait of him], he came to me and he said: 'In three days, you will come to Turin. And I will wait for you.' And I came to Turin. And waited for him. And he came. The first day we went to the opera. The second day we went to bed. We were three days in bed that first time."[68] Explaining who Picenardi was to her interviewers in 1979, she said, "He was one of the most handsome men I've ever seen "[69] Scholar Giovanbattista Brambilla expands: "Guido Sommi Picenardi lived a fast-paced life. He was important enough locally that in World War II the Nazis arrested and tortured him, after which they commandeered his villa. As a result, the sensitive musician had a nervous breakdown, though he first assisted the Italian 'partigiani,' probably in the mountains over Val Dosola, by passing on secrets he obtained through well-placed government sources. A few years later, Guido died of a stroke." His wife, Manana, "a sculptress of exceptional talent, who had however never shown her works . . . after her death was cast to the depths of the lagoon at Venice." She had died quite poor, and her daughter, who hated Manana, had refused to help with the woman's debts.[70] Brambilla also remarks that some people who knew Picenardi find the idea of a sexual liaison with Lempicka "impossible," presumably because of his famous homosexuality and her reputation for sexual excess.

Brambilla's research on the period suggests that Lempicka possibly used Picenardi as her cover; the Venetian count Marcello di Vettor may have been her ardent lover instead.[71] Considering the significance that Guido Sommi Picenardi accorded his occult powers as a medium—he wore the huge stone ring evident in Lempicka's portrait for its mystical powers—the resolutely antispiritualist Tamara may have found him vaguely silly rather than a serious prospect for a love affair. On the other hand, sometime around 1926, Guido tired of the Egyptian antiquities stashed in his father's Cremona castle, Torre de' Picenardi, and destroyed the collection, dismissing his resident medium from Zurich at the same time. Mananà, however, "continued this kind of divertissement for years."[72]

Kizette recalls her mother speaking more intensely and romantically of her Italian lover than of anyone else. Ironically, Tadeusz misunderstood the real competition for his wife's attention; it was not D'Annunzio, regardless of what his telegram had led the frustrated husband to believe. Tamara was too distracted to notice the toxic effect that Italy had had on her marriage: Tadeusz finally rebelled at her liaisons with other men and began to court his own revenge. This latest outrage with a debauched poet convinced him that his marriage was corrupt at its core.[73]

# Chapter 6
~

# EXACTING SUCCESS

*Tamara's misalliance with D'Annunzio* capped a family disintegration long under way. Her eleven-year marriage had been close to collapse since the 1925 Castelbarco show, at least. "After that exhibition, Mother changed," Kizette Foxhall recalls. "She thought that being an artist excused anything she did."[1] If Tadeusz had been the one to bruise and slap his spouse upon their arrival in Paris, Tamara now gave as good as she had received. Sixty-five years later, Kizette vividly recollected such an incident: "One night when my father complained about Chérie's nightlife, she became so angry that she ran into the kitchen and picked up a knife and started chasing my father around the house. I'll never forget the sight of him in his pajamas, running down the stairs, out the accordion door, with Chérie still trying to stab him. Only because the accordion elevator door was open did he escape, I think."

Tadeusz retaliated by openly denouncing his wife's neglect of him and, more important, of Kizette: "You care most about your painting, Tamara, and then about whom you impress, and only with whatever is left over do you love us at all. You ignore your own daughter." Tamara fought back, as she insisted, truthfully if melodramatically, "I do love Kizette with my heart and soul, but the soul of the artist has many needs."[2] In reality, Tamara was trying very hard to mesh artist and mother into one finely nuanced

role, especially difficult since there were few other painters in similar circumstances. As one historian notes: "Virtually all the women writers and artists in Paris had neither husbands nor children. . . . Some of the women who found themselves pregnant, such as Janet Flanner and Djuna Barnes, had miscarriages or abortions or, in the case of Romaine Brooks, gave the child up for adoption. The few with children—H.D. and Colette each had a daughter—were not regularly based in Paris and had other people to care for the children."[3]

It is nonetheless true that Tamara bore the major responsibility for the couple's unhappiness. In spite of her defensive claims that Tadeusz also took lovers, even she stopped short of equating their respective infidelities when in later years she discussed the demise of their marriage. It is entirely possible, in fact, that Tadeusz had been faithful to his wife. Those who recall him from this period, such as his Warsaw friend Andrew Kozlowski, insist that he was "a perfect gentleman and a business lawyer of quality. . . . Maybe he was a playboy (a very English expression) when he was very young [in Russia]—but not later in life."[4] Tadeusz's exemplary manners failed him, however, when it came to forgiving Tamara her cruelty to him: throughout his life (and in spite of Kizette's efforts to quiet him) he would complain to his daughter about her mother's "absurd sense of superiority and self-regard."[5] At the time that their marriage foundered, Kizette's loyalties were conflicted: she adored her mother, but Tamara demanded perfection from her, while Tadeusz rarely complained about anything she did.

Tamara's careless treatment of her family rebounded when Tadeusz decided, soon after the D'Annunzio episode, that he had been exploited long enough. Several months after his wife returned from her early 1927 trip to Il Vittoriale, Tadeusz told her that he was having an affair with Irene Spiess, the daughter of Ludwig Spiess, the extremely rich owner of Poland's largest pharmaceutical company. Upon leaving his dentist's office one day in Warsaw, he explained simply, the two had met on the stairwell: it was love at first sight.[6] Although the matronly Irene Spiess, with her pleasant face and stocky legs, was not the physical type he ordinarily found attractive, she possessed considerable charm and style, a tremendous fortune, and a romantic, spontaneous side that must have reminded him of his early romance with Tamara.

Irene came from an illustrious Polish family. In 1823, Henryk Bogumil Spiess, the son of Mechior Spiess, living in the then German city of Szczecin, had moved to Warsaw to open a small factory that produced mostly vinegar. Quickly successful, he then opened a pharmacy on Kozia Street, near Krakowskie Przedmiescie. By midcentury, when his son Ludwig-Henryk began helping in the family business, the saga of the Spiess industrialists had

begun. Tarachomin grew into a huge factory, and Ludwig became a well-known pharmacist, businessman, and exporter. His son Stefan married Jadwiga Simmler, daughter of the famous artist Jozef Simmler, a history and portrait painter considered a Polish precursor of the Impressionists.

Though Stefan died in 1893, Jadwiga lived until 1944, "revered and loved by her relatives and friends." Jadwiga Spiess served as a model for her father's paintings, but perhaps even more significant, she made her apartments at Chmielna, and then later at Foksal 8, famous as a "gathering place of the crème de la crème of Polish society and Polish artists."[7] She hosted musical soirees at her home that included the leading musicians of the day —Arthur Rubenstein, the Szymanowskis, and the de Reszkes.[8] Jadwiga moved to Czackiego Street during World War II, a period during which she was called Prababcia (great-grandmother) by her entire family, and she died soon after the Warsaw Uprising.[9]

Jadwiga and Stefan had a daughter, also named Jadwiga, and two sons: Ludwig, who became the Polish pharmaceutical king, and Stefan, considered one of the most cultured intellectuals in Poland. Charming and gracious, Stefan appears throughout Arthur Rubenstein's memoirs and in biographies of the pianist as a man who brought together important musical talents at culturally ripe moments.[10] Stefan Spiess's own memoirs were published in Krácow in 1963 as Ze wspomnien meloman (From the Memoirs of a Music Lover). Ludwig, after making the equivalent of millions of dollars from the Spiess pharmaceutical company, invested the money in Swiss bank accounts to safeguard his fortune from foreign intervention. Just before the German invasion of Poland, he patriotically if foolishly withdrew the entire amount in order to support the Polish economy in the face of war. The Germans seized his fortune, and Ludwig died several years later, a near pauper, in Krácow.[11]

Ludwig Spiess's only daughter, Irene, married Leon Malinowski, who soon after their marriage lost Motowidlowka, his enormous estate in the Ukraine near Zytomierz, to maurading Russian soldiers, whom he immediately pursued on horseback. While he was engrossed in retrieving his lands, Irene ran off with his best friend, with whom she lived for the next five years. Leon had the marriage annulled, and their daughter, Lulu (Leonia Malinowska), went to live with her mother. Soon after Irene's lover left her for another woman, she met Tadeusz.

In order to minimize her own role in creating the marital estrangement, Tamara emphasized the culpability of the seductive other woman: "My young husband, very good looking, very good looking, went to a doctor. And when he came out from the doctor, he opened the door and there was a

woman. She saw the very good looking young man, and she said, 'I don't know who you are, but I love you.' And every man is sensitive. So she was not good looking, she was older, but he likes to hear that he is loved. She said, 'I don't care if you are married or not.' He said, 'But, madam, I have a wife and the child.' And she said, 'Then I don't care about your wife and your child. I want to marry you.' And she did marry him."[12]

Throughout 1927, Tadeusz spent most of his time in Poland with Irene. During this period the Lempiccy were still married, and as before, whenever husband and wife were together, fights erupted. Tamara made three trips to Poland to try to win Tadeusz back, and after coming home without him after the second attempt, she decided to take Kizette with her as added inducement.

Kizette felt pressured on several levels. Tamara, clearly devastated by Tadeusz's abandonment, had begun keeping her daughter home from school as company. To the girl's alarm, her mother also curtailed her own social life, a sure sign that something was seriously wrong. Kizette realized that Tamara was counting on her to win Tadeusz back, and the child's relief at the respite from loud quarrels was offset by her mother's sadness, outrage, and frightening new dependency. When Tamara showed up in Warsaw with their daughter in tow, Tadeusz was trapped: he loved Kizette, who missed him and earnestly begged him to come home. The couple agreed on a reconciliation attempt, to be held at a resort on Lake Como.[13] Several years earlier when Malvina, Kizette, and Tamara had vacationed at the same resort, Tamara had gotten her nails painted red for the first time in the local branch of Carita, the prestigious beauty spa. Kizette, who had hated the nail polish because she thought it looked like blood, now felt nervous again at the inauspicious association as the troubled threesome assembled for the reconciliation, Tadeusz arriving separately from Poland.[14]

Tamara herself, though shocked at the apparent seriousness of her husband's affair, could not believe that Tadeusz would divorce her. She thought that she simply needed to remind him of the glories of their little family to win him back. Instead, the vacation resort became the site of the most vicious fight the child ever witnessed between her parents. Every suspicion that Tadeusz had kept private—whether to sustain his ego and or to maintain the facade of a family life—he now shouted at Tamara, loud enough for the management to come to the couple's room and threaten to expel them. To her furious husband's denunciations, the enraged wife bellowed back, "Who do you think you're talking to? I'm an artist! You're a nobody who's too dumb even to have an affair with a pretty girl instead of the first mouse who runs across your path."[15]

Suddenly Kizette was privy to accusations flung back and forth between her parents about the inappropriate intimacy of several family friends with either husband or wife, depending upon whose turn it was to scream. Tadeusz decided he'd had enough, and he departed for Poland, "this time to marry Irene," while Tamara turned her rage and disappointment on her daughter. She accused Kizette of being on her father's side instead of trying to help her. Then, to Kizette's shock and confusion, her mother crumpled on the floor in front of her and wept, "Oh, God, how I love him."[16]

*Tadeusz and Kizette on a dock at Lake Como, c. 1927 or 1928, during one of the reconciliation attempts, which resulted in worse fighting than ever.*

Tadeusz's decisive rejection devastated and scarred Tamara; as a result, in the future she would compartmentalize sex and love. Her initial attraction to Tadeusz had been based on his handsome face and body, on his masculinity, on his strong sense of self, and, somewhat paradoxically, on his numerous mistresses and female friends. None of these qualities had actually disappeared over the course of their marriage, and now, in the wake of her loss, Lempicka appreciated them anew.

Predictably, she turned to the easel to exorcise her sorrow. She began a portrait of her estranged husband—*Portrait d'Homme Inachevé*, as she entitled it—but she abandoned it the following year, when, in 1928, Tadeusz announced that he planned to move permanently to Poland. Though published in at least eleven different sources, the painting has been exhibited only twice outside the Museum of Modern Art in Paris, which chose it as their gift from Tamara's offer of her portfolio in the mid-1970s. Lempicki's oil portrait (Plate 5) is a sharp contrast of black, white, and gray, in homage to Lhote's lessons about the power of neutrals. The palette suggests the domestic drama being played out in life as well as on canvas, with Tadeusz's unfinished left hand, bereft of a wedding ring, in the foreground. The sheen at various points—top left shoulder, fingers of the right hand—comes from an oblique shaft of light.

Though Tamara was notorious for renaming her paintings at will, her most frequent title for this portrait—*Unfinished Man*—refers both to the left hand of the portrait and to the husband who ran out on his marriage contract. Handsome, brooding, larger than life, Tadeusz comes across on the canvas as a Jazz Age Heathcliff. Half leaning against a background of silver skyscrapers and plain steel columns, he seems poised to move on, as soon as this sitting is finished. Dressed in a long double-breasted black coat, he wears a shimmering white silk scarf draped around his neck, his unsmiling face appearing almost to be perched on top of the cloth—on close examination hinting at a symbolic decapitation. Under his right arm is a wrinkled paper, at first glance easily mistaken for a triangular open space. He holds his top hat in his unfinished left hand, underpainted with white.

The work Tamara produced between 1927 and 1929 is among her finest in the period between the two wars. Kizette comments: "Chérie's pattern was either to work almost frantically whenever she was depressed, or to go to bed and stay there for months. She was very unhappy about my father's leaving, but she quickly started going out again. She stayed out late and came home with so much energy, she would paint for twelve hours nonstop. Then she'd take her old favorite medicine, valerian, so she could get some sleep."[17]

Even in early 1927, during the rawest stage of her estrangement from

Tadeusz, Tamara had been fortified by the reviews of salon shows that con-
tinued to praise her work, which, it was implied, escaped easy categoriza-
tion. In January the *Pologne* had pompously intoned: "By now we know the
good style of Lempicka. . . . Her clothing as well as the background of sharp
lines . . . is produced in plain tones, without nuances of colors. . . . We don't
see any objection as long as her model's pose is carefully, intelligently cho-
sen to contribute to a balanced harmony of the composition."

On 1 February the same newspaper fretted: "Tamara de Lempicka, a Pol-
ish artist, what does her choice of style mean? Is she aping French painters?
No, she simply is showing an excess of exoticism." Something caused the
publication to recant, since almost two weeks later, on 13 February, the
reviewer offered, more hopefully, "Life's not so bad, and numerous talented
artists show us that; let's give thanks in honor of Matisse, and Lempitsky
[*sic*], for example, whose work gives us a taste of the charm of nature, play-
fulness of color and light, and perfect curve of the human animal." An Ital-
ian notice appreciated Tamara's classical yet innovative painting: "Works
come from all over the world, but not with as much novelty as [those of]
Tamara de Lempicka, Polish artist. The *Fille en Rose* is perfect, flawless, with
impeccable purity."[18]

Sometime after the Castelbarco show, Lempicka had also come to the
attention of *Vanity Fair*, the glamorous Condé Nast magazine that aimed at
the monied sophisticates of the Roaring Twenties. Not only had Paris
"acclaimed the art of Madame de Lempitzka," but her show in Milan proved
a "momentous event" in the Italian art world, according to the February 1927
issue: she was called Tamara de Lempitzka, the Parisianized Polonaise. Lem-
picka's stature as a serious artist was automatically enhanced by the weighty
material published in the same issue: Clarence Darrow wrote about the for-
eign debt, Aldous Huxley revealed the "truth about the universities," and
Heywood Broun, Corey Ford, Sherwood Anderson, and Theodore Dreiser
contributed pieces as well.

*Vanity Fair* extended its praise to her personal style in an article akin to
the celebrity profiles that began to appear much later in the magazine. In
addition to canvases from two seasons of art exhibitions and gallery shows,
her "exquisitely novel apartment in the Rue Guy de Maupassant—designed
and executed by herself"—was touted as "the talk of the city by the Seine."
In spite of its society-column tone, "Recent Paintings by Tamara de Lem-
pitzka" was listed in the table of contents under the magazine's regular cat-
egory "The World of Art." *Irene and Her Sister* and *The Duchess de la Salle*
were commended for their neoclassical references, but the suggestion

already existed that Lempicka stood apart from the mainstream of the art world. The reviewer treated Lempicka seriously but lacked a coherent context within which to interpret her work in any depth. The extraordinary *Irene*, whose compellingly clear gray dress centers the painting, was cited as an example of "Madame de Lempitzka's talent for portraiture conceived primarily as a decorative arrangement." Vigorous contour, emphatic plastic form—"seen not realistically but stylistically with such artists"—and color as a secondary consideration are the further qualities attributed to the Parisian painter.

More significant publicity appeared the following year in *Die Dame*, Germany's leading monthly fashion magazine. The glossy publication, aimed at a fantasy new woman who worked outside the home and also possessed a personal fortune, commissioned Lempicka to paint a cover for their August 1928 issue. *En Plein Été* was the result, a modest, light summer scene that was to be the first of many illustrations used by the magazine. Producing covers for *Die Dame* must have reminded Tamara of the book jackets that had filled the windows of stores lining Nevsky Prospect.[19] Beautifully designed and colored by the artists of Mir Iskusstva, including Alexander Benois, Mstislav Dobuzhinsky, and Sergei Chekhonin, the comfortable marriage of commercial product and high art had set a precedent for St. Petersburg's younger artists. With her work for *Die Dame*, Tamara joined the ranks of famous artists such as Hannah Höch, who in spite of their individualist, even political, agendas, accepted high-paying commercial assignments. Placing their work in the large-circulation magazines brought them mass recognition as well as solid income.

In later years Lempicka frequently repeated an anecdote about *Die Dame*'s editor accidentally meeting her in Monte Carlo in the early thirties (sometimes she claimed it was the early or mid-twenties), and commissioning her to paint her self-portrait for the magazine's cover. According to Tamara's most consistent account, the editor initially didn't recognize her. Impressed by the stylish, anonymous woman whose yellow outfit matched perfectly the little yellow Renault she drove, *Die Dame*'s editor left her calling card on Tamara's windshield. When the artist called and revealed her identity, the delighted editor persuaded her to do a self-portrait in her automobile for the magazine. Although Tamara cited this serendipitous encounter as the origin of her commissions from *Die Dame*, in fact the meeting between editor and painter occurred several years after she began contributing covers to the magazine.[20]

In the 1920s the fashion in such magazines as *Die Dame* frequently took

its inspiration from high art; Elsa Schiaparelli, for instance, adapted Dali's lobster portraits for one of her very expensive dresses. Tamara's magazine covers undoubtedly influenced couture as well, an art form she had respected for many years. Early on, she had painted several small-scale watercolors of fashion design—studies for the clothes, hats, and gloves she rendered so adroitly in portraits of her wealthy patrons. To the question asked by an interviewer in her later years, "Were you associated with fashion designers or were you very much interested in fashion?" Tamara answered: "I did the fashion. . . . And the [dress] designers copied my fashion. Because it was simple."[21]

Some painters sought to make fashion design into a high art. Sonia Delaunay, for example, had presented her Ballets Russes– and Malevich-inspired coats and dresses in the 1925 Art Deco exhibition. She and the couturier Jacques Heim sold their patchwork, or simultanist, designs at her own boutique until 1925. Delaunay's textiles also covered the seats in the Citroën 5CV, becoming in the process "the equivalent of the Jazz Age for fabrics."[22] And in 1926, Marie Laurençin had designed the sets and costumes for Diaghilev's ballet *Les Biches*.[23] But unlike Tamara, such artists carefully maintained their ties to the avant-garde even as they accommodated the new urban mass culture. The Futurist artist Fortunato Depero might well launch his line of embroidered vests with a fashion show on top of the Eiffel Tower, but he also thought to make Marinetti one of the models.[24]

Tamara, however, cared little about the impact of her commercial popularity upon the cognoscenti. "I knew I painted beautifully, as good as anyone. And the other artists [Delaunay, Laurençin] were my friends," she told her friends and family defensively when the issue arose in later years. "Why was working for the magazines any different?"[25]

Because of the increasing buying power of women, fashion magazines were gaining in respect yearly, and well-known artists and writers clamored to contribute often minor efforts for major financial rewards. By carefully controlling the image of the modern woman, these magazines defined for their readers how to look and what to emulate. Perhaps since this image, most often of an androgynous or boyish woman, had little in common with Tamara's voluptuous female body ideal, her own contributions to *Die Dame* are among her least interesting paintings. Their vapid generic appeal (she obscured the bodies or slimmed them down when exposing them) contradicted her intuitive artistic impulses. *Saint-Moritz* shimmers with her trademark brilliant color, but the vacant expression on the skier's face contrasts with the subtle emotions Tamara's faces usually convey. Similarly, *En Plein Été* almost parodies what the painter did so well elsewhere: the softly

rounded face lacks expression, and the hat and flowers are clichés. Only the hint that summer is already past its peak saves the painting from banality.

Yet at the same time that she began painting for *Die Dame*, Lempicka found her inspiration for what many critics consider a masterpiece of the twentieth century, *La Belle Rafaela*. By now she had executed at least six important nudes, and increasingly the canvases implied an erotic contract between viewer and painting. *The Model*'s aggressive posture, suggesting a nude model about to walk into the audience, developed this relationship; and the lascivious expressions of the women foregrounded in the homo-erotic *Myrtle* sought to seduce the viewers into the scene.

To gain ideas for her nudes, Tamara took her exercise in the Bois de Boulogne, where she observed the bodies of those around her. Occasionally she sat at the outdoor café and sketched the head or hands of someone nearby. One day, lost in thought as she walked, Tamara looked up and noticed those ahead of her turning around to stare at a figure moving in her direction. Curious about the celebrity creating the disturbance, she quick-ened her step. As a young woman approached, Tamara immediately under-stood the crowd's reaction: she was stunning.

Quickly composing herself, Tamara reversed directions and caught up with the woman, whose name, she was told, was Rafaela. As she had hoped, she found that Rafaela had the bearing of a worldly woman in spite of her young age. Her slightly déclassé hat and shoes convinced the artist that she could offer employment without fear of giving offense. "I am a painter," she explained, "and I would very much like to use you for my nude model. Would you be interested in coming to my studio and working for me?" Rafaela agreed to come for her first session the following morning.

At 10:00 A.M. the girl knocked on the door, still dressed in her clothes from the day before. She was asked to disrobe in another room and to slip on the short gown Tamara provided. Instead, she came back into the studio draped in a wisp of chiffon that showed her Botticelli curves to perfection. Rafaela and Tamara settled into a routine that lasted the entire year that the girl worked as her model. Each hour Tamara allowed her a fifteen-minute break, during which time the two women chatted about the girl's life; the elliptical story fragments that Tamara later retold imply that she was a prostitute.

The young woman sat for at least three important nudes, but *La Belle Rafaela* (see jacket) eclipses the others. Boldly filling the entire pictorial space, this oil painting depends upon red, black, and white for its palette. The reclining nude lies on a gray slab lounge, reminiscent of a mattress or chaise, but whose hard triangular presence in the upper right corner suggests

a concrete laboratory table as well. She is bare except for a vestige of a scar-
let cloth draped over a sliver of her right breast and calf. Left arm raised in
a triangle above her head, Rafaela dangles her right hand upon her left
breast, grazing the skin with her two middle fingers. Eyes closed, full red lips
slightly parted, she seems to create her own world.

Unlike many erotic paintings that invite the viewer to be part of a fan-
tasy, this work seduces its audience precisely through the subject's narcis-
sism. Rafaela's self-absorption is easily forgiven, in light of the lustrous gleam
of her skin, the ripe body whose curves echo each other, the extension of
form, which suggests a cat stretching. Even the audacious fleshy fold of her
underarm echoes formally the full upper lip almost touching it, as if the
woman is smelling her own body.[26]

Such earthiness is yet another echo from the Italian past that inspired
Tamara's art. Willem de Kooning, in discussing the roots of Modernism,
explained that "When I think of painting today, I find myself always think-
ing of that part which is connected with the Renaissance. It is the vulgarity
and fleshy part of it which seems to make it particularly Western."[27] Such
traces of the "particularly Western" inform *La Belle Rafaela*, but there is also
something else that exceeds the reach of such a vocabulary. An image of a
sexually avaricious woman, sure of what she wants—her own sexual satis-
faction—the nude woman appears unnatural, beyond vulgarity, because she
is so artfully constructed. At the same time, the specimen won't stay pinned
to its laboratory support; in the end, Rafaela appears self-constructed and
preternaturally free. If, as Rita Felski suggests, in Modernism "feminine arti-
fice is predicated upon . . . dissociation from the 'natural' body of woman,"
Tamara stunningly manages to have it both ways in *La Belle Rafaela*: she
overwhelms us into submitting to Rafaela's "real" beauty, while she creates a
wall between viewer and subject and, implicitly, between viewer and painter,
that reminds us insistently of the artist's deliberate mastery.[28] This uncanny
ability to hold in abeyance the very desire she creates is the source of uneasi-
ness many critics have felt in the presence of her paintings.

*La Belle Rafaela* is arguably the highest achievement of the painter's
career. She exhibited the painting at the Salon d'Automne, where it received
immediate though not extensive attention. Over fifty years later, in the
1970s, the London *Sunday Times* would call it "one of the most important
nudes of the twentieth century."[29] Flouting the Romantic convention that
held genius and originality to be, by nature, male, this painting demolished
the correspondent principle that the talented female possessed "taste," the
domain of the familiar.[30]

*La Belle Rafaela* achieves its place in art history as a result of a technical genius that reproduces, faithfully, the presence of sexual desire. In twentieth-century art lexicons, technique inevitably is linked to representation or, more often, to realism. Critics frequently and approvingly judge the Modernist era to be "technique-poor." In foregrounding the painterly gesture itself, rather than hiding its presence through illusion, modern art is thereby thought to achieve an admirable honesty. When "great technique" is invoked approvingly in Modernist criticism, it refers to the ability to feign the real (before Modernism)—the correlation between a Chardin and the sense of the homely in real life, or the correspondence between a Frederick Edwin Church landscape or a Thomas Eakins medical scene and the realities they depict.[31]

But technical virtuosity is a major component of the genius of artists such as Tamara de Lempicka, whose extraordinary handling of the brush is used to heighten reality. Difficult to categorize, her work is condemned by the very phrases that might have been used to praise it in a different age: glamour, attention to color, tight formal composition, classical mastery of the invisible brushstroke.[32]

Tamara produced paintings with an even higher finish than those typical of the School of Paris figurative works. Interestingly, underneath the polish lay a careless preparation of the canvas. Like many artists, she usually primed the canvas with gesso, a material created by mixing a glue or a similar binder with an inert white pigment such as chalk or plaster of Paris; the preparation created an ivory smooth surface. Tamara's dependence upon gesso attests to her preference for careful composition and a clear, hard finish. But using gesso as a primer is a time-consuming chore, and poorly prepared gesso often leads to rapid paint crackle. Tamara's occasional carelessness in preparing her canvases has resulted in premature aging of several paintings, including the important portrait of nightclub owner Suzy Solidar. Her impatience with preparing the foundation may well reflect her deep distrust of stability, the restless and itinerant movements that would mark her entire life. The dramatic historical displacements due to the Bolshevik Revolution, World War I, World War II—all this showed up on her canvases, whose foundations indicate an uncertainty that they faced a future.

Before putting oil on canvas, figure painters typically prepare a sketch from which to work. First they rub the back of the cartoon with chalk, then attach the paper to the support (canvas, wood, or cardboard) onto which they transfer the chalk by drawing over the main lines with a stylus. Tamara more often depended upon pricking—technically, "pouncing" the cartoon

onto the gesso. After poking holes in the contour lines of the drawing, she would pin the sketch onto the support, and then pounce the areas with charcoal in order to transfer the image onto the gesso. The many pinpricked sketches owned by her family attest to her frequent use of this Renaissance method.[33]

Her draftsmanship was in fact very fine, although this talent is underestimated in most accounts of her work. Among her sketches are four or five designs for a proscenium stage. Set and costume designs were a typical exercise of artists in the 1920s, even when there was no contract to execute. Many artists found the actual commissions highly remunerative, as in 1924, when Picasso, Cocteau, Chanel, and Henri Laurens collaborated on the Ballets Russes production of *Le Train Bleu*. In 1926, André Lhote joined Albert Gleizes and Sonia Delaunay to design scenery and costumes for *Le P'tit Parigot*, a performance collage of stage, film, and Cubist art. That Tamara never participated in such projects is, in fact, surprising, especially since she moved in circles that should have allowed her ample opportunities.[34] But her almost strident individualism might have caused her to demur if she'd been approached to collaborate on a performance; or it might have alienated those in a position to hire her.

There is no doubt that she intended to be counted among the artistic elite. Adopting the habit of many famous painters, she began frequently "forgetting" to sign her works, leaving a space for her signature, which she failed to insert. She carefully constructed the blank, patterning it on the old master model of a ribboned boundary meant to become part of the pictoral effect. In later years she would actually paint a pink ribbon around the signature box, but in the 1920s she most often simply left an unpainted space. Like other famous painters, she was implying that the works should speak for themselves. And like them, she did allow others to sign for her at times, most frequently Ira Perrot and Adrienne, and later, Kizette.[35]

Occasionally her failure to sign pieces indicated that the work was meant to stay in the family and not go on the market, as with *The Carrots* (Plate 11) and *Books and Chair* (Plate 12). These still lifes demonstrate the domestic interest her granddaughters would later recall, an attention to interiors that Tamara rendered brilliantly in her art. Most important, the serene stillness of the highly personal *Books*—the classically illustrated book propped up on the humble chair, the paints, the palette—also proclaims Tamara's sure sense of her calling as an artist.

*Carrots* reveals instead her outrageous sense of humor—"so ribald she would make you blush," in Mala Rubenstein Silson's words—mentioned often by her friends but rarely present in her art.[36] The bunch of brilliant

orange carrots crowned by bushy green foliage could scarcely be more phallic: sometimes a cigar is not just a cigar. The stiff tips of the upper, horizontally placed carrots protrude, forward, with stringy shoots rocketing straight out of them. The bottom carrots, seemingly spent, fall over the basket, limp, touching the blue table below. Until the late 1990s, this piece remained a private family piece, though its brilliant technical achievement makes it a still life worthy of public attention.[37]

In dramatic contrast to such intimate works, Tamara's public commissions in 1927 included a portrait of Grand Duke Gabriel Constantinovich, cousin to the czar. The duke, who with Tamara's friend Prince Felix Yusupov had murdered Rasputin, refused to get a job, instead living off his mistress's earnings. Tamara borrowed a uniform for him to wear when modeling, and the poignancy of his reduced position shows in the agonized man she depicted on canvas. Although her pencil sketch creates a full-length figure, the finished portrait presents the duke half-length, with his impressively broad shoulders spanning the width of the canvas. The scarlet and gold dress uniform bespeaking authority consumes three-quarters of the canvas, yet the slightly defeated face of the duke himself, all angles that converge in his world-weary eyes and noble mouth and nose, makes equal claims upon the viewer's attention.

Such an ability to portray conflicting themes and emotions produced the prize-winning *Kizette on the Balcony* that same year. The eleven-year-old appears sulky and obedient at the same time, eager to join the new world implied by the background's geometrical buildings. Clad in a short plain gray-green dress, Mary Jane shoes, and white knee socks, she sits compliantly on a stool, while her left hand grasps the balcony rail and her right foot is twisted toward the modern city below her.

The portrait won first place for Tamara in the 1927 Exposition Internationale des Beaux-Arts in Bordeaux, home of André Lhote. The prize motivated her to use her daughter as model more often the following years, and Kizette was happy to oblige, since modeling had become the only way she could be guaranteed time with her mother. Nevertheless, "I was treated just like her other models, her traditional way," Kizette remembers. "I sat for forty-five minutes at a time; then I was given a fifteen-minute break. My mother was very pleasant and professional with me, as she was with all her models."[38]

And as she did with her other models, Tamara frequently portrayed Kizette with erotic overtones. Yet because this was her daughter, the paintings hint at, rather than exploit, the girl's nascent sexuality. A precursor for Tamara's paintings of Kizette was the mid-eighteenth-century French

painter Jean-Baptiste Greuze. Like Tamara, Greuze made full use of public exhibitions and became well known through them; like Tamara, he was deeply influenced by the Italian colorists, especially Caravaggio; like Tamara, he had an "abnormal vanity"; and finally, like Tamara, he would fall from favor for the last two decades of his life and be described as "formerly an artist of very great reputation."[39]

Noted most often for his genre paintings, which alluded to Poussin even as they anticipated David, Greuze was an insightful and unsettling portraitist. His pictures of young girls evinced a sensibility and even compositional form that Tamara's early works echo. Greuze's *La Cruche Cassée* and *La Vertu Chancelante* hint at the same decadence playing beneath Tamara's expression of sensuality in *Kizette on the Balcony* and in *First Communion*, where she conveys a hidden sexual charge in the young model's too knowing eyes and her slightly provocative body arrangement. Greuze's *Un Écolier Qui Étudie Sa Leçon* provides an image for the hands Tamara would execute many times. Though the question of influence is as notoriously complicated for Tamara as for most artists, it seems probable that she self-consciously invoked Greuze as inspiration for her paintings of adolescents.

When Tamara painted young girls other than Kizette, she was careful always to include within the portrait a reference to their family, even as she represented the subject's individual nature. With Arlette Boucard, for instance—whom she met through the girl's father, the rich scientist who had discovered the medicine Lacteol—she reproduced a look of detached clinical coldness in the adolescent's clear blue eyes, whose level gaze suggests the loss of innocence. Appearing on the ship's prow in the background is the name "Lacteol." And in her portrait of the lesbian Duchess de la Salle's daughter, Romana de la Salle, in spite of the pink chiffon dress, Tamara deliberately replicates the stern, masculine gaze and body that she ascribed in an earlier portrait to the duchess. By the end of 1927 Tamara's patrons had begun to depend on the painter's psychological acuity to determine how they and their loved ones should be represented.

Her preoccupation with others' psyches allowed her a respite from examining her own. The exact dates are unclear, but by 1928, Tadeusz had convinced Tamara that he would never return to her. Although she had no lack of handsome young lovers, she needed reassurance that she had someone in the wings capable of taking care of her financially and socially, in spite of her own abilities in both arenas. Based on her later accounts, she may have become involved romantically with Baron Raoul Kuffner de Dioszegh during this year. The major problems with reconstructing Tamara's relationship

with Kuffner stem from her loose use of the phrase "while I was getting my divorce." From the evidence of Tadeusz's marriage certificate to Irene Spiess, the messy breakup may not have legally concluded until 1931, though the official process had begun as early as 1928.

Kuffner, a connoisseur of art whose personal collection of old masters included first-rate Dürers and seventeenth-century landscapes, had begun acquiring Tamara's work as soon as he saw it.[40] Slightly stocky, balding, and with protuberant ears and nose, he was respected by all who knew him. The professional respect the baron maintained for Tamara was lifelong, and it played a major role in her acceptance of a man who was not physically attractive to her. If there is a hero in Tamara's life story, it is the dignified, self-possessed Raoul Kuffner.

Born in Döbling, Germany, in 1884, Baron Raoul Kuffner had owned Dioszegh, the largest private estate in the Austro-Hungarian Empire, until the Balkanization of World War I dispersed his property. His father had grown rich by raising cattle and canning beef, which was served at countless tables including the imperial one; and the emperor had bestowed a barony on him as a reward. As a young boy, Raoul Kuffner was trained to help run Dioszegh, where he learned early that democratic principles ultimately produced the greatest financial yield. His father, ahead of his time, paid his workers well, urged them to be creative in their farming, and established ways to use fully the land's resources. Raoul, an eager student, expanded his father's lessons into an enterprise that included beet farming, which produced not only sugar to sell but also waste material for use as cattle fodder. In later years, with the assistance of two economics professors from New York University, Kuffner would write *Planomania*, a book about the family estate that presented his philosophy of humane agricultural management.[41]

In his personal life, Kuffner was calm and unassuming, except that, as his stepgranddaughter recalled, "he wanted the best of every commodity on the market—not a lot of things, just one, the best, of everything."[42] He had followed the aristocratic custom of marrying for companionship and procreation, seeking sexual fulfillment elsewhere, apparently with the consent of his wife, Sara Sarola, whom he married in 1910. The couple had two children, Peter, born 1914, and Louisanne, born 1919.

Kizette insists that Tamara socialized during the late 1920s with Kuffner and possibly his wife, whom the painter was always careful to refer to as a friend. In 1928, Kuffner commissioned Tamara to paint his then mistress, Nana de Herrara, a famous Andalusian dancer. The artist also executed a beautifully detailed domestic pen and ink drawing of the baron reading and

*Raoul Kuffner's family estate, Dioszegh.*

smoking a cigarette. The intimacy of this sketch, as well as the way Tamara later recounted the experience of painting his mistress, suggest that she already had designs on him.

Tamara's goal in painting Nana de Herrara apparently involved making Kuffner aware of his mistress's weaknesses:

> I told [Kuffner] that I had heard of his friend and that she must be very beautiful, if she was a dancer. He said, "I will call and tell her to come to see you." I was very surprised. When she came to my studio, she was badly dressed, she was not elegant, she was not chic. I thought, Oh, no, I don't want to paint her. I cannot believe that's the famous Nana de Herrara. Well, I thought, let's try. So, in my studio, I said, "Sit down." She sits down. I don't like it. And I said, "Take this off." So she takes it off. I don't like it. "The hair," I said. "How do you have your hair done?" "Oh," she said, "just with a flower." "So where is the flower?"
>
> Finally I took everything off her until she was nude. Then I added lace here, there. I said, "Cover up a little bit here, here, and here." As long as she was dressed, it was impossible. So ugly. I couldn't believe it. And I thought, "This man has very bad taste." But when she was nude, then she was a little more interesting. Still, as long as she sat there, she was nobody. And I said, "No, no, no." And I was about to give up the portrait, not do it at all, until I

*said, "When you dance, how do you look?" And she did this*
*expression. And I said, "That's all right," and then I painted her.*[43]

Herrara's contorted pose manages to display Tamara's skills while
emphasizing the dancer's lack of charm. Black lacy chiffon and a stylized
white gardenia create the visual beauty of the portrait, while the dancer's
shapeless body and tense, worried face are off-putting. Perhaps Tamara was
expressing female loyalty to Kuffner's wife; linked as she was to a philan-
dering husband herself, she might actually have been a friend to Sara Sarola
Kuffner, as she always claimed to be.

Or perhaps her repeated references to her friendship with Kuffner's first
wife constitute a preemptive strike against charges of adultery. Tamara's
most frequent account of meeting Kuffner begins, "I received a letter from
[the baron in] Hungary, 'Madame, I bought a painting of yours and I saw
your paintings at this and this exposition. I bought this painting which my
wife and I, we love very much.' And then [my secretary] send him three,
four photographs. And Baron Kuffner, he bought every painting which pho-
tograph I send. And started a big collection of my paintings. And then when
he came to Paris, he wanted to meet me. That's how we met. . . . He was, at
that time, married to his wife, and I was divorcing my first husband. And
then he lost his first wife, who was a great friend of mine."[44] Sara Sarola
Kuffner's only daughter, Louisanne, emphatically denies that the two
women knew each other: "I assure you, my mother had never even met
Tamara de Lempicka before she died."[45] In any event, Baron Kuffner con-
tinued to be among her biggest buyers between 1929 and 1933.

The painting of his mistress appeared on the cover of *Die Dame* in April
1929, but the boldly secular style that brought Nana de Herrara to life soon
began to give way to an experimental blend of the sacred and the profane.
In 1929 Tamara's *First Communion*, a portrait of a stagy, spiritual Kizette,
won a bronze prize in a yearly art contest in Poland—in reality not much of
an honor, since hundreds of such awards were routinely handed out.[46]
Tamara remembered this painting fondly in later years: "You see, that's how
she [Kizette] was dressed, and that's how she looked. And it is as big as she
was. That means a huge painting. All my paintings were huge. And it was
exhibited, it received a medal and prizes and write-ups."

Kizette cannot recall her first communion, though Garreau "Manha"
Dombasle, a family friend from the 1940s, claims to have heard that it was
a "large family festivity."[47] Perhaps the most diverting story concerning this
painting comes from Tamara's old age, when she saw Andy Warhol walk into
the Grand Hotel in Monte Carlo where she too was staying during a fête for

Monoco's royal family. Journalist Joanne Harrison reported Tamara's version of events: "'Sit down, Warkhol,' I say. He is a little man with white hair and a gray face. He has a dirty shirt and no expression. He sits. Soon there are two, eight, twenty people around. He says nothing, then he sees the picture from my catalog [First Communion] on the table. He says, 'Who painted this? It is wonderful, marvelous.' He holds it to his heart. 'I must know who has painted this,' he says. He is always very dramatic and exaggerated. 'Me,' I say. It is my table. I must be polite, so I ask all of these people, 'Would you like a drink, some ice cream?' And I order it. Afterward I go to pay. The captain says all has been taken care of. 'But by whom?' I say. 'These people were at my table. There must have been over twenty of them.' 'Twenty-two,' he says. 'Mr. Warkhol paid for everything.'"[48]

Kizette was becoming closer to Tamara during the period when she painted this portrait, since the girl provided a sense of family for her mother; and Kizette reveled in modeling for her glamorous Chérie as a symbol of their special closeness. At some point during 1929, Irene Spiess met with Tamara and Kizette at a Parisian café to discuss where Tadeusz's daughter would live. "It was a very amicable talk," Kizette says, still surprised at the lack of animosity. "It was very odd, nonetheless, to hear oneself discussed as though a sort of exchange item."[49] Although Tadeusz and Irene wanted the girl to live in Warsaw with them and Lulu, Irene's daughter, Tamara insisted that both for educational purposes and to stanch her own maternal loneliness, Kizette should stay in Paris at least for the few years remaining of her primary education; but she assured Irene that she would allow Kizette to visit Poland often.

After a brief depression and a spell of complete inactivity, Tamara sought refuge from her marital calamity through a renewed frenzy of commissions. Determined to be as rich as she was well known, she signed a contract with the millionaire scientist Dr. Pierre Boucard to complete over the next year at least four paintings of his family—and to give Boucard first rights to purchase anything she painted for the following two years. As the faithful purchaser of even the infamous lesbian Myrto at the Salon d'Automne, her patron exercised his option thoroughly before Tamara wearied of its limitations and begged out of it by late 1930.

Since he was able to fund his art collection through his patent on Lacteol, Boucard could pay Tamara extremely well. Though the artist never revealed the details of their arrangement, Kizette believes it was a financial turning point in their lives. And Boucard himself inspired one of her finest paintings of a man. Portrait du Docteur Boucard exemplifies Tamara's talent for tight composition, chromatic brilliance, and elegant realism—a genre of its own in her hands.

Jacques-Henri Lartigue's 1929 photograph of Tamara's bedroom on Rue de Maupassant proves that Tamara first sketched a powerful charcoal of the picture, drawing directly onto the canvas before painting.[50] Employing the same palette she had used for her unfinished portrait of Tadeusz, she reversed the dominant color of her husband's black coat to render the seated scientist in brightly lit white instead. The test tube in his right hand and the gleaming microscope in his other—symbols of his profession—chasten the elegance of his expensive clothes. Lhote's principle of plastic rhyme creates the picture's formal brilliance: an inch of beige liquid in the test tube mimics the tan fingers holding the microscope, while the triangular white spaces of the background echo the upturned lapels and collar of the scientist's coat. The coat's ambiguity—is it a stylish lab coat or a lightweight outdoor garment, with its pearl tie pin peeking out?—comments effectively on the doctor's dual status as scientist and man-about-town. In this painting, professional and social identity bond in silent collusion, offering support to this member of the newly moneyed, postwar Parisian society.

Boucard's commission, and perhaps Kuffner's largesse as well, allowed Tamara to hire the celebrated French architect Roger Mallet-Stevens to design her Modernist showcase of a studio-home at 7 Rue Méchain, within a block of the Observatory. Inside, the three-level apartment combined the clean lines of Le Corbusier with an obvious attention to detail. Mallet-Stevens designed the chrome-and-glass interior structures, and Adrienne Gorska worked on the funishings: the third-floor American bar (Tamara thought the early evening American cocktail party an excellent social invention), the library shelves, and the bedrooms. Replicating a decorative touch she had admired in Aunt Stefa's St. Petersburg home, Tamara had her initials woven into the gray fabric used to upholster the couch: TdL. She ordered a long, narrow dining room table, capable of seating twenty people comfortably, upon which she stationed two clear wavy glass vases of her own design. Determined to show off her favorite flowers, calla lilies, to their best advantage, she persuaded an electrician to devise black metal bases with lightbulbs and hidden wires, which she attached to the bottoms of the vases for illumination. The combination of Mallet-Stevens's fame and rumors of Tamara's meticulous involvement in the project produced a certain awed press reception to the apartment almost immediately, as the artist must have foreseen.

Tamara's decision to create such a showpiece testified to her belief in the importance of design aesthetics. Partly in response to the severe housing shortage in Paris, where many citizens lived in cold-water flats during the 1920s, the 1925 Art Deco exposition had emphasized the aesthetics of domestic space, furthering a trend already set in motion by the upper classes

over the previous two decades. Since *House Beautiful* had been launched in Chicago in 1896, and the first issue of the *Craftsman* had been published by Gustav Stickley in Syracuse in 1901, interior design had been steadily gaining in prestige.[51] Interiors had become the domain of artists during the twenties: Eileen Gray made lacquer furniture for art connoisseur Jacques Doucet even in the mid-teens, and Sophie Täuber-Arp and Jean Arp designed the inside of the Café l'Aubette in Strasbourg during that same decade.[52] In 1928, René Joubert's design practice, called DIM (Decoration Interieure Moderne), gambled that a model bathroom influenced by Cecil B. DeMille's epics would find a market among the affluent. Complete with "sunken bath, gilded mosaic and Aztec patterns," it created a "pleasingly decadent quality rather than making bathing an austere necessity," as it was for those who lived in unheated flats. Less than a year later, Le Corbusier and two associates exhibited at the Salon d'Automne their version of the modern bath, "with smoked glass and chromed steel."[53]

Even more significant than Tamara's commitment to the aesthetics of contemporary interior design, however, was her need to create a professional "room of her own," in Virginia Woolf's resonant phrase. By the early twentieth century, the artist's studio had become "a focus for avant-garde culture [and no studios] were obtained easily by an independent woman artist," as art historian Gill Perry observes.[54] Tamara felt that her sizable investment in this apartment was a wise risk, since it gave her a desirable professional space within which to work. She depended heavily upon the appropriate mise-en-scène in order to paint: one of her most self-revelatory works may well be the photograph—among the most commonly reproduced pictures in catalogs and books even today—that shows the artist in evening gown and jewels, painting in the middle of her carpeted living room (see page xi). Of course, since most viewers are unaware of the precedent she was invoking—paintings of Renaissance artists bedecked in their finery as they posed at the easel—Tamara's image as a socialite painter, rather than one deeply in touch with her antecedents, is unfortunately reinforced by this image.[55]

By the time that she hired Mallet-Stevens, critics were according her increasingly serious respect. The London *Sunday Times* had compared her male portraiture with Wyndham Lewis's *Ezra Pound*, calling her work "neorealism . . . strengthened by Cubist discipline." And in February 1928 the British magazine *Graphic* had published a large photograph of *La Belle Rafaela* and pronounced it "one of the most effective in the Salon des Indépendants" out of "forty-three rooms of canvases and sculpture." Arsène Alexander, an important art critic of the period, wrote in *La Renaissance* that while he had earlier praised Tamara's paintings by calling her a "perverse

Ingres," he now wanted to note that "an art as disciplined as hers requires much willpower, attention to details, and utmost mental and physical concentration. . . . Lempicka has left behind her the teachings of the French Academy, and her taste for color has led her unconsciously to juxtapose on canvas flat arabesques which are pure Cubism—from this spontaneous geometry sprang the forms and modeling we so admire today."[56]

The implication that Tamara's art was becoming more modern than it had been seemed justified by her *Autoportrait*, probably the painting most quickly recognized by the public today as representing the Art Deco sensibility. Painted as a cover for *Die Dame* in 1929, this paean to the liberated woman became an icon of the age through its continual reproduction in magazines. Not until 1972 was it exhibited as an independent work of art.

*Autoportrait* (variously called *Woman in the Green Bugatti* or *Self-portrait*) is a small oil on canvas whose pictoral space is a slice of a vivid grass-green car, driven by a helmeted, leather-gloved woman dressed in monochromatic gray [Plate 6]. The steely woman and the colorful machine, both of which represented, in 1929, speed and freedom, seem to exchange their energy with each other. Gazing at the viewer with insolent challenge, the female subject appears to have paused in mid-action, her fingers dangling slightly over the steering wheel, as if she is inviting the onlooker in for a ride. Above the door handle, which occupies a middle space at the bottom of the portrait, are Tamara's initials. This time, though, she substitutes for her usual "TdL" the letters "TjL"—the *j* standing for Tadeusz's illustrious Lem-picki branch, Junosza—as if claiming a symbolic connection to her husband would stave off his final departure.

*Autoportrait* depended for its impact upon the new prominence of the automobile as a tool of liberation. (No doubt Tamara was making an obvious pun on the French word for "self-portrait," *autoportrait*.) Replacing the sexually charged image of the horse used in "amazon" portraits, the auto was a symbol of release from past strictures, a sign of speed, wealth, power, and geographical freedom. As early as 1914, Apollinaire had written his own poetic tribute, "La Petite Auto," as he drove from Deauville to Paris upon France's entry into the First World War:

> *We arrived in Paris*
> *At the moment mobilization notices were being posted*
> *We understood my friend and I*
> *That the little car had driven us into a new epoch*
> *And that although both of a ripe age*
> *We had just been born.*[57]

Tamara's exposure to a wide audience through her *Die Dame* covers increased her fame and brought new buyers to her studio at 7 Rue Méchain. During this period she received a letter from an unknown "gentleman" who had seen *Autoportrait* and who implored her, according to Tamara's memory fifty years later: "Madame, I have no money to buy your paintings. But I am a great admirer. Could I come and see your paintings anyway?"

"Yes, come," she replied. When he arrived, he told her, "I'm working daily because I lost all my money. I work until six o'clock. I could come every day at six o'clock in your house and help you to do whatever I can do. Answer the letter, answer the telephone." And so, according to Tamara's narrative, the eager would-be assistant became her loyal secretary in order to have access to her art. Whatever the stricter truth might be, Tamara did need such assistance; she was being inundated with correspondence from all sides. Best of all, the wealthy wrote to ask her if, on their next trip to Paris, she would paint their portrait.

One evening, for instance, as she prepared to go out with the French writer Alfred Savon, she received a phone call from an American.

> *Somebody with a very English accent, they said, Madame Lempicka, I would like to see you today. I said, no you cannot see me today, I go out for dinner. He said, but I'm leaving, I'm in Oxford University with my fiancée and I want that you come to America to do a portrait of my fiancée. . . . And I said well then come right away because I have a rendezvous with somebody at eight o'clock for dinner. And he said we will come in fifteen minutes. And they came to my studio. A man, not very good looking, but very distingué . . . distinguished, with a beautiful woman. Young, beautiful woman. And he said, could you do the portrait of my fiancée? And I said, yes I can do it right away. He said, no because she is going back to America. . . . Could you come to America? At that time for a French painter to go to America, it means money. And I said, yes I could come to America. In four months, I could come. And he said, let's write and he took an official paper and write there that Tamara de Lempicka, painter, will come to America the 14th of October, to paint the portrait of my wife, life size . . . life size for ten thousand francs. And make me sign. And when he wrote this letter, I said I'm sorry I have to go, I have a dinner engagement. And I had a dinner engagement with a writer. And I said to the writer, "Congratulate me, I'm invited to America to paint," and he said, "I hope you got a good price because a cup of coffee costs two dollars, two eggs cost three dollars." I said, "I didn't know . . . I took the*

*same price like in Europe." He said, "You cannot live for one week
for this price. The hotel room costs more."*[58]

The artist immediately wrote the young American millionaire Rufus
Bush that she could not, after all, carry out such a commission. Three weeks
later, he showed up at her door and signed a contract for forty thousand
francs plus expenses, whereupon Tamara agreed to move the date from
October to September.

The painter was predisposed to admire the United States: American
music, literary talents, and money had infused Paris over the previous
decade, and Parisians believed that the country held all that was modern and
industrialized. Tamara had regretted keenly being unable to join the excited
crowd gathered at the Place de l'Opéra to spot Charles Lindbergh's plane
on 21 May 1927, as he approached Le Bourget Air Field; while citywide cel-
ebrations were under way, she was at Lake Como, desperately trying to effect
a reconciliation with Tadeusz. And professionally, she already felt appreci-
ated by Americans: she had been deeply gratified when a friend showed her
the *New York Herald*'s photo coverage of the January Salon des Indépen-
dants early in the year. In a large picture of the salon, picked to illustrate the
"work of every school extant . . . being shown by 2,000 artists from all the
world," *First Communion* and Tamara's *Portrait du Docteur Boucard* com-
manded the reader's attention.[59]

The artist would always recall fondly her first visit to the United States:

> *That was the last time that Paris—the ship Paris—went. That was
> the best ship—French. And it was very gay, six days and I was
> with the table with the Captain and they knew who I was, because
> I was working so well in Paris. And they knew me and I was young
> and pretty and I was with the table of the Captain every day. And
> then I came, and when I came Mr. Bush and his fiancée were there.
> And they met me and they made it easy for me to go through the
> customs. So not to have open the things. And they have two Rolls-
> Royce that were waiting, and they put my things and we went into
> Hotel Savoy which was the best hotel at that time.*

Determined to take on Manhattan as she had other foreign places, she
asked a Savoy waiter to wake her early the first morning in New York, so she
could see what the American "office hour" is like: "I want to see how looks,
America."

From the beginning of her visit, the artist noticed with increasing fasci-

nation and approval the efficiency of Americans. Always industrious, upon unpacking her clothes she asked Rufus Bush if she could begin work. When she was informed that they were waiting for dresses ordered from Hattie Carnegie, "the best dressmaker" in New York, the distressed artist responded that "we have no time to make dresses." She was informed that they would be finished in one day.

> *And we went to Hattie Carnegie. Mrs. Bush [actually still Rufus Bush's fiancée] was here, Mr. Bush was here, and here were all the girls that were selling. And the mannequin came, very beautiful girl, very beautiful dress. One came in a blue dress, turquoise. And I said, "The dress is nice but the color is a little too strong." . . . Then came [another] dress. Other dress, I said, "I don't like the color." . . . Then came the third dress. I said, "Yes, I like the color but it is too light." . . . And I had to look all the collection and what I said was good, they send me. I said, "How much it will take? One week?" "No," they said, "you will have it tomorrow in your studio." And tomorrow they brought beautiful boxes with beautiful paper. All the dresses were there. . . . And they prepared hangers and put all the dresses. And she came, Mrs. Bush. . . . And I said, "Try this dress." It was a red jacket, tailored, with a black skirt. . . . And I start drawing.*

Though stunned at the almost alarming ease and speed of American couture, Tamara was equally surprised at the Americans' "unnatural" mix of work and play. "The bell was ringing and the young man came. . . . 'Oh, darling, she is the painter'—'Oh, she is so lovely, oh, I love her, what is your name,' and so on. . . . They started to drink champagne and I didn't know how to paint. I looked and I said, 'How can I paint? I had to have peace.' I said, 'I will go back to Paris. I will not paint.' And then I said, 'I will try the American way. I will see if I can do or not.' And they were sitting around her and talking and drinking . . . and I was painting. And that was one of my best portraits. And every day they came and every day they talked and every day they changed the dress. And I did the portrait."[60]

When asked if she had a photograph of her first American painting, Tamara replied that it had been lost, in spite of the rich Bush family designing their entire house around the artist's portrait. Ten years after Tamara recounted the story in a 1979 interview, a daughter of the mysterious Bush fiancée read Kizette's memoir and realized that she knew where the picture was. On 7 June 1989, Joan Gayley wrote to Kizette: "I am so happy to be able to share with you our excitement on discovering this extraordinary por-

trait of my mother after reading about it in your book. When we decided to search through my mother's storage in a New York warehouse, there it was, good as new, in perfect condition, untouched by anything in almost sixty years! It was a thrilling experience, like opening up a time capsule! And what a portrait! It still looks so contemporary, so timeless! The clothes could be in this month's *Vogue*!"[61]

Nine days after Tamara arrived in Manhattan, the stock market crashed. The Bushes paid her as promised, but she and Kizette both claimed that the painter lost substantial investments during the first months of the Great Depression. In spite of the economic crisis, Tamara extended her visit to the United States until at least January 1930. At first she wrote frequently to Kizette and Malvina, who stayed with the teenager whenever she was home on break from her Catholic boarding school.

It is unclear how Tamara occupied these five months, except that as a result of Rufus Bush's recommendation, she apparently received multiple American commissions that helped her recoup much of her earlier financial loss. In any case, her press coverage in the United States had been fairly extensive for the preceding three years, though American reporters couldn't make up their minds how to classify her. Sometimes critics included her in the company of such artistic luminaries as Mela Mütter; other times they dismissed her as a mere society painter. Occasionally compared to the eighteenth- and nineteenth-century painter Marie-Louise-Elisabeth Vigée-Lebrun, Tamara was at other times grouped with Mariette Lydis, a painter respected in France but considered primarily a socialite artist in America.

To Tamara, never one to reflect upon the costs of superficial plenty, the United States seemed a land of limitless financial and professional opportunity. Promising in one of her letters to return by Christmas, Tamara expressed to her daughter and her mother her unalloyed pleasure upon this first visit. Then, in late November, she wrote of an invitation she could not afford to pass up: "My mother told us that she would not be home for the holidays after all, because a 'rich cowboy' from New Mexico or Arizona had given her a train ticket to visit his ranch. Later she wrote us that she was shocked to find he was not there; she had traveled on the continental assumption that they were to be lovers, but he apparently was just being hospitable. I cried and cried when I found out she wouldn't be home for Christmas, and my grandmother got very angry at my mother. She went to the closet where Chérie kept her huge, famous collection of hats, and she started tearing them in pieces and feeding them to the fire. She did all this in silence, and she never explained it to me."[62] The hats apparently served as a symbol of her daughter's waywardness, and Malvina decapitated the daughter who

had lost her head, the one whose too passionate love of luxury was nowhere better demonstrated than in her collection of expensive chapeaus. Even the loyal Malvina had lost patience with the artist's willful denial of her position as a single parent. Though Malvina had conveyed to Tamara her own belief in the pursuit of pleasure, she had somehow neglected to teach her aggressive middle child, determined to make a place for herself, that one's family was a higher priority than even fame and money.

# Chapter 7

# RECOVERING *from the* CRASH

*In 1930, when Tamara finally returned* from her visit to the States, winter semester had already begun at Kizette's school, Cours de Dupanloup, where she boarded from Monday to Thursday. The thirteen-year-old girl was happy to miss her mother's discovery of the burned hats, but she couldn't wait for the bus to take her home to 7 Rue Méchain the week that Tamara arrived.

Her mother could hardly stop talking about America, and Kizette heard all about the trips they would take together to see the "ultramodern Empire [State] and Chrysler buildings, which would be finished that year or the next."[1] The accelerated pace of life, the glorification of the individual, the regional differences from New York to New Mexico —all within one huge country—fascinated Tamara. Despite the October crash, American society had retained its joyful recklessness long enough for her to understand that, just as in Paris, "women now smoked, drank, got divorced whenever they felt like it, flirted, and laughed as their men heaped fortune upon fortune and gave away mink coats and diamond bracelets and thousand-dollar bills as party favors." Soon such extravagances would wane, but Tamara had glimpsed the end of the party. Most of all, she approved of what one commentator called the national goal of being or getting the best of whatever was considered valuable.[2]

For several months after coming home, Tamara remained infatuated with America. In addition to bemoaning her early financial losses (quickly recouped) and regaling Malvina and Kizette with lively accounts of a Harlem that contained the "best nightclubs in the world," she described in detail the modern line of Manhattan's skyscrapers, which she believed to be in perfect harmony with her own paintings. Just as Art Deco's popularity was declining in France, the more Germanic version of clear, curvilinear forms was shaping the building facades in America. Bauhaus sleekness had always appealed to Tamara more than the highly decorated, exaggeratedly detailed and colored French Art Deco, often too close to Art Nouveau fussiness and Mir Iskusstva extravagance for her taste. As the October 1929 crash ushered in a more muscular, classical look in architecture and design, both in the United States and in Europe, she felt validated: the conservative aesthetics that had informed her own work from the beginning were being accorded new respect.

But Tamara was uneasy on another level: the French economy registered the American financial disaster almost immediately. Soon after the crash, Janet Flanner recorded for the *New Yorker* that "The Wall Street crash has had its effect here [in Paris]. In the Rue de la Paix the jewelers are reported to be losing fortunes in sudden cancellations of orders, and at the Ritz bar the pretty ladies are having to pay for their cocktails themselves. In the Quartier de l'Europe, little firms that live exclusively on the American trade have not sold one faked Chanel copy in a fortnight. . . . In the Rue La Boëtie a thrifty young Frenchwoman, who as a Christmas gift bought herself a majority of stock in the art gallery where she works, finds that all the forty-nine blue Dufys are still hanging on the wall and that it is not likely her stock will pay a dividend. In the real estate circles certain advertisements have been illuminating: 'For sale, cheap, nice old château, 1 hr. frm Paris; original boiserie, 6 new baths; owner forced return New York Wednesday; must have IMMEDIATE CASH; will sacrifice.'"[3]

The years between the two world wars, particularly the electric but anxious twenties, had depended upon an amalgam of talent and money; without the wealthy Americans, the high living of artists such as Lempicka would have been impossible. Furthermore, the ethos of the modern woman, the image most congenial to Tamara's personal and professional development, had been disseminated by the Americans. "The 1920s were a period of normalization for thousands of Americans. They came in droves to France to graze on herbage more succulent than their senses or stomachs had known at home. . . . The international smart set introduced what seemed to France the unforgettable woman—the very rich American woman with money no

man could control and which she was free to spend," Janet Flanner shrewdly asserted.[4]

Quickly, with an instinct honed by anxiety, Tamara recognized that she needed to consolidate her social and professional gains; and almost immediately upon her return home she began going out every night.

As if betting on sobriety's imminent reappearance, the leisure class now entertained with an air of desperation. The summer of 1930 was full of fancy-dress balls, and Tamara attended three of the most highly publicized, given by socialites Meraud Guinness and Dolly Wilde and by the designer Jean Patou, whose extravagance she recounted excitedly to less fortunate friends and to her daughter.[5] Imitating an earlier bash sponsored by Elsa Maxwell, Meraud Guinness's revelry was a come-as-you-are affair, for which the invitations warned that a vehicle would arrive at an unspecified hour to transport the guests in whatever attire they had on. In reality, the chauffeur gave the "surprised" guests so much time to prepare themselves that cocktails were provided for those already waiting in the limousine that he drove. One of the most famous of the supposedly artless appearances consisted of a woman who had exactly one side of her face perfectly made up.[6]

Of the three parties, Dolly Wilde's costume gala (sponsored by the Duchess of Clermont-Tonnerre) probably appealed least to Tamara's sense of fun, if only because the women guests gathered admiringly around the seductive poet Natalie Barney: Tamara needed always on such occasions "to be the center of attention."[7] It was Tamara's friend Jean Patou who gave the most dazzling party of the season anyway. The guests, according to one observer, were "largely Italian, British, and American, and the decorations silver. To obtain the desired effect, the garden was roofed over, and not only were the walls and low ceiling laid with silver foil but also as much of the trees as was visible, trunks, branches, even the twigs being wrapped in silver paper; and from the metaled boughs hung silver cages, as tall as a man, harboring overstuffed parrots as large as a child. [There were] three small lion cubs, led in by lion-tamers in flowered shirts and imposing breeches; the cubs were then given as grab-bag prizes to guests who, as the story says, may not have wanted but drew them."[8]

Even among the flamboyantly dressed party crowd, Tamara must have stood out. In the few pictures of her that remain from the early thirties, she is dressed in a domesticated version of her mother's favorite designer Paul Poiret, though Poiret's vaguely Oriental styles were now considered outdated. She had traded in her favorite oversize hats for dozens of variations on the cloche, most frequently from the exclusive milliner Rose Descat. Tamara's daytime jewelry typically consisted of multiple strands of various

shaped colored beads, while for evening she displayed five to eight diamond cuffs or bands extending one-third of the way up her arm, with equally dazzling rings and earrings. Only the simplicity of her chin-length, marcelled hair kept her from looking overdone.

Her makeup consisted primarily of false eyelashes and scarlet lipstick, for both day and evening; occasionally she smoothed a dark, almost black, shadow on her eyelids. She plucked out her pale blond eyebrows and penciled in long, thin, straight lines instead. For formal events she ordered fitted gowns from Molinaire or Rochas, who usually offered her free couture in exchange for the publicity; her Polish friend Mala Rubenstein Silson recalls that Tamara was also an early patron of the fashion designers Lucien Lelong and Madame Alix Grès, both of whom became her longtime favorites.[9]

Frenetic social life was not the only way that the French upper classes deflected worry about the dangerous American Depression; art also flourished. A new gallery that opened on the Rue de l'Abbaye, the Galérie de France, exhibited the theater and ballet designs executed during the twenties by some of the city's most famous artists: Bakst, Braque, de Chirico, Gris, Laurençin, Léger, Picasso, and Rouault were among those highlighted. Evoking the glories of the recent past, "when the greatest artists of Europe were scene painters for the brightest theatrical flush Paris has known," the show inadvertently emphasized the uncertainties of the present.[10]

But neither the parties nor the art could obscure the most immediate repercussions of the Wall Street crash, too many of which were experienced directly by the Paris art market. As Malcolm Gee explains, "The art market was sensitive to general financial conditions, and it was specifically dependent on American buyers. . . . In November 1929, Paul Rosenberg used the crash as an excuse for not paying Marie Laurençin more for her work. . . . As the Depression gathered momentum, its effect on the art trade grew proportionately, until it became an acknowledged disaster. Already in 1930 the difficulties were reflected in the figure for auction sales. Whereas in 1929 there had been thirteen sales organized by the contemporary painting specialist at the Hôtel Drouot [Paris's premier auction house], in 1930 there were only six, almost exactly the same number as in 1925, at the beginning of the 'boom' on modern art."[11]

Seizing an opportunity to attack their opponents, some critics exploited the crisis to drum home their thesis: modern art had become too much a commodity anyway. Paintings and sculpture had been transformed into expensive treats, available to the highest bidder. Previously contaminated by its close association with the marketplace, art could now regain the purity some said it had lost in the twentieth century. Instead, a different scenario

developed. During the Depression, "the salons collapsed as a viable alternative, and . . . the private gallery became the focal point of interest and activity. This 'triumph of the dealer' . . . inaugurated an era in the history of art which is still in progress."[12] The new "support system" of gallery owners and dealers that had emerged by 1920 solidified into a structure of art economy that remains little changed at the end of the twentieth century.

Worried that commissions would become scarcer as the formerly wealthy scaled back their expenses, Tamara worked even longer hours than usual, in spite of her renewed social activity as a single woman. She was encouraged by the knowledge that she "had made a million dollars by the time she was twenty-eight," and she found her new independence invigorating.[13] Major provider for her little family, she proved to herself and to her daughter that she could take proper care of them.

When Kizette was home for the weekends, the girl would sometimes awake at three or four in the morning to the strains of *Madame Butterfly*. Peering through the rails of the second floor balcony to the studio below, she could make out the light bathing Tamara's canvas as her mother worked to finish a portrait. At other times, however, the painter took to her bed for days, and Kizette was met at the bus on Thursday afternoons by a worried and tired Malvina. Frequent stomach pain sent Tamara to her room.[14] More demoralizing than even the physical pain (which from the symptoms would probably be diagnosed today as endometriosis) was the depression that had begun to engulf the painter at unpredictable times.

One of the first episodes occurred upon the death of her friend, the artist Jules Pascin, who committed suicide several months after Tamara's return from New York.[15] Pascin wore the mantle of the bohemian artist: "He would frequently rise at midnight and wander the streets, returning the next day remembering nothing of what he had done or where he had been. The wild parties that he gave in his Montmartre studio on Saturdays in the 1920s were famous for their abundance of expensive foods and wines; he drank heavily and was sometimes involved in brawls, spent money prodigally as soon as he got it on entertaining his friends, and had many hangers-on."[16] At Moïse Kisling's frequent parties, Pascin and Tamara had discussed their respective trips to the United States. Tamara and Kisling were devastated by Pascin's death, as was the art world in general. The galleries in Paris all closed on the day of his funeral, the size of the procession caused traffic to halt, and Mina Loy wrote a poem commemorating the popular painter.[17]

In the aftermath of Pascin's death, Tamara spent even more time with Kisling, whose studio had evolved into a favorite meeting place for his artist-friends. Fairly well respected in art circles, Moïse Kisling was known for suc-

cessfully wedding his mad nightlife to highly disciplined work habits, the complete opposite of the unpredictable Pascin. Tamara relaxed in Kisling's presence; he was one of the few talented painters at the time who believed that art and society could publicly mix without harm to either.[18] Even in 1938, when her paintings were not the sort Kisling admired, he kept a dramatic photograph of the glamorous artist tacked to his studio wall.[19]

Not long after Pascin's suicide, Tamara became estranged for life from Ira Perrot, who had served as best friend and favorite model for almost a decade. The only reason Tamara gave, according to Kizette, was that "Ira did something not quite right: Mother found her with her hand in the 'kitty.'"[20] Kizette has at times acknowledged that the two women were lovers, though she sometimes insists "they were best friends, nothing more."[21] But no friend or family member, including Kizette, appears as often in Tamara's paintings as Ira does. In fact, an unusually experimental drawing of Ira, which Tamara stored in her attic and never exhibited or offered for sale, has led dealers familiar with her oeuvre to infer an intimacy between poser and painter.[22] This sketch (Plate 2), one-half colored, the other side in charcoal, bifurcating Ira's hair into red and black, recalls the unnamed, well-to-do redheaded neighbor who befriended Tamara and took her on the momentous trip to Italy in the early twenties. After Tadeusz, Ira Perrot was possibly the major romantic attachment of Tamara's life. The depression that Tamara battled episodically over the next years, and which nearly bankrupted her emotionally by 1935, was surely aggravated by the loss of Ira during the same period that Tadeusz had departed.

But in the spring of 1930, her work saved her from real despair. From 21 to 31 May, Colette Weil's gallery, at 71 Rue de la Boétie, staged Tamara's first solo exhibition. Although she would maintain that Weil had shown her works previously in the twenties, press accounts cite this 1930 exhibition as her first one-woman show at the gallery. The critics were impressed: *Commedia* of 22 May 1930 reported that

*This is an exhibit we will certainly talk about. The success previously ascribed to Lempicka's paintings is sharper today. Her work at Gallery Colette Weil has a particular character: it reminds us of Greuze. [This was apparently the only critic ever to compare Lempicka to Greuze.] In her paintings, everything is caressed with love and with a meticulous brush. At the same time, she shows a skillful confident conception and a taste for pure line and simple shapes. Her drawing is clear and sharp; her painting smooth, with extreme skill and mastering of craft. Her paintings remind us of the classics in museums but with infinitely more seduction and sensitivity. Not*

*really realistic painting: she could be called realistic if the term were enlarged. Her art is not cold despite its precision. Her portraits are alive and even hallucinatory. Sometimes it seems as if her painted characters are about to step out of the frame. The life-size figures seem to show something from the mirror of Lempicka's mind as well as from the model. The Slave in Chains [Andromeda] gives a good idea of her talent. The Portrait of Nana de Herrara—the play with color and the shape of the nude (covered by transparent black lace)—is rendered with a disconcerting assertiveness because of its precision. Whether it is to paint a woman, a flower, or a bird, we find assertiveness and confidence put to the service of a sharp intelligence.*

Buyers with highly respected private collections, including Baron Raoul Kuffner, continued to buy multiple works. Kuffner's patronage and social clout helped Tamara begin the new decade with her career on a sound footing. During this period she also brokered an uneasy peace with Tadeusz, largely by negotiating a businesslike relationship with his prospective wife, Irene Spiess. Sometime during this year Irene and Tamara met once again to discuss Kizette's schooling as well as her trips to Poland. Pleased with her daughter's treatment at Cours de Dupanloup, Tamara proposed sending her to the secondary level of a similar school in Surrey, England. Kizette had enjoyed life at the Parisian boarding school, where her loneliness at home was relieved by sharing nighttime giggles with children her own age. She loved the way the girls would sneak into each other's beds to share candy while they told ghost stories, after lights were out and the nuns had finished their patrols. And the Catholic sisters nurtured her, though their prudery amused her even then: "We were never allowed to take a bath without our petticoats on. It was considered sinful by many people, not just the religious, to expose our bodies totally, so we bathed in a tub, underclothes on, while a nun sat next to us to watch and ensure no immodesty."

Kizette agreed with her mother's decision to send her to the English extension of her French school, St. Maur's in Weybridge. Good schools closer to home existed, but even now Tamara was growing anxious over the tensions escalating in Europe. Maybe England seemed a safer refuge for her daughter, though she told her that she picked the location for its "fresh air and fields of daffodils."[23] Or perhaps at an age when Kizette began to seem like a potential competitor, both in looks and in intelligence, her mother preferred that she be placed at a distance. By now Tamara had decided that Kizette should have a first-class college degree. Oxford or Cambridge would be a smart choice—one that the mother, not Kizette, would make. If it was

*Kizette dressed for riding, St. Maurs, Surrey, England, c. 1932.*

understood that Tamara would select her daughter's schools, it was also part of the family routine that when Kizette received her grades, her mother barely looked at them before waving her hand and saying, "I'm sure they're excellent" (they were). Herself a poor student—because of boredom, she always claimed —Tamara exhibited both pride and envy at her beautiful adolescent daughter's achievements. Kizette remembers that it was during this period that Tamara first introduced her as her sister—"I was no longer announced to new acquaintances as her daughter, since it would make her seem too old."[24]

The 1920s had allowed Tamara the illusion of enjoying life on her own terms; the 1930s once again anchored her to the realities of history. The financial, personal, and professional pressures she was experiencing as the decade began triggered a full-fledged bout of the depression that had previously made only brief appearances. In spite of proving to herself that she was in no real danger of losing social or professional standing, Tamara would spend months immobilized off and on during the next eight years. Her irrepressible urge to be in charge even when ill lent the early episodes of her depression an almost comic aspect.

Prince Franzi Hohenlohe, a longtime friend of both Tamara's and Kizette's, wrote of her attempt at a self-cure: "At one time in her life . . . Tamara, living in Paris, was feeling what was then called 'the spleen,' a general lassitude and 'down' feeling often encountered in those days among people of the higher echelon. . . . Tamara went to see her doctor who told her that he saw nothing physically wrong with her, but that nonetheless he recommended that she 'leave Paris to rest up a while in some quiet place.' 'But,' he added, 'by that I don't mean Deauville, Le Touquet, Biarritz, or one of the other watering places you are accustomed to. I mean a place where you will not come across your usual society friends, and where you will live quietly.'"

As Tamara pondered the doctor's advice, she received a letter from a young American friend living in the U.S., whose parents were sending her to a finishing school in Florence. Upon reading that the girl would like to spend a few days in Paris visiting Tamara, the artist hatched a plot by which she, too, would enroll in the finishing school, passing herself off as a "teenage subdeb."

After her friend approved the scheme, Tamara sat down and wrote the school's headmistress as though she were a mother seeking to enroll her young daughter for the present term. "Mademoiselle de Lempicka" was accepted, and "Tamara rushed around buying flat-heeled shoes, middy blouses, and unsophisticated round-collared dresses. She changed her hairstyle, removed her nail polish, and accustomed herself to go about without makeup. The train she boarded when the great day arrived was due in Florence in the evening, which Tamara hoped would help her disguise, with the fading evening light." No one thought anything awry, and Tamara, along with several other girls, was granted permission to take art courses from the renowned teacher employed by the school.

Prince Hohenlohe recounts that

> *Like all the other girls in the school, Tamara was allowed certain afternoon outings, where she and all the other subdebs met masses of Italian boys, and flirting with them was a great pastime. Tamara even went so far as to get engaged to one of them, a handsome young Tuscan of a very good family.*
>
> *But then, one afternoon, quite unexpectedly, lightning struck. Her art teacher called her into his private office and asked very quietly, "Why are you putting up this masquerade?" Tamara was thunderstruck and began to stutter, thinking, of course, that he had seen she was much older than she pretended to be. But that was not it at all.*
>
> *"You see," he continued most kindly, "I am after all quite well acquainted with the work of all our rising contemporary artists all over the world. And Tamara de Lempicka's work, her brushstroke, her color, her skin tones, are so much her own and nobody else's that I came to the realization that you are Tamara de Lempicka. . . . But I shall not give you away, for if you entered upon this charade you must obviously have had a very good reason."*
>
> *He did not expose Tamara, who finished the term, broke her engagement with her stricken swain, and said good-bye to Florence. When she returned to Paris she was cured of her "spleen."*[25]

Although Tamara did retreat periodically to convents and to art schools, the truth of this narrative, as with most of her myths, lives in the explana-

tory power of its lies. The importance of the anecdote, which Tamara repeated many times, involves her self-aggrandizement: not only did she look young enough to pass as a teenager (and by now she was thirty-five), but her brilliance as an artist was undeniable, here in the land of the greatest painters she could name.

In any event, the cure was temporary, consistent with a probable manic-depressive alternation in her mental cycles. After a brief worry that her career would dissipate with the stock market crash, she was relieved that her work continued to attract critical attention. Press reviews in 1930 lauded her uncategorizable style. *Beaux-Arts* remarked that "she started out not long ago with a purely Cubist style, taking color to shocking excess. Now, though still a little tormented and twisted, her tones are clear and harmonious. But she should beware of a certain taste she has for sadness." On July 1 that same summer, *La Pologne* wrote that "the women that Tamara de Lempicka uses for her models are modern. They don't know the hypocrisy and shame of bourgeois morals. They are tan from the sun and the winds, and their bodies are fit like Amazons. Mrs. Lempicka has the temperament of a fighter. Trauma seems to be her natural element. We rarely see her present a subject with indifference."

Signs of a shifting sensibility had already appeared in her work by 1929. Critics had been taken aback by her new motif of steely coils, almost as if she were translating the ribbons that Renaissance artists had used to cordon off signature spaces into the dehumanization of the modern machine age. Tamara's substitution of harsh metal for soft hair (reminiscent to some critics of Léger, who uses similar motifs to establish distance between himself and his subject) probably reflects the increasing sense of personal isolation she felt during this period and that she spoke of several years later. Exact and mechanized, stylistically dated, her paintings of the early thirties retain their power to startle the spectator. In 1931 she painted *Idylle (Lé Depart)*, on first glance an insignificant though unusual work in her portfolio. Ostensibly depicting a parting between a well-dressed young woman and a handsome, suave sailor, the scene shows a man holding a pipe out toward the harbor as he gazes painfully at the woman he is about to leave. His olive skin and his aristocratic Roman nose establish a vaguely Italian context. In the background, in small white letters very easy to overlook, the ship closest to the foreground is painted with its name on the side—*Lempic*—as the rest of the ship is cut off from the viewer. That Tamara was sadly ending an idyll with a lover seems clear, but whether he really was a sailor, or perhaps was instead one of her noblemen associated with watery Venice or Capri, is unclear. The completion of the painting, with its unfinished surname heading out to sea,

coincides with Tadeusz's announcement that he was formally engaged to Irene Spiess.

Tamara's lovers had included members of the Italian minor nobility at least since the 1925 Castelbarco show. But comments she made to her good friend Victor Contreras at the end of her life implied she had also become "sentimentally" as well as sexually involved with Guido Sommi Picenardi, the prince who, with his wife, Manana, had commissioned several portraits from her in Milan and Turin. She told her confidant—believably, since at this point there was nothing to hide—that the love affair had been secret and decorous. According to Italian historian Giovanbattista Brambilla, by the late 1920s the Picenardis owned a house in Paris, where they would have socialized with many of Tamara's friends. When Tadeusz announced his engagement to Irene, Tamara may have consoled herself with the idea that Picenardi would take her husband's place. Fifty years later, she would refer to her first husband as "Prince," an odd mistake that suggests an unconscious confusion of the similarly handsome men she loved. Tamara showed *Lé Depart* only once, during the exhibition in her own studio in 1932.

Such intensely personal themes would be increasingly transmogrified into mythical or political paintings during the following decade. Tamara's deepening awareness of the return of history, of the growing tensions in Europe as well as a sense of crisis in her own life, motivated her gradual shift in the thirties to more universal themes. In 1931 she executed one of the most powerful paintings of her career, *Adam and Eve.* Painted on wood panel rather than on the more expensive canvas—as were several of her works during this period—the mythical subject shimmers with a beauty rarely achieved except in alabaster. When it sold for almost two million dollars in 1994, the price would revive the old controversy about the painter's true worth. Although the painting's original reception in the early thirties was favorable, Tamara was unable to sell it for her asking price—15,000 French francs, the equivalent of $20,000 in the late twentieth century—nor was it critically elevated above her other works.

Tamara described *Adam and Eve* as having taken shape fortuitously, and her wish that one of her finest works appear spontaneously, almost divinely inspired, suggests the particular pride she took in the painting.

> *I was in my studio in Paris, painting this girl, a perfection of beauty, classic. And I'm working forty-five minutes, and then for fifteen minutes, it's rest. So there was fifteen minutes of rest and she was walking around all nude, and she approached my big black*

*table, a huge table on which there was fruit, beautifully arranged. And she said, "Could I take an apple?" I said, "Naturally, go ahead." She took the apple, and took it to her mouth. And I said, "Don't move. You look like Eve. We need Adam. Now I know the painting I want to do. We need Adam." And then I remembered that in the same street where was my house there was a police- man, a very good-looking policeman. I said, "Wait a minute." And I was in my painting blouse, all dirty from painting, my hair . . . doesn't matter what. I say, "You wait here and eat your apple." I went out of my studio into the street, and I saw the policeman often there so I knew him. And I came to him, and quick I said, "Look, I'm a painter, you know me?" He said, "Oh, yes, madame, I know you and I have a reproduction of your painting. I cut it out and put it on the wall." And I said, "Could you come and sit for a paint- ing?" He said, "When?" I said, "Tomorrow." "I will." . . . I couldn't believe it. So the next day, I was waiting with my model, will he come or will he not come? A policeman! At that minute, he came. And I said, "You can undress and put your things here." In my stu- dio, and the girl was all nude. He undressed and put very cleanly his things, everything corner to corner, put this, put that, and as he was an officer, he put the revolver on top of everything. And then he came and he said, "How to stand?" I said, "Take one arm and put around the girl and the other one, take a position." . . . And while he was there all nude, his revolver was next to me. So there he was all nude with her nude. But the revolver was next to me.[26]*

Although Tamara's implicit erotic investment in her painting imbued *Adam and Eve* with a potent sexual charge, her biblical subject matter sig- naled a turn toward historical, cultural narrative. The fall of innocence, typ- ically emphasized in depictions of sin's origin, proves tangential to her interpretation. Against a background of skyscrapers, two muscular, beautiful adults express an unflinching sexuality, their hard geometric bodies echoing each other as interlocking parts of a whole, implying the irrelevance of blame and the lack of loss. Although Adam has turned his broad back to the viewer, his powerful buttocks form a diagonal line to Eve's breast and to the apple she holds. The viewer confronts a male nude more boldly sexualized than his female counterpart, a rarity in the history of Western painting. The almost translucent buffed-beige flesh is set against Lempicka's familiar black, white, and gray horizon; the dramatic invitation of the red that cov- ers Eve's lips, fingernails, and nipple provides the only color relief.

Tamara had studied countless artistic renditions of Adam and Eve, from

PLATE 1.
Pencil and ink studies,
c. 1920–25

PLATE 2.
Pencil and ink studies, including
drawing of Ira Perrot *(below)*,
c. 1920–25

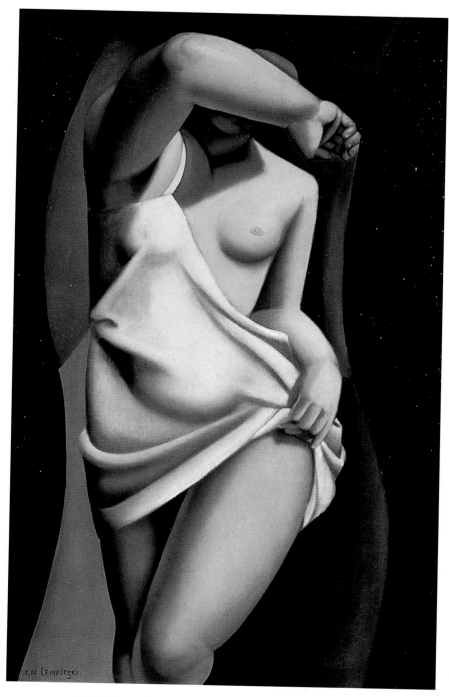

PLATE 3. *The Model*, 1925, oil on canvas, 45.5" x 29"

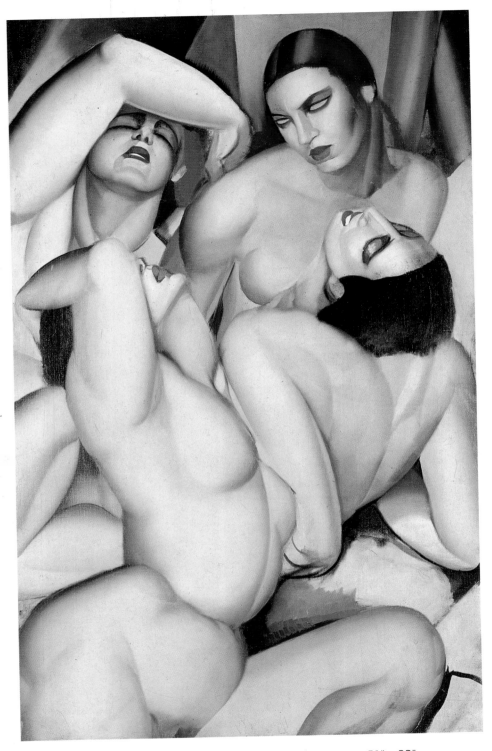

PLATE 4. *Group of Four Nudes*, 1926, oil on canvas, 51" x 32"

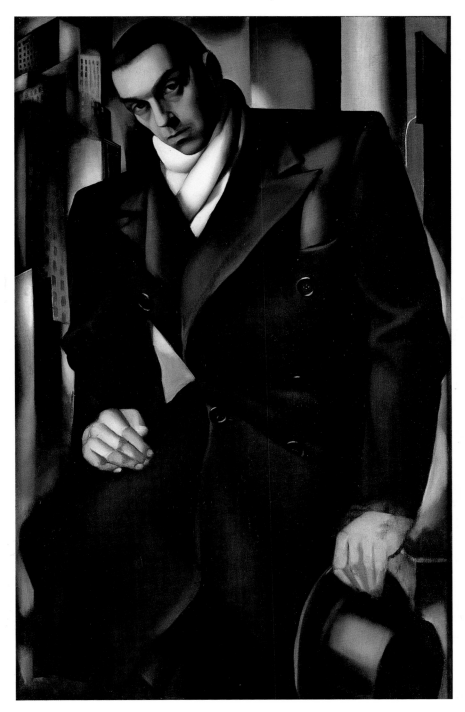

PLATE 5. *Unfinished Portrait of Tadeusz Lempicki*, 1928, oil on canvas, 49.5" x 32"

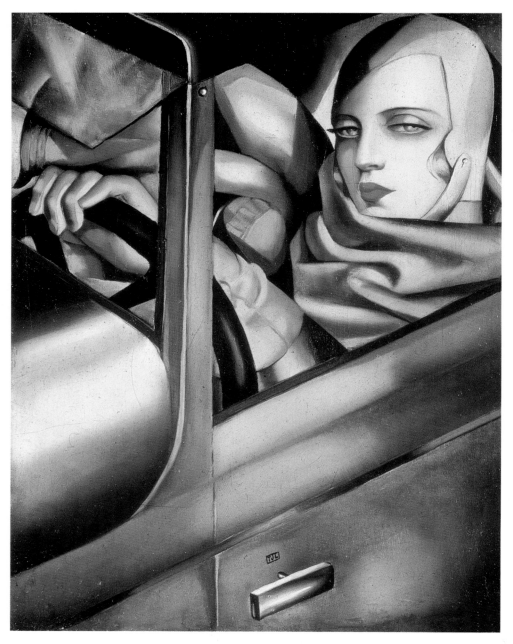

PLATE 6. *Autoportrait*, 1929, oil on panel, 16" x 10"

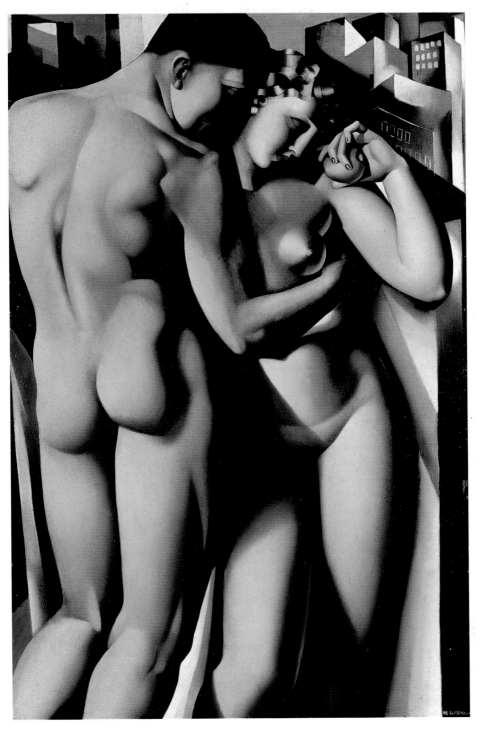

PLATE 7. *Adam and Eve*, 1931, oil on panel, 46.5" x 29"

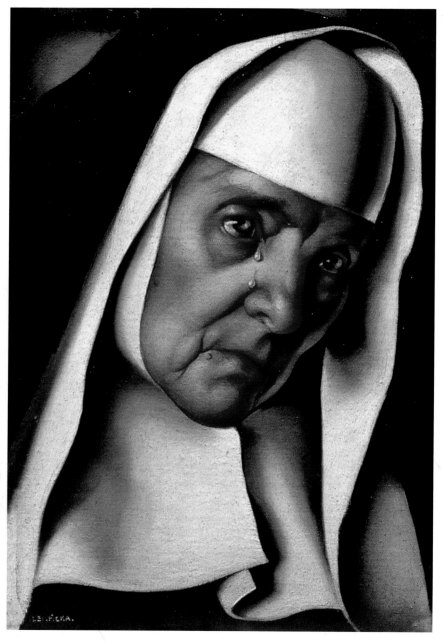

PLATE 8. *Mother Superior*, 1935, oil on cardboard on canvas, 12" x 8"

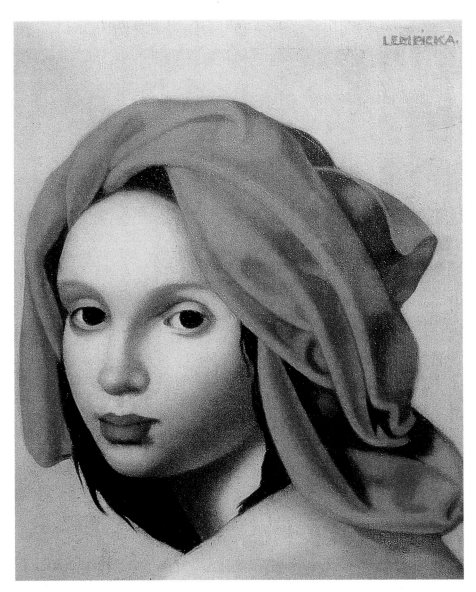

PLATE 9. *The Orange Turban*, 1935, oil on canvas, 10.5" x 8.5"

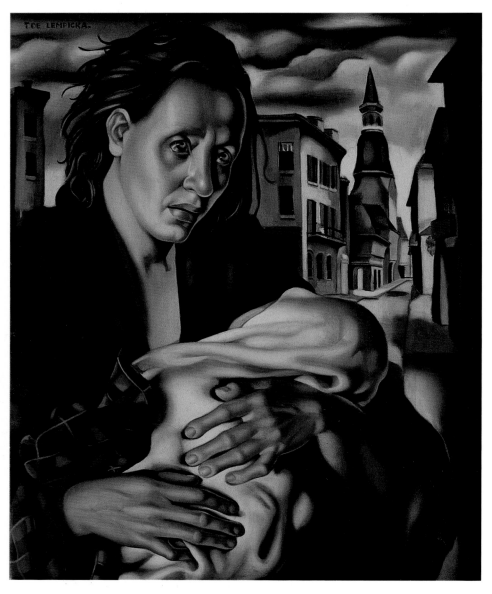

PLATE 10. *La Fûite (quelque part en Europe)*, 1939, oil on canvas, 20" x 16"

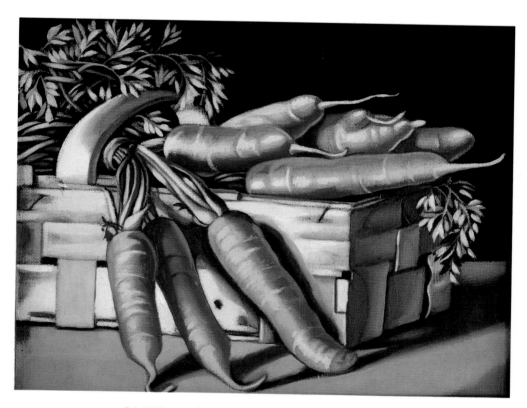

PLATE 11. *The Carrots*, 1943, oil on canvas, 9" x 11"

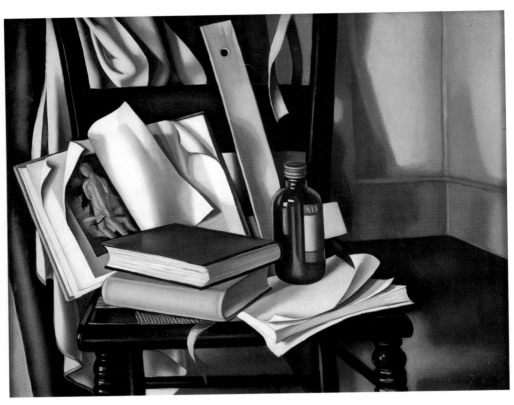

PLATE 12. *Books and Chair*, 1944, oil on canvas, 10" x 12"

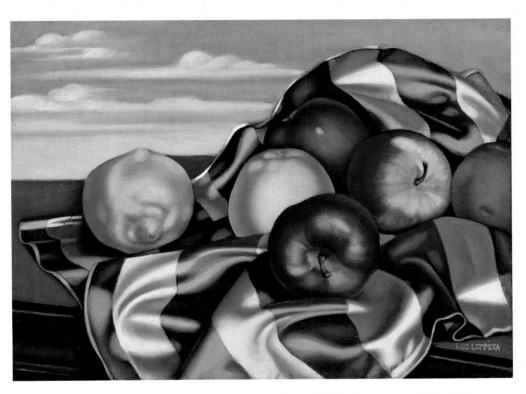

PLATE 13. *Nature morte aux pommes et citrons*, 1946, oil on canvas, 12" x 16"

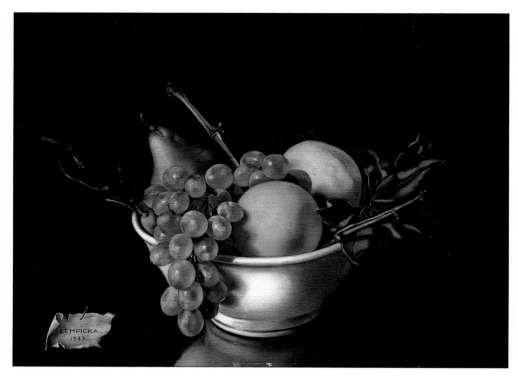

PLATE 14. *Fruits sur fond noir*, 1949, oil on cardboard on canvas, 12" x 16"

PLATE 15. *The Washerwoman*, 1960, oil on canvas, 24" x 15"

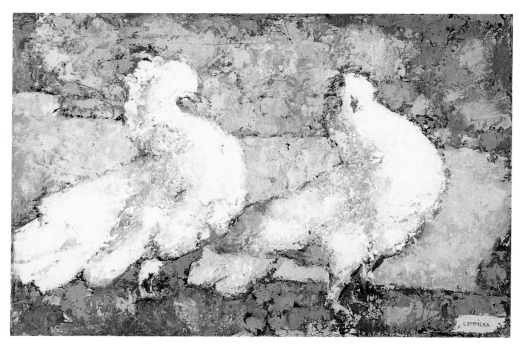

PLATE 16. *The Pigeons,* oil on canvas, 1960, 16" x 23"

Cranach the Elder's to that of her friend Francis Picabia. But her version owes most to her immediate precursor, Suzanne Valadon. From 1918 to 1930, Valadon executed no fewer than three paintings of the Edenic couple. The muscular, overbearing, and unapologetic sexuality of Valadon's work, which remained respected by critics who "feminized" Laurençin and Emilie Charmy, must have emboldened Lempicka, who exhibited with Valadon frequently. At that time, the two painters shared what was considered a masculine sensibility in their works, an aggressivity that critics considered unfeminine.[27]

Just before her death, Tamara was asked to provide a commentary on *Adam and Eve* for a coffee-table book called *Lovers*, edited by Mary Lawrence. The text was probably written by Kizette—Lempicka rarely theorized about her paintings, and certainly not in such lavish prose as this— but the artist must have approved the explication:

> *I have often been asked, "Why did you represent Adam and Eve as modern lovers on a background of skyscrapers?" The answer seems obvious: since Genesis, the destiny of those two lovers has haunted the human race; their images have inspired poets and painters down through centuries. For me, as an artist sensitive to outward forms of beauty, the revelation of this truth struck me one day in my Paris studio as I was making sketches of a nude model, a creature of divine body who suddenly stretched her hand toward a bowl of fruit and carried to her lips an apple, in the irrepressible and timeless gesture attributed to the Eve of Paradise. I was struck with the vision of a modern Eve biting into the forbidden fruit— Eve liberated, her hair crimped in the style of our own emancipated times, naked, yet chaste in her nudity, and therefore all the more desirable.*
>
> *To provide her with a partner seemed to be the next natural step, and Adam was created, in reversal of the divine order. His body is that of a modern sun-bronzed athlete, although his features already bear the traces of human frailty.*
>
> *And behind their intertwined bodies loom the skyscrapers, casting their menacing shadows, threatening to engulf, but never quite destroying, this divine moment of Paradise.*[28]

Between 1931 and 1933, Lempicka frequently chose to paint on wood panels rather than on canvas. Less expensive and more durable than canvas, the panels offered different opportunities for paint texture and color, though they were harder to transport because they couldn't be rolled up. Tamara

may well have taken her inspiration from the Dutch and Flemish paintings that Kizette recalls her studying in the Louvre during the innumerable visits on which the girl accompanied her mother; panel painting was common in the Dutch school of the seventeenth century.[29] Although for the most part Lempicka ceased using panels in the late thirties, by then she was a master at producing exquisite illusions of light. Such ability had been evident in *The Model* nearly seven years before *Adam and Eve;* and she would prove her indisputable virtuosity six years after Eden in *The Orange Turban* (Plate 9), an oil painting on canvas of which she did eight different versions over the course of her life. Tamara's attraction to Dutch painting became even more pronounced in 1940, when she began to transfer its lessons of composition and perspective to fruit and vegetable still lifes.[30]

But in the winter and spring of 1932, she was happy to exhibit in an all women's show at the Musée du Jeu de Paume, which was celebrating its transformation into a permanent museum. On 14 February *Le Figaro* suggested that if the artist would "admit voluntarily more softness, more atmosphere, she would go even further." *Paris Soir,* on 10 March, commented that the Jeu de Paume "has experienced among other beautiful paintings a shipment of works by Lempicka. In her work *Jeune Fille,* we see the beauty of her drawing, the firm palette of the artist." *La Brouille,* on 12 April, noted that "five rooms of the future museum of the foreign arts in Paris are delivered to the public. Finally room 5, under the School of Paris, gathers artists of all nationalities, including Modigliani and Lempicka."

In 1932, Tamara felt confident enough about her professional status to organize an exhibition in her own studio at 7 Rue Méchain. The show received major recognition on 19 May in the publication *Annale Coloniale,* in large part because Tamara had successfully imported the American cocktail party:

> *In terms of fashions, we have lately talked about the proper dresses for a cocktail party. . . . But what exactly are cocktail parties? They are meetings that take place, usually among four or seven people, at which all the guests arrive between six and seven. These little parties can last until eight or eight-thirty, sometimes until ten. To give you an example I would like to talk about those that take place at Tamara de Lempicka's, among the most successful and large. An elegant crowd recently rushed in to view the assemblage of great artists, among whom were the most popular Parisian and foreign personalities. Once again we noticed that the women adopted the color and form of hats and dresses that they liked, rather than a*

*social uniform. It was impossible in fact to see identical hats. . . .
Tamara was simply adorned with a bright red hat, trimmed
brown; and the simple outfit contrasted effectively with the gold of
her hair. . . . But let's not forget that it was in effect a gallery open-
ing, so it was necessary to stay proper. The gentleman who took off
his coat and hat at the entrance to the studio was almost all
dressed in gray with a neutral tie and black shoes, because the
color brown had deserted the shoe stores, and the men who have
taken back the classic uniform style exhibit blue and gray as their
favorite colors. Everyone was standing up, and that was the only
negative thing mentioned by the elders as they drank their tea. We
ourselves went about from group to group, visiting with people talk-
ing about the paintings here or paintings in general. Guests spoke
of sports and of clubs. Sometimes we got near the bar where the
champagne bubbled among the foreign drinks, though I must say
that the champagne was the major success. Delicious fresh fruit
accented the champagne, though we snacked on chips and caviar
sandwiches; we ate so many things that we had no desire for din-
ner, and then we had to leave to run for the theater.*

One week later, *Beaux-Arts* mercifully attended to the art instead of the
social scene:

> *It is in her own studio on Méchain Rue that Tamara de Lempicka
> presented some of her recent productions. Her evolution toward a
> geometric style is clearly in progress. As a result, the curl of hair
> and figures resembles more and more metal chips. The breasts,
> especially, have become voluminous and geometric. [In contrast to
> the nudes,] the portraits are closer to reality. . . . The blue clothing
> particularly is treated with remarkable precision, though the nudes
> are also beautiful with more subtle tones than usual. A scene that
> is highly developed in the painting* La Mère et l'Enfant *shows
> [Lempicka] outside her usual mode; this new style proves her
> power of expression by the infinite sadness the picture exhibits.*

*Excelsior* of 31 May also notes with interest her new "metallic royalty,"
but *Le Monde Illustré*, on 11 June, now finds her style "a little violent and dis-
concerting," though "without being too disappointing."

By 1932 the equal attention paid her art and her social life caused
Tamara's life to resemble those of the Russian female celebrities she had
admired in her late adolescence, Olga Glebova-Sudeikina and Mathilda

Kchessinska. With the press reviewing her personal as well as her professional attributes, she believed she could successfully play out her two loves —art and society—in the same arena. Able to persuade her usually male interviewers of whichever version of the truth she preferred at the moment, she convinced them variously that she was a "Brunhild . . . intelligent and very talented . . . but also a voluptuous woman," or "slender, a petite thing."[31] Even her painted fingernails were noted more than once, although they were no longer a novelty. She had perfected a gesture she used with journalists till she died: with blood-red nails loosely curved around a cigarette, sometimes in a holder, she continually swept her hand grandly throughout the interview, mesmerizing the listener.

Her press coverage accelerated, both because of her calculated publicity efforts and by dint of her artistic excellence. By all accounts, 1932 was an exceptional year for her career. Several publications, including *Le Journal* of 25 June, refer to an early summer exhibit by first noting that it contains a "remarkable poster" by Lempicka, "meant to illustrate the sexuality of a play by Cocteau but forbidden by the police to be performed." And on 28 October her paintings appeared with those of Picasso, Kisling, Foujita, and Laurençin at an exhibition held at Galerie Fauvety, at 50 Faubourg-St.-Honoré. Her daughter remembers, however, that Tamara's spells of depression grew more intense during this period, as she confronted the reality of Tadeusz's absence. On 19 March 1932, Tadeusz Lempicki had married Irene Spiess in Lodz, a city about sixty miles southwest of Warsaw. Lempicki, baptized a Roman Catholic in 1889, got married in an Evangelical Reform church, a Protestant denomination of Dutch origin.[32] The pained and jealous remarks that Tamara made to her daughter imply that she had not gotten over her sadness at losing Tadeusz. His marriage—to a woman Tamara could not dismiss as inferior—made that loss irrevocable.

Kizette remained ambivalent about visits to her father. Irene was superficially pleasant but seemed nervously alert to any competition for Tadeusz's attention, whether from Kizette or from her own daughter, Lulu. The apparently tense relationship between Irene and Lulu made Kizette yet more uncomfortable. Irene was openly jealous

*Unidentified Spiess family member, Irene Spiess, Kizette, Tadeusz, and Lulu in Lodz, Poland, c. 1935.*

*Lulu and Kizette, Poland, c. 1935.*

of the affection between Lulu and Tadeusz, for Lulu had developed an almost comical crush on her handsome stepfather. Irene had her own reasons for insecurity: she possessed the background, the elegant surroundings, and the education to feel equal to other women, but her pretty face contrasted awkwardly with her chunky figure, her thick waist, and stodgy legs. She remained uncertain about Tadeusz's attraction to her whenever her lovelier young daughter or stepdaughter was around, though by others' accounts, the marriage appeared to be a contented one.[33] Adding to Kizette's uneasiness was the way the ethereal, quiet Lulu (who spoke no Polish, since her English governess had raised her almost single-handedly) seemed to lack substance; from the beginning, Kizette felt a little sorry for her stepsister, even as she resented the girl's easy access to Tadeusz. On the other hand, her father continued to turn to her, not to Lulu, to talk about new books they both had read.[34]

Krystyna Wolanczyk, Lulu's half sister from her father's second marriage, remembers Kizette during her Warsaw visits "as an outgoing, friendly, very natural teenager." Wolanczyk's dominant impression was that "she seemed like such a normal kid, unlike Lulu, who always seemed like an oddly protected or otherworldly flower. Even Kizette's clothes—I remember a brown-and-green dress, a little hat—the color and shape had something nice about them, so normal."[35] Kizette had developed a crush on Krystyna's cousin, the handsome, artistic Zbyszek Kretkowski, who was studying at the diplomatic school in Warsaw. Mostly as a holiday diversion, Kizette herself once took a class at the Beaux-Arts in the same city, and she and young Kretkowski would travel to Irene's country home occasionally to see their Polish family.[36]

Lightening the burden of her personal challenges in 1932 was Tamara's prospering financial situation. As the Depression deepened, Tamara actually

profited from those with the most money to lose, who needed to show them-
selves and others that they were not afraid of the economic turmoil that sur-
rounded them. But even though she had within the last year executed some
of her finest pieces, and commissions appear to have continued unabated,
her fears grew. Kizette believes that "we were never without lots of money,
even then; yet Chérie always worried that we'd become poor any day."[37]

As if to emphasize that she was in no way incapacitated by either famil-
ial or historical dramas, sometime during this period Tamara developed the
bizarre habit of paying her own way at family dinners. One day in the early
thirties, Kizette and Tamara were eating at Aunt Stefa's beautiful apartment
in Paris, when the artist ostentatiously slipped some money under her aunt's
plate. "What are you doing, Tamara?" Stefa asked, astonished. Proudly, the
painter responded that she was paying for her meal. A heated argument broke
out, and Tamara jumped up from the table, pulled Kizette by the hand, and
stormed out of Stefa's home. The rich little girl who at age eight had sold
paper flowers on the street to earn her own room and board was now the
artist who seemed unable to accept conventional family generosity.[38]

During this period Tamara's spirits were lifted up by a new sexual rela-
tionship with a woman who was her equal in independence. Possibly Moïse
Kisling introduced Tamara to Suzy Solidar, a chanteuse at the Bôite de Nuit,
a Parisian nightclub. Solidar was to a group of artists a more intellectual ver-
sion of what the popular, earthy singer-proprietor Kiki of Montparnasse had
earlier been to Man Ray, Pascin, Foujita, Kisling, and Derain. Not surpris-
ingly, given her penchant for up-to-the-minute nightclubs, Tamara by 1933
had become good friends with Suzy, whose graceful, athletic body impressed
the painter far more than her ability to write third-rate novels. Before she
died, Lempicka explained that it had been an honor to paint Solidar's por-
trait: "[Suzy said,] 'I know this and this and this man . . . [all the] greatest
names, and I have a very good idea. I will ask the best painters of our time
to do my portrait and I will put them in my Bôite de Nuit.' . . . She said,
'The best people in Paris come to my club at night after theater. I saw your
painting.' 'Mine?' 'I love your paintings. Would you paint my portrait?' I said,
'Who are the other names?' I wanted to know. There were Picasso, Braque
—already two names that were very famous at that time, much older than
me. And I said, 'All right, I will do it.' And she came, and I did the portrait.
It was so small, this portrait. And now it is in the museum, in Cagnes."[39]

Suzanne Rocher—Solidar's real name—had honed her vocal skills in the
resort town of Deauville, where she was born. A sensual young woman of
ambiguous sexual persuasion, Suzy soon sought out the freer mores of Paris,
where she began singing in La Vie Parisienne, a nightclub. By the time

Tamara met her, she had become well known, in part as a result of her self-staged publicity campaign to pose for important artists. For posing, Suzy stipulated that the artist had to give her the painting to display in her Parisian club. The capricious entertainer accumulated thirty-three portraits of herself, all of which would eventually be moved to Cagnes-sur-Mer, near Cannes, where she lived for several decades. Of the entire collection, Lempicka's 1933 version best captured the lust that the singer inspired. Suzy's voluptuous but sleek nude upper body, with one arm raised provocatively above her head, is set against an urban backdrop. Her firm, high breasts and sultry, frank gaze—forthright renunciations of innocence—seduce the viewer. The beauty and softness of her lightly tanned skin and her full red lips suggest a knowing caress between painter and subject.

Lempicka and Solidar became lovers, though Suzy invested less energy in their relationship than did Tamara, who was the pursuer. Their friendship was important enough to the painter that for several decades, even during Solidar's final illness, Tamara and later Kizette would visit the singer in Cagnes-sur-Mer.[40] Although for years before she met Suzy, Tamara had spent enormous effort cultivating press coverage, she would irrationally claim late in life that the singer's commission had been the key to such attention. In 1979 she recounted that Suzy had told her: "'I love your paintings. Would

*Tamara on a cruise, c. 1933.*

you paint me?' I looked at her and said, 'Yes, nude.' She said, 'That's good. I don't care if I'm nude.' And she had a very good figure. When she came to my studio, and while she was sitting for the portrait, she brought the newspaper [writers]. And that was the first newspaper that started [to publish] photographs of myself and my studio. Because of her name: 'That's Suzy Solidar sitting for Tamara de Lempicka.' It was wonderful publicity for me. . . . But she did it."[41]

Although she was sexually involved with Solidar in 1933, Tamara pursued men as well; she sought wealthy older men as her social companions while she

slept with younger, handsomer ones. A countess who had met the artist in Italy recalls that "others in my circle" saw Tamara in seedy Parisian nightclubs during the early thirties, "fondling quite openly a beautiful working-class boy one night, and a girl the next. Her dates always looked mesmerized by her sophistication and beauty."[42] But such relationships were only for pleasure, and Tamara had to consider the practical demands of her life. Before long, her mother had persuaded her to concentrate on marriageable prospects.

Now she began to encourage seriously the attentions of men she had merely flirted with earlier. Foremost among them was Sergei Voronoff, a Russian pioneer in endocrinological surgery, who was famous worldwide for having invented a putative cure for impotence. Born in Voronezh and educated in Paris, he worked as the director of experimental surgery at the College of France. With the experience he gained in this position, he moved to Switzerland and began building on then popular longevity theories. His cure for male impotence involved grafting parts of monkey glands onto human testes. To his credit, he also spent at least as much effort attempting to cure mentally deficient children by using transplanted monkey thyroid glands, work that received less attention at the time.[43] According to Tamara's close friend Manha Dombasle, the painter met Voronoff at a party, very likely one given by his associate and Tamara's patron, Dr. Pierre Boucard.[44] Tamara later said that Voronoff regaled her with stories of the famous men who had come to him in Switzerland for the elixir of virility, though the injections of monkey gland serum were prohibitively expensive. Apparently hundreds of celebrities, including poet William Butler Yeats, were willing to pay dearly for the chance of renewed potency.

At some propitious point in 1933, Voronoff pressured Tamara to marry him. He thought he could persuade her by appealing to the life of ease he could provide for her: she need not work another day if she became his wife. "What would I do then?" she inquired. "Shop, sleep late, and eat bonbons," he proudly responded.[45] Tamara was not impressed by such limited prospects; and Voronoff's sloppy personal dress, corpulent body, and too obvious Russian background would have eliminated him eventually anyway. The famous scientist autographed two of his books to Tamara: *Conquest of Life* was inscribed "To Madame Tamara de Lempicka, A marvelous and genial artist, a woman of strange beauty, *inquiétante et troublante;* tormented soul! . . . devilish spirit"; and *Les Sources de la Vie* was signed "À la belle et géniale Tamara de Lempicna [*sic*] Souvenir affectueux."

Newspaper accounts of various parties in 1933, including one Tamara gave at her own home, suggest that Voronoff remained part of her social life until she found an acceptable replacement. On the one hand, she was in no

rush to remarry; she was supporting herself, Kizette, and Malvina admirably all by herself. On the other hand, she accepted Malvina's wisdom that, because of her age (she was approaching forty), it would be prudent to find a husband soon. She had, for instance, encouraged the attentions of Raoul Kuffner the year before, when, in a gesture of friendship, she painted him flatteringly as a model of male strength and confidence, a transformation of his undistinguished looks.[46] Unlike her earlier sketch of Kuffner, this small portrait presents the baron as intriguingly lustful, even predatory. But a small wart on his chin signals Lempicka's turn to hyperrealism, the genre in which she was to work throughout the decade.

Baron Kuffner, a logical choice for her husband, apparently caught scent of his competition and proposed to Tamara while Voronoff was still wooing her. Tamara usually recounted that "Rollie" wrote her precipitately in 1933 from his home in Zurich, a year after his wife's death from leukemia the previous February, saying that he was lonely and loved her and wanted to marry her. Only occasionally did she slip when telling this story and admit that she had been corresponding with him steadily since his wife died, ostensibly as a friend of the dead woman herself.

Perhaps Tamara really had become very close to Baroness Sara Kuffner. More likely, the two women had attended several social occasions together. Newspaper guest lists for important Parisian social parties in 1928 include the names of Mr. and Mrs. George Clemenceau, elderly friends of the Kuffners, alongside Tamara's name. Clemenceau had played an important political role in the baron's agricultural affairs. Displaced Eastern European aristocrats may have also provided a social circle to which the artist and the Kuffners both belonged.

In any event, Tamara convinced the lonely widower that she had to complete her backlog of commissions before she could make a decision: "I said, 'Please don't ask me, because I have no time to marry. I'm painting, I'm in full success.' That was the beginning of every exhibition. Wherever I send a painting, it was immediately accepted and put in a good place and sold. So my name started to go higher and higher. So I said I cannot marry because I'm too busy."[47] In 1933 she was selling her paintings so fast that she had no time to spend the wealth she was amassing. "I started the money to put into the bank, because I could not spend it. I was painting the whole day . . . early in the morning, at six in the morning until night."[48] In truth she did not have time to consider seriously the proposal from Kuffner—nor, had it not been for her mother, would she have had the inclination. She recalled as an example of her popularity the time that a furious dealer phoned her and complained, "Lempicka, I asked you to send me photographs of your painting. I

have a buyer for your paintings and they want to have photographs and you don't send them." She told him, "But I don't have the photographs." The dealer in essence told her to get some made immediately. Her earnest secretary, who loved her art so much that he worked for free, arranged a photo session the next day, Sunday, in the Bois de Boulogne. He set up ten paintings in good outdoor light and took the photographs himself. Lempicka claimed that the results were so impressive that the resident lab photographer immediately sold her paintings to a customer. How the dealer reacted to such enthusiasm goes unrecorded.[49]

Raoul Kuffner was not Tamara's only discriminating male collector. In 1933, Gino Puglisi, a modest-looking but talented Italian architect living in Rome, had purchased his first Lempicka painting. He continued buying her works until, in 1992 at the time of his death, he owned twenty pieces. Tamara would execute four portraits of Puglisi between 1934 and 1963, more than she did of any other man. Puglisi was intent upon collecting good modern painting in general—especially work by women. He owned pieces by Marie Laurençin and Mariette Lydis, but he and Tamara developed a special friendship. Although no evidence confirms that Tamara's interest in him was sexual, Kizette has claimed that eventually Puglisi and her mother became lovers.[50] Perhaps most important, the small cache of letters that Puglisi's nephew returned to Kizette after his uncle's death constitutes Tamara's only surviving extended correspondence, other than the D'Annunzio exchange. And the letters to Puglisi often refer openly to the emotional distress she was experiencing, in contrast with the brief notes to even her closest friends, which discuss logistics or business arrangements rather than feelings. Opposite in tone and content from the theatrical D'Annunzio correspondence, in these letters Tamara trusts "caro Gino" to understand her painful bouts of depression. The letters stop from 1939 to 1949, but the two would resume their friendship at the end of that decade and continue it until Tamara's death.[51]

In many ways 1933 was Tamara's most successful year to date. She was working hard and enjoying the now bountiful fruits of her labor. Her independence, fortified by an awareness that several wealthy men waited for her in the wings, provided the perfect equipoise to her desires: freedom and security were comfortably balanced. Still, in a gentle letter written to wish her mother a happy birthday, Kizette implies that Tamara has been told to rest more: "Mom Mamy cherie, ne te fatigue pas de trop—ne travaille pas plus que 3 heures par jour, et le reste du temps, sort et amuses toi" (Dear Mommy, don't tire yourself out—don't work more than three hours a day, and rest and relax during the remainder of the day). Kizette discusses their

plans for the approaching summer: "Quels sont les plans pour les vacances?
Je suis bien contente d'aller à St. Jean avec Grand Mere. Mais quand serais-
je avec toi?" (What are the vacation plans? I am happy to go to St. Jean with
Grandmother. But when will I be with you?) After all, she reminds Tamara,
the artist has promised that the first minute she has, they will go on vaca-
tion together, though Grandmother always makes a fine chaperon. (From
vacation pictures taken at St. Jean du Luz in 1933, it appears that Tamara
once again failed to take time off to join Kizette. Apparently the old pattern
of Malvina substituting for Kizette's mother had continued, even into the

*Kizette (second from left) with three classmates, St. Maurs, c. 1932.*

girl's late adolescence.) She ends the letter, written in the shape of a large circle, by sending her mother "millions of kisses."[52] Compared to traditional upper-class European family reserve of the period, Tamara and Kizette's relationship exhibited easy warmth.

"My mother came to visit me fairly frequently at St. Maur's, I must admit," Kizette recalls. "In spite of her work schedule, she wanted to make sure I was happy. The nuns were in awe of her, probably because at the very beginning of my stay, she charmed them into changing the hideous beige sweater they made us wear with the navy blue skirts. Mother went to Harrod's and bought a light blue cardigan instead, and then she convinced the good sisters to order 500 from the department store."[53]

Tamara's exhaustion at balancing professional and personal demands probably contributed to her willingness to heed Malvina's entreaties to choose a spouse; and her reliance upon her mother's emotional and logistical support undoubtedly had drained the older woman by now. Equally important, external events increasingly justified Tamara's intermittent anxiety attacks. By 1934 the Nazi anti-Semitic campaign was unmistakably under way in Germany, and French newspapers speculated on the eventual consequences. Brussels was flooded with frightened German citizens carrying backpacks and no visas, sneaking through fields to escape; Switzerland, where Raoul Kuffner maintained his residence, was open to the refugees, though Zurich forbade the Jewish immigrants to seek work because of the country's high rate of unemployment. If the idea of another world war seemed unlikely in the United States, those in Tamara's circles were aware of the possibility. As Janet Flanner had noted a year earlier, "among upper-class Parisians, there is constant talk of, fear of, war. . . . [The journals] print pages from the official schoolbook-printer of Munich. . . . 'Student; leader; poet; shot; dead; hurrah for our Fuhrer.'"[54] Tamara must have recalled how naive she and her family had been in St. Petersburg, when they ignored the portents of disaster until the end. Now she felt constantly on edge, sure that she would once again lose everything.

Among the more benign changes that Tamara noticed closer to home was a new emphasis on women painters exhibiting in all-female shows. Although she was never fond of gendered aesthetics, the sudden preponderance of such events convinced her to join the ranks. In addition to her entries in the Salon d'Automne and the Salon des Indépendants, Tamara had already exhibited in 1933 in "Les Femmes Artistes Modernes (FAM)," a group show at the Maison de France. She would subsequently exhibit in at least two major women-only exhibitions, in direct contrast to her previous philosophy of showing either in mixed company or solo. By classifying her-

self as a "female artist" in the specialty shows she now chose, she may have been unconsciously if publicly emphasizing that she was a woman painter after all. Such a public reorientation may have allowed her the psychological freedom to look for a man who would support her financially, even as he appreciated her professional status. The Depression's impact on the art market and the uncertain political situation created the need to regroup, whatever aesthetics one upheld. Neither the "shadow of Cubism" nor the "mirage of wealth," which had helped to create a market for her figurative work, existed any longer.[55] The salons had lost their cachet, and private dealers had been hurt too deeply by the market crash to offer artists the same profits as before.

But Tamara's career continued to thrive, even as other artists around her complained of the newly penurious and cautious public. She also took genuine pleasure in the progress of her sister's architecture career. Adrienne, who'd been designing professionally at least since 1923, was working with the equally talented architect Pierre de Montaut, who proposed that they form a partnership. The resultant firm, Montaut et Gorska, became one of the most highly regarded in France. In late 1933 or early 1934, Tamara painted a portrait of her sister's colleague, in which Pierre de Montaut appears handsome, intellectual, playful, and slightly rakish.

Adrienne's new partnership would require more of her time, and probably the change in her sister's life encouraged Tamara to settle her own affairs. Certainly she was at the zenith of her professional success and could now afford to tend to her personal life without fear of losing momentum. On 3 February 1934 she married Baron Raoul Kuffner at his home in Zurich: "That is when we married," she told her interviewers in 1979, "and we went to Egypt for our honeymoon. And that's where I saw the first pyramid."[56]

Art historians Whitney Chadwick and Isabelle de Courtivron have suggested ways in which long-term romantic relationships, especially marriages, infamous for suppressing women artists, have instead supported aesthetic work. Partners who believe in each other's talent have frequently invented flexible roles to encourage artistic exploration.[57] Raoul Kuffner's marriage to Tamara de Lempicka would enable her career in two ways: he gave her the financial security to continue developing as she wanted, even when her art failed to produce income; and, more important, as a discriminating collector, he had believed that she was a gifted painter from the first time he saw her work. Rarely did Tamara mention his marriage proposal without linking it to her memory of Kuffner's early respect for her talent.

And Tamara appreciated her husband's worth as well. In addition to his agronomical expertise, "Rollie" Kuffner impressed her on several levels, not

the least of which was his love of travel and the impeccable understanding of fine cuisine he had demonstrated during their courtship. Kizette recalls that from the first time she met her future stepfather, she was entranced by his sophisticated culinary habits and knowledge. Watching him order wine at the Ritz, Tamara must have admired the "measured, elegant, and respectful gestures [that] gave prestige and nobility to even the simple ritual of drinking a glass of wine."[58] The secure knowledge of the best that money can buy revealed itself not only in the baron's art collection, but also in the quiet ways that his dress, his choice of drink, and his carefully trimmed mustache announced his right to the barony. The true gourmet turned out also to be a father figure who would feed Tamara from his very well-tended plate. If one of Tamara's few fond recollections of her shadowy father was of sitting on his lap while he indulged her with tastes of his food, Kuffner must have been a deeply reassuring echo of her past.

# Chapter 8

# UNION
## *and*
# DISINTEGRATION

*Lempicka's marriage to Raoul Kuffner* was based on the understanding that the spouses would be companions, dedicated to sustaining a friendly conjugal and often financial alliance, and would pursue sexual fulfillment, romantic love, and intellectual, artistic, and social interests primarily in extramarital relationships. Such an arrangement enabled the partners to enjoy mutual affection and esteem while maintaining complete individual freedom. Tamara had very strong ideas on how to keep her husband happy; she could no longer take marital stability for granted after Tadeusz's surprise retreat. Though she appreciated Rollie's perfect grooming and aristocratic mien, he was not physically attractive to her, but his own extensive reliance upon extramarital liaisons would have made Tamara's lack of desire unimportant. Friends who saw them together did not believe they had ever been sexual partners, though their affection for each other was obvious. At the least, they maintained an amicable marriage that fulfilled the baron's regard for proper appearances.

When asked if, after her second marriage, she continued to take lovers with her on her numerous Italian vacations, Tamara answered, "Yes. I had always an inamorato." "Always?" the startled interviewer repeats. "Always. Because

I loved my husband, but for my inspiration, I like to go out with somebody else. I like to go out in the evening, and there is a good-looking man who tells me how beautiful I am or how great an artist I am or he touches my hand. I loved it. I needed that. And I loved my husband. But I needed flirt. And I had, many."

Yet when the interviewer followed Tamara's cheerful admission of sexual freedom with a question about jealousy, the artist explained that she would not want her spouse to have an affair, and she herself "would never hurt her husband." Convinced that a wife must follow certain precautions to avoid losing her husband to a competitor, she advised the increasingly incredulous interviewer to "Supervise the husband. And not let him go with any girl. First, try to be always elegant, always well dressed, all ways. So that in comparison with the other one, the wife will be always the best. And that she has to keep all her life. The husband is like a flirt [for her]." Asked if the husband also had to live up to such standards in order to keep his wife, Lempicka said:

> When [Rollie] was badly dressed, I said, "Darling, go and change, I don't like this costume." So he went and he changed. He wanted to be well dressed. And when we were going out, he came always into my room and said, "Is it all right? Everything?" And I looked at him and I said, "This is here too wide." I wanted always that he be very elegant and aesthetic. And me too. I was always very supervising. . . . My first husband was very good looking. The second had character. And I wanted him to be elegant and well dressed. And he was. He had good figure. I said, "You eat too many macaronis. That will make your stomach big. That's no good." So he said, "Really? Did you notice?" I said, "Yes, I did notice." So he stopped eating macaroni. He said, "I'm glad you tell me that, because I don't want to have a stomach." He wanted me to be like that. I said, "It's nice." And he try to be like that too. We were just like lovers, not like husband and wife. Lovers . . . and this is what every intelligent woman has to do.

She went on to emphasize, "It's very important. Because woman, when she is forty, fifty years old, she thinks, 'Oh, now I'm old.' And then the husband picks up a young girl, sixteen. And this is no good. . . . He has to be always in love with the wife. That's the intelligent woman, how she does."[1]

At the beginning of her second marriage, however, Tamara's depression worsened, hardly a romantic situation. Possibly the awareness that she had chosen a safe fate, in contrast to her adventurous love affair with Tadeusz Lempicki, drained her emotionally. Certainly the conviction that she was married

to a man for whom she felt little sexual attraction must have been stressful. Finally, any attempt to ignore the likelihood of war was becoming impossible. The very stability she sought from marrying "against type" was vitiated as the world her baron symbolized threatened to disintegrate around them.

On 6 February 1934, three days after her wedding, an uprising by forty to sixty thousand Parisians took place on the Place de la Concorde. Known as Bloody Tuesday, it was a messy clash of various factions whose causes were unrelated. Appropriated by opposing camps, the riot was written up by the Communist newspaper *L'Humanité* as a fight against fascism; *L'Action Française*, a newspaper accused of being pro-Hitler, replied that the fight had been against the Communists and other radicals, including Jews. Five or six more papers competed with their own interpretations, with *Le Matin* simply calling the event "a day of civil war," during which approximately seventy participants were killed.[2] It seems likely that Tamara was terrified by this French version of the struggle among Russian factions that had taken place in 1917 before the final Bolshevik triumph.

In September 1934, seven months after she married Kuffner, Tamara began a rest cure at one of her favorite locations, the Hôtel des Thermes in Salsomaggiore, Italy. Flattered by the hotel concierge's revelation that other guests thought she was Greta Garbo, she agreed to pose as the movie star whose achievements she greatly admired, and sign autographs for the duped guests.[3] Two years earlier, the films *Mata Hari* and *Grand Hotel* had made Garbo famous in Paris, and the painter was impressed that now, in 1934, the actress was earning $250,000 to $300,000 per picture, an exorbitant figure for an artist of any sort. Tamara knew her best from her films of the early thirties, including *Queen Christina*, which, by introducing Garbo's husky contralto into sound pictures, allowed the painter to note its similarity to her own deep Slavic-accented voice. Six years after posing as Garbo in Salsomaggiore, Tamara would actually socialize with her and (falsely) claim a close friendship with the actress, whom she enjoyed resembling, though in truth the similarity was slight.

Such amusing encounters played an important role in keeping Tamara's spirits up. A trip late in 1934 to Germany, however, made it impossible for her to dismiss the frightening signs of Hitler's rise to power. Returning from a trip to Poland to visit older family members and cousins, she decided, as the train approached Berlin in the early morning, to stop off and see some friends:

> *I thought, I will ring them, we will lunch and I will take the*
> *evening train to Paris. And so I did. Hitler was not long in power at*
> *this time, but already the streets were filled with Nazi uniforms*

*and the people were afraid. At lunch in the hotel my friend says to
me, "I am so happy to see you, but how did you get the permit to
come?" And I say: "Permit, what permit?" She becomes terribly
upset. "This is terrible," she says. "We must go to the police at once."
We leave the hotel. We go to the police. They are rude. They take
away my passport. They ask my friend many questions. Finally
they take me to the chief authority. He is sitting behind a big desk
in a big room. He is wearing the Nazi uniform and the red band
on his arm. He has my papers. He looks at them and frowns.
"Madame Lempicka, you are a French citizen?" "Yes, I am." "And
you live in Paris?" "Yes, I do." "And why do you stop in Berlin with
no permit?" He looks at me. I am afraid, but I do not show this. I
tell him. He looks again at my papers; then he asks, "Are you the
same Mme. Lempicka who paints the covers for* Die Dame?" "Yes,
I am." "Ah," he says, coming around the desk to shake my hand. "I
am so pleased to meet you. My wife is most fond of your paintings;
in fact, we have collected all of your covers from the magazine. I
will let you pay the fine, the lightest punishment, and you may go.
But you must* never *come back to Germany." And I didn't.*[4]

The official's insistence that Tamara stay away was probably her own
projection: she feared exposure of her Jewish background as well as her
husband's. Though she never discussed Kuffner's illustrious Jewish ances-
try, *The Jewish Almanac of Czechoslovakia* lists his family as "a preeminent
Jewish patriarchy." Raoul Kuffner's choice of Switzerland for his home
during the volatile 1930s was surely motivated by his vulnerability to Nazi
terrorism.[5]

Others around Tamara were nervous, but she was terrified, and her fright
motivated an entirely different kind of realism in her art. Leaving behind the
glamour of the rich and famous, she now focused on the displaced, the poor,
the itinerant, and those who gave succor to the suffering. She had pushed the
portraiture of the twenties and early thirties to its apogee of glamour, daring
to stop brilliantly at the instant just before hedonism degenerated into cari-
cature. Now, risking charges of sentimentality, she began to seek the moment
that preceded bathos. She entered a period of hyperrealism. Incorrectly and
most frequently referred to as Naturalism, her style was a complex, unusual
blend of German Expressionism and Italian quattrocento.

Tamara was ready to move in a new direction. Uninterested in compet-
ing with the reigning ideology of the moment, she nonetheless valued
remaining up-to-date. This paradox, according to her granddaughter,
reflected the artist's sense that her own life exhibited the constant flux of

displacement. Peripatetic to the end of her life, she was intensely alive to the politics of the day.[6]

Perhaps partly to ensure her daughter's safety, Tamara had by now enrolled Kizette at St. Hilary's College, Oxford, where she would graduate with a degree in linguistics. Tamara and Kizette had spent limited time together for the past three years, but her daughter's departure for university signaled the inevitable movement into adulthood of her only child, a sign of Tamara's own loss of youth. And with Kizette's absence, any reminder of the painter's previous life with Tadeusz was gone.[7]

On 18 January 1935, Tamara wrote Italian collector Gino Puglisi, describing frankly her poor mental state. Ever since her visit to Zurich to spend time with her new husband in their official residence, she had been deeply depressed. Now, from Valmont, Montreux, she wrote:

> *Kind sir,*
> *I thank you very much for your good letters and best wishes. For more than two months I have stayed always in bed. After Zurich, I have come to Valmont, but I always am feeling very sick. For only one hour am I able to get up, for the rest of the day always woes, who knows? And the endless nights of being unable to sleep. I can't work nor read, my depression is too great. My head doesn't work anymore.*
> *It's also this climate without sun. I always feel worse. I'd like to leave all this one day to come to Italy! I'm sure I will feel better. . . .*
> *Don't get angry that I write so very little, but I think of you often, and whatever good there is in me you can also find in my paintings in your collection.*
> *Thanks also for your kind news, you who know artists and the real value of a good word to them.*
>
> *Tamara de Lempicka*
> *P.S. If I'm in Rome, may I write you, perhaps to come see you?*

Gino Puglisi's role in Tamara's life is known only through the few letters that survived from their long correspondence, and from Kizette's vague admission that they were lovers. At the least, the letters from the 1930s reveal that when Puglisi apparently asked her to talk more of herself, she explained to him that her art expressed the best of who she was. It seems likely that Tamara felt vulnerable in her identity as a painter, given her new role as a wealthy baroness. Furthermore, adusting to a passionless marriage apparently required great emotional resources. Because her friendship with Puglisi had begun earlier, when he purchased her work, she was comfortable

revealing to him her emotional conflicts. Perhaps he functioned as a safe surrogate for Raoul Kuffner.

On 12 May 1935, Lempicka wrote Gino from the Hôtel Sabinius, in Rheinfelden, Switzerland:

> *Dear Friend, and it is thus that I must write to you now, because I feel that your news [reference unclear] for me is beautiful, human, pure, very man-to-man [reference unclear]!*
>
> *I haven't written to you in a long time; I wasn't able to relate anything good. I am always sick, always with more woes, physical and moral. I can't work right now, I hate my life, which is useless, without scope.*
>
> *For two weeks, I have been staying in a little countryside [sic] near Zurich.*
>
> *For more than a month, I have been in bed.*
>
> *I don't get up! And why?*
>
> *I am all alone, and better off that way.*
>
> *For two weeks, the doctor wishes that I make a little journey. (Maybe I'll come to Italy.)*
>
> *And afterwards have to return to continue the cure.*
>
> *Tamara de Lempicka*[8]

Six months after her first letter, on 7 June 1935, she again wrote Puglisi, who, judging from the letter's tone, had risen in her affections. Residing in Zurich at the Hôtel Baur au Lac rather than at the Kuffner apartment at 24 Mythen, she had already initiated the couple's routine of staying in separate residences, even in the city where they had a permanent home.

> *Dear Friend—I have not written to you—because I have been at work, and also am feeling unwell. I have finished three little paintings for the exhibition "les Femmes Articles Modernes" at the Galerie Bernheim. Also I have begun two new portraits without finishing the other work I have begun.*
>
> *My unhappiness "depression" has not left me—I have no interest in living. I want so much to die! Please excuse me for writing so frankly—but you "know" so well: this torment that never ends.*
>
> *I reflect on your great "empathy."*
>
> *Tamara de Lempicka*

Tamara was not a letter writer; her correspondence with D'Annunzio was notable both for its very existence and for the histrionic style she copied

from the poet himself. In contrast, her letters to Gino Puglisi are sincere expressions of her emotions, written in competent if idiosyncratic Italian, with minor misspellings and occasional French substitutions. D'Annunzio scholar John Wayne has noted that in these letters Tamara seems to be mimicking a conventional Italian writing style, both physically and in the turns of phrase, as if seeking to reflect her sympathy with the culture through her use of its language.[9]

Open to Puglisi in ways that she avoided with her friends and family in Paris, she told him truths while she fed frivolous accounts to everyone else. When alluding to her depression during the thirties, for instance, she later breezily told acquaintances that she had been afflicted with the general malaise all hardworking artists encountered; or she referred to the sadness and anxiety that accompanied the signs of war all over Europe. But the letters to Puglisi, their omissions about her new life with Kuffner speaking loudest, imply that her depression was linked most strongly to her marriage, to the differences between her relationship with Tadeusz Lempitzki and her marriage to Raoul Kuffner, or to the tension between her desire for freedom and her need for security. Even the practical, straightforward way that Kuffner asked Tamara to marry him—basically as an appropriate replacement for his dead wife—and the equally efficient way that she accepted, contrasts deeply with the reckless romance and illegitimate pregnancy of her first marriage.

Her correspondence with Gino Puglisi usefully documents her mental health throughout the decade. On 19 August 1935 she wrote Puglisi about delivering a painting to him personally, though she insists it would be hard to get to Italy and, even more bleakly, that the trip to her beloved land would fail to restore her as it had in the past:

> *About the 9th of September, it will perhaps be possible for me to go to Rome, or to Lake Como for a while, but what little hope.*
> *I can bring you the large nude I'm holding for you. Or write me in Paris if you want me to send it instead.*
> *On 17 October I will be having my show at the Galerie of André Weill (Avenue Matignon) until 1 November; then I return to New York.*
> *For about two years my health has been very bad. Heart-trouble—I must make life very tranquil—perhaps attempt to work.*
> *Hoping you are well?*
>
> *Best wishes,*
> *Tamara*

The phrase "what little hope" in the context of the otherwise flat language, lacks melodrama. Indeed, even Tamara's mention of the André Weill show is conspicious for its perfunctory tone, unlike the excitement she typically exhibited for such events. Since there are no records or memories of heart disease among her family until the end of her life, she was probably repeating her doctor's euphemism for depression. She may also have been experiencing erratic heart rhythms produced by stress, which would justify the medical prescription for tranquillity. Still, the subsequent "perhaps attempt to work" did not qualify, especially for Tamara, as a sedative. Remarkably, her low expectations for relief were to be confounded by the epiphany she experienced when she did travel to Italy.

Rather than visiting Lake Como or Rome, Lempicka traveled to a convent near Parma, but this time she presented herself undisguised. Years later in Cuernavaca, she explained the experience to journalist Joanne Harrison, "rolling her eyes back and masking her face with her widespread fingers":

> I was in an artist's depression. When you create, create, create and put out so much of yourself, you become drained and depressed. I had gone to Italy to deal with the depression, and there I suddenly decided to give it all up, to enter a convent near Parma. I rang the bell. A lovely nun answered and I asked to see the mother superior. "Sit down, my child," she says. I sit on the hard bench and wait. I do not know how long. Then I go into a wonderful Renaissance room with the ceiling and the columns and there was the mother superior, and on her face was all the suffering of the world, so terrible to look at, so sad, and I rushed out of the room. I forgot for what I came there. I knew only that I must have canvas and brushes and paint her, this face.
>
> But already we are packing to leave for America, my second husband, the baron, and I. So I must wait. We arrive in New York. We are staying in the Ritz Hotel, but I have a studio in another place, an old, dirty studio with a cat, just like in Europe.
>
> I take from my hotel black cloth and white cloth and in the studio I put them on an old armchair that is on the podium in the good light and then I see her, the mother superior. It was as if I am in a trance, a fever. I talked to her and told her to turn more to the left and so on and so on. After three weeks I worked and worked and it was finally finished. It is small, no bigger than this magazine. My husband put it on the mantel in the hotel. He looks for a very long time in silence. Then he says, "This is the best, I think."[10]

Her less carefully edited account to her Japanese interviewers in 1979 added several interesting details, turning her act of painting into a kind of hallucination:

> *I was very depressed. . . . I will go in a Catholic convent. And then I will be a nun. And then I could paint. But I don't want to exhibit, I don't want to see people, I don't want to have success. Depression, nervous depression. And I was in Italy in Salsomaggiore. And I asked, "Where is the convent?" and they said, "But here, Parma, it's quite close to Salsomaggiore." [She found the convent and met the nuns.] And they said, "Sit down, my child." It was so good that they called me "my child." I was so depressed. And I was waiting, maybe ten minutes, maybe twenty, I don't know. A long time. And then I saw an older lady that came to the table, and that was she. That was the mother superior. . . . She said, "Viens mon enfant . . . child, the mother superior is here." [I asked her to] take me in the convent. But all of a sudden I wanted to paint this fantastic face, the expression of this woman. Her eyes were suffering. I didn't say anything and I left. I left without saying a word. My husband and I were about to go to America. And when we came to America, I said to my husband, "I want to paint. I have no studio. I have to rent a studio." He said, "But can you paint here in the hotel?" and I said, "No, I cannot." And through some friends, painters, I rented a studio in New York. It was first time I went to New York. And I was going every day in this old dirty studio. Poor, but good light. I put a chair like this. I put a piece of black material and a piece of white material. And she was there. . . . The mother superior was there. She was sitting on the chair. And I was talking to her. I said, "Little more . . . the head to the left. . . . Thank you very much, let's rest." I became like crazy. I was talking to her, I thought that she's there. She was like a light. And I was painting her and talking to her. And my husband said, "But where are you the whole day?" I said, "Don't worry, I'm working, I'm working." And I worked three weeks on this painting. I thought that she was there with me. And after three weeks, I brought this small painting to the hotel, and I put it in the room. And I said to my husband, "I will go and lie on my bed. If you want to look, this is the painting I did." And I went to my bedroom, closed my eyes, and didn't want to think about anything. He was looking at the painting and then he came in with tears in his eyes. And he said, "Now I understand that you were working. You created the most beautiful painting you ever did in your life." The painting was exhibited and every museum wanted to buy the painting.[11]*

In fact, *Mother Superior* was not exhibited until 1939, when Tamara returned to the United States. She never believed she was offered enough money for it, however, and she eventually donated it to the first museum that had bought her work in the twenties, the Musée de Nantes.

Italy continued to be Tamara's favorite retreat from her home life, and she had as many friends there as in Paris.[12] During this period, the talented singer and former member of Manhattan's elite social register, Cobina Wright, whom Tamara had met in New York, spent time in Venice showing her beautiful teenage daughter—Cobina Junior, as she was called—the sights. At Harry's Bar, which Tamara frequented almost as much for its figs, which she loved, as for its clever patrons, the painter introduced Cobina to Italian acquaintances who haunted the "smartest" restaurant around.[13] Their schedule would have been full: "There are a thousand things to do . . . some wonderful receptions, a grand ball, three very important concerts. . . . "[14] Socializing with the wealthy and interesting American reminded Tamara of how comfortable she had felt when visiting the United States.[15]

But her despair kept resurfacing. Kuffner urged her to become part of the social life of Budapest and Vienna, since he spent much time in those two cities. Budapest at least should have pleased Tamara, since it was, according to her friend Martin Shallenberger, "more swinging than Paris in the mid-1930s. Budapest was even jazzier than Vienna; nightclubs ran all night, we danced on balustrades. Hungary, the baron's country, was rich, with lots of food and grain, and only about 15 million people. And Tamara was good friends with Baron Hotvani, from a big Jewish family of Franz Joseph's time, whose marvelous house on the hillside with several layers of gardens impressed everyone." Shallenberger recalled, however, that Kuffner was considered "newly made," not old aristocracy, and that Tamara forced herself on the local nobility too much to be accepted. "And," he added, "people were inevitably jealous of her. She was domineering; she commanded any scene she was in. She'd attend the spring horse races in Budapest every year, and all the attention would be on her."[16]

Sometime during late 1935, when the usual social events had failed to revive his wife's spirits, Kuffner arranged for her to seek psychiatric help at a famous Zurich rest clinic, the Bircher Clinic, where at least five years earlier the baron himself had taken his first spa cure. During the thirties, belief among the upper classes in nutrition and exercise as cure-alls was widespread. Paris's greatest hostess, the American Elsie de Wolfe (Lady Mendl) explained to any interested parties that she owed her healthy advanced age to her separation of starches and proteins, her consumption of raw vegetables, and her adherence to a diet of light eating, with one main meal a day

of fish and green vegetables, accompanied by a martini and followed by ice cream, with perhaps some champagne afterward.[17] Tamara adhered to a similar diet, including the passion for ice cream, throughout her life, and in her last years repeated Lady Mendl's "lifelong preference for youthful company" as the antidote for aging.[18]

The Bircher Clinic itself, dedicated to healthy living, became a staple of Tamara's life for several decades. Directed by Dr. Bircher-Benner and his wife, Bertha Brupbacher-Bircher, the clinic was the chic choice in the thirties, forties, and fifties for rich Europeans, who went there to live simply for three weeks in a sanatorium. "It was a very liberal clinic for the times," Kizette remembers. "Jews were allowed without question; no one asked where you came from."[19]

Bircher was a vegetarian, and for the duration of their expensive visit, his patients ate a strictly monitored diet heavy on whole grains and raw vegetables. The cookbooks he later published include exhortations to use all natural ingredients, and to cook fruits and vegetables as little as possible. The famous Bircher muesli, which became a staple on European grocery shelves, so impressed Tamara that she began carrying around her own apple peeler in order to make the cereal herself. But though Tamara would later adopt the clinic's nightly routine of oatmeal, she was initially resistant to its precepts.

Kizette recalls that her mother would often pretend to follow the regimen and then sneak off to the bakery down the hill to eat as many napoleons as she could. On one occasion when Kizette accompanied her to the clinic, Tamara sneaked out, bought a giant sausage at the local butcher shop, and finished it off within minutes. "Her eyes actually seemed to shine when she cut into the gleaming sausage, which had been absolutely forbidden," her daughter recalls.[20] The rich meat made her ill, but Tamara refused to tell the clinic's doctor what had caused the problem until he insisted: "You did something. You have to tell me what you did." Finally she capitulated: "I went out because I wanted some meat. And I bought a whole big sausage and ate it all."[21]

Kuffner was not so much interested at this point in Tamara's physical ailments as in her mental health, and he persuaded her to see a psychiatrist at the Bircher Clinic. Whatever the doctor's effect on her depression, Tamara quickly sanctified the psychiatrist by using him as the model for a painting of St. Anthony the healer. Notable for the humility of the saint's pose, the portrait reveals Tamara's interest in hands, which she now exaggerated into a surrealistic suggestion of the skeletal.

In spite of the Bircher Clinic's interventions, in early May 1936 Tamara felt worse than ever, judging by an awkward letter she wrote to Gino Puglisi, a letter that also suggests the ambiguity of their relationship.

*Dear Friend,*

*When I had written that your friendship for me is "pure and human, like a man for men," your letter in response seemed to me a little strange, as if ironic? Why? Maybe I didn't understand? Maybe you didn't understand?*

*Also, you had written nothing to me about my latest works, which you must also have received with the photographs?*

*Your friendship for me is not for a "woman"—it is for a being who suffers, who torments herself in an eruption, but also in living! This, which I understand so well. But I hope that for you I am not a "married woman," a "lady," a "blonde"??*

*Sometimes I myself forget to say what I am!*

*Am I a "lady"? No! I am an unhappy being, tormented, without a homeland, without a race, always alone!*

*If I am able to work?*

*But in order to work, to say something, I must have the need to say I am empty. I am like a dead person, useless, stupid, I live without reason, without enthusiasm, without verve.*

*I know that I require "patience" to get by, etc., etc. No, I won't go any further.*

*At this moment, I was brought your last letter of 28/5.*

*My Self-Portrait?*

*No, I cannot talk about this. Every one of my paintings is a self-portrait.*

*I want above all to finish my painting of St. Anthony, which I began last year at Zurich. I want a subject that will bring me peace. A self-portrait would be: disquieting.*

*Late tomorrow I will be in Monte-Verita again, a magnificent place in Switzerland on Lago Maggiore, near Italy. Tomorrow I return to Zurich (Baur au Lac).*

*If you are religious, if you believe in God, go into a little church, so beautiful, so Sicilian, so "humble," and pray for me.*

*T.L.*

It is hard to know what to make of this extraordinary letter, especially since the next one extant is dated ten years later. Between Tamara's idiosyncratic use of language, and the absence of Puglisi's letters to her, many of the most tantalizing sentences remain a mystery, though their relation to Tamara's concerns about her professional identity seems clear. Perhaps Puglisi had implied that he was attracted to her, and she was belatedly establishing the relationship's boundaries: "Sometimes I myself forget to say what I am!" But she immediately implicates her personal life within her role as an

artist when she declines to discuss her self-portrait, saying that "every one of my paintings is a self-portrait." Unlike the "peace" she hopes to achieve by painting her doctor, only disquiet would result from a literal self-portrait. That Tamara was in search of some existential meaning in 1936 is obvious from her artistic output of 1935 to 1939. The work of these years—*The Old Man, The Peasant, St. Anthony, Mother Superior, The Refugees, Somewhere in Europe*—substantiates the religious and philosophical questioning that preoccupied her during this period. Looking for peace, she executed a series of yet again uncategorizable portraits. A slight exaggeration of form, psychology that borders on the cartoon: such pieces deliberately combined the realism of the Renaissance masters and her favorite seventeenth-century Dutch portraitists, a culmination of her earlier tendencies. The dramatically positioned tear in *Mother Superior* reappears in 1937, in *Girl among the Lilies*, a painting so tense that it borders on the surreal. The warts, veins, and downturned lips that now become commonplace in Lempicka's portraits contrast boldly with her earlier depictions of perfect skin.

During 1936, Tamara exhibited in Paris at the prestigious Bernheim-Jeune Gallery, in a group show, *L'Exposition des Femmes Peintres.* If the avant-garde of the thirties was closed to most of the female painters of Paris, critics like Louis Vauxcelles, André Salmon, Maurice Raynal, and Guillaume Apollinaire nonetheless praised their attention to the figure, if only to offer a dissenting voice to proponents of surrealism. Maria Blanchard, Marevna, Alice Halicka, and Tamara thus constituted an alternative to the reigning Parisian aesthetic.[22] Such male support, although often chauvinistic, encouraged Lempicka to translate her emotional turmoil into narrative painting. In 1937 she showed in two other all-woman exhibitions, *Les Femmes Artistes d'Europe* at the Jeu de Paume, and *Femmes Artistes Modernes* at the Galerie Charpentier.

In spite of Tamara's lack of interest in gender politics, she benefited professionally from the heightened attention being paid to areas associated with femininity, as exemplified in the convergence of fashion and photography. If the preceding decade's collaborations between the textile industry and artists such as Raoul Dufy, Sonia Delaunay, and Paul Iribe had not established fashion as an art form, the now hard-won respectability of photography did. A sculptural emphasis, redolent of André Lhote's own plastic rhyme, undergirded high fashion in 1937, when Tamara's favorite designer, Madame Alix Grès, showed her "Temple of Heaven" dress, whose Grecian lines were especially flattering to tall women like Tamara. Jane Owen, Tamara's friend and a fellow devotee of the couturier, recalls, "We both adored the way Alix had of draping the material so perfectly that she could have been a sculptor herself. She loved classical allusions, though she

depended upon the folds for the effect, not upon elaborate materials. Almost any woman could look wonderful if draped by Madame Grès."[23] Tamara approved of the respect being accorded fashion designers: After visiting Coco Chanel in her apartment at the Hôtel Ritz, Tamara noted that the couturiere's approach to decorating was not from this century and yet it still looked "right," because she understood the principles of style. She subsequently treated Chanel "almost with deference," according to her granddaughter Victoria. "Grandmother even let her go first in an elevator once, murmuring her greetings, when we were visiting Paris in the 1960s. I was unaccustomed to such treatment from Tamara except for royalty."[24]

The intersecting worlds of fashion, politics, and art had preoccupied French culture since at least the Arts Décoratifs exhibition. One successor to that 1925 show was the 1931 Exhibition Internationale Coloniale, staged in the Paris suburb of Vincennes. At that time, the organizers had tried to encourage a "colonial style," with only the Surrealists protesting the approval of colonialism implied by the exhibition. Now, in 1937, Paris hosted the Exposition Internationale des Arts et Techniques dans la Vie Moderne, which feigned an internationalism capable of accommodating warring ideologies. This exhibition revealed the tensions of the time, even though it was intended to present a unified front, suggesting hopefully that an organic harmony was still possible. The architecture told a different story, however: immediately upon entering the exhibition grounds visitors saw the German and Soviet pavilions competing on opposite sides of the Champs-de-Mars. The Nazi pavilion, 54 meters high, was capped by a huge eagle, while the Soviet building was crowned by an enormous 33-meter-high statue of a worker and a farm girl holding a hammer and sickle.[25] Both structures appropriated the conventions of classical architecture to serve the purposes of totalitarianism. Art Deco, which similarly evoked the ideals of a classical past, became linked to such an aesthetic, causing it to be viewed suspiciously by conservative and liberal critics alike.

Adrienne's presence on the jury of the 1937 exhibition was probably the only reason that Tamara's 1931 *Adam and Eve* was exhibited, and it received little notice in the midst of the massive enterprise. By this time, Adrienne had become almost as successful as her sister. Several years after she formed the partnership with Pierre de Montaut, the small company opened an office in Cannes, which he headed while Adrienne directed the Paris branch. Their most famous collaboration would be the project they began in the early thirties, originally called *actualités cinéma*, then CINEAC, and today U.G.C. Newsreels. Funded by a very "rich and distinguished Englishman named Ford," according to Pierre's daughter, Françoise Dupuis de Montaut, these

mini–movie houses were built to show hourlong, continuous newsreels; they were located most often in or near train stations where customers could dash in and out at their convenience. By the time they were finished, the partners had built 190 late Art Deco–style theaters whose sleek, neoclassically inspired exteriors harmonized with the similarly styled new high-speed trains next door.[26]

The project was an immediate hit, and the Gorska-Montaut buildings became so well known that in the 1940s the Société Française d'Éditions d'Art published a volume dedicated to their work, *Vingt Salles de Cinema.* Tamara was extremely proud of her sister's achievement, toward the end of her life telling interviewers, "When you are in France, ask where are the movies that are only one hour. It's still her idea and that was fifty years ago."[27] In 1937, Pierre de Montaut was among the first architects to design a cinema complex, which was built in Marseilles. Adrienne turned her attention at this time to "advising him on decoration, colors of walls, seats, curtains."[28]

While her sister immersed herself in cinema architecture, Tamara sought ways to create a stronger marriage and family life. During the winter break in 1938, Kizette accompanied her mother and stepfather to Lake Como, where they had one of their best Christmases ever. While Rollie and Kizette were out shopping, Tamara took sheets of bright red paper, cut "hundreds of connected stars, and strung them up on a beautiful spruce tree in the room. It is among my happiest memories—she was in such a good mood, and the tree was so beautiful," her daughter remembered sixty years later.[29] Kizette, who affectionately called the baron Papali, appreciated Kuffner's paternal attitude, especially his role of peacekeeper between her and her mother. As Kizette got older, her own strong will began to assert itself more often against Tamara's. The only confrontation at this particular reunion, however, was a loud and heated argument between the Kuffners. The baron was shocked by his wife's profligate spending habits; to his criticism she replied that she had money of her own. The shouting disturbed other guests, and the embarrassed management tapped on the Kuffners' door to request more decorum.

But Tamara felt that Rollie listened to her, and his faith in her talent emboldened her to ask him to emigrate from Europe. Her friend, the Bulgarian Jules Pascin, had acquired American nationality very easily in the early twenties, and he had not had any difficulty traveling back and forth between Paris and the United States; this was what Tamara apparently had in mind for the foreseeable future. She found examples that suggested she would be appreciated in America just as she was in Europe. Alice Halicka, her Polish compatriot, had in only the three years between 1935 and 1938 organized two shows of her work in New York—one at the M. Harriman Gallery and

the other with Galerie Levy. Halicka had managed within that same period to design several ballet sets in New York, including those for *Jardin Publique* from Gide's novel, a production mounted at the Metropolitan Opera and later at Covent Garden in London.[30] Equally reassuring, Halicka and her artist husband, Louis Marcoussis, had moved among the best social circles in Manhattan, where dinner parties and teas were held in their honor.[31]

During 1938, Tamara was preparing emotionally as well as physically to leave Europe. That spring Kizette graduated from Oxford, where she had excelled athletically and academically. A member of the university's rowing team, the young woman, a natural athlete, had earned Oxford's coveted blue sweater, the British equivalent of lettering in the Ivy League. Kizette's com-

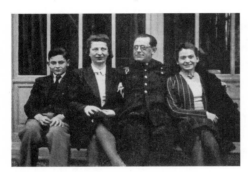

*Adrienne and Pierre de Montaut, with his children, Jean-Pierre and Françoise, c. 1939.*

petence and independence freed her mother to concentrate on her own efforts to escape what seemed to her an inevitable war: the Munich Accord would only buy time; Hitler would triumph, and Tamara wanted out of Europe. When Adrienne confided that she and Pierre de Montaut, whose wife had died in 1937, were to be married the following year, Tamara realized that her sister's new life would undoubtedly make her less available, a thought that added to her motivation to make practical plans for the future.[32] Luckily, Adrienne's marriage would ensure a good home for Malvina, so that Tamara did not have to arrange for her mother's care.

Successful finally at persuading Rollie to leave Zurich, she helped Kizette arrange a visit to Tadeusz in Warsaw, telling her daughter that she and Papali were planning a trip as well. The Kuffners then quietly arranged to have the Castle Dioszegh estate treasures shipped to the United States. They told friends and the newspapers that they were traveling to New York for Tamara's work. At a going-away party in early 1939, the artist announced that she looked forward to seeing everyone soon: "I will be back for the next wonderful party with my friends after I finish my commissions in America."[33] On 24 February the *Paris Midi*'s coverage of another farewell celebration elaborated on this story: "The occasion was the send-off of Tamara de Lempicka to America. Tamara, the beautiful artist whose extreme talent leaves behind yet another portrait of the singer Suzy Solidor, says a temporary good-bye to Paris. She left yesterday, fortunately for a trip of only a few

months to New York, where she has been commissioned to do several por-
traits. She reluctantly agreed to leave her beautiful studio in Rue Méchain
to make the trip. Before leaving, Tamara, also the Baroness Kuffner, gathered
her friends for a cocktail party. She was dressed in a long black dress, very
simple, decorated with a big sequined fleur-de-lys. The artist, smiling
wickedly, told those who complimented her on her outfit, that the 'fleur of
lys is the symbol of my purity.'"

But in reality the Kuffners had carefully prepared for what they assumed
would be a long-term if not permanent change of residence. It was impossi-
ble for a couple so weighted down by expensive possessions and residences
to transport their assets across the Atlantic surreptiously, and they would
inevitably take serious losses in becoming émigrés. For Tamara freely to give
up wealth and possessions meant that she felt the stakes were enormous, a
belief revealed in one of the last paintings she completed prior to her move
to the United States. The 1939 *La Fûite* (Plate 10) is a testimony to her fears:
a disheveled woman, similar in age to Tamara, holds a child in her arms as
ominous clouds gather overhead. The streets in the background are deserted;
gone are the optimistic, vital, urban backdrops of earlier works. The woman,
her sunken eyes vacant, is a refugee on the move. A somber beige dominates
the canvas, intimating a hovering anxiety. In 1979, Lempicka stated that
although the actual scene came from her imagination, she had been inspired
by news accounts of the day: "I suffered. . . . I suffered very much because
people were running away from their houses and people were killed by the
Germans. So I was very sad and very nervous and I imagined a woman who
is running away and the father and maybe another child is killed. I was very
serious person. . . . And I suffered very much in my life."[34]

In spite of the narcissism that partly drove her claims of great suffering,
Tamara had, in fact, already once been cruelly forced out of one life and into
another by the brute weight of historical events. And despite her renewed
efforts after 1917 to control her own narrative, history once again was prov-
ing itself the victor. The American women's movement would promote the
lesson that "the personal is the political," but Tamara de Lempicka embod-
ied its wisdom thirty years earlier as she was forced to acknowledge that no
individual strength could overcome the poison of fascism. Now, in 1939, she
had no choice but to abnegate her claim to the center stage she had finally
won. She and Raoul were Jewish, and they were rich, high-profile socialites.
As if to appease the gods for her proud ambition, when she departed for
America with her second husband in February 1939, the renowned artist
and diva filled in the visa application space for "calling or occupation" with
one word: "housewife."[35]

*Chapter 9*

# The HOLLYWOOD INTERVAL

*Tamara and Raoul Kuffner set sail for* Manhattan in February 1939, but their visit to New York was merely a smokescreen for their real destination— Havana, Cuba. Apparently the Kuffners needed to ensure that no quota restrictions against Jewish immigrants fleeing Europe would be levied against them, and Raoul's expertise in beet farming and sugar production would provide that assurance.[1] After years of speaking and consulting on the modernization of agriculture, Kuffner had achieved an international reputation as a forward-looking businessman as well as a wealthy farmer of the old Austro-Hungarian Empire. Now he would teach the owners of Cuban beet plantations how to increase their profits while treating the workers more humanely. Then, with the help of the U.S. Embassy in Havana, he would be entitled to apply for immigration to the United States under the privileged category of "expert agronomist."

From their arrival in the United States until mid-July, Tamara lived at the Waldorf-Astoria, though she took several trips to Connecticut and Pennsylvania to paint wealthy patrons. Her husband stayed at the hotel for two or three weeks, then went ahead to set up their home and begin work in Havana. His absence allowed her to socialize at the

breakneck speed she enjoyed most, in a society whose prosperity confirmed the Kuffners' decision to make new lives in America. As one commentator noted: "Production was up, unemployment was down, the mood of the country was optimistic, and the upheaval in Europe was 3,000 miles away."[2] This American assurance, this public security, had encouraged Tamara Rosalia Gurwik-Gorska de Lempicka Kuffner to trade everything she had achieved in Europe for a chance to start over in the New World. She no doubt compared the sense of opportunity and newness in the Paris of her early success to the atmosphere she was now entering.

Even the aesthetics surrounding her augured well for her professional future. In 1939 the World's Fair was held in New York, an event whose Art Deco–inspired futuristic architecture reassured the artist that her new country would welcome her talent. The lavish sets of such Hollywood movies as *Trouble in Paradise, One Hour with You*, and *The Greeks Had a Word for Them* were also Art Deco, as were the sets of most of Busby Berkeley's musicals. In reality, the aesthetic that triumphed at the 1939 World's Fair, Streamline Moderne, represented Tamara's older work, instead of her new, slightly fussy hyperrealism.[3] But the painter would always appreciate Art Deco's sleek, muscular line, a principle she would incorporate into future turns of her own art. More important, the overt celebration of the aesthetic through which Tamara had gained fame and success surely comforted her. It must have seemed auspicious that the glamour from her early years in Paris had been transplanted onto American soil.

It also reassured Tamara that New York at this time was filled with other wealthy Europeans. Newspaper society columns of the period reveal that Sergei Voronoff, the scientist who had continued to socialize with Lempicka after she married Kuffner, appeared at Manhattan parties with his own new spouse, who vindicated Tamara's choice of husbands: "I would have gotten fat and lazy, just like the woman he married," she later confided to Kizette after joining the Voronoffs for cocktails.[4]

But more significant than such friends from home were the Americans she had met before and who could now help ease her way into local society. One such acquaintance, Cobina Wright, returned the hospitality Tamara had offered her in Venice by arranging the painter's immediate inclusion in her social circles in New York. One of Tamara's first American publicity ploys was in conjunction with Cobina, who arranged for the *New York Times* to photograph the two women arriving at a hat contest held at the Sherry Netherland Hotel.

In many ways, Cobina's experiences had paralleled Tamara's. A promising young classically trained singer, Cobina had married into the highest

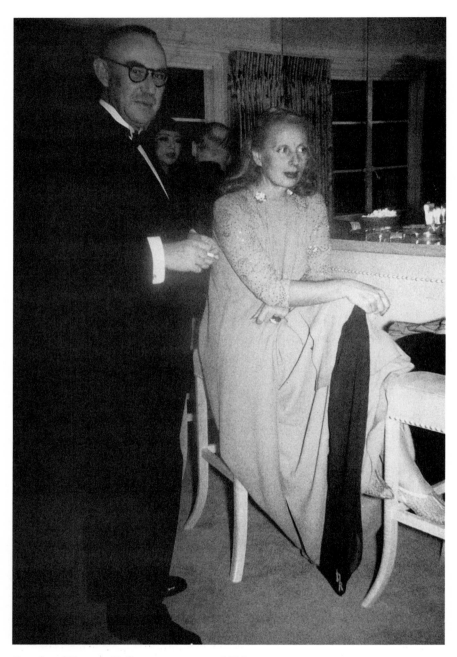

*Raoul and Tamara Kuffner on a cruise, c. 1938.*

reaches of old society; she went on to help her third husband, Bill Wright, make millions on the stock market in the twenties. Like her friend from Paris, she patronized the designer Paul Poiret; and Cobina, like Tamara, also enjoyed designing and sewing her little daughter's dresses. Throughout the 1920s, the singer-socialite alternated between renting Carnegie Hall, where she performed to excellent reviews, and retreating to build a new mansion or give ever bigger and more creative parties. Like Tamara, she had always "believed I could have the best of all possible worlds—both worlds." By the late twenties, however, her marriage to Wright was failing, and she had lost her chance at a career: "I never sang at the Metropolitan Opera House. If I had put my [singing] first . . . but I never did. If I had discarded it altogether . . . but I never could." After the Wrights lost most of their wealth in the crash of 1929, her husband left her for another woman, and Cobina began singing in clubs and restaurants to earn money for herself and her daughter, Cobina Junior. She encouraged the girl, who was considered one of the beauties of the age, to pursue a career in Hollywood; there she immediately was offered a film contract, sweet compensation for Cobina, whose prodigious creative energies had, for several years by then, been poured into her daughter's life instead of her own.

It was Cobina who had helped to create in New York the very kind of café society Tamara so loved. In the mid-twenties she had brought together New York society to fête a singer from the Comédie-Française. At that time, when "the lines were still firmly drawn" between social classes, she had accomplished an extraordinary feat: newspapers announced that "if a society woman succeeds in inducing celebrities to come to her home of their own accord and in droves, and the people of her own gilded world will come also, she has achieved the goal of all New York matrons—a salon."[5] Tamara benefited from the social freedom created by Cobina, as members of diverse groups began to mingle as equals.

In press accounts, Cobina is cited more consistently as Tamara's guest or friend than anyone else. Certainly she would have respected the painter's capricious disappearances when her work demanded it. Within days of her February arrival, for example, Tamara began preparing for an important show, which took place from 2 to 23 May 1939 at the Paul Reinhardt gallery in Manhattan. On 15 May 1939 *Art Digest* described her painting as "a deposit of virtuosity," encouraging her that her reputation in America would advance, unchecked by her refugee status.

But the paintings displayed at 730 Fifth Avenue—*The Old Musician, Blessed Virgin, Peasant with Jar, Saint Antoine, Peasant at Prayer, The Refugees, Old Man, Three Girls, Suzanne au Bain, Claudia, The Virgin and Child,* and

*Girl with Flowers*—mostly centered on humble subjects, a constant theme in her work for the next three years. They did not reflect America's Streamline Moderne aesthetic, as had her work during the previous decade, nor did they embody the muscular Social Realism that the WPA had validated, and yet they participated in both styles. Tamara's latest portfolio once again defied easy categories and provided no clues as to how to approach her art. In this first exhibition after leaving Europe, she began setting the stage for the confusion that would undermine her reputation in the United States.

After the Reinhardt show in May, Tamara stayed for a month in Woodbury, Connecticut, where several other European artist-émigrés had gathered.[6] She spent the Fourth of July in New Hope, Pennsylvania, the famous Bucks County artists' colony, where, Kizette remembers, her mother had been hired to paint a portrait.[7] Pictures processed by the town's single photo lab show Tamara, dressed in culottes that emphasized her long legs, sitting on the expansive lawn of a Victorian country house, with a masculine-looking woman crouched behind her, her hand on the artist's shoulder. In other shots, a middle-aged man appears with the two women.

Soon after this apparent commission was finished, Tamara joined her husband in Havana. Tiny sepia-toned pictures found in the bottom of Kizette's photo drawers in a bag marked "1939" show scenes typical of the sugarcane fields east of Havana and surrounding Santiago de Cuba. One picture, shot from a distance, focuses on neatly thatched roof huts and banana trees. Another photograph shows a donkey outside a Cuban store, with the Spanish letters on the sign barely visible. Judging from the remaining pho-

tographs, however, such humble scenes played little part in Tamara's two-month residence in Havana from July to September. Several pictures suggest that the Kuffners enjoyed the pleasures typically available to wealthy visitors or expatriates. Tamara and Raoul are frequently shown seated in garden chairs in front of a lavish colonial house. A rock-filled stream nearby pro-

*Tamara in New Hope, Pennsylvania, 4 July 1939.*

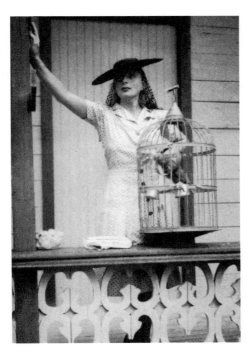

*Tamara in Cuba, 1939.*

vides an excuse for the artist to pose with her dress hiked up over her thighs, as she gazes flirtatiously at the camera. Close to their house were the Yacht Club, the Tennis Club, and the Country Club, all crowded with women whose clothes were "straight out of *Vogue.*" "Veritable palace[s] by the sea, with sea breezes sweeping in from the jeweled Gulf of Mexico across sparkling white sand to cool tiled and scrubbed floors," the clubs nonetheless were shadowed by the "hideous shacks" on the other side of Havana where thousands of desperately poor families eked out a living.[8]

Tamara, with her attachment to upper-class luxuries, was always uncomfortable around poverty; regardless of how rich she was, poverty was what she feared most. She reacted to obvious deprivation by sentimentalizing such people with whom she personally came into contact: "The poor people are the only pure ones. They're the only innocent people left on the earth."[9]

But the baron's genuine interest in promoting humane work conditions would have appealed to his wife. Tamara, who tended to reduce theories immediately to their practical application in her own life, recast Rollie's humanitarian impulse into a personal creed that "as individuals it is important that we give of ourselves—an animal searches for what he can get; but life is meaningful when we give." She believed that through her painting she contributed to the world, because her art left society richer in beauty than it was before. "Smart, for me," Tamara would claim, "is a person who achieves something," and beauty and business both qualified as achievements.[10]

Back in Paris, Adrienne, at the height of her achievement, was awarded the prestigious Legion d'Honneur on 4 August 1939. Kizette, living with the Montauts by now, was sorry to miss the ceremony; following her mother's plan, she was visiting her father at his country home just outside of Warsaw, where he now worked as legal consul for a state-owned industry.[11] Adrienne and Pierre Montaut traveled to Poland themselves in mid-August to dedi-

cate another cinema. Thinking it would be more fun to return to Paris with them instead of traveling by herself later, Kizette took advantage of their offer of a ride back. As the threesome approached the German-Polish border, they "were shocked to see German tanks and panzer units stationed up on the hill, several miles away." It was 29 August; the little family escaped the capture of Warsaw by one day.

The Kuffners wanted their daughters to leave Europe, but first they had to get their own affairs in order. On 11 September 1939, Tamara and Raoul flew Pan American flight 213 from Havana to Miami, where they entered the United States as resident aliens. Immigration papers cite the couple as preferred German émigrés because of Kuffner's agronomical expertise. Both he and Tamara are listed as Czech citizens, not Hungarian, since officially after the 1920 Treaty of Trianon, Dioszegh belonged to Czechoslovakia. Asked about their "final destination," they wrote that they intended to become permanent residents of California. According to publisher Robert West, Tamara appears to have been carrying the kind of trumped-up documents that wealthy Jewish Eastern Europeans routinely were obliged to purchase in order to emigrate. The Swiss papers attesting to her having been born in Warsaw state vaguely that "she showed convincing papers to the official," in lieu of the standard birth certificate.[12]

Tamara always claimed to have emigrated to the United States directly from Europe through New York Harbor. No one remembers her ever mentioning a visit to Cuba, and Kizette and Louisanne Kuffner Glickman claim to know nothing of such a trip. Havana, a stylish haven for writers, painters, and socialites during this period, would seem to have been a natural addition to Tamara's repertoire of travel stories. Her silence about the city she

*Kizette, Tadeusz, and Irene in Poland, c. 1935.*

listed in 1939 on her immigration papers as her "last permanent residence" must have been related to her near paranoia over communism—even in the 1930s, Cuba struck Raoul as unstable—and her fear of exposing the truth about the couple's carefully planned emigration rather than the story they had fed their friends in Paris.

After their immigration papers were cleared in Miami, the Kuffners traveled to New York, where they spent much of the next four months procuring travel permissions and documents for their daughters. During this time, Tamara's name appeared in a newspaper column with no mention of her title of baroness, which marriage to the baron had conferred. Instead, the gossip columnist described her as an eccentric painter:

> *Until recently, New Yorkers have had only one concern as to their hands—that they were clean and well manicured. Now along comes Tamara de Lempicka and a revolution. Tamara, as she is generally known, was born in Poland but has really lived her life in Paris. Her first real exhibit of her paintings was in Milan in 1925 and it won plaudits from Gabriele D'Annunzio and other well-known personages in the world of art. Ten years ago she brought her collection to America. Recently she returned to this country with one favorite topic of conversation—hands. She has found that hands, whether those of a busboy or a great musician, have an artistic phase that can be put on canvas. Because she does just that, around the nightspots even the most blasé New Yorkers can be observed taking stolen ganders at their digits. Tamara's no palm reader. But she has made New York hand-conscious.*[13]

Tamara was imitating Jean Cocteau, who in his never-ending quest for attention had briefly fetishized hands several years before. More seriously, as her painting of St. Anthony shows, she had long been interested in the way fingers were depicted; Dürer's pen-and-wash studies of hands had influenced her treatment of the gnarled fingers in her 1939 painting *The Refugees*. Both the sixteenth-century painter and the Modernist imbue the hands with a sense of their own life, so that the fingers seem on the verge of speaking to the spectator.

Between the time she read the newspaper piece and several weeks later, when the Kuffners departed for California, Tamara had parlayed the story into a new publicity opportunity. On February 5 the *Los Angeles Examiner* announced that "vent to her flair for the bizarre recently was given by the artist when she arranged an exhibit of her paintings in which no color but white appeared. In similar vein will be her next exhibit—at the Julien Levy

Galleries in New York next April 23—when only hands will be hung; those of the Archduke Franz Joseph and D'Annunzio among them."[14] (Lempicka had begun to cite the chimerical commission by Il Comandante whenever she thought it added cachet to her artistic worth.) The hands-only show never took place.

Baron and Baroness Kuffner of Paris, the *Los Angeles Examiner* noted, "arrived [in California] by United Airlines from New York." They explained to acquaintances that though they had initially planned a two-month visit to the West Coast, they had become so enamored of the area that they decided to stay. A week after their arrival in Los Angeles, they flew to San Francisco to visit unnamed friends, where they stayed for three or four days at the fashionable Mark Hopkins hotel. The *San Francisco Examiner* dutifully reported that after leaving their Paris home the previous summer to show Tamara's paintings in New York, the couple had been caught in the United States by the outbreak of war in France.[15] After Tamara visited the Courvoisier Gallery, where she had arranged a forthcoming show, she and Raoul returned to Los Angeles and rented a suite at the Beverly Hills Hotel.

Just as she had in Paris, Tamara immediately sought to establish herself among the socialites of Hollywood, who she assumed would be a conduit to important artists. Over the next two years the Kuffners—or Tamara by herself—entertained hundreds of guests every month, either at home or in restaurants. For this style of entertaining they were indirectly indebted to Cobina Wright: the New York café society that she had helped create in the twenties now proved, fifteen years later, well suited to the casual yet opulent style of Hollywood. Café society made it possible for people "to entertain outside their homes, to give their dinners and parties and teas and luncheons in cafés, hotels, restaurants, instead of at home. . . . [In the past] great houses were maintained, with their own ballrooms and banquet halls. No real member of Society entertained in any public place, except in very rare and formal exceptions where a larger ballroom was needed, and then certain more staid hotels were used." But, as Cholly Knickerbocker announced, "Society has become excessively bored with itself," and Hollywood was a perfect place to relieve that boredom by expanding the sites and guest lists for society get-togethers.[16]

It was not, however, the social opportunities that motivated Tamara's choice of Hollywood for her "permanent residence," as she stated on her immigration papers. Tarnished as the community was even then by the Tinseltown image, it laid claim to Tamara's respect from the beginning. Her decision to live there was a natural outgrowth of her deep respect for motion pictures, the art form whose development had paralleled her own coming of

*Baroness Tamara Kuffner, c. 1939.*

age. Though the first Russian feature film had been made only in 1908, by the next year there were twenty-three Russian motion pictures; in 1917, the year Tamara fled the country, the number stood at five hundred. Furthermore, Italian films were imported to Russia throughout Tamara's young adulthood, adding another positive association of the cinema to the lands she loved.

Years later, when telling actor Tonio Selwart that Italy's culture had helped her to understand her sister's innovations in cinema architecture, Tamara explained that "people always speak to me of Pola Negri because she was Polish, but I talked first to the Italians about the cinema, because they are always the most artistic people of all. That's who these people who want to know about movies should go talk to." Unlike the shift to narrative that occurred in other film capitals during the 1920s, the Busby Berkeley–like mixture of song, dance, and story that had been a favorite part of Tamara's Russian childhood memories remained part of the Italian cinema until the end of World War II.[17]

Tamara was convinced that her sensibility was compatible with what she assumed would be Hollywood's arduous work ethic and appreciation of great talent. From her earliest weeks in California, she spun stories for the press that she thought would work well there. At first, she decided to create a fictional version of her work habits, and to distance herself from outmoded Modernism: "Indefatigable in her devotion to her art, Mlle. Lempicka said last night she has no free time in which to accept commissions for the next two years. An interesting sidelight on her unusual career with the palette is the fact that she paints five or six subjects at a time—completing them all within a week after they have been begun. 'I'm through with all isms in my art,' she said last night, after describing her experiments with Cubism and Surrealism."[18]

Though in France Surrealism had won the battle for the avant-garde by the late 1920s, it was still struggling to gain a stronghold in America during the war years, and Tamara, who during her early years in the United States had executed several fairly successful Surrealistic paintings, might have done well to continue in that direction. Her quick wit and pleasure in the absurd, mentioned repeatedly by her friends, lent themselves to the genre, and those same qualities won her the loyalty of Salvador Dalí, one of the few artist friends from Paris whom she continued to see in America. His 1934 painting *Enigma of William Tell* depicted Lenin's exposed buttocks with a giant phallus (parodying a rocket) inserted between his thighs. Deeply offended by the insult to one of their heroes, other Surrealists were thereafter suspicious of Dalí's politics, further strengthening Tamara's conviction that Dalí was worth taking seriously. The scent of radical left-wing politics that usually clung to French Surrealism certainly dissuaded her from exploring her interest in it. An art movement whose members openly and commonly joined the Communist Party was anathema to Lempicka; and its emphasis on psychological themes instead of the purely painterly contrasted with the artist's worshipful embrace of beauty as art's sole concern. The notorious unwillingness of the movement's male painters to sanction female painters as equals would have further discouraged Tamara from working in this genre and from competing among those painters who were ultimately victorious over it, the Abstract Expressionists.

But during this first year in California, Lempicka could not know that an indigenous American aesthetic would soon overturn all previous notions of easel painting and that her art, with its inevitable vestige of the Old World, was hopelessly ill-suited for the new life ahead. The "isms" of the recent past were not Tamara's enemy: her old-fashioned devotion to the figure and to conventional beauty was. Determined to take her place among

the vanguard, she believed that the evolution of her style into its current mannered naturalism, or hyperrealism, was perfectly tuned to the age. Perhaps if she had still been living in Paris, her assessment would have proven correct. But she misread totally the map of the American art world of the early 1940s.

One of the first people Tamara met in Hollywood was George Schoenbrunn, a writer and director. The English painter Cecil Everly introduced his friend to Tamara in the Beverly Hills Hotel restaurant, where many of Hollywood's elite gathered to gossip. Schoenbrunn socialized with her at several parties given by director Atwater Kent, who particularly appreciated Tamara's melodramatic qualities; and the writer also often encountered Tamara on the Santa Monica beach, where she loved to sunbathe. Over the years, Schoenbrunn would become one of her shrewdest critics, mingling fondness with exasperation.

His recollection of others with whom Tamara regularly socialized includes Gloria Vanderbilt Sr., Lady Thelma Furness (Vanderbilt's sister), Gaylord Hauser, Count Maximilian Henckel-Donnersmark and his sister, Baroness Erich Goldschmied-Rothschild, and the artist Federico Pallavicni. Except for Hauser and Pallavicni, the friendships failed to last beyond these years. But Tamara's proudest social conquest was her rapidly developing friendship with her idol, Greta Garbo; she claimed to have played tennis with her, though no one can recall Tamara being much of a player. For the next three years, however, she referred to Garbo so frequently that the actress seemed to be a fixation for the painter. She announced to the press that she was doing Garbo's portrait, but none has been located. The physical resemblance that hotel guests had supposedly seen between the two women seven years earlier predisposed Tamara to admire the actress, and the parts she had played further impressed her. In 1935, Garbo starred in *Anna Karenina*; in 1937 she played opposite Tamara's friend Charles Boyer as Napoleon, the artist's hero, in *Conquest*; and in 1939 she starred in *Ninotchka*, a satire on Bolshevism that delighted the painter.

Perhaps she mentally projected herself into Garbo's place. Material for such a fantasy was close at hand in the form of a sketch she had done of Charles Boyer in 1930. Since Tamara rarely painted from a photograph, preferring to work with the live model, she must have known Boyer at least ten years before she moved to Hollywood. Pictures of the two on the Hollywood sets of the early forties show them with intimate, almost smirking smiles, suggesting that they were already well acquainted.

Several months after moving into the Beverly Hills Hotel, Tamara felt she had appraised the social scene thoroughly enough to choose the best res-

idence; and so she leased director King Vidor's luxurious villa in Coldwater Canyon. It was an expensive choice and perhaps as a result of such profligate spending, Raoul Kuffner arranged in late spring 1940 to have a document drawn up that kept the couple's incomes separate: all lands, property, and monies held by Kuffner before their marriage remained his alone, and he was free to dispense them as he chose upon his death. The baron was probably motivated by his lack of power in his adopted country, by the Hollywood culture of excess that encouraged his wife's spending, and by his desire to ensure the welfare of his children, Louisanne and Peter, if he were to die. In reality, Tamara continued to spend money freely until her death, with income that clearly originated from the baron as well as from her own resources.

It is easy to see why Kuffner was becoming nervous about his financial future. To publicize her presence, in June 1940, Tamara arranged for a glamorous head shot—with veiled black hat; long, painted nails; a triple strand of pearls; and large rings and bracelets of pavé diamonds—to be printed in at least twelve southwestern newspapers. All bore the same caption: "Tamara de Lempicka, Polish Baroness Kuffner, who has arrived in America where her paintings are being shown in Chicago, Los Angeles, and San Francisco. She has been invited by the Department of Fine Arts, Carnegie Institute, Pittsburgh, to exhibit her work." Perhaps oddest is her careful pasting of these multiple newspaper notices into her scrapbook, a practice that she continued until her death. The visual impact of staring at a dozen replicas of the same publicity shot emphasizes how important Lempicka considered press coverage, even of her dinner parties. And the narcissism that the pages reflect helps explain the immediate rapport she and Andy Warhol—master of the sequence picture—would feel upon their first meeting, years later.

In a move Warhol himself would have approved, Tamara devoted the month of June to constructing an audacious, complicated publicity stunt. She planted an announcement in the Los Angeles newspapers about her unusual and liberated method of finding just the right model for her current painting, L'Opéra. She told the Associated Press that she had originated a contest to find the physical twin to the nude she had used for Suzanne au Bain; her model had stayed behind in France, and Tamara wanted a lookalike to replace her. The AP reported that over one hundred coeds posed nude for Lempicka, until she found just the right "twin." From the Buffalo Courier Express to the Los Angeles Examiner, the contest for the perfect double was reported. On 10 June 1940 a picture of the winner, Cecelia Myers, was printed in Life magazine: "Blonde coed at the University of California at Los Angeles, has become a model," announced dozens of papers intrigued by

Tamara's novel approach. But this story, repeated by commentators throughout the years, was another fabrication: the whole event was staged.

Tamara did use Cecelia Myers, a friend of a friend's daughter, for a small amount of modeling, as the former coed, now Cecelia Whitehouse, recently revealed: "Those one hundred applicants are pure fiction dreamed up by [Tamara's] press agent. . . . The picture was shot in front of the Vidor estate with me clutching a drape over my bathing suit. (I hated the picture because it certainly did not flatter my legs!) . . . I had no idea that she was a famous artist. I was conned into the publicity shot and am not sure what, if anything, I got paid for it. But I was glad to sit for the Madonna [actually the *Woman at the Opera*] in the interest of a little spending money—remember, we were just coming out of the Depression. However, when she asked if I was interested in sitting for a nude, I declined. In retrospect I realize I was both naive and exceedingly modest."

Cecelia Myers met with Lempicka once more: "On the occasion of my second and final meeting with Tamara, our lunch, which was served by a very correct male servant, was a mixture of greens, tomato, and chunks of cheddar cheese served from a large salad bowl. I remember because I'd never seen cheese added to a salad before and indeed had never before been served a salad as a full meal. . . . In my teenage eyes, Tamara was so sophisticated with an aristocratic air about her. However, she was also quite tactful, never making me feel like the unworldly girl I still was at the time. She was nice, but subtly aloof. In my hearing she was always 'Baroness.'"[19]

Franco Maria Ricci in 1977 reprinted the story of the one hundred coeds in his expensive edition of Tamara's art, whereupon the anecdote entered the tiny treasury of "authentic" biographical information thought to exist on the artist. "The competition [for a model who looked like the French Suzanne] was announced to the female student body of the University of California in Los Angeles, and about a hundred candidates responded. The winner was a certain Cecelia Meyer [*sic*], a Susanna blossoming from the opulent society of America."[20] Kizette repeated the same account in her 1986 memoir.

But such publicity stunts worked. After only five months in Hollywood, Tamara was becoming known locally as an important artist. For the first time in years her depression seemed to have vanished; she was filled with purpose and the hope of a new beginning. And while she was deciding how to create the best social and professional image, she was also working hard to get Kizette and Louisanne Kuffner out of Europe: Paris, where Kizette and Malvina lived with the Montauts, was being invaded by the Germans.

As the war progressed, "you could hear the far-off artillery and bombing

from our apartment," Kizette recalls. Though she would not know the details until later, Tamara could guess that her daughter faced danger from Adrienne's courageous patriotism as well as from the German invasion. She was right: increasingly aware of an inordinate amount of whispering between Ada and Pierre de Montaut, Kizette finally confronted the couple. Ada explained that she, Pierre, and his son, Jean-Pierre, were working with the Resistance and that Kizette had to keep that information secret. Inspired by her relatives, Kizette began working for the Polish propaganda office in Paris, where, as a result of the Montauts' influence as cinema architects, she was in charge of film and newsreel propaganda for the exiled Polish government. But she wanted to be with her mother and Papali.

For many European artists and their children, obtaining an American visa was complicated by the U.S. government's fear that the refugees were left-wing agitators. André Gide and Henri Matisse, for instance, found themselves working as undercover operatives to help their friends cross the mountains and escape to Spain.[21] Even Louisanne and Kizette, whose parents had arranged through their connections the girls' emigration papers, struggled uncertainly for days to reach Lisbon's port, as Kizette's university newspaper would recount five months later in a lengthy, informative interview:

> Last May 27, Kizette De Lempicka, now a Stanford grad student, finished her morning's work at the office of the Ministry of Propaganda for the Polish Government in Paris, ate a leisurely lunch with some friends, discussed her three weeks' vacation, which she planned to spend in St.-Jean-du-Luz or Biarritz, sniffed in a rather bored fashion at an air raid alarm.
>
> "That day the idea of German invasion or even of real danger seemed preposterous," she says.
>
> But the next morning she was just one of a stream of hundreds of evacuees who were flooding the roads leading toward southwestern France. And then just one of the many struggling to find a place —any place—to sleep in Bordeaux, already straining at the seams with hordes of distracted government officials. Just one standing for days in a line trying to get Spanish or Portuguese visas. Just one in a mile-long string of cars at the Spanish border. Just one trying to get passage on a ship out of Lisbon.
>
> "It's strange, but at the time I had no feeling that I was what they call a refugee," she laughs. "Of course, I'd seen the Belgian refugee center in Paris. There were so many that they had to block off the street."

*During the last year in Paris, the feeling among the people was one of complete confidence, according to Miss De Lempicka. The popular song of the day in both French and English was: "We're going to hang our washing on the Siegfried Line . . ."*

*Orders to evacuate the propaganda office came on the day that Leopold surrendered. First the feeling was one of complete bewilderment. Then wild rumors began to circulate about General Gamelin —that he'd been captured, that he'd committed suicide, that he'd turned traitor.*

*In Bordeaux, Laval and Pétain [leaders of the Vichy government] were seen often in the cafés (food was still plentiful there), but no crowds cheered. It took just twenty days for [Kizette] and her sister to get the various visas and permits necessary to get out of the country.*

*On June 18, at seven o'clock in the morning, they reached the Pont Nationale between France and Spain. The line of cars stretched ahead of them. During that nine-hour wait, the feeling along the line was one of camaraderie and fellowship. Then a car with a swastika drew up and a Prussian-looking man with a camera carefully photographed the license plate on every car. ("For the German propaganda office, I suppose.") They crossed the bridge into Spain at five o'clock that evening.*

*"The Germans reached Biarritz two days later; and the frontier was closed," she went on. "But we had no idea they were so close. Neither did the peasants in the country we had just driven through. They laughed at us for running away."[22]*

The Kuffners had finally procured permission for the girls to enter the United States, and Kizette and Louisanne obtained passage on a Greek steamer, the *Nea Hellas*, on which they traveled in first class. One of the menus Kizette saved, from 8 July 1940, lists the evening meal: potage crème de petits pois, filets de poisson Orly, cotellettes de veau grillées, pommes Jaquette, salade Laitue, asperges à la parmesan, and croquet aux amandes, as well as desserts and coffee.

The fortunate girls reached New York in mid-July. In an interview Kizette gave soon after she arrived, she told reporters that "you do not know what it means to us to see the lights of your New York. It meant a friendly world again. A world of peace, and freedom. You can underline 'freedom.'"

That freedom was particularly appealing to a twenty-four-year-old girl. Upon disembarking at the harbor, Kizette and her stepsister were thrilled to find waiting a brand-new black Ford convertible that Tamara and Raoul had bought and had delivered. The stepsisters drove cross-country to join

their parents, leisurely stopping to visit tourist sites along the way, including the Grand Canyon, where Louisanne gained a new boyfriend from among some local marines. For young women never before in the United States, it was an adventure they would not forget. "It was not only all right with Tamara," Kizette recalls emphatically, "it was most certainly all right with me."[23]

They arrived at the Kuffners' Beverly Hills home in late July. Once there, Kizette was urged to find something to do with herself immediately, probably because Tamara had announced publicly that she had no children. She introduced Kizette as her sister and encouraged her to enroll at Stanford, where she would be fairly close but distant enough to suit them both. Deciding to seek a master's degree in political science, the girl was immediately called upon to give public speeches about her last year in France, and to discuss the differences between her new country and the war-stricken nation she had just fled. Kizette spoke to local youth groups, including the Junior Red Cross at Palo Alto High School, and with college officials, who ensured that the interviews were well publicized. Tamara apparently forgot to instruct her daughter on how to rewrite her past, an omission that yielded privileged information: the first dispatches recount that "one of the most interesting of the students at Stanford this fall" is Kizette de Lempicka, "born in St. Petersburg of Polish parents, educated in France and at St. Hilary's College at Oxford."[24] Her mother must have quickly explained how their personal histories were to be manipulated, because later press reports name Paris or Warsaw as Kizette's place of birth.

Several years later, when recounting the story of her daughter's escape, Tamara explained that only because she had personally implored Eleanor Roosevelt to expedite a visa for Kizette did the two girls receive immigration papers. But the "emotional" letter that supposedly persuaded Mrs. Roosevelt—so effective, Tamara said, that it was published in a California newspaper—never existed. Once again, Tamara had seized an opportunity for a good story after the fact. Eleanor Roosevelt was deeply involved in helping American immigrants get their European families out of war-threatened lands; she publicized fund-raisers for the war cause and wrote a syndicated column that carried war news. As a result of her push for liberalization of the "mercilessly strict visa regulations," Mrs. Roosevelt had been recruited in 1941 by the "extraordinary operation sponsored from the United States known as the Emergency Rescue Committee, whose aim it was to help artists, intellectuals, and political refugees escape to America."[25] After the first lady dutifully noted in her column Tamara's efforts on behalf

of Paderewski Day in 1941 to raise money for the Polish pianist-statesman's relief efforts, the material existed for Tamara's retrospective myth-making about Kizette's special visa.

The everyday truths of her life remained less satisfactory to Tamara. When her daughter arrived in Beverly Hills, the artist noted that Kizette's adolescent beauty had come into its own. Tall, athletic, with long, wavy blond hair and a spontaneous smile that seemed to light her face from within, Kizette appeared in a newspaper photograph dressed in a dark shirt-dress, saddle shoes, and white socks. She stands, smiling broadly, on the massive concrete steps of an administrative building at Stanford University, a confident young adult of twenty-four. It was at this point, as Kizette was building her own life, that her glamorous but middle-aged mother began treating her with greater severity and leveling harsh remarks and insensitive criticism against the young woman.

Tamara may have been distracted by concern over her marriage. By now Baron Kuffner was spending less and less time at home, having tired of the vapid social conversation saturating their lives in Hollywood.

Kizette recalls being shuffled off almost as soon as she arrived, partly because her mother was deep into another major publicity campaign, this time in the form of conspicuous charity. Tamara had grandly announced that she was donating $1,100 to rent the local Hawaii Theater from 29 July to 5 August 1940 on behalf of British War Relief; the money would underwrite a week's showing of the "great pictorial story of England," *Cavalcade.* Her simulanous bid to gain access to the monied circles of southern California and to acquire more newspaper coverage for her art worked: the *Los Angeles Times* obligingly reported on 23 July that "Mme. de Lempicka is a painter of international repute and is another of those Poles who believe that England now is the hope of all the free peoples of the world, and of those who temporarily have lost their freedom. If the Britishers here rival this Pole in aiding their country, the British War Relief is going to prosper."

The movie, hosted by Mr. and Mrs. Basil Rathbone, was one of the major social events of the season. Merle Oberon and Douglas Fairbanks Jr. appeared at the opening night show. Written up all over the country, the charity evening was invariably associated with Tamara, though she was most often referred to simply as Baroness Kuffner. In New York, however, the Hollywood maneuver seemed more histrionic than sincere. The leftist *Daily Worker* on 30 July expressed disbelief at what passed for charity in Beverly Hills: "Ten bucks on the line will admit you to the British War Relief Party at Ciro's on the 29th. The party is sponsored by Mrs. Basil Rathbone and the

Baroness Kuffner de Lempicka yet. And that ten bucks doesn't include liquor at a buck a throw. . . . Whose war is it now?"

In reality, Lempicka was deeply interested in politics. From the time she was a tiny child, Kizette had watched her mother read more than the requisite two newspapers most citizens bought—albeit in bed, with her breakfast tray beside her. "She studied the papers for information on European governments, and for all sorts of other international news. She said more than once that she wished she had been a lawyer, and I know she meant it, though it surprised me every time she said it."[26] But her lack of confidence in her limited formal education, and her tendency to amalgamate several languages, motivated her to shield her intellect behind the mask of the flirt, the socialite who ends any potentially serious statement with a quip or an arched eyebrow. At a dinner party on 1 August 1940 a guest mentioned that "down through history, European nations have been warring constantly," and according to the *Los Angeles Herald* on 1 August, "the Baroness de Kuffner interspersed: it is so. But look at all the different peoples, their countries, how closely they are crowded together. There are Russia, Germany, England, France, Italy, Spain and all the Slavic countries. And over here look at you. Always fighting and you just have Republicans and Democrats!" She knew,

*Tamara in Hollywood, King Vidor's estate, c. 1940.*

however, that it was not her intellect (remembered by her friends and enemies alike as formidable) that won her newspaper coverage. On 7 October the *Examiner* wrote that "this charming European has quite captivated Los Angeles and Pasadena society, with her strong personality, graciousness and chic."

During the fall of 1940, Tamara helped Kizette settle into graduate school at Stanford. Having ensured that her daughter was safely removed from her social life, Tamara spent early 1941 in a near manic state, developing her dual roles as socialite and artist as dramatically as she could. She used her rented home as a social canvas: thought by many to have the best view in Beverly Hills, the palatial King Vidor estate high atop "Wink o' Pink" Hill on Tower Road became the showcase for both her art and her circle of friends. The estate, according to a description in the *Los Angeles Examiner* on 5 August 1941, had "an enormous patio and extensive gardens. And none of the innumerable palatial homes of film land [lent] itself more handsomely to festive occasions. Several miles of verdant rolling countryside intercept its far-flung view of city lights beyond." The baron, who had grown up tracking bear on Dioszegh, began traveling to Montana, Wyoming, and Alaska on extended hunting trips. Away more than he was home, "the mysterious Baron Kuffner" was rarely seen at his wife's parties, according to George Schoenbrunn, "but I heard that he was like a pussycat."[27] Tamara had the estate to herself much of the time, and on the infrequent occasions when her husband was home, he apparently slept through the parties, often failing even to put in a perfunctory appearance.[28]

Parties, receptions, or the "little fiestas" she held at home dominated Tamara's social life throughout the beginning of 1941. She had scheduled a mid-year show sponsored by the prestigious Julien Levy Gallery, and the publicity building up for several months before the exhibition also kept her in the public eye. Beverly Hills had found an "internationally known artist" who not only lived in Hollywood but reveled in it, unlike the majority of serious artists who were known to tolerate, not celebrate, the scene. Whereas other Los Angeles newcomers—including Max Ernst, Man Ray, Thomas Mann, and even William Faulkner—retained a certain aloofness, Baroness Kuffner gratified the movie community by so obviously enjoying their company.

Tamara's popular parties typically included 250 to 400 guests, numbers the King Vidor house easily accommodated. "American" cocktails were served—champagne would have been too boring—accompanied by live music ranging from show tunes to Mexican dance numbers. The food she served could be anything from delicate finger sandwiches to bigos, a Polish

peasant dish of six meats that Tamara simmered for two days before the party. She drew her guests from the Hollywood elite; representatives from the art world were few. A typical party included Walter Pidgeon, who entertained guests with his version of "Old Man River"; Basil Rathbone; Mary Pickford; Charles Boyer, a frequent guest; diet doctor Gaylord Hauser; and Arthur Rubinstein, Tyrone Power, Mrs. Vladimir Horowitz, Gloria Vanderbilt, Douglas Fairbanks Jr., Merle Oberon, Paul Gallico, Baron de Rothschild, Dolores Del Rio, and Theda Bara. Social events (morning, afternoon, or evening) were sometimes held in conjunction with Tamara's activities as the new chief of staff of education of the Woman's Emergency Corps, as a board member of Freedom Speaks, or for no particular reason at all.

Los Angeles was impressed in spite of itself by the artist's parties, opulent even by Hollywood standards. But the attention paid to Tamara's social life increasingly trumped her work as a painter. Typical coverage appeared in the *Examiner*, where Tamara's celebration for visiting opera star Lily Pons was written up because it extended beyond the announced "4 to 8 o'clock cocktail party," requiring an impromptu dinner to be served "peasant fashion in the garden, and for the blithesome guests that lingered longer, a midnight repast!" On 8 October the newspaper quoted Tamara as asking her 350 guests, "And why should it stop?" Another gossip column noted that "As usual, the mythical Baron de Kuffner was nowhere to be seen, but his stunning artist wife (Tamara Lempicka) is suavely capable of doing a party all by herself. It's always fun to go there."[29]

During 1940 and 1941, Tamara's obsession with Greta Garbo was also played out in the press. She mentioned the reclusive actress every chance she could, making it sound as if they were together constantly. In fact no one can remember the two even being friends, and Victor Contreras recalls that Tamara later disparaged Garbo's voice and listless personality. "I believe Tamara wanted nothing to do with her, not the other way around," the sculptor insists.[30] But in early 1941 the painter enthusiastically described to a reporter the details of playing tennis with her sexy friend, "looking like a boy" in her shorts and white blouse. While Garbo "was collapsing" onto the grass, the artist was busy "forgetting everything around her. . . . I admire the rhythm of her body. And I like Greta even more in private life than I do in pictures."[31] Garbo's path had mysteriously crossed with Tamara's in Europe at Salsomaggiore, and now, on 27 March, the *Los Angeles Times* announced that Garbo was the subject of Tamara's newest planned portrait.

The painter's earnest concern about the fate of Europe led her to expend large amounts of energy on the British War Relief. Her patriotic contributions are easily overlooked in the wake of her heavy-handed the-

atrical style, but her efforts were motivated both by her past and by her political convictions. She assuaged her anxiety over the war by feeling she was actively engaged in winning it. In early March 1941, for example, she held an afternoon tea where she donated *Dimanche*, a painting of European refugees, to Freedom Speaks, a fund-raising group. The organization included Charles Boyer, Mary Pickford, Douglas Fairbanks Jr., Basil Rathbone, Merle Oberon, Ronald Colman, Greta Garbo, and Annabella and Tyrone Power, and so Tamara's participation in its activities served more than one purpose.[32]

In the midst of her war relief activities, she was also preparing for what was potentially the most significant exhibit she had had since the 1925 Castelbarco show. In April 1941 the Julien Levy exhibition devoted to her work would open in New York City.[33] Although Levy, married to poet Mina Loy's daughter at the time, had befriended many European artists, he had until now focused more on the Surrealism or the Romantic Expressionism of Lempicka's friends Tchelitchew and Dalí rather than School of Paris painters. The war, however, had devastated his financial resources, leading him to develop the unusual idea of creating a caravan to transport his exhibits to cities across the United States, including San Francisco and Los Angeles; Tamara's work would thus benefit from broad exposure. A passing comment in his memoirs reveals why Levy was uncharacteristically willing to show Tamara's paintings: Kuffner himself financed a large part of the tour.[34]

How Tamara originally connected with someone as far afield from her interests as Levy remains unclear. Various artists' networks existed that might have promoted the contact: Yves Tanguy and Kay Sage, two of Levy's Surrealists, recently fled from Paris, were in 1940 part of an artists' colony in Woodbury, Connecticut, a town frequented by Tamara when she visited New York. It is also possible that the odd pairing of Lempicka and Levy was arranged by his secretary, Lotte Biehm, who spent time in Chicago, where a large, wealthy Polish contingent had emigrated, and where Kuffner occasionally went to conduct business. Martin Shallenberger, the friend who socialized with the Kuffners in Budapest and Vienna, remembers that many of the couple's Eastern European friends had in fact settled in Chicago during this period and even earlier, in the aftermath of World War I and the Balkanization of their lands.[35]

However the painter met Levy, she was a bizarre choice for a dealer whose stable included Matta, Max Ernst, and Joseph Cornell. For the Levy association to enhance Tamara's professional reputation, two things needed to occur: Levy had to champion her art beyond the commercial enterprise of the caravan, which he didn't do; and Tamara had to openly commit her

*Tamara at her easel, Hollywood, c. 1940.*

loyalties to her art, unequivocally eschewing the obvious glamour of Hollywood, which she failed to do. What could have been an important venue for her work—influential collectors and critics including Peggy Guggenheim and Clement Greenberg took note of Levy's artists—instead backfired. More than one person in the art world guessed that the artist's wealthy husband had bankrolled the production, given Levy's weak finances and the dramatic contrast Tamara's paintings made with his usual fare. The exhibition was seen as a whimsical vehicle for a moneyed European socialite, and America's premier artists, like their European counterparts, still preferred the Romantic myth of the artist as outsider.

Determined to position herself among the classical French painters, Tamara had asked (and perhaps paid, an acceptable French tradition) André Maurois to write a preface to the Levy show catalog. Four months earlier she had attended a Salon Français at which Maurois was the guest speaker, and the *Los Angeles Times* reported on 26 January 1941 that he "held enthralled this assembly of women and their friends." If Maurois's literary eloquence

had impressed the local salon, why not put him to use on a larger scale, she must have reasoned. The European tradition of art criticism, generally more poetic than its concise American cousin, nourished Maurois's lyrical critique:

> *Nothing is more difficult, for an artist, painter, musician, or writer, than to combine the permanent qualities of the great artists of all time with the technical qualities which give the art of our times its peculiar and original character. . . .*
>
> *Tamara de Lempicka, whose pictures are exhibited here today, has evidently mastered the techniques of André Lhote, and she certainly does belong to the contemporary French school. But she was wise enough to realize that if Cubism provided the artist with new means of expression, the things to express remained the same. The human body, human faces, human joys and sorrows, are to her, as they were to the great painters of the past, the materials out of which all artistic beauty is made. She did not succumb to the easy and dangerous temptation of purely abstract art. "Art," Bacon said, "is man added to nature." Which means that man's mind and its abstractions have their place in the scheme of art. But nature must be present too. It is nature, ordered and classified by mind, that is the subject matter of all art. Tamara de Lempicka possesses both science and sensibility, and that is why she is a painter well worthy of this quattrocento, which gives its name to one of her pictures.*[36]

It is hard to imagine this fulsome tribute receiving more than a polite, slightly incredulous nod from the gallery owner himself, and any artist competing for a Modernist mantle at the time would happily have dismissed one more contender. Tamara herself seems to have remained oblivious to the incongruity of her upcoming show. She was excited about the chance to launch her American career through Julien Levy. After all, four years before, his successful New York exhibition of Frida Kahlo had enabled Kahlo to travel to Paris in late 1938 and mesmerize Picasso, Duchamp, Kandinsky, and Schiaparelli.[37]

Before the April opening of Levy's New York show, Tamara ensured that reporters would be present when she arrived in Manhattan on the Union Pacific; during this first major national exhibition of her work, she planned to be noticed. When she stepped off the train at Grand Central "wearing several pounds of trinkets and carrying a remarkable traveling bag made from the skin of one pig, whole and entire," she was photographed and interviewed by the Associated Press. Between her comments concerning Garbo ("She is so completely harmonious and always alive") and the amazed

writer's descriptions of her jewelry ("She had a ring that weighs a half pound"), the paintings got relegated to the final sentence of the quarter-page article: "Her work has been described as having 'the luminous quality of alabaster.'"[38] "Très Hollywood just about characterizes the work of Tamara de Lempicka. Not that the Polish baroness has resided in the film capital for long, but she seems always to have belonged there," chimed one critic prior to the New York opening.[39] Such notices were not likely to endear Tamara to the New York art critics, whose elitist position toward the popular culture of California usually assumed the worst.

But in many respects, Tamara was her own worst enemy. In contrast to the emphasis on the paintings alone that her hyperrealism demanded, she decided to coordinate social events with the exhibit, for which she had designed a theatrical background suggesting a secular cathedral.[40] She also arranged for the show to benefit the Paderewski Fund for Polish Relief, with its opening-night party hosted by Mrs. Otto Preminger (Ilka Chase). The reviews were mixed, but the exhibition was a great public success, with the admission line at times spilling onto Fifth Avenue. "It was said 2,000 visitors packed the gallery," according to a later reminiscence in the *San Francisco Examiner*.[41] The only artists listed as attending were Dalí and Tchelitchew.

If newspaper reporters were thrilled at the easy copy that Tamara provided, she defied the expectations of the serious art world: "The Baroness was more eager to talk about Hollywood than she was about her paintings," one exasperated would-be admirer finally wrote.[42] The painter's only comments about her art supported a jejune realism: "God's creation is best. Our job is to imitate, not transform."[43] Whether through exhibition notices or personality profiles, Tamara de Lempicka Kuffner, Baroness, became a nationally distributed commodity from the time of her Julian Levy debut, as the nation's wire services sent her glamour shots and vaguely mysterious musings across the country: "Baroness with a Brush—she's tawny-haired and majestic . . . she hates trivialities like dancing and playing cards. She likes American cigarettes and smokes three packs daily."[44]

Intrepidly following the example of the great Russian dancers of her youth, Tamara assumed the role of beauty and love adviser to the masses. "Women with large heads should wear their hair in abundance . . . the girl with the square face should beware of bangs," she explained as seriously as if she were speaking of glazing her canvas.[45] "Small, plump women should beware of the wide-brimmed hat models,"[46] and "fit clothes to your personality, there must be something about you which makes you stand out above the crowd" were among her other oracular pronouncements in 1941.[47] A long article entitled "How to Flirt, in One Lesson," distributed by the Asso-

ciated Press, was published during the New York run of her show at the Levy gallery. It contained such tips as "Don't flutter your eyes; it's too obvious," "Look sincere," and "Remember the voice. Low. Smooth. Never high or shrill." She must have seemed a silly anachronism to the avant-garde Americans already seeking reasons to divorce themselves from European art.

A critic for the *New York World Telegram*, however, wrote intelligently of the bewildering painter: "One doesn't speak in the Julien Levy Galleries these days, except perhaps in whispers. The place has the air of a cathedral . . . the hush is occasioned by Tamara de Lempicka's paintings and their extraordinary installation. The place is in darkness, except for tiny spots set into the ceiling so each canvas is flooded in light and surrounded by blackness, and its colors glow like the panes of stained-glass windows. At either side of the door is a column bearing white Easter lilies and white orchids. The whole arrangement is a little terrifying. One has difficulty breathing. . . . Really, Lempicka's pictures don't need this sort of spurious exoticism to put them over. The brilliance of the artist's technique must be obvious to anyone. No one I can think of among contemporary artists draws with greater perfection."[48]

During the New York exhibition, Tamara and Raoul Kuffner applied for American citizenship. To the *Los Angeles Examiner,* the artist declared that she was ready to exchange her "fancy title for Mrs." and that "the greatest ambition in my life now is to make my home in the Southwest and continue my work here."[49]

She returned to Los Angeles by train on 28 April 1941. The first week back in Hollywood she was photographed visiting the movie set of *Hold Back the Dawn,* with stars Charles Boyer and Constance Moore beside her.[50] Although busy preparing for her upcoming San Francisco and Los Angeles exhibits, she lost no time reimmersing herself in the Hollywood social scene. The parties resumed immediately: "The baroness mixes artists, movie stars, old Californians and socialites of all languages, gives them pleasant company, deluxe eats and drinks, and the best view in Beverly Hills, with the result that her parties are a brand all their own and very much enjoyed. There is always a peep at a few of her canvases, which is a treat in itself. In spite of the fact that the public prefers half-starved artists who live in an attic, the baroness's recent show in New York was pronounced a success and important sales were made as far afield as South America."[51]

On 13 May 1941, Tamara joined Charles Boyer and Theda Bara to honor Mrs. George Washington Kavanaugh, "prominent New York City socialite, and her daughter, Mrs. Leonora Warner, and approximately 150 of Los Angeles Mayfairites [who] were bidden to attend between the hours of five and

seven."[52] The Mayfairites included Gloria Morgan Vanderbilt, Mr. and Mrs. Conan Doyle, and Mr. and Mrs. Basil Rathbone. The international section of the *Los Angeles Times* declared that "license plates from practically every European country could be seen on the cars standing in a long line winding from the foot of the hill to the house. Artists, writers, sculptors, musicians, and composers augmented the usual group of socialites."[53] Only in its social pages two days earlier was the painter referred to without her title; and only these pages emphasized the putative highlight of the evening: Lempicka's *Mother Superior* had been specially displayed for the guests. "The room more popular than the bar was the library. Here in darkness voices became hushed as guests saw the lighted portrait of a weeping nun. For the Baroness, known in the artistic world as Tamara Lempicka, had this single masterpiece of her brush on display, the others being in New York on exhibit." Tamara's friends back in Paris, as well as Baron Kuffner, must have been shocked to read of the metamorphosis of their money-driven companion: "This amazing person, who is so completely an individualist, has decided to remain in Los Angeles and hopes to fulfill her dream to teach art for art's sake, which means, of course, with no financial gains to herself."[54]

By August the artist was busy working on war relief committees with Cobina Wright and her daughter, Mrs. Vladmir Horowitz, Mrs. Ronald Colman, Mrs. Charles Boyer, Mrs. Douglas Fairbanks Jr., and Eva Gabor. She was happy because she felt socially and artistically respected and personally and politically safe. Her show opened to an enthusiastic reception in San Francisco, which provided a favorable setting in part because it lacked the already entrenched antagonism between New York and Los Angeles. As a result, the reviews were more thoughtful, and little attention was paid to the artist's Hollywood ties. For the first time, Tamara's still lifes were deemed more successful than her portraits: "Fundamentally Lempicka paints as a patrician. There is no compromise here with the fundamental passions. Her art is remote and delicate and is to painting what Herrick's was to writing. One is reminded of Fromentin's celebrated remark on eighteenth-century portraits of gentlemen in ornamental steel cuirasses: 'Everything is steel except the armor.' . . . [T]he exhibition at Courvoisier's is well worth a visit. It is seldom you will see pictures of such adroitness or sophistication."[55]

Yet when the San Francisco reporters allowed her the opportunity to talk about her career, Lempicka was unwilling to risk a straightforward account. "I live for my painting. I have no children. My pictures are my children," she announced melodramatically to the *San Francisco Examiner* on 15 September 1941. Continuing that she found it difficult to combine her work and social activities, she asserted that she nonetheless painted fourteen hours

a day, beginning every morning at six o'clock and working on eight to ten paintings at a time. "This allows each coat of thin glaze time to dry completely between applications," Tamara said as she explained the source of the paintings' extraordinary luminosity. Relying on her old method of flattering whatever community she inhabited, she declared that "the light here is so much better than in Los Angeles. I plan to move here immediately and buy a studio." The only public hint that her heart still belonged to Europe was the belt she wore, studded with rhinestones that spelled the words "New York," "Los Angeles," and "Paris," which could be positioned variously on her waist: "Depending upon circumstances, someday I hope Paris will be in the front again," she admitted.[56]

The third installment of the Levy show opened in Los Angeles on 15 October, shortly after the close of the Courvoisier exhibition. Among the attendees were the familiar stars who frequented her parties: Charles Boyer, Walter Pidgeon, Arthur Rubenstein, Mary Pickford, Constance Moore, and Basil Rathbone.[57] The *Los Angeles Herald* revealed that "the artist in private life is the Baroness de Buffner [*sic*], who shunned a social career to devote herself to her art."[58] The exhibition on Sunset Boulevard duplicated the lighting and presentation of the New York exhibition; and like the San Francisco show, it made little profit for the Manhattan gallery owner. In his memoir twenty years later, Levy still could hardly disguise his disdain for having contaminated his eastern establishment with West Coast frivolity: "They liked the free food, but no one bought a single painting."[59] In contrast, his artist was happy. At the end of the tour, Levy presented as a gift to the Los Angeles County Museum Lempicka's sketch entitled *Mother and Child*, which the museum kept for two decades, selling it just before Lempicka was rediscovered by Hollywood. By the end of her show, Tamara was reassured by her role not only as a leading southern California artist (most of her paintings displayed by Levy had been completed since she moved to Los Angeles) but also as a nationally recognized media figure. She was becoming a real American.

By November 1941, Tamara de Lempicka had also become chairperson of the Committee for Freedom of Speech. Although volunteer work was a conventional way for wealthy women to make themselves useful, during the early forties it also became a patriotic badge of honor. Unlike the routine charity work of middle America, however, Tamara could persuade Jeanette MacDonald to sing at the meetings.[60] She had also arranged for Kizette to participate in a fund-raiser for the Paderewski Testimonial Fund, proceeds of which were to be sent to a hospital in Edinburgh, Scotland. Commandeered by her mother, Kizette arranged a "Polish Market Day" that included a horse

show by the "Franciscan Lancers" at the Palo Alto baseball field, as well as a candy table and dancing that "were among the most popular features." On 11 November the local newspaper, the *Palo Alto Times*, reported that in spite of bad weather, the benefit "realized a substantial profit." Kizette enjoyed the responsibility and relished her mother's belief in her ability.[61]

The painter felt strongly about supporting Paderewski's humanitarian projects, since the musician-statesman represented to her the proud legacy of her beloved Poland. Born in Kurylówka on 6 November 1860, Ignace Paderewski was one of the leading pianists and composers of the late nineteenth and early twentieth centuries. Although often in poor health, he gave hundreds of concerts throughout the United States and Europe. He had also served as prime minister and as minister of foreign affairs in the newly independent Poland following World War I; and it was Paderewski who had signed the Versailles Treaty for the Poles. Since the German invasion of Poland, he had been conducting a massive campaign in the United States for assistance to Poland. After he died in New York City, on 29 June 1941, his cause had assumed even more of a sense of urgency, and Tamara contributed to it frequently.

In late 1941 the Kuffners moved out of Vidor's estate and into the Beverly Hills Tower. During this period, Tamara frequented Santa Barbara, California, and Palm Beach, Florida, where she was the guest of Atwater Kent, a man who evoked dramatically different impressions from his associates. Some thought him the Hollywood host nonpareil, while others insist that he was an unimpressive man determined to make himself look better than his true mediocrity deserved. Cobina Wright was generous: "Strangely enough, Hollywood's most successful host was a very shy, gray little man, always a kind of shadowy figure at his own feasts. But he would go to any lengths to provide food, drink and entertainment for hundreds of people. His great pleasure in life was to see others have a good time. His solicitude for his guests, his earnest, eager desire to please them was heartwarming. Atwater was that rare thing, a genuine philanthropist, and while he gave thousands in musical scholarships and the like, he did it quite impersonally. Only at his parties could he stand by and observe any happiness that his money brought, and for that reason they were personal to him, and he enjoyed them more than any single person I have ever known."[62] George Schoenbrunn, who attended the same parties as Cobina did, viewed his host less charitably: "He was a pompous little toad who couldn't make it in Palm Springs."[63] And, as Schoenbrunn points out, even Cobina Wright gently alludes to Kent's limitations: "Atwater . . . was very vague when receiving his guests. . . . 'Cobina, my dear,' he said, 'so nice to see you. How are you?'

'Atwater,' I said, 'my mother just died.' 'How charming,' he replied sweetly, passing on to the next guest."[64]

The attack on Pearl Harbor on 7 December closed the year on a sober note, and Tamara began searching for ways to contribute more directly to the war effort. During early 1942 she spent less time socializing and more performing volunteer work. If the women's war relief effort had at times bordered on the frivolous, after Pearl Harbor no one could deny its importance; and Tamara's involvement had always reflected her deep political convictions as well as her social inclinations. She wanted America to fight and win. Soon after the Pacific disaster, the Hollywood Women's Emergency Corps stepped up its pace. Organizing nightly educational meetings at the Horace Mann School on everything from first aid to infantry drill, the corps found experts to teach machine mechanics and ambulance driving, rifle and pistol shooting (practiced in Coldwater Canyon), chemical warfare and fire precaution, public address, and chorus. "Sergeant Tamara de Kuffner, Chief of Staff of Educational Department," was quickly promoted to lieutenant, perhaps when she volunteered to design the women's uniforms. With the close-fitting jackets and slender skirts that she sketched, Tamara created the look of a stylish ministering angel. Kizette recalls the pride her mother took in the smart, flattering blue uniforms, which allowed the women to retain their femininity while appearing competent at the same time.[65]

The peripatetic Kuffners alternated months between the now serious activities of Los Angeles and the revelry of Palm Springs. It was probably in this desert retreat that Lempicka befriended the eccentric minor talent, Patrick Mahoney. A writer whose foppish ways and family money allowed him to enter Hollywood's inner circles, Mahoney shared with Lempicka a sense of life as a stage. Both of them shared an attention to the public persona that seemed not to hide the real person beneath but instead to suggest that there was little distinction between one's exhibitionism and an inner private life. Aware that Mahoney was not of her caliber artistically, Lempicka nonetheless appreciated his social aspirations and professional dedication. George Schoenbrunn, predictably, describes Mahoney more bluntly: "He was a third-rate writer and a parvenu."[66]

In the early forties, when Tamara first met Mahoney, Palm Springs was a perfect place for earnest socialites such as the determined writer; and the painter would have found his bluster amusing. During the previous decade, Palm Springs had become a "gold-plated desert mirage . . . [which] gathered a random selection of the richest people in America, strenuously enjoying all that money can buy." Outside of its great rows of palm trees and smart shops filled with designer clothes, Palm Springs failed to impress Tamara. Her hus-

band liked it even less: Palm Springs represented the worst of the California life he was rapidly growing to despise, a dislike that would profoundly influence Tamara's future. The baron would have agreed with the Philadelphia gentleman who declared Palm Springs "a concentration of everything that is vulgar, meretricious, and nouveau riche in America."[67]

Tamara did enjoy watching others play tennis at the Racquet Club in Palm Springs, a gathering place for movie stars, and she subsequently joined the club in order to gain access to the right people wherever she lived. Within several years of her first trip to Palm Springs, the community established another exclusive club, the Palette Club. There the wives of millionaires and movies stars took painting lessons together to prove that true culture was alive and well in Palm Springs. The ladies gathered in a comfortable old Spanish house "for a painting lesson or a cocktail, or a painting lesson and a cocktail, draping their furs over their easels."[68]

Tamara's own status now collided dangerously with that of the socialites, talented wives of wealthy men who painted for "culture's sake" rather than because they were driven in their art or financially dependent on its success. The press headlines that read "Baroness with a Paintbrush" delivered the truth: in spite of Lempicka's attempt to have it both ways, class now trumped profession.

She was relieved from the burden of any introspection, however, as the chaos generated by World War II prevented much attention to anyone's interior life. The type of upheaval she had experienced in 1917 wherein she had suddenly lost her entire way of life now seemed to threaten everyone in California. But this time her fellow citizens shared the same loyalties.[69] Furthermore, the war fed Lempicka's optimism that she would continue to advance as an artist. Between 1941 and 1945 many male artists had to put aside their work to serve in the army, and their absence allowed women to enjoy expanded opportunities similar to those experienced during World War I. Just as when Tamara had emigrated to Paris, there was now literally more professional space available for women to fill. But the vocabulary invoked to categorize and evaluate female painters was still gender-coded in a way that denigrated talents such as Tamara's; it began on one end with "feminine" and progressed to "virile" on the other. As a result, Tamara's paintings appeared disquieting and bizarre to the public. Their traditional— decorative—beauty was paradoxically executed in the most muscular, aggressive masculine style. There was no place to put her, no school to explain her, no manifesto to rely upon to neutralize her unsettling eccentricity.[70]

In 1939, Clement Greenberg had published his seminal essay "Avant-Garde and Kitsch," which mapped out the boundaries for what American

critics and painters would henceforth consider acceptable modern art.[71] By 1942 his prescriptions had been canonized among the period's most successful artists and historians. "Forget illusion and perspective: pay attention not to real flesh, but to the medium of painting itself," evangelized the American doyen of Modernism. Until recently, Greenberg pointed out, the brushstroke's invisibility had been a triumph; now, it was expected to foreground itself. The brushstroke could become important only when illusion was not. Unfortunately for Tamara, her genius lay in her brushstroke, conscientiously practiced until she could reproduce the finish of her Renaissance mentors. But Greenberg's concept of Modernism demanded that each medium seek to define for itself its uniqueness from all others. Painting, therefore, was to highlight its own painterliness, not pretend to be sculptural or capable of reproducing external objects or events truthfully.[72] Unlike the traditional histories of art influenced by Renaissance artist and biographer Giorgio Vasari, who emphasized the progress of painting as deliberately achieving a three-dimensional (sculptural) appearance on a flat canvas, Greenberg's aesthetic commended flatness itself as the proper focus of painting.

Although the war created some support for realistic painting, including works by Thomas Hart Benton and Edward Hopper (artists whose approach was highly compatible with Lempicka's art from the twenties), Greenberg's position would dominate the next twenty years of American painting. And these years would, as a result, prove antithetical to Lempicka's notions of the true object of art.

But during the Second World War, Tamara remained optimistic that society would be open to her talent, just as it had been after the Great War. She knew she needed to position herself to take advantage of the future she foresaw; even her husband was urging her to plan more carefully time to paint without distractions.[73] Consequently, Tamara must have felt relief when Kizette was taken off her hands in 1942. Within a few months of entering Stanford University, the young émigré had fallen in love with one of her tennis partners. Harold Foxhall was a charming, handsome twenty-five-year-old geologist whose accent and family stories spoke of Texas oil wealth. The two graduate students briefly courted, with Foxy gallantly taking Kizette for rides in his small plane. Tamara clearly sanctioned the relationship, since a letter from Malvina to "Tomchek" (the nickname she started using for her daughter) mentions approvingly the upcoming nuptials.[74]

Tamara was preparing for an important show at the Milwaukee Art Institute when Kizette decided to marry, and her professional obligations provided an excuse to avoid elaborate preparations for a wedding of her

inconveniently mature daughter. In Kizette's own retelling of the event, there remains a trace of regret that Tamara cared so little about re-creating for her daughter her own mythically large wedding to Tadeusz. The Stanford graduate student eloped with Foxy to Las Vegas in early 1942, where they called Tamara to confirm that they were now married. The artist invited them to come to Beverly Hills for a luncheon she would give in their honor, and when they arrived, Tamara effusively greeted her new son-in-law. "Mother had a wonderful borscht made for us, and we took a friend with us for the meal. It was quite lovely, and Foxy was totally charmed by my mother, like everyone was," Kizette remembers.

Throughout her life, Tamara liked Harold Foxhall, whose charm and goodwill are still legendary in Houston. She was worried from the outset, however, that he might not have enough money to support her daughter properly, so she spoke to the couple about the need for Foxy to look for work as a private geologist with the high-paying oil companies. Although the new husband promised to follow her suggestion later, his immediate response was to move with his bride to Washington, D.C., to contribute to the war effort.

Luckily, Tamara was engrossed in her own work and able to ignore the symbolic loss of her daughter. From 2 to 30 March the Milwaukee Art Institute held an exhibition of her paintings. Two other major shows overlapped with hers, a retrospective of George Grosz and a large selection of Picassos that had traveled from earlier shows at the Museum of Modern Art in New York and the Chicago Art Institute. Grosz's and Picasso's notices were accompanied by biographies clearly written by the institute's curatorial staff. Tamara's, however, is a clumsy, self-written public relations attempt:

> Her technique is noted for its classic mastery and compares with the technique of Holbein, Memling, Roger van der Weide [Rogier van der Weyden], and for her colors—a very difficult alabaster white of which André Maurois has written that "it has the richness of pearls," and a limpid blue which has been called "Lempicka blue"; Alix in Paris made dresses to match it. In the course of a fantastic life all her luck and all her adventures have always resulted from her painting. She has met a good half of the world's notables because they were impressed by her work.
>
> Her personal idiom has progressed through a study of cubism and the various "modernisms" until after fourteen years of research she has developed a new classicism which is distinctly her own and of today.

The biography concludes with a list of the prestigious collections containing Lempickas ("Musée de Nantes, Collection Gino Puglisi"). Other painters, including Grosz and Picasso, did not typically include such information in their biographies, and Tamara's self-aggrandizement looked defensive, as if she had to prove to everyone that she was a noteworthy artist.[75]

The cover of the bulletin featured her *Mother Superior*, whose mannered naturalism was by now assumed to be Tamara's forte, since she publicized such paintings more than any others. Because her painterly qualities—the clear color and invisible brush technique that very few artists employed anymore—inevitably reproduce flatly, newspaper and magazine photographs of Tamara's narrative works often resembled caricatures. Renaissance narrative paintings were received in a historical context; there was no question of anachronism in reproductions of the masters upon whom Lempicka depended. When Tamara's representative art was reprinted, however, it was easily trivialized, since the technical execution on which its effect depended did not translate well into the contemporary media.

Upon Tamara's return to Beverly Hills, the Kuffners precipitously, and for no clear reason, decided to relocate. Perhaps Kizette's move to Washington influenced the couple's decision to leave the West Coast, and by now they would have realized that the serious art world excluded Hollywood from real consideration. Perhaps most important, Pearl Harbor had changed everything; the painter was on the wrong coast to sustain the security for which she had left Europe. By 1942 the Kuffners had left California for what, as usual, they told their acquaintances would be a short trip to New York.

Always politic with society, if not with the art world, Tamara explained her decision to depart Hollywood as entirely the baron's choice—he wasn't the celebrity type. Later she told her New York friends that he could not stand the West Coast crowd she had collected and had spent most of the Hollywood years off hunting. But Tamara's press coverage had also diminished by 1942, indicating that she had cut back on her socializing or at least was receiving less notice for it. If the creative chaos in the *année folles* had made Paris a perfect fit for Lempicka, Hollywood society was never quite sure about the odd Slavic woman. She had taken the measure of the glitter surrounding her and reached out in similar style, but she had failed to play the game with enough subtlety to gain an artistic stronghold in Hollywood. Even for Beverly Hills, she was too obvious—paradoxically, in her singular fashion, too honest. Her frivolity appeared oddly authentic; her seriousness inconveniently sincere.

No one in Los Angeles could understand Tamara. She seemed genuinely to enjoy the Hollywood milieu, but she painted pictures of the suffering and the poor instead of sticking to the winning prescriptions of her earlier Paris portraits. She perplexed her audiences, gradually becoming an object of curiosity, a wealthy socialite who confounded expectations: was she patronizing the poor or condescending to the Hollywood crowd? Hollywood would resolve its uncomfortably ambiguous perception of the painter when, after her death, it reinvented Tamara in its own fantastic image.

But neither her encounter with Los Angeles in the 1940s nor her later resurrection in its midst was destined to grant her a place in the Modernist canon. The glamorous baroness sabotaged her reputation in the American art world by assuming that her sincerity would be enough to mediate any rift between art and artist; and her refusal to compete with, or even to acknowledge, the current artistic values set her up to be ignored. The decision to launch her American career in Hollywood was possibly the worst choice that Tamara would ever make.

# ART
## in the
# NEW
# WORLD

*Upon their move to New York in 1942, the* Kuffners rented a suite at the Waldorf-Astoria while they waited to close on their purchase of a duplex apartment on East Fifty-seventh Street, near Sutton Place. Told by one of the earliest investors, Cobina Wright, about the luxury building that overlooked the East River, the couple was impressed by what Cobina accurately described as "a most unusual apartment, featuring a very large terrace and banks of plate glass." Cobina had been at a 1928 party for composer Maurice Ravel when she first learned of the plans to build the high-rise cooperative, a circumstance that doubtless added cachet in Tamara's eyes.[1] Now, in 1942, the Kuffners purchased for $240,000 what even twenty years later a New York estate lawyer would describe as "a gem of an apartment."[2] The couple paid between $600 and $700 a month in the early forties, when $350 was considered a substantial monthly mortgage payment.[3]

The apartment was a jewel, second only in design to Tamara's beloved 7 Rue Méchain. Occupying the sixth and seventh floors of the twenty-story building, the duplex consisted of seven rooms and three baths. Facing north, its win-

dows spanned the entire two floors, a feature cherished by the artist who
depended on northern light for her painting.[4] The upper level contained the
Kuffners' separate bedrooms, baths, and dressing rooms. Tamara's bedroom,
furnished with Louis XIV furniture rescued from Castle Dioszegh, con-
trasted with the simpler yellow and natural wood designs of Raoul's bed-
room and study. The apartment boasted an expansive living room with an
eighteen-foot-high ceiling, a large fireplace with a marble hearth and man-
tel, and an ornate stairway providing access to the upper floor; decorated in
blue satin with a reddish-blue carpet, the room echoed the opulence of
Tamara's private quarters. Elaborately carved white stucco mirror frames
and tables from Raoul's family castle lent Old World elegance to the other-
wise modern interiors. A large, up-to-date kitchen and an oversize dining
room occupied the rear of the apartment. In the spacious front hall, black-
and-white checkerboard floors complemented Kuffner's antiques, creating
such an arrestingly eclectic look that Tamara's New York friends began ask-
ing her to decorate their own homes. She lavished most of her attention on
arranging the couple's art collection, which included her own work.

"I remember well the way my mother filled the walls with her paintings,
and those from Papali's old masters collection," her daughter reminisces.
"She had a meticulous sense of space and shape, so she'd lay pieces of paper
cut to scale on the floor, creating a grid that she'd re-create when she hung
the actual art. She had a long stick that she used to push the pieces around
until she achieved the right effect. She always used this method, even when
she helped me, years later, with my home in Houston."[5]

As usual, Tamara wasted no time resuming her frenetic entertainment
and work schedule. New York's social world proved easy to conquer, partly
because the Kuffners' previous summer rentals of a Connecticut country
home had introduced them to the city's elite. These new acquaintances had
been impressed by the seriousness with which Raoul and Tamara studied
U.S. law during their vacations. Eager to become naturalized citizens, the
couple approached learning about their new country with an earnestness
typical of less privileged immigrants.[6]

Tamara continued to alternate intimate gatherings with lavish dinner
parties—a few Vanderbilts might visit one night, a party for two hundred
filled the living room the following evening. She grew very fond of the
apartment; except for 7 Rue Méchain, it was the only home she mentioned
throughout her life. Lily Pons, whom the painter had entertained frequently
in Hollywood, maintained an apartment in the same building, and the
Kuffners could hear the diva rehearsing when the windows were open.[7]

Other Hollywood friends lived there as well, including Myrna Loy and Marion Davies, the mistress of William Randolph Hearst. A few floors above was Vincent Bendix, a Swedish aviator whose flair for entertaining competed with Tamara's own. Borrowing furniture from the apartments around him, he routinely gathered "odd mixes of intellectuals who were in turn invited to bring their most unusual friends. His parties were friendly, interesting, exciting gatherings where the champagne flowed freely all evening," recalls Martin Shallenberger.[8]

When the baron was in residence—never more than half of each year— the couple would dine nearly every day in various favorite restaurants. Raoul ate early in order to "savor the flavors," while Tamara joined him hours later when more of a crowd had gathered. Often they would move to a second restaurant in pursuit of a particular dessert.[9] Perhaps because he no longer filled his days overseeing the painstakingly careful canning of meats and brewing of beer at Dioszegh, Raoul Kuffner transferred his fastidious habits to ensuring the quality of the couple's meals. Before going to lunch, he would telephone the chosen restaurant in the morning, in order to learn of the day's freshest ingredients. From this report, he and the chef would concoct the perfect meal, to be served at the ideal temperature at the exact moment the baron expected it. For such treatment, he gave four times the normal tip.[10] Tamara, fascinated by a man who was as obsessive about details as she was, felt protected by her husband's rituals.

Raoul's passion for hunting large game also must have increased his wife's emotional security, if only unconsciously. "Tamara told everyone that story about people eating the flesh of the dead horse during the Russian Revolution, over and over again," Cuernavaca developer and writer Richard White recalls.[11] Her fear of deprivation was allayed by her competent husband's reassuring focus on food, and this, as much as her own desire for periods of privacy, motivated her to encourage Raoul's hunting trips. When he left for Montana or Austria, his two favorite sites for big game hunting, she felt taken care of, not abandoned.

And she enjoyed the freedom such periods provided her; now she could meet friends at Gene Caballaro's restaurant, the Colony, at Sixty-first and Fifth Avenue, a very fashionable spot that her husband found uncongenial. "She would sail in like the queen bee, refusing to pause to speak to people —merely nodding instead—as she strode to her table. She inevitably became the center of attention, and she also created a lot of resentment and envy," says Shallenberger. Although "shy" was not an adjective ever applied to Tamara, she did feel inept when encountering people of whose approval she

was uncertain: either she sat quietly in the background when the scene was beyond her control, or she pretended to be beyond the reach of anyone in the vicinity. At the Colony, she practiced the second approach.

While her husband was away, Tamara also haunted the Stork Club, the nightclub popular with café society in the 1940s and 1950s. Sherman Billingsley, its owner, welcomed social eccentrics like Lempicka, since they provided easy fodder for gossip columnist Walter Winchell. Tamara used the forum to establish her still extravagant sense of fun, rather than her identity as a serious artist. The hat designer Mr. John joined forces with Tamara, making her wear his outlandish creations to the clubs. "He wore lots of makeup, really big on pancake makeup. He'd go to the rest room when he first arrived somewhere, put on his makeup, and prance out, outrageous," according to an observer.[12]

Manha Dombasle, Tamara's friend from the early thirties, recalls that Lempicka "loved New York society." She continues, "My husband, who was part of the French Resistance against Pétain, and later an ambassador to Mexico . . . , was a Sunday painter, and so he enjoyed mingling with real artists, and he found Tamara always very amusing. Tamara was such a character, a real personality, that it seems logical to me that she would have sought New York and Hollywood when she wanted to escape from the war. She had to be around interesting people to survive, and many people did not understand her. But I did, and I loved her. She was a very good, dear friend." Because so few character testimonials have been offered for Lempicka, it is noteworthy that those friends who do defend her are, without fail, known for their own high character and quiet confidence, the latter at odds with their friend's flamboyance. Manha Dombasle is thought by her large circle of friends and family members to be one of the kindest, most intelligent members of French society. Her sincere testimony about a friend who would ask many unreturned favors of her holds particular significance, both because of Dombasle's own reputation and because of the friends' apparent dissimilarity.[13]

In spite of the brutal pace at which she had resumed socializing, Tamara was adhering to her equally demanding painting schedule. Now, perhaps satiated by the glamorous world of illusions, she began to develop her earlier interest in still lifes. *Plante Grasse et Fiole* offers an oddly intriguing arrangement of a glass beaker, a deck of cards, a matchbox, and a large domestic plant in a plain terra-cotta pot, realistically rendered. Tacked to the wall behind the richly variegated green fronds is a small postcard of Vandyke's self-portrait. A swath of blue-and-white striped fabric borders the arrangement of objects on the right; two books and a rolled-up poster

enclose the scene on the left. The satin fabric, with its voluptuous, seductive folds, impresses upon the viewer the sensual nature of even the common-place, transformed by a fresh aesthetic.

Between her artistically productive phases, however, Tamara again sank into depression and took to her bed for weeks and sometimes months at a time. Her family, typical of the times, attributed these episodes to her "artis-tic temperament." At one point, during the manic phase that usually pre-ceded her depressions, she painted nonstop for days at a studio she had rented while waiting for renovations to be finished in the apartment. Kuffner worried about the pace she was maintaining, but she persuaded him to leave her alone. After she failed to return home for two days straight, he sent the butler to take her some food. Finding her sprawled, unconscious, on the floor, the distraught employee summoned an ambulance. "The doctors said it was exhaustion, I was working too hard," Lempicka claimed years later. "They told me I had to rest more. But I needed to work."[14]

It was probably around this time that she concocted one of her most eccentric plans to stay busy. Deciding that she should take a break from her painting, she read the employment ads in the newspapers; finding one for a window designer for Elizabeth Arden, whom she knew slightly, she rushed to the store's employment office. Once there, she sat in a room with dozens of other eager applicants, only to be told that the job entailed washing the windows, in addition to arranging their displays. "Come with me, girls," she instantly announced to the disappointed assemblage. "Maybe you want to be a maid, but that's not what I came for. Come home and I'll make you lunch."[15] This kind of spontaneous friendliness, most often spurred by dis-covering something in common with a stranger, continued to endear Lem-picka to a mix of incongruous companions until she died.

By now Tamara had begun to miss the company of such fellow artists as Moïse Kisling and Jean Cocteau and even her old teacher André Lhote. When Kisling returned to New York from Hollywood in 1943, he sought to replicate his French studio, attracting the artists and intellectuals currently exiled from Paris, in many cases the same people who had emigrated to the French capital twenty-five years earlier. Tamara was included in his artistic circle, but now, as a prominent member of American society, she mingled less easily with the old guard. Nonetheless, Kisling's presence, and his visi-ble reminder of other School of Paris transplants, bolstered her confidence enough that she produced superb still lifes for the rest of the decade, in spite of diminished sales. Tamara's productive first decade of painting in Manhat-tan resulted partly from her belief that, just as Paris had supported a varied international scene after World War I, so too would New York welcome artis-

tic diversity, even though it might be a few years before she joined the American ranks. Kisling, however, would decide otherwise by 1946 and return to Paris, only to discover that the artistic world there no longer held a place for him either. He remained in France, where Tamara apparently visited him in early 1950, just a few years before his death.[16]

At least until the end of the 1940s, Tamara believed she could establish a place for herself among the East Coast art establishment, regardless of the unexpected directions art was taking in her new country. Accolades would be hers, she maintained, once she brought her talent to the public's attention. Peggy Guggenheim opened her Art of This Century Gallery in Manhattan, a sign to Lempicka that she was in the right place for a capacious reading of twentieth-century painting. That Guggenheim would ignore Lempicka in every possible instance, even beyond the strictly professional— even, for example, in their mutual old age when they were part of the same social circle in Mexico—seems incomprehensible. But Tamara frequently alienated other strong women, a handicap that contributed to her permanent status as an outsider. Though in truth her imperious behavior functioned as a preemptive first strike to disguise her insecurity and assert her importance, it offended others.[17]

Guggenheim's gallery in 1942 should have found a place for Lempicka among its stable of artists. But although its first major exhibition a year later, 31 Women Painters, was created by a European, Max Ernst, Tamara was not included. Nonetheless, in 1943 she could still legitimately draw hopeful conclusions from the cultural landscape. Throughout the thirties, after all, the American establishment had rewarded realism and good draftsmanship. Edward Hopper, whose slightly mannered realism and elegant spacial configurations shared her own painterly vocabulary, suggested one direction in American art that appealed to Tamara. She believed herself poised to take advantage of her relocation to New York, just as she had reaped rewards when she emigrated to Paris in 1918. At the same time, the infusion of European refugees during the war—from Surrealists to Expressionists—allayed her fear of being too alien. Expanding her classical treatment of still lifes, she now developed her earlier flirtation with Surrealism into a series of disconcertingly disembodied hands, oddly positioned among bouquets of pansies and roses. These works, influenced by Tamara's study of Albrecht Dürer's paintings, include a painting of a skeletal Daliesque bleached white hand imposed upon bunches of gaily colored posies. Tamara had long admired the languid-looking hands that the late quattrocento artist painted; and she seemed prouder of the (later discredited) Dürers that Kuffner had brought

from Hungary than of any other art they owned. Dürer's pictures, noted for "the artist's big intelligence, his scientist's self-confidence, his learning and his pride," were worthy of emulation.[18]

Confident of her professional progress, Tamara felt content for other reasons as well. It was easy to visit Kizette and Harold Foxhall in Washington or, better still, to persuade her daughter to take the train to New York for the weekend. According to Kizette, in lieu of active military duty Foxy drew maps at the Pentagon for the top-secret excursions that prepared for the invastion of Normandy. The couple lived in an attractive little apartment in the city: "Chérie thought it was cute, and I really loved our time there." Doing her part for the war effort, Kizette greeted returning wounded soldiers at the airport, then transported them by van to the terminal, where the men were served coffee and doughnuts and encouraged to socialize with others before leaving for nearby hospitals or going home to rejoin their families. "It was a wonderful job," Kizette recalls. "I danced with all the men who were able to. Mother approved deeply of my contributing to my new country, especially since at first I was sad to leave Paris, which I loved and where I had a boyfriend I would meet in the stairwell during the air raids. Now I was happy. The job required me to be available around the clock. More often than not, the telephone call would come in the middle of the night, someone saying, 'Kizettte, it's your turn.' My little uniform, not as nice as the one Mother designed in Hollywood, included a white cap with a red cross and an RAF blue skirt and jacket. It was sweet."[19]

Kizette hoped that through her volunteer work she was indirectly contributing to her father's well-being. She worried about him constantly, since she frequently read accounts of the terrible conditions in Warsaw. With coal an extravagance, even the formerly rich were chronically cold in the city's below-zero weather. Food was rationed, and many people ate only one meal a day, often consisting of cubes of lard rinsed down with vodka.[20] By 1944, Warsaw would be systematically destroyed by the Germans, and Kizette would remain uncertain until the war's end of Tadeusz's safety.[21]

Both Kizette and Tamara were nervous about Adrienne and Pierre as well, since they knew the Montauts were involved in dangerous resistance work. Only after the war ended, however, did they realize just how much danger the couple had faced. Pierre de Montaut's daughter, Françoise, remembers their efforts:

> *My father and Ada perhaps were not, strictly speaking, members of the Résistance during the war, but father had building projects*

*in la zone libre [the part of France that was not occupied by the Germans at first], and he often crossed the demarcation line—fraudulently, of course. He would take the train with his bicycle to the village nearest the line then make a dash for it through fields and woods and get on another train on the other side of the line. . . . During these escapades he often brought with him war prisoners who had escaped from their camps and were fleeing the Germans. He also helped some Jews cross into unoccupied France. He was denounced by someone and tried by the Germans. During his trial he acted as his own lawyer. He was sentenced to five months in the famous Paris jail La Santé, where Ada and I brought him clothes and food. One day, among his dirty laundry Ada found threads with knots in them. She understood it was messages in Morse code through which my father was giving her addresses of families of other prisoners who could not have visitors. She would then pass on their news to their families. The great danger when you were in prison at that time was that you risked being chosen as a hostage to be executed in reprisal for Germans killed by the Résistance. It was a deadly lottery.*[22]

While her relatives in Europe fought for their future, Tamara sought to imbue her New York life with elegant reminders of her past. Sometime in 1944 she instituted her own version of the Left Bank Parisian salons hosted so famously by women in the twenties. Every Thursday afternoon from four to five-thirty, she received between eight and fifteen people for tea at 322 East Fifty-seventh Street. Her guests were usually women she had met socially and whom she now wished to befriend. "Sometimes my mother would find an attractive struggling artist and she'd invite him as well," Kizette maintains. "You might see a duchess or a countess talking to someone like herself or seated instead next to a scraggly young man half her age." Recalling the Russian tradition of hospitality, Tamara would use her family's turn-of-the-century samovar at these gatherings. When Kizette visited her mother, she was asked to pour for the guests—"which was always amusing"—while the Kuffners' butler passed around tea cookies, the only food served.[23]

Since one of her best friends in New York, Mala Rubenstein Silson, "never attended soirees at Tamara's," it seems likely that the artist used this forum primarily to collect new members for her social circle.[24] Silson recalls that their own friendship revolved around frequent dinners out and numerous evenings spent at her apartment, where the two women gossiped about mutual European acquaintances and where Tamara entertained Mala with "her wonderfully risqué jokes," which Silson decorously refuses to share.

They discussed painter Alice Halicka's unattractive habit of preferring titled friends to all others, even as they continued throughout the 1950s to enjoy Halicka's parties in Paris, where her distinguished guests included the sculptor August Tamoyski, Princess Natasha, wife of their favorite designer Lucien Lelong, and Nabokov the musician.[25] But in spite of the time the two friends spent together over the years, Mala believes that she "never met Tamara's husband."[26]

Mala was one of Tamara's few friends to meet her daughter. Although Kizette and her mother stayed in close touch, Tamara continued to maintain publicly that she had no children and that Kizette was her sister, a subterfuge meant to hide her age. Yet this denial of her daughter was more complicated than a simple manifestation of her plentiful vanity. The model for successful women artists in Paris had largely excluded child-rearing; now, the New York painters were establishing sterner, even macho, standards that allowed no room for mothers. And according to Victor Contreras, who discussed such issues with the painter in her last years, Tamara's fear of acknowledging her birth date reflected her dread of dying. Still, the death she sought to defer by denying Kizette's age included more than her own literal demise: loss of her professional, sexual, and social powers as a price of the years served as preludes to her own end.

Soon Malvina's death would contribute to Tamara's fear of mortality. As with most events that really mattered to her, she barely spoke of it. "I felt so sad. My mother died and there was the war and I couldn't go to her," was all she would say to her Japanese interviewers in 1979.[27] According to Adrienne's stepdaughter, Malvina died soon after the end of the war, too soon for Tamara to have profited from the lifting of travel restrictions. Françoise Montaut de Dupuis was very fond of her stepgrandmother: "She [Malvina] lived with Ada and my father throughout the war, and just after Paris was burned, she had a stroke or a heart attack. She lived a little while and was taken back to Warsaw, where she died soon afterward."[28]

But in other ways Tamara was pleased with her family's progress. Harold Foxhall was appointed chief geologist for the state of Arkansas, a post that came with a large office in Little Rock. Adrienne and Pierre began developing plans to move to the south of France, an area Tamara loved, where they could indulge their love of sailing. And in 1945 the Kuffners became U.S. citizens. After the couple received their papers, they took a quick trip to Europe to visit their family and check on their property. "She did not want to be gone often or long until her citizenship had been permanent for several years," Kizette says. "I think she was irrationally afraid her papers would be revoked."[29] In the interviews she granted to French reporters, Tamara con-

tinued her idiosyncratic policy of idealizing wherever she happened to be at that moment: "She told them all that she would be finding a way to return to Paris to live as soon as possible," her daughter states. Asked if this was really the painter's intention, Kizette says that her mother never stopped looking for the right place to call her real home, and whatever location inspired her at a particular moment would lead to an honest, if briefly sustained, declaration of loyalty.[30]

At the end of her life, Tamara claimed that during the war years her "success was big in America," but she added, "I wanted always to send the paintings back to Europe. During the war I could not do it. I kept the paintings, and then after the war I started to bring them to Paris. I wanted to exhibit in Paris and sell them in Paris. There are collectors who have many paintings in America, but I didn't know who or what. I was only interested in Paris because that was the center of art. And that's why I was working."[31]

But Paris was not ripe for her return. During the decade following World War II, Tamara's "virile" yet feminine style continued to complicate her reception among French critics and the buying public. Just as Suzanne Valadon was uneasily lauded for her "unfeminine" or "masculine" bold form and color, Tamara could have manipulated such a perception in her favor. She steadfastly refused, however, to explain her strange, iconoclastic new canvases, ranging from the Surrealistic hands among pansies to Dutch-inspired still lifes; instead, when journalists interviewed her about her career, Tamara threw out sexy innuendos or tantalizing bons mots.

In 1945 and 1946, while the men were still recuperating from the war, the private galleries in Paris sponsored many solo shows of women artists, including Valadon, Marval, Charmy, and Laurençin. Tamara correctly believed that women as a group were more entrenched in the French art market than they were in the United States—not that such a climate ensured that they would be taken seriously. As scholar Gill Perry notes, during the 1946 Salon des Femmes Peintres et Sculpteurs in Paris, the predominant critical position maintained that "women artists occupy a separate area of artistic production, concerned essentially with 'decoration,' 'sensibility,' and 'delicacy.' . . . [Reviewers] wrote that these women artists showed a markedly superior ability to produce works which were 'midway between nature and decoration' and which allowed them to create a 'natural delicacy.'"[32]

Although she was willing to exhibit in all-women shows, Tamara never courted or even acknowledged gender-based praise of her "superior ability," in spite of the niche such an identity might have provided. And so, during the mid-forties, though French critics appreciated the talent behind her still

lifes and portraits of everyday subjects, the paintings fit neither the category of women's art nor that of contemporary painting. Tamara's kind of painterly genius, the antithesis of what was exciting the art world in America, failed to fit with any European agenda, either. A group of elite artists centered in Manhattan was becoming famous for a philosophical commitment to an indigenous abstract art, free of European decay—and at the very least, the French sought an aura of newness with which to defend themselves.[33] This period was deeply inhospitable to Lempicka's willful insistence upon openly and unabashedly pursuing in her work and her life a luxuriant aesthetic that others saw as ideologically retrograde.

Increasingly after World War II the virtues of Tamara's paintings became grounds for critical dismissal. Even worse, she was unaccountably excluded from the only rubric she might have fit successfully—the School of Paris, which was still selling in expensive Fifth Avenue galleries. Clement Greenberg's essay "Art," in the *Nation*, 29 June 1946, had isolated the "hedonism" and "decadence," that supposedly marked much of the painting of this school. Though consistently omitted from catalogs of its members, Tamara shared the school's interest in the figure, in "rich surfaces [and] decoratively inflected design," which constituted the category. And although she had resisted being categorized in the 1920s, retrospective inclusion now within the broad perimeters of the School of Paris at least would have ensured her continued viability in America. But in the late 1940s, and especially in the 1950s, the New York galleries that specialized in School of Paris collections failed to include her. Ida Gleizer, whose prestigious Madison Avenue gallery was a primary conduit of such art, claimed in 1997 that until she was interviewed, she "didn't know who Tamara de Lempicka was."[34]

Temporarily, however, Tamara was able to blame the cultural upheavals inherent in the aftermath of war for the lack of interest accorded her career in New York. Confident of her worth, and deeply involved in working on still lifes, she produced several stellar pieces, worthy of her best nudes. But her choice of this genre and her approach to her subjects encouraged her omission from histories of Modernism; her stylistic turn was similar to that taken by Georges Braque, who, urged by the dealer Paul Rosenberg, rendered exquisite still lifes after 1925. Just as Braque's later work was unjustly eclipsed by his innovative early Cubist paintings, what little currency Lempicka maintained as a painter of note rested upon her reputation as an Art Deco portraitist. Her serious turn to still lifes doomed her: Americans weren't interested, and Europeans would chauvinistically regard 1939 to 1952, the years when she produced such works, her "diminished" period related to her leaving the more fruitful French shores.

Yet these paintings of the forties and early fifties, inspired by Dutch and Flemish art, ravish the eye with their extraordinary clean painting and finish. Asked at the end of her life to account for their beauty, the painter rehearsed her dislike of Cézanne: "[My paintings] were neat and they were finished unlike the work of others, which was undecided. . . . Instead, my paintings were very neat . . . a white dress . . . was pure white against a pure red, against a pure blue. . . . Why [mix] blue and red and green like Cézanne did? . . . I see it clear and neat and clean. And this is the painting I want to do. And my paintings, if you see them in color you would see that they are clean and neat. And this is probably the difference between me and all the other painters of my time that didn't do [it] my way. They did it like Cézanne."[35]

Discouraged but undeterred by the critical neglect of the 1940s, Tamara continued to develop in new directions. Her awareness of history had always informed her paintings, but now she began to mark her work with specific cultural references. By 1946, as seen in *Trompe l'Oeil de Botticelli*, she was painting a Renaissance-inspired key to many of her still lifes, a conceit she would use in her later trompe l'oeil compositions as well. This oil on wood panel reproduces the aged wood grain of the painting's material support; upon the trompe l'oeil wall hang a painted key and a painted reproduction of a frayed Botticelli Madonna. The edges of the faux Botticelli curl and cast shadows with a masterful realism. Occupying only the center of the canvas, the virgin's face is angled toward the long key and pink ribbon hanging in the upper right corner of the painting. Few images are more overdetermined with meaning, both historical and personal, than this key. In Renaissance painting, Christ handing over the keys of the kingdom to St. Peter represented the legitimacy of the Roman Catholic church, and the presence of a key thus symbolized the divine authority of church and state. When Peter the Great founded St. Petersburg, the iconography of St. Peter's key was transferred to the Russian city. And, of course, more commonly the key is the instrument by which one reveals what is hidden, or, conversely, locks away what is in plain sight. Tamara's use of the icon in her still lifes throughout the 1940s was meant to remind viewers of the authority of history that informed her art.

While Tamara continued to paint ten hours a day, Raoul Kuffner sought adventure far from home. During 1946 the baron told his good friend Robert Lambert, owner of the Heineken breweries, that he wanted to hunt Alaskan white bear. Lambert rented a yacht and hired a young man from Montana, Richard White, to crew for him. A child of the Depression, Dick White was thrilled to earn two dollars a day. When the boat's hired chef got drunk in

Juneau and was thrown in jail, White quickly offered to take his place: he had often helped his mother in the kitchen at home. Reluctantly, Kuffner and Lambert gave the boy a trial, whereupon they discovered that he was a superb cook.

Baron Kuffner was deeply impressed by White's loyalty, good-humored intelligence, and attention to duty. He told Lambert that White needed an education abroad, and the Heineken heir gave the grateful boy a $10,000 tip. "There is one condition, however," he said. "You are a rube from the wilderness; you need to go live in Paris for a year." Sometime during that year, a mysterious man arrived at White's apartment in Paris and gave him money from Lambert to lease a charter boat; White went on to develop the small business into a major charter industry in the Pacific Northwest. Lambert's instincts were right: the young man he sponsored would develop Pioneer Square in downtown Seattle and would work with art museums on the side.

Now retired, the Cuernavaca resident was a friend of Tamara's during the last decade of her life and recollects the oddness everyone ascribed even in the forties to the baron's marriage: "We'd laugh about his wife," White recalls, "whom we'd never met, because she so clearly didn't want to spend any time with him. They were simply never together." He also remembers that the yacht crew was "actually fairly attuned to the baron's sexual life. He brought his heart doctor, a famous physician from Zurich, on the trip with us, in order to check out the women the baron would discover along the trip, before he would sleep with them." The baron made them laugh, too, when he became frustrated with the inefficiency of the plumbing: "He would take his cane and hit the toilet repeatedly, muttering all the time."

A less amusing incident took place one morning when Lambert, displeased over the noise level on board, publicly and loudly blamed White. The young man politely demurred, saying Lambert had merely heard the normal motor sounds of the ship. "You bastard, don't you contradict me!" his employer shouted. Despite Kuffner's presence, the cabin boy–cook grabbed Lambert by the collar and enunciated very clearly: "Don't you ever call me a name like that again. Do you understand?" Lambert flinched and asked the young man to come to his cabin. Once inside, Dick White was offered an apology by his future patron, who confessed he had talked that way only to impress Baron Kuffner, "who, after all, expected such control by the superiors."[36]

Although Kuffner was genial and well liked, he was a perfectionist and, in his own way, a demanding man. Tamara appreciated such a personality, and his grandchildren remember that Papali taught them the importance of purchasing quality goods carefully but not extravagantly. "He was scandal-

ized when he found it difficult to buy Pears soap outside of New York and Chicago; and the apartment always smelled of the pine-scented Vitabath he used, which reminded him of the outdoors that he loved. Papali was a great blend of kindness and precision, a sort of Germanic Santa Claus," his grand-daughter Victoria Doporto recalls.[37]

*Raoul Kuffner on hunting trip, late 1940s.*

When the baron was not traveling, he spent his days in New York working on a manuscript about his family's experiences at Dioszegh and how those lessons might be transferred to the modern, humane capitalist state. Although he had been an avid reader all his life, this book was his only attempt at sustained writing, and the final result, *Planomania*, is an intelligent, insightful, provocative study.[38] Employing two New York University professors of economics to help him with his English and to flesh out his theory, Kuffner reveled in the project. The academics loved going to the baron's house for the excellent meals, especially the Hungarian goulash, which Tamara had taught Walter, her cook and butler, to make. Walter was the Kuffners' only full-time servant except for a housekeeper who lived in the maid's room, and he showed up faithfully every weekday morning, year after year, though he traveled long hours by subway to get there. According to Kizette, "It wasn't just the money [that motivated Walter]; he was incredibly loyal to my mother because he adored her." Over the years he became indispensable to the smooth running of the household, and Tamara entrusted him eventually with her secret recipes. Once, when a society writer raved about a dinner at the Kuffners', Tamara announced that she had cooked the meal by herself, when in truth Walter was tending the stove alongside her, as usual.[39]

She continued giving parties for New York's elite, assuming that she would advance in society if "the best" came to her house, and that such connections were one path to artistic prominence. Casting her first decade in Manhattan in the same light as her years in Paris, she later told journalists that "in New York, at 322 East Fifty-seventh, in [my] two-floor apartment with windows two floor high, I was giving big parties, cocktail parties, and big receptions. [Designers] wanted to do [free] dresses for me, Patou wanted to do me a dress. Then somebody else wanted to do me a hat. I was very well dressed, and I didn't pay because they were all given to me."[40]

In spite of her many trips abroad over the next three decades, Lempicka never again visited Poland. In Warsaw, Tadeusz and Irene Lempicki had ingratiated themselves with the city's Communist government. Early in 1946, Tadeusz's stepdaughter, Lulu, had moved to France when that country opened its doors to yet another flood of Polish refugees. But both Tadeusz and Irene possessed the type of charm and sophistication that could be put to good diplomatic use, and so in 1947, Tadeusz was appointed Polish consul general to Toulouse. Embarrassed by what they considered to be opportunism on the couple's part, Irene Spiess's anti-Communist family and the couple's friends nonetheless understood the Lempiccy's desire to become more financially secure.[41]

*Tadeusz Lempicki with his stepdaughter, Lulu, and wife, Irene, Poland, late 1940s.*

In New York, Tamara was seeking ways to wed her talent for color and line with the new spirit of the art world, though she had difficulty understanding its values. In 1947 she welcomed Surrealism's last battle to gain a stronghold in the contemporary art world, when two of the movement's champions, André Breton and Marcel Duchamp, mounted a summer show in Paris, *Le Surrealisme en 1947*. It contained a Hall of Superstitions, a Rain Room, and a special-edition catalog with a foam-rubber falsie glued to the cover. Miró, Matta, David Hare, and Tanguy were among the artists shown. The show, with its echoes of the recent past, pleased Tamara, who had previously been ambivalent at best toward Surrealism. At this point she felt like her later friend Octavio Paz, who wrote, "I arrived in Paris in December 1945. . . . Surrealism attracted me. At the wrong time? I would say, rather: against time. It was an antidote to the poisons of those years: Socialist realism, littérature engagée—politically committed in the manner of Sartre—abstract art and its sterile purity."[42] But as Calvin Tompkins declared, "Instead of revitalizing Surrealism, the 1947 exhibition turned out to be the movement's last hurrah."[43]

The crux of the issue was that American artists were poised to move away from "relational art." Jackson Pollock, Clyfford Still, Willem de Kooning, Barnett Newman, Mark Rothko, and Franz Kline had in various ways "assimilated Cubism and Surrealism [and] moved beyond them, and in doing so, they changed the course of modern art."[44] The Abstract Expressionists represented the very opposite of Lempicka's aesthetic: "all-over" painting celebrated process, not finish. One of the most insightful art historians of our age, T. J. Clark, asserts as a "Modernist piety" that art's medium must denote the "absence of finish or coherence," the very qualities central to Tamara's work. In 1945, for instance, when Duchamp had suggested cutting eight inches off a Pollock mural that was too long for Peggy Guggenheim's apartment, Pollock himself apparently didn't think it mattered enough to protest. Lempicka would not have understood such a whimsical approach to painting, though she admired Pollock's works themselves. But it was Jackson Pollock's "inspired scattering and dripping of pigment on can-

vas" that would "haunt, overshadow and to a large extent direct the subsequent course of American painting through the second half of the century."[45]

Whatever Lempicka's emotional resources for maintaining confidence in her art, her lack of public success showed itself in her limited financial contributions to the family. By 1948 her lavish entertaining and the Kuffners' extravagant travel schedule had strained the couple's finances intolerably. They had by now hired an accountant, Henry Kolar, who would remain the baron's trusted adviser until his death. According to Kizette, who was in New York visiting the couple, Kolar "sat them down and said, 'You're going to run out of money if you keep on like this.'" Their immediate solution was to take to auction their extensive collection of Flemish and Dutch art from the Dioszegh estate, now in their New York apartment. Handled by Parke-Bernet Galleries (later to become Sotheby's), the auction took place on Thursday evening, 18 November. Comprising sixty-nine paintings by Dutch and Flemish old masters and by minor masters of the Italian Renaissance, including works by Steen, Van Reymerswaele, Jordaens, van Ostade, Brueghel the Younger, and Ghirlandaio, the lavishly illustrated catalog for the sale provides a picture of the comprehensive collecting habits of Kuffner's parents, from whom he inherited the paintings: still lifes, landscapes, genre paintings, and portraiture are all equally represented in the collection. In the prefatory note to the auction catalog, the author remarks that in 1908 an annex was added to the picture gallery of the Kuffners' ancestral home to accommodate the growing collection and to provide free access to the public. The author also reports that the collection was removed from the Castle Dioszegh in "successive stages" between 1930 and 1938 and brought to the United States in 1940.

On 14 November the *New York Times* reported the upcoming auction and provided a description of some of the most valuable paintings up for sale. The day after the auction, the newspaper noted that the sale had brought $28,775—a low total, considering the quality of the collection. "The Kuffners got ripped off by Sotheby's," William Simpson, an art dealer in Houston, insists. "The baroness blamed it on her husband's bad business sense, but the truth was that Parke-Bernet spent so much on reframing and restoration, and then on working through those shaky communities of bidders around town, that the Kuffners ended up practically giving away the collection."[46]

At the end of 1948 or the beginning of 1949, Tamara visited her daughter's new home in Texas. After four years in Little Rock, Kizette and Harold Foxhall had moved to Houston, where Foxy had accepted a position as chief geologist for Dow Chemical. "Foxy loved geology and everything that had

to do with the earth. He was good and he discovered all sorts of things for the company—made lots of money for them too," his wife proudly asserts. The couple was accompanied to Houston by their two-year-old daughter, Victoria Ann, nicknamed Putti by her grandmother because she resembled a curly-haired Renaissance angel. For almost a year the Foxhalls rented a house behind the beautiful Houston hotel, the Shamrock, where they were allowed to use the pool and tennis courts and to socialize at the nightclub. Christie Tamara Foxhall, the couple's second child, was born during this happy period. All Harold Foxhall ever wanted for his girls, as he told people throughout his life, was that they be allowed to live like ladies, from the time they were born, and he was grateful that his mother-in-law was willing by her irregular but generous contributions to provide the wherewithal to achieve such status.[47]

By the late forties, Tamara had resumed a peripatetic life that suggested unsettled ambitions and unclear loyalties. As if preordained never to have a home—or at least to feel that she "had no homeland," as she had written Gino Puglisi over a decade earlier—she now constructed a life that for the next twenty years consisted of spending three or four months in one place and then moving on to another favorite location for two or three more months. She stored her paints and canvases at the luxury hotels she patronized year after year. Loyal to her couturiers, with whom she scheduled fittings a year ahead of time, she took most of her business to Madame Alix Grès, whose training as a sculptor Tamara believed accounted for the fluid lines of her dresses. On her trip to Europe in 1949, Tamara had several dresses actually sewn by Alix herself, and even adopted Madame Grès's Cabouchard perfume as her signature scent. "I loved how Chérie's closet emitted the most beautiful flowery scent anytime I opened the door," Victoria says.[48] George Schoenbrunn, as usual, demurs: "I don't remember her smelling like the Arabian nights, I can tell you that. She didn't use deodorants, and she wore all these heavy furs whenever I saw her in Europe."[49]

Near the beginning of her first extended trip to Europe since the war, Tamara contacted Gino Puglisi in Rome. On 7 January 1949, from the Grand Hotel Palace in Lugano, she wrote the collector for the first time in a decade:

> *Dear Friend,*
>      *I am benefiting from the presence of a woman friend to write you this letter, a bit long, but, you know, although I never forget my friends, I have the weakness, and almost the impossibility, of not being able to write. Disgracefully, I have also nearly forgotten Ital-*

*ian, and if it wasn't for my friend's thoughtfulness, you would perhaps not receive this missive, although all of your news gives me great pleasure. I've spent the last ten years in America, and by the grace of intense labor, I've been able to support myself for the best for this terrible period of time.*

*I have thought of my so-beautiful Italy, and naturally remember our friendship as well.*

*In my painting, there remains a strong evolution, and I can state—without false modesty—I have had great success in America.*

*I'm sending you some photographs of my work, but shamefully, of the most recent I haven't any, just as I have no recent ones of myself.*

*My projects are vague, actually I find myself here at Lugano, but it's possible I'll withdraw to Florence for some weeks, and, if this doesn't happen, maybe to Paris (7, Rue Méchain, Paris). It's most possible that I'll return to America for two months, but this is still uncertain. If the political situation permits, I'll return to Europe again, after my brief sojourn in the United States.*

*I'll tell you about my projects, so that you can suggest—I hope —a meeting. I send my best greetings.*

*Tamara Kuffner-Lempicka*

Tamara's "intense labor," her paintings from the mid- to late forties, had produced work that she knew was very good. Realizing at the same time, however, that every brushstroke emphasized her allegiance to a European past, she decided to investigate moving back to Paris permanently. But her first chance to explore post–World War II Paris had unnerved her.[50] Her friend Manha Dombasle recalls that Tamara was shocked at the changes in her beloved city. "When I saw her, she was scared, I could tell, that everything seemed so different here," Dombasle remembers. "She seemed depressed, even from the beginning, because Paris looked so strange to her." Somber and impoverished, Lempicka's beloved adopted city showed few signs of the excess and extravagance that had flourished in the aftermath of 1918. Even more threatening, only tepid enthusiasm greeted her tentative professional inquiries. "She wanted to come back here, where she was famous," Dombasle remembers. "But a new type of painting was already popular, and people were looking at the American styles. She became so sad, I worried about her. She stayed at the Ritz—hardly ever at her studio anymore, just went there to paint during the day—and lay in bed for weeks at a time. She asked me to throw a party for her, because I had such a great

cook, she said. I did, and she was so happy. It was a big affair, with many people and wonderful food."[51]

Tamara's remark to Puglisi that her painting continued to evolve was, however, entirely accurate, and at this point it must have seemed reasonable to expect an appreciative audience again. In 1949 she executed one of the finest paintings of her career, unlike anything she had previously done. *Fruits sur fond noir* (Plate 14), a still life of a white porcelain bowl filled with four fruits, set against a black oil background, is a dazzling example of her ability to master humble subject matter. In her nudes, Tamara had combined Pontormo's dramatic artifice with Ingres's voluptuousness to create monumental figures that theatrically dominate the canvas; *Fruits* of 1949 achieved a similar effect in an entirely different genre. The white bowl's three-dimensionality threatens to obscure the perfectly shaded and restrained orange, lemon, pear, and green grapes, while the illusion of an almost mystical light spilling over the front of the fruit composition contrasts with the forced perspective of the twigs and leaves sticking out from the sides of the bowl. The altered, slightly flat effect of the twigs, played against the rounded rim of the bowl, unconventionally asserts the presence of the painter, in contrast to more typical still lifes that efface the artist. A small cartouche bearing her name and the date is painted to look as if it's nailed to the bottom left corner of the canvas, where the bowl's reflection confounds the space.

In the presence of this painting, and other still lifes of the next ten years, it is hard to countenance the commonplace critical position that Lempicka's work fell off after she married Baron Kuffner in 1933 or after she left Europe in 1939. Françoise Gilot proclaimed many years later that she was shocked to hear, as late as 1972, Tamara de Lempicka discussed solely as an Art Deco painter.[52] Perhaps it takes the postmodern imagination to overturn the conviction that first-rate Modernists don't paint like Lempicka.

Over the next few years, Tamara experimented both with geometric abstracts (probably influenced by the American painter Stuart Davis) and with fluid abstracts more obliquely indebted to the French Cubist tradition. But her statement to Puglisi in 1949 that she had "great success in America" seems an odd reading of her critical reception. Without a doubt, she must have felt exhilarated as her talent expanded yearly. Between her emigration from Europe in 1939, however, and her statement to Gino Puglisi a decade later, she had only three shows in the United States—possibly five if the Julian Levy traveling caravan counted as separate exhibitions.

While Tamara was reacquainting herself with the earlier sites of her success and happiness, Tadeusz Lempicki, whom Kizette had not seen since the

day she fled Warsaw, took his last vacation with Irene Spiess and his step-daughter, Lulu. Six two- by two-inch black-and-white photographs from that vacation are in Kizette's possession, with annotations on the back whose origins have never been explained, because Kizette finds the topic too painful to revisit. One photo shows husband and wife with an unidentified woman. The inscription reads, "He probably had an affair with her too." A photograph of Irene and Tadeusz alone says, "The happy couple." A picture of the Lempiccy with Lulu asserts, "In spite of everything, we love each other." Possibly Kizette, influenced by her mother's prejudices, wrote the captions ironically years later, when the photographs came into her posses-sion. Since they probably belonged initially to Lulu, the only person from the group likely to have contacted Kizette over the next decade, Lulu her-self might have written them. The figures all look more content and at ease than the comments suggest. Perhaps the "overexcitable" Lulu, as her rela-tives have referred to her, exaggerated the competition for her handsome stepfather's attention. Throughout her life, Lulu displayed large pho-tographs of Tadeusz more prominently than those of her mother.[53]

Tamara was no longer interested in Tadeusz's family life as she struggled in the early 1950s to create a congenial place for herself in America. She often appeared restless to her New York companions, "somewhat like a caged animal," says her actor friend Tonio Selwart. "She never quite figured out the vibe of Manhattan in the 1950s. There was a sense of lethargy that was part of the cultural scene, including art, and Tamara particularly couldn't under-stand all the drinking. She thought the sexual liberation and everything was just fine, but then she'd say, 'Everyone is either drunk or sloppy-looking, so who wants to have sex anyway?'"[54] And artistic and literary types who did fit in drank heavily.[55] Drugs, "except for the legal uppers and downers dis-pensed by our psychiatrists and analysts on request," were for the beats, Ginsberg, Kerouac, and sometimes Norman Mailer, the stars of the new bohemian culture who regarded Tamara, who had used cocaine regularly in the 1920s, as an anachronism.[56] But Tamara never particularly enjoyed alco-hol, except for the glamour of champagne; the unpredictable effects of drunkenness collided with her belief that people should always be in con-trol of their actions. Regardless of the history being created in Manhattan at the Cedar Tavern, where Jackson Pollock and Willem de Kooning argued over their drinks, Tamara would not have joined them, even if she had been invited.

Tamara flew to Houston, which she contemptuously referred to as "that little town," to visit the Foxhalls whenever she particularly felt like an exile. She stayed at the Warwick Hotel because Kizette's home was not large

enough to afford her the privacy she desired. The smallness of their house was, in fact, an early contributor to her decision to supplement the young family's income on a regular basis. Tamara wanted to ensure that Putti and Chacha (Victoria and Christie) could be reared as she herself had been, with private lessons, beautiful clothes, elegant restaurants, and lavish travel. Kizette began routinely asking her for money to cover all the extras that were beyond the income of a chemical geologist; when Foxy tried to encourage less dependence upon Tamara, the artist swiftly disabused her daughter of such ideas. She insisted, for instance, that the couple send their children to private rather than public schools; she paid their tuition, and she never let the Foxhalls forget her generosity. Since her teenage years, Kizette had been redefining the relationship with her domineering mother, and now Tamara's giving and withholding of money became the point of contact between the two. In a cartoon she sketched on a yellow legal pad, Tamara shows herself in the middle of the floor, with Kizette, Foxy, and the grandchildren all calling out "Money!" Kizette drew a response on the back of the paper, with her mother in the center of a family circle of love. For a perfectionist like Lempicka, who wanted everything clean, exact, and ordered, money was a more precise measure of involvement than emotion. Catrina Huerta, Lempicka's last nurse, once ruminated about the dynamic between mother and daughter: "Tamara worked all her life, you know. Painting. But her daughter never worked because she always depended on her mother. And [Tamara] always gave her money. Whenever the daughter telephoned and said, 'I need five thousand, I need ten thousand, I need twenty thousand,' [Tamara] called the bank and said, 'Give my daughter the money she wants.'"[57]

The artist believed it important that Kizette not only educate her daughters correctly but also that she and Foxy have the resources to socialize and entertain properly. Tamara's own routines in New York included weekly dinner parties for eight, where she'd seat four people at each of two tables. The baron went to bed before the guests arrived, but they would jovially call up the stairs, "Batoupcee [Tamara's pet name for the baron, playfully repeated by their friends], please come down and see us." Kuffner would then "descend like an angel from heaven" in a white starched cotton gown to the floor, sporting an embroidered red crown on the left breast. "He'd go around and kiss hands and sit down and talk, and then return upstairs to bed. Papali tended to be a hit with the older ladies," Victoria remembers.[58] Kizette recalls fondly that "at these small soirees Tamara was shining, covered in her best jewelry; in their own way, they made a wonderful couple."[59]

But Tamara began to get bored with her limited role in New York—basi-

*Tamara's cartoon about her role as financial provider, c. 1962.*

cally that of a wealthy socialite—and so she began traveling more often to Houston, where her favorite activity was hand-sewing exquisite clothes for the little girls, a practice she would continue until they were married; however, she forbade the family to tell anyone for fear that she would be considered a housewife rather than a painter. And in spite of the tension that money created between them, she and Kizette were too close to stay angry at each other for long. Kizette, emotionally as well as financially dependent upon her mother, had realized long ago that sensitivity was not Tamara's strong suit. She was not, therefore, surprised to find out summarily in 1951 of her father's death. One hot summer day, while she and her mother sunned at poolside, Tamara abruptly told her daughter that Tadeusz was dead. "Chérie just casually mentioned that my father had died. She didn't tell me anything more," Kizette recalls. Asked if Lempicka ever elaborated on Tadeusz's death, Kizette admits, slowly and painfully, that her mother had shared frightening implications with her, which she refused to repeat. But according to many of their friends in Poland, Tadeusz and Irene had become too comfortable with the life of leisure that their position in France provided—at least from the Polish Communists' vantage. The Lempiccy had openly enjoyed Toulouse, where they were able once again to hold elegant

teas and participate in the pleasures of capitalism. But in 1950, Poland's Communist government recalled Tadeusz to Warsaw. Supposedly it was to be a brief visit; he was to bring only a suitcase with him. Once there, he was hospitalized, the official reason being noted as cancer. Most of his acquaintances believed that he was killed by the government because he had become too cozy with the Western authorities.

Although the possibility of Communist foul play is not out of the question, those Polish diplomats closest to his case believe that the simple story found in his official folder is more likely: Tadeusz had finished his normal three-year appointment as consul general in Toulouse; he had cancer; he was hospitalized in Warsaw and died.[60] Tadeusz's cousin by marriage, Andrew Kozlowski, says he "feels certain Tadeusz died a natural death of cancer."[61] But if Tamara had needed any further reason to fear the Communists, Tadeusz's death provided one.

Kizette had loved her quiet, gentle, and gentlemanly father in spite of his formal ways. She mourned him, especially since she had been given no chance to say good-bye to him. Kizette may well have stayed in touch with Lulu,

*Tadeusz Lempicki's stepdaughter, Lulu (third from left), at her Paris apartment with (from left) Marquise Paulle de Grammont, her daughter, and Krystyna Wolanczyk. Tadeusz's portrait is on the mantel.*

although she claims she never visited her stepsister or Irene again, despite the many trips to France that she made before either woman's death—Irene's in the 1980s, and Lulu's in the early 1990s. Pictures from the next ten years suggest that even Tamara once visited Tadeusz's stepdaughter and her new husband. But, says Kizette, "I know that Lulu married a handsome man, Jan Szczeniowski, and that there was a friendly divorce some years later. And apparently Lulu, who had always been a kind of childlike hypochondriac, really was in pain for many years before she died. That's all I know."[62]

Tadeusz Lempicki's second family nonetheless created enough drama in the following years that Tamara and Kizette must have been privy to the minor scandals, and Tamara surely reveled in the news. Lulu had become friends with the Marquise de Grammont, who treated the young woman like her own child, while she relegated her own daughter to the status of a Cinderella. Lulu moved into the marquise's luxurious living quarters, and Parisians began gossiping about her being the marquise's lover. Irene, whose fortune had been obliterated during the war, came to live with the couple, a move that created jealousy and competition among the three women. Irritated that the marquise seemed less interested in her welfare than in the healthy Lulu, Irene turned to her daughter for financial and emotional sustenance. The two continued their always complicated mother-daughter relationship, competing for the affection of the marquise as they had once competed for Tadeusz.[63] Irene was ill throughout the fifties, and Lulu's neglect added to her mother's distress, according to Irene's cousin Andrew Kozlowski. But Lulu's half sister, Krystyna Wolanczyk—who had been so impressed with the teenage Kizette she had met years earlier—believes that Lulu should be commended for tolerating her mother, not condemned for abandoning her. Krystyna went to Paris in the early 1950s and lived with the two women for one year—"one of the worst of my life." Irene, worried that Parisians would learn the true, desperate state of their finances from Krystyna's impoverished state, manipulated the facts so that the marquise believed the young woman to be their maid.[64]

Kizette herself had no need of an extended family anymore, especially such an unstable one. A busy Houston society matron and mother of two girls, she did not lack for excitement. Wade Barnes, a literary agent who would broker Kizette's memoir of her mother years later, met Kizette before he was married, when he was working for several months in Houston. He, Kizette, and her friend from Oxford days, Prince Franzi Hohenlohe, who visited frequently, often went to the Racquet Club where, Barnes recalls, "wives hung out who wanted to pick up men for flings." Kizette had been tutored by Tamara, after all; marriage and sexual fulfillment were two separate

things. Houston friends remember that the gentle Harold Foxhall looked the other way when Kizette seemed to emulate Tamara's early indiscretions.

Perhaps unconsciously maneuvering to keep her daughter tied to her, Tamara ensured that Kizette could travel often, unhampered by her husband's limited financial resources. The Kuffners frequently took her and the girls to the Bircher Clinic in Switzerland, while Foxy stayed in Houston, tied to his job at Dow Chemical. Though the baron and his wife spent little time together, one of their regular joint activities continued to be "the cure." The couple would take a corner room with two beds, while Kizette, Putti, and Chacha had a little room of their own down the hall. Because the Kuffners were longtime regulars, they were accorded special treatment. At 7:00 A.M., for instance, a nurse would rouse them personally while the rest of the guests were awakened with a bell. The beginning of their stay included sitting for a complete battery of blood tests, the results of which formed the basis for the individualized routine they were to follow while at the clinic. Every detail of their waking hours, including when to eat, sleep, and relieve themselves, was scheduled. Accompanying this regimen was a strict vegetarian diet, the ingredients of which were grown in the clinic's garden.[65]

Tamara had suffered intermittent stomach pain and frequent diarrhea for at least ten years.[66] Usually treated for her condition by a doctor in Paris, she was startled upon one of the clinic retreats during the early fifties to hear Dr. Bircher order the nurse to confiscate her twelve different medications: from now on she was to use Bircher's natural prescriptions only. According to Kizette, his method did help to alleviate her pain, enabling her to avoid surgery. Relieved that something could help her, Tamara returned to the clinic twice a year until the late 1960s.

"But don't think that just because she was getting older and her stomach bothered her, Mother was now an angel when she was at the Bircher," Kizette says. "Getting older hadn't changed her a bit, not even her appetite for food. She still sneaked off for tea when she was supposed to be resting at the clinic—and she ate her napoleons with her tea. She even fit in an occasional sausage or two as well."[67]

When Kizette accompanied the Kuffners to the Bircher Clinic, she tried to think of diplomatic ways to leave her mother and visit her aunt Ada, who now lived with Pierre in Beaulieu-sur-Mer on the French Riviera.[68] Adrienne had functioned as a warmer mother to her than had Tamara, and this knowledge led the painter, mildly jealous though mostly grateful, to insist that Kizette wait until they were all finished with the cure in Zurich and could travel together to her sister's. Once they got there, Tamara continued to pay

Adrienne for her meals, sustaining the odd practice she had developed at Aunt Stefa's table when she first began to earn her own living in the 1920s. Adrienne took her sister's behavior in stride, however; along with Raoul Kuffner, she continued to be Tamara's major emotional support throughout her life. Both sister and husband had believed in the painter's superior talent from their first glimpse of her work, and since they were exemplary individuals in their own right, their confidence in Tamara sustained her belief in herself when the buying public for her art seemed to evaporate.

By 1953 the artist was receiving more press coverage in Italy than in France or America, a situation similar to that of 1925. Sexual liaisons must have been easier for a fifty-five-year-old cosmopolitan to resume in Italy, too, since America increasingly seemed made for the young. Traveling that year to Rome, Lempicka painted a third and very good portrait of Gino Puglisi. She was careful to keep Kuffner and Puglisi apart, confirmation that she and Puglisi were lovers by now. According to Alain Blondel, Lempicka sent a telegraph to Gino telling him that she had to cancel suddenly their scheduled meeting in Rome: her husband had shown up unexpectedly in Vienna.[69]

Back in New York, Mala Rubenstein Silson was concerned that Tamara rarely spoke of her painting, though she was unsure exactly why her friend seemed to be taking a hiatus from her work. "I think she was discouraged at the time," Silson ruminates. "So she decided to turn to interior design, and her first—maybe only project—was my sister's apartment. Muzka [Bernard] basically turned over her apartment to Tamara. The results were beautiful but so opulent, so baroque. Tamara insisted upon doing it her way, finding each piece of material herself, the perfect paint, and so on. She used lush and unusual burgundies, even in the bedroom. Frankly, I believe my sister was shocked. The apartment was absolutely amazing."[70]

During this period, Tamara ensured that the creamy off-white of her luggage matched her Chrysler limousine. For extra effect, she often wore the same color when she went out in the evening. Her particular élan appealed to Revlon, which sent over several representatives to work with the artist on developing the perfect red lipstick color. "My grandmother enjoyed mixing the pigments, adding just the right amount of yellow and so forth, until she got the color she wanted. I think they used it, but I can't recall its commercial name," Victoria Doporto recalls.[71]

By the mid-fifties, Lempicka was working determinedly at a series of abstract paintings, far afield from anything she had done before. She painted them both in New York and in Paris, where she worked in her studio at 7 Rue Méchain during the day but slept at the Ritz. During this period she

revived the motif of an open book, which she had used significantly twice before: once ten years earlier in her Dutch-inspired *Wisdom* (1945), in which a girl is reading, and also in *Chair and Ribbon*, her painting from the same period in which the book represents the old masters who influenced the painter. Now the realistically rendered book positioned in the middle of her abstracts once again signals the artistic genealogy of her authority as a painter. Her most successful abstracts include *Number 1960* with its illusion of pearl-studded fabric, and *Cuernavaca Orchids*, with a strong Surrealistic rendering of plants.[72] Although the fifty or sixty nonfigurative paintings she finished from the late forties to the early sixties do not exhibit the urgency of her portraits and still lifes, they frequently bring a clean, finished closure to abstract form, creating an intriguing if uneasy and ultimately unsuccessful aesthetic.

From the middle of the 1950s to the end of the decade, seeking to rekindle her old sources of inspiration, Tamara determinedly socialized more often with the friends of her early painting days. Through such companions, she met interesting new people, an important part of her commitment to keeping current. One of her favorite sites for mingling with new artists remained Capri. The island, worshiped by artists and writers for its roman-

tic scenery, was a favorite retreat for the avant-garde. It was at the Blue Grotto, one of Capri's most famous natural wonders, that Tamara encountered Françoise Sagan, whose book *Bonjour Tristesse* had rocked the postwar generation. The painter wanted Sagan to join her dinner party and so began to list the distinguished guests who would also be in attendance. The young writer insolently responded, "Who cares who will be there?" but she accepted the invitation anyway. That night Tamara and her guests waited patiently for

*Tamara at Capri, one of her favorite retreats, mid- to late 1950s.*

*Prince Felix Yusupov and a young Victor Contreras—"the son who dropped from the sky"—Paris, mid-1950s.*

the guest of honor to arrive, but eventually they had to begin eating without her. Many hours later, Sagan finally made an appearance. Casually dressed, wearing no shoes, smoking a cigarette and eating a sandwich, she was ushered into the dining room where she proceeded to eat a very late dinner, much to the surprise of her hostess. Despite her slovenly conduct—behavior Tamara would have found reprehensible in others—Sagan charmed the guests as well as the painter, who believed talent prevailed over everything else.[73]

She also frequently got together in Paris with old companions like Felix Yusupov and Jean Anouilh. It was at a long, leisurely lunch in 1957 or '58 that she met the young Mexican artist Victor Manuel Contreras, whose flamboyance would be a consolation for Tamara at the end of her life. Born in Guadalajara to a lower-middle-class family, Contreras had shown early talent in painting and sculpture. After studying in Italy on a state scholarship, the handsome young artist landed in Paris, where he hoped to study further before returning to Mexico. He met Prince Yusupov when the nobleman handed him an award he had won, and he soon joined the intellectual circle surrounding the prince. "But I was a struggling artist, don't forget that!" Contreras says, demonstrating the gift for melodrama and whimsy that would draw Tamara to him. "Once I needed money and so I worked in a Parisian hotel as a busboy. In the bathroom I saw beautiful fourteen-karat gold fixtures, and so—of course, I'm an artist, what else could I do with such beauty? —I took a bath in the glorious tub." According to one story, Contreras was promoted as a result of his hubris; another account claims he was fired. In either case, his irrepressible high spirits and devotion to aesthetics made him a popular figure in Paris, and he became a favorite of Prince and Princess Yusupov, "the son God sent me from Heaven" as the prince announced.

One day Yusupov invited Contreras to join him, Jean Cocteau, and "a painter you'll find interesting" for lunch at the Hotel Ritz. "I saw this marvelous-looking creature, very dramatic, very impressive. But I was thinking of my own work, and of artists who were currently influencing me. I promptly forgot about Tamara de Lempicka."[74] Lempicka was around sixty years old now, and Contreras would meet her again—believing it to be the

*Chacha, Kizette,
Tamara, and
Victoria, late 1950s.*

*Chacha, Tamara,
and Victoria,
Christmas at Reba
Drive, 1955.*

*Kizette Lempicka
Foxhall, Christmas
at her home on Reba
Drive, 1955.*

first time—more than fifteen years later. At that time he would realize that his own country's Diego Rivera had painted two portraits in the mid-1940s, *Nude with Flowers* and *Portrait of Natasha Z. De Gelman*, for which Tamara's earlier portraits could have served as antecedents.

During the late fifties, Tamara began thinking of new ways to develop her painting. But she allowed herself to take time off from work to introduce her nearly adolescent granddaughters to the European social world. Knowing the right people, she believed, was central to their future. Tamara determined that Venice provided the greatest resources for her purposes—and that Raoul's presence would add authority to her mission. Her husband stayed at the Hotel Danieli, while Tamara, Putti, and Chacha lodged at the Grand Hotel Excelsior on the Lido. "Grandmother's strategy was for us to mingle socially with people who were both rich and interesting," Victoria recalls. "Neither quality was enough without the other. We had played in the sand with Marisa Berenson when we were around seven and nine; now she even arranged for us to meet the dark and mysterious Greek Princess Aspasia, ninety years old. She had us over for tea on her own private island, and I thought it was totally cool to own a little country!"[75]

During this period, Tamara began urging the girls to emulate Napoleon as a model of willpower: "Napoleon could sit on a chair and announce he would now sleep for two hours, and do so. I want you to think of him whenever you have to achieve something that takes discipline."[76] But the geniality with which she delivered such severe lessons endeared her to Putti, if not to her less malleable younger granddaughter, Chacha. "Most of all, Grandmother was just lots and lots of fun," recalls Victoria. "Ordinarily she purchased her clothes on trips to Paris, for example, and the things she needed on the spur of the moment in New York she bought at Bergdorf Goodman. But she also sometimes played a game of style at Woolworth's, where she took us to shop when she was in a good mood. 'What is the challenge of buying my jewelry at Chanel?' she would ask us grandly. 'Any fool with enough money can do that. When you find a necklace for a dollar fifty and wear it to a gala and receive praise for your wonderful style: that means you have excellent taste.'"[77] The joy was all the greater, Tamara explained to the girls, because out of the thousands of dime-store items set out to confuse you, only one or two would prove worthy of being purchased.

Tamara's grandchildren at times perceived her enthusiastic guidance as unfair control, which Chacha especially resented. "But I tended to forgive Grandmother her excesses because at night, when she tucked us into bed, she sometimes worriedly asked, 'Was I too severe with you today?'" Victoria remembers.[78] Others not so continually affected by Tamara's aggressive

methods admired her "lifelong practical decree to inspire others, whatever their economic or social status."[79] Connie Stutters, her nurse-assistant in Houston, remembers her employer urging her to paint more often, encouragement that astonished the nurse, since she was but a Sunday painter.[80] Kizette herself believes that "the most important people [to Tamara] were the ones she could inspire. 'Robert, what have you accomplished today?' or 'Victor, have you finished your drawing for the swimming pool?' No matter how important or how trivial—the accomplishment of one task in which she had participated gave her immense pleasure. At that moment she was both creator and master."[81]

In 1959, when Victoria was twelve years old, she accompanied Tamara to Italy. From the city of Anacapri, where they stayed at the Hotel Grand, they set out for Pompeii in an excursion that Putti came to realize was a longtime routine of her grandmother's. Obsessed with the tale of Vesuvius suddenly erupting, she repeated to the girl that "everyone was stopped dead in their tracks, even the boy eating the piece of bread; he was instantly crushed." Indeed, "Chérie seemed mesmerized as we stood there, to the point that I was almost frightened. She kept talking about that little boy and how sudden his death was. Over the years I figured out that the suddenness with which her old way of life had died overnight in 1917 somehow got mixed up with Pompeii in Grandmother's mind. And the issue of food being taken away meant something to her too."[82]

Around the turn of the century, new excavations had revived interest in Pompeii, parts of which had been uncovered in 1748 by archaeologists and scholars, including Joachim Winckelmann. The discoveries, written about extensively by Winckelmann, had influenced art schools during Tamara's own years in St. Petersburg, resulting in well-publicized paintings of the site. Certainly Tamara's attraction to Pompeii was too strong, too psychologically resonant, for her art not to register it. By 1959, already in her sixties, she turned to a style of painting meant to echo the fresco-like sense of decay and the muted colors of the Pompeii ruins. Like Titian, who late in his career put down his brush and took up the palette knife to paint thickly encrusted works, Tamara, so long averse to muddiness and imprecision, now chose the same plebeian tool to begin another stage of her career. Friends remember that she was intensely excited about this new path; it felt right to her, unlike her tentative ventures into abstract art. Old Winston Newton catalogs, their pages well thumbed, attest to Kizette's memory of her mother determinedly locating palette knives of the perfect size and just the right white paint for the undercoat. She decided to limit her palette to trios of colors—either the earth tones of beige, tan, and coral, or the brighter values of pink, orange, and lavender.

*Tamara and Raoul Kuffner on one of their many visits to Pompeii, mid-1950s.*

For fifteen years she had complained that the French pigments she had used before World War II were unparalleled—and unavailable. Her son-in-law, the chemical geologist, had patiently mixed colors until the painter got exactly what she wanted, and now his talents were tested to produce the new shades Tamara sought. Among the startling results are paintings of flowers that nearly offend with their aggressive colors. For the most part, Tamara chose modest subjects for her new style—a washerwoman, two pigeons, an earthenware jug. But it is the lovers of Adam and Eve who speak volumes. This version contrasts dramatically with her 1932 Edenic couple, whose strong vertical composition and muscular bodies had echoed Michelangelo's heroic David. This time Tamara executed two separate pieces: on one canvas a woman; on the other, her male partner. The new Adam and Eve recline, suggesting the quietism that will suffuse the palette knife paintings of Tamara's last major phase. Placed side by side, however, the sundered lovers recall that image in the ceiling of the Sistine Chapel, where God and Adam, in the ultimate creative act, stretch toward each other as they seek, in E. M. Forster's Modernist admonition, to "connect, only connect."

Chapter 11

# A DECADE FRAMED by DEATH

The palette knives assumed deep importance to Tamara because she hoped they would provide a second act to her career. She truly believed that her new paintings would establish her presence in the contemporary art scene. And as in the twenties, success would have to manifest itself both financially and critically. Tamara was chafing at the reduced budget her husband had imposed on the family. One day in early 1961, Henry Kolar, the faithful accountant who came weekly to the house to take care of the couple's business, delicately pointed out that the painter had earned little money the previous year. This prompted Kuffner to tell his wife, "I don't have enough money for two if we continue to live this luxuriously." According to her daughter, who was visiting at the time, Tamara cried when she and Kuffner fought about money—the only source of tension between them that Kizette can remember.

"Baron Kuffner and my mother were high rollers, both traveling in the fast lane. Nothing but the best would do, whether it was in hotels, in food, or in housing. At this time their finances came to a screeching halt and Mr. Kolar

announced that the baron no longer had the revenue to live in the style Tamara had become accustomed to," she recalls. But the couple continued indulging their expensive and often idiosyncratic habits. When they traveled to the same destination, one would go by plane and one by ship, both first class. Each year they spent several months in Paris, but Kuffner stayed at the Hotel Westminster and his wife stayed at the Ritz, though she had re-painted the Rue Méchain rooms in the "masculine" colors of green and brown that she thought her husband would prefer.[1] The demands of her painting and the couple's separate sex lives dictated this expensive dupli-cation of living space.

Although Tamara continued to drop coy hints to the French newspapers about moving back to Paris, the Kuffners were content to live in the United States. Acutely attuned to world politics, they did not believe that Europe was strong enough to safeguard democracy, and their deepest instincts about Soviet oppression had been confirmed when Russia invaded Hungary. But offered a chance in 1961 to exhibit in Paris at Ror Volmar Gallery from 30 May to 17 June, Tamara excitedly prepared to present her new works in the city that had originally nurtured her talent. Caught yet again between her various worlds, she forgot that Europe had not seriously acknowledged Abstract Expressionism until 1958; though already passé in the United States, the style had only recently crossed the Atlantic, ensuring its present enshrinement as the style du jour. Optimistic that she was among those whose ideas of the modern were sympathetic to her own, Tamara eagerly displayed her palette knife paintings, along with her geometric paintings of the fifties and several early pieces, including *First Communion*. But the new palette knife paintings that felt so right to her proved completely out of sync with the abstract painting that the European art community believed to be America's most significant style.

Nonetheless, in contrast to the family mythology, which holds that no one liked the show, lavish praise in Paris newspapers indicates an enthusias-tic reception, though not from the avant-garde critics whose opinions car-ried far greater weight in the artistic community. Still, too many positive reviews were printed to justify the commonplace judgment among Lem-picka collectors that the show was a disaster.[2] The exhibition did not, how-ever, launch Lempicka anew, the reward she had sought.

On 26 May *Juvenal*, in one of the earliest reviews of the Ror Volmar show, counseled that "here comes a female painter of a talent reminiscent of the great Corot. In order to move others, she begins by being moved herself. Her style—original and provocative—is ornamented by elements of rare beauty. . . . Through three categories, 1930–1960, the visitor will discover a

very strong sensibility, a true vision that has explored painting under different aspects. Cubism and abstraction, whose excesses she rejected, inform her solid, figurative style while her new palette knives exalt nature with her special intensity." "Back from America" was the title of the review in the 31 May *Une Semaine de Paris*, which proceeded, "Her admirable talent is known well; she has works at the Museum of Modern Art in Paris. Here she shows a far-reaching body of work: on the one hand her abstract works, with incredible nuances in her brushstrokes—evanescence where beige, pinks and blues dominate. Then there are beautiful frescoes inspired by Pompeii. And finally, older ravishing portraits, lovingly aged and patinated, where acute technique mingles with feeling and beauty." *Nouveau Jour* reminded readers that Tamara "is a student of André Lhote, a woman who knows how to be modern without trying to astonish, a rare honesty, especially to manifest itself with as much brilliance as she has in this exhibit." *L'Information* claimed that "placed next to her older works, the most recent pieces of Tamara de Lempicka bear witness to the artist's success in renewing herself. In fluidity and lightness, she finds again the poetry that was characteristic of her earlier painting."

In early June, *La Renaissance* praised the "painter of incomparable finesse and extreme minutiae . . . who belongs to the French contemporary school. Her painting . . . started with Cubism [but] has gone through different transitions—Neo-Cubism, neorealism, abstract, and figurative. Her interiors, her still lifes, her portraits, are all of a rare quality and they show an elevated and poetic spirit." *Arts* states that "the exhibition of Tamara de Lempicka demonstrates the evolution of this painter. She shows an extremely rare sincerity. Her works, which started in a rather contrived fashion, belonged to the same family as the works of Leonor Fini. Her paintings have escaped little by little from this style, where mostly what counts is virtuosity. After abstract attempts that helped her elude the past, Lempicka has returned to the figurative style with much more freedom than before. She allows her sensibility and her imagination to assist her efforts to achieve delicate tones with rich and thick paint." *Carrefour* lauded her "very surprising evolution," and *Hors Cote* admired "all three phases" of the "undeniably gifted" painter.

It is true that Tamara was not breaking ground by using the palette knife; most twentieth-century artists had experimented with the tool. Prior to the Impressionist movement, however, artists considered the palette knife primarily a utilitarian object for mixing paints. Titian had been an exception, but his late, very loosely painted works, their excellence now acknowledged, were thought in his own day to be unfortunate aberrations. Gustave Courbet, among the first artists to display publicly his palette knife paintings, also saw his works rejected. Van Gogh's *White Roses*, painted in 1890,

mimics the method with its thickly applied paint, projecting a shimmery, energetic rhythm onto an otherwise traditional still life. Although palette knife painting had a long history, for Tamara the method represented a radical and courageous departure from her earlier work, especially since other prominent painters were not exploiting the form.[3]

The grays and beiges in such paintings as *The Pigeons* (Plate 16) and *The Washerwoman* (Plate 15) evoke the Renaissance color extractions developed from the medieval technique, grisaille. Though the term means various things to art historians, its earliest aesthetic of sparingly applied color (often only black and white were used) had modulated into a painterly imitation of stone and fresco by the time of Michelangelo. But Tamara also sought to re-create the vivid colors she had obtained in the twenties and thirties in France, in spite of her claim that such pigments were now unavailable: willing to mix her paints with linseed oil to create the superior French medium she loved, Foxy was able to produce the results she sought.

Tamara's choice of the palette knife was intuitively correct: her homage to an Arcadian past received new life in the romantic fresco references, and her brilliance in both composition and color took on new form. Although the Parisian press didn't center its praise on the palette knife paintings alone, the reviews were enthusiastic enough to rekindle Tamara's confidence in her future. On 1 July *La Revue de Deux Mondes* singled out the palette knives: "Whereas the 1930s portraits and the abstract compositions of the fifties have linear precision and colors worthy of Ingres and Picasso, the paintings from 1960 are vaporous with soft contours and graduated tonalities. Swans, views of Venice, pigeons, are all the pretext for symphonies ranging from pearl gray to pale beige to rose to sepia. We are allowed to admire an artist whose craft involves treating models in such different manners, each time imposing a mastery. . . . André Maurois [correctly writes that] 'the human body, human faces, sorrows and human joys are for her and for the great painters of the past, the materials without which there cannot be artistic beauty. She has science as well as sensitivity.'"

One critic who used the occasion of the Ror Volmar show to recall Tamara's own past was the social gossip Michel Georges Michel. In a long column in *Aux Écoutes*, on 16 June, he wrote,

> I received this week a note inviting me to an exhibit in the
> Faubourg-St.-Honoré of the new works of Mrs. Tamara de Lem-
> picka. Tamara, oh, those crazy years between the two wars! Cos-
> mopolitan salons where the Marquise Casati would receive
> [guests] naked, with only a peacock feather in her hand. The

*embassy attaché coming to ask her to retain some reserve. . . .*
*Tamara, I remember. First a sinister encounter in one of the most*
*sinister streets of the old Cannes. At the counter, at the tables,*
*sailors [whose] faces could have beaten someone up or done some-*
*thing illegal, girls with eyes that were even crazier than the men's,*
*or more threatening than the pale faces of young intellectuals*
*exchanging their acidic discussions. . . . And in the darkest corner*
*of all, a woman wearing house slippers, and on her head, the most*
*incredible donkey hat, her hair going through the ears of the ani-*
*mal, but her great eyes shining like diamonds. I was watching her;*
*she shrugged her shoulders and turned her back to me, a back that*
*was magnificently naked all the way to her rear. That night I*
*attended a party in one of the most sumptuous villas of the Riv-*
*iera, in a rather closed society which would not have accepted even*
*the most famous star of the future film festivals. I was amusing*
*myself looking at the small tables bearing the dinners, floating on*
*the huge illuminated swimming pool, when all of a sudden I*
*received a strong slap on my back. "You were in very strange places*
*this morning." In front of me was the girl I'd seen in the sailors' bar,*
*but this time shining with jewelry, from her beautiful earrings to*
*the diadem necklace wrapped around her hair. We were intro-*
*duced. The splendid creature's name was Tamara, Baroness*
*Kuffner. She was a painter and had painted King Alphonse XIII,*
*Mussolini, all American nobility, and Middle Europe as well, in*
*strokes of strong hardness, violent but rare tones, high color—*
*Slavic, certainly. "I receive tomorrow, come," she commanded me.*
*"You will meet at my house your friend Lily Pons, and several for-*
*mer grand dukes." Of course I went; her studio was covered in gray*
*satin, an interior I later found reproduced in her other houses in*
*London, New York, Venice, and Montparnasse. On the walls in all*
*these towns, she had hung reproductions of all the paintings she*
*had ever done. "My victims," she said. . . . And now, after more*
*than thirty years of work, an unexpected reaction from this vio-*
*lently impulsive artist. Next to her older works—sometimes brutal*
*—Tamara exhibits this week the most delicate, the most subtle sen-*
*sations of her soul today. Between the tough precision of her por-*
*traits and the unforgiving logic of her abstractions, these are almost*
*solely suggestions, motifs, lines, and colors. Some of them reach*
*pastel-like qualities or recall the frescoes, half faded yet still flam-*
*boyant, on Pompeian walls.*

In response to her reception in Paris, Tamara was reviving. In contrast to
her earlier periods of depression when she visited the capital and asked

*Raoul Kuffner, c. 1960.*

Manha Dombasle to host her dinners, she even entertained again. One social column in the *Revue de Deux Mondes* lists among the guests at a dinner hosted by Tamara and Raoul "Mr. and Mrs. Peter Kuffner"—Raoul's son and daughter-in-law. "Papali was always very proud of Chérie's painting; in fact, he was her biggest fan," Kizette recalls. "He would have liked showing off her talent to my stepbrother especially, since he was so serious about life."[4]

After the Ror Volmar show closed, the Kuffners traveled to Switzerland and Italy; the baron then took an extended side trip to hunt and to tend to his land holdings and investments in Austria. Just as his wife stored easels and paints at the hotels in which she took up frequent short residences, so he stored his weapons at local gun shops for his return visits. The guns were his prized possessions; among the eighteen rifles he owned were two Churchill twelve-gauge double-barrel shotguns and a Mannlicher-Schoenauer hunting rifle with a Zeiss Zielver scope.[5] In the early autumn he left for Austria while Tamara returned to Manhattan to prepare for a show of her new work. The Iolas Gallery in New York would host in December the first American exhibition the artist had held since 1941.

But on 3 November Tamara's longtime butler, Walter, nervously told her that Henry Kolar had just arrived to talk to her. Dreading what she assumed would be more depressing financial news, she greeted the accountant cautiously, especially upon noting his pained expression. "I have very bad news for you, Baroness," he began. "The baron had a heart attack on board the *Liberté* when he was coming home. He died on the ship."

Tamara became hysterical. She called Kizette, who recalls her shock at the depth of her mother's grief: "I never dreamed my mother would take it quite so hard when Baron Kuffner died; she was truly devastated. She felt abandoned again."[6] Not only did Tamara's friends know little of her husband or of their marriage; even her own daughter, treated kindly by her stepfather, had failed to appreciate the depth of security the relationship had afforded her mother, or equally important, the value of his belief in her talent. "I was

desperate," she explained to an interviewer who years later mentioned Kuffner's death. "I lost my husband who was an admirer of my paintings, very great, and my husband who I loved very much. I lost . . . all."[7]

No obituary of Baron Raoul Kuffner appeared in the *New York Times*, probably at his wife's behest; Tamara would have been terrified that someone unknown to her might surface with claims upon the estate. She arranged a memorial service for Kuffner (he had been buried at sea), for which she paid the Universal Funeral Chapel in Manhattan $1,270.60. Goldfarb Florist provided the flowers.[8] Both Louisanne Kuffner Eklund and Peter Kuffner attended the service, marking the last time Kizette saw either her stepsister or her stepbrother. According to Louisanne, Tamara despised her stepchildren and turned Kizette against them.[9] If such hatred existed before the estate was divided in 1961, no evidence of it exists. It seems more likely that Lempicka had felt nothing worse than indifference to Kuffner's children. After all, just two months earlier, the Paris press had reported that Raoul's son and his wife attended the party connected to the Ror Volmar show. And Louisanne, today Mrs. Nathaniel Glickman, still owns a small portrait of herself painted by her stepmother. But after Kuffner's death, a wearisome melodrama of accusations and resentments played itself out in the family. David Cohen, the lawyer who settled the estate, recalls Tamara repeatedly complaining about the children's desire to remove from the apartment those things they claimed belonged to their father. "They're not really his children anyway," she raged. "He was impotent all his life."[10] Since Raoul Kuffner's first wife, Sara, had enjoyed a spotless reputation, it seems certain that Kuffner had indeed fathered their children. But the angry charge of impotence would shed an interesting light on the odd sexual accommodations that Raoul and Tamara made throughout their marriage.

Papers filed at the time the estate was probated state that Kuffner's financial holdings were worth approximately two million dollars.[11] He owned shares of stock in AT&T, Seagrams, General Electric, and Louisiana Land and Exploration, among others, and he held interest in land and buildings in Vienna. He had also filed claims against the Czechoslovakian government for reclamation of his lands appropriated during the world wars. In storage, four crates held hundreds of pieces of silver and porcelain from the castle, Dioszegh. Cataloged on eleven pages are items such as "eighteen continental silver-handled two-prong fruit forks, monogrammed and with crown," and "six silver gilt coffee spoons," "asparagus tongs server," "pair of floral repoussé silver bases and attached footed plateaux, monogrammed and with crown." Included among the baron's personal possessions were

"four oil paintings" by Tamara de Lempicka: *Nude Woman Reclining, Nude Woman with Child, St. Moritz,* and *Portrait of Baron Kuffner.* Although the appraisals sought to keep the estate valued as low as possible for tax purposes, it is nonetheless revealing of Lempicka's artistic stature in 1961 that the IRS upheld the $50 total value placed on her four paintings.

Kuffner's will was unremarkable in most respects. Except for a $20,000 bequest to his accountant, he split the estate in half between his wife on one side, and his children, Louisanne and Peter, on the other. A clause that was often included in such documents at the time, however, upset Tamara deeply: she would inherit her half only if she did not die within the first sixty days after Kuffner's death. The provision was apparently interpreted by Tamara as a reason to worry ceaselessly that she might somehow lose her life within the next two months.

Kuffner clearly felt no obligation to provide for Kizette; he must have assumed that Tamara's legacy would be sufficient to cover his stepdaughter. But one addendum is considered by estate lawyers to be somewhat irregular: Kuffner included a strongly worded statement about his legal right to exclude anyone he wished from his estate, even those claiming to be his family. To ensure this, he left one dollar to settle all claims brought forth by anyone not designated by him as an inheritor. This passage in his will hints that he feared claims by possible illegitimate children, perhaps from as far back as when Tamara painted his mistress, Nana de Herrara.

Tamara paid over $45,000 to have the estate probated by three different law firms. Upon Kuffner's death she first hired the prestigious law firm Coudert Brothers, only to fire them after a few months. She then retained White and Case for an equally short time. Finally Mala Rubenstein Silson helped her find Leon, Weill and Mahony, the firm she stayed with. David Cohen, the young lawyer assigned to the baroness, remembers her vividly more than thirty years later: "She was the most difficult woman I've ever known, and I've met quite a few over the years. I both liked and disliked her. She was imperious and demanding, but also funny and spontaneous. I did have the distinct impression that she was a very sad and lonely woman." Though she hired the best, she apparently believed lawyers to be generally inept, in large part because they were unable to fashion the law to suit her needs. Nor could they hurry along processes that she felt took too long.

David Cohen did not realize then that Baroness Kuffner, as she referred to herself, was a famous painter. "She boasted of her various exhibitions, but I didn't pay much attention to all that at the time. I figured she was exaggerating everything. She even showed me some catalogs, but I still ignored

her self-descriptions. She herself was so dramatic that it was hard to notice anything else. She wore extravagantly large hats, long gloves, and other clothes from a bygone era. I suppose her clothes were quite memorable, but I remember more the imperious voice and demanding manner." Cohen recalls that the Kuffners' apartment was a "little jewel. Although not many rooms, it was a duplex with a gigantic two-story living room—very big in all dimensions. The living room seemed sparsely furnished, but would have seemed so no matter how much furniture was there. Carpeting was gray and I think the soi-disant Dürers were in the living room—I don't recall any other artwork in that room. I think the furniture there was quite large, and had been brought from Europe by Baron Kuffner. Off the living room was a small room whose walls were plastered with paintings, some rather valuable (Foujitas, etc.). Overlooking the living room was a balcony leading to one or two bedrooms. In one of the bedrooms was an interesting sleigh-type bed which I think had also been brought from Europe. The apartment was nicely, but not lushly, furnished. . . . It was a comfortable and impressive apartment for a couple without children."[12]

Tamara had developed the practice in Hollywood of giving small works of art to those who were especially helpful to her, and so to David Cohen she gave a study for a stained-glass window. As a young girl, she had mentioned to her aunt Stefa, on one of their early visits to Paris, that she would like to design stained-glass windows for the czar's palace. Years later, when trying to sell the piece, Cohen explained to Sotheby's that Tamara had expressed her appreciation for his work, urging him to select one from a group of her paintings. After he picked one, she signed it to increase its value.[13]

Kuffner's death had occurred only three weeks before the painter's long-anticipated bid for American recognition. Scheduled to open her show at the Iolas Gallery on 5 December, she distracted herself from her grief by working feverishly on gaining advance publicity. The photograph that accompanied the *New York Herald Tribune* interview on 28 November 1961 shows her holding her head unnaturally high, an attempt at her usual haughty smile now modulated into a look of almost sweet vulnerability. The Iolas show would be the first time she had had to perform publicly without Kuffner's emotional support in over thirty years.

If she had planned a stillborn birth, Lempicka couldn't have picked a better midwife than the headline writer for the *New York Herald Tribune*, who established the painter's social credentials while ignoring her art: the interview meant to generate interest in the Iolas exhibition was titled "Femme Fatale Likes Castle in Manhattan."

*Every now and then we meet a woman who's a mixture of grande dame and femme fatale and is living proof of all those stories that filter down from the thirties about women for whom men killed themselves. No girl these days likes to think those women really exist, but we met one the other day who makes the stories believable.*

*She's the Baroness Kuffner de Dioszegh. The other morning she was wearing a zebra printed lamé dressing gown which she says is just a little thing she picked up in some store or other, but which it turns out, the Dior salon asked to copy one year when she took it to Paris. And she was wearing an enormous, fist-sized topaz on her finger which her old friend Gabriele D'Annunzio sent to her hotel in Rome by a mounted horseman, early the morning after he met her at a party.*

*She's flamboyant and witty, talks amusingly a mile a minute, is splendidly domineering and catches up all those around her with her charm, just the way a great lady should.*

Finally, under a smaller headline, "Portrait Painter," the interviewer noted that "the baroness is also Tamara de Lempicka, a very good painter whose work is represented in museums here and in Europe and in private collections the world over." Pausing briefly to mention the ongoing exhibit at the Iolas Gallery on Fifty-fifth Street, the writer next rehashed the saga Lempicka had trotted out for her: a painter at fifteen, she now "works fourteen hours a day, sleeps eight and eats for two." Her current project "is to paint all the pictures she has done over the years in a different, more Impressionist manner." The interviewer gushed equally over Lempicka's enthusiastic description of her Dürers and her preference for small versus large dinner parties nowadays because "the burners on American ranges are [too] close together for big pots." The article concluded by describing the new widow's efforts to live in a time and place of her own making, with pieces of the past reinterpreted in the present: "The superb apartment [in New York] really is a baronial castle. The ceiling in the studio living room is twenty feet high and gold curtains cover the eighteen-foot windows. The extravagantly carved furniture she and her husband brought over when they sold their old castle in Hungary in 1939. The furniture once was gilt wood, but the baroness busied herself painting it white for the elephant gray walls, and she loves her New York castle dearly. Said she, looking about and recognizing much of her wonderful life, 'It really isn't a middle-class apartment at all.'"[14]

Such press coverage inevitably squandered whatever opportunity there was for critical attention. On 9 November the *New York World Telegram,*

apparently unaware that the artist had lived in Manhattan for almost twenty years, announced that "Heads swiveled when exotic Tamara de Lempicka (Baroness de Kuffner), who is in town for her one-man show at the Iolas Gallery on Nov. 20, made an entrance at Quo Vadis the other day." The rest of the column is devoted to the story of D'Annunzio's gift, the "oversized and handsome topaz ring on her left hand." On 2 November Walter Winchell in the *New York Mirror* observed that "Jane Pickens Langley looked charming in white. . . . Elsa Maxwell wore a toreador's cape and the whole world wore black, including the Duchess of Bedford, Diana Vreeland and Mrs. William C. Breed. But Tamara de Lempicka—the artist—had ideas of her own—like a large bejeweled hat and a chinchilla coat. Which are not bad ideas if you can stand the upkeep." Even among society, Tamara caused "heads to swivel," not necessarily in admiration. By 22 November, when Winchell referred to the "exotic Tamara de Lempicka, now exhibiting her paintings at Iolas Gallery," the mention served as a short preface to his retelling the story of the D'Annunzio topaz ring.

In the Sunday *New York Journal*, on 26 November, she was featured in a preshow publicity ploy as a Hungarian hostess. "The Mood and the Food," a column by Florence Pritchett Smith, carried a good-humored account of the artist's formula for entertaining well at home—especially tending to one's male guests. "Tamara Lempicka, as the wife of the late Baron von Kuffner, Hungarian hunter and sportsman, developed a taste for game. A Pole by birth, Tamara Lempicka, though well known as a painter in Paris, is holding her first New York exhibit in a few weeks." The rest of the article presents the painter as Old World hostess:

> *"I love good food," the tall, slim Tamara Lempicka stated. "I talk good food. I eat good food, and I always have among my guests at least one person who shares my concern. . . . My menus are not from a caterer, nor is dinner cooked by a party chef who travels from house to house. My recipes are my own, translated from dishes enjoyed by generations of my family in Poland, or my husband's Hungarian family. Poles have a great culture and history of which to be proud, not the least of which is our food. Numbered among us is our most famed gastronome, who, under the name of Ali Bab [sic], wrote one of the most known and accepted books on French cooking, La Gastromonie Pratique. I never give dinners for more than ten, so the food will be as good as my small range can cook without strain.*
>
> *"Wild mushrooms in pastry, with drinks before dinner, are a unique taste sensation. Some day make a batch, and freeze them*

*for coming nights when you want something special. Sorrel soup is
wonderful preceding any rich dinner. Pike is so tender it literally
melts in your mouth. Rinse the fish in cold water and lemon juice
first, to make it nice and white. Striped bass would be an excellent
substitute for pike. Don't be afraid to cook fish in white wine. You
never taste the wine. If you do, you've used too much. Venison, with
its I-either-like-it or I-hate-it flavor is tender and moist prepared
the Polish way. Buckwheat groats are unexpected, and take the
place of potato or rice. After such a glorious, rich repast, a bit of
fluff is just the right touch. Plum is the perfect flavor with which to
close a venison dinner."*

Possibly the interview had been conducted before Kuffner's death,
though the editor's setting of the scene sounds eerily as if Lempicka had
entertained recently, offering meat her dead husband had thoughtfully shot
earlier:

*Dinner for ten at the height of the deer season, with venison as the
pièce de résistance. The season for stalking deer on the eastern
seaboard is a moment when hunters polish their rifles . . . their
mouths watering for venison steak. Tonight the same anticipatory
look of pleasure flickers across the faces of the guests arriving at
Tamara Lempicka's East 57th Street studio duplex. The gray,
white and lemon-yellow color scheme of the fascinating apartment
is warm and welcoming on a blustery night. Cocktails are served
in a library-bar on the balcony, overlooking the huge 22-foot-high
living room. Three sides of the library are walnut glass-doored
bookcases, filled with a rare collection of political and art books.
Down below, the oversize living room has been furnished with over-
size antiques from the Kuffner castle in Hungary. Across one end of
the room, against a backdrop of 20-foot-high lemon-yellow cur-
tains, stands a Spanish Renaissance refectory table whose top is
one slice of a former forest giant. The table is 11 feet long! It's a
massive room and magnificent high baroque mirrors and wall
sconces add to the feeling of size. Silver candelabra and a silver
basin filled with very low cut yellow chrysanthemums are the only
decorations on the table, which has been set with lemon-yellow
damask napkins and royal blue and gold antique porcelain of the
period of Maria Theresa. In one corner, an easel displays our
hostess-artist's latest painting.*

Tamara valued perfection in all aesthetic endeavors, including the culi-
nary, and so constructing the perfect dinner party environment would have

monopolized her conversations with this food columnist, who recounted the artist's method of creating a leisurely atmosphere: "This is a night planned to make men happy—to fill their ears with good conversation, and delight their gustatory desires with one of the great dishes of the world. Dinner is therefore called for 8:30, because 'I like to give the men time to unwind at home before winding up again for the evening,' the sensitive Baroness von Kuffner observed. 'This is not a dinner before going on somewhere,' she commented laughingly, 'this is dinner for dinner's sake alone. Food should not be gulped, but savored,' she concluded, 'and that takes time.'" But with her insistence on presenting herself as a woman of style first and foremost, Tamara merited the almost incidental allusions to her paintings.

If her show at Iolas had reinvigorated her career in the United States as she had hoped it would, she might have summoned the energy to resume her life in Manhattan without Kuffner. She was, however, carelessly and con-descendingly reviewed by the *New York Times* on 21 November as a painter of flower pieces. Tucked among laudatory notices of young artists just start-ing to exhibit in New York galleries were two short paragraphs that made no apology for the writer's obvious ignorance of Lempicka. "A stylish palette knife is wielded in flower paintings by Tamara de Lempicka at the Iolas Gallery, 123 East Fifty-fifth Street. One may have a few tiny reservations about their being expressive of art's absolutes, but when André Maurois [praises her], one can only yield to the opinion of a member of the Académie Française." Slighting even Lempicka's reputation from the twenties as a por-trait painter, the reviewer concludes by confusing the early subjects who sat for the artist with the recent collectors who actually bought the palette-knife paintings: "King Alphonso XIII of Spain, Gabriel D'Annunzio, Baronne Jacques de Kap-Herr, Count Furstenburg-Herdringen, Princess Zalten-Zalesky, and Suzy Solidar thought well enough of them [the palette knife paintings] to thereby embellish their collections." At least this notice improved on the *Times* piece of 19 November: "An exotic artist named Tamara de Lempicka will display her oils at the Iolas Gallery here Novem-ber 20. For the Albert Schweitzer Fund. She was one of the amours of Ital-ian poet Gabriele D'Annunzio." One publication treated her exhibition respectfully: on 20 November the *New York Journal* announced simply that "Tamara de Lempicka's first exhibit of oils here in twenty years begins today at Iolas Gallery. Tamara, who is the Baroness de Kuffner, has pictures in top museums all over the world." And on 25 November, in its "Gallery Guide," the same newspaper printed that "Tamara de Lempicka's pigments blossom into a veritable garden of visual delights at Iolas, 123 East 55th Street. Paint-

ings of fresco-textured tones . . . capture romantic moods in still life and landscape. *Two Nudes* blends classic and contemporary motifs."

Tamara de Lempicka—her husband dead and her career moribund—turned her efforts to concluding the estate legalities and figuring out where to live. Although Kizette was extremely unhappy at the thought of having her mother living nearby, she was worried about Tamara's increasingly severe depression: ever-faithful Walter reported that nothing he could do would persuade his employer to get out of bed nowadays. With no network of close friends, no family, and no career tying her to New York, her mother would be better off in Texas, and so in 1963, Kizette reluctantly agreed that Tamara should sell the Manhattan apartment and move to Houston; there she could rent a suite at the Warwick Hotel, which she had always liked. Walter, ending his twenty years with the Kuffners, cried as he helped mother and daughter pack up the apartment. At times Tamara circulated the story that she was forced to move to Houston because the baron's children "had cleared out the apartment on Fifty-seventh Street," a false account that allowed more for her dignity in abandoning the art capital of the world than it did the truth. And within a few years of moving to the Warwick, she bought an apartment at the Regency House on Westheimer Street nearer her daughter's expensive River Oaks neighborhood.

The mother-daughter relationship had become increasingly strained as Kizette and Tamara both aged, but it became overtly abusive now. Never hesitant to tell Kizette what to do, Tamara dictated more stridently than ever to her daughter, who alternated between ceding control and fighting back. One day, for example, when Kizette was out of town, the artist decided that the Foxhalls' colonial house on Reba Drive would be much improved with a coat of pale purple paint. Herv Kraft, Kizette's next-door neighbor, remembers Tamara insisting that her browbeaten son-in-law apply stripe upon stripe of paint to the front of the house, until she decided upon the perfect shade. Cars slowed down as they passed the site, suddenly so incongruous among the neighborhood's stately houses and classical architecture. Finally Tamara was satisfied, but when Kizette returned, she forced her mother to abort the project. The stripes, however, remained for weeks, and 3235 Reba Drive became a kind of local tourist attraction. Eventually the artist came up with an acceptable pink that transformed the residence, and passersby began stopping to ask what the shade was called. Now proud of her house's paint job, Kizette informed them that "this paint had to be blended by an artist and chemist together."[15]

Harold Foxhall found himself trying to satisfy two demanding women,

both competing for his attention, both invariably demeaning him in the process. Tamara was especially difficult: "She was always telling Foxy and Kizette, 'I am it, you are nothing, I am the money, I have given you everything.' It seemed so clear to me that she was really asking for love," Alexander Molinello, Tamara's former grandson-in-law recalls. "She didn't know how to manage emotions at all. Even when Foxy was dying in 1979, I was on the phone with her and she was distraught. 'When is he going to die? I can't wait any longer. I must speak to him now,' she kept saying. She was not even that nice to him when he was alive; she ordered him around, and he always complied. When things got too intense among the women in Reba Street, he'd go outside and smoke. He was really good to her—he mixed her paints, and she said that only he could create the right pigments for her."[16] Neighbors remember that on days when Lempicka was bored or lonely, she'd come to the Reba Street house and sit on the back porch, chain-

*Harold "Foxy" Foxhall, Puerta Vallente, early 1960s.*

smoking. When she and Kizette started up their usual shouting matches, the long-suffering Foxy would wander out to the front of the house, where he'd stand alone and smoke his own cigarettes until it was safe to return inside.[17]

"Harold Foxhall worked his derriere off just trying to make the payment on the River Oaks house," Molinello continues. "He was not one of the millionaires there; this guy had a job with Dow Chemical as a geologist, and for him the house was an enormous thing to afford. Tamara basically came in and said, 'You can't send the kids to private schools, or to Europe, you're miserable and poor and I'll take care of everybody.'"

Foxy was good to his family, especially Kizette, whom he adored. "She was his queen," Molinello believes. "She was the love of his life, she could do anything. She could play with her friends, and be a totally free woman, unencumbered by normal marital expectations. I think with Kizette it came down to human contact, the need to be loved. I know she was not happy. Only

when Foxy feared losing her . . . did he take a stand." Kizette's inattention to her good-natured husband was set up by Tamara from the beginning of their relationship, according to Molinello. "Kizette had fallen in love with that Prince Franzi [Hohenlohe] at Oxford, and when he came over to Stanford from England, Tamara spewed contempt at her daughter for not noticing that her prince had a constant male companion. Tamara used to tell the story to people right in front of Kizette, like she wasn't even present. 'We had to fix things,' she would say. 'Here came this Foxy and at least he was a normal man.' Kizette just sat silently while her mother recounted this version of their romance."[18]

Kizette and Foxy were well liked among Houston society, and Tamara assumed that their social status would allow her to be quickly accepted. She had been welcomed, after all, by New York society, and so she assumed that Texas would be proud to receive her. Instead, the local socialites wanted nothing to do with a bizarre Slavic woman who wore odd clothes, had bad teeth, and sounded like a loud Zsa Zsa Gabor when she entered a room. "Tamara had loved New York society," Manha Dombasle recalls, "but she complained when she visited me that she hated Houston, 'that little place.'"[19] She was open about her disdain for this "uncivilized location," according to Texas antiques dealer William Simpson. "I remember that she used to complain loudly, no matter who might be around, that 'I can't abide this town, I must return to Paris.'" Tamara loved repeating gossip about the "European greats," he remembers, and she "expected local society to recognize their names, which they usually did not."

Despite her defensive posture around those who treated her with amusement or contempt, she became good friends with philanthropist Jane Owen and prominent local lawyer Robert Piro. The Houston gossip columnists also genuinely liked Tamara: "She was incredible. I was awed by her," claims Betty Ewing. "She wasn't a grande dame in the way we Texans have our type—like Ima Hogg, for instance. She was more a femme fatale, even though she was pretty old." Journalist Anne Holmes echoes the praise: "I adored her."[20] Nonetheless, a description Holmes enthusiastically wrote for the *Houston Chronicle* nearly a decade later suggests how Tamara must have appeared to the city's somewhat stunned citizens: "At Jones Hall, she catches all eyes at intermission as she strolls the corridors in a giant classic beret with a matching costume of matching platelets, like some medieval queen in chain mail."[21]

William Simpson recalls vividly the day in the mid-1960s when he first met Tamara:

> *She came into my shop by herself and showed me the sheepskin*
> *proclamation from Emperor Franz Joseph granting a barony to*
> *Kuffner's father. The proclamation used the typical formal language*
> *of the times, saying he also now became Prince of Bavaria. . . .*
> *Every minor nobleman's papers said that. Those land designations*
> *no longer had meaning, but Tamara at least acted as if she took it*
> *all seriously. She said she was selling the sheepskin because "it*
> *looks like they're never going to give me my lands back!" But even*
> *then I could tell she had an incredibly wry sense of humor, so I*
> *wasn't sure if she believed all that stuff or not.*
>
> *Later, when I visited her apartment, I was struck that nothing*
> *in the entire suite referred to the baron at all, though perhaps there*
> *was something in a private room I didn't see. For a Middle Euro-*
> *pean, it was very strange, because they usually go into protracted*
> *periods of mourning, and the baron had only been dead a couple of*
> *years. Just once did she really mention her late husband again: she*
> *explained to me that her finances were a mess due to Kuffner's neg-*
> *ligence in doing his papers, because he had no business head.[22]*

Simpson grew very fond of Tamara, whom he considerd "sharp as a fox, which is one reason she had such a low threshold" of tolerance for lazy people. "I really liked the old lady—she had a lot of spontaneity," he says. He became even fonder of her as the years passed, and he decided that Tamara was "a tough-as-nails European woman who had clawed her way into a very tough field. I admired that." But he found her way of addressing him as if he were a large audience disconcerting. "She talked to me almost as if talking to or through an object—in a funny way, her personality made sense, given the attention she paid to the object in her paintings. . . . [She] had this commanding air about her, always making big dismissal gestures with her hands. In my business, I've known many interesting and eccentric people, but the baroness was the most eccentric and interesting of them all—and extremely intelligent to boot."

A few months after the sheepskin episode, Tamara returned to Simpson to sell a piece of silver, "not because she needed the money, I'm sure," the dealer asserts. She arrived wearing house slippers, which she often walked around town in, with her hair and makeup elaborately done. This time Tamara asked Simpson if he was interested in working for her. "I need a sizable tax write-off. Give me an appraisal of the antiques in my rooms at the Royal Oaks [she had recently moved to a high-rise apartment] and tell me who to donate them to," she told him. "She had incredible things, all the highest quality," Simpson recalls. "A wonderful Louis XV love seat; great oil

paintings, a perfect set of Louis XVI sterling silver plates, a complete Popov set of Russian china [from] around 1830."

Because Simpson knew that the IRS would carefully review the tax write-off, he took copious notes. One night, as he wrote down measurements on a yellow legal pad, Tamara emerged from her bedroom and scolded him: "Mr. Simpson, how can I feel comfortable if you use such poor-quality paper? Working like this, you give me no confidence at all; you must bring better paper with you next time." Such control of details exhausted the dealer even as it amused him, and the following week he decided to take two nights off from his work at her apartment. But the first evening of his break, Tamara phoned him at 7:00 P.M., demanding that he come at once. When he informed her that he had other commitments, she told him, "I am your commitment; I need you here now." Simpson responded, "It's not possible," and Tamara declared, "Only I decide what is possible," and hung up. When he returned to her apartment the third night, expecting her to be upset, she was instead her "normal, cheerful self, supercilious but friendly to me. Her mood swings were always frequent and severe."

While Simpson was doing the appraisal, he discovered that Tamara "had lots and lots of money. . . . One day she went into a swoon and said, 'Would you answer the phone, I can't answer it one more time.' It was her stockbroker, almost screaming into the phone about a one-million-dollar portfolio whose status was urgent, that they needed to address. Tamara waved her hand like she did, dismissively, and kind of shuddered. 'Dreadful man . . . Mr. Simpson, you get the information and tell him I'll talk to him tomorrow,' and then she walked out of the room."

Simpson enjoyed discussing art with the painter, especially in light of the memories she was eager to share. "She had known and liked Picasso," he recalls. "At the time, I owned *Blue Dove* in crayon and paper, and when I told her I wanted $1,800 for it, she said, 'I could have gotten gifts like that for free from him.'" Tamara still wanted to collect Picassos long after she had ceased to buy anything else, and so she sent Kizette to Simpson to bargain for a lower price for *Blue Dove*.

After one discussion about art, Tamara disappeared from the living room for about fifteen minutes and then returned with a gift for Simpson: an 8-by 10-inch green and blue study of "mathematical" rocks and squares, which Simpson "didn't like at all; I thought it was ugly." The paint was still damp, a sign that the painting had been recently finished, though by the mid-sixties Tamara had, publicly at least, forsaken her experiments with abstract geometrics. Simpson noticed that she hadn't signed the painting, and so she took a pencil "then and there and signed T. Lempicka in the right corner in the

soft paint." When he commented that "this isn't like your other stuff," she responded, "I'm an experimenter; I've always been an experimenter, everything I've done has been an experiment." Possibly she was now exploring a way to combine her earlier Cubist lines with both her abstract paintings of the 1950s and her new fresco-inspired works.

"What seemed oddest to me," Simpson recalls, "is that she had all this art hanging on her walls, and not one single piece painted by herself. She displayed late-eighteenth-century to early-nineteenth-century European art, with a few early-eighteenth-century French paintings, mostly portraits. But nothing by her. I didn't understand it then, and I don't now." She did display a collection of pencil-on-paper sketches of many of her paintings: "Oddly, they didn't appear to be preliminary studies for the oils, but more like the aftermath of the actual works, as if she had a strange desire to have these images in her possession. And I've never seen such an impressive archive of photographs of a painter's work; she had Mark Vaux, the most famous photographer of Paris painters, make pictures of every painting she did in Europe, and the black-and-white photos all hung on one wall."

Simpson remembers Tamara inviting a few local gallery owners to her apartment to discuss exhibiting her palette knife paintings, but "she refused to use any of the major Houston art dealers. She seemed to hold almost all dealers in contempt, because she didn't believe they were honest." It is understandable, given the ascendancy of Lempicka's reputation after her death, that William Simpson could believe that the neglect of the painter was of her own making, but in reality the opposite was true. "My mother invited a dealer over to see her new palette knife paintings," Kizette recalls. "She was so nervous—she always got this way when someone came to look, even the patrons she had painted. When the dealer arrived, she acted as if she didn't give a whit. But after he left, having said that he really had no use for this art, she became hysterical, and slashed several times through the large canvas she had worked on the longest."[23] Meredith Long, owner of a prestigious local gallery, ignored her work completely. "I only had the pleasure of meeting Tamara de Lempicka occasionally and found that she was a very impressive person. I think the aesthetic value of her work is based on the revival of art of that period," Long carefully explains.[24]

Hoping for new professional recognition, Tamara got a disheartening reception instead: very few people knew or even cared who the eccentric woman was, or who she had been. And there was no interest in her palette knife paintings. David Attick, a local artist, also worked with palette knives in the sixties, and the genre had taken on a kind of glossy, commercial aspect

—"dumbed down Impressionism," as Molinello puts it. Even so, it was typically young artists, not those at the far end of their career, who were working with palette knives. Writer Joanne Harrison recalls that any hope for Tamara's recognition from John and Dominique de Menil, Houston billionaires whose collection was one of the finest in the country, was ruined after an encounter between Tamara and John de Menil. The stories vary, and Dominique de Menil, before her death in 1998, declined to discuss Tamara. What is certain is that the painter developed an antipathy toward the de Menils that was unusual for her. It seems likely that only what she perceived as extreme disrespect could have created the antagonism. Without a doubt, the de Menils were not sympathetic to Tamara's kind of art in any of its forms, and Dominique, the power behind the couple's collection, had never hidden her prejudice against women artists. When the de Menils' Rothko chapel was dedicated in Houston in 1971, Tamara, arguably the greatest painter then living in Texas, was not invited.

Such neglect increased the painter's demands upon Kizette, whom William Simpson recalls as "cowed publicly in her mother's presence, always acting the part of the child," even though she was managing the logistics of Lempicka's life. But though Tamara "dismissed Kizette imperiously in front of everyone, it was also clear that she loved the girl tremendously."[25] And Tamara's proximity to her adolescent granddaughters damaged at least her relationship with Chacha. "I feel her excessive control was responsible for much of the unhappiness in my life," Kizette's younger daughter states. The artist was allowed considerable power over the girls; after she sewed matching clothes for them, she dictated when they should wear each outfit. Even when they were in high school, the girls were often required to dress like twins; luckily they attended separate schools. One Christmas, Tamara held a society tea for the teenagers at the Warwick Hotel. The picture that appeared in the *Houston Chronicle*, showing two bored-looking young women, "was the second, happier shot," Victoria remembers. "The first one, which was taken just after we argued, told the whole story."

Their grandmother's saving virtues of wit, vulnerability, and high expectations were not appreciated by the teenage girls, who became increasingly offended by her intrusiveness. "She tended to emphasize the negative so that we'd do better," her older granddaughter recalls. "If we made four A's and two B's, she'd neglect the A's and ask why we made the B's. Every Christmas our duty was to prepare a list of our achievements that particular year and wrap the list in a box, as our present to Chérie. I hated the humiliation, the lack of privacy. But it was all over quickly anyway; Grandmother couldn't

stand to have mess in the house, so she practically had the tree down and thrown outside before we finished opening our presents. In her rush to clean up, more than once she accidentally threw something out that we wanted." On the other hand, Tamara was in many ways more fun than the grand-mothers of Victoria's friends. "Chérie once told us that we could drink as

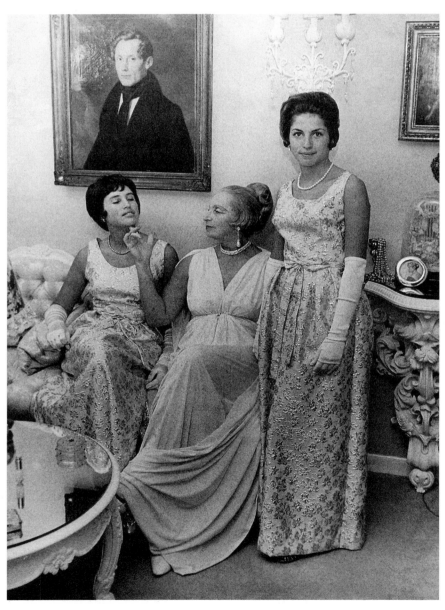

*Tamara's tea at the Warwick for her granddaughters, Chacha and Victoria, 1963.*

much champagne as we wanted. I was about thirteen or fourteen, and I drank it like soda. Suddenly I had to lie down, I was so sick and dizzy. That episode cured me of ever drinking too much again."

The girls did like accompanying their grandmother to the Bircher Clinic in Switzerland. Victoria recalls, "The crunchy gravel felt so good beneath our feet early in the morning—in the crisp Swiss air at six A.M. By the time we took the obligatory walk, we'd be more than hungry for breakfast. And Grandmother always ran into so many people she knew there. It was healthy, and also a bit like one large social party."

Tamara thought her interventions in the girls' lives were signs of her love. She took them with her to Italy and France several times, and she taught them to appreciate art. Victoria, her "Putti," relishes the memory of her grandmother's lessons. "She would take me to the Louvre and say, 'Notice the color, the way the light falls here, on this one, and the poor line on the painting next to it.'" Traditional high culture was not Tamara's only interest: "Grandmother took me to see the Beatles in Paris, before they were even big in the United States. She wasn't as interested in the music as in the crowd. She kept saying, in wonder, 'Look, Putti, look, at all the people crying and screaming.' All of that fascinated her. And she took me to see *Hair* twice; she liked seeing everyone take their clothes off."[26]

But Chacha, named after her grandmother (Christie Tamara), rarely enjoyed traveling with Tamara. She remembers the European trips primarily for their tension, since the painter was determined that the girls "see" and think hard on their grand tours. After one foray to a Parisian museum, Tamara paraded them up and down the Champs-Élysée, telling them to "look in the windows and observe." Afterward she sat them down at a café and asked what they could recall, at which point the waiter approached them with an enormous tray of pastries. As Chacha contemplated the sweets, her grandmother became impatient and told her she had exactly one minute to decide what to take. Sixty seconds later, no decision having been forthcoming, the artist ordered the tray removed. In later years, Chacha would explain her need for periods of radical disengagement from her family as a reaction to the extreme control Tamara exerted in countless episodes like this one.[27]

In 1964, Tamara took Victoria to Venice for the famous Biennale art show. Unfortunately, one of the most prominent of the new exhibitors was the Argentine painter Lucio Fontana, whose controversial 1961 Manhattan show had received a prominent review on the same *New York Times* page that categorized Lempicka as a painter of floral bouquets. Tamara's appreciation of the artistic premises behind the art of the past twenty years—the gestural style of the Abstract Expressionists and the formal principles of

Rothko, Still, and Newman—was limited to their participation in the "reti-
nal, in the sense that their appeal was to the eye rather than to the mind."[28]
Minimalism, Op Art, and Pop Art, which were winning ground in the sixties,
contradicted her deepest conviction that art was about surface beauty; as for
concepts, people could read books or attend plays and movies for them.

"Making it new" was again the battle cry of the art world, but to Tamara
that now seemed to mean replacing beauty with ugliness. Lucio Fontana
himself was known for the gashes and slashes in his canvases, creating what
he called spatial art. Hilton Kramer acerbically reviewed his work in the *New
York Times*: "Mr. Fontana's pictorial signature is the razor slash on a mono-
chrome canvas. This altogether limited expressive gesture he performs to
perfection. It is just austere enough to seem meaningful, just violent enough
to seem spirited, while the results keep comfortably within the boundaries
of impeccable taste. It is another one of those 'daring' ideas that turn into
something chic before they can menace a single one of our esthetic assump-
tions."[29] Although Tamara was not closed to new directions in art, she hated
the 1964 Venice Biennale. "When she saw the jars of excrement at the Bien-
nale (one of the more conceptual entries), she said, truly confused, 'What is
this doing here?' We went outside to the canal, and she leaned over and ges-
tured as if she were about to vomit. She said, 'Art is dead, believe me,'" Vic-
toria recalls.[30] That Fontana could win a top prize at the 1966 Biennale
surely came as a shock to Lempicka, whose dedication to Italy as the bastion
of great art must have been shaken.

But Venice itself remained one of Tamara's favorite cities, a unique site
whose innate drama matched her own and could even now revive her spir-
its. On their 1964 trip, she and her granddaughter stayed in their favorite
hotel, the Grand Excelsior on the Lido. Among the rows and rows of striped
tents, just as in Thomas Mann's *Death in Venice*, colored crests flew in the
wind, identifying which royal family occupied which cabana. The suddenly
shifting light and water pleased her artist's eye, but almost as important was
the presence of Venice's grand passions. Elsa Maxwell gossiped about Aris-
totle Onassis, whose yacht was in port that day, and she helped circulate inti-
mate details about the crazy behavior of various ousted royals. Throughout
the 1960s, Venice seemed a hothouse of such personalities: Queen Alexan-
dra of Yugoslavia was said to have "become anorexic to spite her mother,"
Princess Aspasia, whom Tamara had known in Paris and whose private little
island had so delighted Victoria several years before when her grandmother
took her there for tea. Princess Aspasia's daughter insisted on being served
ahead of her mother in restaurants since she was a queen and her mother
was merely a princess. Victoria recalled, "Grandmother told me that the

skinny queen—who always looked to me like a fossil dressed in black—used to be a beautiful woman in her day, one who received company for her dinner parties with a boa constrictor always around her neck."

This was behavior that made sense to Tamara: grande dames, whether in Houston or in Venice, were women whose personalities demanded a larger stage than was needed by the boring, uninspired masses, among whom Tamara feared her own daughter and granddaughters might end up if she failed to tutor them well. The painter took Victoria to Venice in 1964 because the girl had just graduated from high school, and it was time, Tamara decided, to start looking around in earnest for a suitable husband. She believed that the Lido would provide Putti with the most chances to meet an eligible, preferably titled Old World bachelor. Tamara encouraged the excited girl to go to parties, and when Victoria returned from her evenings out, the older woman grilled her eagerly about whom she had met, and who would be inviting her to another party soon. "It was a lot of pressure," her granddaughter remembers. "It made those times five or six years earlier seem relaxed, because now everything was serious; my future was at stake. I always felt

*Victoria and Tamara in Italy, 1964.*

I didn't measure up if I didn't get a really impressive date. I felt humiliated if I had to say that no one had asked me out." One day on her own she met a man she liked, and they went out for ice cream. "When I returned, Chérie was furious. 'Don't you know that was dangerous?'" Tamara picked out the royal candidate she envisioned for Putti and spent one entire evening making the girl practice till exhaustion the art of the curtsy. But Victoria ended up encountering the young prince on the beach, and he turned out to be attending school in Texas. When introduced, he breezily waved and said, "Hi, y'all." Vicki laughed as Tamara muttered disconsolately.

When not involved in matchmaking, Tamara took her granddaughter on the side trips she herself had enjoyed since the 1920s. One day they took a detour to the tiny island of Torcello in order to taste the figs and pasta Lempicka loved to eat in great quantities. On Murano, another Venetian island, they watched the glassblowers, a sight that mesmerized the artist. After leaving the Lido, they stayed in Venice at the Palazzo Mocenigo on the Grand Canal, one of Lord Byron's former haunts.

And, inevitably, they visited Pompeii, where Tamara had taken the girls when they were younger. They returned to the same frescoes, where Tamara repeated the comments about people stopped dead in their tracks. This time, as she admired the art treasures, she also relished the attention paid to her by the locals, many of whom recognized her after her myriad visits to the site.[31]

It is safe to say that by 1965, after she had digested the experience of the 1964 Venice Biennale, Tamara consciously put aside her hope for a continued professional career. Until 1965 she worked ambitiously in her palette knife style, but after mid-decade she began to slow down. By 1967 she had begun to consider the project of copying her old paintings. Inspired by the example of the Dutch painters who had done similar copying, she felt no embarrassment about this work, but to those around her who were not schooled in art history, the idea seemed pathetic. She also completed a few still lifes, and she once again painted Gino Puglisi, this time, unaccountably, in the style of Bernard Buffet; it was her fourth and final portrait of the Italian friend and collector. Although her eyes had begun to grow weak, she refused to paint with her glasses on; and her hands had started to shake very slightly. Still defiant, however, she began experimenting with her favorite color, lavender, as a background for her new paintings.

Her frustrations took their toll on her relationship with Kizette, as their loud public fights became legendary in Houston. At first people assumed the arguing was an aberration, but when they noticed it recurring, they backed off from appearing at social events where both women would be present.[32] Tamara once arranged for a psychiatrist to attend a lunch with her and Kizette to observe the lassitude and apathy she felt inhibited her child's ambitions. Instead, the man gently told the painter that he couldn't diagnose someone without her knowledge or, even then, after just one meeting. During this same period, Tamara wrote in her address book, next to a neurologist's name, two comments: "I hate you" and "Maybe a brain tumor?" It seems clear to her granddaughters that she believed Kizette's anger to have a neurological source. Tamara had been raised in an Eastern European tradition that did not easily accommodate the American manners and expectations of the adult Kizette Foxhall.

Kizette and her family were granted an occasional reprieve by the artist's extended travels. They would drive her to the airport and give her a big farewell, relieved that she was off to Paris, Venice, Zurich, and Cannes: her trips lasted three or four months, and she often made two a year. Several times she varied her routine by taking a voyage around the world. As she would confide in 1979, "After I lost my husband, I was in such despair that

I could not work. I could not stay in one place . . . [but] I didn't find any-thing."[33] No place looked better than what she already had, however, especially when she realized that, with her health declining, her options were becoming limited.

On one of her trips to Paris during this period, she suggested to Nicholas Anouilh, son of her friend Jean, that he take a cruise with her. Wade Barnes recalls that they had an affair, although the cynical George Schoenbrunn believes it improbable, because at this time "she had little to give him, and she was even making this son of a famous playwright pay for his own ticket to London!"[34] Whatever the truth, Tamara was clearly lonely and seeking to create a life for herself that didn't depend upon her Houston family.

In Paris, Tamara sought out Manha Dombasle, who insists that "though Tamara continued to ask too much from me, she was always a very dear, kind friend." Dombasle continued to worry about her friend. "She just never wanted to stay in her beautiful apartment anymore when she came to Paris, though she had always loved it so. She said she couldn't find good help, though I could have gotten her some. She suffered a nervous breakdown almost every time she visited Paris, and I tended her. She was nervous about everything; worried that Kizette wouldn't become a writer and do something with her life; afraid her granddaughters would marry the wrong men."[35]

In 1967, Tamara's older grandchild, Victoria, married Julio Doporto from Buenos Aires. Initially pleased that her pretty granddaughter, now twenty years old, was about to embark on an international life with a handsome Latin husband, the painter quickly soured on the marriage when Julio made the mistake of asking Harold Foxhall, instead of the girl's grandmother, for Victoria's hand. "But that's how it's done in America," the exasperated young bride-to-be responded to her grandmother's indignation. "How absurd!" she was told. "You know I have been the head of this household financially, and now, as its oldest member, respect is due me." Victoria refused to ask her fiancé to repeat his request, especially since the very idea of asking a female relative instead of a male for permission was more than he could fathom. Even worse, the couple declined Tamara's offer to take the Kuffners' heavy old European furniture with them to Argentina. The furious artist then announced that she had cut them out of her will.[36] In further retaliation—and with a meanness inconsistent with her typical eccentric behavior—Tamara arranged to bequeath to Rice University in Houston all the estate silver, which Kizette had intended to use for her wedding reception. Transporting it to the school in a shopping cart, she alarmed the officials there who hardly knew the proper response.[37]

Over the next seven or eight years, Putti and Tamara did not speak to each other, until Chacha's husband, Alexander Molinello, arranged a meeting between them in a Houston parking lot. Victoria brought her two baby girls, Tamara's great-granddaughters. "The meeting was an incredible occasion," Molinello recalls. "All this holding back of emotion, then the release. In a movie it would be one of those powerful scenes that make everyone cry."[38] Victoria herself remembers "how painful the estrangement was. I loved Grandmother, and I missed her."[39]

Tamara's paradoxical blend of imperiousness and vulnerability was noticed by Françoise Gilot, who met her in 1966, when both Gilot and Lempicka were visiting the Paris studio of the Egyptian painter Raymond Abner. Gilot was at first impressed by the commanding presence of the artist, then disturbed by the emotional and even physical neediness that Tamara exhibited.

> What insolence, what poise in her allure, what authority in her sonorous voice, what flow in the sophisticated waves of her red-gold hair! You had to be seduced, you felt compelled to do her bidding or else be relegated to some forlorn limbo. Tamara decided to befriend me and began to call on me often, alternately using her artist's name or her title, Baroness Kuffner, a sign I wrongly interpreted as a lack of confidence in her intrinsic worth as an artist. She would come to my studio unannounced, and once there abruptly depart as if swept away by the gusts of some inner tornado. . . . From the glow in her eyes to the rapid tempo of her movements, she radiated energy, power, and determination. . . . She had liked my book about Picasso [Gilot's longtime lover] and found me intelligent. "The first quality of an artist is to be intelligent," she'd say, coming closer to me and probing deep into my eyes with a hypnotic stare. I felt like a goat about to be swallowed by a python. She made up her mind that I should write a book about her. She insisted that I see her work and visit her studio.

Lempicka was working regularly at 7 Rue Méchain again, and Gilot toyed with the idea of pursuing the professional friendship. But even for this artist, who prided herself on usually "being attentive to the work of my predecessors as well as to the women painters of my own generation or younger," Tamara's "flamboyant personality deterred my natural curiosity. I did not wish to know if her creations would sweep me off my feet. . . . Her displays of Slavic temperament inhibited me. . . . It did not quite occur to me at the time that she might have a crush on me, but I intuitively felt the

vulnerability beneath her sophistication, the deep wounds and anxieties of the refugee under the golden veneer of the baroness. And, having undergone dark hours myself, I did not want to lead her on."

Gilot did not see any of Tamara's paintings until 1977. More intelligently than perhaps anyone who has written of the painter, she recounts the salutary effect of the artist's sensibility upon the work, in contrast to the negative impact it had on her personality: "If the theatricality of her demeanor had been an obstacle, her work had a strength and presence that I appreciated right away. Even though artificiality was a part of her rhetoric as a painter, in her work it held a positive value, whereas in life it raised doubts about her sincerity. . . . I had my revelation of Tamara's greatness as an artist." She continues that "from the start she seemed able to fully articulate her vision, to be clear about what she wanted. She harbored no self-doubt; she was steadfast and single-minded. . . . Her subjects are detached from impressionistic reality; each image she creates acquires magic, becomes unforgettable. . . . She knew how to push down the corners of a brooding mouth without falling into caricature . . . the fleeting emotions that unlock the secrecy of an apparently serene face." Gilot concludes that "in Tamara de Lempicka's painting, as always in great art, there is great taste, sometimes great bad taste but never middle-class 'small good taste.'"[40]

Tamara needed to make new friends like Gilot, since so many of her older ones had died in the past decade. By 1968 the painter, who nearly every summer spent several weeks at the Beverly Hills Hotel, also began to notice a decline in her Hollywood friends' interest. George Schoenbrunn remembers how unhappy she was when she returned to Los Angeles for short visits during the late sixties and no one invited her anywhere. "So I insisted that she exert herself: I made her call up Gaylord Hauser and we had dinner with him, also with Patrick Mahoney, who had us there for dinner with the Metropolitan star Stella Roman, and we dined later on, all of us, at the Beverly Hills Hotel, where she stayed. I had to go out for dinner with her every night, buy her cigarettes (she never stopped smoking) as well as oranges, which were more expensive at the hotel, had to bring her a spot remover and take her to Ohrbach's to buy clothes in her big size 16. . . . She boasted all the time how rich she was and then at the time, when the money was still good, she left a miserable tip at a four-star restaurant in Monte Carlo, where Cecil Everly and I dined with her. She wore outrageous clothes for which she no longer had the figure, wore ridiculous wigs some times (à la Harpo Marx)— was no longer blond as in the forties when her black roots showed."[41]

Unkind as her friend's description sounds, it is true that by the late sixties Tamara was undergoing a transformation from exciting femme fatale to

potentially comical elderly woman. High drama at her age was allowed only when played with a certain air of self-parody, and though still wicked in her riposte, Lempicka rarely made fun of herself. Afraid of relaxing without a purpose, she only knew how to take herself seriously.

But if some people welcomed the chance to laugh at her self-importance, others felt differently. Jane Owen, one of the most respected women in Houston, says, "Tamara was a dear friend of mine. I don't deny her faults—she did not treat Kizette well, at least in public. But her strong sense of self was not defined by anyone or anything except her own beliefs. You could just feel her self-possession. She made some people jealous because she came off as so self-sufficient. And that impression was correct: She had integrity."[42]

On 9 October 1969, with no warning, Tamara's beloved sister, Adrienne Gorska de Montaut, died. The sadness that had engulfed Tamara at the beginning of the decade now threatened to overwhelm her. Pictures of Adrienne's funeral in Beaulieu-sur-Mer show an uncharacteristically subdued, frail but still tall woman in black. Almost always, she is looking down at the ground. Only Tamara's flamboyant, oversized floppy hat showed she hadn't given up yet.

*Tamara (bottom, third from left) at Adrienne Gorska de Montaut's funeral, Beaulieu-sur-Mer, 1969.*

# PARADISE
## *in*
# MEXICO

$\mathcal{T}$*amara and* $\mathcal{K}$*izette had just flown to the* south of France for a short vacation when they got word that Adrienne had suffered a heart attack. "Within twenty-four hours of the attack, we were at my aunt's bedside," Kizette recalls. "But by the time we got there she was dead." The only mention that Tamara ever made of Adrienne's funeral was how impressed she was by the tribute paid her sister through the presence of so many city officials. Indeed, Beaulieu-sur-Mer's leaders filled the church where Adrienne Gorska de Montaut lay in state. The architect had served as a councilwoman for several years before her death and, with her assertive, no-nonsense style, had accomplished much for the town whose Riviera coastline had offered ten years of fantastic sailing for her and Pierre. The Montauts had even won several prizes in races, in spite of Adrienne's recurring struggle with phlebitis in her left leg. "The town really wanted a beach, but there were formidable problems with the sea wall," Françoise Dupuis de Montaut remembers. "My stepmother drew up plans showing how huge boulders could fasten the sand securely from wandering out to sea or beyond the beach, and she convinced officials to try it. She proved absolutely correct."[1] Kizette adds, "Ada, so efficient, so smart, was very impor-

tant to my mother. I can't tell you how often Chérie said, often in my aunt's presence, that if it weren't for her sister, she wouldn't have become an artist."[2]

As the painter was adjusting to the loss of her sister and the need to refocus her life in general, a young Parisian art historian, unknown to her, was preparing to excavate as much of her oeuvre as he could find. Alain Blondel had studied architecture at the École des Beaux-Arts, where he became interested in Hector Guimard, the architect of the Paris Metro entrances. Blondel made a short feature documentary on Guimard, in the process winning the prestigious Lion d'Or award in Venice in 1966 and a chance to finance his own enterprise. He subsequently opened a small Paris gallery that specialized in Art Nouveau and Art Deco, though at that time neither style commanded much respect or interest in the serious art world. Challenged by the lack of information available on these periods, he sought to revive interest in artists from the Arts and Crafts movement in England, from the turn-of-the-century design schools of France, and from the Art Deco period of the twenties and thirties. One day in 1969, looking through an old book from 1929, *La Renaissance de l'Art Français et des Industries de Luxe*, he paused to read the article by Arsène Alexander called "Tamara de Lempicka," which had pleased the artist when it first appeared. "It was on page 331," Blondel still remembers. "I went crazy. Her paintings were so beautiful, and I didn't know anything about her. You must understand that the official art history left out such painters totally."

Blondel and his partners—Yves Plantin; Michèle Rocaglia, later Blondel's wife; and Françoise Blondel, his sister, later Plantin's wife—looked in the Paris phone book in the hope that Tamara might still be listed. She was and they called her while she happened to be painting at 7 Rue Méchain. When they explained that they would especially love to see her old work, she tried to dissuade them. "It's totally out of fashion," Alain recalls her telling him. "I had to keep reassuring her that we understood her work and admired it." The four partners hastened to Tamara's studio, where she waved them upstairs to see what she had. After several hours spent joyfully examining some of her best pieces—including *Adam and Eve*, *La Belle Rafaela*, and *Duchess de la Salle*—Blondel persuaded Lempicka to allow him and his friends to restore the art and eventually mount an exhibition at their gallery, Galerie du Luxembourg. His greatest obstacle was convincing her that people would attend and that they would not laugh at her oeuvre, however "out of fashion" she knew it to be. "Her reputation was already so low, but she kept worrying that if I showed her old stuff the public would be prejudiced against her new terra-cottas [palette knife paintings]. She didn't

seem to understand the total lack of interest in them anyway. In 1969, in her early seventies, she was still painting for the future, not depending on her past reputation at all."

Blondel tried first for several years to sell some of the older pieces. "I offered them at very low prices," the dealer laments, "and still almost no one was interested. No one bought anything. 'It's ugly,' they all said. I exchanged a piece here or there with a dealer, that was all."[3] Blondel offered the paintings at prices ranging from $3,000 to $10,000; despite the lack of buyers, Tamara insisted he was pricing the paintings much too low. He did, however, sell the *Adam and Eve* to the Petit Palais Museum, a sale that made Tamara very proud. Several years later, before her prices had risen, the museum deaccessioned it.

By the end of 1971, as a result of the proliferation of books, exhibitions, and critical articles on Art Nouveau and Art Deco spurred by the 1968 Paris exhibition, the value of art from these periods soared. Newly emboldened, the partners at Galerie du Luxembourg cajoled Tamara into putting together a collection of forty-eight pieces, restricted to the early period, 1925 to 1935. Running from November to December 1972, the exhibition became one of the "must see" shows of the year. "Even the posters became so popular we couldn't keep any up; as soon as we nailed one to a post, it disappeared ten minutes later," Blondel recalls. The gallery sold several pieces, but more important was the new appreciation of Tamara's work that the show inspired.

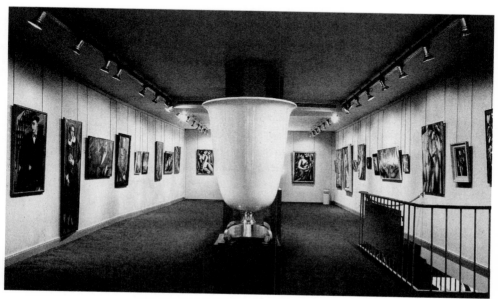

*Galerie du Luxembourg exhibition, 1972.*

Manha Dombasle still remembers how shocked her friend was when she and Tamara arrived at the gallery on opening night. "She fussed and fretted the entire way over, sorry that she had ever said yes to the owners. 'No one will be there,' she kept worrying. When she saw the crowd, she was so moved that she started to faint, and we had to put her in a separate room to recover."[4]

Tamara visited the gallery regularly during the month that the show ran. Blondel found her fascinating: "She talked with a tragic Russian tone, playing with her voice. This was perhaps not a handicap to [high] society, who found her an eccentric. She was very intelligent and had a very good sense of humor." But he still remembers her difficult side: "She was abrupt and didn't try to be cooperative. If she forgot a date, for instance, she didn't act apologetic." Above all, she was "a great artist who failed miserably to set up a relationship with galleries, dealers, et cetera and tended to [associate with] high society instead. When she got back to Paris, all her links had been cut," he says, still trying to understand her lack of professional stature.[5]

The reviews of Tamara's show were positive, in some cases enthusiastic. "Tamara de Lempicka, a very unusual portrait painter of the 1930s, produced sculptural hyperrealism with strangely contemporary accents," wrote the *Nouvel Observateur* on 26 June 1972. The same day, *L'Express* commended Lempicka as "an artist from 1925 who has understood the spirit of her time." But the important British art publication *Burlington Magazine* dismissed the collection as paintings that "conjure up everything that is meant by the word 'smart'—exclusive, up-to-the-minute, tinny, and second-rate." During the same month *La Galerie* advised its readers:

> You must stroll to the Rue St.-Denis, which has become one of the most attractive streets in Paris. Please, Philistines, do not smile; street girls—and they are pretty, actually—are not necessarily the only reason to stroll in this neighborhood. . . . Among sex shops, pizzerias, antiques shops, and clothing shops, a gallery with a strange name—in this instance, Luxembourg—and an elegant and functional interior [offers] a string of well-prepared exhibits. The exhibit of Tamara de Lempicka, present until July, will be for many a happy surprise and discovery. The artist had appeared before the war with other women painters who have today become part of history. Marie Laurençin, Hermine David, the friend of Pascin. . . . However, it appears that Tamara de Lempicka has not yet been recognized like her women colleagues until now. It still is a very strong body of work. And in a certain way mysterious. As a critic said long ago, "We have here a strange mixture of extreme Modernism and classical purity which attracts and surprises and pro-

vokes." She began to paint in 1921 and as early as 1924 to show in
the Salon d'Automne at the Tuileries and at the Galerie Charpen-
tier. Stemming from Cubism, her work retains the taste for strong,
muscled drawing, of very well delimited volume which made [the
artist] Bourdelle say of her work, "If you didn't have such beautiful
colors, I would love for you to sculpt." She, however, continued to
paint completely independently. Willing to play at mundane life as
well as art, her social salon was famous before the war. But she
was never untrue to what was best in her style . . . whether the
reality was banal, or universal and timeless. I would like to see
Tamara de Lempicka recognized as an ancestor of hyper-figuration.

The *Calendrier des Arts* noted that "The Luxembourg Gallery exhibits
in June and July works from Tamara de Lempicka, 1925–1935. This artist,
today rather forgotten, acquired in portraiture a very justified reputation.
Influenced by the spirit of 1925, her portraits are ageless." *Nouvel Observa-
teur,* on 26 June 1972, was more equivocal: "A very strange portrait painter
from 1930s, whose sculptural hyperrealism has strangely contemporary
accents."

In August, Florent Fels, a respected French art critic and founder of *Art
Vivant*, extolled in an article titled "Phoenix Rising" the virtues of the redis-
covered painter who knew the difference between serious art and that which
was currently passing for art in the contemporary world:

> To have denied the primordial elements in the art of painting, the
> magic turn of a head, the beauty of a face, the wild freedom of col-
> ors, is to have contributed to the death of art.
>
> Unaware of, and perhaps even scorning contemporary anar-
> chistic trends, Tamara de Lempicka has found her place in the long
> line of true artists who have taken their inspiration from
> mankind's noblest expression and from nature's own beauty. . . .
>
> She has gone to the sources of classical beauty for her inspira-
> tion, particularly to Cranach the Elder to whom she owes her
> impeccable design; she has constructed a lasting work of power as
> well as of emotional impact, evoking a joyful response in the
> beholder.
>
> Today, as we are witnessing the death throes of an art, let us
> hope that thanks to the few artists who have remained true to
> their trade, the art of painting will undergo a resurgence and a
> renaissance which will once more make it a thing of joy and
> beauty for all.
>
> To these ends is Tamara working.[6]

In the aftermath of the Galerie du Luxembourg show, Tamara was happier than she'd been since Kuffner died. After the initial excitement faded, she found herself content to settle once more into a routine that revolved around her Houston family. During 1972, Chacha married Alexander Molinello, whose vaguely Eastern European accent and Old World airs reassured Tamara that her lessons had not been wasted on her grandchildren. Molinello, who found Tamara fascinating, enjoyed spending time with her, but he quickly found himself mediating the tensions between his wife and her grandmother. "I was aware from the beginning that my then wife had a strained relationship with her grandmother," Molinello says. "After we were married, Chacha refused sometimes to go to her mother's house, because Tamara would be there, and she would want to design dresses for her. 'She designed our dresses all the time we were going to school and we looked so weird, different from everyone else. Now I'm grown up and I'm married, I don't want her to design a dress for me,' Chacha told me." Yet the couple did accept a lavish wedding gift from Tamara of crystal from Kuffner's Hungarian estate; and more significant, Tamara gave Chacha a collection of palette knife paintings, geometric abstracts, still lifes, and drawings, many of which were stored in the attic of the couple's Houston house. "We hung a number of the paintings—they were beautiful, especially in our little house. It was a wonderful sight to see. A lot of the *nature morte*—still lifes of lemons and fruits and arrangements," Molinello remembers.[7]

Tamara took the newlyweds with her to Cuernavaca, where she increasingly went for winter vacations. Only two hours by plane from Houston, Cuernavaca is snuggled in a semitropical valley 5,057 feet above sea level, an hour south of Mexico City. Immortalized in Malcolm Lowry's 1947 novel *Under the Volcano*, the city had served at least since the twenties as a weekend retreat for wealthy citizens of Mexico City, as well as a mecca for artists and politicians from all over the world. Convinced during their first visit in the early 1960s that this was the perfect escape from Houston, the Foxhalls made Cuernavaca their regular vacation site, and Tamara, of course, often accompanied them.

Tamara loved the winding stone-paved streets, the colorful market in the center of town with its workshops and stalls selling everything from "silver baubles, guitars, hand-blown glass, Huichole beaded jewelry, ceramics, and rugs," and the outdoor cafés where she lingered over coffee and cigarettes—a scene that must have reminded her of Paris before the war. Rich Mexicans, North Americans, and Europeans lunched often at the Posada Los Mañanitas, one of Tamara's favorite places to socialize. Typical of Cuernavaca's modest exteriors masking luxury inside, the inn's plain street entrance yielded to

carefully appointed colonial rooms that overlooked lush grounds where pea-
cocks and ibises strolled at leisure. Tamara frequently visited Cortés's palace
to study Diego Rivera's famous murals on the inner walls, depicting the bru-
tality of the early imperialists and the triumphs of the Mexican Revolution.
According to her granddaughter, Tamara was more interested in the formal
qualities of the murals than in the political statements.[8]

As real evidence of Tamara's fondness for Cuernavaca, the city had
begun to substitute for Capri on the artist's yearly itinerary. Among the first
people there to befriend her were the Americans Muriel and Jack Wolgin,
whose classical Spanish house was the oldest in Cuernavaca and who had a
superb collection of twentieth-century art. Muriel Wolgin was a friend of
Peggy Guggenheim, Mexican painter Rufino Tamayo ("I was the only gringo
invited to many of his parties," she proudly claims), and the local movie star
crowd, which included Helen Hayes and Merle Oberon. She and Tamara
became close, in part because Muriel liked her enough to be frank when
Tamara "needed reining in." Wolgin intuitively understood Tamara, though
the artist never disclosed her background to her friend: "It was clear to me
all along that she was Russian, with her knowledge of the language, her
accent, her appearance. And the outlandish way she treated Kizette as well."[9]

Through Wolgin's contacts, Tamara met artist Pedro Friedeberg, whose
strong presence in American museums pleased her. Of even more conse-
quence to her daily life, however, was Robert Brady, a talented dilettante
who was close friends with Peggy Guggenheim and with Josephine Baker.[10]
Brady, who spent a small fortune meticulously restoring a colonial palace on
Netzahualcoyotl Street, paid proper attention to Tamara. He collected inter-
esting art from all over the world, turned his home into a crowded museum
even when he lived there, and designed admirable tapestries on the side.
Tamara and Kizette enjoyed going to his home for cocktails served in the
shadow of Cortés's palace. And, at least to her face, Robert Brady treated
Tamara as a serious artist. Unlike Françoise Gilot, who admits that Tamara's
use of "baroness" misled her to think the painter was insecure about her art,
Brady was far more appreciative of the status attached to a title. But in spite
of the collector's charms, Tamara, usually a good judge of character,
remained unswayed by his flattery. She understood that he was shallow and
that his loyalties were flexible: "He could be a very mean-spirited man,"
more than one Cuernavaca resident has stated.[11]

In truth, Tamara valued anyone who imbued daily life with creativity;
she herself sought new ways to extend her sense of beauty into her envi-
ronment. No longer needed to sew her granddaughters' clothes, for exam-
ple, she started designing dresses for herself in Cuernavaca; her outfits were

invariably accompanied by an oversize matching beret. Local Mexican seam-
stresses would stitch dozens of sequins and little mirrors onto a two-piece
dress that Tamara had created in an animal-print fabric and in a range of vivid
colors like emerald green and rich violet. She was thrilled that such beauty
could be hers for ten dollars an outfit.

In spite of the pleasure her three-month visits to Cuernavaca provided,
Tamara continued to make frequent trips to Paris, largely because she felt
her reputation was enmeshed with European sensibilities. During one visit,
in 1973, she was approached by Franco Maria Ricci, the Milanese publisher
of the glossy society art magazine *FMR*. He had seen her show the year
before at the Galerie du Luxembourg and had been stunned by the beauty
of her work. Now he wanted to produce a book based on her art. "I knew at
our first meeting this would not be an easy relationship," he gushed in print
several years later. "Ours was to be a difficult love."[12] New to Tamara's work,
Ricci was impressed enough to offer to publish the first major survey of her
art. The artist and the publisher arranged to meet in Milan, on Via Bigli,
where Ricci conducted his business. On 27 June 1973, Tamara signed what
she thought was an agreement that would lead to serious international fame.
She must have considered it auspicious that her new reputation was to be
launched from the city that had so lavishly underwritten her love life and
her portraiture: "I, Tamara de Lempicka, c/o Ritz Hotel, Paris, authorize Mr.
Franco Maria Ricci de Milan, editor, to publish my works in a book that will
be prepared for this service. . . . The text will have to be approved by me
before the publication of the book."[13]

Back in Houston, Tamara shared her pleasure over the forthcoming pub-
lication with her friend Countess Anne-Marie Warren. The young wife of the
French consul general assigned to Houston, Anne-Marie was in awe of the
theatrical painter "who, in her purple period, wanted me to sleep on her hor-
rible purple sheets when I was a houseguest!" Tamara was extremely fond of
both Anne-Marie and her husband, Reginald, and she worried aloud because
the couple's finances "forced" Anne-Marie to work as a teacher—in spite of
her friend's repeated assurances that she loved her job. "She would dream of
schemes by which we could get money, including Reginald divorcing me,
marrying an heiress, then, as a rich man, remarrying me; but on the other
hand, she'd ask me to a luncheon during my hour off, then have it drag on
all afternoon, as if I could just leave the classroom to its own devices." Accus-
tomed to her older friend being the center of attention wherever they went
—"she was an exhibitionist"—Anne-Marie was shocked when several con-
servative upper-class French visitors snubbed Lempicka at a gathering in the
consulate. "They were visiting from Paris, and when they saw Tamara, she

looked suddenly very uncomfortable and got quiet. They said, in an odd voice, 'What are *you* doing here, Tamara?' It was a strained atmosphere." The embarrassed, subdued artist muttered something incoherent, Anne-Marie remembers. "I'd never seen Tamara like that before, but after she left, I found out why. One of the guests told me that Tamara was not welcome among many of the refined lady's circle because of her obscene practices back in the roaring twenties."[14]

The young teacher, in spite of her own title, was impressed by the artist's singular grandeur: "Tamara was against face-lifts, though most society women in Houston approved of them. Yet she loved to be flamboyant. I enjoyed her memories of the times she spent talking with the Surrealists at Les Deux Magots in the twenties. They thought that tomorrow was the end of the world, and she was far too practical to believe that. But when we traveled to Paris together, I didn't know what to do when she would suddenly stop short and start crying in the middle of the Place de la Concorde. 'Poor Marie Antoinette,' she would say sadly, as if just yesterday she had been beheaded."[15]

When Tamara cried in Paris for the memory of Marie Antoinette, she was mourning the desiccation and humiliation of the noble world into which she as well as the queen had been born. Though she never whined at being omitted from the American art world, Tamara identified with others whom history had effaced. In some respects, Tamara's allegiance to old times—of which she was, after all, a part—was a matter of maintaining her pride. She feared that she was being written out of the twentieth-century art histories she had previously assumed she would inhabit.

In addition, by 1974 it appears likely that Tamara's increasingly unstable behavior stemmed in part from hardening of the arteries. Jane Owen believes that "much of Tamara's odd behavior the last five or so years of her life surely had to do with changes in her brain. I could see the difference—the way she talked and moved, and even in . . . her treatment of Kizette."[16] Her friends and associates from this period remember vividly her loud verbal abuse of her daughter.[17] "She actually did dominate Kizette," former Cuernavaca resident Jeanclaire Salsbury states. "[Kizette] and Foxy often came to us to use our telephone because Tamara listened to all of their conversations."[18] Muriel Wolgin recalls similar incidents: "I told her to stop treating Kizette like a slave. I liked Kizette; when Tamara started demanding this or that of her daughter, I would say, 'Stop yelling at her all the time. It's sick.'" Referring not to Kizette's intellectual capacity but to the ways she appeared to mismanage her life, Tamara responded, "I'll make it okay. It's just that she's so stupid I can't stand it."[19]

George Schoenbrunn also speaks harshly about Tamara during this time, possibly because he laments that she "nearly made me lose all my money, since I was stupid enough to listen to her claims of being a financial genius, and I followed her investment advice." Schoenbrunn continues: "She became very difficult . . . nasty and mean to Kizette . . . smoked incessantly, throwing ashes all over you (and your car). . . . She treated poor Kizette like a maid; she once invited a not very wealthy young man to accompany her to England and I heard her on the phone (from the Paris Ritz) demand a *modest* room for him. Generous she was not. Very gifted, yes."[20]

During the mid-seventies, Tamara hired Robert Piro, a high-profile Texas lawyer, to handle her legal affairs. Unlike the majority of her acquaintances in Houston, Piro enjoyed and appreciated Tamara, though he did not realize at the time her status as an artist. "She showed me a few catalogs from her past, but I really didn't pay much attention to them," he recalls. Both Piro and his client shared a strong sense of self, and they were interested in people secure enough to seek out other confident achievers. Piro began to invite Tamara to his Sunday night family dinners, occasions he used to teach his teenagers how to serve meals properly. "Tamara was always horrified. She kept saying, 'You should have the servants do that, not the children.'" His adult daughter remembers vividly the elderly artist: "She had magnificent eyes. I'll never forget them as long as I live. Piercing blue, huge and hooded, they fixed on you with such interest, as if she wanted to know everything about you. And she had long black dramatic lines that she drew on her lids."[21]

When Tamara told Piro that she was looking for a traveling companion for her next three- to six-month trip to Europe, he suggested a young acquaintance, Pattie Davidson, who had baby-sat for his children while she was in college. Fluent in French and already well traveled in Europe, Davidson eagerly accepted Lempicka's telephone offer to accompany her in Paris, Venice, and Zurich. Immediately upon their first meeting in Paris, however, Davidson realized that her employer contrasted dramatically with the image she'd fantasized of a "sweet, dependent elderly woman."[22] Although the gulf between the employer and the earnest but impatient recent college graduate proved too deep for them to bridge, Davidson's reflections paint a colorful picture of the artist, then in her late seventies.

Almost twenty years later, Davidson remembers being impressed by the "yearly routine Tamara maintained—a month or so at the Ritz in Paris, a month in Zurich, two or three months in Venice. This pattern became clear to me even in the little time I stayed with her. Everywhere we went, the staff knew her from the previous years." In a letter to her parents about her first few days with Tamara, Davidson noted that her employer "had on a very

unobtrusive dress, but with about 20,000 strands of pearls and all these gold bracelets, a cigarette (decadently chic) in her right hand—I have never seen her use an ashtray, except for to put 'em out with. Let the ashes fall where they will—on her coat, on my coat, on the Oriental rugs of the Ritz Hotel. And her hat she never takes off except to sleep. Thus far it's been the same one—beige felt, with beige grosgrain ribbon around and a wide brim that dips on one side—it's times like this when I wish I could draw. It is indeed rare when people don't stop dead in their tracks when she walks by."[23]

Interested in educating her young companion to the ways of the world, just as she had taught her granddaughters, Tamara pointed out the "big names" among the boutiques lining the streets near the Ritz. "Eventually we passed a jewelry store and to your basic three-carat emerald-cut diamond she said curtly, 'That's not big enough.' So we sat down and had ice cream, and she gave me my first lecture on communism, and how if Mitterand [*sic*] had won she would have gone back to the USA. This lady is a capitalist like you wouldn't believe, and it's really paradoxical. She has all the aesthetic sensitivity of any artistic temperament without the hostility toward mundane aspects of life. In fact, she is obsessed with politics and the future of her millions, which is really her *historia calamitatum*—voilà your basic aristocrat."

On the other hand, Tamara's intense loyalty to the United States impressed even the young woman: "Today we were at lunch at this vegetarian restaurant which is out of this world, and she engaged in conversation with the lady sitting across from us (in German, so I didn't catch all of it). Well, it so happened that the lady was thinking about going to America, and baroness, Americanophile that she is, went bananas. By the time it was time to pay, baroness bought her lunch! . . . [A]fter the lady left, she said, 'If she'd stayed a little longer, I'd have paid for her trip to the US.'"

The next letter Davidson wrote to her parents, however, mentioned a basic problem: her definition of a travel companion failed to fit her employer's very different expectations. Instead, she complained that her job was "like being a doctor. You're on twenty-four-hour call, and you have to steal any time alone. I may as well be working a twelve-hour day. . . . I am trying so hard to be patient and do what she wants, but she wants me to *think* for her, and I just can't do it. She wants me to plan our days together down to the hour, but either she rejects my proposals or something goes wrong that I get blamed for."

Tamara, who confounded adults her own age, made no sense at all to her new companion. She "spoke six languages but was illiterate" when it came to writing letters; she professed sophistication but wore clothes that elicited

every response, "from a snicker to gaping astonishment." When she wore a "slinky, shiny jersey dress in a brown, black, gray, and white print, [with a hat] made out of the same material in a kind of overgrown floppy beret . . . one man even took out his glasses to get a good look." After attending the ballet *Firebird*, Tamara complained all the way back to the hotel about how superior the Russian ballet had been prior to "the dirty Communists." On another occasion Tamara and Davidson went to see Fellini's *Amarcord*, which the elderly artist slept through; increasingly she succumbed to exhaustion.[24] At least Tamara was willing to attend the avant-garde film, however, and with an eagerness that surprised Davidson. The young woman did not realize that Fellini had been born in 1920 in Rimini, and that any artistic enterprise beholden to the Italian Adriatic of that period would guarantee Tamara's interest.

The relationship between an unexpectedly homesick young woman and her unsympathetic, difficult, nervous "old bag" employer, as Davidson began to call Tamara in her letters, was doomed to disintegrate. Tamara defensively accused Pattie of going about "with a long face" all the time. When the girl started talking of leaving, Lempicka lectured her not to be so immature as to worry her parents. Self-interest aside, the artist was doubtless sincere when she responded to Pattie's plan to call her mother and father by admonishing her: "Don't call them and get them all upset and nervous. Send them a cable instead."

Davidson was far too young to negotiate the minefields the artist laid even for those she cared about deeply. Moments of closeness occurred, usually when she asked Davidson to join her for her oatmeal dinner delivered each evening by room service; at such times Tamara shared her unhappiness about her little family with the girl whose own mother and father were her best friends. Moved by Tamara's "anguish" over the fact that "her only daughter hates her" and her realization that "of course Baroness is tormented by all of this," the young Davidson lamented to her family back in California that every evening, over cereal, the "small talk" disintegrated into repetitions of "how she sent her and her grandkids to the best schools, bought them clothes and new cars and what-gratitude-do-I-get." The earnest companion tried hard to be compassionate—"I don't mind listening to all of it that much"—but she couldn't countenance Tamara's obvious depression causing her to "treat everybody mean."

Most telling is Davidson's account of the artist's mental state: "She is extremely high-strung, and from time to time she gets so nervous and starts breathing heavy and huffing and puffing so hard that I fear she's gonna have a cardiac arrest one day on the Banhofstrasse!" When she accompanied

Tamara to a shoe store, she encountered more than her employer's nervousness: "She only has one pair of shoes and the heels were getting worn down so she decided to have them fixed. . . . She had tried on God-knows-how-many pairs of shoes, and all of a sudden she looked up at me with a blank expression on her face and said, 'Where are we?' I told her we were in the shoe store on the Banhofstrasse. She didn't remember coming to Zurich, nor that she had ever been in Paris, nor where I fit in to the whole picture. I thought for a minute she was pulling my leg, so I did what I thought best. I got her to leave the store, and she snapped to once we got out and started walking to the taxi. But she still couldn't remember coming from Houston to Paris to Zurich. When we got to the hotel, I tried to call her doctor, but since it was a holiday of course he wasn't home, so I got the hotel doctor. He said that the cause of it was just having so much on her mind that she suffered a mental blackout. He's making her take tranquilizers and told her that smoking as much as she does, plus the fact that she never sleeps well, will both aggravate things like that. So now she is a little stoned all the time, but easier to coexist with."

Doubtless Tamara was suffering from the incipient arteriosclerosis that would be diagnosed, full-blown, a few years later. At this point, it was not only the young woman who had trouble making sense of the artist's behavior: the harried waiters at Tamara's beloved Dolder Grand Hotel in Zurich asked Pattie, "How can you put up with her?" From Davidson's letters it appears that the painter stopped to see her doctors and lawyers in Zurich, where she chatted excitedly about her upcoming stay in Venice. But while she extolled the wonders of medical care in Switzerland, especially her "thirty years" at the Bircher Clinic ("a terrible place," snorts Countess Warren),[25] she warned Pattie Davidson that if she became ill in Venice, "just plan on dying."[26] In the end, the young woman came to feel that her own progressive politics put her at odds with Tamara. "I was reading *La Monde* every morning, worrying about the plight of the workers, while my employer was fretting aloud that if there was a strike, she might lose access to her bank accounts." Tamara's almost obsessive concern with her financial affairs impressed Countess Anne-Marie Warren during this period too: "She always kept at least a half million dollars in her checking account, but she spent almost nothing on anyone, and you'd have thought she was in danger of starving."[27]

Tamara may well have envied her young companion's strong attachment to her family. Pattie Davidson was clearly more interested in receiving letters from her loved ones than in taking lessons in worldliness from an eccentric, difficult artist who enjoyed teasing her about her radical politics: "There

go your brothers, the hippies," she said whenever a disheveled man walked by.[28] Her own younger granddaughter had confounded her by taking up an alternative lifestyle after her marriage, and so Tamara projected her displeasure onto Pattie as a surrogate for Chacha. In reality, Tamara's contempt for hippies was more situational than a matter of deep conviction. A few years later, for example, when her adoring Texas nurse Connie Stutters took her to the zoo in Houston, she enjoyed playing up the contrast between her generation and the new bohemians. "She wore her long fur coat and a beret. . . . Her fingernails were polished a bright red and she wore matching bright red lipstick. As we walked around the zoo I kept trying to show her how much fun the zoo is. But Tamara kept looking at the young girls in tight jeans and would make an awful face, pucker her bright red lips, and point her long red fingernails at them and say, *'dirty people.'* She kept this up until I burst out laughing and had to sit before I fell down—I was laughing so hard I was crying. Tamara started laughing too and the two of us must have made quite a spectacle—her in her fur coat and me in my nurse's uniform."[29]

Pattie Davidson, however, had expected a different type of employer. She was appalled by the itinerary in Venice: "We're staying way out from the city at the Hotel Excelsior Lido and mornings we will spend together on the beach. Then comes lunch and siesta until 3:00, and then we'll take a boat to Venice and stay the rest of the afternoon. . . . I'm sure this is worse than prison. In effect, all I am is a literate baby-sitter."[30] Davidson could not yet appreciate the wit that seasoned Tamara's otherwise antagonistic ripostes, and with great relief, she boarded a plane back to California and her own loving family.

Cutting short her own trip to Europe after Pattie Davidson returned home, Tamara spent more time than usual in Cuernavaca. There, at a dinner hosted by Nacho and Lee de Landes, from whom she had rented (and would soon buy) the modern house, Tres Bambús, she met a friendly couple, Jeanclaire and Allen Salsbury, who had lived in Cuernavaca for five years. Witty and worldly, the husband and wife quickly impressed Tamara, who invited them to dinner a week later; after the Salsburys reciprocated, their friendship was established. The Salsburys found Tamara "fascinating, inspirational; we loved her paintings, her inimitable, elegant style, her self-discipline, her rare, mysterious beauty."[31] To some extent, the Salsburys courted Tamara: "We were in Seattle and the San Juan Islands part of that year, but when we returned we found that Tony and Beagle Duquette and Gladys Knapp of Los Angeles were all her houseguests. I had made a fabulous mango ice cream for Tamara before we left, and when I invited them all over, she requested that I make it again. I did, and it became one of her favorite foods," Jeanclaire recalls.[32]

Tony Duquette, whom others believed to be an intimate friend of Tamara's during the Hollywood years (Duquette politely claims that he cannot remember their relationship), returned to public notice in 1998 with a line of jewelry and furniture he designed for Bergdorf Goodman.[33] He and his wife, along with Tamara, accompanied the Salsburys to the ancient town of Tepotztlán in the mountains north of Cuernavaca, a favorite retreat for artists that the painter immediately loved. Later in the week they all attended a huge paella party thrown by a handsome young banker, Felipe

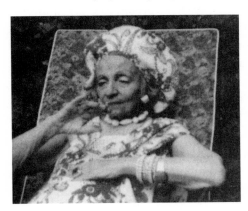

*Tamara relaxing at a Cuernavaca party in one of her matching outfits, 1979.*

Monasterio, at his wealthy parents' Cuernavaca home. Tamara, whose blue print dress and floppy matching beret coordinated with the blue chaise on which she reclined, seemed especially happy, probably because her fellow guests included Princess Beatrice of Savoy (daughter of the last reigning king of Italy), the Monasterios, the Salsburys, and old companions like the Duquettes.[34] Such gatherings tamed her compulsion to take center stage; when Princess Beatrice was present, "Tamara was humble, the only time I ever saw her like that," one friend remembers, although "Beatrice couldn't have cared less. She was dealing with her own dramas, such as shooting her husband, Luis Reynes."[35] But Tamara's reverence for titles seemed based on respect for the office rather than the person. If others, including Beatrice herself, thought her ridiculous for curtsying to the notorious swinger, Tamara was grateful for the chance to pay homage to royalty by heeding such protocol. "Even when Grandmother saw Beatrice in a string bikini, she treated her with a very sincere, special kind of respect," Victoria Doporto recalls.[36] "I remember giving a party where Tamara even kicked Kizette to make her curtsy to Beatrice," Muriel Wolgin recounts.[37]

Her behavior registered in Mexico as it had elsewhere. In general, just as Houston had snubbed her, Tamara "was not completely received by the Cuernavaca 'regulars' either. She resented this slight, having been the center of interest in Paris, Beverly Hills, and European cities. . . . When Tamara hit the scene, people in town were somewhat in awe of her. She was dramatic, spunky and a bit bizarre. . . . I guess [the regulars] saw a certain worldly

arrogant haughtiness about her," Jeanclaire Salsbury says.[38] Tamara's stature as an artist was not well known in Cuernavaca, or perhaps a city that was home to painter Rafael Tamayo and the playground for sculptor Isamu Noguchi did not have room to value an artist of her sort.

Nonetheless, the art of throwing cocktail parties, which Tamara had mastered during her Hollywood years, served her in good stead in Cuernavaca, where she invited small groups of Americans over for the less-taxing gatherings she now preferred. Indeed, one of her greatest disappointments in her new community was that its wealthy exiles preferred entertaining on a much larger scale, and Tamara no longer felt she could compete with elaborate theme parties and special dinners for hundreds.[39]

But whether or not there was a social event to attend, in 1974, Tamara still devoted much energy to her appearance. Friends noticed that even in her late seventies, she was "always impeccably groomed with intense orange lip rouge and heavy eye makeup."[40] She was not one to deny her own aged appearance, despite her refusal to specify her correct birth date. She had acquired the wrinkles and sagging skin of a lifetime of cigarettes and sun worship, and now she lamented that, in contrast to the past, people complimented her on her clothes, not her beauty. And in truth, she took great care to ensure that her clothes would draw attention. She explained that the somewhat baggy dress she often wore had, years before, been admired by Christian Dior, who had incorporated it into his own collection. Later, she changed the story, saying that Dior had originally created the dress, which she then copied. Jeanclaire Salsbury, an accomplished seamstress herself, found Tamara's hand-craftsmanship exquisite; and each of her "ninety-eight dresses and berets . . . was identical—sleeveless and long—but each of an exquisite rare silk or unusual fabric."[41] Both Kizette and Tamara wore hats daily, an anomaly among the women in Cuernavaca. "Tamara told me that her large nose looked much better balanced by a big hat, and she was correct," painter Raymond Abner remembers. "She also had unfortunate legs, so she kept them covered as well." Tamara's oversize floppy berets were "held in place with a large jewel pinned above her left eye," while Kizette invariably wore a "safari-type" hat with back and side pieces of material that matched her dresses, falling to her shoulders. When Tamara wore her "caftan-type" Mexican garments instead of the ersatz Diors, she complemented them with "large-brimmed floppy straw hats."[42] Whether at 8:30 in the morning, or twelve hours later, the Salsburys "never saw Tamara without her head covered or with her legs uncovered."[43]

The artist's eccentricity proved ready-made for Cuernavaca, a haven for celebrities in retreat from the world. Tamara had landed, just as she had

in Hollywood, among some of the best-known figures in the contemporary scene. Muriel Wolgin recalls that rarely did a community attract such an assortment of famous people: "I especially enjoyed the visits of Maria Callas, who would stay with me on summer visits. She was torn over Onassis—she cried about how he made her have an abortion. But she was a typical example of the . . . interesting visitors who frequented the city when Tamara lived here."[44]

One local celebrity who proved simpatico with Tamara was Canta Maya, the "Venus of Flesh," whose real name was Elizabeth Gimbel. A famous courtesan and dancer in Berlin during the 1930s, Gimbel says, "We understood each other. I'll tell you about myself, and why Tamara and I got along. I married Gimbel, of the department store, but I made a mistake. You get more money and more diamonds if you refuse to marry them [men]. I myself made a deal with Gimbel. I don't like sex; it is messy and unpleasant. It lacks beauty, doesn't it? So I would make him take a bath and put on a clean, starched white nightshirt before coming to me in my bedroom. Maybe I was wrong, but that's how I handled him. Tamara understood me."[45] At first glance an odd example to prove their mutual sympathy, Gimbel's story suggests that Tamara too saw sex as a quid pro quo, an exchange peculiarily narcissistic in the end, the expression of which appears in the artist's famous nudes from her early period.

"[Tamara] was very much alone," Gimbel continued. "When I met her in Cuernavaca, she asked me to visit her very often, if possible every afternoon. And so I did. . . . She did not like her paintings anymore because she said her hands trembled. . . . Tamara often showed me her hands and said with these hands I made my money and [now] what will happen? My daughter will spend this money on [men]!"[46] When Tamara proposed that the two women go to Paris together, Elizabeth Gimbel demurred: "I was not about to take such a trip with her," the nonogenarian laughs. "I felt sure she wanted a sexual relationship."[47] Others maintain that Tamara's habit of touching people's faces as she talked to them, as if flesh made conversations resonate, misled both men and women: "She was just a very physical person," Victor Contreras insists. "I doubt there is any proof at all that she wanted sex with Canta."[48]

In Cuernavaca, as in Paris, Tamara mingled with people whose fame and talent impressed her. Muriel Wolgin may have been the hostess to introduce her friend, Nobel Prize winner Octavio Paz, and his wife, Maria, to Tamara. Paz and Tamara took an instant liking to one another, and from the time of their introduction, they began huddling together at parties, deep in conversations that were unlike those she had with others. "They were always talk-

*Octavio and Maria Paz in Cuernavaca,
late 1970s.*

ing, usually intensely about art," recalls
Jeanclaire Salsbury. "Paz so obviously
shone with a remarkable brilliance," her
husband adds. "Still he managed to
make other talents around him feel par-
ticularly smart and good."[49]

Although the person to whom she would feel most connected in her old
age was another native Mexican man, he was almost magically a piece of her
past. Elizabeth Gimbel thinks it was in 1974 or '75 that she reintroduced
Victor Contreras to Tamara: "She wanted to meet artists! So Victor was my
only friend and I introduced him. It was not too good an idea of mine
[because Victor no longer paid attention to Gimbel]," she recalls.[50] It was
months into their acquaintance before Victor and Tamara remembered their
previous meeting twenty years earlier, when they both lunched with Prince
Yusupov and Jean Cocteau in Paris. If Contreras remains a mystery to those
who love him, and a slightly suspicious character to those who don't, his
relationship to Tamara was undeniably the most important one in her last
years. Victor was a serious, opinionated, debonair artist, the kind of intelli-
gent man Tamara liked best. A sculptor of some renown who in 1998 was
knighted in St. Petersburg by the Russian government, Contreras has been
commissioned by patrons as various as the state of Tennessee and his home
town of Guadalajara to create site-specific pieces.

Bound by a "mutual understanding as artists," the odd pair developed an
intense friendship. Tamara, who loved the chance to pass on wisdom to the
young, appreciated the near daily invitations to his studio that her courte-
ous if at times overtaxed friend issued; ensconced on a tall stool, tapping her
ashes into a battered tin cup while Victor painted or sculpted, she nagged

him: "Be careful, you're social-
izing too much." Contreras
recalls, "Tamara told me many
times not to mix the social and

*Victor Contreras with Farah
Pahlavi, wife of the deposed Shah
of Iran, and mystic Gabino
Pineda, 1979, Cuernavaca.*

art worlds. She realized late in life that she had spent too much time social-
izing." The two friends talked of art, with Tamara expressing her enthusiasm
for Leonor Fini, the Argentine painter living in Mexico City, and for the
superb draftsmanship and composition of Salvador Dalí. Olivier Picard,
Contreras's teacher, shared Tamara's assessment of Dalí's brilliant technique,
but he regretted the Surrealist's "abusing the perfection of his technique—
the spirit of his work gets lost in the detail." Tamara nodded her agreement,
leaving Victor to wonder if she understood Picard's implication about her
own work.

Designated the International Women's Year by the United Nations,
1975 at least brought Lempicka belated, and ambivalent, satisfaction for her
lifelong struggles, as her sex now thrust her art back in front of the public.
The Petit Palais in Switzerland sponsored a large exhibition that explored
the role of women in artistic achievement. For some critics, this topic
seemed passé. Nonetheless, as one writer maintained, the year's organizing
theme

> still gives us several exhibits of great interest, even useful because
> they allow us to discover real talents as well as to recognize great
> artists who may have been forgotten. . . . In Geneva, [for instance],
> the Petit Palais has presented a body of work that should be espe-
> cially noted, particularly from the historical point of view of the
> female painters of the School of Paris. Among this numerous crowd,
> never truly a school, a very small number have become famous. In
> painting there are only two: Marie Laurençin and Suzanne Val-
> adon. . . . What, however, appears to me the most important here
> are works from artists whose names are scarcely known, none of
> which in fact shows feminine charm but instead demonstrate a cer-
> tainty of conception and strength of realization often absent among
> most of their male colleagues. Here is Gontcharova, but this one at
> least has already merited fame. Here is Maria Blanchard, repre-
> sented by a Mother and Child, a masterpiece of Cubism. Here is
> Tamara de Lempicka, whose . . . monumental muralism can be
> compared . . . advantageously to compositions of Fernand Léger.[51]

That the new appreciation for Tamara occurred under the auspices of a
feminist-inspired exhibition was ironic, both because she herself discounted
the women's movement and because the feminists wanted nothing to do
with her. Privy to her psyche more than most, Victor Contreras—as a mod-
ern man who understood the American women's movement but also as a
Latin gentleman who still worshiped a mythical female—was interested in

his friend's response to the ideology. After all, he figured, she had surely been among the most independent, emancipated women of the twentieth century. Yet she dismissed his sociological interest with an impatient wave of her cigarette holder and simply replied, "Victor, it is hard to be a woman in this world. You have to use your body and your sex to survive, and then that's all people think of you. It is not easy at all."[52]

She continued to paint nearly every day, but "she spoke with great sadness about her failing eyesight," Contreras recounts. "She hoped she could get some ideas for a new technique from watching me work, as if new materials would compensate for her eye problems. She actually painted at first in my studio. But of course, there was not any way to make up for her physical infirmity." Sharing with Victor her most intimate emotions, she informed him proudly that "I have done everything there is to do," and she gradually realized that she was "absolutely certain" that one day her worth as a painter would be recognized. She nostalgically explained to him why *Mother Superior* was her favorite painting: "She was suffering so badly herself when the nun immediately read her mind upon their first meeting," and the painting exorcised Tamara's depression.

Despite her honesty with her friend, she still pretended that her replications of earlier works simply reflected a common practice among artists— an accurate observation, except that when Diego Rivera, for instance, painted his copies, his hand was not shaky nor was his eyesight uncertain. Though she had done reproductions intermittently before, in the seventies she adopted this mode almost exclusively, first tracing the original painting onto carbon paper, then transferring it directly onto a new canvas. Sometimes in the middle of such an enterprise, she would begin to feel emotionally lost, and she'd telephone Victor. "I'm nervous and shivering," she would cry, and he'd stop his own work to go raise her spirits.[53] Victor substituted for a husband or son; she trusted him enough to discuss her family's troubles in detail. When she wanted to talk during more conventional daytime hours, they often met for extended lunches at the Cuernavaca racquet club.

Victoria was still in Buenos Aries, and Tamara's other granddaughter, Chacha, was experiencing conflicts as she sought to define an adult identity free from Tamara's control and Alexander's strong influence. Kizette, thrilled at the free time her mother's prolonged visits to Cuernavaca allowed her and Foxy, enjoyed Houston's social life again. As usual when her family was not available, Tamara turned to artistic challenges to mollify her restless and increasingly lonely spirit. But she shocked even the jaded Cuernavaca community by spending a bored weekend painting the inside of her house lavender. "One Monday afternoon I arrived in her house and nearly fainted,"

Elizabeth Gimbel remembers. "Everything was lilac. Tamara, together with her nurse, had painted the living room and the bedroom violet. It looked terrible, but she acted very satisfied. The two went out and bought cloths for the tables on the terrace. In many colors! I think Cuernavaca inspired her to love colors."[54] Jeanclaire Salsbury laughs at the memory: "It was quite extraordinary. She did everything during this period in violets and lavenders—clothes, accessories, sheets, her house, the backgrounds of her paintings."[55]

Finally acknowledging at the end of 1975 that she no longer needed a studio in Paris, Tamara gave her old friend Manha Dombasle a key to show 7 Rue Méchain to prospective buyers; she breezily assumed that her friend, now in her seventies, wouldn't mind organizing the storage of her paintings and her hundreds of dresses. Dombasle donated the best of the gowns to the Musée du Costume in Paris, and she transported several dozen paintings to her own house for museum curators to examine. Tamara's strong belief that an artist's reputation lived on through public access to her works—museums rather than private collections proving the touchstone of reputations—had emboldened her to invite the French government to choose paintings to hang in the country's most important venues. "I will never forget the day all these serious, impressive men stood in my apartment and bickered over the pictures," Manha Dombasle recalls. "Kizette and I stood by and watched them; Tamara was sick, resting in Houston. The Pompidou chose four, and a man from the Louvre allotted about twelve to various regional museums."

In fact, the Musée National d'Art Moderne (the Pompidou Centre) took three pictures: *Portrait of a Man, Calla Lilies,* and *Bowl with Grapes.* Curator Jean Lacambre of the Louvre acquired *La Chinois* and *Orange Turban* for Le Havre's museum; the *Mother and Child* for the museum at Beauvais; *Studio in the Country* and *La Mexicaine* for Nice, and others for St.-Etienne, Orleans, Nantes, and Grenoble. On 22 April 1976, Kizette wired the news to her mother, who was temporarily staying at the Foxhall home on Reba Drive: "Congratulations. Museum Modern Art and Louvre Museum accepted with great admiration and appreciation fifteen Lempicka paintings of all periods for Paris, Grenoble, Nice, etc. Mother Superior for Nantes. Love, Kizette and Manha." The mention of only one specific painting—*Mother Superior*—testifies to Tamara's special fondness for it, and the disingenuous assurance that "all periods" had been taken assuaged the artist's anxiety over being too narrowly represented. After the paintings were dispersed, Dombasle sold the apartment and most of its furnishings (it had been redecorated in the 1950s) to the very "Arabs" Tamara feared were overrunning the city; she continued to write Tamara "constantly" to reassure her of all sorts of practical details. But the loyal friend never received in grateful return even

a single painting or sketch from her friend of forty years. "That was quite all right," the unfailingly gracious woman insists. "Tamara was good to me all those years; she was just different from other people."[56] One way Tamara sought to return Manha Dombasle's kindness was to take an interest in her grandchildren, Gilbert and Arielle Dombasle, who were living in Mexico at the time. "She loved to sit with the younger people at dinner parties," Arielle Dombasle, a successful movie actress, recalls. "She sometimes refused to sit at the correct table because she said the people all made her feel so old. She loved the energy and beauty of the young. And my friends and I enjoyed being around her. She acted her age, but she was just so wonderfully curious and open."[57]

During the dispersal of her paintings in Paris, Tamara had remained in Houston to recuperate from surgery. Four weeks earlier, on 29 January 1976, she had complained of a sore on her tongue. On 10 February she was admitted to Park Plaza Hospital with a diagnosis of "invasive squamous cell carcinoma of the left side of the tongue," probably the result of her longtime habit of smoking three packs of cigarettes daily. She underwent a left partial glossectomy to excise the cancerous area and tolerated the surgery well. Except for a history of chronic diarrhea, her medical records cited no other problems. Released a week later, Tamara modified her smoking habit as a result of this scare. Within weeks, however, she was reaching for the same number of cigarettes as before, despite her worsening shortness of breath.[58]

After the sale of the apartment and her recovery from the operation, the artist returned to Paris to help pack whatever was left at 7 Rue Méchain. "There wasn't that much to take home at this point," her daughter remembers. "Chérie had given boxes of her valuable silver to Rice University years before. She started crying when we packed the little blue demitasse cups with gold lines rimming the tops. They were from Napoleon's time, and she had bought them in New York. She got so depressed that she suddenly started running around the apartment with scissors, threatening to kill herself or me. I called Manha, who had gone home, and she came back, all pale and shaken."[59] Tamara could reverse her mood in a matter of moments, however, an emotional instability that became more pronounced from this period on. Kizette said that "her sadness turned on and off like a water faucet —when the phone rang, she'd become happy again."[60]

She was temporarily revitalized by the respect being accorded her paintings in current exhibitions. During the summer of 1976 the Victoria and Albert Museum in London mounted an exhibition, "Fashion 1900–1939," that provided British art lovers with their first major exposure to Tamara's work. On 22 August 1976, Bruce Bernard wrote in the *Sunday Times Mag-*

*azine* that "our archaeologists of Art Deco haven't missed much, but they do seem to have overlooked one painter of extraordinary power, Tamara de Lempicka, whose exhibition in Paris in 1972 went almost unnoticed over here." The critic continued enthusiastically that the magazine's reproduction of *Girl with Gloves* would startle its audience in Great Britain because "of its unfamiliar synthesis of styles, its powerful erotic charge, and an incisive lack of the familiar kind of elegance found in the other paintings there by Van [*sic*] Dongen, Dufy, and others from the Paris of the same period." The sensitive critic referred deferentially to the aged painter: "Now in her seventies, very much alive and painting in Houston, Texas, and in Paris, she thoroughly dislikes interviews, and detailed information about her is difficult to come by." But her painting spoke for itself: Bernard concluded that *La Belle Rafaela* was "one of the most remarkable nudes of the century." Unusual in his grasp of the paintings' complexities, the critic also invoked a more historically acute vocabulary than the poetic universal language still dominant in art criticism of the late seventies: "Her best painting *commands* respect. She rejected the influence of drawing room Cubism and evolved an extraordinary personal style, which although sometimes reminiscent of the sterile products of Fascist idealism is saved from Roman or Teutonic aridity by her strongly sympathetic feeling for individual human beings. She *is* a portrait painter. And the film studio lighting, the stylishness, and the explicit eroticism place her firmly in unidealistic Paris." Here, then, was the handle to placing Tamara within the rubric of Modernism: she too, like those anointed by Clement Greenberg and his followers, placed the artfulness of painting in the foreground, through her own extraordinary narcissism, which was no less iconoclastic than Jackson Pollock's. In spite of her clear subject matter, her explicit artifice contributed to an art whose real reference was its own status as a constructed art object not interested in trespassing its proper painterly boundaries.

Perhaps the new appreciation she was receiving encouraged Tamara to think she would live forever. According to Robert Hewell, president of River Oaks Bank in Houston, it was around this time that Tamara took out a two-million-dollar annuity, ignoring his advice that she risked losing a great deal of money. Frantic that she'd outlive her ability to provide for herself financially, she was betting on living at least long enough to make the investment worthwhile. The investment was guaranteed to provide her a monthly income as long as she lived, though at her age, it was probable that the guarantor would benefit the most.[61] She returned to Cuernavaca, reassured of her future security and indifferent to the damage she was doing to her estate. Hewell remembers looking forward to his visits with the artist, who would

sweep into the bank as if onto a stage: "She was interesting and great fun." Leaning forward, as if sharing a secret, he whispers, "But I was shocked, I must admit, at the way she would refer to Kizette. 'You cow,' she'd call her daughter, who even as a middle-aged adult would drop her head and slump her shoulders in response. It was appalling."[62]

The artist stayed less and less often in Houston, since she fit more easily into the Mexican community of expatriots and wealthy visitors. Kizette, Foxy, and Tamara spent much of the summer of 1976 in a swirl of social activities in Cuernavaca. On 17 July Kizette participated in the Allen Salsbury First Invitational Tennis Tournament, hosted by their good friends. Kizette, an excellent player, was mortified by her mother's habit of watching her from inside the court until the restless older woman would announce that she'd had enough and drag her daughter off to get a cool drink.[63] In August and September, Tamara was elated at her social standing among local society; her friend Princess Polignac was visiting from Paris, and Cuernavaca residents showered the artist and her visitor with attention—luncheons, cocktail parties, and dinners.[64]

During the latter part of 1976, according to Victor Contreras, Tamara was unusually self-reflective about her own career. Perhaps the success of the Blondel show, coupled with the imminent release of Franco Maria Ricci's book, for which she held great hopes, allowed her a resurgence of pride: "I know my work of the twenties and thirties is banal in theme, but to make a superficial topic truthfully appear as such is no easy feat," Contreras recalls her telling him. This memory, which sounds too self-effacing for Tamara to have uttered, may be colored by the pronouncements of his own teacher, Olivier Picard, who had evaluated Tamara's works in similar language. More significantly, Contreras noticed that Tamara refused ever "to put her paintings into a field—not Art Deco, not École de Paris. And she considered her work of the forties and fifties very successful, her Surrealistic pieces included."[65]

Early the next year, Robert Piro once again tried to assist his friend and client by locating a companion for her. In January or February 1977 his brother Richard, who had been searching for an interesting job, left California and moved to Cuernavaca, where he lived with Tamara for one and a half years—"all I could stand." His memories of his employer are laced with irritation at her difficult personality: "What was enjoyable? Well, I remember that she spoke French almost exclusively, and she had great medieval furniture from her second husband. At that time she was usually working on new versions of her paintings from the twenties and thirties, like *La Belle Rafaela*. People always mentioned how elegant she looked, but up close she was

unkempt—chipped nails, stained designer clothes, lipstick askew. My own theory is that she was a closet Jewish lesbian: one time I was playing a Barbra Streisand album, and she loved it, until I showed her a picture of the singer. 'She's Jewish,' she said, and threw the cover down in disgust at Streisand's large nose [similar to her own]." Piro finally quit after Tamara harassed him beyond his endurance. "I can distinctly remember the trivial incident that symbolizes how impossible it was to work for her. One afternoon I avoided filling up the car because the baroness wanted me to stay with her that evening. The next day we started out and she scolded me for the near empty tank. I replied that I had merely done as she had told me, and she screamed angrily at me. She was crazy."[66]

At least the frivolous environment she inhabited indulged such craziness. On 6 April 1977, for instance, she attended an elaborate affair, the annual theme party given by the stylish Salsburys. For this "pink" spring picnic, everyone, including Tamara, wore pink, ate pink food (borscht, strawberry ice cream, radishes, and red peppers), and admired the pink tablecloths and flowers. For the next few weeks, she socialized a great deal with Countess Orlowska and other friends, but she complained of feeling jittery. In late April, concerned about her rapid heartbeat, she returned to Houston where she was treated at Park Plaza Hospital's emergency room and released. Back in Cuernavaca by the beginning of May, she hosted Kizette's old friend from Oxford and Stanford, Prince Franzi Hohenlohe. Though outwardly pleasant, the event took its toll on Hohenlohe, who reported to George Schoenbrunn that he could hardly wait to get away; Tamara had grown unbearably demanding in her old age.[67] Within a month, on 27 May, she was admitted again to Park Plaza for tachycardia, with a heart rate of 160, shortness of breath, and a cough. Although Tamara's medical history included a rapid heart rate, she told the doctors that her major problem was nervousness from the "problems with her daughter." Discharged a week later with a diagnosis of chronic heart failure, chronic bronchitis, and arteriosclerosis, she returned to Mexico, where she immediately resumed her painting. Comments she made to friends and to Kizette suggest that she was increasingly afraid to be alone; by the end of June she was attending dinners nightly, and within another week she began hosting cocktail parties and luncheons at Tres Bambús again.

By the late summer of 1977 she felt stronger physically, her recovery encouraged by the new critical attention being lavished on her art. During this period the Council of Europe mounted a huge four-part exhibition in Berlin, *Trends of the Twenties*. The ambitious project received serious and laudatory press reviews, largely for the role it played in revamping tired art

chronologies: "[The exhibition] is the fruit of the major recasting of the history of the modern movement that has been going on for some years past," one critic reported. "[The] perspectives by which we now see the early decades of this century have lengthened and broadened, and a new generation of historians has grown up to be fascinated by the events, movements and works of those times."[68] After briefly recapping previous discussions of the Constructivism and Dada sections, the reporter enthusiastically moves on to "The New Reality," subtitled "Surrealism and the New Objectivity." Consisting of about two hundred paintings by seventy-five artists from seventeen countries, the exhibition "is, in effect, a demonstration of the figurative element in the modern tradition, from which are derived not only Surrealism as such, but also the more generalized Surrealistic sensibility, sometimes barely more than a gentle sense of the incongruous, or an ironical detachment, that has informed all figurative painting ever since. Thus, alongside the familiar work of Dalí, Ernst, and Miró, and its antecedents in Dada and the metaphysical paintings of de Chirico, Carra, Grosz, and Morandi, we see something of the hefty classicism of Picasso, the forceful Expressionism of Beckmann, the decorative domestic of Matisse, and Léger's proto-Art Deco Cubism. . . .

"Many familiar works are shown, and artists such as Magritte, Miró, and Ernst today need no special pleading; but there are also splendid surprises, and a few real discoveries. Schad, Schlicter, and Tamara de Lempicka can no longer be considered mere curiosities."[69]

For Tamara's art to be included in such company heralded a serious turn in the appraisal she would receive in Europe, though another two decades would pass before the American art world would rethink Modernism as expansively as did the Germans in 1977. At least the *Connoisseur*'s Dorothy Bosomworth included Lempicka's *Young Girl in Green*, with "its sharp contrasts of tone and haunting shadows," among "the most attractive of the works" in the mammoth exhibition.[70]

Although Tamara continued her usual activities for the first two weeks of October, she reentered Houston's Park Plaza Hospital on 15 October with chest pain. Her medical reports note evidence of an untreated heart attack that had occurred many years earlier—an "old inferior myocardial infarction"—and her history of "smoking three packs of cigarettes a day for many, many years." In addition to her shortness of breath and persistent cough, X-rays showed spinal degeneration and "osteoarthritic conditions." Her release papers added back problems, psoriasis, and hypertension to the earlier list of heart and lung ailments. Her doctors described her as cooperative and men-

tioned their pleasure at treating her. Given Tamara's depiction of her psychiatrist years earlier as St. Antoine, and her fond memories of the medical staff at the Bircher Clinic, she probably was on her best behavior with members of the medical profession.

She wanted to be discharged quickly, however, so that she would be back in Cuernavaca before the Ricci book was released. If the artist needed a cause to keep her energy high, the forthcoming book provided it. And in truth, Tamara had reason to be excited: Ricci had promised that he was publishing—first in Italy, then in France, then in the United States—a beautiful compilation of her works. Since he had granted her contractual rights to review the text before publication, her obsessive need to control the interpretation of her life seemed ensured.[71] With Ricci's exquisite volume—of course her savior would be Italian—the new chance granted unexpectedly by Alain Blondel's 1972 exhibition was to yield its ultimate profit. This was the culmination of fifty years of seeking respect as an artist: this was the book that would ensure her serious reputation.

# THE ART
### *of the*
# VOLCANO

*Sometime in November 1977, Tamara* received a phone call from either Octavio or Maria Paz, whom Franco Ricci had been visiting in Mexico City, hoping to enlist the writer in an Italian project. Her friends had seen an advance copy of the Lempicka book; worried, they gently warned Tamara that it contained correspondence between her and D'Annunzio. She was stunned and then outraged. Subtitled "with the diary of Gabriele D'Annunzio's housekeeper," the limited edition book was as concerned with Aélis Mazoyer's lewd journal recollections of the visits Tamara had made to Il Vittoriale in 1925 and 1926 as with Tamara's art.

To Ricci's credit, the book was lavishly produced, with forty well-rendered color reproductions, and a 6,000-word critical introduction by Giancarlo Marmori. Three thousand numbered copies of the first edition were printed on handmade paper. But the paintings were interspersed among Aélis's diary entries, followed by a section of the book devoted to handsome replicas of Tamara's letters and notes to D'Annunzio, printed with inks and on paper that matched the originals.

Appalled that such material had been included without her approval, the indignant artist wrote Ricci: "You agreed to give me review rights." With Kizette's help she

frantically consulted lawyers, but for once the increasingly fragile painter concluded that legal action was the wrong solution.[1] It would only create greater interest in the book, and litigation couldn't address the real issue anyway: Tamara's profound disappointment. She had believed herself on the threshold of true international fame; instead, she now feared, she would become the butt of crude jokes. She began lugging the oversize book to parties where she would denounce it, impotent retaliation at best.[2] Friends believe she was sincere in expressing her outrage, but since in the process she was publicizing the offensive material, she must have decided too that at this late stage of her life, any kind of attention was preferable to neglect. Although she began worrying obsessively that she would be remembered only for the scandal the book promoted, she was even angrier at the book's implication that she was a figure of the past, known only to a few collectors. Though content with Marmori's puzzlement over her personal history— basic biographical details were unknown—she was enraged at his claim that before the Galerie du Luxembourg's exhibition in 1972, "no one knew or had ever known who she was, this painter who had been in fashion at the time of the couturier Paquin, a woman with a mysterious, doubtless Slavic name, possibly taken from the sophisticated repertoire of Art Nouveau pseudonyms."[3] Having permitted Ricci to share Alain Blondel's well-deserved credit for "rediscovering" her, the artist now decided, irrationally, that the Galerie du Luxembourg was implicated in this current injustice. Within two years, she was passionately if airily telling interviewers, "Oh, I hate the gallery. . . . They sent me Ricci, the man who wrote the big bad book. Oh, I hate them."[4]

Her blood pressure became dangerously high again by December, the month she had expected to be basking in adoration. Instead, Tamara returned to Houston and hired as her private duty nurse the effervescent, high-spirited Connie Stutters, who had cared for her in the hospital earlier in the year. Lempicka paid her $55 a day for several hours of companionship, but the irrepressible Stutters remembers the period for its personal rewards more than for the money.

> *When I first started with her it was instant harmony and bonding between us when she found out I was into oil painting also and shared her love of the arts and theater. She asked me to bring my oils and canvas and we would paint on the screened porch on Reba Drive. She taught me the proper way to view a painting by standing a distance from it instead of on top of it and to have plenty of light when painting. She constantly criticized my paints, saying that there were no more paints worth buying because the*

*colors were not as true as when she was in her prime of oil paint-
ing. She nicknamed me her little Rembrandt because I preferred to
paint in the dark. Once she got the bright idea to paint me in the
nude. I told her "No way," and she kept trying to persuade me by
telling me I could put on her fur coat. But I didn't because I didn't
feel it would be very professional. Sometimes I could kick myself for
not letting her try to paint me with the fur coat on. [I painted a
large picture of ] Jesus while I was caring for her, [which] will
always be precious to me, since I did it under her guidance. She
had such an effect on me that I found myself trying to paint my
husband in the nude while he slept.[5]*

At the end of December, Tamara sent the nurse a thank-you note: "Connie dear, thanks for your sweet Christmas gift, and your patience and devotion during those difficult long days of my illness. Tamara Lempicka-Kuffner." On the bottom, Kizette appended, "Thank you Connie and love to you and your little family—Kizette."[6]

Tamara flew back to Cuernavaca for the Christmas holidays. The photographer Dorothy Norman, an intimate friend of Alfred Stieglitz, was visiting from New York, and through her Tamara met a very bright, ambitious young doctor, Alvin Friedman-Kien, who would become well known for his research on dermatology and molecular biology at New York University. Tamara, he recalls, "was an enchanting, eccentric figure of incredible beauty despite her advanced age. She was a commanding presence who left an indelible memory."[7] During his Christmas vacation in Cuernavaca, he offered to buy one of the copies of her paintings that Lempicka was now producing. She insisted at first that he take the painting as a gift, but when he demurred, she announced that she would donate whatever he chose to pay her to the local charity drive. According to a mutual friend, "Alvin gave her an envelope with the $500 check inside, and after he left and she opened it, she was so insulted at the, to her, small amount he had paid for her work, that she immediately phoned him and said she could not sell a painting of hers for such a sum; it would ruin her reputation!"[8]

As if to compensate for the dispiriting conclusion to the year that was supposed to have ended gloriously, the *Houston Chronicle* decided in late 1977 to conduct a long interview with Lempicka. Fine Arts Editor Anne Holmes, who had enjoyed Tamara's "outrageousness" for years, cited in the article the recent attention, "welcomed or not," that the artist was receiving. Hoping to placate Tamara, Holmes discussed the homage paid her by Larry Rivers, whose figurative art in the fifties had braved the "terror of abstraction" that Tamara too had found oppressive. During the summer of 1972 as

Rivers walked along Rue St.-Denis, he noticed a poster advertising Tamara's show. "I was overwhelmed—even the reproduction was incredible," he recollects. "I went to the exhibit at the Galerie du Luxembourg and was just bowled over. Superb sense of form and color—she was absolutely interesting the minute I saw her work." Purchasing a poster to take back home, Rivers believed Lempicka's "fantastic talent" to embody the "modern."[9] He "continued to think about her for several years, and her stuff inspired me to start a lot of new work."[10] Upon returning to New York, Rivers began a series of paintings based on Lempicka's pieces from the twenties and thirties. Most impressively, he copied her *Woman with a Mandolin* and then overpainted the reproduction with transparent rainbow stripes. He called his version of Tamara's painting *Resurrection of Tamara de Lempicka*, a title that no doubt profoundly irritated the painter, who was still recovering from the shock of Giancarlo Marmori's reference to her as an unknown. Rather than accepting the compliment of imitation, she grumbled that artists should use their own paintings, not copy from others. In her refusal to "network," as Alain Blondel complained—even when "it was the obvious thing to do"—she stayed true to her instincts, however self-defeating they were.[11]

By failing to accept Larry Rivers's professional overtures, Tamara missed an excellent opportunity to enter the contemporary art world; at this point, in the late seventies, Rivers was being rediscovered himself. Defiantly creating anachronistic figurative art in the midst of the 1950s reign of Abstraction, he had steadily seen his reputation effaced until by 1970 he too was relatively unknown. His discovery of Tamara, who he felt had been lost to Modernism because of her preoccupation with the figure, coincided with his own renascence. *Newsweek* published an appreciation of Rivers by art critic Thomas Hess, who explained the critical "resurrection" of Larry Rivers in terms useful to understanding Tamara's professional challenge as well: "A compensating, if not a saving, grace is that [the] compulsion to 'keep it new' extends to millions of professional historians, and 'new history' is most easily cobbled out of a neglected past. In other words, what's swept away with one hand as obsolete and irrelevant is gleaned, savored, and lovingly packaged with the other. Every curatorial subdivision is dedicated to the three R's—rediscovery, reassessment, revaluation."[12] The essay was accompanied by a quarter-page reproduction of Rivers's *Resurrection* of Tamara's painting.

More than two decades after he discovered Tamara, Larry Rivers recalled his one phone conversation with her. "She really sounded like an irritable old lady when I finally talked to her," he says. "It's a shame, because I'd have liked to get to know her, and to see more of her work. But she wasn't

interested, so I said fine."[13] In a perfect postscript to the celebrity stature the painting had gained, Andrew Crispo tried in the mid-1990s to sell his financial interest in the original *Woman with a Mandolin* in order to stave off bankruptcy. Tamara might well have appreciated this dramatic nexus of money and her art more than she did Rivers's homage.

But Tamara did have reason to resent contemporary accounts of her career, which tended to imply that she had painted for one glorious decade and then packed away her palette. Yet she inadvertently contributed to such myths by feeding society's new desire for symbols of the 1920s. She had, for instance, recently granted Panther Paperback Books permission to reproduce her *Autoportrait* as the cover for their reissue of Aldous Huxley's *Point Counter Point*, scheduled for publication in 1978. The publisher summarized the book as "packed with wit and brilliance," acting as "a crowded canvas filled with all sorts and conditions of men and women, for the most part interested in art, science, politics, philosophy, and love"—primarily from the Jazz Age. Lempicka's painting would become an overused, nostalgic emblem of the brief post–World War I burst of artistic energy and personal indulgence. With such an identification, the artist would again be consigned to function as far less than she was. Nor did she alter such impressions when, for the first time in decades, she granted interviews again in which she grandiosely dictated her own terms. Just as in the early forties she had claimed that her paintings were her children, she even now brushed aside the personal and the familial when discussing her art. "Both temperamental and enormously attractive by turns, she is fiercely solitary when discussing her career, determined to be sans family," one awed interviewer records. "'I am only myself, an artist and the brush.'"[14]

Such performances continued to marginalize her in the serious art world. Her adopted country failed to honor her talent; every time critics stumbled upon her art, they acted as if no one else had ever heard of her. On New Year's Day 1978 she received her first major coverage in the *New York Times* in almost five decades: the article began by asking, "How could a streamlined siren with a flair for stylish painting and a glittering multitude of admirers on two continents disappear into obscurity as rapidly as she had swept into the celebrity spotlight? That is only one of the mysteries surrounding Tamara de Lempicka, a Polish painter of a certain age (70?) who may be living somewhere in Houston or Paris or Monte Carlo." Continuing what is basically a gushing appreciation of Ricci's book (the American version published recently by Rizzoli in New York), the writer concludes with the myth perpetuated by legions of art critics: "In 1938, Lempicka, accompanied by her second husband, a Hungarian baron, set sail for America

where, for a decade, she dazzled society and gossip columnists. Then, like a nova, the lustrous Lempicka faded from sight. But the legend of the beautiful Pole lingered on, enhanced by her own glossy paintings of an era she helped to make glamorous." Accompanying the New Year's Day article were two pictures, one of *La Belle Rafaela* with the caption, "Lempicka exhibited this abundant nude at a 1927 Salon"; and the other a glamour shot of the artist, photographed by the famous d'Ora, with the caption, "Lempicka's mysterious beauty intoxicated D'Annunzio."[15]

Tamara's desire for critical reassessment did not stem, as her ambition in the twenties had in large part, from a need for money. Although she would never feel secure financially, her bank account at Houston's River Oaks Bank contained a total of $1,353,000, divided among her checking account, tax-free bonds, a trust account, Swiss francs held in a safe, and traveler's checks. She maintained an account in Paris at the Chase Manhattan Bank, where her assets totaled about $21,000. More money would have reassured her, but now most of all she wanted respect. Disastrously, to her mind, Marmori's critical introduction to the Ricci book had projected her as someone who had made a brief appearance in the Parisian art world and then disappeared. "Unknown!" she raged when discussing the book with one reporter. "Unknown to whom? To these nobodies only! I have never been unknown. I have always been painting. They have not always been looking. I do not wish to live in *souvenir*. I am continuing every day. My best painting is the one I have not yet done. Every time I *commence* I am certain that this will be the greatest, and every time I finish I am disappointed."[16]

She returned to Houston and plotted her strategy against the Italian publisher. On 17 February 1978 she mailed to her Cuernavaca friend Robert Brady a copy of her original contract with Ricci, dated 27 June 1973. "Dear Bob," the accompanying letter said, "Please note paragraph six: 'The text will be approved by me before publication of the book.'" She had written Ricci, she explained, that "I consider the text of this book an insult to my reputation as an artist, and my dignity as a person." Underlining these passages in her bold red ink—"Mark it in red if it is important!" she always said to Victoria—she concluded that she would call him after she finished a series of doctors' appointments over the next few weeks.[17] Apparently, from her request that her artist-friend "keep the two letters of information included with the book," Tamara meant for her reaction to guide that of Cuernavaca residents viewing the book.

Characteristic of the continued wave of positive press was the May 1978 article in *Viva* by Giancarlo Marmori, the author of the Ricci book's introduction. Basically a reprint of his earlier text, the essay, subtitled "Portrait of

a Forgotten Artist," began: "In July 1972, when the Galerie du Luxembourg in Paris opened a Tamara de Lempicka retrospective, no one knew or had ever known who she was." The article refers to the "woman with a mysterious, doubtless Slavic name. [Now] all that circulated were rumors about this once famous and now revived artist." Buried in the welter of truth and fiction was an occasional insight: "The ignorance of the artist's past existence and the lack of any meaningful analysis of her work furnish proof of the barbarous iconoclasm to which a great many artists who did not play the game of the School of Paris avant-garde were subjected."[18]

The Ricci debacle proved valuable in at least one way: motivated to publish her own account of her career, Tamara decided to dictate her life story to Kizette, who faithfully recorded seven pages of her mother's remembrances before the two decided the project was too large for them to handle on their own. Preferring always to deal with people she already knew, Tamara cajoled the young couple she had befriended in Houston, the French consul Reginald Warren and his wife Anne-Marie, into interviewing her in Cuernavaca, after which Reginald was to write her biography. But Warren, who stayed at Tres Bambús, was quickly exhausted from dealing with Tamara's nightmares and, even worse, from her adroit parrying each day of his most basic questions about her past. Within a few weeks he proclaimed the task impossible and returned home to Switzerland.[19]

As Tamara developed her various plans for countering Ricci's version of her life and art, she decided to protest to the publisher directly:

*Sir*
*I have just read your book entitled* Tamara de Lempicka, with the Diary of Gabriele D'Annunzio's Housekeeper, *and I must express to you my surprise and indignation. In the first place, we had an understanding, confirmed in writing, that you would submit for my approval the* text *of this volume. This has never been done.*

*In the second place, I vigorously protest against this title which links my name as an artist of established reputation with the diary of some housekeeper, which diary is nothing but a conglomeration of backstairs gossip.*

*Thirdly, at the time you asked my authorization to write a book about my Art, there was no mention of introducing this "diary" nor to use the literary efforts of some servant at the Vittoriale in order to provide a lengthier text for this book.*

*Fourthly, concerning the Introduction, there are several gross inaccuracies, and moreover I protest very strongly against the rest*

*of the text which I consider an insult to myself, as well as to the memory of a great Italian poet.*

*This letter is to let you know my feelings in this matter, as well as the indignation of people who have read your book which is an insult to my reputation as an artist and my dignity as a person.*

*I hope you can find a solution to counteract the disastrous impression which this publication has created.*

*Tamara de Lempicka*[20]

On 13 April 1978, Ricci finally responded:

*Dear Madame,*

*I have delayed answering your letter because I have only now returned from a long trip to South America, and also because I have wanted to wait till the feeling of disappointment caused by your letter would have somewhat abated.*

*I do think that the risk and considerable expense I went to in publishing such an important book in three editions, which is something every important artist of today would wish to have done about his work, is sufficient proof of the interest and regard I bear to the artist Tamara.*

*If there are any improprieties in this presentation, I think they are a misunderstanding due to the fact that I had put Mr. Marmori directly in touch with you. As to your displeasure about the documents concerning D'Annunzio, I assure you that they are historical documents from the Vittoriale and it is an Editor's duty to make such information known when publishing a work of historical research.*

*Moreover, you yourself are not compromised in this story since you are maybe the only person who resisted his advances. From all this correspondence it is very clear that a spiritual admiration was all you felt for the Poet.*

*Finally, I do think that thanks to my book, your name has experienced a new wave of popularity. For instance the* New York Sunday Times *has published an article with colored reproductions from this book.*

*I hope, but now I do not know what to hope, that you will be pleased to know that a cheaper edition of this volume will be published in larger quantity, and without the text concerning D'Annunzio. The first deluxe edition will therefore remain a curiosity, reserved only for those book lovers for whom it was originally published.*

*Again I mention my great disappointment at the lack of appreciation I was expecting.*

*Very sincerely yours,*
*F.M. Ricci*[21]

Although the correspondence between Ricci and Lempicka does not contain her response to his explanation, Tamara's notes state that on 20 May 1978 she sent him a copy of the original contract along with a request to submit the text of a proposed paperback edition to her before publication. Ten days later Ricci's secretary replied that they would like Tamara to edit Marmori's critical introduction; the publisher himself failed to understand what she found so offensive about the essay, especially since she had approved the writer beforehand. On 30 May 1978 the secretary wrote that they "have no problems changing the text by Marmori. You have the book, so please indicate the modifications and we will make the changes in new editions."[22]

By now, Ricci had tried to placate the artist by announcing that he intended to issue a cheaper, more accessible version of the expensive coffee table book; consequently Tamara worried that "soon everyone will read these lies."[23] Since Ricci had already promised to excise the journal, Tamara was concerned about the potential damage done her at the hands of Giancarlo Marmori, the "supposed critic," as she snorted, who had never seen her work until now. One month later, on 20 June, Kizette directed an assistant, Helen R. Auster, to respond to Ricci's staff: "Miss Rossi, your letter of May 30th. adressed [sic] to Baroness Kuffner de Lempicka has been received. Mme de Lempicka is at present traveling for her health and this letter cannot be forwarded to her for the time being."[24] But Kizette always knew how and where to send Tamara's mail, regardless of her mother's travels; this time either she feared being tethered to yet another of the artist's involved projects, or she preferred that Tamara stay irritated at the publisher. Letters crossed in mid-June; Ricci's complained that "I have never received a list of changes that you would like me to make." Tamara's personal notes about the dialogue express indignation: "THIS LIST WAS REQUESTED THROUGH HIS SECRETARY ON MAY 30th, exactly 2 weeks previously, which did not even allow time for a reply!"[25] On the one hand, the painter clearly did not realize the demands of publishing deadlines and the time pressures of revisions. Ricci, however, had not played fair: the contract had stated unequivocally her right to approve the manuscript before its original publication.

Nonetheless, the Ricci book indisputably brought attention to Tamara

on many fronts. In Texas, for instance, very little interest in the resident artist had existed previously; now, in the summer of 1978, Tom Garreau of the *Houston City Magazine* sent veteran reporter and former academic Joanne Harrison to interview her. Harrison produced some of the best descriptions ever written of Tamara, so good that Kizette would borrow anecdotes from the article for her own memoir eight years later.[26] "The warm Cuernavaca morning was heavy with the scent of frangipani. Birds of paradise grew in well-trained rows beside the still blue surface of the pool," the amazed reporter wrote after her first encounter with the painter.

*White lace butterflies with wingspans wide as swallows' moved nervously against a backdrop of towering black-green pines. Around a corner of the baroness's villa, near the herb garden, an old man with brown leather skin, a spotless white shirt of much-washed manta cruda, and an ancient broad-brimmed straw hat was sweeping rhythmically. He swept away the dozen or so leaves that had fallen overnight to mar the green perfection of the lawn. The gardener stopped at the sound of the baroness's footsteps on the flagstones.*

*She moved beautifully, floating by in a floor-length swirl of vivid colors, full-blown roses silkscreened on a virtually diaphanous material, her picture hat casting shadows on her face. She paused on the path beside the pool, an ethereal figure reflected in the water.*

*The gardener stood very still, holding his homemade broom of twigs. She passed by. He tipped his hat.*

*I stood on the patio of the guesthouse, in the shade of a lavender-flowering jacaranda, and watched the scene being played out: direction by George Cukor, production design by Cecil Beaton.*

*She saw me and beckoned, an imperious gesture, balletically graceful.*

*"Come, child, it is time to work." I followed her into the shad-ows of the veranda where she arranged herself on a chaise longue, as artfully unselfconscious as an odalisque by Ingres.*

*Her voice is dusky, mesmerizing, slow—a deeper version of the young Lauren Bacall's. Her accent is Mayfair overlaid with czarist Russian and with new chic French—all elegant Parisian vowels playing counterpoint to deep-throated Slavic consonants. She shades every word as if it were a bar of music, a part of something larger but at the same time perfect in itself.*

*Probably she no longer speaks any language in its pure form. Instead, her speech is now a colorful argot of her own devising, a*

*fascinating juxtaposition of vivid expressions borrowed from most of the languages of Western Europe.*[27]

Nearly twenty years later, Harrison still remembers Lempicka fondly. "I was blown away," the journalist says. "She was eighty years old, but she had every gesture down to a science. While we talked, she made sure that she was illuminated to her best advantage." No stranger to exoticism, Harrison was nonetheless "mesmerized. Tamara used a long cigarette holder to emphasize her broad hand movements as well as her perfectly polished nails. She was completely gracious to me, and in fact she took an immediate interest in my appearance, insisting that I should have worn white slacks and a blue blouse—Cuernavaca demanded it."[28] Tamara's charm and vulnerability, her Rabelaisian lewdness, the "extraordinary intelligence" noted by Dick White—qualities loved by close friends such as Manha Dombasle, Mala Rubenstein, and Jane Owen throughout the years—were more accessible now to those she might have intimidated earlier.

"We conversed in a weird mixture of English, French, and Italian," Harrison recalls. "In several European languages they use the word 'original,' meaning someone who is unique." Tamara, she decided, qualified.[29] More than most accounts, Harrison's interview captured the aura Tamara created even in old age: "After dinner the maid placed a shaded lamp beside the baroness's chaise longue. For just a moment it illuminated the upper part of her face, dramatizing her eyes—huge, strange, glowing, Pacific blue, their basilisk expression emphasized by dark lines defining the edges of her eyelids. Then she moved, and her face was hidden in the shadows. A curl of cigarette smoke snaked upward in the pool of yellow light. Her left hand reached out and with a casually elegant gesture tapped ashes into a beaten copper tray. The lamplight glittered off the giant square-cut topaz on her middle finger and the thick gold bracelet studded with hundreds of tiny rubies that complemented the vermilion lacquer on her nails. Her hands are still lovely, long and slender, belying her advanced age." But Harrison spoiled the moment by asking the painter about "the book." "*C'est un scandale!*" she raged. "How can they print such scandals, such servants' gossip, such lies?"[30]

Regardless of the spleen Lempicka spewed everywhere over the "vulgar" inclusion of the D'Annunzio materials in Ricci's publication, she directed her greatest anger at what she believed was Marmori's trivializing introduction. Deciding that the best defense left was to commission a professional art historian to write her story, she flew to Paris in October 1978, where she stayed at the Hotel Trémoille instead of her usual apartment at the Ritz. She kept exhaustive notes on her plan to control the damage Ricci's book had

done to her reputation. Her first concern was "to meet and talk to writers and editors interested in the publication of a new book on TAMARA DE LEMPICKA, text by a serious art critic or writer, reproductions of her entire artistic career (3 phases, of which about 100 were *not* recently reproduced or exhibited)." The text, she continued,

> *[would be written] by Mr. GERMAIN BAZIN, former curator in chief of the Louvre Museum (paintings), Paris, and Member of the INSTITUT DE FRANCE, Academie Des Beaux Arts. Mr. Bazin is the author of over 30 books on Art: Rubens, Memling, Rembrandt, Corot, Manet, among others. Mr. GERMAIN BAZIN is also the holder of many titles and distinctions in France, in the U.S. and in South America. A TEXT by a man of such background would certainly counterbalance the disastrous effect created by the vulgar and unprofessional TEXT which appeared recently in the Italian publication "T. DE LEMPICKA."*
>
> *In spite of the fact that the Texts of this Italian book were so bad, the colored reproductions of the paintings by LEMPICKA attracted buyers, and created a great wave of interest among art lovers, intellectual circles, and the press, both in France and U.S.A. For example: in U.S. several articles with colored reproductions, in the New York Times, in "Viva" magazine, in the LONDON TIMES, etc. and in France: "LE POINT," "SPECTACLE DU MONDE," etc. And in Paris, the great interest expressed by GON-ZAGUE ST. BRIS. Therefore a new publication seemed timely—LEMPICKA'S PAINTINGS now, symbolize to a new generation an epoch of elegance, refinement, simplicity to which they aspire once again. As she herself in the 1920s expressed in her paintings a revolt against all things ugly, common, banal, so now, a young generation has picked up those same ideals.*
>
> *P.S. While in Paris, Mme de Lempicka received in her hotel the visit of several people connected with the Museums, amongst others Mr. Germain Viatte, Curator in Chief of the Musée Pompidou (The French Government had acquired 23 of her paintings in 1976).*

Gonzague St. Bris was the young commentator of a nightly radio show in Paris. Leader of a fledgling movement, "the New Romanticism," St. Bris had aired a detailed version of the D'Annunzio story in February. Tamara, however, overlooked this transgression in favor of his position that "the new look among the young generation today" was indebted to Tamara's art of the 1920s.[31]

Tamara's choice of Bazin, a deeply respected, internationally known art

critic, and her decision to include the entire span of her career, substantiate her daughter's claim that in the seventies the painter believed she would receive her historical due.[32] Bazin agreed to her offer of 60,000 francs, average pay for such a commission; most important, he liked the woman and had admired her art for many years.[33] Germain Bazin would not finish the text in time to serve Tamara's needs, but within several weeks he had motivated her to plot the outline of the French book, to be translated into "Anglais, Espaniol, et Allemand," as she proudly recorded in her notebook. She titled her plans "Projet de Livre sur les Oeuvres de Tamara de Lempicka," and underlined the words in red. Though the plans were to be discussed *avec editeur,* Tamara arranged everything from the size of the book (31 by 24 cm) and the number of pages (120), to its complete contents: a preface by Bazin, a two-page biography of Lempicka, a list of museum holdings, a list of exhibitions, and finally, 115 reproductions of her works, with accompanying critical text.

As part of her preparation for the book, Tamara wrote an "explanation by the artist" to set straight the erroneous impressions created from the time of the Galerie du Luxembourg retrospective. Furious that all her years of serious work from 1935 to 1965 were now routinely effaced by her resurrection as an Art Deco painter, and embarrassed at the neglect she had encountered during the sixties, she contrived a story that ignored the complete lack of exhibition offers during the previous decade:

> An impression of the "forgotten" artist has purposely been created in the text of the book by Franco Maria Ricci, "Tamara de Lempicka" (published in Dec. 1977) and also by the Galerie du Luxembourg (Lempicka retrospective exhibit in 1972) in order to give more importance to their "rediscovery" of the painter LEMPICKA.
>
> Those years of so-called oblivion belong to the period between 1962, date of the Jolas [Iolas] Gallery exhibit in New York, and 1972, date of the Retrospective exhibit at the Galerie du Luxembourg in Paris.
>
> Because of divergent tendencies in Art during this ten-year period (OP, POP, etc.) this Artist refused all offers of exhibition, but continued to paint for those collectors who appreciated her work.[34]

During the October 1978 trip to Paris, Tamara discussed with SPADEM (Société de la Propriété Artistique et des Dessins et Modeles), the French artists' rights protection organization, measures to take against Ricci. For the most part, they advised her to demand that he uphold his 1973 commitment

to her prior approval in any future editions of the book; it was too late to do anything now about the version already published.[35]

While in Paris, Tamara witnessed further repercussions of the Ricci publication. A small book containing fifty color reproductions of her work was published by Chène; essentially the Ricci book without the D'Annunzio diary or letters, the text reprinted Giancarlo Marmori's preface, which paid homage to the "unjustly forgotten artist."[36] That same winter a *Herald Tribune* review of the 1977 German show, which had now moved to London, first acknowledged the "prominent names . . . Dix, Beckmann and Grosz," then enthusiastically cited the "comparative unknowns who are the real revelation": Christian Schad, Karl Hubbach, Franz Radziwill, Albert Aereboe, "and the introspective portraits of Tamara de Lempicka."[37] Disgusted at the idea that she needed to be rediscovered, she retaliated by attacking the loyal Alain Blondel: "I suppose the Galerie du Luxembourg agrees with the analysis of Mr. Ricci and they don't have any interest in helping you procure a new editor," she had written to Manha Dombasle, whose help she had enlisted on behalf of her book project. She soothed her indignation by attending an exhibit at the Galerie Abel Rambert on Rue de Seine, where her friend Jules Pascin was being similarly "revived"—though as a School of Paris painter—and touted for his use of prostitutes as models.[38]

By December 1978, Tamara had returned to Cuernavaca, where she hoped that her busy holiday social calendar would relieve her obsessive worry over the Ricci fiasco. On Christmas Eve, she and Kizette hosted a "beautiful luncheon" for the Salsburys, their houseguests from Vancouver, and a few others. Jeanclaire Salsbury also remembers in detail a lavish New Year's Eve party, which Tamara attended for at least a few hours. The next day the painter attended the first party of the new year at the Salsburys' house, where "she was in her prime!" Two to three hundred guests were invited—to be admitted only if they wore yellow, orange, or white in honor of the theme of the day, "Fiesta del Sol." "It was a very happy party," the hostess still remembers. "Streamers of orange and yellow banners everywhere— banners of the sun hung on garden walls. Decorative chefs' hats and aprons of orange cotton twill and tablecloths of orange and yellow plaid."[39] Such festivities kept Tamara's spirits high.

Her New Year's resolution for 1979 was to grant interviews in the hope of regaining control over her image. A Mexican newspaper persuaded her to talk to them for a program to be printed and televised "to an audience of forty million people in the United States and Mexico." The writer, Oscar Cevallos Figueroa, makes it clear that even at eighty years old, Lempicka

retained her vigor and her sense of indignation when others failed to respect her. "Upon arriving at the residence of the Baroness, we found an extraordinary woman elegantly dressed in a long dress, a wide hat, a beige caftan, a regal bracelet of rubies and a ring with a large diamond on her left hand. Reclining on a chaise longue she received us.

"'I'm furious. I don't want interview. I'm furious, furious!' While she was saying this the cameramen were installing their cameras. . . . 'I've been filmed in Paris, New York, et cetera, and they don't have to tell me what to do!'" Cevallos Figueroa, delicately asserting that she was "difficult of character, like all the great geniuses," is clearly relieved when "she accepts the proffered cigarette and the interview begins." Immediately asking her to name the famous people she has painted, he is told peremptorily, "I've painted kings and prostitutes. I do not paint because people are famous. . . . I paint those who inspire me and cause me to vibrate." Later requested to evaluate other prominent painters, she says of Picasso, "I knew him, but I don't like the last phase as a painter," and "I adore Chagall; he is very poetic."[40] Repeatedly in her encounters with reporters during the 1970s, Tamara emits a peculiar sweetness, a vulnerability that crosses playacting with an obvious desire to like and be liked, as if her histrionics had always been meant to entertain, not to offend. In her old age, her character came through more sympathetically.

Friends sought to energize her by celebrating the new attention she was receiving. Still in existence, for instance, albeit of little significance to contemporary artists, the Salon des Indépendants held a special retrospective of *les années folles* from February through March 1979. *Le Monde* listed the most important artists represented: Modigliani, Duchamp, Pascin, Foujita, van Dongen, Man Ray, Miró, Arp, Sonia Delaunay, and Lempicka.[41] Several people took photographs to show Tamara how her art commanded the crowd gathered in a room filled with far more famous canvases than hers.[42] But any pleasure Tamara would ordinarily have taken from her renewed acclaim was completely undercut by the sad news that Foxy had been diagnosed weeks before with lung cancer; in spite of the removal of one of his lungs, the doctors announced in late spring that he would probably die within six months.

Panicked at this dramatic reminder of her own mortality, Tamara placed even more inappropriate demands on her daughter than usual. During early November, as doctors predicted that Foxy's death was imminent, Tamara insisted that Kizette decide whether or not, when widowed, she would come live with her in Tres Bambús. "I will give you the house if you promise to come here," she told her daughter. "I don't want your house," the exhausted

Kizette retorted. Tamara was genuinely worried about her daughter's future as a widow: she didn't feel that Kizette was independent enough to take care of her own financial or emotional needs. When she was approached by a journalist about the arrangements for an upcoming interview, all the frantic artist could talk about was her anxiety: "I don't know what will happen. If he [Foxy] dies, maybe she will sell the [Houston] house and come here. Maybe she will not sell the house and I will go there. I don't know what will be."[43]

Throughout Foxy's last days of life in November 1979, Tamara made small, sad comments to her friends about her son-in-law. Though exasperated at his lack of wealth, she had always liked the cheerful geologist.[44] And she had actually bought Tres Bambús on the assumption that Kizette and Foxy would live with her once she owned the property. They could take care of Tamara while their own financial needs were being met. Now, as she told her nurse, she was terribly worried that she did not have millions of dollars to leave Kizette, who had never held down a job and was too old at sixty-three to enter the working world. In truth, she was terrified that her daughter would have to live after Foxy's death without any financial resources except her own and what Tamara could give her. Her nurse secretly told visitors, "Tamara is worried about money all the time, not for herself but for her daughter. Because she says she will die soon. And she is worried that . . . she has nothing to leave for her daughter. And . . . she is very upset about this house. . . . She asked her daughter should she buy the house or just keep on renting the house. And the daughter said go ahead and buy it . . . and now her daughter doesn't want it. . . . She is mad with her daughter."[45]

Imperious in her manner even when acting out of charitable impulses, Tamara was trying to ensure Kizette's welfare as much as her own. She failed to understand, for instance—or she wanted to deny—that Kizette couldn't leave her dying husband for "just three days" to fly to Cuernavaca to sign a new mortgage ceding Tres Bambús to her. Tamara's nurse overheard her employer "screaming and crying" every time mother and daughter talked during this period—usually at least once a day. Concerned that Kizette had "this big house in Houston" and would be "all alone if her husband died," Tamara demanded that her daughter sell the River Oaks home and prepare to move to Cuernavaca after Foxy's death.[46] Not interested in discussing mortgages as she attended her husband's deathbed, Kizette raged at her mother: "I don't want Tres Bambús. . . . [I have a house]. . . . I just want money."[47]

During Harold Foxhall's battle with lung cancer, Tamara allowed an enthusiastic art student, Eiko Ishioka, who planned to write the painter's

biography, and her translator, Mitsuko Watanabe, to live with and interview her at Tres Bambús for several days in November. Disinclined at first to indulge them until she had Kizette at her side, she eventually decided their promise to produce a book dedicated to her greatest art was too important to ignore. During the five days that she talked to her visitors, she fumed at the damage the Ricci book had done, especially the "critical" introduction by the art amateur Giancarlo Marmori: "He never said that the painting is beautiful. He said that the faces are stupid. So that's why I don't [want you to] write about [the Ricci] book. Skip that, it's nothing to do with my career."[48] Quickly after this outburst, she worried inexplicably that she had already said too much, that although she herself was too old to be hurt in the future, she had left her daughter vulnerable to lawsuits because Ricci was so clever. "[Ricci's] a nasty man. Maybe he wrote a bad book in order to have scandals. Because he can sue me for this book. And then my daughter will have scandals. I will be dead, but she will have the scandals. I would not like to speak about Mr. Ricci. That Mr. Ricci did a book which is not in my favor and that is all. . . . So I leave this story . . . leave it out. Speak about my art."[49]

Throughout Foxy's illness, Tamara's fear of death grew: "She was more afraid of dying than anyone I've seen," Victor says. "I do not know why." When asked about Tamara's spirituality, he replied, "I don't know, but she was very Catholic with me; she attended mass at Cuernavaca cathedral on Sundays with me often. I think she was a woman of great faith and was very religious, though most people did not see that through her mask. She had great compassion, and people never realized that, either." The one approach to spirituality she could not sanction still was mysticism. "She refused to listen to me talk to her of the famous guru Gabino Pineda, a great mystic who had studied homeopathy and could heal with his hands. Even the Shah of Iran, who lived across from Tamara during 1979, consulted him when I invited the guru to Cuernavaca, but Tamara would not come to his meetings. She said she absolutely did not believe in any of such hocus-pocus." Occasionally she'd break down and cry softly in front of Victor; and she plaintively told her interviewers during this period, "I don't know why God is punishing me now. What have I done wrong? I tried to do the right things."[50]

Her friend Muriel Wolgin had always felt "funny" about Tamara's behavior in the little private Catholic chapel she had maintained in her Cuernavaca house. "Tamara would enact some supposedly Catholic rituals, yet something about the whole thing seemed off to me," she claims. "I was confused about her religion all the time."[51] The artist admitted to dark fears, but she preferred to depend upon herself, not God, for sustenance. Often the

strength she displayed as a matter of principle misled those around her. Most people who knew her in the 1970s, for instance, have remarked on Tamara's relentless, humiliating public treatment of her adult daughter. Though agreeing that Tamara talked abusively to Kizette, Contreras complicates their relationship: "When Kizette was due over, Tamara would beg me to stay until she left. And when Kizette got angry, she would become violent, and throw things around the room, with the weak and shriveled mother hunched over in her chair." He continues, "I believe Tamara was afraid of Kizette, even of her physical strength. She was much larger and stronger than her mother, and she has always been a very smart woman, capable of just as much manipulation as Tamara. I think that this is why Tamara made money so important between them—it was her only way of controlling her daughter."[52]

Tamara's aura of strength prevented friends such as George Schoenbrunn from appreciating her frantic efforts to buy love, sex, and companionship. Having neatly compartmentalized her psychological needs at least since her divorce from Tadeusz, she now lacked the emotional means to create the intimacy she increasingly sought. Kizette bore the brunt of her mother's loneliness, but Tamara did not trust her daughter's devotion. She herself had not been the kind of mother to love unconditionally, and now she believed she had to bully and pay her daughter to ensure her constancy.

But while Foxy lay dying, Kizette could not tend to her mother in person, and Tamara became depressed. Cathy Huerta, her self-important nurse, was eager to play a part in the interviews of the Japanese visitors and explained to them the signs of her employer's decline: "Before, she fixes herself real beautiful. For her fingernails, her makeup, her hair, she goes to the beauty parlor every other day. . . . Now she doesn't care. . . . That's why she's losing lots of her friends. Because people invite her to go to their place for lunch or for dinner or for tea, and she will not go."[53] Tamara confessed to her guests from Tokyo, "I felt so bad, to the last minutes, I did not know if I would be capable enough to talk to you. . . . You know that's the husband of my daughter who is dying. . . . And when my daughter speaks to me, she cries on the phone and I cry."[54]

Asserting that Tamara did not understand health insurance, the nurse confided that Kizette was able to bilk her mother out of money by using Foxy's illness as her excuse. The artist did not realize that Foxy had health insurance through his job, and that the hospital bills were therefore already covered. Huerta explained to the visitors that Tamara had had to pay $27,000 in hospital bills for one of her grandchildren, who did not have insurance; as a result of that experience, she assumed that now Kizette's finances were being ravaged.[55]

Worrying about money—that people wanted it from her, or that they misjudged her ability to provide endless amounts of it—preoccupied the artist. When Eiko Ishioka innocently inquired about the period when people called her "La Femme D'ore" Tamara, alarmed, quickly responded, "La quoi?" The exchange was repeated—"La Femme D'ore," "La quoi?" again— until the exasperated translator had recited the phrase three or four times, adding, "Your nickname was 'a lady of Gold.'" Lempicka tensely denied ever hearing the phrase, and demanded that the interviewers explain what they meant by this alarming suggestion which, to her, referred to her status as a wealthy artist. "The publisher in Tokyo [says that] in society, among society people, they called you 'La Femme dorée.'" The painter replied, "What, gold? . . . The Golden Woman? Why gold?" The women tried to soothe her, but they failed to clarify that the word "gold" was meant as a compliment on Tamara's appearance, not a comment on her financial worth. Later, Cathy explained to them privately that Tamara wanted people to think that she was poor.[56]

In spite of subtle and adroit questioning—and over forty hours of conversation—the Japanese women found themselves losing patience with Tamara's unwillingness to answer basic questions about her life. "But how will you write a whole book?" the painter kept asking, puzzled. "You'll have to write from your imagination, because there is nothing much to say except the stories about my paintings." Repeatedly the interviewers gently encouraged their evasive subject: "Just tell us about your life. People will find your life very interesting." "But I don't have much to say," Lempicka inevitably responded. To such questions as "Where were you born?" the artist replied, "I don't remember." Incredulous, the interviewers persisted day after day, but their clever host eluded their grasp, repeatedly lamenting, "How can you write a biography? There isn't enough to say." Rephrased attempts to get her to describe her years in St. Petersburg produced nothing, as she steadfastly claimed—in 1979—that the subject was too dangerous to discuss: "The czar was killed, all the family killed. And I don't want to speak politics. Not a word, not a word. That's why I don't want to speak about that."[57] Several minutes later, when discussing how in the 1920s she had met several escaped Russian aristocrats in a restaurant in Nice, she frantically recollected herself: "Don't speak about that. Remember the Communists are still there. I'm speaking to you but don't put that on the papers."[58] More interested in whether the women believed Japan would turn Communist or return to a (safer) imperial rule, Tamara ultimately defeated her determined interviewers. They finally departed for Tokyo, where they published a high-quality portfolio of 110 works, with an intelligent foreword based on their interview.

Limited by the information available at the time and concerned primarily with her Art Deco period, Ishioka's introduction unavoidably repeated false information: "Born in Warsaw, Poland, as a daughter of a wealthy family," Tamara was said to have painted a total of 200 oils, instead of her real portfolio of 500.[59]

Back in Houston, Kizette was exhausted and overwhelmed as she tended to Foxy in the last weeks of his life, and she had little patience with her mother's demands. The pampered wife and mother who had spent her life sustained by Foxy's indulgence and Tamara's ferocious, controlling love was now expected to become an adult overnight. She performed well, but for Tamara, frightened at the nearness of death, she wasn't devoted enough. The artist was facing her own worsening health, including a breathlessness that demanded the occasional use of oxygen. Friends from Cuernavaca remember her changing her will at least seven times in 1979, often in the middle of the night. Panicked from some dream, she would wake up and call her lawyer, Louis Reynes, whose proximity to royalty (he was married to Princess Beatrice) must have reassured Tamara. The changes she wanted him to effect inevitably pertained to Kizette's inheritance; if Tamara thought Kizette was being loyal to her, she left most of the estate to her daughter; if not, she cut her daughter out entirely.

Harold Foxhall died on 13 November 1979. In Tamara's green leather address book, she listed on the last page, under the heading "Died," three names and dates: "My husband—Baron Kuffner, died November 3, 1961"; "My sister, Ada Montaut, died October 9, 1969"; and "My son-in-law—Bobsi, died November 13, 1979"—next to which is written "seventeen years ago." This probably refers to the association Tamara made between the November death of Kuffner (actually eighteen years ago) and that of her daughter's husband. All three entries were underlined in red, with an x next to the word "died." On the morning of Foxy's death, Tamara "saw" her son-in-law on her balcony, she told Victor, even before Kizette phoned her of the event.

Assaulted by the infirmities of age, Tamara despised her increasing inability to direct her life, a loss of control which she translated into midnight demands that her will be changed. It was, in fact, her will that she most desperately wanted to assert again. Instead, she was dependent upon the kindness of anyone who would care for her. Unable to trust in anyone's love, she promised those close to her that she would leave them part of her estate—on the condition that they remain at her side until the end. Only Victor Contreras escaped her endless manipulations: Tamara related to him as an artist and soul mate; like her, he was a free spirit. Indeed, she remanded

her soul and body to him. Contreras vividly remembers a conversation in late 1979 when Tamara said, "Victor, I want you to promise me something." He replied, "Yes, Tamara, anything. What is it?" "When I die, will you spread my ashes on the top of El Popo [Mount Popocatépetl, the 17,887-foot volcano halfway between Cuernvaca and Mexico City]?" After arguing over who would die first, Victor promised Tamara, "Yes, I will do exactly as you've asked."[60]

Partly to spite her ungrateful daughter, Tamara had arranged for Victor Contreras to buy Tres Bambús for $100,000, most of which he borrowed from a bank. The deed of exchange was granted on 13 November 1979, the day Foxy died; it stipulates that Tamara be allowed "to live in the house until her death."[61] Victor had to come up immediately with a total of $66,000 to pay off the remaining mortgage on Tres Bambús; Tamara had already paid the rest, and she gave him her portion as a gift. She was to pay $1,500 a month rental, which covered the gardener, cook, household help, and electricity.[62] Some months later Kizette became incensed that Tres Bambús was taken from her, even though her mother had offered it to her before turning it over to Victor. That the offer had come in the midst of a traumatic time for Kizette seemed not to have bothered Tamara. In her mind, the urgency of her own needs—to ensure someone's presence at her side if she became disabled—deserved to come first with her only child. When Kizette denied Tamara's ostensibly generous offer during Foxy's last month, the artist had felt rejected, convinced that her daughter's loyalty was unreliable.

On 21 November, one week after Foxy's death and the transfer of the deed, Juan Dubernard Smith notarized the following statement for Tamara: "I cede the rights to the only heir of my works, Maestro Victor Manuel Contreras: it is my desire [that he] share with Kizette 50% of the total number of works or monetary benefits obtained from their sale."[63] Tamara asked Victor to select thirty pieces from the collection she had stored in Houston after closing her studio in Paris, and to donate those works in her name to good museums in the United States.

Six weeks later, in January 1980, Tamara felt well enough to attend the Salsburys' now annual Fiesta del Sol at Barbara Hutton's former home. Watching Jeanclaire and Allen expertly organizing games, conversations, and food for hundreds of guests reminded Tamara of their reputation for efficiency, and she asked them if they would be available in the near future to witness her revising her will. Happy to do so, they were nonetheless startled at the number and rapidity of the changes she made between January and March. "It was the calling us up at midnight when a new notion took hold of her that was so difficult," Jeanclaire sighs. "We all showed up faithfully at

Tres Bambús whenever she called, including her lawyer, Louis Reynes, regardless of having just been there."[64]

Tamara's social life was confined during these months to seeing only a few people at a time, usually for cocktails and in her own home. Often Victor and several other friends, including Canta Maya, Robert Brady, and occasionally Oscar D'Amico, would go to her house for lunch or drinks and end up helping her shuffle to her bedroom, where she kept her oxygen tank. D'Amico was the flamboyant founder of a commune of southwestern American artists dedicated to his new version of Constructivism; before his arrival in Cuernavaca, he had known of Tamara only through the Ricci book. He was thrilled to become acquainted with such a celebrity and recalls their friendship fondly. "Even though she was so old and usually lacked energy from all the smoking, she loved getting the driver to bring her to my studio to learn about my work—and even though she was such a neat painter (she used her bedroom for her studio then), and I was so messy."[65] D'Amico, who now lives in Arizona, continues, "She called me almost every day to come eat dinner with her, and many times I spent the night at Tres Bambús, where I slept in a bed covered in nets to protect me from mosquitoes. She showed romantic interest in me. One night I was sleeping and I awoke and saw her watching me." Tamara was suffering consistently from nightmares by now, and she was obsessively worried about dying, so her nocturnal visits were most likely not sexual advances. But D'Amico persists: "Once she said to me,

'Tell me how much money you want,' with the idea that I'd have sex with her! She was a lovely lady, very mysterious. She wanted to marry me."[66]

D'Amico invited a visiting friend from Philadelphia, photographer Leah Erickson, to accompany him to lunch with Tamara. Erickson was amazed by the "enormously impressive woman, so interesting that I couldn't stop staring at her. The way she moved her hands, the charm she exuded, even then,

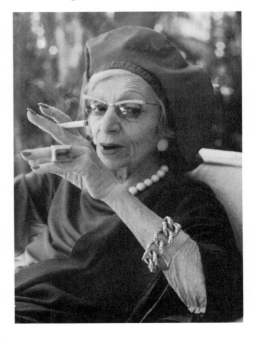

*Tamara wearing D'Annunzio's topaz, 1979.*

when she clearly was not in perfect health. I asked to take her photograph, and she demurred, saying she looked too old, too bad. After practically begging her, I got her to agree, and I took a series of shots that show her marvelous purple caftan and floppy beret, and that topaz she always wore, that D'Annunzio had given her."[67]

In part because the frail painter seemed like an easy target for greedy predators, stories circulated, inevitably, that Victor Contreras had cheated Kizette out of Tres Bambús, although those on both sides of the debate basically agree on the legality of the sale. Several of Tamara and Kizette's American friends now worried that the daughter would be cut out of her mother's will totally. Their fears materialized in late February when Tamara, in a pique, revised her will yet again and declared Contreras sole inheritor to her entire estate. Contreras himself remembers begging Tamara to remember her duty; her only child should be her heir, not a friend. "Victor," she had replied, "they say that blood is what matters, but I don't know."[68]

Tamara's close relationship with Victor prompted jealousy in Kizette. One day in early 1980 she walked into the room to find Victor's head snuggled against Tamara's shoulder. "Why don't you treat me like that?" the sixty-four-year-old woman shouted. Embarrassed, Victor tried to skulk away unnoticed, but Tamara, appearing frightened, begged him to stay. Both mother and daughter were depressed and in need of emotional support; with no energy to expend on each other's suffering, they vented their anger and anxiety on each other instead.[69]

Victor continued trying to help both women, and they both turned to him, at times competitively. Tamara often asked him to stay overnight at Tres Bambús. Obliging her at least once a week, Contreras was inevitably moved by the sight of his elderly friend standing at her easel after he thought she had gone to bed.

The writer Joanne Harrison had been similarly impressed by the sight, and in her magazine article on Tamara she transformed the scene into a poetic narrative:

> *Random handfuls of stars are scattered on the indigo Mexican sky. Black cloud shapes at the edges meet the mass of bare volcanic mountains to the north.*
>
> *The veranda is in darkness. The lighted pool glimmers watery blue, a giant square-cut aquamarine. Tiny paper lanterns here and there glow yellow in the pine trees at the border of the garden. A breath of wind ruffles the bamboo, then twists through the lush night-blooming jasmine.*

*Around the far corner of the house, a single jarring light spills out from a sliding glass door ten feet high.*

*She moves, adjusting the canvas slightly on her easel until the light strikes the painting from above and slightly to one side.*

*She pauses. In her right hand is a slender, long-handled sable brush; her left is held near her side, bracelet and topaz glittering, wisp of smoke curling from the omnipresent cigarette.*

*She applies a touch of paint and then stands back, brush still poised, holding the pose: a portrait of the artist as her own creation —an elegant figure perfectly framed in the lighted doorway set against the backdrop of a soft, black night.*[70]

Achieving this elegance required great effort by now. On 4 March 1980 several of those regularly involved in the ongoing drama of her will persuaded Tamara to distribute her wealth to others in addition to Victor Contreras: in a straightforward document Tamara left $50,000 to her nurse, Cathy Huerta; $100,000 to the Little Brothers orphanage (a local charity made fashionable by Helen Hayes, who produced a film about its rector); and the remainder of her estate to her daughter, "provided she stays with me and takes care of me until my death"—the same stipulation she added to her nurse's bequest.[71] This version did not mention Victor Contreras, apparently because she had already taken care of him. He had Tres Bambús—and the notarized paper she had given him promising him half of her art collection, now housed in Houston.

On 15 March Tamara had several friends over for dinner, among them Scott Salsbury, the son of her Cuernavaca friends. In town for a solo show at a new gallery in the Borda Gardens, the young painter was happy at the seri-

*Victor Contreras and Tamara, 1979.*

ous attention Tamara bestowed upon him. Always eager to encourage begin-
ning artists, she urged him to "get his work out there, in front of the public."
Salsbury was deeply impressed by her "uniqueness," her shrewd intelligence,
her engagement with the company in spite of her obvious discomfort. Upon
going home that evening, he painted a watercolor of Tamara, her huge floppy
hat falling over one eye, and signed it with "See ya, Tamara," making the pun
on her name (she hated the broad American pronunciation).

Victor and Kizette both helped the painter prepare for bed. When she
needed assistance walking, as she did tonight, she held on to the shoulders
of the person ahead of her and shuffled slowly behind. Once she was settled
into the twin bed in the room she shared with Kizette, she adjusted her oxy-
gen device. Victor kissed her good night and left. He was barely inside his
house when his phone rang, and he answered quickly, to avoid waking his
mother and stepfather. "It is over, Victor," a weary Kizette told him in a flat
tone. "She is dead."[72] He got in his car and drove back to see his friend yet
again upon her unpredictable, peremptory, and this time final summons.

# POMPEII REVISITED

*The beginning doesn't matter, as long as there's a good end.*
—TAMARA DE LEMPICKA

*Officially, Tamara de Lempicka died a* natural death some time in the early morning of 16 March 1980. But perhaps it is inevitable, given the mystery she so successfully cultivated throughout her life, that even her death is hard to interpret with confidence. In any case, the major participants in the artist's last days have voiced their confusion about the oxygen mask found dangling at Tamara's bedside. They all claim that when they said good night to Tamara on 15 March, the painter had already placed the mask on her face. And there was no hint beforehand that she was in any particular danger. To the dinner guests she had entertained that evening, she had seemed rather energetic. Why would she suddenly die now? Did someone—maybe Cathy Huerta, the nurse who sometimes seemed to intimidate her employer—hasten the inevitable by deliberately knocking off the mask?[1]

Such speculation might mean more if Tamara had not already been mortally ill with emphysema and arteriosclerosis, or if the suspicions occurred among others than the two people most invested emotionally in Tamara at the end of her life.

When Victor arrived back at Tres Bambús at 2:00 A.M., Kizette begged him to take over all the funeral arrangements for her mother. Among his first actions was to reprimand Huerta, who was chatting on the phone with her husband about their inheritance (Tamara had informed her earlier of the bequest) while her employer lay dead in the next room. Victor's parents soon arrived at the house; Victor led them, Kizette, and the servants in saying the rosary. Contreras also arranged for a rosary to be said at the cathedral on each of the following nine days, when he, a few friends, and the servants would walk together from Tres Bambús to the church.

In accordance with Tamara's wishes, her body was taken to a funeral home in Mexico City for cremation. Mexican law required that someone watch the body enter the crematorium and that the same person collect the ashes from the other side. Contreras accepted the responsibility, but it was one of the most agonizing things he had ever done. "I knew nothing about cremation. It was horrible, unbelievable. I had to watch Tamara enter the flames on this kind of trolley, and the heat makes you sit up, as if you're alive. It is hideous, it makes you get sick to your stomach. And then they give you the sack with the ashes—and you see the oven. I couldn't believe it—the little bag was lavender, her favorite color!"

On 20 March a requiem mass was offered at Cuernavaca's Catholic church, where forty or fifty people gathered, among them Dick White, Katie Hatch (an American journalist), the Salsburys, and Canta Maya (Elizabeth Gimbel). The small number of mourners angered Victor: "So many people made excuses, mostly 'I'd rather remember her like she was.' They just liked Tamara when they could have cocktails together and gossip." The American artist Robert Brady delivered the eulogy. "I could not do it," Contreras explains, "I was too upset to stand up and give a speech."

Brady spoke eloquently of his friend:

> We are all here today to say our last farewells to our dear and good friend, Tamara. We must not be sad—as Tamara would not want this sort of sentiment. She would, I think, prefer us to remember her as the remarkable personality she was, and above all, as the great artist she is.
>
> As a fellow artist, I shall always be grateful to her for sharing with me much of her vast experience in matters of art, and her constant and practical encouragement during the years I had the privilege of knowing her.
>
> She has left the world a body of incredible work, paintings that shall continue to be respected and admired as major contributions to the art history of the twenties and thirties, and particularly to

the School of Paris. Her stylish post-Cubist paintings are as unique
as the stylish woman who created them.

We are all so fortunate to have known and loved Tamara de
Lempicka, both as a dear friend and as an important artist of the
twentieth century. The most pertinent thing I can think of about
Tamara—and something I often told her—was that the good Lord
allowed her to live long enough to see in her own lifetime the
incredible renaissance of interest in her art. This does not often
happen to an artist—and we should all be grateful that Tamara
was one of the special few.

We shall all miss her deeply. But we thank God that she has
left the world with such a great aesthetic legacy—one that will last
much longer than the sturdiest of marble monuments.

May God bless her, and . . . au revoir, Chérie.

A week later, on 27 March, a mass, organized by Victor Contreras, was
said at the Cathedral of Cuernavaca, where Contreras sang "Ave Maria" as
his farewell to Tamara. Immediately after the service, around 11:00 A.M.,
Contreras carried the sack of ashes to the helicopter awaiting him and
Kizette. He believed strongly in honoring the wishes of the dead, and so he
felt obliged to fulfill his friend's request to spread her ashes at the summit
of Mount Popocatépetl, even though the rough winds at the top posed dan-
ger to any aerial approach. Kizette had tried to talk him out of his plan:
"Surely she was just kidding when she asked you to do that, Victor!" Still,
she admitted that Tamara had on many sleepless nights spoken of her desire
to be part of the grandeur that Mount Popo lent to Cuernavaca, as its snow-
capped peak towered over the tropical landscape. "There was an iron grid on
our bedroom balcony," she recalls. "Mother would look at the light shining
through the crosses that the steel grillwork created, and say that they traced
a path all the way up to Mount Popo, which we could see out of our win-
dow. She said she'd like to be buried up there, but I thought she was just
talking."[2]

Angry that he had been left to make all the funeral arrangements, Vic-
tor Contreras insisted that Kizette—objecting all the way—accompany him
in the helicopter to disperse Tamara's ashes. Informed that no one was will-
ing to fly to the crater, he had finally arranged through a friend to hire a pilot
whose helicopter would depart from and return to the Cuernavaca Racquet
Club, incidentally one of Tamara's favorite local sites. The pilot initially
wanted a copilot to accompany them, but when weight restrictions forced a
choice between Kizette and the copilot, Victor demanded that Tamara's
daughter go aboard.

The winds proved treacherous, and the pilot kept begging them to abort the mission. Unable to maneuver above the crater, he insisted that they compromise on a nearby ledge instead. Victor carefully removed the bag of ashes from the lavender container and, leaning forward, silently emptied the contents onto El Popo. At first the ashes started to float away, but suddenly a smattering swirled back into his face. Looking down, he saw that a piece of Tamara's skull remained in the container. With the pilot shouting that they could no longer risk the dangerous winds, the helicopter descended, some of Lempicka's ashes now part of the volcano, some, as if shaken from an incense burner, clinging to Victor Contreras.

When she died, very few facts were known about Tamara. The *Guardian* of London, which titled its 12 October coverage of her death "The Strange Life and Work of Tamara de Lempicka," probably conveyed the most information:

> *She was breathtakingly beautiful, the embodiment of Slavic charm. The elderly Gabriele D'Annunzio himself seems to have pursued her—without success. She was born in 1893—or 1898, 1902, or 1906—probably in Warsaw. She frequented the high society of Paris, New York, and Hollywood. During the 1930s, she was the talk of the gossip columnists because of the parties she threw in her Rue Méchain* hôtel particulier, *designed by the architect Robert Mallet-Stevens and decorated by her sister Adrienne Gorska; at the Ritz in the Place Vendôme; in luxury-hotel suites at Monte Carlo; at her "cottage" in Beverly Hills. And she painted. We don't know much more about her. . . . Tamara de Lempicka turned out a number of astonishing portraits, mostly in the decade 1925– 1935, and there are undoubtedly works still to be unearthed from private collections. . . . De Lempicka painted society portraits, if you like—but they are more than that, something that really hasn't yet been analyzed completely.*

The *Houston Chronicle* on 19 March led off its obituary by referring to Tamara as "a renowned artist whose paintings are in many of the world's great art museums." Only late in the article were mentioned the vintage Lempicka fabrications, which might have pleased the painter almost as much as the paper's respectful opening: "[She moved with Baron Kuffner] to Hungary, where she lived in his 75-room castle until the outbreak of World War II. 'We managed to catch the last boat to America,' Miss de Lempicka said." On 20 March the *New York Times* published a six-inch, double-column obituary, which began "Tamara de Lempicka, a fashionable painter

of European notables in the 1920s and 1930s," setting the tone for the rest of the piece. The "facts about her life are somewhat mysterious," though she "was a native of Warsaw, originally named Gorska by one report." The *Herald Tribune* on the same day basically reprinted the *Times* account, though it added that she "was born either in 1907 or more likely in 1898." *Time* magazine printed a death notice on 31 March: "Died. Tamara de Lempicka, eightyish, stylishly eccentric Polish-born painter whose glossy Art Deco portraits of European socialites ('languid, aristocratic, very decadent,' according to one authority) made her a millionaire in the 1920s and '30s, when her work was the rage of Paris; in Cuernavaca, Mexico." The other death notices printed in *Time*'s 31 March "Milestones" included best-selling psychoanalyst Erich Fromm and Marcel Boussac, the "second-generation French tailor who built a small textile business into a sprawling empire that at one point included . . . the firm of Christian Dior," company that would have pleased Tamara. On 3 April, Mexico City's paper, *The News*, lamented that "not even Bob Brady let us know. We had to read in *Time* that the extra chic famous eccentric painter Tamara Lempica [*sic*], 82, once the toast of art circles of la belle France, died in Cuernavaca one day last week [*sic*]."

When Eiko Ishioka, Tamara's Japanese interviewer, heard of the painter's death, she "felt a heavy lump of regret pressing my heart." Spending five days with the ailing but enthusiastic artist had, to her surprise, inspired in her a real affection for the difficult artist. "I had been driven on a very personal emotional level by a desire to make her happy, a desire aroused deeply by my stay with Tamara. I had long lost the will to make a book as a purely objective critic who sits anonymously in the audience. . . . I felt immeasurably saddened when I thought that Tamara no longer lived," Eiko wrote.

⌇

The artist's fame resurged in France the year after her death. Claude Picasso, son of Pablo and Françoise Gilot, told Eiko Ishioka that "in Paris now Tamara is talked of everywhere." Suddenly, he said, many people were trying to buy her paintings, but in spite of offering large sums of money, they were unable to persuade the owners to sell the works. "Tamara was still a mystery in Paris, where various sorts of rumors about her were being circulated," Picasso explained. Informed inaccurately that Larry Rivers was painting another Lempicka project, Eiko visited the artist's Southampton, New York, studio, where Rivers stanched the rumor. "I stopped making the painting since Tamara, although we never met, called me one day to ask me to [cease using] her portrait as the motif."[3]

Meanwhile, Canadian director Richard Rose had mounted a play based on the D'Annunzio episode presented in the Ricci book. The hit of the 1981 Toronto Theatre Festival, the interactive drama allowed audience members to feel they were participating in a piece of radical theater. After an eight-month run in an old Toronto mansion, the show was purchased by Canadian entertainment entrepreneur Moses Zeiner to take to Hollywood.

In May 1984 the play opened in Los Angeles. The evening started with cocktails in order to give the audience a chance to study their instructions: They had to decide which scene to follow among simultaneously occurring vignettes, all ostensibly revolving around Tamara's encounter with Gabriele D'Annunzio in 1926. At intermission, Ma Maison catered a lavish buffet, and after the show, guests were invited to sit and chat over a glass of champagne. That Lempicka would have found repugnant this reduction of her art to a sexual intrigue apparently escaped everyone's notice, though true to her belief in litigation, Kizette was bent upon suing Moses Zeiner. Victor Contreras convinced her that the play was a good thing for the estate, since it at least brought attention to Tamara's early years. In return, Zeiner treated Contreras handsomely (as he did Kizette), sending him two tickets for the Los Angeles production, and putting Victor and his mother up at his "beautiful Hollywood home."[4]

Sleek, vivid, and well acted, the play *Tamara* became the vehicle by which Tamara's name was resurrected in the 1980s. Undeniably, the play gave her the only name recognition she has ever had in America. *Vanity Fair* did a feature on it a year after its premiere in California, calling it "a voyeuristic, audacious, ridiculous, intriguing theatrical event that has crashed through avant-garde barriers and emerged the cultural darling of the West Coast. . . . When Anjelica Huston took over the title role, Jack Nicholson, Lauren Hutton, Steve Martin, Arnold Schwarzenegger, Lorne Michaels, and a slew of other Nike-shod celebrities showed up for her first night in this den of decadence."[5] On 22 July 1985, *People* magazine published a feature article, complete with pictures of the set and the famous audience members inevitably drawn to the event. "The people in front of us were Bette Midler and Charlene Tilton and Molly Ringwald and Doug Barr," the writer confided.[6]

Lynn Wexler, whose husband, Barry, was the play's associate producer, remembers how its author, John Krusank, originally developed the unusual structure. "He was working in a bookstore at the time, where he came across the Ricci book. He wrote a conventional proscenium stage play based on the D'Annunzio letters and diary. Necessary Angel, a fledgling production company, mounted it, with the actors using someone's large house for rehearsal space. It was too distracting for them all to be in one room, and they started

farming out scenes to different places in the house. Thus was born an 'architecturally dimensional theatrical piece'!"[7]

The play opened in New York in 1987 and ran for three years in spite of its exorbitant ticket prices. "At the time, the highest ticket in New York was for the prestigious import *Nicholas Nickleby*, with $100 the top seat. That extravaganza only ran for six weeks, because it was just too expensive," Wexler recalls. "But our Manhattan tickets for *Tamara* ranged from $85 for matinees to $135 for Saturday evenings." Il Vittoriale, D'Annunzio's estate on Lake Garda, was re-created in the Park Avenue armory, an enormous facility and historical landmark. "Only 199 guests" were admitted, where they were to "play voyeur and co-conspirator with the cast who conduct dangerous liaisons in and out of the palazzo's many rooms."[8] Lacking a traditional script, the play was correctly billed as "a walk-through soap opera, a voyeur's dream come true." At the beginning, the audience assembled to watch a scene that set up the seduction plot and introduced all the players. The viewers voted on which actor should lead the plot that night, and after the count, the audience then followed the winner through four different rooms, where various scenes vaguely relating to Tamara were taking place. In each room, the lead actor for the night entered into the scene already under way and then moved to the one next door. At the end of the evening, the players all gathered on one stage and presented their conclusion. The play rewarded repeat visits, since the experience could be different each night, depending on which actor was picked as the leader.

In keeping with its focus on decadence, the play provided an open bar ("all you can drink, *on us*"), including a special creation, the Tamara Cocktail. Gianfranco Ferre did the costumes, possibly the only part of the evening that would have won Lempicka's approval. *Newsweek*, whose art critic would term Lempicka's paintings "soft porn" seven years later, intoned solemnly that "no play takes an audience closer to the border between reality and representation." A representative from the *Los Angeles Times*, on the other hand, wrote that it was "great high-trash fun, like an Italian *Dallas* . . . just as outrageous as when it opened [in Los Angeles]."[9] Mel Gussow wrote an appreciative review of the play in the 3 December *New York Times*. Admitting that the "entertaining party game and murder mystery theme park" was barely about Tamara or D'Annunzio, he lauded the stylish and well-paced production. On opening night at the Park Avenue armory, Kizette wore the ring that D'Annunzio had given to Tamara in 1929, a sight that caused a *Washington Times* reporter to gasp in a 17 December article at "that enormous, knuckle-size topaz ring set in gold."

Encouraged by the press attention Tamara received after her death,

Kizette offered in 1986 to donate to the Metropolitan Museum of Art the *Lady in Blue*, and the curators of twentieth-century paintings enthusiastically accepted her gift. On 19 October 1986, Kizette wrote Lowry Sims, an associate curator, that "this was Tamara's greatest wish, to belong in a museum in the city she loved so much and had lived in more than twenty years." Also aware of Tamara's growing fame, Franco Maria Ricci in 1986 published an issue of his glossy magazine *FMR* devoted to her life and work.

This time, however, Ricci was preempted by Abbeville Press, which began publicizing Kizette's account of her mother, *Passion by Design*, to be released within the next six months. She had originally intended it to be ghostwritten by her old friend Wade Barnes, but ended up instead telling her story to author Charles Phillips. The slick and breezy book recounted Tamara's life in a collection of broad, juicy sound bites, but Kizette was pleased that she had avoided making it into another *Mommie Dearest*. The *New York Times Book Review* reflected the ambivalence surrounding Tamara when she was alive: the newspaper was so taken by the subject that a glamorous photograph of her accompanied the short review, but the critique itself was largely dismissive, both of the memoir—"De Lempicka's two husbands and daughter remain shadowy figures; her place in the Parisian art scene is never seriously broached"—and, astonishingly, of the painter herself: "Today, the stylized, sleekly androgynous Art Deco portraits that the Polish-born artist Tamara de Lempicka painted and exhibited in Paris during the 1920s and '30s exist primarily as period pieces. They don't hold a candle to the era's great paintings nor to Art Deco's major achievement—which occurred largely in the area of design."[10]

Regardless of the terms of the current evaluations, it was becoming clear to Kizette that her mother had left behind a much larger enterprise to manage than either woman had anticipated. By the late eighties, Kizette had hired Houston attorney Henry Radoff to oversee the estate. One of his first acts was to alert Freddy DeMann, former manager, now business partner of Sire/Warner Brothers recording artist Madonna, to the singer's unauthorized use of a likeness of *Autoportrait* in her live concerts. The controversy was settled by a modest payment to Kizette, but it would not be the last conflict over Madonna's use of images from Tamara's paintings.

In the meantime, prices for Tamara's portraits and nudes continued to climb. In 1988, *Andromeda* sold for $510,000 and the *Portrait of Madame Boucard* went for $775,000, but a still life from the thirties or forties, *Limon et Oignon*, brought only $9,500. In comparison, during the same period, similarly sized and important pieces by Marie Laurençin brought in $380,000 (*Les Danseuses*) and $330,000 (*La Barque*). In 1990 both Marie Laurençin's

and Tamara's prices escalated as women's art became highly marketable. Sotheby's typical sales for Laurençin were in the $300,000 price range, with several paintings going for at least double that figure. Her famous 1925 piece *La Vie de Château* brought $1,300,000. Lempicka's market value also soared: at Sotheby's her prices broke during this year, for the first time in auction, the million-dollar barrier, when the 1930s *Portrait de Mrs. Alan Bott* brought $1,200,000. The 1933 *Portrait of Madame M* went for $900,000, but her later abstract work was largely ignored; *Gray and Pink Composition* sold for $8,000.

In 1992, Madonna, who continued to be among Lempicka's major collectors, once again attracted Kizette's attention, this time by reproducing large images of several of Tamara's paintings in two music videos of her songs "Open Your Heart" and the very popular "Vogue."[11] Even though she owned the originals, Madonna's reproductions of the paintings, which she then altered, angered Kizette, who sued the singer for violation of moral rights and invasion of privacy, claiming that Madonna had created "mutilated versions" of her mother's works.[12] But Madonna's videos had been created prior to the U.S. Copyright Reform Act of 1990, upon which Kizette based her claims. Probably as a strategic public relations move, Madonna apologized and paid Kizette $10,000, which copyright lawyers not involved with the case regard as a mere courtesy payment, not the "victory" the estate claimed it to be.[13]

Other venues treated Tamara's art with the respect Kizette thought it was due. In early 1994 the Alessandra Borghese Cultural Center in Rome sponsored a major retrospective of fifty-seven paintings, spanning Tamara's career of fifty years. As always with Lempicka exhibitions, the show was immensely popular with the public. One of its more august visitors, Pierre Théberge, director of the Montreal Museum of Fine Arts, was so impressed with the exhibit that he arranged to bring it to his home institution. Running from 16 June to 2 October 1994, the Montreal show became one of the museum's most popular exhibitions ever as well as the largest North American exhibition of Tamara's work. Press releases argued the need to expose a vastly underrated twentieth-century "great" who "does not even warrant a mention in *The Oxford Companion to Twentieth-Century Art*, published in 1981."[14] The Montreal museum prefaced its presentation of Lempicka's art with three works (1917–1922) by André Lhote, so that viewers could begin to develop a historical context for the later artist.

The Montreal exhibit also revealed the broad ownership of Tamara's works, ranging from the world's great museums (the Pompidou and the Louvre) to high-profile dealers (Barry Friedman and Andrew Crispo) to

even higher profile private collectors (Jack Nicholson, Wolfgang Joop, Madonna, Luther Vandross, Jerry Moss, and David Geffen). Once again, however, the West Coast collectors cast a pall upon the seriousness of Lempicka: she was clearly too accessible, too easily appropriated by popular culture to warrant inclusion in Modernism's pantheon. American museums were conspicuous by their lack of representation; Tamara's paintings resided either in European institutions or in private collections.

Consequently, when Tamara's *Adam and Eve* brought almost two million dollars at Christie's March 1994 sale of Barbra Streisand's Art Deco collection, the assumption among critics was that the singer's name elevated the price. But Christopher Burge, the chairman of Christie's who also served as auctioneer, explained that while the "smaller lots brought higher prices than we normally see . . . the celebrity value [meant] less on the more important pieces."[15] Reporters and critics alike seemed unaware that Tamara's prices had been steadily climbing toward this level for the last decade.

If Tamara de Lempicka was gaining a larger public, her fans knew her primarily through two paintings. During the mid-nineties, references to her art were usually limited to *Adam and Eve*, which seemed to be on the cover of every book or album with an erotic theme, and to *Autoportrait*, an equally ubiquitous symbol of the twenties and the new woman. Kizette did not hesitate to license the images as long as she would be paid, especially since she resented having sold or given away the majority of her mother's works before their value had risen so high.

In 1994 many of Tamara's later copies of her previous works started wending their way to the marketplace. A 1970 Lempicka copy of her own *La Belle Rafaela* sold for $65,000 at Sotheby's, along with a small (and poorly executed) version of the famous *Autoportrait* for a comparatively low $20,000. Tamara's later "original" work, *Still Life with Lemons on a Red Chair*, sold for only $14,000 at the same auction. Throughout 1995, her paintings continued to command wildly disparate prices. At Sotheby's a 1975 version of *La Belle Rafaela*, a weak rendering from the original, sold for $80,000 while the far superior *Girl with Crock Jar* (1961) went for $6,000. Nudes continued to outsell her other subjects, but occasionally someone with a good eye noticed the range of her artistic worth: her fifties' abstraction *Orchidee Nesta Foresta di Cuernavaca* brought $50,000.

In 1997, Alain Blondel once again intervened in Tamara's reputation when he helped curate an exhibition of her work mounted in four Japanese cities. Between 1 July and 10 November the show traveled to the Isetan Museum

of Art, Tokyo; the Hiroshima Museum of Art, Hiroshima; the Matsuzakaya Art Museum, Nagoya; and the Daimaru Museum, Osaka Umeda. The dealer himself had recently finished his project of twenty years: a descriptive catalog of Tamara's work that listed over 500 oils, 150 drawings, and numerous watercolors and prints. Providing incontrovertible proof that she was not a painter of soft porn or of only eighty-six paintings, as *Newsweek* had asserted only a few years before, the catalog is an important resource for scholars and collectors alike.

But even Blondel, for all his outstanding scholarship, continues to maintain the European position that her Art Deco portraits done before she left Paris for the United States were the only great manifestation of her talent. In contrast, Jack Nicholson, whose eye is considered among the best by connoisseurs, can be credited with quietly appreciating Lempicka's palette knives: he went about acquiring them well before they became of interest to the art market at large.

Although Barry Friedman of Manhattan remains this country's most prominent Lempicka dealer, other serious vendors are making their presence known. Michel Witmer, whose client was the underbidder for the *Adam and Eve* in 1994, is rapidly becoming a key resource for collectors. And small gallery owners, such as Royce Burton in Washington, D.C., are amassing an astonishing knowledge of Lempicka's techniques and canvas preparations. Both her status as cult figure and her earlier anonymity seem guaranteed things of the past.

And yet the interesting dilemma of where to include Lempicka in the histories of twentieth-century art remains. Ongoing discussions about Modernism have yet to clear a space for a talent of her size, her political incorrectness, and her defiance of the painterly conventions of the age.[16]

Tamara de Lempicka's kind of painting fits uncomfortably into any current aesthetic paradigm. We could choose to enlarge the available boundaries or to create new ones. Or we can maintain a category for the mavericks, the iconoclasts, those who set into high relief the achievements of mainstream Modernists. But we cannot deny greatness because it inconveniently demands that the fundamental tenets of a reigning ideology be reexamined.[17]

What happens to an artist who holds fast to quattrocento ideals in the age of Picasso and then Jackson Pollock? Eccentricity is indeed an invaluable commodity to the marketing of artists, but such idiosyncrasy is supposed to appear countercultural, only incidentally resuscitating the oldest cultural traditions. Pollock, Willem de Kooning, even Picasso all produced art that depended upon its estrangement from the past, whatever its inspi-

rations. And the giant myths of misbehavior that inform their biographies, their flagrant denials of norms, somehow neatly fit our notion of what enables "true art": drunkenness, madness, cruelty, poverty, and great self-made wealth. In the twentieth century, "Art" is supposed to come from outside the ranks of the marketplace, not from within.

In contrast, Tamara was not afraid of openly courting commercial success and displaying her pride in it. She assumed a relationship between artist and audience that was far different from the twentieth-century notion of the alienated artist. She painted for consumption, as do almost all artists, but unlike most in the twentieth century, she proudly admitted it.

In addition, the "woman question" inevitably begs to be asked. Tamara insisted, on the one hand, upon complete artistic autonomy, and on the other, on maintaining either a handsome or rich male escort at her side at all times. She wanted her professional success to be her own. But from the end of World War I until the 1960s, no major female painter would succeed commercially unless she was linked to a prominent male artist whose interest in her was sexual as well as professional. Inevitably connected with female artists whose names have survived in the annals of twentieth-century art are the men whose personal investment helped position the women for success: Guillaume Apollinaire (Marie Laurençin), Marcoussis (Alice Halicka), Alfred Stieglitz (Georgia O'Keeffe), Diego Rivera (Frida Kahlo), Jackson Pollock (Lee Krasner), Man Ray (Lee Miller), Robert Motherwell (Helen Frankenthaler), Picasso (François Gilot). The pattern announces clearly that female talent, however great, could not then afford to be out of touch with male genius in the marketplace.[18]

"Who's right about Lempicka, the critics or the movie stars?" read the provocative subtitle in Newsweek's review of the 1994 blockbuster Montreal show. Sky-high prices still have not dispelled the suspicion that a woman of Lempicka's glamour and fame, superciliousness and anachronistic ideals, could produce great art. No doubt art histories would treat the painter less skittishly if she had been attached to a struggling, significant male painter, if she had professed poverty, or if she had taken the revolutionary side of the twentieth century's ideological struggles. Lempicka's wild success at painting the rich and famous made her politically unfashionable in a modern art world predicated upon Romantic myths of suffering artists wallowing in angst to produce their art. She repudiated the cult of ugliness that she believed underwrote the Modernist landscape; she insisted instead that the beauty of fifteenth- and sixteenth-century Italian painting could be put to frankly sensuous ends in the twentieth, with results that would enrich rather than impoverish a contemporary aesthetic.

Implicitly, a large question underlies this biography of Tamara de Lempicka: what are the boundaries of Modernism (or modernism, which implies a whole other dilemma)? What do we do with a first-rate painter whose creations defy the characteristics that give Modernism its meaning? Why has such a painter been left out of virtually all written accounts of Modernism, even those seeking to reclaim women who'd been omitted from earlier official accounts? If we deem Tamara's talent worthy of serious attention, do we expand the term "Modernism," making it capacious enough to include her? Or do we learn new ways to talk of iconoclasts whose talent is as fine as that of any painter in the official culture—which, after all, only a few years before was the counterculture—and proclaim Tamara's painting the true alternative culture instead?

Lempicka painted against the currents of the most earnest dicta of the times. She softened Cubism into a decadent lushness, taking it to the exact moment before such narcissism turned in on itself. She abhorred what she called the muddiness of Impressionism and sought the clarity of the old masters; Pontormo, Michelangelo, and Vermeer were as important to her painting as Picasso and Braque. But a radically different concept of beauty has ruled in art, at least since Marinetti's Futurist Manifesto in 1909; and Tamara worshiped unabashedly at the altar of Renaissance aesthetics instead. Where did this leave her? Was it an automatic invitation to be taken less seriously than other artists more in tune with their times? What are the dynamics of decadence in life and art, the consequences of cultural transgressions?

Tamara de Lempicka didn't have a chance under the conditions that sanctified certain artistic values over those congenial to her sensibility, often demoted to kitsch. Instead of celebrating the flatness of her medium, for example, she exalted in producing the illusion of sculpture, of three-dimensional bodies, in pigments only oil paint could produce. She worked masterfully at exacting an extraordinary brushstroke which produced such luminosity of paint surface that one is shocked, when viewing the actual painting, at how impossible it is to catch the quality of her light in reproductions—a problem also encountered in the work of that genius of light, Vermeer.

An appreciative, contemplative Washington, D.C., art dealer, Royce Burton, who helped reframe many of Lempicka's pieces for a show in 1994, wonders at the discord between her poorly prepared canvases and her high, brilliant finish. "You just wouldn't expect someone who makes the polish so central to her painting to spend no time at all ensuring the foundation will hold."[19] Yet the more I came to understand the problem with Lempicka—that there is no there there, just here—the more I recognized the coherence

in the painter's methods. Lempicka did not make a distinction between mind and matter, between style and substance. What she wanted to appear to the world was what she was: "underneath" did not denote a privileged place of truth, where we can look for the answers. What you saw was the real thing, the only thing.

Far from being at the "end of a line, not productive of the new," as *Newsweek* claimed, she was sui generis in her art. In the best Modernist fashion—her own—she enacted the necessary illusion of her medium: her high artifice proclaimed the paradoxical dishonesty of all representation that aspires to paint without reference to its necessary subterfuge, its very artfulness. The role of the artist as interpreter, as medium of meaning, rarely comes through with such force in any other painter. Lempicka establishes a distance between viewer and object that proclaims her omnipotence, and in this space she assumes the Romantic and Modern stance of the artist as God the Creator, just as the painters coming after her, Modernism's darlings, would shatter the canvas with their claims of representing their own minds as subject matter.

It used to be that biographies of artists ended with their death: No more. Family politics, estate litigation, and new ways to write histories all affect more clearly than ever before the life and worth—retrospectively—of the artist. Tamara would undoubtedly have despised this ultimate loss of control over her own narrative: she desperately wanted to have the last word. But her last act as a physical being—her remains urgently whirling through the helicopter winds to become part of El Popo's own force field—ensured that the artist would continue to haunt the living on her own terms. Her art, inextricably linked with her person, was now one with the elements—unpredictable, aggressive, and everlasting.

Today, driving the seventy-minute route between Mexico City and Cuernavaca, under the continually steaming volcano, makes it easy to understand why the painter considered the area among the most beautiful places on earth. Its slightly surreal aura becomes even more impressive as volcanic detritus periodically drifts onto the busy roads of Cuernavaca, showering its inhabitants with a light gray film. Mount Popocatépetl, the scientists keep warning the complacent residents, threatens daily to blow its stack. Stanley Williams, professor of geology at Arizona State University, has placed nine monitoring stations in El Popo's crater and on its slopes, hoping to predict the volcano's changes. Williams periodically issues disaster prevention

*Mount Popocatépetl, spewing ashes.*

instructions, most of which are ignored, to the inhabitants of some of the world's most beautiful land, not to mention the planet's most populous city.[20] "The riddle they can't yet answer," according to one journalist, "is when El Popo, as the volcano is known by millions, is likely to pop, and how and with what force."[21]

Tamara de Lempicka's friends and family—her daughter, her grand-daughters, her great-granddaughters—believe they know the answer. The day Tamara's ashes get hot enough, the mountain will erupt; not even nature can absorb the heat she generates. Victor Contreras, whose growing artistic reputation would please his friend, shuts the heavy iron gate guarding his colonial home on Callejón Borda, the metal sounds clanging through his lush garden, reverberating in the open space of his studio above. Staring at the luminescent veil of volcanic ash shimmering on Cuernavaca's narrow stone streets, he sighs fondly: Tamara darling, you never know when to stop.

# NOTES

## Introduction

1. Countess Anne-Marie Warren, interview, McLean, Virginia, January 1997.
2. Victoria Foxhall Doporto, interview, Houston, March 1997.
3. According to the spate of notes Tamara wrote toward the end of her life, her mother "named me after the Lermontov poem." Tamara is the female protagonist in *Tamara* and in the longer epic, *The Demon*, both tales of intrigue, lust, and sexual power.
4. Quoted in Arthur Gold, *Misia*, 9.
5. Bernard Berenson (1865–1959), a connoisseur of Italian art, developed a theory useful in evaluating Tamara's place in history. Daringly, he maintained that an artist's personality could be reconstructed on the basis of the paintings, so that "long familiarity with a painter's works can lead to the building up of a mental picture of his character that is often perfectly expressed by a particular face in one of his pictures." He then invokes this assessment of character to explain why an artist might not be well received in his own time. Appended to the external factors that we cite today—art patronage, the circulation of power within a culture—Berenson's idea of a history of personal styles enriches the attempt to understand Lempicka. *Studies in the Theory of Connoisseurship from Vasari to Morelli*, 246–47.

## Chapter 1. Mythical Beginnings

1. Michel Witmer, a dealer who works with high-profile clients, has been extraordinarily generous in his discussions with me over the past four years. The account of the Christie's sale comes from his memories of the event and the days preceding it.
2. The anonymous buyer rotates his collection in several homes around the world. In 1994 the *Adam and Eve* hung in his Tokyo residence.
3. Victor Contreras, a great friend of Lempicka's during her last years in Cuernavaca, Mexico, provided a detailed account of her last evening alive.
4. This explains why private legal teams and the Polish State Department archivists, who spent months searching, uncovered no record of Tamara's birth in Warsaw. "The records must have been bombed during the war" became the standard, exasperated reaction from any new detective. The city's more than forty Catholic parishes contain no birth certificate for Tamara; nor can the Ronald Lauder Foundation locate such a document among the Jewish records. The current disarray among Russian government archives ensures that even if a record of Tamara's birth in Moscow still exists, it may not be located for a long time.

5. Françoise Dupuis de Montaut, letter to the author, November 1997.

6. I am indebted to the city archivists of Beaulieu-sur-Mer, home to Adrienne Gorska de Montaut for the last half of her life, for researching their files to help verify this claim.

7. In an interview in Houston in April 1995, Alexander Molinello, ex-husband of Tamara's granddaughter Chacha, cited this explanation as the tag to any story Tamara recounted about her family's affluence.

8. I take this information from the notes Tamara dictated to Kizette in 1978, in Cuerna-vaca, Mexico, in preparation for what she had decided would be her own account of her life (hereafter unpublished notes). This (for her) extraordinary willingness to go public with much that she hitherto had believed private was in large part motivated by her outrage at Franco Maria Ricci's tell-all account of her relationship with D'Annunzio, discussed in Chapter 5. Unpublished notes, 2.

9. Ibid.

10. Clement Dekler, phone interview with his daughter, Olga Campbell, 2 May 1996; repeated to me by Olga Campbell, interview, Washington, D.C., January 1997.

11. Boris Gurwik-Gorski (or Gurwich-Gorski, due to spelling variations) is listed in the genealogy records of Baron Raoul Kuffner, Tamara's second husband. Although Lempicka lied on official documents (including immigration papers) about her nationality, residence, and age, she apparently believed aristocratic heritage too important a matter for misrepresentation. She never referred to the full last name elsewhere; although Gorski was a common Russian name, Gurwik was Jewish.

Slavic languages use *i* for masculine and *a* for feminine endings. Thus Tamara's family name was *Gorska*, while her brother's last name was *Gorski*. The politics of speaking Russian rather than Polish in Tamara's youth, as well as the significant numbers of French, Dutch, and Germans living in Moscow and St. Petersburg, resulted in multiple spelling variants for names pertinent to her childhood. Generally, I have adopted the most common anglicized version of Polish and Russian names.

12. Muriel Wolgin, interview, Philadelphia, November 1996.

13. Kizette Lempicka Foxhall (hereafter KF) said on at least five different occasions that this is the only comment her mother ever made about Boris Gorski.

14. Unpublished notes, 5.

15. In her own memoir from 1987, *Passion by Design: The Art and Times of Tamara de Lempicka*, Kizette nonetheless retained the standard versions of anecdotes Tamara had circulated throughout her life.

16. Unpublished notes, 5.

17. Olga Campbell, phone interview, May 1996.

18. As one observer noted wryly, "It seems very paradoxical, but it is nevertheless a fact that it is far easier for a married woman than for a spinster to find a husband. The breaking off of an engagement creates a scandal, but the severing of matrimonial bonds is becoming quite the usual thing. The most insignificant misunderstanding causes husband and wife to break their marriage vows and go their different ways. Gossips chatter about impending divorces as much as of budding engagements." Rosemary and Donald Crawford, *Michael and Natasha: The Life and Love of Michael II, the Last of the Romanov Tsars*, 34. Before she died, the poet Anna Akhmatova was asked why she had gotten divorced during the early decades: "Everyone was getting one," she succinctly responded. Volkov, *St. Petersburg: A Cultural History*, 230.

19. From the useful lengthy interview with Tamara de Lempicka conducted by Eiko Is-hioka in Cuernavaca, November 1979, 52, hereafter referred to as "unpublished interview." I have used the transcriptions in the Lempicka family archives in Houston, in most cases retaining Tamara's idiosyncratic English.

20. Unpublished notes, 3.

21. KF reinterpreted the account she had previously written of this event when I stayed with her in Houston during March 1997.

22. Unpublished interview, 7.

23. See, for example, Benjamin Buchloh et al, eds., *Modernism and Modernity: The Vancouver Conference Papers;* Francis Franscina, ed., *Jackson Pollock and After: The Critical Debate;* and John Golding, *Visions of the Modern.*

24. Norman Davies, *Heart of Europe: A Short History of Poland,* 109.

25. Ibid., 316.

26. KF, phone interview, November 1996.

27. Well into the second half of the twentieth century, Tamara enjoyed reminiscing about the aristocratic background of her childhood with Kizia Poniatowska, a direct descendent of the king himself and a Houston socialite whose husband, an ophthalmologist, sought to ameliorate Tamara's failing vision in her later years. Poniatowska recounts that she and Tamara enjoyed most, during the twenty years of their superficial but "connected" friendship, the chance to talk about current events, since their similar perspective proceeded from a shared background, phone interview, April 1996.

28. Quoted in Ron Nowicki, *Warsaw: The Cabaret Years,* 7. Nowicki conducted the interview in 1986 in Topolski's London salon.

29. Prominent antiques dealer Stanislaw Meyer quoted in Nowicki, 8.

30. Class structure in imperial Russia was more complicated; though every citizen was supposed to be registered in one of five official estates, those estates established legal status but not social or occupational standing. A lawyer might well be cross-registered, for instance, since he could even be a member of the nobility: the rank was sometimes granted to government workers who had risen high in their jobs, and the title was then bequeathed to subsequent generations. For a neat summary see Crawford, 35–36.

Throughout her life, Tamara would impress upon her daughter and granddaughters the respect due to titled men and women. What seemed most striking, at least to Victoria Foxhall Doporto, Tamara's older grandchild, was Tamara's belief that it was the form itself that deserved the genuflection—quite literally—regardless of the real status of the often, for instance, deposed or exiled ruler.

31. KF, Cuernavaca, June 1996.

32. See, for instance, the descriptions in Alfred Horn and Bozzena Pietras, eds., *Poland.*

33. Grace Humphrey, *Come with Me through Warsaw,* 48. Because this book was written in 1934 as a celebration of the author's childhood city, it is particularly useful for gaining a sense of the city life during Tamara's youth.

34. Olga Campbell, interview, Washington, D.C., January 1996.

35. Ibid.

36. Information about the Gorski family's habits came from Kizette Foxhall, Clement Dekler, and Mala Rubenstein Silson.

37. Arthur Gold and Robert Fizdale, *Misia,* 24.

38. Crawford, 42, 43.

39. Ibid., 37.

40. KF tells this story in *Passion*. It was repeated to me in greater detail in a conversation with KF, Houston, April 1995.

41. Tamara repeated this story of her ingenuity more frequently than any other personal anecdote. The middle sibling made a childhood career of calling attention to herself and of cajoling people into giving her what she wanted. Born within a year or so of each other, all three of Malvina and Boris's children—Stanzi, Tamara, and Ada (Tamara randomly called her sister either Ada or Adrienne)—faced the inevitable challenge of carving out their own niche in the tightly spaced family constellation.

42. Unpublished note, n.p.

43. KF, Cuernavaca, Mexico, January 1995.

44. Throughout our phone conversations, letters, and interviews from 1994 to 1998, Kizette elaborated upon the relationships among the children.

45. KF, Houston, March 1997.

46. Unpublished interview, 56.

47. KF, phone interview, November 1996.

48. Kizette also recounts this story in *Passion*, and she repeated it to me in greater detail in Houston, April 1997.

49. Mala Rubenstein Silson recalled details of this story during our discussion in New York City, June 1996, though it was first told by Kizette in *Passion*.

50. Unpublished notes, 4.

51. Recounted in KF, *Passion*, but fleshed out in Tamara's own notes.

52. Unpublished notes, 3.

53. KF, phone interview, November 1996.

54. KF, phone interview, December 1996.

55. Although there is a confusing run-together quality to Tamara's dictated notes at this point, she clearly states that she went to Italy first at age nine and to Monte Carlo at age twelve. In stories she told to Kizette, she conflated the two trips, and the fact that she was gone from school and from home for a year makes it more likely that the two southern destinations were part of the same vacation.

56. Translations from the Italian courtesy of John Wayne, formerly of the Library of Congress.

57. KF, *Passion*, 25.

58. Unpublished notes, 3; KF, phone interview, March 1995.

59. KF, phone interview, April 1995.

60. This and subsequent accounts of Tamara's trip are taken from her unpublished notes, 5 and 6, and n.p.

61. Martina De Luca, "Tamara de Lempicka," 1984 Montreal Museum of Fine Arts catalog, 25.

62. This description fits Tamara's vague references to her opulent childhood retreat, though it is Arthur Gold's and Robert Fizdale's account of the country house of Misia Sert, Tamara's Polish acquaintance. *Misia*, 17.

63. Crawford, 113.

64. KF, *Passion*, 22.

65. Ibid., 22, 36.

66. A version of this memory appears in KF, *Passion*, and was retold to me by Kizette in Houston, December 1996. Tamara recalled her boredom for the Japanese interviewers in 1978, unpublished interview, 56.

67. Gold and Fizdale, *Misia*, 22.

68. Letter to author from Professor Alexander Lempicki, Boston, January 1997.

69. Kizette has referred repeatedly over the past four years to the deep impact that Clementine's tutoring, especially at the Louvre and the Uffizi, had on Tamara's association of love with masterpieces of art.

70. Details of her conversion to Italian aesthetic ideals are presented in Chapter 3.

71. V. I. Lenin, quoted in Robert C. Tucker, ed., *Lenin Anthology* (New York: Norton, 1975), 555–56.

72. Angus McGeoch, *Moscow/St. Petersburg*, 139, 195. This little book provides one of the most trenchant and succinct descriptions available of the appearance and history of old St. Petersburg.

73. Crawford, 43.

74. One of the richest and liveliest accounts of St. Petersburg is found in Solomon Volkov, *St. Petersburg: A Cultural History*. Tamara's interactions with the world Volkov describes emerge from three conversations I had with Kizette Lempicka Foxhall and one exchange with Alexander Lempicki. The general references to the city life, however, I take from Volkov, 146–47.

75. KF, Houston, April 1997.

76. Unpublished interview, 196.

# Chapter 2. Coming of Age in St. Petersburg

1. Professor Alexander Lempicki, phone interview, December 1996.

2. Russian State Historic Archives, group 229, Office of the Minister of Communications, inventory 19, file 470.

3. Because Tamara was closemouthed about Tadeusz, and since their child's acquaintance with her father was fairly superficial, I have had to rely upon the efficient, generous research efforts of others to uncover Tadeusz's past. The information about Tadeusz Lempicki's background comes from the following sources: Jarolaw Lasinski and the Polish embassy, Blitz Russian-Baltic Information Center, Richard Davies at Leeds University Russian Archives, the Hoover Institution at Stanford University, Krystyna Wolanczyk and Andrew Malinowski, and Alexander Lempicki. They in turn relied upon everything from personal memories to government documents, commerce records, telephone directories, published genealogies, and church records.

4. Elena Tsvetkova compiled the neighborhood records for the period that the Lempiccy lived at 29 Millionnaia Street.

5. The information on Tadeusz's schooling comes from the application he filled out for Poland's state department, at the end of World War II, when he was applying for a government position.

6. Arthur Gold and Robert Fizdale, until "the thunder . . . ," where they quote Harold Acton, *Misia*, 140.

7. KF, phone interview, April 1995.

8. Whenever Tamara narrated a story to more than three sources over a period of many years, I have allowed it to pass as her personal folklore. Gradually I have come to realize that her allegiance to a small repertoire of anecdotes reveals their importance to her self-definition, and that while the basic structure of the event is often true, the details are even more important. They shed light on the emotional resonance of the scene. The biggest challenge, then, is to interpret the tale within the context of her entire life.

9. Rosemary and Donald Crawford, *Michael and Natasha*, 44.

10. Kizette, phone interview, April 1994.

11. Arthur Gold, *Misia*, 15.

12. Recounted in KF, *Passion*, 25; Tamara's statement was quoted to me by KF via telephone, February 1996.

13. On both the marriage and death certificates of Tamara's sister, Adrienne Gorska de Montaut, her deceased parents are listed, at the time of their deaths, with the last name "Gorsk" or "Gorska."

14. From various conversations with Victor Contreras, who recounted Tamara's recollections about her past.

15. Between 1995 and 1997, Kizette and Mala Rubenstein Silson reconstructed their memories of Tamara's conversations about several of her adolescent trips to Paris.

16. KF, phone interview, April 1995.

17. Gill Perry, *Women Artists and the Parisian Avant-Garde*, 16.

18. Both in her dictated notes and in the Japanese interview she mentions her early devotion to the galleries and museums of Paris.

19. Mala Rubenstein Silson, New York City, June 1995.

20. Tamara was notorious for breezily claiming—apparently correctly—that she knew all the famous painters and salon figures during the 1920s, though when pressed for specific information, she dismissed the curious interviewer with a wave of her hand: "It's not important." In many cases, the only way to ascertain whom she met and when is to piece together bits of different anecdotes or rare historical records that make probable, versus absolute, a particular event. Thus Tamara's acquaintance with Marcoussis is based on others' affirmation that the artists had known each other in Europe, and that Tamara's family socialized with their famous countrymen and women enough to offer Tamara and Adrienne entree into these circles.

21. KF, phone interview, March 1996.

22. Interview with Tonio Selwart, New York City, October 1996.

23. This usage of "dacha" entered the vocabulary only in 1896, suggesting that a summer home remained the luxury of a few.

24. Mala Rubenstein Silson, New York City, June 1996.

25. Tamara talked to both Mala Rubenstein Silson and to Victor Contreras about her acquaintance with the Yusupovs and her experiences with her aunt's family. Interviews with Mala Rubenstein Silson, New York City, September 1996; Victor Contreras, in Cuernavaca, June 1996, and telephone interview, November 1996.

26. Kizette talks about the luxury of Tamara's St. Petersburg life in *Passion*, 25.

27. Quoted in Crawford, 168.

28. See, for instance, the six references she makes in the 1979 Japanese interview to her fear of Russian retaliation; because of this concern, she says she must give no dates or names when she can avoid it.

29. Crawford, 214.

30. Solomon Volkov, *St. Petersburg*, 192.

31. Ibid.

32. Quoted in Volkov, 192–93.

33. Tonio Selwart, who met Tamara in the 1940s, claims that the only time she ever mentioned to him her life before Paris was to stress the continuity between life in czarist St. Petersburg and her life in France in the 1920s. New York City, September 1996.

34. Art experts have long suspected that Tamara's claims of receiving no training prior to 1919 were lies. An unguarded moment during an interview for the *New York Herald*, as well as a slip she tried too late to recover in the Japanese interviews, confirm the truth implied by her quick mastery of technique in Paris.

35. Mir Iskusstva referred to the magazine devoted to art and general design as well as the loosely linked artists who combined decorative styles with stark, clean lines. Throughout her life, Tamara, just like the Mir Iskusstva artists, would return to St. Petersburg's eighteenth-century amalgam of the classical with the extremely ornamental Rococo style.

36. Alexander Benois, quoted in Volkov, 131.

37. Volkov, 132.

38. This account of the art scene in Petrograd is taken from the friend of Tamara's family Ignace Paderewski, in *The Paderewski's Memoirs*, 110–13, and from discussions with several professors of art history in Baltimore, Maryland.

39. Volkov, 185.

40. Although Tonio Selwart could recall few discussions with Tamara that included references to other artists, the comment she made about Altman stood out in his recollections, probably because she mentioned the movie director first, before she and Selwart together worked out what she meant. New York City, April 1996.

41. Volkov, 187.

42. During this period, as she entered the world of lettered men and women, Tamara developed what evolved into a lifelong passion for reading newspapers. Her daughter and granddaughters recall her subscribing throughout her life to at least three daily papers, which she read from front to back, even, according to Kizette, during the frenetic days when she was beginning her career.

43. Recounted in KF, *Passion*, 26; KF shared details with me on the phone, March 1996.

44. Julian Lempicki's employment records were provided by Jaroslaw Lasinski.

45. This story, told to me by Kizette in February 1995 in Houston, was part of family lore. That Tamara's aunts maintained at least some of the same details as Tamara suggests partial truth, in spite of Tamara's tendency to diminish Tadeusz's standing with her daughter anytime she dared do so.

46. KF, *Passion*, 26.

47. KF has refused to discuss this issue with me, but the American Immigration and Naturalization Service possesses immigration visa application #8159, issued by the American Consulate at Havana, Cuba, citing Marie Cristine de Lempicka (Kizette's birth name) as born in 1916.

48. Richard Davies, of the University of Leeds Russian Archives, kindly provided this information. Unfortunately, the Central State Historical Archive in St. Petersburg is, at the time of this writing, still closed to researchers, so that the church's marriage registries, even if preserved, are unavailable.

49. Mala Rubenstein Silson was but one of many who told me of Tamara's proud description of the wedding gown of 1916. New York City, June 1996.

50. Mala Rubenstein Silson, phone interview, October 1995.

51. See John Bowlt, ed. and trans., *The Salon Album of Vera Sudeikin-Stravinsky,* xii and xv–xvi.

52. Quoted in Volkov, 248.

53. Marcel Liebman, *The Russian Revolution,* 98. Most of my account of the Revolution of 1917 comes from Liebman's narrative.

54. See Richard Pipes, *A Concise History of the Russian Revolution,* 75–98.

55. Ibid., 223.

56. Crawford, 273.

57. For a concise explanation of the various factions, see Pipes, 234–35. In general, "Whites" was the label adopted by the Bolsheviks for their opponents. Taken from the Bourbons' color, white, during their counterrevolutionary showing in the French Revolution, the name during the Russian Revolution signaled a large, loose-knit group of troops committed to reconvening a constituent assembly and enforcing the laws of the provisional government.

58. Fifteen years later, Nadezhda Mandelstam, wife of the poet, experienced the arrest of her husband in almost identical circumstances, from the early morning intrusion to the search for compromising papers, to the self-important air of low-level government police. *Hope Against Hope,* 4–5.

59. KF, *The Life and Times of Tamara,* unpublished manuscript, 1985, 1.

60. The version Tamara told Richard White was slightly different: "In the late 1970s, Tamara explained to me several times how she and her husband often butchered their own meat from the dead horses all around Petrograd in the fall of 1917," he remembers. RW, Cuernavaca, September 1998.

61. Ibid.

62. Crawford, 364.

63. Everyone from Tamara's New York friend Mala Rubenstein Silson, to her granddaughter Victoria Doporto, conveyed variations of this account. And every time the story was repeated to me, there was a suggestion that it sounded like a chapter out of a novel to the storyteller, too.

64. KF, Houston, February 1996.

65. Kizette tells this story in *Passion,* 32; and she offered various modifications in Houston, May 1997.

66. Tonio Selwart remarked to me that when Tamara told him the story, she became agitated and took "one of her pills," presumably a tranquilizer. She emphasized to him the quid pro quo of the sexual exchange between the consul and herself. What elements of the real event triggered her emotional response remain unclear.

67. For the major outline of Tadeusz's capture, the subsequent flight out of Petrograd, and the ostensible reunion with Tamara in Copenhagen, I am following the story told by Kizette in *Passion* but adding to its broad strokes additional insights gleaned from my forty or so conversations and interviews with her over the past four years, as well as information from the Polish State Department records on Tadeusz Lempicki.

68. Countess Anne-Marie Warren, McLean, Virginia, January 1997.

69. KF, *Passion,* 33, and in discussion with the author.

70. In the early forties in California, Tamara and Kizette participated in a large fund-raising gala in support of Paderewski's Polish relief efforts.

71. Tamara told this to her family and friends, quietly and sadly, often enough that it appears to stand under its own weight. In addition, any pictures of Lempicki after this time show a suddenly aged and unhappy-looking young man.

72. Kizette Foxhall recounted the escape narrative and the story of the Siamese consul three or four times to me over the period from 1994 to 1998. Tamara referred to the events herself at various moments in the Japanese interview in late 1979.

73. Letter to the author, 30 October 1997.

# Chapter 3. The Practical Émigré

1. KF, phone interview, February 1995.

2. KF, Houston, April 1996.

3. Marevna Vorobev, *Life in Two Worlds*, 228.

4. Tamara's cryptic remarks to her interviewers in 1979 made it clear that the rest of her family traveled to France ahead of her, with her family of three following later. Unpublished interview, 57.

5. Carol Mann, *Paris Between the Wars*, 15.

6. Rosemary and Donald Crawford, *Michael and Natasha*, 385.

7. KF, Houston, April 1997.

8. Unpublished interview, 21, 57.

9. Vorobev, 148.

10. This account is told in various pieces in *Passion* as well as in Tamara's own unpublished notes; it was repeated to me by KF, phone interview, February 1995.

11. Unpublished interview, 55.

12. Unpublished interview, 37.

13. KF, phone interview, June 1996.

14. Ibid.

15. Djuna Barnes quoted in Andrea Weiss, *Paris Was a Woman*, 173.

16. In a letter to the author, dated 31 October 1997, Françoise Dupuis de Montaut, Adrienne's stepdaughter, corrected Kizette's published statement that Adrienne had attended the Beaux-Arts, and she defended the École Spéciale: "It was a very good school which still exists." Tamara's pattern of borrowing information from a nearby situation to create her own reality explains her false account: Françoise, who briefly attended the same school as Adrienne, actually graduated from the École des Beaux-Arts herself, a fact that undoubtedly encouraged Tamara to recast her sister's academic pedigree.

17. Ibid.

18. Adrienne herself relayed this information to Kizette during her niece's visits to Beaulieu-sur-Mer as an adult. KF, phone interview, April 1996.

19. Unpublished interview, 57.

20. This story became an important part of the family history; Kizette recalls that Tamara repeated it often in front of Adrienne, in appreciation for her sister's role in her career.

21. It is likely that the young Tamara had been uncharacteristically subdued in admitting the degree of her interest in art. Even as a young child, Adrienne had been singled out by the

family for her artistic ability: everyone assumed that the disciplined youngest child would ful-
fill her talent. Although the adolescent Tamara had come back from Italy as if she were an evan-
gelist for Italian museums, no one necessarily expected the spoiled middle child to spend the
energy or time to convert her enthusiasm into a profession. Tamara was meant to get ahead in
the world on the force of her personality, whereas Adrienne—solid, dependable, smart Adrienne
—had the mark of a working woman about her, albeit an artistic one.

22. Kizette told me of the search for Stanzi; Houston, May 1996.

23. KF, phone interview, May 1997.

24. For a detailed explanation of this amalgamated military group see Norman Davies,
*Heart of Europe*, 57.

25. R. F. Leslie, *The History of Poland Since 1863*, 125.

26. KF, Houston, March 1997.

27. KF, Houston, November 1995.

28. Unfortunately, the art institutes did not keep records of their students in the 1920s.

29. Tamara's resistance to school training seems to have been based on principles similar
to those Picasso used to guide his mistress, Irene Lagut: "Quit the Académie Julian" (where she
had enrolled to study painting), and "above all, develop your faults" instead. John Richardson,
*A Life of Picasso*, 400.

30. Quoted from "Definition of Neotraditionism," *Art et Critique* (Paris), August 1890,
23–30.

31. Lempicka's unpublished notes make clear her contempt for the "mystical jumble," to
which Victor Contreras added his memories of her dismissals of such "pseudo-religious stuff."
VC, Cuernavaca, June 1996.

32. In the early twenties she executed a small, beautiful Cubist cityscape of New York in
oil on panel, which has flummoxed dealers in dating it, since she did not visit the United States
until the last part of the decade. Michel Witmer has been an invaluable source of information
on the mostly neglected influence of the French Cubists upon Lempicka.

33. Unpublished interview, 137.

34. In the unpublished interview, for instance, she says, when dismissing her training with
Denis: "There is nothing academic in me or nothing which is what the other people do," 137.

35. Tamara's conversation with Adrienne was repeated to me by KF, phone interview, Jan-
uary 1995.

36. Jean Rhys, *Quartet* (New York: Vintage, 1974), 7–8.

37. Unpublished notes, 1.

38. Information from the Polish government files on Tadeusz Lempicki, courtesy of
Jaroslaw Lasinski, Republic of Poland Embassy, Washington, D.C.

39. KF, Houston, February 1995.

40. Ibid.

41. Weiss, 17.

42. Raye Virginia Allen, *Gordon Conway*, 193.

43. One of the few people still alive in 1996 who had known Tamara in her early Paris
days, Ewa Sosnowska, told me of Tamara's routine during her first years in the city. Sosnowska
was not a close friend, but apparently she met Tamara at one of Stefa's lunches, to which she
had accompanied her own aunt. She later arranged to meet Tamara at the Deux Magots sev-
eral times, and the two women had a very brief sexual relationship in 1923 or 1924.

44. Roger Shattuck, *The Banquet Years*, 8.

45. KF, phone interview, June 1995.

46. Calvin Tomkins, *Duchamp*, 114–15.

47. See Samuel Putnam, *Paris Was Our Mistress: Memoirs of a Lost and Found Generation*, 78.

48. Tonio Selwart, New York City, May 1996. During our conversation, Selwart recalled Tamara's rare comments to him on the discordant art worlds of Paris café life in the 1920s.

49. Unpublished interview, 18.

50. Although her memoirs imply the homoerotic nature of the relationship, today Kizette maintains that "I never actually saw anything going on between the two that I can remember." KF, Houston, March 1997.

51. Leonore Kühn, *Wir Frauen*, 145–49.

52. Unpublished notes, 2.

53. Ibid.

54. Unpublished interview, 35.

55. In various conversations, Kizette has emphasized to me that though she never doubted her mother's love, she always was aware that Tamara's art, "of course," came first.

56. Kizette briefly recounts both of these episodes in *Passion*, 38, 42. She repeated them to me several times during our four years of conversations, as if her mother's yielding to impulse held special meaning for the daughter.

57. In fact, however, if the dating of Tamara's *Card Player* is correct, it may well have influenced *The Blue Room*, done by Valadon three years later in 1923. Valadon's reclining heavyset woman, smoking as she seems to meditate on something from the two books closed beside her, reproduces the same treatment of bandeau and breast, with the top piece of the apparel seeming to sustain the weight of the most obvious sign of the aggressive-looking woman's sex.

58. Maurice Denis, "From Gaugin and van Gogh to Classisism," reprinted in Francis Frascina and Charles Harrison, eds., *Modern Art and Modernism: A Critical Anthology*, 54.

59. Kizette refers to Perrot as "Ira Ponte" in *Passion*.

60. Tamara's own notes and Kizette's recollections of Ira Perrot's friendship with her mother lend credibility to this interpretation.

61. Unpublished interview, 15, 82, and 23.

62. KF, various conversations. This episode may actually have occurred several years later, just before Tamara's 1925 visit to Emmanuel Castelbarco in Milan.

63. Unpublished interview, 6. Tamara continued: "But [their] names . . . are today forgotten. And mine is not." At the time of Lempicka's remark, in 1978, it is true that her name had been revived, primarily as a result of a show mounted by the Parisian dealer Alain Blondel in 1972, and also because of the revival of interest in Art Deco during the seventies. Paradoxically, "Tamara de Lempicka" is not a name that appears in most feminist studies of twentieth-century art, even those dedicated to recovering the women artists who had been left out of the canonical Modernist histories.

64. Jean Rhys, *Quartet*, 9.

65. Gill Perry, *Women Artists and the Parisian Avant-Garde*, 6, 16.

66. David Cohen, who became friends with Tamara for a few years in the early 1960s, received as a gift the artist's study of a heavily leaded cathedral window. Even Kizette, usually informed of her mother's works, had no idea Tamara had ever contemplated such a project. Interview with DC, New York City, April 1996.

67. Anne Middleton Wagner, *Three Artists (Three Women): Modernism and Art of Hesse, Krasner, and O'Keeffe*, 45.

68. Perry, 2.

69. Tonio Selwart was particularly struck by the distance Tamara kept whenever she encountered Alice Halicka at cocktail parties in New York. When he asked her why she didn't like Halicka, she assured him that she entertained no hard feelings against Halicka at all; she just didn't enjoy thinking about the contrasts between their lives, both good and bad. Upon further prodding, Tamara admitted that she envied Alice's hold upon "her Pole," Louis Marcoussis. Still, she commented, Halicka had been too easily swayed from her own sense of truth in art. Interview with TS, New York City, June 1995.

70. Mala Rubenstein Silson mischievously maintained that because Halicka's unattractive nose stood out at cocktail parties, neither she nor her friend Tamara was interested in pursuing a relationship with the artist. Letter to author, June 1997.

71. See Perry, 49.

72. Vorobev, 235.

73. The anecdotes about Marie Laurençin are from John Richardson, *A Life of Picasso*, vol. 2, 240.

74. Though probably not, as she later claimed, at the art school, the Grand Chaumière.

75. Jane Lee in *Art Criticism since 1900*, ed. Malcolm Gee, 85–87.

76. Daniel Robbins in *The Dictionary of Art*, ed. Jane Turner, 297.

77. Ibid.

78. Unpublished interview, 135–36.

79. Letter from Hananiah Harari to the author, 22 July 1997.

80. Michael Kimmelman, *Portraits: Talking with Artists at the Met, the Modern, the Louvre, and Elsewhere*, 133.

81. Richardson, 213.

82. Perry, *Women Artists*, 174.

83. Ibid.

84. Kimmelman, 132.

85. Ibid.

86. Explanations of Lhote's theories of painting appear in numerous books about Cubism, School of Paris painters, French painting of the early twentieth century, and even Art Deco. In addition, the few publications on Lempicka that exist, including Kizette Foxhall's memoir, Gioia Mori's account of the first fifteen years of her painting, and the catalog from the Montreal exhibit of 1994, all discuss Lhote's plastic rhyme.

87. KF, phone interview, March 1996.

88. Tamara's first salon appearance was earlier by a year than the date she would later cite.

89. Unless otherwise noted, citations to the press accounts come from one of the family's five voluminous books of clippings containing any mention of Lempicka's name from 1923 until the present. At times, as with these two notices, the journal or newspaper name is obscured: when the review is significant, I have tracked down the reference.

90. Perry, 15.

91. The painter Marevna reported that "one heard [everywhere] 'Those dirty Russians! Traitors! Spies! All the Russians in Paris ought to be sent packing, have a kick on their behinds, not to be given anything to guzzle." Vorobev, 148. To compound the insult, in Moscow, publi-

cations had begun to scorn the "Parisian Russians," some of whom dared to exhibit at the Salon d'Automne while still pretending to be champions of the avant-garde—the domain of the true revolutionary Russian. Volkov, *St. Petersburg: A Cultural History*, 317–18.

92.  Until the fight between the analytic and synthetic, or salon, Cubists broke out in 1914, even Picasso, while refusing ever to show in the salons himself, had regularly attended in order to look over what was being produced each year. He insisted that interested viewers attend his one-man shows at Galérie Paul Rosenberg. But Picasso, partly because he had shrewdly allowed his canny dealer to control his image, occupied an anomalous position in the Paris art world. Though the painter was enjoying the financial fruits of his labor, he continued to cultivate carefully the image of the bohemian artist.

93.  A major reason the state salon changed shape in the late nineteenth century was the public's difficulty in locating their favorite art. Faced with huge exhibitions, spectators began to compare the ease of the department store (such as Le Printemps, built in 1883) to the shapeless sprawl of art they might not be interested in. The new culture of the consumer that emerged during the nineteenth century thus affected the way art was presented and appreciated. See Patricia Mainardi, *The End of the Salon*, chapter 6.

94.  KF, phone interview, January 1995.

95.  Putnam, 105.

96.  Samuel Allen, *Paris Was Our Mistress*, 208.

97.  KF, Cuernavaca, January 1995.

98.  Unpublished interview, 141.

99.  Kay Redfield Jamison, *Touched by Fire: Manic Depressive Illness and the Artistic Temperament*, 103. Jamison, a psychiatrist at Johns Hopkins University Hospital, studies the creative lives of artists exhibiting the classic signs of manic-depressive illness, careful in the process to avoid reducing to a formula the creations of these artists.

100.  Vorobev, 236.

101.  Told to the author by the very gracious Alexander Chodkieweitz, in a lengthy, delicate, and sometimes awkward phone conversation. Due to the prurient content, Chodkieweitz was understandably at times reluctant to reveal "ancient" episodes, though he decided that "I suppose it's okay for me to gossip now, since no one but me is still alive." Chodkieweitz called me after "another intimate of our little group," a mutual friend of his and Tamara's, read my request for information about the painter in the *New York Times* and contacted him. Early in my conversation with him, I became convinced that he had indeed known Tamara de Lempicka.

102.  Ibid.

103.  Kizette was, of course, aware only of her mother's painting habits. Her knowledge of Tamara's drug use, typical among artists of Montparnasse, came later.

# Chapter 4. Early Success in Paris

1.  Raye Virginia Allen, *Gordon Conway*,, 9–10.

2.  Maud Lavin, *Cut with the Kitchen Knife*, 10.

3.  The phenomenon of the emancipated woman had emerged in the previous decade when women as well as men began to flout sexual conventions. Tamara herself had listened to the salacious details of the demimonde's improprieties, including the ease with which Misia

Sert's husband, Alfred Edward, had located fashionable women eager to satisfy his coprophilia. Similar breaches of decorum, the grist of middle-class gossip during the interwar liberation of the sexes, demolished the conventions of feminine propriety.

4. Unpublished interview, 137, 138.

5. KF and Victoria Doporto, Cuernavaca, June 1996, and Houston, May 1997.

6. KF, Houston, February 1997.

7. Almost immediately upon her arrival, Barney became the close friend of French critic Remy de Gaurmont, editor of the influential *Mercure de France* and mentor to T. S. Eliot. Gaurmont was in love with Natalie throughout his life and referred to her as an amazon, a term that quickly entered popular usage. Andrea Weiss, *Paris Was a Woman*, 111. The term appeared, for instance, in reviews of Tamara's paintings.

8. Although Alain Blondel and Gioia Mori have both searched exhaustively for the identity of the Duchess de la Salle, neither scholar has yet found out who she was.

9. KF, Houston, August 1995.

10. Truman Capote, quoted in Weiss, 111.

11. Weiss, 112.

12. Janet Flanner, quoted in Weiss, 133.

13. Tonio Selwart, New York City, June 1996.

14. Moreover, Barney's defiantly open lesbianism, combined with her reactionary politics, resulted in much of upper-class French society snubbing her, so that even her lovers and friends often played down their association with her.

15. KF, Houston, March 1997.

16. Such a significant title is rare in Lempicka's portfolio.

17. Lempicka sold the painting that same year for 15,000 French francs. Most artists in the salon of 1923 asked around 1,500 francs for their work.

18. Pesci works with Barry Friedman, the major North American dealer for Lempicka. She made this comment to me at Friedman's gallery in New York City, June 1995.

19. The *Pologne*, 15 December 1923, plaintively asks: "pourquoi écorche-t-il son nom polonais en Limpitzky à la manière byzantine?" ("Why does he torture his name to Limpitzky in such a convoluted manner?")

20. KF, Houston, April 1996.

21. George Hamilton, *Painting and Sculpture in Europe*, 284.

22. Ibid., 426.

23. Clement Greenberg, "School of Paris," *The Nation*, March 1944.

24. For a concise and interesting account of the Courbet nude, see Calvin Tompkins, *Duchamp*. The famous Freudian psychoanalytic revisionist Jacques Lacan acquired Courbet's painting soon after World War II.

25. Gill Perry, *Women Artists and the Parisian Avant-Garde*, 26.

26. As Kizette Foxhall learned during her own youthful education at St. Maurs in Paris, girls during the 1920s were not supposed to be comfortable with their nude bodies; well-brought-up young ladies, at boarding schools and at home, took baths only while clad in their petticoats and with an older female companion by their side to ensure that no unseemly self-interest could develop.

27. Bernard Dorival, for instance, one of the most influential critics of the time, sought to commend the oddness of Valadon's work with this "compliment." Dorival continues, in an

attempt to save Valadon from complete virilization: "Perhaps in [her] disregard for logic lies the only feminine trait in the art of Suzanne Valadon, that most virile—and greatest—of all the women in painting," 132.

28. Perry, 34.

29. *Sunday Times*, London, 1973.

30. See Lynda Nead's account of Kenneth Clark's study of "ideal art" in *The Female Nude*, 20.

31. For those interested in the more theoretical aspect of aesthetic traditions, Terry Eagleton's remark that "aesthetics is born as a discourse of the body" (*The Ideology of the Aesthetic*, ix) is a useful preamble to observing that the body in Western history has most often meant the female.

32. Antony Copley, *Sexual Moralities in France*, 173.

33. In an Internet discussion group on Lempicka, clearly organized around lesbian libidos, one participant wrote of *Two Friends*, "I'd like to write a love poem to this artist," December 1997.

34. Given her extreme dislike of Cézanne's paintings, she must have taken particular pleasure in this commission, since Gide had been the buyer of Maurice Denis's sycophantic *Homage to Cézanne* (1900).

35. Victor Contreras, Cuernavaca, June 1996.

36. In 1995, Ewa Sosnowska remembered witnessing this incident between Tamara and "a good friend" during Sosnowska's late teen years in Paris.

37. Description of Otto Weininger and early-twentieth-century discussions of homosexuality, Lavin, *Kitchen Knife*, 186–87.

38. KF, Houston, April 1996.

39. KF, Houston, April 1996. Kizette also describes this scene in *Passion*, 42.

40. Letter from Alexander Lempicki, March 1996.

41. Samuel Putnam, *Paris Was Our Mistress*, 166.

42. Joanne Harrison, *Portrait of an Artist*, 40.

43. Quoted and explicated by Barbara Spackman, *Fascist Virilities*, 7. The Futurism of men like Marinetti, with their paeans to heterosexual virility and the good of the race, arguably laid the foundations that fascism would later build on.

44. KF, *Passion*, 74.

45. Ewa Sosnowska, phone interview with the author, March 1995.

46. Spackman, 8.

47. KF, Houston, March 1997.

48. Victor Contreras, phone interview, January 1997.

49. Putnam, 173.

50. For the first twelve months after Tamara moved to the United States in 1939, she repeatedly announced to startled newspaper reporters that she planned an "all hands show." Though she never revealed the date or place of the exhibition, she allowed the statement to be published several times.

51. Indeed, Tamara's pretense that she only played at a degenerate nightlife because she was, after all, married and a mother, with a very respectable family in the same town, damaged her reception among her peers. Such a tactic did allow her to continue doing what she wanted while she maintained an aura of social decorum at the same time. But the enabling duplicity cost her the chance to fit in with the right people, to be part of a bona fide artistic group. Had the

bohemian artists understood her truly marginal personality, their suspicions that she wanted only to be a social painter might well have been allayed, subsumed in their admiration of her instead.

52. Alexander Chodkieweitz, phone interview, November 1994.

53. Carol Mann, *Paris Between the Wars*, 113.

54. Countess Anne-Marie Warren, McLean, Virginia, January 1996.

55. The history of the canny Surrealist Louis Aragon illustrates her error: precisely because the handsome patrician had deliberately revolted against his blue-blooded family, he was free to mingle with whomever he pleased. Aragon had nothing to prove. Even as he spun out his odes to communism, the degenerate writer experienced no contradiction in displaying proudly the expensive first editions he collected. Whitney Chadwick, *Women Artists and the Surrealist Movement*, 204.

# *Chapter 5. Coming of Age in Italy*

1. KF, *Passion*, 87.

2. KF, Houston, April 1997.

3. Victor Contreras, Cuernavaca, June 1996.

4. During a trip to Venice in the 1960s, Lempicka lectured her granddaughter, Victoria, about the trajectory of modern art.

5. Carol Mann, *Paris Between the Wars*, 151.

6. Among the few painters represented were Gris, Léger, and Ozenfant.

7. Carolyn Burke, *Becoming Modern: The Life of Mina Loy*, 339–40.

8. The first person to use the phrase in English was the British art historian Bevis Hillier in the late 1960s, and from then on, "Art Deco" functioned as valid nomenclature. Art critics often explain their unwillingess to use the category except for marginal painters by reminding readers that Art Deco was never considered a movement in its own time, an era when every innovation proclaimed itself through manifestos issued in pamphets, books, and magazines.

9. James R. Mellow, "Ugly Was Beautiful Too," *New York Times Book Review*, 4 December 1994.

10. Octavio Paz, *Essays on Mexican Art*, 17.

11. Edward Lucie-Smith, "Moderne Art," 211.

12. Edward Lucie-Smith, *Art Deco Painting.*

13. Walter Benjamin, in his 1934 essay "The Work of Art in the Age of Mechanical Reproduction," presents one of the best-known arguments that fascism is an aesthetic. Questions of the morality of art—whether a tendency or school represents a moral depravity, creates it, or reinforces it—are obviously worthy ones. Inevitably, however, the issues of historical versus formal evaluations of art's worth are involved topics, too grand to elaborate here.

14. Unpublished interview, 67.

15. Janet Flanner, *Paris Was Yesterday*, xx.

16. Tonio Selwart, New York City, June 1995.

17. Letter to the author, Connie Stutters, September 1995.

18. Andrea Weiss, *Paris Was a Woman*, 23–24. The black women reveled in Paris's apparent lack of color barriers, the city where "nobody cares—not even Americans, it seems—whether an artist is white, black or yellow or, as Forster says in *A Passage to India*, 'pink-gray,'" commented author Jesse Redmon Fausset. Less innocently, Baker was freely celebrated pre-

cisely because of her color, according to the prevalent stereotype that ascribed animal sensuality to blacks.

19. Tonio Selwart, New York City, June 1996.
20. Lempicka's references to jazz come from my conversations with Kizette and with two of Tamara's assistants in her later years, Pattie Davidson and Richard Piro.
21. KF, phone interview, December 1995.
22. KF, Houston, April 1997.
23. KF, Houston, April 1994.
24. Paul Hofmann, *That Fine Italian Hand*, 108–9.
25. In various conversations KF has confirmed the account she provides in *Passion*, 53. Her chronology of the various exhibitions of 1925 is not entirely accurate, however, and I have amended it where necessary. Emmanuele Castelbarco later married Arturo Toscanini's daughter, in the process assuming an even larger role in Italian culture.
26. KF, *Passion*, 57.
27. From conversations with KF.
28. Giovanbattista Brambilla, letter to the author, September 1997.
29. Quoted in Gill Perry, *Women Artists and the Parisian Avant-Garde*, 167.
30. Unpublished interview, 146.
31. Alexander Chodkieweitz, phone interview, November 1994.
32. In September 1996 while delivering a paper at the University of Witwatersrand in Johannesburg, South Africa, I mentioned Tamara de Lempicka. A hand shot up in the Johannesburg auditorium, and a young man in his early twenties asked proudly, "Is that the painter who does all the lesbian stuff?" Among Tamara's current audience under the age of forty, she is recognized almost exclusively for her implications of bisexuality or homosexuality.
33. Press clippings collection.
34. Giovanbattista Brambilla, letter to the author, September 1997.
35. Ibid.
36. Brambilla, letter, June 1997.
37. Modernism as the collapse of pure categories—of high versus low culture—was expressed most persuasively through the high-quality production of such popular forums.
38. Unpublished interview, 57–58.
39. Ibid., 58.
40. It seems that anyone who spoke with Lempicka about her professional beginnings heard this exact account repeated. The only variation regards the date.
41. Unpublished interview, 57–58.
42. In describing these visits, I have followed Giovanbattista Brambilla's research rather than Kizette's narrative. Mr. Brambilla feels sure it was Picenardi with whom Lempicka stayed in Milan, rather than the Pignatellis. Letters to the author, June, August, and September 1997.
43. John Wayne, "Gabriele D'Annunzio: Fire and Roses, Mountain, River and Sky," lecture given at Italian Culture Institute, Washington, D.C., February 1997, 15.
44. Ibid., 18.
45. Ibid., introduction.
46. Ibid.
47. As dictated by Tamara in 1978 to her daughter, who used the reminiscences to construct her memoir, *Passion*.
48. Ibid.

49. For the fullest treatment of the relationship between Lempicka's paintings and the Italian Mannerists, see Germain Bazin in "La Dea dell'Epoca delle Automobili," in *Tamara de Lempicka*, Tokyo exhibition catalog, 1980.

50. Piero Chiara and Federico Roncoroni, eds., *Tamara de Lempicka: With the Journals of Aélis Mazoyer, Gabriele d'Annunzio's Housekeeper*, 136.

51. Ibid., 138. This letter is dated simply "Sunday, December," similar to the first letter, "Friday, December."

52. Although European servants expected clear social divisions, in D'Annunzio's household the categories were based on his sexual favorites rather than on class.

53. Chiara and Roncoroni, 145.

54. KF, Houston, May 1997.

55. KF, Houston, April 1997.

56. Chiara and Roncoroni, 152, 45–46, 56, 64, 86, 114, 88, 99, 89.

57. Victoria Doporto, phone interview, August 1997.

58. Chiara and Roncoroni, 132.

59. Ibid.

60. This mixed account comes from KF, *Passion*, 69–71; from the housekeeper's diary in Chiara and Roncoroni; and from Kizette's comments to me throughout numerous conversations.

61. Wayne, 14.

62. Ibid., 17–18.

63. From the unpublished manuscript "The Life and Times of Tamara" by Kizette de Lempicka Foxhall, 15 July 1985, based on material dictated by the artist to her daughter in 1978, 1–4.

64. Chiara and Roncoroni, 148.

65. Jane Owen, interview in Houston, April 1995, and phone conversation in Houston, April 1997. Owen is the restorer of the famous eighteenth-century utopian homestead New Harmony founded by her ancestor, Robert Owen. A widely respected Houston grande dame—and one of the few to befriend Tamara during her years in that city—she is passionate about the singular nature of Lempicka's self-assurance.

66. Ibid.

67. Unpublished interview, 155.

68. KF, *Passion*, 58.

69. Unpublished interview, 98.

70. Giovanbattista Brambilla, letter to the author, June 1997.

71. Judging from Lempicka's painting of the count, such a relationship seems plausible: he exhibits the same sexual smirk she used to portray other men she was involved with, such as Raoul Kuffner, in 1929.

72. Brambilla, letter, June 1997.

73. KF, Houston, April 1997.

# Chapter 6. Exacting Success

1. KF, Houston, April 1997.

2. KF, Houston, October 1995.

3. Andrea Weiss, *Paris Was a Woman*, 21.

4. Andrew Kozlowski, a cousin of Irene Spiess, has shared important insights through an exchange of letters and transatlantic phone calls. This information comes from his Warsaw letter of 29 August 1997.

5. KF, Houston, April 1997.

6. Ibid.

7. This account of Irene Spiess's genealogy and past was kindly provided in detail over a period of three years by Krystyna Wolanczyk, daughter of Irene's first husband. The time she took to compile a painstakingly detailed chronicle, as well as her constant accessibility to me, were real acts of kindness.

8. Harvey Sachs quoting from Rubenstein's memoirs in *Rubenstein: A Life*.

9. Krystyna Wolanczyk, ibid.

10. See, for instance, Harvey Sachs, *Rubenstein*.

11. Krystyna Wolanczyk, letter, August 1997.

12. Unpublished interview, 32.

13. Kizette thought, in 1986, that they had met at Monte Carlo, but in 1997 she told me she had been confused. The family actually stayed at Lake Como, which, along with Lake Garda, Monaco, and the south of France, was a frequent rest stop for Tamara throughout her life. Houston, May 1997.

14. KF, Houston, February 1997.

15. KF, Houston, April 1997.

16. Ibid., and *Passion*, 90.

17. KF, Houston, April 1995.

18. This excerpt appears to have been taken from an Italian newspaper, though the scrap in Tamara's press journals is identified only as "Italian review."

19. Solomon Volkov, *St. Petersburg: A Cultural History*, 150.

20. The anecdote, as Tamara liked to tell it, appears in *Passion*, 95.

21. Unpublished interview, 35.

22. Carol Mann, *Paris Between the Wars*, 89.

23. Isabelle Anscombe, *A Woman's Touch*, chronology at back of book.

24. Ibid., 90.

25. KF, phone interview, April 1995.

26. It is hard to disagree with those who believe that Tamara was infatuated with her model; Kizette confirms her mother's romantic obsession with Rafaela, *Passion*, 82.

27. Quoted by Octavio Paz, in *Essays on Mexican Art*, 228–29.

28. Rita Felski, *The Gender of Modernity*.

29. The actor Jack Nicholson, whose private art collection is among the most respected in the world, bought the painting in the late eighties before Lempicka once again became a hot commodity.

30. See, for instance, Bridget Elliott, *Women Artists and Writers: Modernist (im)possition-ings*, 95 and 91. Elliott conducts a survey of turn-of-the-century publications on the subject, including Otto Weininger's *Sex and Character*, Max Nordau's *Degeneration*, and Cesare Lombroso's earlier but still read *The Man of Genius*. Typical of the tracts' tone is Weininger's 1907 statement that "a female genius is a contradiction in terms, for genius is simply intensified, perfectly developed, universally conscious maleness," 96. Elliott points out that Gertrude Stein was

influenced in her self-styling as a "male genius" by Weininger's theories: "Pablo and Matisse have a maleness that belongs to genius. Moi aussi perhaps," 96.

31. Bruce Fleming fleshes out the audience evaluation of "technique" in his provocative essay, "On Technique in Painting: The Church Exhibition," 159–68, *Centennial Review,* winter 1996.

32. Any brushstroke that depends particularly on its ability to convey illusion seems less suited to reproduction in magazines, books, and newspapers than does artwork after the 1950s. Lempicka's case involved the deliberate smoothness of her stroke; van Gogh's rough stroke, a mark of his own painterly genius, often looks equally facile in reproduction. Much of the critical underestimation of Tamara de Lempicka stems from the overproduction of cheap imitations of her paintings, which are peculiarly dependent upon the "original" for their "aura," as Walter Benjamin might say. And Lempicka's works are housed largely in private collections, as are most Art Deco paintings, making them less accessible to would-be viewers than works in other genres, which are better represented in public holdings.

33. She used pouncing primarily for pictures she planned to repaint later.

34. Given her theatrical personality, it does seem unfortunate that she didn't design something on a grand scale for a proscenium stage.

35. Background on Lempicka's methods of signing—or not signing—her work comes from interviews with Kizette in Houston, and from Royce Burton of Burton Fine Art in Washington, D.C.

36. Mala Rubenstein Silson, New York City, June 1995.

37. Michel Witmer located these two pieces, basically forgotten and stored in Kizette's attic in Houston. Probably never shown except to her family, they are now back on the public market.

38. KF, Houston, February 1997.

39. Michael Levy, *Painting and Sculpture in France,* provides a thorough overview of Greuze's painterly tendencies, 217–25.

40. Tamara kept these landscapes until her death. They now hang in Kizette's living room in Houston.

41. Raoul Kuffner, *Planomania: Capitalism Makes Sense,* 195.

42. Victoria Doporto, interview, March 1997.

43. KF, *Passion,* 94.

44. Unpublished interview, 95–96.

45. Louisanne Kuffner Glickman, letter to the author, 20 November 1997.

46. Gioia Mori, *Tamara de Lempicka: Paris 1920–1938,* 75.

47. Garreau "Manha" Dombasle, then ninety-seven years old, was kind enough to answer my questions during a lavish luncheon her cook prepared for me and my translator, Hedvich Prieur, when we visited Madame Dombasle in Deauville in July 1995. Arielle Dombasle, a well-known French actress, followed her gracious grandmother's lead and called me in Paris the following day, where she confirmed previously published anecdotes about the encounters she'd had with Tamara during the 1970s (cited in chapter 10).

48. Joanne Harrison, "A Portrait of the Artist," *Houston City Magazine.*

49. KF, Houston, April 1997.

50. Alain Blondel reminded me of this photograph when we were discussing Tamara's various methods of preparing the canvas. Letter, 9 June 1997.

51. Chronology at the back of Isabelle Anscombe's *A Woman's Touch.*

52. Mann, *Paris Between the Wars*, 140.

53. Ibid.

54. Gill Perry, *Women Artists and the Parisian Avant-Garde*, 82.

55. See, for instance, Ludwig Goldscheider, *Five Hundred Portraits*.

56. Arsène Alexander, *La Renaissance*, 57, July 1929.

57. From *Calligrames: Poèmes de la Paix et de la Guerre*, 1918; quoted in John Richardson, *A Life of Picasso*, 348.

58. Unpublished interview, 111–12.

59. *New York Herald*, Paris, 19 January 1929.

60. Unpublished interview, 112, 114.

61. She continues: "Yes, your mother was right—the Rufus Bush was of the Bush Terminal family and not Anheuser Busch. My mother was only nineteen when they were married and the portrait was painted—they were divorced about three years later and my mother went to Greece where she met and married my father, an American archaeologist. She put all her New York belongings into storage, where they remained until this year!" The rest of the letter and its follow-up five months later discuss Joan Gayley's increasing pleasure and shock at the prices that Tamara's works commanded in the late 1980s.

62. KF, Houston, March 1997.

## Chapter 7. Recovering from the Crash

1. KF, Cuernavaca, January 1995.

2. Cobina Wright, *I Never Grew Up*, 172, 238.

3. Janet Flanner, *Paris Was Yesterday*, 61–62.

4. Janet Flanner, *An American in Paris*, 9.

5. Conversations with Tonio Selwart, Mala Rubenstein Silson, and KF from 1995 to 1998.

6. Flanner, *Paris Was Yesterday*, 69.

7. Countess Anne-Marie Warren, McLean, Virginia, January 1996.

8. Flanner, *Paris Was Yesterday*, 69.

9. Mala Rubenstein Silson, letter to the author, November 1996.

10. Flanner, *Paris Was Yesterday*, 65–66.

11. Malcolm Gee, *Dealers, Critics and Collectors of Modern Painting*, 288.

12. Ibid., 286.

13. KF, phone interview, October 1995. Richard White of Cuernavaca remembers Tamara as recounting this achievement to him often during the last years of her life. In spite of the comparative worth of one million dollars in 1929, Tamara's friends support the likely truth of this story. Interview, Cuernavaca, November 1997.

14. KF, Houston, February 1997.

15. Pascin's erotically tinged teenage girls, the most frequent subjects of his painting in the 1920s, suggested Tamara's own figures thematically if not stylistically.

16. Jane Turner, ed., *The Dictionary of Art*, vol. 24, 224.

17. Carolyn Burke, *Becoming Modern*, 371–72.

18. In several conversations in Houston, Kizette emphasized how close Tamara and Kisling were.

19. This picture is reproduced in Carol Mann, *Paris Between the Wars*, 45.

20. KF, letter to author, September 1996.

21. KF, letter to author, March 1996.

22. Michel Witmer, for example, says that "of the hundreds of sketches extant, Tamara has nothing remotely like this—a drawing of a dear woman friend, whose face and hair were worried over so much. One half of the painting is color, the other half charcoal—very unusual especially for an artist of Tamara's precision. I would bet, without knowing anything else except this extraordinary drawing, that they were lovers." New York, November 1996.

23. KF, Houston, April 1996 and February 1997.

24. KF, Cuernavaca, January 1996.

25. Prince Franzi Hohenlohe, letter to the author, February 1995.

26. Unpublished interview, 147–48.

27. The Dekler family's consensus of Adrienne Gorska fit her older sister equally well: "She was intelligent like a man. That's how we all thought of her." Little wonder that Tamara had experimented with the masculine ending of her name—Lempitzki—early in her career. KF, Houston, February 1997.

28. Quoted in Mary Lawrence, ed., *Lovers,* 110.

29. KF, phone interview, October 1995.

30. Michel Witmer first suggested this influence to me, July 1996.

31. Piero Chiara and Federico Roncoroni, *Tamara de Lempicka,* 2.

32. Information is from official documents, courtesy of the Polish embassy, via cultural liaison Jaroslav Lasinski. Tadeusz Lempicki's records remain classified because of his government work during World War II, but Lasinski was allowed to read them and convey to me nonclassified information.

33. Krystyna Wolanczyk, interview, July 1997, Arlington, Virginia; Andrew Kozlowski, letters from Warsaw and Paris, September and October 1997.

34. KF, Houston, April 1995.

35. Wolanczyk, interview, July 1997.

36. Ibid.

37. KF, Cuernavaca, June 1996.

38. KF, Houston, February 1997.

39. Unpublished interview, 60.

40. KF, Houston, May 1997.

41. Unpublished interview, 61.

42. Phone interview, Countess Maria Suzpichiana, Hotel Capri, 26 October 1997.

43. Hazel Muir, ed., *Dictionary of Scientists,* 533.

44. Interview with Madame Garreau "Manha" Dombasle, Deauville, July 1995.

45. KF, Houston, May 1997; also recounted in KF, *Passion.*

46. Tamara's family and various associates of Kuffner invariably have used the term "teddy bear" to describe the baron's affable appearance.

47. Unpublished interview, 89–90.

48. Ibid., 108.

49. Since Tamara had for several years paid the well-respected Mark Vaux, a favorite photographer of School of Paris painters, to maintain an archive of her completed paintings, it is likely that it was he and not Tamara's secretary who took the pictures. Vaux's collection of photographs, now in the Georges Pompidou Center, still provides the strongest visual documentation of Lempicka's early career.

50. KF, Houston, May 1997.

51. I am deeply grateful to Alain Blondel for sharing with me the letters that Tamara wrote to Puglisi. Kizette apparently lent these letters to Blondel upon receiving them from Puglisi's nephew. All references to the letters are to this collection, owned by Kizette Foxhall but under Blondel's guardianship.

52. Letter from Kizette Lempicka to Tamara, 25 June 1933, Weybridge, Surrey.

53. KF, Houston, April 1997.

54. Flanner, *An American in Paris*, 111–12.

55. Malcolm Gee, *Dealers*, 286.

56. Unpublished interview, 6.

57. Whitney Chadwick and Isabelle de Courtivron, *Significant Others*, 8–9.

58. Arrigo Cipriani, *Harry's Bar*, 16. Cipriani describes the grandeur of French sommeliers in terms similar to those applied by friends to Baron Kuffner's culinary routines.

# Chapter 8. Union and Disintegration

1. Unpublished interview, 143, 201, 202.

2. Janet Flanner, *Paris Was Yesterday*, 113–14.

3. Unpublished interview, 57.

4. Interview with Joanne Harrison, "Portrait of the Artist," in *Houston City Magazine*.

5. Thanks to Robert West, Bethesda, Maryland, for tracing Kuffner's Austro-Hungarian estate back to the Jewish roots listed in the Czechoslovakian almanac.

6. Victoria Doporto, phone interview, April 1997.

7. Unpublished interview, 164.

8. An appended phrase on the letter—"Viva Mussolini"—appears to be the recipient's ironic comment on Tamara's new use of the Italian "voi" instead of the French pronouns she had used earlier. Mussolini had dictated that the use of the Italian language without foreign substitutions was necessary to prove one's loyalty to the country.

9. John Wayne, translations and notes of the Puglisi letters, October 1996.

10. Joanne Harrison.

11. Unpublished interview, 63.

12. Indeed, the response of the French government to Mussolini's aggression in Ethiopia during the summer of 1935—sanctions against Italy—had discouraged Tamara. Even her two adopted countries were unable to maintain peace between themselves.

13. Cobina Wright, *I Never Grew Up*, 255.

14. Quoted in ibid., 254, as a remark by Toscanini's daughter Wally, now married to Emmanuele Castelbarco, who had launched Lempicka's career in 1925.

15. Tonio Selwart, New York, June 1996.

16. Martin Shallenberger, interview, Cuernavaca, November 1997.

17. Janet Flanner, *An American in Paris*, 109–10.

18. Tamara apparently attended the lavish Gold Ball that Lady Mendl sponsored during the Depression, since she later commented approvingly on the hostess's nerve at dying her hair green.

19. KF, Houston, May 1997.

20. KF, Houston, February 1997.

21. Unpublished interview, 164.

22. Gill Perry, *Women Artists of the Avant-Garde*, 141.

23. Jane Owen, Houston, November 1995.

24. Victoria Doporto, phone interview, May 1996.

25. Carol Mann, *Paris Between the Wars*, 156–60.

26. Letters from Françoise Dupuis de Montaut to the author, 10 February 1997 and 31 October 1997.

27. Unpublished interview, 57.

28. Françoise Montaut de Dupuis, letter, January 1998.

29. KF, Houston, February 1997.

30. Perry, 153.

31. Tamara, who had occasionally associated with Halicka in Paris during the twenties, enjoyed discussing "how Alice, so snooty to us, was really quite unattractive, with that bird-beak nose," Mala Rubenstein Silson recalls. New York City, June 1995.

32. Adrienne's stepchildren, Françoise and Jean-Pierre, remember her fondly, though not as a surrogate mother: "She was always quite correct with my brother and me," Françoise recalls, "but we did not have a very warm relationship, probably because of her strong character." The couple would live in a luxurious apartment building at 69 Avenue de la Grande-Armée for the next two decades, until Peugeot tore down the building to erect its company headquarters. Letters from Françoise Dupuis de Montaut to the author, October 1997 and October 1998.

33. *Le Figaro*, February 1939.

34. Unpublished interview, 217.

35. Application for Immigration Visa, American Consulate at Havana, Cuba, September 1939, #8159; copy obtained from the U.S. Department of Justice, dated 31 July 1997.

## Chapter 9. The Hollywood Interval

1. According to Martin Shallenberger, Raoul Kuffner was well connected to many influential businessmen in Chicago, friends who had emigrated to America after the Austro-Hungarian Empire was dismantled (Cuernavaca, November 1997). Possibly they suggested the Havana agricultural plan as the best way to expedite his immigration request.

2. *Art Deco: The Crooners*, CD liner notes, Columbia Records, 1993, 8.

3. For a discussion of America's obsession with Streamline Moderne, see Maria Day, "Art Deco Reconsidered: Streamline Moderne in the Architecture and Sculpture at the 1939 New York World's Fair," master's thesis, University of Maryland, 1994.

4. KF, Houston, November 1995.

5. Cobina Wright, *I Never Grew Up*, 45, 152, 168.

6. Photographs record her time in Connecticut, with the year and place on the back. Kizette recalls that her mother "had a country home" in Connecticut, though in truth it seems highly unlikely that she ever actually bought a house there.

7. The backs of the photographs bear an industrial stamp of the town and the date, 4 July 1939.

8. Erna Fergusson, *Cuba*, 261.

9. Victor Contreras recalls her saying this often when she encountered members of the underclass in Mexico. VC, Cuernavaca, June 1996.

10. Letter to the author from Lempicka's nurse Connie Stutters, April 1996.

11. In 1933, Tadeusz passed the bar exam in Poland. On his application to the state bar, he cited a number of prominent lawyers and judges as character witnesses. Among them was also one of Poland's major poets of the day, Jaroslaw Iwaszkiewicz.

12. Robert West read and commented on these Swiss documents, October 1997, Bethesda, Maryland.

13. L. L. Stevenson, "New York Lights," in syndication, quoted here from Springfield, Ohio, 8 January 1940.

14. *Los Angeles Examiner*, 5 February 1940.

15. *San Francisco Examiner*, 13 February 1940.

16. Quoted in Wright, 146–47.

17. Tonio Selwart, interview, New York City, June 1996.

18. *Los Angeles Examiner*, 5 February 1940.

19. Letter to the author, Cecelia Myers Whitehouse, 15 August 1997.

20. Marmoni in Piero Chiara and Federico Roncoroni, *Tamara de Limpicka*, 21.

21. KF, Houston, April 1997.

22. Jean Nowell, *Stanford Daily*, 3 October 1940.

23. KF, Houston, April 1997.

24. Nowell 3 October 1940.

25. Lynn Nicholas, *The Rape of Europa*, 149.

26. KF, Houston, May 1997.

27. Letter to the author, September 1997.

28. Alexander Molinello, Houston, November 1994.

29. *Script*, 11 October 1941.

30. Victor Contreras, Cuernavaca, November 1997.

31. *Gloversville* (New York) *Leader*, 13 March 1941.

32. *Los Angeles Herald*, 4 March 1941.

33. Though Tamara's works would be shown in a solo show, several other artists' paintings would be presented in adjacent exhibitions, all under Levy's sponsorship.

34. Julien Levy, *Memoir of an Art Gallery*. In Levy's book, the generous Raoul Kuffner is cited only as the "baron Kufner [*sic*] who suddenly withdrew his funding as precipitously as he gave it."

35. Interview, Cuernavaca, November 1997.

36. Preface to the catalog of the 1941 Lempicka show, Julien Levy Galleries.

37. Hayden Herrara, "Frida Kahlo," *Vanity Fair*, 186. Although Lempicka had little if any actual contact with Frida Kahlo, she appreciated her habit of "doing what she wanted" while she "kept her husband [Diego Rivera] happy." Presumably Tamara was referring to the myriad affairs Kahlo had during the thirties, with celebrities ranging from Isamu Noguchi (later a friend of Tamara's) to Leon Trotsky. What Lempicka overlooked in her admiration of the Mexican couple was Diego Rivera's canny tutoring of Frida. He urged her to make contacts in the social and art worlds that mattered in the U.S.—"from the Rockefellers and Louise Nevelson . . . to that other amazon of art history, Georgia O'Keeffe," in Herrara's words.

38. *New York World Telegram*, 24 March 1941.

39. *Art News*, 14 April 1941.

40. *New York Times*, 13 April 1941.

41. *San Francisco Examiner*, 15 September 1941.

42. *New York Journal American*, 24 March 1941.

43. *New York Times*, 26 March 1941.

44. *Sunday Mirror Magazine*, 6 April 1941.

45. Cheyenne, Wyoming, *State*, 9 April 1941.

46. Baton Rouge, 19 July 1941.

47. Columbus, Ohio, *Dispatch*, 20 April 1941.

48. *New York World Telegram*, 12 April 1941.

49. *Los Angeles Examiner*, 24 March 1941.

50. *Los Angeles Times*, 8 May 1941.

51. *Script*, 24 May 1941.

52. *Los Angeles Herald Express*, 14 May 1941.

53. *Los Angeles Times*, 18 May 1941.

54. *Los Angeles Times*, 15 May 1941.

55. *San Francisco Call Bulletin*, 18 September 1941.

56. *New York Times*, 18 November 1941.

57. *Los Angeles Times*, 10 October 1941.

58. *Los Angeles Herald Express*, 4 October 1941.

59. Julien Levy, *Memoir of an Art Gallery*, 98.

60. *Los Angeles Express*, 30 November 1940.

61. KF, Houston, February 1996.

62. Wright, 295.

63. Letter to the author, September 1997.

64. Wright, 299.

65. To the painter, the dual roles of famous artist and dress designer were not incompatible. Fashion and art had wed publicly and successfully in France during the previous decades; even Christian Bérard, who showed with Tamara in one of the 1941 Levy exhibitions, had designed costumes for a French production of *Cyrano de Bergerac* two years earlier. She simply failed to notice that such marriages of aesthetics were not encouraged in the United States.

66. Letter to the author, November 1996.

67. Stephen Birmingham, *The Right People*, 247, 253.

68. Ibid., 262.

69. KF, phone interview, February 1995.

70. Gill Perry's *Women of the Avant-Garde* describes postwar shifts in the professional positions occupied by women painters and the lack of a new critical vocabulary with which they could describe their visions.

71. Clement Greenberg, "Avant-Garde and Kitsch," *Partisan Review*, 34–39.

72. I have relied heavily upon Arthur Danto's interpretations of Greenberg. Danto delivered the spring 1995 series of Mellon lectures at the National Gallery in Washington, D.C., during which he elaborated upon the theories Greenberg put forth throughout his career.

73. KF, phone interview, February 1995.

74. Kizette showed me the only extant letter from her grandmother, Houston, April 1997.

75. *Bulletin*, Milwaukee Art Institute, March 1942.

# Chapter 10. Art in the New World

1. Cobina Wright, *I Never Grew Up*, 197.
2. David Cohen, letter to the author, November 1996.
3. Martin Shallenberger, Cuernavaca, November 1997.
4. Ibid.
5. KF, Houston, February 1997.
6. Ibid.
7. KF, Houston, April 1996.
8. Shallenberger, Cuernavaca, November 1997.
9. Anne-Marie Warren, McLean, Virginia, January 1997.
10. KF, Houston, May 1997.
11. Richard White, Cuernavaca, July 1996.
12. Shallenberger, Cuernavaca, November 1997.
13. Garreau "Manha" Dombasle, Deauville, France, 27 July 1995.
14. Unpublished interview, 203.
15. Kizette recounts this episode in *Passion*, 145; and Tamara describes it herself, unpublished interview, 67.
16. Mala Rubenstein Silson, New York City, June 1996.
17. Ibid.
18. *Washington Post*, 2 February 1997.
19. KF, Houston, March 1997.
20. Simha Rotem (Kazik), *Memoirs of a Warsaw Ghetto Fighter*, 85.
21. KF, Cuernavaca, November 1995.
22. Françoise Dupuis de Montaut, letter to the author, 31 October 1997.
23. Ibid.
24. Silson, letter to the author, January 1997.
25. KF, Ibid.
26. Silson, New York City, June 1996.
27. Unpublished interview, 203.
28. Françoise Dupuis de Montaut, letter to the author, October 1997.
29. KF, Houston, April 1996 and May 1997.
30. KF, phone interview, November 1996.
31. Unpublished interview, 14.
32. Gill Perry, *Women Artists and the Parisian Avant-Garde*, 144, 148.
33. Jonathan Fineberg, *Art Since 1940: Strategies of Being*, 153.
34. Ida Gleizer, phone interview, December 1996 and January 1997.
35. Unpublished interview, 108.
36. Richard White, Cuernavaca, July 1996 and November 1997.
37. Victoria Doporto, phone interview, May 1996.
38. Raoul Kuffner, *Planomania*.
39. KF, Houston, May 1997 and April 1996.
40. Unpublished interview, 15.
41. Krystyna Wolanczyk provided her memories of the Polish community's reaction, and the Polish embassy provided documentation of the appointment.

42. Octavio Paz, *Essays on Mexican Art*, 20.

43. Calvin Tompkins, *Duchamp*, 361.

44. Ibid.

45. Michael Peppiatt, summarizing Carter Ratcliff, *New York Times Book Review*, 16 February 1997.

46. William Simpson, phone interview, November 1995.

47. KF, Houston, November 1996 and March 1997.

48. A brief history of Madame Grès appears in Madge Garland, *Fashion: 1900–1939*, 59.

49. George Schoenbrunn, letter to the author, July 1997.

50. In her last years, Tamara still conflated the endings of the two world wars. Although she had experienced the 1918 armistice in Paris and V-E day in New York, she transplanted her account of the latter onto her fondest early memories, collapsing the two wars into one victory: "The war was in Europe. I was in the street in Paris. I went into a shop. And in this shop was a television, that the war was won. America won the war, the war was finished, and we all kissed each other, in the street. The vendeuse were kissing me and I was kissing the passersby. And we were so happy that the war was over . . . [and then] I decided to go back to Europe." Unpublished interview, 87.

51. Garreau "Manha" Dombasle, Deauville, July 1995.

52. Françoise Gilot, *Arts and Antiques*, 87.

53. Krystyna Wolanczyk showed me her pictures of Lulu's living room in Paris, where she exhibited large portraits of her stepfather.

54. Tonio Selwart, New York City, June 1996.

55. As Joan Didion remembers, "When we left New York to go to California, I think I'd had a low-grade hangover for eight years. . . . With all those drinks at lunch, and drinking all night, I think we all did." Quoted in Dan Wakefield, *New York in the Fifties*, 232.

56. Wakefield, 232.

57. Unpublished interview, 174.

58. Victoria Doporto, Houston, April 1996.

59. KF, Houston, March 1997.

60. From Tadeusz Lempicki's State Department file, the Republic of Poland, courtesy of Juroslaw Lasinski.

61. Letter to the author, September 1997.

62. KF, Houston, March 1997.

63. Krystyna Wolanczyk, interview, Arlington, Virginia, July 1997.

64. Ibid.

65. The book *Bircher-Benner's Health Giving Dishes* describes this routine, but Kizette explained the exact regimen her family followed. Not everyone remembers the clinic so fondly; Anne-Marie Warren says, "It was absurd, a silly place." McLean, Virginia, January 1997.

66. When questioned about comments on the late medical records noted such intestinal problems, Kizette said, "Oh, yes, my mother was often in pain throughout her life from her stomach and [from] female problems as well." Houston, May 1997.

67. KF, Cuernavaca, November 1995.

68. Ibid.

69. Alain Blondel remembered reading the telegram quickly several years ago, when a family member showed him correspondence between Puglisi and Lempicka.

70. Mala Rubenstein Silson, New York City, June 1995.

71. Victoria Doporto, phone interview, June 1998.

72. Kizette claims that her mother had not yet visited Cuernavaca at this point; if her memory is correct, then the painting was named retrospectively, or by someone else.

73. KF, Houston, February 1997.

74. VC, in conversations in Cuernavaca and in various telephone interviews. Contreras quotes this statement often.

75. Victoria Doporto, phone interview, August 1997.

76. Ibid.

77. Ibid.

78. Ibid.

79. Connie Stutters, letter to the author, July 1996.

80. Ibid.

81. KF, letter to the author, 13 June 1996.

82. Victoria Doporto, Houston, March 1997.

# Chapter 11. A Decade Framed by Death

1. KF, Houston, March 1997 and May 1997.

2. Even Alain Blondel, in his various conversations with me, has dismissed the show this way.

3. Michel Witmer kindly provided the historical perspective on palette knife painting in a letter to the author, 15 January 1996.

4. KF, Cuernavaca, January 1995. Peter Kuffner remains a shadowy figure in Tamara's life. To two letters he has responded that he has "nothing to say about my stepmother, Tamara de Lempicka, or my father." Newspaper accounts confirm Kizette's recollection that Kuffner was among the first men to land on the Normandy beaches. After his return from the war, he attended the University of Chicago. He now lives in a small town in Texas.

5. Miscellaneous documents from the estate papers of Raoul Kuffner de Dioszegh.

6. KF, Houston, March 1997. Tamara told Kizette how she heard the news from Henry Kolar.

7. Unpublished interview, 189.

8. Estate papers, Albany, New York.

9. Letter to the author, 20 November 1997, Springfield, Oregon. In general, both Peter and Louisanne Kuffner declined to speak of their father or stepmother.

10. David Cohen, New York, June 1996.

11. Estate papers.

12. David Cohen, New York City, June 1996, and in letter to the author, 20 February 1997.

13. Letter from David Cohen to Polly Rubin, Sotheby's, New York, 24 November 1980. When, after Lempicka's death, Sotheby's contacted Kizette to verify the study's authenticity, the daughter pleaded ignorance. Almost twenty years after the gift was given to Cohen, in 1980 it could not even meet the reserve of $2,000 set by the auction house when the owner tried to sell it.

14. Priscilla Chapman, *New York Herald Tribune*, 28 November 1961.

15. KF, Houston, March 1997.

16. Alexander Molinello, Houston, November 1994.

17. Herb Kraft, phone interview, June 1997.

18. Alexander Molinello, Houston, November 1994.

19. Garreau "Manha" Dombasle, Deauville, July 1995.

20. Phone interviews with Ewing and Holmes, Houston, November 1995.

21. Anne Holmes, *Houston Chronicle*, 17 December 1977. Though this description was printed ten years after Tamara's move to Houston, friends confirm that Tamara created the same dramatic appearance whenever she first appeared in public in "that little city."

22. Phone interview, January 1996.

23. KF, Houston, February 1996.

24. Letter to the author, 6 November 1996.

25. William Simpson, phone interview, January 1996.

26. Victoria Doporto, phone interviews, Houston, November 1996, March 1997, and January 1997.

27. Alexander Molinello, Houston, November 1995.

28. Calvin Tompkins, *Duchamp*, 345.

29. Hilton Kramer, *New York Times*, 3 November 1963.

30. Victoria Doporto, phone interview, November 1996.

31. Victoria Doporto, phone interview, November 1996, March 1997, and 12 August 1997.

32. Countess Anne-Marie Warren, McLean, Virginia, January 1997.

33. Unpublished interview, 20.

34. George Schoenbrunn, letter, 21 September 1997; Wade Barnes, phone interview, 12 May 1997.

35. Garreau "Manha" Dombasle, Deauville, July 1995.

36. Alexander Molinello, Houston, November 1994.

37. Anne-Marie Warren, McLean, Virginia, January 1997.

38. Alexander Molinello, Houston, November 1995.

39. Victoria Doporto, phone interview, 11 January 1997.

40. Françoise Gilot, "Tamara," *Arts and Antiques*.

41. George Schoenbrunn, letter, 28 January 1997.

42. Jane Owen, Houston, November 1995.

# *Chapter 12. Paradise in Mexico*

1. Françoise Dupuis de Montaut, letter to author, 2 October 1998.

2. KF, Houston, May 1997.

3. Alain Blondel, Paris, July 1995.

4. Garreau "Manha" Dombasle, Deauville, July 1995.

5. Alain Blondel, Paris, July 1995.

6. Florent Fels, Monaco, August 1972.

7. Alexander Molinello, Houston, November 1994.

8. Victoria Doporto, phone interview, Cuernavaca, January 1995.

9. Muriel Wolgin, Philadelphia, November 1996.

10. Rumors were circulated that during the last years of her life, Josephine Baker was married to Robert Brady. The archives at the Robert Brady Museum in Cuernavaca contain speculative gossip on the match, but they establish no proof.

11. Muriel Wolgin, among others still living in Cuernavaca, affirmed the "nasty underside" of the charming Robert Brady, Philadelphia, November 1996.

12. Franco Maria Ricci, introduction to Pierre Chiara and Federico Roncoroni, *Tamara de Lempicka*, 13.

13. From the contract, originally in French and translated into English at the time of transaction, 27 June 1973, Milan.

14. Countess Anne-Marie Warren, McLean, Virginia, January 1997.

15. Ibid.

16. Jane Owen, Houston, November 1996.

17. Robert Hewell, Robert Piro, Muriel Wolgin, and Anne-Marie Warren were among the many friends who mentioned this behavior; Countess Warren believes that Houstonites became embarrassed by the spectacle and stopped inviting Tamara anywhere as a result.

18. Seattle, June 1997.

19. Muriel Wolgin, Philadelphia, November 1996.

20. George Schoenbrunn, letter to the author, 28 January 1997.

21. Robert Piro and his daughter, Carolyn, Houston, November 1994.

22. Pattie Davidson, Washington, D.C., September 1994.

23. Pattie Davidson was kind enough to share with me the letters she wrote to her parents during her brief employment with Tamara, from which the following quotations are taken.

24. Pattie Davidson, Washington, D.C., September 1994.

25. Anne-Marie Warren, McLean, Virginia, January 1996.

26. Pattie Davidson, letter.

27. Anne-Marie Warren, McLean, Virginia, January 1996.

28. Pattie Davidson, Washington, D.C., September 1994.

29. Letter to the author, Connie Stutters, 15 April 1996.

30. Pattie Davidson, letter to her parents, Zurich, 4 June 1974.

31. Ibid.

32. Based on her social records, Jeanclaire Salsbury reconstructed her schedule from the years with Tamara; this record is called "Calendar Gleanings."

33. Tony Duquette, phone interview, June 1997.

34. Jeanclaire Salsbury, "Calendar Gleanings," 3.

35. Allen Salsbury, Seattle, June 1996.

36. Victoria Doporto, Houston, March 1997.

37. Muriel Wolgin, Philadelphia, November 1996.

38. Jeanclaire Salsbury, letter to the author, 6 July 1997.

39. Ibid.

40. Ibid.

41. Ibid.

42. Raymond Abner, phone interview, June 1998.

43. Jeanclaire Salsbury, Seattle, June 1996.

44. Muriel Wolgin, Philadelphia, November 1996.

45. Elizabeth Gimbel, Cuernavaca, July 1996.

46. Gimbel, letter to the author, July 1997. The comment about guitarists refers to Kizette's boyfriends; acquaintances in Cuernavaca claim that she was quite open and casual about such relationships at the time. It would have been awkward for her mother to protest on moral grounds, given her own past, but the affairs made Tamara nervous because of their pub-

lic nature and the money Kizette inevitably spent on the men. The 1970s had ushered in a freedom that Tamara considered indecorous because it lacked even a tacit code of conduct.

47. Elizabeth Gimbel, Cuernavaca, July 1996.

48. Victor Contreras, Cuernavaca, November 1997.

49. Jeanclaire and Allen Salsbury, Seattle, June 1996.

50. Letter to the author, 5 April 1996. According to Contreras, she had aged "tremendously" during the twenty years since they had last met.

51. *Tribune De Genève*, 2 September 1975, "Au petit palais," Arnold Kohler.

52. Victor Contreras, Cuernavaca, January 1995.

53. Victor Contreras, Cuernavaca, January 1995, June 1996, August 1995.

54. Elizabeth Gimbel, letter to author, July 1997. Jeanclaire Salsbury also recalls what a dramatic sight the newly purple Tres Bambús provided after Lempicka took her paintbrush to the house itself. Seattle, June 1996.

55. Jeanclaire Salsbury, Seattle, June 1996.

56. Garreau "Manha" Dombasle, Deauville, July 1995.

57. Arielle Dombasle, phone interviews from Deauville and Paris, July 1995.

58. The medical information comes from the records released to me by Park Plaza Hospital in Houston; information on Tamara's cigarette habit from various anecdotes told by her friends.

59. KF, Houston, April 1995.

60. Ibid.

61. The buyer of such an annuity is in effect betting on outliving the purchase: if the invested funds were spent in ten years, for example, and the investor lived twenty years, she would be receiving ten years of "free" monthly income. Conversely, if she lived only five years, the underwriter of the annuity would benefit.

62. Roger Hewell, Royal Oaks Bank, Houston, November 1995.

63. KF, Houston, March 1997.

64. Jeanclaire Salsbury, "Calendar Gleanings," 5.

65. Victor Contreras, Cuernavaca, January 1996.

66. Richard Piro, Houston, November 1995.

67. George Schoenbrunn, letter to the author, September 1997.

68. William Packer, "Dada and the New Reality," *Financial Times*, 20 September 1977.

69. Ibid.

70. Dorothy D. Bosomworth, "The Arts in Europe," *Connoisseur*, September 1977.

71. In reality, she apparently had trusted Ricci to produce the book she wanted, since she had not written him a reminder that she had the right of review before publication.

# Chapter 13. The Art of the Volcano

1. Her friend Elizabeth Gimbel recalls that Tamara became noticeably weaker during this period. Letter to the author, September 1997.

2. Richard White, Cuernavaca, June 1996 and November 1997.

3. Marmori in Piero Chiari and Federico Roncoroni, eds., *Tamara de Lempicka*, 15.

4. Unpublished interview, 73.

5. Letter to the author, 15 April 1996.

6. Included in Connie Stutters's personal papers, copy sent to the author, 15 April 1996.

7. Letter to the author, 15 March 1996.

8. Richard White, Cuernavaca, June 1996.

9. Quoted in Anne Holmes, "Tamara de Lempicka," *Houston Chronicle*, 18 December 1977.

10. Larry Rivers, phone interview, November 1996.

11. Alain Blondel, Paris, July 1995.

12. Thomas Hess, "Larry Rivers Strikes Again," *Newsweek*, 14 November 1977.

13. Larry Rivers, phone interview, November 1996.

14. Holmes, "Tamara de Lempicka," 21.

15. Dorothy Seiberling, "Siren of a Stylish Era," *New York Times*, 1 January 1978.

16. Joanne Harrison, "Portrait of the Artist," 46.

17. Letter to Robert Brady, 17 February 1978. Victoria Doporto mentioned to me several times her grandmother's advice about using red to highlight important events.

18. Giancarlo Marmori, *Viva*, May 1978.

19. Countess Anne-Marie Warren, McLean, Virginia, January 1997.

20. Letter to Franco Maria Ricci, 20 December 1977.

21. Letter from Ricci, 13 April 1978.

22. Letter from Ricci, 30 May 1978.

23. Harrison, "Portrait," 45.

24. Letter from Helen R. Auster, 20 June 1978.

25. Tamara's notes, "Complete Correspondance [*sic*] with Ricci," Cuernavaca, 20 September 1978.

26. Harrison, whose lively intelligence is accompanied by a largesse of spirit, ironically notes that Kizette, "so quick to sue anyone who might have infringed on her rights to the estate," in fact lifted sections from Harrison's work for her memoir, *Passion By Design*. "The family asked if I was interested in doing a biography of the artist, and I simply didn't want to get involved in all the control issues involved," she states. Houston, November 1995.

27. Harrison, "Portrait," 46.

28. Harrison, Houston, November 1995.

29. Joanne Harrison, "Inside City," *Houston City Magazine*, August 1978.

30. Harrison, "Portrait," 47.

31. This material taken from Tamara de Lempicka, "Notes on Paris Trip," October 1978.

32. KF, Houston, April 1995.

33. The payment is recorded in Lempicka's personal financial records of the October trip to Paris; Garreau "Manha" Dombasle testified to Bazin and Lempicka's mutual admiration and friendship.

34. Several copies of this statement are filed in the family records (Houston) of the Ricci publication and its aftermath; they are invariably underlined in red.

35. Letter from W. Duchemin, SPADEM, to Tamara de Limpicka [*sic*], Paris, 24 October 1978.

36. "Le Corps et Son Image," *Echo Therapie*, Paris, #24, 1978.

37. "Around the Galleries," *Herald Tribune*, Paris, 30 December 1978.

38. Among Lempicka's financial papers and notes for the October trip is a torn-out page listing the local exhibitions with the notice of the Pascin show highlighted.

39. Jeanclaire Salsbury, Seattle, June 1996.

40. Oscar Cevallos Figueroa, "Tamara de Limpika [*sic*], Marvellous Painter of Kings and Prostitutes," *Diario de Morelos*, 18 June 1978.

41. Genevieve Breerette, "Expositions," *Le Monde*, 17 February 1979.

42. Barry Friedman says that he can easily envision such a scene, based on his experience at the 1991 *Metropolis* exhibit at the Montreal Museum of Fine Arts. In a room of exquisite twentieth-century masterpieces, the Lempickas "stood out, no matter what was around them. They're what everyone wanted to examine first." New York, February 1995.

43. Unpublished interview, 209–10.

44. Jeanclaire Salsbury believes that in spite of the way Tamara "praised him to the skies" after he died, the artist never believed Harold Foxhall was right for Kizette. "He was a sweet, tolerant man," Salsbury recalls. "But he wasn't the man [Tamara] thought her daughter should have married."

45. Unpublished interview, 167.

46. Ibid., 176.

47. Victor Contreras, Cuernavaca, June 1996.

48. Unpublished interview, 193.

49. Ibid.

50. Ibid., 209.

51. Muriel Wolgin, Philadelphia, November 1996.

52. Victor Contreras, Cuernavaca, June 1996.

53. Unpublished interview, 173.

54. Ibid., 95.

55. Ibid., 175.

56. Ibid., 173, 210.

57. Ibid., 55.

58. Ibid.

59. Eiko Ishioka and Tsuji Masuda, eds., *Tamara de Lempicka*, 10–11.

60. Victor Contreras, Cuernavaca, November 1997 and January 1995.

61. Three or four people have related this story to me, but Victor Contreras's thorough chronology and financial records appear to substantiate and complete the others' memories.

62. Victor Contreras, August 1995. Tamara's transaction called upon Louis Reynes for the legal work; copies of this and other such papers are among the archival collection Victor Contreras maintains at his home in Cuernavaca.

63. From the business files of Victor Contreras, Cuernavaca, August 1995.

64. Jeanclaire Salsbury, Seattle, June 1996.

65. Oscar D'Amico, phone interview, November 1996.

66. Ibid.

67. Leah Erickson, phone interview, December 1996.

68. Victor Contreras, Cuernavaca, January 1995.

69. Victor Contreras, Cuernavaca, June 1997.

70. Harrison, "Portrait," 48.

71. Last will and testament, Tamara Kuffner de Dioszegh, filed 15 April 1980 with the county clerk, Harris County, Texas. The document refers to the painter by three name variations, not including her professional name.

72. Victor Contreras, Cuernavaca, various conversations, 1995–1997; Jeanclaire Salsbury, Seattle, June 1996; letters and phone calls from Salsbury, January 1996–1997.

# Chapter 14. Pompeii Revisited

1. Huerta, now dead and unable to defend herself, seems to be the major focus of such conjecture for both Contreras and Kizette Foxhall.

2. KF, Houston, April 1995.

3. Eiko Ishioka and Tsuji Masuda, *Tamara de Lempicka*.

4. Victor Contreras, Cuernavaca, August 1995.

5. Wanda McDaniel, "Strolling Players," *Vanity Fair,* May 1985.

6. George Spelvin, "With an Audience of Stars and a Mansion for a Stage, Hollywood Gets a Bright Tamara," *People,* 22 July 1985.

7. Lynn Wexler, phone interview, May 1996.

8. All quotations are taken from the promotional brochure for the New York production.

9. Ibid.

10. Robert Smith, "Deco and Decadence," *New York Times Book Review,* 8 November 1987.

11. *Art in America,* November 1992.

12. Henry Radoff, Houston, November 1994.

13. *Art in America,* November 1992.

14. Ann Duncan, "Montreal Puts Extra Effort into Museum Day Celebration," *Montreal Gazette,* 25 May 1994.

15. Ibid.

16. The gracious and equally forthright Agnes Gund, president of the Museum of Modern Art in New York, wrote that "about Lempicka's work, I am not any kind of expert or even very knowing at all, yet I find it fascinating as a style of a period. I don't know if I'd be able to live with one except if I had the surrounding ambience, decor, furniture. The work is bold, sensuous, and forceful. One can become a bit overwhelmed by it." Letter to the author, February 1997.

Even Poland's art world is unsure whether to claim Tamara or not. In 1997 the minister of culture told me politely that Tamara's works are not well known in Warsaw because the Polish cognoscenti have never been particularly interested in haute bourgeoisie painting. Russia will perhaps experience the same problem if historians try to write her into their annals. And Europe wants her only in her manifestation as a Parisian painter, the very rubric that has limited appreciation of her until now as well as heightened it among Hollywood devotees of Art Deco.

Very few histories of twentieth-century art include Tamara de Lempicka either, even ones dedicated to resuscitating women whose achievements were unfairly buried. Edward Lucie-Smith proves the exceptions; he cites Tamara in *Race, Sex, and Gender in Contemporary Art,* 139.

17. See the provocative articles on defining Modernism by Arthur Danto, "Too Old for MOMA?" *New York Times,* 28 October 1998; and by Roberta Smith, "Defining a Term Depends on What You're Looking For and At," *New York Times,* 28 October 1998.

18. Not that such association alone would promote the talented woman's chances: Jane Freilicher, "adored" by the men she hung out with at the Cedar Tavern (Frank O'Hara, and Larry

Rivers, whom she married and later divorced), was painting her flower pictures in the fifties to no great interest, either among her artist friends or the general public. Only forty years later would she begin to gain the respect she had sought during the peak of Abstract Expressionism.

19. Royce Burton, Washington, D.C., June 1994 and September 1996.

20. Stanley Williams, *Christian Science Monitor,* June 1996.

21. Howard LaFranchi, "Popocatépetl Sure to Erupt, but When?" *The News,* Mexico City, 29 June 1996.

# BIBLIOGRAPHY

～

Allen, Raye Virginia. *Gordon Conway: Fashioning a New Woman*. Austin: University of Texas, 1997.

Alpers, Svetlana. *The Art of Describing*. Chicago: University of Chicago, 1983.

Altshuler, Bruce. *The Avant-Garde in Exhibition: New Art in the 20th Century*. New York: Abrams, 1994.

Anscombe, Isabelle. *A Woman's Touch: Women in Design from 1860 to the Present Day*. London: Virago, 1984.

Arwas, Victor. *Art Deco*. New York: Harry N. Abrams, 1980.

Ashton, Dore. *The New York School: A Cultural Reckoning*. New York: Penguin, 1972.

Bailey, Anna. *A Time of Transition: Female Representation in France 1914–1924*. M.A. Thesis, Courtauld Institute, 1991.

Barolsky, Paul. *Michelangelo's Nose: A Myth and Its Maker*. University Park: Pennsylvania State University Press, 1990.

Barr, Alfred H., Jr. *Cubism and Abstract Art*. New York: Museum of Modern Art, 1936.

Battersby, Martin, et al., eds. *Fashion: 1900–1939*. Exh. cat. London: Scottish Arts Council and the Victoria and Albert Museum, 1975.

Belyakova, Zoia. *The Romanov Legacy: The Palaces of St. Petersburg*, ed. Marie Clayton. New York: Viking Studio Books, 1994.

Benjamin, Roger. *Matisse's Notes of a Painter: Criticism, Theory, and Context 1891–1908*. Ann Arbor, Mich.: U.M.I. Research Press, 1987.

Benjamin, Walter. "The Work of Art in the Age of Mechanical Reproduction." In *Illuminations*, edited and with introduction by Hannah Arendt, translated by Harry Zohn, 219–53. London: Fontana/Collins, 1973.

Benstock, Shari. *Women of the Left Bank: Paris, 1900–1940*. Austin: University of Texas Press, 1986.

Berenson, Bernard. *Studies in the Theory of Connoisseurship from Vasari to Morelli*. New York: Garland, 1988.

———. *The Italian Painters of the Renaissance*. London: Phaidon, 1952.

Betterton, Rosemary, ed. "How Do Women Look? The Female Nude in the Work of Suzanne Valadon." In *Looking On: Images of Femininity in the Visual Arts and the Media*. London: Pandora, 1987.

Bircher-Benner, M.O. *Health Giving Dishes*, ed., Bertha Brupbacher-Bircher. London: Edward Arnold, n.d.

Birmingham, Stephen. *The Right People*. Boston: Little Brown, 1958.

Blondel, Alain. *Tamara de Lempicka: Catalogue Raisonné 1921–1979*. Lausanne, Switzerland and Paris: Editions Acatos [forthcoming].

Bossaglia, Rossana. "The Enigmatic Wanda." *Arte* 20 (November 1990): 90–93.

Bowlt, John E., ed. and trans. *The Salon Album of Vera Sudeikin-Stravinsky.* Princeton, N.J.: Princeton University Press, 1995.

Breeskin, Adelyn D. *Romaine Brooks.* Exh. cat. Washington, D.C.: National Museum of American Art, Smithsonian Institution, Smithsonian Institution Press, 1986.

Buchloh, Benjamin H. D., S. Guilbaut, and David Solkin, eds. *Modernism and Modernity: The Vancouver Conference Papers.* Halifax: The Press of the Nova Scotia College of Art and Design, 1983.

Burke, Carolyn. *Becoming Modern: The Life of Mina Loy.* Berkeley: University of California Press, 1997.

Cahm, Eric. *Politics and Society in Contemporary France 1781–1971.* London: Harrap, 1972.

Calvesi, Maurizio, and Alessandra Borghese, eds. *Tamara de Lempicka: Elegant Transgressions.* Rome: Accademia di Francia; Montreal: Museum of Fine Art, 1994.

Capote, Truman. *Answered Prayers: The Unfinished Novel.* New York: Vintage, 1994.

Chadwick, Whitney. *Women Artists and the Surrealist Movement.* Boston: Little, Brown and Co., 1985.

———. *Women, Art, and Society.* London: Thames and Hudson, 1996.

Chadwick, Whitney, and Isabelle Courtivron, eds. *Significant Others: Creativity and Intimate Partnership.* London: Thames and Hudson, 1993.

Chiara, Piero, and Federico Roncoroni, eds. *Tamara de Lempicka: With the Journal of Aélis Mazoyer, Gabriele d'Annunzio's Housekeeper.* Translated by John Shepley. Milan: Franco Maria Ricci, 1977.

Chipp, Herschel. *Theories of Modern Art: A Source Book by Artists and Critics.* Berkeley: University of California Press, 1968.

Cipriani, Arrigo. *Harry's Bar: The Life and Times of the Legendary Venice Landmark.* New York: Arcade Publishing, 1996.

Clair, Jean, ed. *The 1920s: Age of the Metropolis.* Exh. cat. Montreal: Montreal Museum of Fine Arts, 1991.

Copley, Antony. *Sexual Moralities in France, 1780–1980.* London: Routledge, 1989.

Crane, Diane. *The Transformation of the Avant-Garde: The New York Art World, 1940–1985.* Chicago: Chicago University Press, 1987.

Crawford, Rosemary, and Donald Crawford. *Michael and Natasha: The Life and Love of Michael II, the Last of the Romanov Tsars.* New York: Scribner, 1997.

Danto, Arthur. *After the End of Art.* Princeton, N.J.: Princeton University Press, 1997.

Davidson, Abraham A. *Early American Modernist Painting: 1910–1935.* New York: Harper and Row, 1981.

Davies, Norman. *God's Playground: A History of Poland,* Vol. II. New York: Columbia University Press, 1982.

———. *Heart of Europe: A Short History of Poland.* Oxford: Clarendon Press, 1984.

Day, Maria Anne. "Art Deco Reconsidered: The Streamline Moderne in the Architecture and Sculpture at the 1939 New York World's Fair." M.A. thesis, University of Maryland at College Park, 1994.

De Grazia, Victoria. *The Culture of Consent: Mass Organization of Leisure in Fascist Italy.* Cambridge: Cambridge University Press, 1981.

Denis, Maurice. "Definition of Neotraditionism." In *Théories: 1890–1910.* 4th ed., 1–13. Paris: Rouart et Watelin, 1920.

Derrida, Jacques. *The Truth in Painting.* Translated by Geoff Bennington and Ian McLeod. Chicago: University of Chicago Press, 1987.

Dorival, Bernard. *Les etapes de la peinture française contemporaine.* 3 vols. Paris: Gallimard, 1943, 1944, 1946.

———. *The School of Paris in the Musée d'Art Moderne.* New York: Harry N. Abrams, 1962.

Dowling, Linda. *Aestheticism and Decadence: A Selective Bibliography.* New York and London: Garland Publishing, 1977.

Duncan, Carol. "Virility and Domination in Early Twentieth-Century Vanguard Painting." In *Feminism and Art History: Questioning the Litany,* eds. Norma Broude and Mary Garrard. New York: Harper and Row, 1982.

Duncan, David Douglas. *Picasso Paints a Portrait.* New York: Abrams; London: Thames and Hudson, 1996.

Dunford, Penny. *A Biographical Dictionary of Women Artists in Europe and America Since 1850.* Philadelphia: University of Pennsylvania Press, 1989.

Eagleton, Terry. *The Ideology of the Aesthetic.* London: Routledge, 1989.

Eisler, Benita. *O'Keeffe and Stieglitz: An American Romance.* New York: Penguin Books, 1991.

Elliott, Bridget, and Jo-Ann Wallace. *Women Artists and Writers: Modernist (im)positionings.* London: Routledge, 1994.

Felski, Rita. *The Gender of Modernity.* Cambridge: Harvard University Press, 1995.

Fergusson, Erna. *Cuba.* New York: Knopf, 1946.

Fineberg, Jonathan. *Art Since 1940: Strategies of Being.* New York: Prentice Hall, 1995.

Flanner, Janet. *An American in Paris: Profile of an Interlude Between Two Wars.* New York: Simon and Schuster, 1940.

———. *Paris Was Yesterday.* New York: Angus and Robertson, 1973.

Fleming, Bruce. "Technique in Painting." *Centennial Review.* (Winter 1996): 159–69.

Forgacs, David, and Robert Lumley, eds. *Italian Cultural Studies.* Oxford: Oxford University Press, 1996.

Frascina, Francis, ed. *Jackson Pollock and After: The Critical Debate.* New York: Harper and Row, 1985.

Frascina, Francis, and Charles Harrison, eds. *Modern Art and Modernism: A Critical Anthology.* London: Open University Press, 1982.

Friedlander, Max J. *On Art and Connoisseurship.* Boston: Beacon Press, 1960.

Fromm, Bella. *Blood and Banquets: A Berlin Social Diary.* New York: Carol Publishing, 1990.

Garb, Tamar. "L'Art Feminin: The Formation of a Critical Category in Late Nineteenth-Century France." *Art History* 12 (1989): 39–65.

———. *Women Impressionists.* London: Phaidon, 1986.

Garland, Madge, et al. *Fashion 1900–1939.* London: Idea Books, 1975.

Gee, Malcolm, ed. *Art Criticism Since 1900.* Manchester, Eng.: Manchester University Press, 1993.

———. *Dealers, Critics and Collectors of Modern Painting: Aspects of the Parisian Art Market Between 1910 and 1930.* New York and London: Garland Press, 1981.

Gibson-Wood, Carol., ed. *Studies in the Theory of Connoisseurship from Vasari to Morelli.* New York: Garland, 1988.

Gilot, Françoise. "Tamara," *Arts and Antiques* (February 1986): 25–27.

Gimpel, René. *Diary of an Art Dealer.* London: Hamish Hamilton, 1986.

Gluck, Sherna Berger, and Daphne Patai. *Women's Words: The Feminist Practice of Oral History.* New York: Routledge, 1991.

Gold, Arthur, and Robert Fitzdale. *Misia: The Life of Misia Sert.* New York: Knopf, 1980.

Golding, John. *Visions of the Modern.* Berkeley: University of California Press, 1994.

Goldscheider, Ludwig. *Five Hundred Self-Portraits: From Antique Times to the Present Day in Sculpture, Painting, Drawing, and Engraving.* Vienna: Phaidon, 1937.

Goldwater, Robert J. *Primitivism in Modern Painting.* New York: Harper and Row, 1938.

Green, Christopher. *Cubism and Its Enemies: Modern Movements and Reaction in French Art, 1916–28.* New Haven: Yale University Press, 1987.

Greenberg, Clement. *Art and Culture.* London: Thames and Hudson, 1961.

———. "Avant-Garde and Kitsch," *Partisan Review* (Fall 1939):34–49.

Guggenheim, Peggy. *Out of This Century: Confessions of an Art Addict.* New York: Universe, 1946.

Guilbaut, Serge. *How New York Stole the Idea of Modern Art: Abstract Expressionism, Freedom, and the Cold War.* Translated by Arthur Goldhammer. Chicago: Chicago University Press, 1983.

Halecki, O. *A History of Poland.* New York: Roy Publishers, 1942.

Hall, Michael, and Eugene Metcalf, eds. *The Artist Outsider.* Washington, D.C.: Smithsonian Institution, 1994.

Hamilton, Charles. *Auction Madness: An Uncensored Look Behind the Velvet Drapes of the Great Auction Houses.* New York: Everest House, 1981.

Hamilton, George Heard. *Painting and Sculpture in Europe 1880–1940.* New Haven: Yale University Press, 1993.

Harrison, Joanne. "Portrait of the Artist," *Houston City Magazine* (August 1978): ii, 38–49.

Heine, Marc. *Poland.* New York: Hippocrene Books, 1987.

Hess, Thomas B. "Larry Rivers Strikes Again," *New York Magazine* 14 (November 1977): 117-19.

Heymann, David C. *Poor Little Rich Girl: The Life and Legend of Barbara Hutton.* Secaucus, N.J.: Lyle Stuart, 1983.

Hillier, Bevis, and Stephen Escritt. *Art Deco Style.* London: Phaidon, 1997.

Hippius, Zinaida. *Between Paris and St. Petersburg.* Trans. and ed. by Temira Pachmuss. Urbana: University of Illinois Press, 1975.

Hobhouse, Janet. *The Bride Stripped Bare: The Artist and the Nude in the Twentieth Century.* London: Jonathan Cape, 1988.

Hofmann, Paul. *The Fine Italian Hand.* New York: Henry Holt, 1990.

Hofmann, Werner. *Turning Points in Twentieth-Century Art: 1890–1917.* Trans. by Charless Kessler. New York: George Braziller, 1969.

Holme, Bryan, ed. *Master Drawings.* New York: American Studio Books, 1943.

Horn, Alfred, and Bozena Pietras, eds., *Poland.* Boston: Houghton Mifflin, 1996.

Humphrey, Grace. *Come with Me Through Warsaw.* Warsaw: M. Art Publishing, 1934.

Huyghe, René, ed. *Histoire de l'art contemporain; le peinture.* Reprint of the 1934 edition. New York: Arno Press, 1968.

Hyland, Douglas K. S., and Healther McPherson. *Marie Laurençin: Artist and Muse.* Birmingham: Birmingham Museum of Art, 1989.

Ishioka, Akiko. *Shozo shinwa: meikyu no gaka Tamara do Renpikka* [Tamara de Lempicka]. Tokyo: Parco, 1980.

Jackson, Kenneth T., ed. *Encyclopedia of New York City*. New Haven: Yale University Press; New York: New York Historical Society, 1995.

Jamison, Kay Redfield. *Touched with Fire: Manic Depressive Illness and the Artistic Temperament*. New York: Free Press, 1993.

Jay, Karla. *The Amazon and the Page: Natalie Clifford Barney and Renee Vivien*. Bloomington: Indiana University Press, 1988.

Jullian, Philippe. *D'Annunzio*. Trans. by Stephen Hardman. New York: Viking Press, 1973.

Kertess, Klaus. *Joan Mitchell*. New York: Harry N. Abrams, 1997.

Kiki. *Kiki's Memoirs*, ed. Billy Klüver and Julie Martin. Hopewell, N.J.: The Ecco Press, 1996.

Kimmelman, Michael. *Portraits: Talking with Artists at the Met, the Modern, the Louvre, and Elsewhere*. New York: Random House, 1998.

Krauss, Rosalind E. *The Originality of the Avant-Garde and Other Modernist Myths*. Cambridge: MIT Press, 1985.

Kuffner, Raoul. *Planomania: Capitalism Makes Sense*. Introduced by Willard E. Atkins and A. Anton Friedrich. New York: Richard R. Smith Publisher, Inc., 1951.

Kühn, Lenore. *Wir Frauen*. Langensalza: Beyer und Sohne, 1923.

Lavin, Maud. *Cut with the Kitchen Knife: The Weimar Photomontages of Hannah Höch*. New Haven: Yale University Press, 1993.

Lawrence, Mary. *Lovers*. New York: A & W Publishers, 1980.

Lempicka Foxhall, Kizette de, Baroness. *Passion by Design: The Art and Times of Tamara de Lempicka*. As told to Charles Phillips. New York: Abbeville Press; Oxford: Phaidon, 1987.

Leslie, R. F. *The History of Poland Since 1863*. Cambridge: Cambridge University Press, 1980.

Levy, Julien. *Memoir of an Art Gallery*. New York: G. P. Putnam's Sons, 1977.

Levy, Michael. *Painting and Sculpture in France: 1700–1789*. New Haven: Yale University Press, 1993.

Lewis, R.W.B. *The City of Florence*. New York: Farrar, Strauss and Giroux, 1995.

Liebman, Marcel. *The Russian Revolution*. Trans. by Arnold Pomerans. New York: Vintage, 1970.

Loos, Adolf. "Ornament and Crime (1908)." In *Programs and Manifestoes on 20th Century Architecture*, ed. Ulrich Conrads, 19–24. Trans. by Michael Bullock. London: Lund Humphreys, 1970.

Loy, Mina. *The Lost Lunar Baedecker*, ed. Roger L. Conover. New York: Farrar, Strauss and Giroux, 1996.

Lucie-Smith, Edward. *Art Deco Painting*. New York: Clarkson Potter, 1990.

———. "Modern Art," *Art and Auction* (October 1990): 211.

———. *Race, Sex, and Gender in Contemporary Art*. New York: Harry Abrams, 1994.

———. *Sexuality in Western Art*. London: Thames and Hudson, 1972.

McGeoch, Angus. *Moscow/St. Petersburg*. Munich: Nelles Verlag, 1994.

McKay, Gary. "And the Baroness Was an Artist: The Brushstrokes of Tamara de Lempicka." *Ultra* (March 1988): 26–32.

Mainardi, Patricia. *The End of the Salon*. Cambridge: Cambridge University Press, 1993.

*The Major Works of Tamara de Lempicka, 1925–1935*. Introduction by Giancarlo Marmori. Trans. by John Shepley. Milan: Idea Editions, 1978.

Mandelstam, Nadezhda. *Hope Against Hope: A Memoir*. Trans. by Max Hayward. New York: Atheneum, 1970.

Mann, Carol. *Paris Between the Wars*. New York: The Vendome Press, 1996.

Marchesseau, Daniel. *Marie Laurençin: Catalogue Raisonné of the Paintings*. San Francisco: Alan Wofsy Fine Arts, 1986.

Marmori, Giancarlo. "Tamara Is Forever: Portrait of a Forgotten Artist," *Viva* (May 1978): 59–62.

Marquis, Alice Goldfarb. *The Art Biz: The Covert World of Collectors, Dealers, Auction Houses, Museums, and Critics*. Chicago: Contemporary Books, 1991.

Mather, Frank Jewett. *A History of Italian Painting*. New York: Rinehart and Winston, 1962.

Matthews, Patricia. "Returning the Gaze: Diverse Representations of the Nude in the Art of Suzanne Valadon." *Art Bulletin* 73, no. 3 (1991): 415–30.

Meskimmon, Marsha. *The Art of Reflection: Women Artists' Self-portraiture in the Twentieth Century*. New York: Columbia University Press, 1996.

Michener, James. *Poland*. New York: Random House, 1983.

Morel, Pierre, ed. *Forty Painters and One Model: Suzy Solidor and Her Portrait Painters*. Paris: n.p., 1936.

Mori, Gioia. *Tamara de Lempicka: Paris 1920–1938*. Paris: Herscher, 1993.

Morris, James. *The World of Venice*. San Diego: Harcourt, Brace, 1974.

Mroczek, Krystyna, ed. *An Outline History of Polish Culture*. Warsaw: Wydawnictwo Interpress, 1984.

Mulvey, Laura. *The Visual and Other Pleasures: Language, Discourse, Society*. Bloomington: Indiana University Press, 1989.

Muir, Hazel, ed., *Dictionary of Scientists*, New York: Larousse, 1994.

Munce, Howard. *Drawing the Nude*. London: Pitman; New York: Watson Guptill, 1980.

Nacenta, Raymond. *The School of Paris: The Painters and the Artistic Climate of Paris Since 1910*. New York: Alpine Fine Arts, 1981.

Naumann, Francis. *Making Mischief: DADA Invades New York*. Exh. cat. New York: Whitney Museum of American Art, 1997.

Nead, Lynda. *The Female Nude: Art, Obscenity and Sexuality*. London: Routledge, 1993.

Nemser, Cindy. *Art Talk: Conversations with Twelve Women Artists*. New York: Scribner, 1975.

Neret, Gilles. *Tamara de Lempicka, 1898–1980*. Translated by Michael Scuffil. Khöln: Benedikt Taschen, 1993.

Newton, Esther. "The Mythic Mannish Lesbian: Radclyffe Hall and the New Woman." *Signs* 9 (1984): 1017–49.

Nicholas, Lynn H. *The Rape of Europa: The Fate of Europe's Treasures in the Third Reich and the Second World War*. New York: Knopf, 1994.

Nochlin, Linda. *Women, Art, and Power and Other Essays*. New York: Harper and Row, 1988.

Nowicki, Ron. *Warsaw: The Cabaret Years*. San Francisco: Mercury, 1992.

Olivier, Fernande. *Picasso and His Friends*. Trans. by Jane Miller. New York: Appleton-Century, 1965.

Olszewski, Andrzej. *An Outline History of Polish Twentieth-Century Art and Architecture*. Warsaw: Interpress, 1989.

Ozenfant, Amedée. *The Foundations of Modern Art*. New York: Brewer, Warren and Putnam, 1931.

Ozenfant, Amedée, and Charles-Edouard Jeanneret. *La peinture moderne*. Paris: G. Cres, 1925.

Paderewski, Ignace Jan, and Mary Lawton. *The Paderewski Memoirs*. New York: Charles Scribner's Sons, 1938.

# Bibliography

Parker, Rozsika. *The Subversive Stitch: Embroidery and the Making of the Feminine.* New York: Routledge, 1984.

Parker, Rozsika, and Griselda Pollock. *Old Mistresses: Women, Art and Ideology.* New York: Pantheon Books, 1981.

Paz, Octavio. *Essays on Mexican Art.* Trans. by Helen Lane. New York: Harcourt, Brace Jovanovich, 1993.

Pepper, Terence. *Dorothy Wilding: The Pursuit of Perfection.* London: National Portrait Gallery, 1991.

Perloff, Marjorie. *The Futurist Moment: Avant-Garde, Avant Guerre, and the Language of Rupture.* Chicago: University of Chicago Press, 1986.

Perry, Gill. *Women Artists and the Parisian Avant-Garde.* Manchester, Eng.: Manchester University Press, 1995.

Perry, Gill, F. Frascina, and C. Harrison, eds. *Primitivism, Cubism, Abstraction.* New Haven: Yale University Press, 1993.

Perry, Gill, and Michael Rossington, eds. *Femininity and Masculinity in Eighteenth-Century Art and Culture.* Manchester, Eng.: Manchester University Press, 1994.

Petteys, Chris. *Dictionary of Women Artists: An International Dictionary of Women Artists Born Before 1900.* Boston: G.K. Hall & Co., 1985.

Pipes, Richard. *A Concise History of the Russian Revolution.* New York: Knopf, 1995.

Pollock, Griselda. *Vision and Difference: Femininity, Feminism, and Histories of Art.* London and New York: Routledge, 1988.

Potter, Hugh M. *False Dawn: Paul Rosenfeld and Art in America, 1916–1949.* Ann Arbor, Mich.: U.M.I. Research Press, 1980.

Putnam, Samuel. *Paris Was Our Mistress: Memoirs of a Lost and Found Generation.* New York: Viking Press, 1947.

Raynal, Maurice. *Modern French Painters.* Trans. by Ralph Roeder. New York: Tudor, 1934.

Reed, John. *Ten Days That Shook the World.* New York: International Publishers, 1934.

Richardson, John. *A Life of Picasso.* Vol. II: 1907–1917. New York: Random House, 1996.

Rolley, Katrina. "Cutting a Dash: The Dress of Radclyffe Hall and Una Troubridge." *Feminist Review* 35 (1990): 54–66.

Rose, Jean. *Modigliani: The Pure Bohemian.* London: Constable Press, 1990.

Rosinsky, Therese Diamand. *Suzanne Valadon.* New York: Universe, 1994.

Rotem, Simha (Kazik). *Memoirs of a Warsaw Ghetto Fighter: The Past Within Me.* Trans. and ed. by Barbara Harshav. New Haven: Yale University Press, 1994.

Roussier, Francois. *Jacqueline Marval, 1866–1932.* Grenoble: Didier Richard, 1987.

Ruehl, Sonja. "Inverts and Experts: Radclyffe Hall and the Lesbian Identity." In *Feminism, Culture, and Politics,* eds. Rosalind Brunt and Caroline Rown. London: Lawrence and Wishart, 1982.

Ryan, Alan, ed. *The Reader's Companion to Mexico.* Orlando, Fla.: Harcourt, Brace and Company, 1995.

Sachs, Harvey. *Rubenstein: A Life.* New York: Grove Press, 1955.

Schama, Simon. *Citizens: A Chronicle of the French Revolution,* New York: Knopf, 1989.

———. "Homer's Odyssey." *The New Yorker* (July 15, 1996): 60–63.

Schimmel, Paul, and Judith Stein. *The Figurative Fifties: New York Figurative Expressionism.* New York: Rizzoli, 1988.

Scruton, Roger. *Sexual Desire: Philosophical Investigation.* London: Weidenfeld & Nicolson, 1986.

Secrest, Meryle. *Between Me and Life: A Biography of Romaine Brooks.* Garden City, New York: Doubleday, 1974.

Shattuck, Roger. *The Banquet Years: The Arts in France 1885–1918.* New York: Harcourt, Brace, 1955.

Sieniarski, Stefan. *Sport in Poland.* Warsaw: Interpress, 1972.

Silverman, Deborah. *Art Nouveau and Fin-de-Siècle France: Politics, Psychology and Style.* Los Angeles: University of California Press, 1989.

Slatkin, Wendy. *Women Artists in History from Antiquity to the 20th Century.* New Jersey: Prentice Hall, 1985.

Solidor, Suzy. *Fil D'Or.* Paris: Les Editions de France, 1940.

Souhami, Dianna. *Gluck: Her Biography.* London: Pandora, 1988.

Spackman, Barbara. *Fascist Virilities.* Minnesota: University of Minnesota Press, 1996.

Steiner, Wendy. *The Colors of Rhetoric: Problems in the Relation Between Modern Literature and Painting.* Chicago: University of Chicago Press, 1982.

Suleiman, Susan Rubin, ed. *The Female Body in Western Culture: Contemporary Perspectives.* Cambridge: Harvard University Press, 1986.

Sutherland, Ann, and Linda Nochlin. *Women Artists: 1550–1950.* Los Angeles: Los Angeles County Museum, 1976.

*Tamara de Lempicka de 1925 à 1935.* Exposition Galerie du Luxembourg. Paris: Galerie du Luxembourg, 1972.

*Tamara de Lempitzka: mostra personale.* Milan: Bottega di Poesia, 1925.

Teitelbaum, Matthew, ed. *Montage and Modern Life: 1919–1942.* Cambridge: MIT Press, 1992.

Thormann, Ellen. *Tamara de Lempicka: Kunstkritik und Künsterinnen in Paris.* Berlin: Reimer, 1993.

Tibol, Raquel. *Diego Rivera: Illustrator.* Mexico City: Direccion General de Publicaciones y Medios, 1988.

Tolstoy, Leo. *Anna Karenina.* Trans. by Constance Garnett. Cleveland: World Publishing, 1946.

Tompkins, Calvin. *Merchants and Masterpieces.* New York: Henry Holt, 1989.

———. *Duchamp.* New York: Henry Holt, 1996.

Troy, Nancy. *Modernism and the Decorative Arts in France: Art Nouveau to Le Cobusier.* New Haven: Yale University Press, 1991.

Turner, Jane, ed. *The Dictionary of Art.* New York: Grove Press, 1996.

Van der Marsk, Jan, et al. *In Quest of Excellence: Civic Pride, Patronage, Connoisseurship.* Exh. cat. Miami: Center for the Fine Arts, 1984.

Vergine, Lea. *L'Autre moitie de l'avant-garde.* Paris, 1982.

Volkov, Solomon. *St. Petersburg: A Cultural History.* New York: Free Press, 1995.

Vollard, Ambroise. *Recollections of a Picture Dealer.* Trans. by V. M. Macdonald. New York: Dover, 1978.

Vorobev, Marevna. *Life in Two Worlds.* London: Abelard-Schuman, 1962.

Wagner, Anne Middleton. *Three Artists (Three Women): Modernism and the Art of Hesse, Krasner, and O'Keeffe.* Berkeley: University of California Press, 1996.

Wakefield, Dan. *New York in the Fifties.* New York: Houghton Mifflin, 1998.

Warnod, Jeanine. *Suzanne Valadon.* Naefels: Bonfini Press, 1981.

Weiss, Andrea. *Paris Was a Woman: Portraits from the Left Bank*. San Francisco: Harper San Francisco, 1995.

Wheeler, Kenneth W., and Virginia Lee Lussier, eds. *Women, the Arts and the 1920s in Paris and New York*. New Brunswick, N.J.: Transaction Books, 1982.

Wolf, Reva. *Andy Warhol, Poetry and Gossip in the 1960s*. Chicago: University of Chicago Press, 1997.

Wood, Paul, et al. *Modernism in Dispute: Art Since the Forties*. New Haven: Yale University Press in conjunction with The Open University, 1993.

Wright, Cobina. *I Never Grew Up*. New York: Prentice Hall, 1952.

# ACKNOWLEDGMENTS

The kindnesses of people to whom I was often a stranger allowed me to bask in those luxuriant moments that bring to life a biographer's elusive subject —only for her to fade back into the ghosts of history, when the living quite rightly demanded priority over the dead. At the risk of absentmindedly omitting names important to this book—and to its author—I acknowledge gratefully the following, who rendered help of a bewildering variety:

Raymond Abner, Iran Amin, Jim Austin, Betty Bennett, Shari Benstock, Sandy Bresler, Royce Burton, Olga Campbell, Mary Carroll, Leo Castelli, Whitney Chadwick, Scott Charles, David Cohen, Yvette Cohen, Janet Cohn, Judy Cope, Drew Crispen, Ella D'Agostina, Kim Davenport, Michael Daves, Pattie Davidson, Norman Davies, Richard Davies, Stefano Pignatelli de Cerchiara, Clement Dekler, Michael Diamond, Arielle Dombasle, Garreau "Manha" Dombasle, Michael Dressman, Tony Duquette, Leah Erickson, Betty Ewing, Barbara Fairfield, Richard Farr, Suzanne Ferris, Cathleen Fleck, Franz von Hohenlohe, Barry Friedman, Alvin Friedman-Kien, Karen Gannett, Joan Gayley, Dalia Giladi-Mckelvie, Françoise Gilot, Elizabeth Gimbel (Canta Maya), Ida Glezier, Louisanne Kuffner Glickman, Jeff Goldenberg, Marga Goldwasser, Agnes Gund, Hananiah Harari, Joanne Harrison, Robert Hewell, Anne Holmes, Lucero Isaac, Benzion Jacobs, Andrzej Jaroszynski, Philip Jason, Wolfgang Joop, Andrew Kozlowski, Elizabeth Langland, Jaroslaw Lasinski, Carol Leadenham, Alexander Lempicki, Adam Lerner, Shirley Littlejohn, Harry Lloyd, Kent and Leyla Lopez, Laurie McGahey, Jim Mahoney, Alina Magnuska, Kristine Mansky, Nadine Markova, Bruce Marine, Paula Marsili, Maxine Messenger, Scarlett Messina, Diane Middlebrook, Alexander Molinello, Françoise Dupuis de Montaut, Mary Mortensen, Cecelia Myers Whitehouse, Ed Nate, Jane Owen, Eva Pape, Roger Pearson, Debra Pesci, Richard Piro, Robert Piro, Kizia Pontiakowska, Mimi Poseur, Michael Rabinowitz, Henry Radoff, Abbas Raza, Elizabeth Rees, James Riggs Jr., Larry Rivers, Robert Rosenblum, Mala Rubenstein Silson, Deborah Rubio, Larry Russell, Jeanclaire and Allen Salsbury, George Schoenbrunn, Otto Scholz-Forni, Martin Shallenberger, Jane Sharp, Richard Siegman, Ray Simpson, William Simpson, Sally Sloan, John Son, Seymour

Stein, Christina Stelljes, Stephen Stifter, Connie Stutters, Cristophe Tant, Jan Thompson, Anne-Marie Warren, Jack Wasserman, John Wayne, Robert West, Lynn Wexler, Richard White, Rosemary White, Robert Winer, Joseph Wittreich, Krystyna Wolanczyk, Marjery Wolf, Muriel Wolgin.

*Institutional Acknowledgments:* AP/World Wide Photos; Beaulieu-sur-Mer City of Commerce; Carnegie Mellon Art Institute; Museum of Modern Art, Paris; Clark Library; Crédit Lyonnaise, Paris; The French Embassy, Washington, D.C.; Hoover Institute Archives, Stanford University; Leeds University Russian Archives, Leeds, England; Los Angeles County Museum, Los Angeles; *Los Angeles Times*, Los Angeles; The Louvre Museum, Paris; Lucerne Chamber of Commerce, Lucerne, Switzerland; Mary-Anne Martin Gallery, New York City; Milwaukee Art Museum, Milwaukee; Montgomery County American Red Cross, Maryland; Mormon Geneological Society, Silver Spring, Md.; Musée de Beaux Arts, Montreal, Musée de Nantese; National Museum of Women in the Arts, Washington, D.C.; *New York Herald*, New York City; Philadelphia Museum of Fine Arts, Philadelphia; The Polish Embassy, Washington, D.C.; Rice University Art Gallery, Houston; Ritz-Carlton Hotel, New York; The Russian Embassy, Washington, D.C.; *San Francisco Examiner*, San Francisco; The Swiss Embassy, Washington, D.C.; U.S. Department of Justice (Immigration and Naturalization), Washington, D.C.; U.S. Naval Academy, photo lab, Annapolis, Md.; University of Southern California Alumni Office, Los Angeles; University of Texas Art Museum, Austin; Yale University Art Museum, New Haven.

I greatly appreciate the sponsorship of this project from 1994 to 1996 by NARC (Naval Academy Research Council) and its leaders Carl Schneider and Reza Malek-Madani, a group that believes that professors teach future admirals best when funded to pursue their own quixotic interests; and I thank chairmen of the English department at the U.S. Naval Academy, Charles Nolan and Michael Parker, who energetically and loyally sought that funding at every turn. In addition, the research librarians at Annapolis went far beyond the call of duty; besides providing insights on untapped lines of inquiry, they were genial and patient regardless of the increased workload that resulted. Barbara Breeden, and especially Flo Todd and Katherine Dickson, deserve my deepest gratitude. My students, too, proved both energetic and insightful in talking about my subject, far from their own interests of the

moment. Most of all, they taught me about grace under pressure, and I am grateful.

For providing resplendent hospitality over the past five years, even when their patience had finally expired, and hours of priceless conversation, even after they had long tired of the subject, I thank Victor Contreras, Richard White, Nadine Markova, and Larry Russell in Cuernavaca and Mexico City; and for places where I could hunker down, whenever deadlines pressed too tightly or when I needed a base away from home, Cyril Prieur in Paris, Garreau Dombasle in Deauville, the Lempicka family in Houston, Joe and Rosemary Blaney in Woodstock, N.Y., and various friends in Baltimore, Mt. Airy, and Annapolis.

I am particularly grateful for my good fortune in finding the two best research assistants in the world, Ph.D. art history students Elissa Auther and Maria Day. Quick, creative, smart, supportive, efficient, sophisticated: What more is there to ask for? I know that one day I will be quoting from their authoritative research: Elissa on the hierarchy of art and craft in the 1960s and 1970s; and Maria on the Omega workshops in the London decorative art movement.

They would join me in agreeing that anyone working on a book about Tamara de Lempicka inevitably encounters Alain Blondel, who singlehandedly has done more to forward her career than any other person. He has been unstintingly helpful to me, answering quickly my frantic queries about dates and sales, and granting patient interviews, in person or on the phone, whenever I needed a thoughtful exchange of ideas on our mutual subject. His recently published catalogue raisonné, the result of twenty years of work, will allow serious scholarship on Lempicka to proceed from a solid foundation.

In more general ways, special thanks for intellectual support is due Arthur Danto, who encouraged me to continue this project when I badly needed an expert's enthusiasm, and who gently but frankly told me when my early efforts went badly astray; Michel Witmer, for his unfailing generosity in tutoring me in the ways of the art markets and auctions, and in histories little limned by the conventional texts; John Wayne and Gianbattista Brambilla, both of whom talked to me of all things Italian, though translated into English, through their rich courtesy; to Bruce Fleming, for his tireless rereadings of chapters and translations of tricky French passages, whenever and wherever, however outrageous my needs proved, and for his unconditional friendship that fueled such efforts; to Krystyna Wolanczyk, who immediately responded to my every concern, from forming Polish plurals to

her memories of Tamara's family; to the thoughtful and gentle Octavio Paz, for motivating "serious scholarship" on his friend, though, sadly, he died before he could read the final product; to my agent, Robert Levine, and his partner, Peter Thall, for their consistent encouragement, their patient reassurances, and their creative resolutions of problems; to Annetta Hanna, my editor at Clarkson Potter, whose vision sustained this project when others lost faith, and who went far beyond the usual call of duty in allowing me to shape and reshape multiple versions of the manuscript, each one bettered by her unflagging efforts; to Donna Ryan, the copy editor who sensitively caught errors I thought I had surely never committed; to Vincent La Scala, the incredibly efficient production editor, whose patient and energetic to and fro was indeed productive; and to Jane Treuhaft, whose book design outstripped even my own heady fantasy.

Tamara's family—Chacha, and especially Victoria and Kizette Foxhall—were wonderfully generous in sharing their time, memories, and archives with me, in spite of their reservations about having their matriarch's life cross-examined. They have enjoyed some of what I have unearthed and wished I had remained silent about other discoveries, but in any event, they have withstood admirably my inconvenient pursuit of truth these past five years, and the often painful memories that journey resurrected for them. I hope they feel they have gained more than they have lost by indulging the intrusiveness that biography demands.

Finally, I thank my own family, the joyous last task for any writer lucky enough to be indebted to their love, patience, and encouragement; here is the space where language inevitably announces its limitations. My mother, Mary Powell, and my sister, Marybeth Butdorf, their faith a constant in my life, were materially and spiritually present until the end, as they have been in all my endeavors. And the support of my mother- and father-in-law, Fay and Samuel Oppenheimer, who have bolstered my spirits every time they were in danger of sinking, is all the more remarkable because they sustained me during times of deadlines and challenges of their own, which they managed with extraordinary grace and aplomb. My children were unfailing in their support, wise and encouraging and loving in ways that inspire happiness and awe on a parent's part. Ian and Geof, my older, thoughtful generation of artist sons, shared insights along the way—Ian even rewriting a

passage here or there, always intelligently, to show me what he thought needed doing; and Colin and Devon, my little ones (at least when I began), accepted the laptop as part of every vacation for too many years, sympathized aloud with my worries, and fed the dogs without complaining. Perhaps most impressive, they finally learned not to be embarrassed at the art in our home, ultimately even gently reprimanding their less enlightened (five years ago) friends who giggled at the underdressed portraits on our walls.

Still, as is always true when marriage is a gift, I owe my greatest gratitude to my husband, Dennis Oppenheimer. One morning at the breakfast table, noticing my pleasure at the *New York Times* reproduction of Lempicka's *Adam and Eve*, he urged me to become acquainted with her work firsthand. Remembering the 1991 exhibition of Polish women artists that he, but not I, had seen, he reminded me that Lempicka's paintings had left nearly everyone gaping in astonishment. As such things inevitably go, this innocent spousal camaraderie returned to haunt the pattern of his days for years to come. Unfailingly patient in his belief that this book was worth writing, in spite of the noxious demands it made upon our household, he has made me think about more than I ever thought possible—many worlds, many ways. It is to him, of course, that I dedicate Tamara's story.

# INDEX

*The abbreviation TdL refers to Tamara de Lempicka.*